TRUCKLOAD OF ART

THE LIFE AND WORK OF
TERRY ALLEN

AN AUTHORIZED BIOGRAPHY

BRENDAN GREAVES

hachette
BOOKS
New York

Hachette Books
Hachette Book Group
1290 Avenue of the Americas
New York, NY 10104
HachetteBooks.com
Twitter.com/HachetteBooks
Instagram.com/HachetteBooks

First Edition: March 2024

Published by Hachette Books, an imprint of Hachette Book Group, Inc. The Hachette Books name and logo is a trademark of the Hachette Book Group.

The Hachette Speakers Bureau provides a wide range of authors for speaking events. To find out more, go to hachettespeakersbureau.com or email HachetteSpeakers@hbgusa.com.

Books by Hachette Books may be purchased in bulk for business, educational, or promotional use. For information, please contact your local bookseller or Hachette Book Group Special Markets Department at: special.markets@hbgusa.com.

The publisher is not responsible for websites (or their content) that are not owned by the publisher.

Library of Congress Control Number: 2023951175

ISBNs: 9780306924545 (hardcover); 9780306924521 (ebook)

Printed in the United States of America

LSC-C

Printing 1, 2024

To the Allen family,
whose stories I've harvested,
for their trust.
And to my family,
and our stories still unsown,
for their patience.

We are all re-living the future, consequently . . .
all art is viewed from behind.

—"Prologue," *RING*

CONTENTS

PART III: THE SANTA FE SECTION

INTRODUCTION

Today's Rainbow Is Tomorrow's Tamale

I remember once he was reading this big book on the life of John F. Kennedy . . . and he was furious. He told me he thought the whole idea of biography was pure bullshit . . . some powdered-up, sick, perverted form of necrophilia.

"Look," he said, "I met Jack Kennedy once, and he was an asshole. The guy couldn't keep a normal appointment if it killed him."

—*Bleeder*

WHEN I FIRST VISITED TERRY ALLEN AT HIS HOME IN SANTA FE, IN THE SPRING of 2017, he was working on a piece of art in which to inter his friend Guy Clark's ashes, which, exactly one year earlier, had traveled eighteen hours from Nashville to New Mexico on a tour bus, accompanied by a cortege of family and friends. Terry sat in his south-facing studio, which overlooks mountains through a fringe of cottonwoods, worrying a length of barbed wire with his gnarled fingers, bending it and straightening it, examining its rusted plaits—he is one of those people whose hands are always busy—while explaining the theoretical procedure of shoving Guy Clark's ashes up a goat's ass.

"He died and left me with a job to do—one last 'fuck you,'" Terry deadpanned in his resonant high-desert drawl. The abiding joke between Clark and Allen, sparring partners and collaborators of three decades who billed themselves on duo tours as Los Dos Rockin' Tacos and thrived on their competitive bouts of wit and volleys of works-in-progress, was

that Allen would cast a bronze goat and install Clark's remains in its rear. After Guy's death on May 17, 2016, Terry, faced with the reality of his friend's request for his earthly form to be incorporated into a sculpture, reconsidered, settling instead on a treble-sized coal-black crow, eventually completed in 2018. He titled the funerary piece *Caw Caw Blues*. Its feathers pebbled with Clark's silver-gray cremains, which Allen poured into the molten bronze at the foundry, it resides in the Witliff Collections of Texas State University in San Marcos, while a smaller brother (sans cremains) perches on a fountain on the patio of Allen's home.

In his final years battling lymphoma, Clark had become preoccupied with two crows' nests discovered in a windmill and displayed in the collection of the American Windmill Museum, in Allen's notoriously windswept and tornado-prone hometown of Lubbock. Woven from scavenged scraps of barbed and baling wire, they seemed the perfect symbolic incarnations of, and poetically pertinacious responses to, the harsh flatlands habitats of West Texas. Clark struggled fitfully to write a song about this ripe metaphor and its corvine architects, periodically reciting lines to Terry in person or on their regular phone calls. "It got to where every time I'd see him, he'd talk about those nests," Terry told me. "It was like an obsession." But he could never finish the song to his satisfaction or famously high standards—due to his declining health, but, also, Allen suspected, due to the forbiddingly morbid subtext of legacy-leaving that the nests represented.[1]

The fixation was also aesthetic. "He loved that they built those nests so beautifully out of almost nothing," Allen remembered. "Just like a song." Terry was talking about his friend, and about mortality, but he was also describing his own protean artistic process. The sentiment and the sculpture itself—the final collaboration between friends beyond the veil—are apt metaphors for Allen's life's work, which generously joins music, visual art, and theater and often enjoins friends and family to collaborate, in the service of exploring the strange terrain of memory, of conjuring indelible stories, horrific and hilarious alike, out of the howling West Texas wind, by whatever means necessary.

I KNEW ALLEN first not through his work or reputation but as a disembodied voice over telephone lines, slashing the miles between Santa Fe

and Philadelphia with that knife-sharp West Texas accent. In 2003, when I was twenty-five, I began working at the Fleisher/Ollman Gallery in Philadelphia, where Allen had exhibited in 1994. In the gallery's back room, an enormous bloodred drawing of the eponymous Panhandle Texan prostitute whose real-life Depression-era diary inspired the play *Chippy* leered from the stacks, savage and rigorous through dark nebulae of pastel and charcoal marks.

Occasionally Terry called the gallery to chat with my boss, John Ollman. I was often the one to pick up the phone and transcribe his affectionately biting and amusingly colorful insults and imprecations for John. Allen always had an anecdote or a question for me; he laughed and cussed a lot. His speaking voice, the keen Lubbock accent exotic to my Eastern ears, rolled low and long, like an alien wind. Our telephone conversations gradually veered away from gallery business.

For my birthday one year, John asked Terry to mail his entire discography to me. Previously, I'd known Terry primarily through John's tales: how quickly Allen and his cohort could drain a bottle of whiskey, or how the only time John has felt actual fear at a musical performance was after witnessing Terry hurl a keyboard to the ground, smashing it into shrapnel. John often quoted Terry's song "Truckload of Art" to my friend and colleague William Pym and me, who together drove many such trucks down many highways, occasionally breaking down, and once, terrifyingly, searched by Homeland Security at the Holland Tunnel while transporting sculptures made of missile shells and human remains (the work of family art collective TODT, not Allen). We never ran off the road and caught fire like in the song, but we came close a few times, like when our art-packed U-Haul sprang a fuel line leak in the Appalachian foothills of West Virginia, not far from where Terry's father began his baseball career.

There in the gallery, I began poring over this mysterious pile of albums, each a world unto itself. Even without the context of the expansive body of related artwork, *Juarez* (1975) first hit me the hardest. At once inviting and impenetrable, elegant and raw, prayerful and profane, immediate and cryptic, it offered an elliptical distillation of everything I loved about American vernacular music and contemporary art alike, while remaining unknowable, oracular, resistant to the tired apparatus of criticism, which felt puny and impoverished beside its recursive

haunting. ("Talking about art," Allen once wrote, "is like trying to French kiss over the telephone.")

Terry's music, and his deeply imbricated visual art and theater pieces, as I followed those braided rivers upstream toward their headwaters, opened a frontier for me. Beyond the rich imagery and sonics—and the lapidary language that undergirded both—I appreciated the uncompromising stance Terry seemed naturally to assume, somehow shouldering through the various contorted, classist strata of art and music, writing and theater, with graceful disregard for precedent and position, perennially reinventing himself and challenging provincial desires to genrefy or to police spurious and artificial borders between modalities of art.

TERRY ALLEN OCCUPIES an utterly unique position straddling the disparate and usually distant worlds of conceptual art and country music. I'm not sure that you could say the same about anyone else, ever, and certainly no one with the same aplomb, acclaim, and prestige in each discipline—not to mention the same lacerating, self-effacing sense of humor about it all. That's not to say that his work fits comfortably into either of those normative forums, because it doesn't, really; it's far too unwieldy and rangy, willfully unconcerned with fashion and specious cultural hierarchies. For over fifty years, Allen has dedicated himself to ignoring, and even relishing, such distinctions, confounding popular perceptions of contemporary art and country music and the traditional mutual alienation of their respective core audiences. His wide-ranging and border-crossing career reveals important insights about interdisciplinarity and collaboration—most notably with actor and writer Jo Harvey Allen, his wife and creative partner of over sixty years—bridging and belying the widening divisions that define and distort American culture and politics, now more than ever. As Allen sometimes quips, "People tell me it's country music, and I ask, 'Which country?'"

Much of that cold-blooded independence can be attributed to his upbringing. Born in 1943 and raised in Lubbock, Texas, just two generations removed from the Civil War, Allen is the only child of a professional baseball player turned wrestling and music promoter father and a barrelhouse piano player turned cosmetician mother. He grew up ringside and sidestage, serving drinks and watching legends like Ray Charles, B. B. King, Elvis Presley, Hank Williams, and Gorgeous George perform.

Over the course of a celebrated career that dates from his graduation from the Chouinard Art Institute (now CalArts) in 1966, Allen has unflinchingly dissected the contested histories and cultural collisions of the American West (and the American imaginary) through his interrelated visual, sonic, and theatrical bodies of work. His ductile and often darkly humorous storytelling across numerous media—encompassing musical recordings, mixed-media drawings, prints, sculptures, large-scale installations, theatrical productions, videos, radio plays, prose, and poetry—both typifies and transcends the limits of traditional narrative structures, demonstrating the mutability of his American, and often specifically Southwestern, mythologies. Over the last nearly sixty years, Terry has opened a space as vast as his native Llano Estacado on which to stage his exploratory campaigns into unnavigable oneiric narratives of history and desire—and our desire for history.

Allen's adventures in art and music, from the mid-1960s through his recent renaissance, offer a fascinating alternate, or parallel, history of American artistry. It is a history in which established geographies and genre barriers do not hold—in which a song can also be a sculpture, and a play can spring forth from drawings—in which an unlikely confluence of Californian conceptualism and Texan country-rock challenges our preconceptions about the limits and borders of expressive culture, the longevity and productivity of artist marriages and creative partnerships, and what one artist can accomplish in one lifetime. He has generally operated as an outlier, a cult artist acclaimed and claimed by influential friends and substantial fan bases but occupying the margins—sometimes by choice, often by necessity. He has manifested a Zelig-like ability (though decidedly active rather than passive) to orient himself with ease within the slipstream of popular American culture—in proximity to, respected by, and in collaboration with more famous artists whose names populate mainstream histories of art and music—all while doggedly pursuing an uncompromising and singularly multivalent artistic practice distinct from, and often contrary to, prevailing currents.[2] In doing so, he has managed to generate his own propulsive countercurrents and eddies, inspiring and mentoring generations of younger musicians and artists, especially in recent years.

"Today's rainbow is tomorrow's tamale," Allen announces at the end of side A of *Juarez*. This gnomic metaphorical pronouncement—perhaps

the most enigmatic koan by a master of aphoristic wisdom—has capti-
vated and confused his fans, including me, for decades. What might it
mean? What does it suggest about time, about hope, about sustenance,
about the transformative power of art? Terry won't tell, claiming even he
isn't certain.

Allen thrives in this mode of ambiguity; as moving, frightening, and
naked as his work can be, it's never entirely clear what is (auto)biography
or fiction, memory or dream, deadly serious or cruel joke. ("If it isn't a
lie," he once claimed about songwriting, "it's probably satire.") Boundar-
ies between story and symbol are effaced and blurred—those categories,
like genres and media, interpenetrate and collapse. These distinctions
are irrelevant to Allen; for him, as he has often told me, "the truth" (if
there exists such a solemn, tedious thing) "is multiple," residing among
those very ambiguities, those mysterious vectors of meaning that define
the totality of the work. Or, again, in his words: "Art is the shortest dis-
tance between two question marks."

Allen's art is essentially narrative and folkloric in nature, permuta-
tions of his idiosyncratic storytelling idiom. Much of it concerns the
instability of memory, the ways in which our memories—the stories we
tell ourselves and each other—are dynamic and disputed. He has pro-
posed a trinity of identities and voices he perceives within every great
artist: the criminal (the artist must break rules), the child (the artist
must exercise their innocence), and the lunatic (the artist must function
on another plane of experience and consciousness). Each of these fig-
ures, significantly, interrogates and bends the "truth" in various ways to
serve his own ends. "There is no difference," Terry has written provoca-
tively, "between the 'real' and the 'imaginary.'"

Allen is untroubled by the way accumulated folklore—disseminated
both by himself and others—bleeds through his stories. He finds the
unstable contingency of memory, the constantly evolving nature of the
stories we tell ourselves, the way they accrue baroque details or erode
to skeletal nubs over time, a source of both morbid curiosity and per-
verse humor. The mirages and ravages of memory, its half-life and rate
of decay, the fragmented ways we remember and are remembered—he
titled his recent autobiographical series of drawings, texts, and a video
installation *MemWars*—are his essential subject matter, refracted kalei-
doscopically through a multiplicity of media:

Memory is pretty much the ultimate fiction . . . even when you take notes. There are just way too many vantage points at any given time to say THIS IS THE WAY IT WAS or THIS IS THE WAY IT IS. . . . THESE ARE THE WAY IT WAS or THESE ARE THE WAY IT IS seems a better way of putting it. PLURAL.[3]

He took a *lot* of notes.

I believe that Allen's art is not so much *about* remembering as it *is* remembering, an untidy record of the iterative act itself, the ritual exercise of private and public remembering—in galleries, on stages, outdoors, in the air (on wings of song), and, most elementally and comprehensively, on paper. A prolific and disciplined keeper of methodically annotated journals, notebooks, workbooks, and songbooks dating back to 1960, Terry has habitually drafted and developed the story of his own life and work in the paper laboratory of these many thousands of pages, sometimes returning to ideas originally ventured in inchoate form decades prior. Time erodes, attenuates, and effaces our memories; it can also transpose, magnify, and amplify them. Terry's art inhabits the spaces between those distortions and fabrications and their effects on us. For Allen, the erosion of our memories gives them texture, abrading them into some essential, ambiguous, and potentially more universal and seductive artifact, like sea glass.

I STAYED IN touch with Terry after moving to Chapel Hill in 2006 to pursue a graduate degree in folklore at University of North Carolina and first interviewed him that year for an essay I wrote for Bill Ferris's class on Southern music. Terry sent me catalogs and a mixtape containing his 1992 radio play *Reunion (a return to Juarez)*, accompanied by some of his favorite Tex-Mex, Tejano, and country music—*música de la frontera*—on which he had scrawled the title "BORDER BURN." I persisted in periodically badgering him about reissuing his albums on vinyl. Finally, he relented. Since 2015, in my capacity as a founder and owner of the record label Paradise of Bachelors, we have been collaborating closely on a campaign to reissue his music within the context of his visual and theatrical art. The process has involved in-depth archival research and countless hours of interviews and oral history recordings with Allen, his family members, and his myriad friends and associates.

For the past nine years or so, we've talked on the phone regularly, often weekly, and the relationship has grown into a friendship. It's been an honor, what Terry's longtime musical partner Lloyd Maines calls "dream work," to undertake these massive restoration and reframing projects.

Although Terry is the greatest and most compelling storyteller I know—an artistic alchemist capable of turning rainbows into tamales and back again and making you believe it—most of his stories remain untold in print. In the summer of 2018, he asked me to help tell them. Guy gave Terry a job to do, the work of memorializing; Terry has given me one in turn.

This is, of course, fertile but treacherous territory for a biographer. Allen himself has tackled the absurdities and conflicts of biography and autobiography throughout his work. As the characters in *Dugout* reflect about aging and memory: "Your life just turns into a bucket full of stories, with a little bitty hole in the bottom. . . . Or a bucket full of holes, with a little bitty story in the bottom." In *Bleeder*, the inscrutable eponymous character candidly assesses "the whole idea of biography" as "pure bullshit, some powdered-up, sick, perverted form of necrophilia."

So here we go, through the little bitty hole in the bottom of the bucket, into the terra incognita of what Allen has mapped as the "geography of memory," into the wilderness of bullshit and necrophilia—deep into the real and the imaginary.

PART I

THE LUBBOCK SECTION

The past moves faster than a grassfire
An tomorrow can't come another day too soon

—"Late 1961 (or the 3701 28th St. Cowboy Blues)"

CHAPTER 1

INNERMISSION

Hide in a movie
You can't tell
If you're on the earth
Or in a diving bell
I've been in the dark all of my life
Waiting for the wake of the red witch

 —"Wake of the Red Witch"

ON THE NIGHT OF FRIDAY, OCTOBER 16, 1959, WHEN THE WORLD DISLOCATED and his childhood disintegrated, he was standing in line in the lobby of the Arnett Benson Theatre at 105 University Avenue in Lubbock, Texas, waiting on a nine o'clock screening of *Tamango*, a movie about which he knew nothing but the musky whiff of scandal promised by an eighteenth-century slave ship setting and its racially and sexually charged poster depicting Dorothy Dandridge ravaged by Cürd Jurgens.[1] The film itself was largely irrelevant, another excuse to escape from home and its nascent hauntings. Most Fridays, since his father had taken up residence at Methodist Hospital on Main Street and his mother's behavior had become progressively more erratic and nocturnal, found him retreating to this very place and posture: a date beside him, his unruly curls, prone to frizz despite their still respectably conservative length, tamed with pomade, wearing his best striped button-down shirt, heavy glasses over hungry eyes, and a wide, wild grin, at once roguish and infectious.

 The boy studied the crowded choreography of the film posters, considering their outlandish promises, their busy Californian collisions of

stylized sex and violence trapped beneath the glass of their frames. He'd been to California once with his parents, but he knew there was more to it than what he had seen through the narrow glass of the Hudson's windows and the few disjointed details his mother had told him of her years there. One day, he told himself, he would return to the place that had produced those posters and the stories they sold. As he squinted, his broad, scarecrow shoulders cocked forward in a raw-boned hunch, as if anxiously angling into an indistinct future (a restlessness inherited from his barrelhouse piano player mother, for whom the barren South Plains offered no anchorage) and somewhat belying his height (a stature inherited from his ballplayer father, before his sinewy, battered body had withered into its current wasted shape, curling like yellowed paper). He was sixteen years old, a sophomore at Monterey High School, where he had recently begun to practice the roles of sardonic malcontent and fledgling beatnik to increasing institutional infamy. His father was seventy-three and sick in his bones. His mother was fifty-five and sick in other, more obscure ways, deeper and less tangible than bone. Strangers sometimes mistook his father as his grandfather, which filled the boy with seething, clenched rage—out of a rigid adolescent sense of honor and protectiveness (from the implication of his father's more imminent mortality) but also the self-conscious knowledge of his family's oddness, their obvious difference. When deployed as a deliberate taunt by other kids, this generational misidentification had on certain occasions provoked him into graceless but mercifully succinct fistfights.

Fixated on the film posters, chewing on popcorn, he didn't hear the phone ring—no one listens for the phone in a movie theater, it occurred to him later, we're all anticipating imminent transport elsewhere—but he did hear a jittery usher page him, speaking his name through loudspeaker crackle that cut through the lobby murmur. He startled, swallowed, excused himself, and stumbled to the ticket booth, consumed by creeping, chest-deep dread. Ruth Hanus, a family friend, was on the line. She had an accent—Lithuanian, they said, but how would he know—and sometimes worked for his father as an usher at Fair Park Coliseum. Her brooding husband, Frank, a member of the same Shriners temple as the boy's father, walked with a limp, because (they said) he'd been tortured by Nazis, a fact that never failed to impress West Texans, toppling the

ramparts of their natural xenophobia. Tonight Mrs. Hanus's voice sounded stranger than usual, aching somewhere behind her accent. She told him that his friend Jo Harvey Koontz—whom the boy would marry two and a half years and a lifetime later—had told her where to find him. He and Jo Harvey had planned to meet up at a party after the movie. He'd been looking forward to it.

"He's gone," Mrs. Hanus said. "Your daddy just passed away. I'm sorry. You better go home now and wait. There are a lot of things your mother has to tend to. Lot of papers to fill out."

He made some sounds in reply—"OHHHHHH," he wrote later, "I guess I better go"—blindly handed off the phone, waded through a shoal of pitying stares, and found himself sitting at home alone, though he would later forget how he traveled those three miles southwest. His mother did not come home for a long time. In a sense, she never completely returned; at least she never returned complete.

In his brief time on earth, which had already begun to feel as interminable and monotonous as the High Plains horizon, his teenage ennui writ large across the desolate landscape of the Llano Estacado—an interminably flat, semiarid mesa larger than the state of Indiana that spans eastern New Mexico and northwestern Texas—other giants had fallen around him, and he had felt the sere earth shudder.[2] On New Year's Day 1953, the city had collapsed into a zombie stupefaction of mourning for Hank Williams, found stiff with rigor mortis in his Cadillac in Ohio (the boy would one day make art about that). His father had been the one to bring Hank to Lubbock to play; the boy had watched him, spellbound, as he had watched so many others shake his dad's stages. Just eight months ago, fellow Lubbockite Buddy Holly, seven years the boy's senior, whom he hadn't known personally but had admired sufficiently from afar to emulate his style, wearing copycat glasses, had died in a plane crash in Iowa. (Few in his hometown seemed to notice or care much until quite later, when Holly's legacy had been established; the boy himself had even lost a fifty-dollar bet with a classmate against Buddy ever having a hit, based solely on the handicapping fact that he attended rival Lubbock High School.) But the sudden emptiness this time, the raw lack, despite its bitter foretaste through years of his father's illness and rapid decline, was seismic in its impact, isolating in its suffocating closeness. It was a new kind of wound, a new

kind of loss. That Friday he began a slow, agonizing slide through the different absences his parents left that night, leaving those two black doors to recede behind him—his father's shut forever, his mother's ajar, its sliver of light gradually dimming—and emerging through the aperture of another life, another world.

CHAPTER 2

BLOODLINES I (BASEBALL):
A GREAT HIGH AND FAMILIAR ARC

Oh my mother
She is a mountain
And her breast
It touch the sky
And my father
He is a river
Running through her
Sweet bye and bye

——"Bloodlines I"

DUGOUT, ALLEN'S BODY OF WORK THAT EXPLORES HIS PARENTS SLED AND PAULINE
Allen's remarkable lives and his own childhood, begins (in conception)
and ends (in chronology) with that September day in 1959 when his
father died, a defining hinge in his life. But Terry would not embark on
this interdisciplinary speculative history until the early 1990s with the
radio play *Dugout.*[1] He returned to *DUGOUT* in earnest a decade later
with a series of exhibitions and performances, and he would not put the
project to rest until 2005, with the publication of the eponymous book.
Terry's traumatic teenaged experience of his father's death—the Arnett
Benson, the funeral, the ongoing ache and anger—never features explic-
itly in *DUGOUT.* His own perspective manifests through the composite,
generic character of Warboy (also known to his befuddled parents as
Whatsit), and the death itself is rendered obliquely, but powerfully, as a
private moment between Sled and Pauline (or rather, the anonymous

"He" and "She" characters).[2] After holding on long enough to watch the World Series on television, His soul follows a "great high and familiar arc" out of His body that echoes—telescoping back into time—the thousands of pitches and fly balls He caught in a long career as a baseball catcher.[3]

In *DUGOUT*, Allen chronicles the saga of his family and its lineage in lyrical and dramatic, if elliptical, fashion and with much fictionalized embellishment, embroidery, and infill. Allen himself has described the *DUGOUT* cycle as "a love story, an investigation into how memory is invented, a kind of supernatural-jazz-sport-history-ghost-blood-fiction that rolls across the late nineteenth century into the mid-twentieth century."[4] The title refers to five family "dugouts" mentioned in the cycle: the frontier dugout home, "stuck half-in and half-out of a small Oklahoma hill" in which Allen's mother was born in 1904; a supposed Civil War veteran ancestor's harrowing tale about spending three days in a blood-flooded trench; the baseball dugouts Sled inhabited for years; the Satin Dugout, a fictional Denver speakeasy; and implicitly, everyone's graves. The tales unfold kaleidoscopically and nonlinearly through every medium at the artist's disposal—poetry, drawing, sculptural installation, theater, radio, and music—typifying his range across disciplines. Eschewing strict biographical or historical research, he wrote expressionistically, almost entirely from the stories his parents and relatives had told him, inventing episodes and dialogue to flesh out the patchy mise-en-scène, riddled as it was with missing information. His scraps of knowledge and narrative extended only to his paternal and maternal grandparents, which, given the age of his parents when he was born, was roughly equivalent, in chronological reach, to the average person of his generation knowing something about their great-grandparents. Sled and Pauline effectively "skipped" a generation by having children at their age, fifty-six and thirty-eight, respectively, giving Terry an unusual proximity and access to the past but one that receded quickly into oblivion, with many family elders long dead or unable or unwilling to remember. "The moment the present ends, and memory begins," Terry has observed, "it becomes fiction."

DUGOUT is explicitly about the propinquity and precarity of that history and those memories. It is a mature work by a middle-aged artist stitching together the rags of the past and allowing the process to repair

him reciprocally. But the closer you look, the clearer it becomes that Terry's life and art alike have always been haunted by family history and by memory's failing ever adequately to reconstruct or rehabilitate the collective and personal stories that we deploy to define ourselves. And so a thorough accounting of Allen's ancestry is critical to an understanding of his life and art, including but far beyond the bounds of *DUGOUT* itself.

ALLEN'S GRANDPARENTS' AND great-grandparents' lives were implacably shaped by war and restless westward migration. Despite, or perhaps because of, upheaval and relocation, the two sides of the family shared similar milieus and often inhabited identical landscapes, sometimes as near neighbors. Pioneers and border-crossers to a person, they were, by and large, rugged agrarian hillfolk of the Ozarks and Appalachia—people often denigrated as hillbillies—from communities cast in the fastnesses and dappled folds of mountain hollers, the topographical opposite of the Llano Estacado.[5] Terry's maternal grandmother, Nancy Cora Pierce (1876–1942), known as Cora, born in Howell County, in southern Missouri, was the twelfth of thirteen Tice children. His paternal grandmother, Mary Ann Allen (1854–1927), also born in Howell County, was the eighth of thirteen Galloway children. The two women and their large families may have been acquainted, though their grandchildren would meet by chance on a railroad platform far away in Amarillo, Texas, unaware of any prior family connections. Those Missouri-Arkansas borderlands remained sparsely populated then, a thickly forested wilderness of Osage, Quapaw, and settler hunting grounds at the wild fringe of what European Americans condescendingly deemed civilization, the "jumping off" point for westward frontier expansion.[6] Howell County did not even exist as a recognized governmental entity until three years after Mary Ann Galloway was born. West Plains, the county seat, was only incorporated three years before Sled was born there in 1886.

Samuel Allen (1854–1916), Mary Ann's husband, Sled's father, and Terry's grandfather, was born one of sixteen siblings, half siblings, and stepsiblings to David Allen (1812–1856), hailing from Orleans Parish in Louisiana, and his second wife, Angeline Strong (1820–1885), of Tennessee, on February 3, 1854, in Scott County, just north of the Missouri Bootheel, in an alluvial floodplain situated in the northern reaches of

the lower Mississippi Delta, near the confluence with the Ohio River at Cairo, Illinois.[7] Family lore, amplified graphically in *DUGOUT*, holds that Samuel served as a Confederate soldier in a Tennessee volunteer regiment during the Civil War, traumatized into silence by a battle fought in "a dugout dirt trench full of blood up to his chin"—when he emerged, "he seen more human guts layin' in the dirt then they was blades of grass"—alongside his fellow Confederate "baby brothers" who "warred for the cause" and against three brothers who served in the Union army. Missouri was one of four border states that did not secede and harbored both Union and Confederate allegiances, often within the same communities and families. After much bitter debate, the state narrowly adopted an official (and schizoid) position as proslavery but also pro-Union, although the reality, in homes and hollers, was much messier and bloodier. "Day they left, they stood right out there in town road solemn as preachers and shook hands," explains Mary Ann to her son Sled in *DUGOUT* (though Allen gives none of the characters proper names, only pronouns). "Shook hands and went off different directions to kill one another . . . brother 'gainst brother. Them was dark days." She goes on to tell how Samuel's father, the David Allen character, was so disturbed by the family schism, his own household Civil War, that he killed his wife and then himself, shooting her in the heart and himself in the mouth.

The historical evidence for the veracity of these tales is inconclusive. Since Samuel Allen would have been only seven years old at the 1861 outbreak of the war, only nine two years later, when his two half brothers Benjamin Franklin (1834–1898) and Cyrus Jefferson Allen (1837–1867) enlisted in the Confederate and Union infantries, respectively, and eleven when Robert E. Lee surrendered at Appomattox, it seems unlikely that he saw action as a regular combatant, especially in Tennessee, where the closest battle of consequence was over a hundred miles from his home. He might, however, have served in some other military support capacity more accommodating to children and requiring less physical strength, fortitude, and endurance—as a musician or messenger, for example. As for the murder-suicide, David Allen died in 1856, years before the dawn of the war; his widow, Angeline, survived until 1885; and her subsequent preacher husband, Thomas Carpenter (1824–1901), Samuel's stepfather, lived until 1901. Regardless of the precise mathematics of murder and fraternal and filial strife, such

internecine tensions certainly would have irrevocably riven the Allen and Carpenter families.

According to his front-page obituary, when he was eighteen, in 1872, in the ragged wake of war, Samuel moved five counties west, a thousand feet higher, and deeper into the frontier to Howell County, Missouri, up on the Ozark Plateau by the Arkansas border. Seven years later, having become "prominent in political and religious affairs" of the county as a staunch Baptist, he married local girl Mary Ann Galloway.[8] Samuel and Mary Ann settled in the tiny hamlet of West Plains, Missouri, Mary Ann's hometown.

Scraping a living out of the Ozark soil and its vast, dense forests was brutal and unforgiving work. Like virtually everyone else they knew, Samuel worked primarily as a farm laborer, likely as a tenant farmer or sharecropper, and Mary Ann kept house and assumed the bulk of parenting their considerable family in their rented home. Oscar James Allen, known as Ott, was born in 1880 (d. 1953), followed by William Samuel, who went by Willie or Bill, in 1883 (d. 1940). Middle child Fletcher "Sled" Manson Allen was born in West Plains on August 23, 1886, nearly five years before Roy (1891–1986), the youngest brother.

Regardless of his father's direct involvement or lack thereof, Sled was born into a border community still grotesquely scarred by the Civil War and its death spasms of vestigial violence. West Plains, so close to the border between the Union and the Confederacy, had, like Scott County, been ravaged by guerrilla warfare and nearly burned to the ground. Many had fled after Confederate brigadier general James Haggin McBride declared martial law and ordered all Union sympathizers to enlist in the Confederate army, and by the end of the war, nine out of ten residents of the overwhelmingly white Howell County had completely abandoned it.[9] That devastation, violence, and depopulation would have been palpable and visible, as great ruptures and voids on a denuded landscape, and viscerally present in the memories of neighbors who remained through the relentless raids by Red Leg and jayhawker vigilantes or returned to their charred properties after the war.[10]

Fletcher earned the nickname Sled from his older brothers, a teasing tribute to his massive feet. They did far worse than tease, so the nickname stuck; it was a mild and amusing indignity amid a childhood rent by violence. In 1899, when Sled was thirteen, after an arduous, weeks-long trek

by covered wagon, the Allens found themselves 350 miles west in Okla-
homa, in a township called Geary, lying on the border of brand-new Blaine
and Canadian Counties, northwest of inchoate Oklahoma City. Both
Blaine County and the state's future capital had only recently been named,
as a result of the Land Run of 1892, which opened the Cheyenne-Arapaho
Reservation to white settlement, and which, along with several previous
and subsequent land rushes and auctions between 1889 and 1895, may
have provided an impetus for the Allens to relocate under the heady spell
of "Boomer" fever.

THE STORIES THAT Sled told his son in their sixteen years together were
nearly all marked by brutality. Livid bruises on his life, he shared them
unsentimentally, not to glorify the violence itself or to wallow in the
barbarous details, but to illustrate the worlds, ancient and arcane even
to his own son, through which he had passed and because the stories
explained how he arrived, through long trial, to his position of promi-
nence in West Texas. Terry relates some of these stories in *DUGOUT.*
 When Sled was six, in the summer of 1892, he told Terry, his father,
Samuel, threw him "in a great high arc through the air" into the Missouri
River, the Big Muddy, a sink-or-swim lesson in survival. When, in *DUG-
OUT,* he crawls up the muddy bank panting and choking, his father com-
ments, "Whatever happens now . . . the li'l sum-bitch can swim." (The
Missouri River is 160 miles north of West Plains, so it seems likely the
immersion might have happened in a tributary closer to home.) Two
years later, at age eight, in the midst of a blizzard outside their Missouri
farmhouse, his neck "swollen big as a bucket" from tonsillitis, his father
and his older brother, probably Ott, held Sled down while a country doc-
tor shoved a burning poker "slow and deep into his throat and burn[ed]
out his tonsils," blistering his mouth shut for weeks and indoctrinating a
taciturn nature. "After that," Terry writes, "he never said more than he
had to." A popular, and particularly gruesome, bedtime story for Terry
as a boy concerned Sled's childhood dog, whom he found dead one day,
tangled in a barbed wire fence, its legs "gone green and big as gourds."
One of his older brothers, again likely Ott, claimed to have found the dog
that way, but Sled never believed it, "because his brother was a damn
born liar and had also hated the dog anyway." Sled's anger at his broth-
ers festered into his adulthood, and as a result, Terry barely knew his

two surviving uncles or their families. (Bill, the only brother for whom Sled maintained affection, was allegedly decapitated in a car wreck in 1940.)

DUGOUT credits an older brother for explaining to Sled—or the He character—the function of a catcher's mitt, which their father brings home as a curious novelty one day during the summer of 1895, having traded a plug of tobacco for it. The Pa character, Samuel, who grew up in a world without baseball, is unsure what the mysterious artifact might be, perhaps a cushion or some kind of hat: "He tried out various other speculations on it . . . none of which worked worth a damn." Sled cottoned to the game quickly, learning the rules with his brothers (who claimed it was invented by Thomas Edison) and beginning to play that very summer after seeing his first game at a church social. He wasn't a fast base runner—his gangly six-foot-one-inch frame and namesake giant feet didn't help—and never was much of a hitter either, but he had a powerful arm and excelled as a catcher. "He knew he could do it," Allen writes in *DUGOUT*, "and he knew it beat hell out of farming." In an extraordinary act of will, he broke with his family's long tradition of subsistence agriculture to light out for the territories, pursuing a life in sports and entertainment. Throughout the convolutions of his long and patchwork careers, which until after Terry was born and he achieved financial security necessitated backbreaking supplemental work to scrape by, he always defined himself as an athlete first and foremost, his core identity inhering in his body and what it could withstand. "Whatever else happened in his life," Terry has said, "he was a ballplayer."

Sled played his first professional games in 1908 for the Wheeling Stogies, a West Virginia minor-league team, but ended the season in Enid, Oklahoma, with the Class-C Railroaders of the Western Association (they were so impoverished a club "they only had one baseball," Terry exaggerates in *DUGOUT*). In the major-league draft of September 1, 1909, he was selected by the St. Louis Browns, a dream come true. He debuted at first base on May 4, 1910, against the Cleveland Naps, but transitioned to playing primarily as a third-string catcher. After appearing in a grand total of fourteen games for the appallingly bad Browns, the losingest team in the league, his major-league career ended unceremoniously on August 5, in yet another loss to the Philadelphia Athletics.

He completed the 1910 season back in the minors, as a catcher for the El Paso Mavericks—"Sled appeared in a Mav. uniform which was about three sizes too small for the large one," reported the *El Paso Herald*, "but such catching!"[11]—after which his contract was purchased by the Class-A Louisville Colonels, for $300 a month.[12] In 1911, he joined the Class-B Houston Buffaloes of the Texas League, "the meanest of them all," remaining until 1916, his longest tenure as a player and, at twenty-nine years old, the end of his career as a strictly professional player. His brother Roy joined him as a Buffaloes pitcher in 1914, winning 141 games, often playing with Sled as a fraternal pitcher-catcher duo, including one game in which Roy pitched eight straight no-hit innings with Sled behind the base.

The informal country baseball that Sled encountered as a boy was not only alien to him but also, as Terry describes in *DUGOUT*, abstract—procedurally, spatially, and conceptually—compared to today's game. (A corresponding *DUGOUT* drawing renders the baseball diamond as a levitating black charcoal form, like those of Russian Suprematist painter Kazimir Malevich.) The dugout itself had only recently been introduced, and the rules were still being codified. Sled blamed his .130 batting record with the Browns on his inability to hit within the confines of the newfangled foul lines. It was also a far more savage game, with players whose itinerant existences resembled the rough-and-tumble lives of carnies. Once when a wild pitch smashed into a batter's throat, crushing his larynx and causing him to collapse in convulsions, Sled leapt up from behind home base, yanked out the man's tongue, and harpooned it beyond his lips with a pencil to prevent him from swallowing his own tongue. He died anyway, "purple as a turnip," and they finished the game.

Baseball took a grim toll on Sled's body. "All his fingers were broken a hundred times, but he stayed in the game," Allen writes in *DUGOUT*. "That's the only way the game is played . . . with heart and for blood. Nobody made any money." In 1913, while playing for Houston, Sled was beaned on the head, and his skull was fractured. Terry has described the sense-memory of holding Sled's large, calloused hands in church as a child; they'd been so repeatedly wrecked and splintered that they felt like "oak knots on a gnarled tree trunk." By the time Terry was old enough to demonstrate any serious interest in sports, his father was no

longer physically able to participate without pain, so the two played backyard catch together only rarely.

While playing for Enid and still living with his family in Geary, Sled met Viola Catherine Short (1891–1943), who had been born and raised Catholic in St. Louis but was living in Oklahoma City. They were married in Oklahoma County on September 28, 1910; he was twenty-four and she was twenty. Their only child, Fletcher Manson "Manse" Allen Jr., was born in Houston on June 30, 1913 (d. 1980), while Sled was with the Buffaloes, nearly thirty years before his half brother Terry would arrive.

After Sled's final contract with Houston was not renewed in 1916, he appears not to have worked in baseball for five years, and when he returned to the sport on a semipro basis, he had to seek piecemeal jobs off-season to make ends meet. During this difficult period, and again during the Great Depression years, he exhibited a remarkable versatility and persistence with his ever-changing pursuit of gainful employment, leaving his wife and child to hop freight trains from town to town to find sundry work as a carpenter, at hardware stores, and for three nauseating days, at a pork slaughterhouse (he never ate bacon again). By 1921, the young Allen family had moved to Polytechnic, Texas, outside Fort Worth, and Sled was working as an auditor for an oil-refining company.

The next year the Allens relocated to Lubbock, where Sled helmed the Class-D Lubbock Hubbers for their inaugural 1922 season and quickly established himself as a genial and admired fixture of Panhandle culture. A March 31 article in *The Lubbock Avalanche* announced that "Skipper Sled Allen" and his teammate, third baseman Elmer "Gobe" Gober, had purchased the Busy Bee Café, one of three such establishments in town. "Baseball will be the first consideration," Sled reassured local fans, "for that is what we're here for, and we are certainly going to give our best efforts to that."[13] He achieved some of his greatest athletic successes with the Hubbers, whom he led to victory at the Denver Post Tournament—known as the "Little World Series of the West"—in 1925, winning the Spalding Trophy. Manse served as a bat boy.

In late October 1927, on its front page, the *Amarillo Globe* congratulated "Fighting Sled Allen" on his appointment as skipper of the brand-new Amarillo Texans of the Western League, who almost always lost to their Lubbock rivals due to their superior "leadership and pitching force."[14] The job separated Sled once again from his family; he moved

the 125 miles north to Amarillo several months before they did. For the next fifteen years Sled embodied the road-dog ethos of Terry's "Amarillo Highway," "makin' speed up old 87" between Lubbock and Amarillo as he moved back and forth for work. The satisfactions of a new player-manager position in a new town were brief. Sled's mother, Mary Ann, died on December 12 in West Plains, where she had returned after Samuel died in 1916; Viola's mother passed away in Kansas City, Missouri, two months later; and the Texans only survived one more season before dissolving. Despite his disappointment, and a brief return to Lubbock, the family stayed in Amarillo for five more years, forcing Sled to diversify yet again. In late February 1928, he opened a "spare rib boarding-house" in the Carter Hotel in Amarillo, catering to ball players; he apparently even intended to serve as chef, with the *Globe-Times* reporting on his grocery-shopping trips.[15] He and Viola took on roles as comanagers of the Hillcrest Golf and Country Club in Amarillo (Sled later was also affiliated with the club of the same name in Lubbock). With Sled presiding over its annual golf tournament, Manse excelled at the game, becoming a star at Texas Tech and one of the finest golfers in the region. In 1931, Sled began to dabble in the promotion of area wrestling matches, which would gradually become his chief occupation as he moved away from baseball and into entertainment, from one form of theater to others.

After seven years in the wilderness of Amarillo, the prodigal Allens returned triumphantly to Lubbock in June 1933. They moved right back into their home at 2020 Eighth Street, and Sled resumed his old job as manager of the Hubbers. In October, having recently been issued "a professional wrestling promoter's license by the state department of labor," he also assumed management of a venue called the Auditorium, a "local fight hall . . . formerly known as the Uptown Dance Palace, the indoor pavilion and amusement center located on North Texas Ave."[16] The *Avalanche-Journal* quoted his plan to hold indoor sporting events, classes, dances, wrestling, and—with partner promoter Dee Puckett—boxing matches in this "place of good, clean entertainment where anybody can feel at home and enjoy the program."[17] It was very much a family business. Viola managed the financial side of the enterprise, "keeping books, handling publicity, and selling tickets,"[18] with a side hustle peddling "pedigreed Scottie and wire-haired terrier puppies, priced reasonable"

out of their home.[19] Manse worked as an usher. On Christmas 1938, the *Avalanche-Journal* ran a Christmas card from the Auditorium—"We take this opportunity to thank our friends and customers for past favors"—prominently listing Sled, Viola, and Manse's names.[20]

As the business grew, Sled switched venues several times over the next two decades. The original Sled Allen's Arena, which opened on June 5, 1935, was an open-air lot at Thirteenth and Avenue F.[21] For several years in the late 1930s and early 1940s, he leased a shuttered Pentecostal church building at 924 Thirty-Fourth Street. After World War II, he briefly booked wrestling matches at a location out on the Slaton Highway and at Jumbo Webster Park, a softball field by day. In addition to weekly Wednesday-night wrestling cards, Sled began to book concerts and dances, sometimes on his own or in collaboration with other concert promoters, charging fifty cents for tickets to see the likes of Bob Wills's Texas Playboys and Paul White's Orchestra.[22]

As a sportsman éminence grise and one of the foremost entertainment entrepreneurs and impresarios of the Panhandle and West Texas, Sled was a well-recognized and well-respected figure in Lubbock and Amarillo throughout the 1930s. But the Depression years were lean even for such a relatively celebrated personage, and he was cobbling together odd jobs to provide for his family until at least the mid-1940s. The 1940 census lists him not as a promoter but as "operator, golf course" at Lubbock's Hillcrest Golf and Country Club.

In April 1942, Sled was back in Amarillo once again, beginning a short tenure, as the *Amarillo Globe-Times* put it grandiosely, as "venerable business manager of the Amarillo Gold Sox," another young Class-D team in the West Texas–New Mexico League, and moonlighting at the Amarillo Hardware Co.

MANSE, STILL LIVING at his parents' home at age twenty-seven, was working as a geologist for oil companies, including the Honolulu Oil Corporation of Midland, his employer when he registered for the draft in 1941, in the wake of Pearl Harbor. On Christmas Eve 1941, Manse married Eleonora Elizabeth Sokol (1908–2002), five years his senior, born in the German immigrant town of Schulenberg, Texas. When Manse was discharged on November 29, 1945, after two years of service as a gunner, including action at the Battle of the Bulge, he returned home to Lubbock,

his hearing permanently damaged by artillery fire and his body convulsed by epileptic seizures. His mother was dead; his father had remarried a woman only four years older than his own wife; and he had a two-year-old half brother named Terry, the same age as his own son Sammie (1943–1995), named after his Missourian great-grandfather.

CHAPTER 3

HOLD ON TO THE HOUSE

Ahh stand in the Den
Stand in the Bath
Make your stand in the Living Room
If you can stand to call it that
But you better HOLD ON
Better HOLD ON . . . TO THE HOUSE

—"Hold On to the House"

DUGOUT DESCRIBES A VIVID MEET-CUTE: "HE'S A LOT OLDER, BUT SHE LIKES his big open grin. 'Hi there, sunshine,' she says. Instead of going on where they were going, they go to supper. They like each other's hands."

The reality was rather darker and more desperate. Sometime in the summer of 1942, with the headlines screaming of war, Sled and Pauline met on the platform of the Santa Fe Depot, Amarillo's Mission Revival–style railroad station. He was just shy of fifty-six years old, and she was about to turn thirty-eight; both had August birthdays. They caught each other's eyes through the clarifying, brassy sunlight slanting onto the stucco and vibrating off the tracks, moving deliberately in the thick heat under the slim shade of the red-tiled roofs. The attraction was instantaneous and palpable, unsettling them out of their interiority and wounded hesitancy.

Pauline and Sled found each other at extraordinarily vulnerable, damaged moments in their respective lives. Both sought in Amarillo a city of refuge from their crumbling realities, a place to escape the unresolved anguish of their pasts. Perhaps they sensed in each other,

standing there, together but alone on the baking platform in the high incandescent light of summer, their mutually unsteady demeanors, their weak and watery shadows floating unmoored over the brick paving like their attenuated and tattered souls. Pauline had recently returned to Amarillo in retreat after her second divorce ended in a maelstrom of alcoholism, jealousy, and abuse. Although he had begun working in Amarillo baseball again, Sled was technically still a registered resident of Lubbock, sharing his longtime home on Eighth Street with Viola. In fact, he was living a shadow life alone at the Ross Hotel in downtown Amarillo, and the Lubbock house stood empty.

Contrary to the timeline in *DUGOUT* and to what Terry has always believed based on the fragments of information his father reluctantly shared about his previous life and first family, when Sled and Pauline first met, Viola was not "recently dead" of throat cancer. Since March 1941, she had been institutionalized at Big Spring State Hospital, a psychiatric facility one hundred miles south of the home she and Sled owned in Lubbock. One year, nine months, and ten days later, on January 3, 1943, at age fifty-one, she died there of what the newspapers euphemistically referred to as "paralysis" but was in fact general paresis. Also known as general paralysis of the insane or paralytic dementia, general paresis is a severe degenerative neuropsychiatric disorder that can result in deterioration of mental and physiological functions, dramatic personality changes, delusional behavior, and psychosis. The proximate cause of general paresis is untreated syphilis—or, as Viola's death certificate more clinically and archaically calls it, "lues," officially diagnosed, in her case, three years earlier. When she finally passed away, Viola was likely physically incapacitated and bedridden as well as inexorably psychologically transformed and likely incoherent, if she was able to communicate at all. She may have suffered from chancres and grotesque physical, and particularly facial, disfigurement. Present in her hospital room in her final moments were her only son, Private Manse Allen, on emergency family leave from Camp White, Oregon, as well as Sled and his brothers Oscar and Roy. The end of her agony must have come as a relief to her family.

Sled moved back to Amarillo just weeks after committing Viola to Big Spring, adding more than a hundred more miles between them. He found solace with Pauline, whose vivacity, energy, glamor, sense of humor, and

musical talent—as well as her mercurial temperament, sometimes erratic behavior, and emotional precarity—were as intoxicating to him as the straight vodka she habitually drank. Two broken and bereft people, they guided each other through the wilderness of their sorrow into a new, whole life together.

Their courtship was brief and ravenous; neither had sufficient time or patience to be tentative. They always said they married six weeks after they met. Perhaps they eloped. No marriage certificate exists, however, and Sled and Viola were never divorced; their marriage ended only with her death. While Sled and Pauline's marriage may never have been formally enacted, and in any case would not have been legally binding in the timeframe they recounted—because Sled was still married to Viola—the state of Texas does recognize common-law marriages, so legally speaking, after Viola's death they were indeed married if they represented themselves as such. When Viola died, Pauline was five months pregnant with Sled's second son, Terry.

It is unclear how much Manse and the rest of Viola and Sled's family knew about Pauline initially, but the torturous timing of their affair and pregnancy was eventually either revealed or deduced. Manse and his family forever treated Pauline, and Terry by proxy, with undisguised contempt and resentment when they were unable to ignore or dismiss them entirely. To them, Pauline was, understandably, the interloper and the younger, non-Catholic other woman—and even worse, an unrepentant musician and drinker—who stole Sled away from Viola at the hour of her greatest need, and Terry was the bastard spawn conceived in sin while Viola suffered in an asylum.

In the aftermath of Viola's death, family tensions at a fever pitch, Sled and Pauline fled again, this time escaping to Wichita, Kansas, for several months in 1943. Sled took a wartime production job at the Cessna aircraft factory there, a temporary disentanglement and reprieve disguised as a financial opportunity. Pauline would have been showing, visibly pregnant to anyone who saw her, which must have made day-to-day public life in conservative Amarillo mortifying for a divorced woman involved with a married man who was a public figure. The 1943 Wichita city directory lists an F. M. Allen living in Burden, with no mention of Pauline, so she may have joined him after he moved or immediately but incognito. According to a May 2, 1943, piece in the *Wichita Eagle*—five

days before his son's birth—Sled had just led his new employer's corporate baseball team, the Cessna Aircrafters, to another victory.[1]

LIKE MANY CHILDREN, Terry grew up in the shadows of his parents, but their shadows were pitchier and more ancient than most. Both parents were performers, albeit in different modes, who lived and thrived in the public eye—Sled on ballfields, on the golf course, at his arenas, and among his communities of Masons and Shriners. His life is extensively documented. Pauline, on the other hand, haunted obscure stages and cinemas, drifting from bar to nightclub to beauty parlor across Texas, New Mexico, California, and Colorado. Little has been documented about her life before Sled beyond the stories she herself told Terry. Pauline lived her life—to borrow a Terryism—"lying low as a snake," living the difficult bohemian life of a female artist of her generation, and limiting her exposure to public record through multiple marriages and name changes.

Terry fell into their lives almost as an alien foundling, the "Whatsit" of *DUGOUT*, manifesting in time to fulfill the final chapter of his father's life and to furnish a fateful hinge in his mother's. In *Warboy and the backboard blues*, the performance that closes *DUGOUT*, the title character first appears on the ramp of a UFO, a 1950s rock-and-roll alien: "His body is painted completely white and he is naked except for blue jockey shorts. . . . He is small and wiry with hair slicked back into a greasy 1950-style ducktail." He keeps time with a basketball, marking the hours until his surrogate father dies and he can return to his planet, tracing that "high familiar arc" that recurs as an asymptotic curve throughout the story.

ON MAY 7, 1943, at 6:31 a.m., a boy, substantial but unnamed, was born at John Wesley Hospital in Wichita, Kansas, weighing eight pounds, nine and three-quarters ounces.[2] ("Terry Allen was born 'Mr. Baby 1943' . . . World War Two was doing swell and he was the swell," he wrote in 1969 in the liner notes for his first recording, the "Gonna California" / "Color Book" single.) Dr. Everette L. Cooper attended, and the whole deal cost twenty-five dollars. The birth was traumatic for Pauline and did not immediately catalyze any maternal instincts or affection. "God, what a shock," Allen writes in *Dugout*.

It came right out of space . . . out of nowhere . . . right out of vapor. They wouldn't even show it to her for three days . . . then, when they finally did, she passed out on the spot.

It looked exactly like a weird piece of red jelly . . . like it had been pulled out with a pair of pliers . . . or maybe a claw hammer and then beat with it.

It didn't look like anybody in her family . . .

A forceps baby . . . or more like a "spoon" baby.

Kind of a puddle.

The first time she nursed it she couldn't even look.

She prayed deep for vodka.

The idea of a child was unsettling enough at their age . . . at any age . . . but this?

This . . . WHATSIT!

It was a lot closer to a Martian landing than any human birth.[3]

Legally, he was "Boy Allen" on paper until May 10, when they officially settled on the name Terrence Lain Allen. As a bald, bemused baby, he had the wide eyes and searching stare of Pauline but didn't resemble Sled particularly, at least not in any obvious way she could cite in the baby book she kept.[4] (According to public opinion, maybe that was for the best; in October 1942, the *Amarillo Daily News* described someone as "ugly as Sled Allen."[5]) In fact, unlike his half brother Manse, who shared his father's rangy physique and long, slightly gaunt, equine visage—with its flat cheekbones, thin lips, and protruding ears—Terry never grew into a direct resemblance of Sled.

They made the six-hour, four-hundred-mile trip back to Amarillo in Sled's gray 1939 Ford a few times during their exile. Throughout the summer of 1943, the *Amarillo Globe-Times* reported on Sled's whereabouts and his periodic visits home, speculating about the eventual return of the prodigal son and hometown hero. On June 28, the *Amarillo Daily News* mentions Sled, "a resident of Wichita," playing golf at the Amarillo Country Club with his brother Roy.[6] In July the *Avalanche-Journal* announced Sled's grandson Samuel's birth,[7] predicting that Sled would return home from Wichita after the war and claiming that he was considering buying lots of land in Amarillo with fellow ballplayer and professional wrestler Cal Farley, who also employed Sled at his local tire

shop later that year.[8] In any case, in December 1943, they were back in Amarillo and installed at 1613 Goliad—joined by Pauline's younger sister Zevilla (1906–2005), known as Villa, and her husband, Earl Twymann Lynn (1901–1983), known as Uncle Shorty—in time to celebrate their first Christmas with Terry and his first birthday six months later.

After a brief move to 111 East Ninth Street in Amarillo, in early 1945 Sled and Pauline purchased and moved into the home that would haunt Pauline and inhabit Terry's dreams (and, occasionally, his artwork) for the rest of their lives: a one-story, three-bedroom, two-bathroom, 1,750-square-foot ranch house built in 1941 at 1501 South Rosemont Street. Situated on a one-fifth-acre lot on a slight incline, it faces the street shyly, its front door tucked away to the far left of its facade beneath an uneven, asymmetrical gable. Where you might expect multiple windows or a large picture window looking out onto Rosemont Street, the facade is oddly blank and somewhat forbidding, with one small casement cowering at its rightmost edge, as if avoiding the only other aperture into the structure. Though they stayed in this home barely a year, moving in 1945 into a diminutive house on Twenty-Fifth Street in Lubbock, it was here that Terry's conscious memories begin, between the ages of eighteen months and two and a half years old—the final months of World War II.

TERRY'S FIRST YEARS, like most of ours, were shaped largely by his family and environment. In his case, that meant his childhood was at once conventional, situated squarely within the circumscribed milieu of a white, middle-class war baby born on the cusp of the Silent Generation and the baby boomers and raised in conservative West Texas, and exotic, a product of his parents' unusual generational, vocational, and social contexts.

Sled and Pauline existed simultaneously within the culturally and morally narrow confines of mainstream Lubbock society and totally outside that world, within the alternate dimensions of professional sports, music, and entertainment, which trafficked in importing often outlandish and dangerously racialized and sexualized sounds, sights, and corporeal feats from far-flung locales to the ostensibly prudish and sometimes puritanical Panhandle. Although they almost certainly did not plan to have a child when they did, and despite Pauline's lack of

experience with child-rearing, Sled and Pauline wholeheartedly, if cautiously, embraced their new identity as a familial trio. They strove to provide a stable home for Terry, complete with the trappings of the middle-class respectability to which they publicly aspired—if only nominally and somewhat ambivalently—despite the somewhat disreputable reputations of their respective professions. Allen glimpsed evidence of his parents' otherwise effaced past lives when their rowdy ex-colleagues would occasionally invade their house for nocturnal revelry and reminiscence, as recounted in *Dugout*:

> They'd come late at night . . . all through the late '40s and early '50s. They'd come scratching on the screen, pounding on the door . . . shooting fireworks off in the yard. Old ballplayers and old musicians . . . come to tell their stories. She would cook and giggle and play the piano like a house on fire, and they would all sing and drink . . . and talk loud and colorful around the great deep gaps inside of their lives. And when it was over they would all hug each other and cry . . . then get in their cars and drive away. They'd come late at night, turning their memory into a story, until 1955. After that, most of them were dead.

The Allens behaved, superficially, like many other families in Lubbock. Pauline was a member of the Presbyterian Women's Circle, even occasionally hosting meetings. Though their denominational affiliations, determined by Pauline, were rather irresolute—growing up, Pauline attended, and was married in, a Methodist church, and later in life she belonged to the First Baptist Church of Amarillo—the family attended church at Westminster Presbyterian on Sundays.[9] They hosted birthday parties for Terry that were sufficiently socially prestigious, or sufficiently adorable on slow spring news days, to merit mentions, including their kiddie guest lists, for his fourth- through eighth-year celebrations, in the *Avalanche-Journal*. His first friends, April Showers and Bobby Jones, were among the guests at his fourth birthday in 1947, for which he wore a head-to-toe cowboy outfit, including chaps, a leather vest, and holsters, a gift from Sled and Pauline that initiated his lifelong fondness for cowboy boots—even if, as in "Amarillo Highway," he "don't wear no Stetson" (these days he prefers a Borsalino). By that time, the

family had moved to 2118 Thirty-Fourth Street, a street that now faces a busy commercial strip but then remained unpaved.

"AIN'T WE GOT fun?" Pauline asked in a spasm of relieved joy at such conventionally happy moments as Terry's birthdays. She dutifully enumerated, with the besotted detail of a new parent, Terry's milestones and accomplishments in his baby book. At two years old, he was reciting both nursery rhymes and items in a hardware catalog, prefiguring, perhaps, his talents as a lyricist and maker of objects. Sled called Pauline "Big Sugar"; Terry was "Little Sugar" or "partner," like in a cowboy movie. Pauline called Terry "kid," like a film-noir femme fatale.

Despite their ostensibly conventional suburban appearances and impedimenta, in other ways Terry's parents did not behave at all like other parents in their community. "I had a sense of how other kids functioned with their parents," he recalled, "and I always felt I didn't function the same way with mine." From an early age they granted him an unusual degree of independence and lenience, even by the much laxer expectations of the times. He was free to roam the streets from a very young age, and like many only children he "spent a lot of time alone." More debatable by contemporary standards was the total lack of any prescribed or enforced bedtime.

Those late nights facilitated an extraordinary introduction to public performance. At the age of four, as early as February 18, 1948, he was making special appearances at Sled's wrestling matches, which at this point occurred primarily in a warehouse at 606 Texas Avenue in downtown Lubbock. Between matches, the referee would ring the bell, and Terry would bound up into the ring, which was slick with sweat and blood, wearing his cowboy outfit, to demonstrate a variety of outrageous wrestling moves in quick succession, much to the delight and hilarity of the audience, who laughed and shouted uproariously and threw coins. (Or as Terry wrote in 1969, in typically self-deprecating style—and in the third person—"he did zany acrobatics in the ring during intermission at the Golden Glove tournaments and people would throw money at him until he stopped.") On at least one occasion in 1948 he also performed his favorite song, "Signed, Sealed, and Delivered" by Cowboy Copas, a hit that year. It was his first experience with a microphone and his debut as a musician.

He had been practicing the song for a tap-dancing recital at the Lar-rymore School of Dance, where Pauline had signed him up for lessons. The 1909 musical-theater cowboy number "My Pony Boy" fleshed out the repertoire of his first, all-Lubbock tour, shortly after his fifth birthday.[10] A photo of Terry in his signature cowboy getup, grinning tentatively, eyes suspicious, hands on his belt and hat tipped back behind his curls, was reproduced for a postcard and newspaper advertisement for the Sled Allen Arena: "Terry Says: *For Real Entertainment See* WRES-TLING *Every Wednesday Night* at Sled Allen's Arena." To drive home the family nature of the enterprise, and to prevent any confusion between Sled's two Allen families, the photo was helpfully captioned "Terry Allen."

Terry's theatrical and musical activities earned the "born showman" multiple mentions in the *Avalanche-Journal*, including following a match on April 1, 1948—April Fool's Day—in which the reporter praised his ability to imitate "the grunt and groaners" and Terry revealed his uncontroversial opinion that he preferred wrestling to boxing.[11] The paper took to calling him "Terrible Terry" in tribute to Major General Terry Allen, a US Army hero of both world wars, claiming that he "probably does as much to make Sled Allen's arena amusing as any one person"—quite a responsibility for a four-year-old.[12] As an adult, Terry recognized that wrestling introduced him to the dramatic arts, which arguably comprises the axis of all his art (certainly according to his art-critic friend Dave Hickey, who believed that Terry is at the core "a theater person"): "As far as my early experiences with theater, well, wrestling is the last great public theater. It's pure theater; nobody bets on a wrestling match. It has the classic good guy/bad guy tension."

By the tender age of six, Terry was regularly working at Sled's events, selling "Cokes, popcorn, candy, and peanuts every night" as well as the all-important "set-ups": wink-and-a-nod citrus-and-soda fixings intended for surreptitious cocktail mixing in dry Lubbock County: "They dressed me up as a *Hee Haw* idiot.[13] I had a metal Coke holder, a tub with straps around my neck, full of ice and Cokes. . . . I'd sell cardboard buckets with lemons or limes and Cokes, and someone else would haul the ice bucket, because I was so little. Everybody brought their own alcohol and left the empty bottles under the seats." On fight-night Wednesdays, he often worked alongside stoic Manse, who picked up shifts as an usher after

returning home from the war—as if nothing had changed, when in fact everything had changed, on both home and battle fronts, as evidenced by his own ruined body. Relocating to Lubbock brought Sled closer to his business interests and to his older son and grandsons—primary motives for the move, now that Terry had ratified, if not exactly legitimized, his relationship with Pauline. The proximity perhaps felt somewhat less poisonous after the exile in Wichita and the sojourn in Amarillo. But palpable tension festered between his two families, whether Sled acknowledged it or not.

It must have galled Manse, as a grown man and a wounded veteran struggling with hearing loss and epilepsy, to watch his younger bastard half brother, thirty years his junior, assume poster-boy status for the business he had helped his father build. Why wasn't his own son Sammie, Sled's first grandson, in the ring and on those posters? It must have been excruciating, from his perspective, to watch Terry monopolize Sled's time and occupy his new home, his new heart, to behold his father bewitched, corrupted, and unrecognizably metamorphosed by Pauline, Manse's new stepmother only nine years his senior, while his own children were comparatively snubbed. Pauline supplanted not only Viola's role as Sled's wife and Manse's mother but also Viola's position in the family business. The new Mrs. Allen began selling tickets to matches and concerts at Wiley Drugs downtown, a block away from the deposit box where Sled would drop cash revenues from ticket and concession sales late at night after events. She also sold tickets ringside, the smiling face and wry wisecracking mouth of Sled's entertainment empire. Manse and Eleonora's second son, Jimmie (1946–2012), a few years younger than Terry and Sammie, was born with severe mental challenges. Little evidence of Jimmie remains among Allen family ephemera or official records, but his presence likely contributed to the tensions among the two families, not only complicating Manse and Eleonora's home life and compounding their feelings of competition and jealousy but also throwing Terry's golden boy status into sharper relief.

Until 2022, when I informed him what my research had uncovered, Terry remained utterly unaware of the timing of Sled and Pauline's affair and of the nature of Viola's illness. But he retained disturbing memories of his ill treatment by Manse and Viola's side of the family. What then, and thereafter, felt like inexplicable, petty cruelty came into focus as

understandable, and even forgivable, behavior once he was able to con-
sider Manse's position, the visceral pain and betrayal he must have felt.
Pauline and Terry were the obvious scapegoats, deservedly or not, and
unfortunately, Terry, as a child, could not comprehend or exonerate, let
alone respond or retaliate, as Pauline could. Although Terry liked Sam-
mie and considered him a peer, more like a cousin, he was technically
Sammie's uncle, despite being only two months older than him. But an
inevitable imbalance of power and perception created what Terry expe-
rienced as mysterious "friction in the family," dooming their potential
boyhood friendship. The two boys enjoyed their time together at offi-
cially sanctioned, and increasingly rare and overwrought, family gather-
ings, but they were not allowed to play together otherwise. When Sled
would occasionally drop Terry off at Manse and Eleonora's home for
babysitting, they treated him spitefully, like an unwelcome second-class
citizen, or neglectfully, like an inconvenient phantom. "They didn't want
a bastard in their house," Terry realized retrospectively, "so they dealt
with me like I didn't exist." He was ignored, or worse, deprived. They
would serve milk to Sammie but refused it to Terry, who was given, if he
was lucky, a glass of water. He sensed that there was something wrong
but did not understand what he had done to deserve this. At the time, "I
never felt secrecy as much as I just felt stoic about the whole situation,"
he mused.[14]

AS OF 1950, Sled's bifurcated family life mirrored the architecture of his
two Panhandle houses. In February 1949, he and Pauline took out a
mechanic's lien from First Federal Savings and Loan to buy a double lot
and build a new house at 3701 Twenty-Eighth Street, on the corner of
Twenty-Eighth Street and Louisville.[15] The location was out on the west-
ern fringe of Lubbock, which was steadily expanding, creeping into the
immense cotton fields that were then only a few blocks away. The terrain
was flatter than the Rosemont Street rise in Amarillo, but the neighbor-
hoods, both quiet and working-class, were otherwise not too dissimilar,
rigidly gridded and punctiliously rectilinear.[16]

 Pauline had secured the plans for the Rosemont Street house, which
they used to design the Twenty-Eighth Street house. It was identical in
every detail of its floor plan and exterior, though its facade—again fea-
turing that unsettling, reticent blank between door and lonesome

window—was brick instead of siding. The decision to duplicate their prior home may have been purely pragmatic—they knew from firsthand experience that they already liked the design and layout—but much later, Pauline would eventually make an inconveniently protracted move back to the original Amarillo home, revealing a totemic fixation, something approaching architectural obsession. These uncanny twin houses provide a metaphor for the singular strangeness and creativity of Terry's childhood, suspended, in a condition of adolescent awestruckness, between the performative worlds of children and adults, sports and show business, a constant spectator—and aching to leave it all behind. In *DUGOUT III: Warboy and the backboard blues*, Allen traces a memory map of their home's interior, a perfect exemplar of "a typical . . . and absolutely vicious . . . Panhandle Geometry," an insipid symmetry that he reproduced in *DUGOUT II: Hold On to the House*, both sculpturally and in song: "Make your stand in the Living Room/If you can stand to call it that . . . you better HOLD ON . . . TO THE HOUSE."

THE NEW HOUSE was right next to Terry's new school, Overton Elementary, which he attended for six years. He only had to cross an unpaved alley, ride his bike across a field and parking lot, and walk through the front doors. "I was always late anyway," he smiled.

For Terry's eleven years of public education in Lubbock, ages seven to eighteen, the mere prospect of going to school in the morning filled him with revulsion and dread. The only thing that got him out of bed and out the door was imagining pencil on paper, "that great feeling"—the scratching sound, the clean mineral smell, the dull pressure on fingertips as the graphite tip dragged dark, shiny lines across cool white paper, diminishing itself to a sweaty nub in the process, transubstantiating carbon into image, into word, into meaning. "So there was something there," Terry supposed, "some kind of need to make a mark, even from the time I was a little kid."[17] With no enforced bedtime, he was often up—and later, out—late into the night, meaning he was perennially exhausted at school, revived only by art class or baseball, basketball, or football practice.[18] Until he died, Sled was always the parent to wake Terry for school; some mornings he was the only parent present.

As for Pauline, who had "arranged everything in what she called 'The Most Profoundly Baptist Manner,'" as Terry writes of Her in *Warboy*,

"periodically she'd just disappear." That hard "Panhandle Geometry" to which she aspired—both in interior design and psychology—closed in on her from time to time. In *Dugout*, the He character realizes that "the piano in the living room was not enough" ballast to anchor Her at home. She was not, ultimately, able to hold on to the house. At first, Sled, like his fictionalized avatar, alternately panicked and brooded, torturing himself with agonies of distress and jealousy, but eventually he resigned himself to her periodic absences, both physical and emotional. She always came back, sequestering herself in the dark bedroom, offering few explanations but emerging hours, or a day, later from the haze of tobacco smoke, restored and reconstituted to her beautiful, charming, gregarious, put-together self. There were always two Paulines inhabiting those fastidious twin houses. In his age and wisdom, Sled was equipped to cope with two Paulines. After Sled died—and the gulf between his two mothers widened—teenaged Terry was not.

CHAPTER 4

WIND AND DISTANT ENGINES

A vacant see
A vacant sea
A vacant sí
Yeah for you and for me
On the highway

 —"Honeymoon in Cortez"

IN 1541, WHEN THE SPANISH CONQUISTADOR FRANCISCO CORONADO encountered the Llano Estacado, he described the "sea of grass" as limitless, "with no more landmarks than if we had been swallowed up by the sea . . . not a stone, nor bit of rising ground, not a tree, nor a shrub, nor anything to go by."[1] An 1852 US Army field report similarly described the bleak mesa at the heart of the Comanchería, the once-mighty but crumbling Comanche empire, as "a treeless, desolate waste of uninhabitable solitude . . . almost as vast and trackless as the ocean."[2] Neither correspondent was aware that millions of years ago the Llano was indeed beneath a shallow inland ocean, the Western Interior Seaway, or that it had for twelve thousand years hosted dispersed human habitation and hunting—although even among those adapted to survive in this harsh tableland terrain, it was primarily a place to hide, to cross, or to raid without lingering long. Stealing a rider's horse was a death sentence in a barren, unvarying topography that lacked water, shade, and even a natural echo.

The Llano has always been a landscape in which to disappear. In his body of work *JUAREZ*, Allen, a compulsive punner, repeats a three-way

homophonic pun, three "vacancies" that offer a formula for his adolescent perception of Lubbock's landscape of desire and distances—a sea of grass grown over an ancient ocean, a Great American Desert devoid of indigenous visual and cultural stimuli, demanding existential acquiescence to its emptiness:[3]

Vacant See
Vacant Sea
Vacant Sí

As below, so above: there was, in those long Lubbock days of Terry's childhood, an oppressive atmosphere of peril and fear in the air—the actual air, rife with not only freak meteorological catastrophes but also airborne contagions of the viral and chemical as well as the cultural and geopolitical varieties (as Terry puts it, both disease and "dis-ease"). The boundless sky above the Llano contained imminent menaces both natural, like tornados and dust storms, and unnatural, foremost among which was the constant threat of the atomic bomb, as delivered by the wrathful and bewildering Soviet Union. Terry and his classmates, as early as first and second grade, practiced regular atomic bomb drills at school, similar to their tornado drills but more abstract and Disneyfied. They watched cartoons produced by the Federal Civil Defense Administration starring a dopey, Eeyore-ish existentialist reptile in a military helmet named Bert the Turtle, who encouraged them to "duck and cover" if they saw the blinding flash of a nuclear explosion.[4] Terry rehearsed this absurd kabuki of Cold War security over and over, alternating with the similarly prone postures that would supposedly keep him safe from natural disasters. Tornados and dust storms seemed more likely, since he'd seen them sandblast and rend any vertical anomaly on the endless horizon, as if actively enforcing its monotony. But adults warned that either cataclysm could strike at any moment, so he had to be prepared. There were, however, certain aerial phenomena above the Llano for which one could never prepare.

ON THE NIGHT of August 25, 1951, three Texas Tech professors sighted an unidentifiable U- or V-shaped formation of rapidly flying blue-green lights and reported it to the *Avalanche-Journal*. Several more sightings

of these "Lubbock Lights" were reported over the course of the next month, and on August 30, a Tech student managed to capture the UFOs in photographs that have still never been debunked as fakes. A subsequent official air force investigation ventured a prosaic (and preposterous) explanation involving some magical coincidence of vapor streetlights and plovers, which no one in Lubbock believed.

Conspiracy-mongering proliferated among those convinced that if not actual space aliens, it was a secret government project, or perhaps, as Allen ventures in *Warboy*, "Jesus . . . or Russia." On one of those hot late-August nights, Terry was with his parents at the Sunset Drive-In (until 1952 known as the Five Point Drive-In) at the end of Thirty-Fourth Street, at the intersection with Slide Road and Brownfield Highway.[5] While his parents were buying popcorn, Terry, gazing out that "perfect planetarium" of their 1949 Hudson Hornet's curved rear window, witnessed the event itself: "Tiny blue V-shaped lights . . . WHATSITS streaking across the sky!"[6] The family in the next car over peeled off, dust spraying behind them, their daughter's terrified, pale face visible in their own rear window. Driving home from the drive-in that night, the Sled and Pauline characters of *Warboy* are "jittery . . . like this [had] happened before."

THE PRIMARY MENACE of Allen's childhood, however, was something more elemental—the air itself, and how the eerie, elevated flatlands, unwrinkled by topography, twisted and funneled it into destructive shapes that scraped and scoured the land.[7] Terry, like everyone in Lubbock, lived with a persistent, ambient fear of tornados, often freighted with the suggestion of divine retribution. The Allens kept extra mattresses to pile up in the southwest corner of the house, frantically fort-building like kids with couch pillows, and they'd open the appropriate windows to prevent implosion or explosion. At school during drills, students would huddle under their desks, taking advantage of any scrap of shelter, however meager, pathetic, and practically useless. Tornados were long the default Halloween costumes for Lubbockites: "You just wrap yourself up with two hula hoops in a sheet and tape and sew all kinds of junk and shit to yourself, then spin like hell. Only problem is you get dizzy and sick with all that candy."

More common, however, were dust storms, enabled by the ideal conditions on the Llano of near-constant turbulent winds, low relief, lack of

vegetation, and loose caliche topsoil. The most dramatic example hit Lubbock on a Friday afternoon in 1954, the result of three years of accumulated drought. Terry's entire fourth-grade class had been, as he writes in *MemWars*, "suckled and weaned on the awful stories of when the dust came before . . . people eating tumbleweeds, coughing from dust pneumonia until their ribs popped out of their skin, little sick blue babies blowing out of cribs and flying like leaves in the air." The fluorescent lighting popped and fizzled, and the green wall of wind hit the brick walls of the school "like a freight train" that "sounded and looked like the end of the world." His teacher closed the blinds and, in abject terror, at a loss for how to comfort herself and her students, perversely began reading Joel Chandler Harris's Tar Baby stories to the children, querulously declaiming at the top of her voice over the wind and whimpers, her hair "sticking straight out of her head like *The Bride of Frankenstein*," static electricity sparking from her head down her bare arms. The air outside the windows was displaced by a roaring tidal wave of brown plasma, as if a wet brown paper bag had descended over the entire school. As dust filled every nook and cranny of the room, the hysterical, blinded students sobbed, coughed, and prayed together, faces pressed to their desks, wheezing laboriously through wet paper towels, spitting and drooling fine grit.

That night, back at home, still paralyzed by fear, Terry listened to the wind howl and the pyracantha thorns scratch the glass outside his bedroom. The next day, bandanas over their faces, he and his pals reenacted desert military operations like the British Eighth Army's defeat of the German Africa Korps outside Cairo. By Monday, the wind had dissipated, and he was back at his silt-blanketed school, listening to stories of the casualties as he traced lines in the dust still covering his desk, his books, and every other horizontal surface. One kid, taken by surprise on the street, had apparently been blown over while riding his bicycle, cracking his skull open on the curb. "Another kid," he reports in *MemWars*, "climbed up the scaffolding inside the bell tower of the new Church of Christ that was under construction, and the wind blew him off the edge and he fell forty feet to his death on a pile of bricks. Several of us talked about the ins and outs of the religious nature of this last event. Did God do it on purpose because he was messing around in the church before it was finished? . . . 'He was a mean little shit and probably even a Catholic.'"

The 1954 dust storm had been "scarier than polio"—the ultimate metric of fear and paranoia for Terry and his friends. Quarantines were a regular precaution at Lubbock's public schools, and everyone knew someone who had been paralyzed. It was rumored that the virus was spread by minorities and their unsanitary living conditions, which added an even more virulent edge to the racism and institutional and practical segregation of Lubbock. White parents warned their kids to steer clear of Black and Tejano children, and the pool at Mackenzie Park was designated as a particular danger zone to avoid, a cesspool of germs and viral miasma. Terry swam there in the hot summers anyway. (He excelled at swimming, and at nine, he was the youngest kid in Lubbock ever to earn a lifesaving certificate, "which shows how much they know about water in that part of the world.")

The South Plains Fair was held every autumn on a generous sixty-five-acre fairgrounds located at the southwest corner of Mackenzie Park and the western rim of Yellow House Canyon, Lubbock's sole fold on the landscape. (Fair Park Coliseum, where Sled booked his biggest matches and concerts, was part of the same complex.) One year the most popular attraction was the March of Dimes trailer, where, as emblazoned on a banner whipping in the wind, you could "SEE THE GIRL IN THE IRON LUNG!"—a dire augury of what would happen if polio got you. Terry paid his dime and waited in line; as he writes in *Warboy*, "he want[ed] to look polio right in the eye." He took a deep breath and squeezed inside, disoriented for a moment. The mechanical girl was not above him, as on a stage, but below. You had to look down, as if peering into a grave, at the sickly cyborg. Waxy, wan, and only speculatively human, she looked like a priestess encased in a science-fiction bathysphere. It was like visiting some impassive, mute oracle:

> Inside the trailer, there's barely enough room for the big iron spaceship-looking lung, pumping and wheezing with a head sticking out.
>
> When it's his turn, he leans over a tiny rope barrier and looks straight down at the upside-down face.
>
> It's pale as death and never blinks . . . like a zombie in a trance.
>
> During the day, stuff has fallen out of people's mouths while they file through to look at her.
>
> Chili and mustard and cotton candy are splattered all over her face.

After their pilgrimage to the Girl in the Iron Lung, Terry and his friends were frightened into immediate compliance, dutifully lining up for their polio vaccine shots when they finally became available—by that time Terry was in fifth grade—just as they had for the smallpox vaccine.

IN *DUGOUT*, TERRY tells a true story about a classmate who, as a result of his mother taking the tranquilizer Thalidomide during pregnancy, was born without eyes or eye sockets, "just smooth skin stretched across his forehead with a sheet of bone underneath and some hair on top." Most kids embraced him in his difference, and he became "a kind of living canvas"—a real live Disney character—on whom they drew "human eyes, dog's eyes, cat's eyes, Mickey Mouse eyes, Martian eyes. It didn't bother him. . . . He had no concept of what an eye was anyway." He moved away for a few years until junior high, and when he returned, as Terry writes, "he was radically altered":

> They'd broken into his face and made these huge holes and then, in some convoluted partnership between parental country club para-noia and the medical marvels of the day (probably along with advice from the local pastor as well), stuck very spooky large glass supposedly-eye-looking balls inside these holes in his face and then threw some stupid horn rim glasses on top of that. . . . All they really achieved was totally stripping him of his identity and completely destroying the most unique thing anybody ever remembered him by. . . . They just wanted another little puppet.

Exposure to dangerous chemicals was a regular occurrence in that era. Riding up and down Lubbock's barren, dusty axes on their bicycles, Terry and his gang would get "lost in great plumes of white smoke . . . chasing the DDT truck down the alleys." In *DUGOUT*, the Terry/Whatsit character has just emerged from a session of DDT-surfing when his parents tell him about his father's cancer diagnosis.

Young Terry gravitated to outsiders and outcasts. In third grade he befriended Danny Parrish, who suffered from hemophilia, and volunteered to push his wheelchair when he was able to attend school. For *Anterabbit/Bleeder*, his "fictional 'autobiography' of an enigmatic Texas gambler, religious fanatic, possible gangster, magician, and hemophiliac"

modeled on Parrish, Allen explained: "I did a lot of drawings, because one of the things I remember when he was a kid is going to the hospital, and [Danny] would be on his deathbed and giving all his stuff away, all his toys. He would write these wills, and he did these drawings— elaborate, goofy drawings. In a way the drawings that I did were like a child's drawings too, even though they were much more horrific."

THE WACO TORNADO, the deadliest tornado since 1900, hit downtown Waco—like most things, five hours from Lubbock—on May 11, 1953, a few days after Terry's tenth birthday, killing 144 people and injuring 597:

> A tornado had devastated Waco. No telling how many were dead, and a statewide plea was out for blankets and canned goods. . . . I remember . . . hearing this broadcast crackle in from the living room, and outside the wind moaned through the weather stripping, and it sounded like ghosts trying to get inside the house. The whole house moaned like a spook. But that same wind seems to be in every radio show I've made, and in a way, being raised where I was raised, you can't hear a radio without it.[8]

Like many postwar families, for many years the Allens' primary source for home entertainment was radio. They all sat and stared at "the big maple console radio" to absorb their favorite programs from this "box of stories," communally "watching the radio, watching the sounds, anticipating television," which was anticlimactic in comparison. Many of Terry's indelible childhood memories were accompanied by the radio's constant murmur: *The Shadow, Sky King, Sergeant Preston,* and eventually the shows Sled himself produced.

Unlike most kids his age, who relied exclusively on faraway radio stations for their musical exposure, Terry's experience was firsthand— immediate, in-person, and often intimate, backstage at Sled's venues and at makeshift remote radio studios. January 28, 1950, marked the first *Western Jamboree* radio broadcast on KSEL, live from Allen's Arena on Texas Avenue. The country music talent show and weekly Saturday-night concert and broadcast continued through 1953 at the newly christened Jamboree Hall, a derelict hangar at Reese Air Force Base, and featured country stars like Hank Locklin, the Delmore Brothers, the Maddox

Brothers and Rose, and Minnie Pearl, as well as local aspirants like Tommy X. Hancock, High Pockets, Buddy Holly, and Sonny Curtis.[9] On Sunday mornings, the artists who had played the previous night often joined Sled at the John Halsey Drugstore at 2424 Broadway by Texas Tech, where they played, chatted, and pitched their records live on air.

For over a decade, Sled maintained a regular weekly schedule of entertainment: wrestling matches, his bread and butter, on Wednesday nights (and often other nights as well); Black music, mostly blues and rhythm and blues, on Friday nights; and white music, mostly honky-tonk and Western swing but occasionally bluegrass bands or pop orchestras, on Saturday nights. In his final years, he increasingly booked rock-and-roll and soul acts too; ultimately a businessman more than a music enthusiast, he'd book anything that would sell tickets.

Given the harsh climate of segregation in Lubbock, as well as Sled and his partners' and radio sponsors' greater financial investment in the country and western concerts, Terry had more direct access to the white artists his father booked than to the Black artists. But the range and caliber of the legendary figures he saw, across race, culture, and genre, were phenomenal. As a kid born into the business, he naturally took his front-row and backstage access to these musical giants for granted for years, until he eventually started telling his new art school friends in California where and how he came up (sheepishly at first, like many from the middle and south of the country divulge their origins to coastal urbanites, and then with increasing confidence when he saw their awed reactions). On Saturday evenings in the early 1950s, he saw honky-tonk icons Hank Williams and Ernest Tubb at Jamboree Hall. On Friday nights, he managed to catch, among many others, Lowell Fulsom, T-Bone Walker, Fats Domino, and Little Richard, whom he particularly idolized. Terry harbors a dim memory of handing B. B. King ("back when he was 'Blues Boy'") a bucket of ice in the dressing room of Jamboree Hall. He was probably six years old at the time; King would have been twenty-four, bemused by this enthusiastic white kid decked out in his piebald cowboy duds. When Sled booked Jimmy Reed at the Cotton Club—a long-standing, but periodically burnt and rebuilt, Lubbock institution—Terry witnessed the bluesman in a compromised, but still utterly fascinating, performance, assisted by his wife. He recounts the scene in the text of his 2019 drawing *Storm on the Ghost of Jimmy Reed*: "One Saturday night when

it was storming they snuck us into the backdoor of the Cotton Club and let us peek in at him from the dressing room door behind the stage. He was slumped over in a metal folding chair slurring out his deep slow hypnotic heroin groove. . . . A large woman wearing a gold dress and green high heels was standing behind him bent over whispering lyrics in his ear while he was nodding out a harmonica ride."[10]

Pageantry and outlandish fashion were a weekly experience for Terry at Sled's concerts and even more so at the wrestling matches, those exemplars of "the last great public theater." In one of his notebooks, he recalls a particularly memorable blockbuster fight between Gorgeous George and Danny McShane at the Fair Park Coliseum in October 1952. George was then at the peak of his powers and popularity, one of the highest-paid athletes in the world, despite approaching forty years old. Sled and Gorgeous George worked together throughout the 1950s, an unlikely odd couple—the lanky, dour-faced, paternal Skipper and the swollen, vain, golden-tressed "Human Orchid"—and the 1952 Lubbock fight cemented their business and personal bond. Thereafter, every Thanksgiving until Sled died, the Allens received gorgeous tributes in the form of turkeys stuffed with George's signature gold-plated "Georgie Pins."

Terry's appreciation for the flamboyant style and showmanship of wrestlers may be part of the reason why he gravitated more to rock and rollers like Elvis Presley, Little Richard, Chuck Berry, and Bo Diddley than Buddy Holly. (In his surviving early notebooks, he periodically refers to himself as a "heel," appropriating a common wrestling term for a villain, usually in reference to guilt over bad behavior with girlfriends or with Pauline.) But country artists modeled their own enticingly rebellious behavior. On December 4, 1954, Tex Ritter played the Fair Park Coliseum, and there was a loud heckler in the crowd. "Finally he had enough, I guess," Terry chuckled. "He sat down and pulled off his boot, threw it and knocked this guy out cold. He finished the song in one sock, then got his boot and put it back on, all while the band was playing. I was selling Cokes at that gig."

IN *DUGOUT*, ALLEN links rock and roll to the specter of the atomic bomb—for him, the music "really did hit like a bomb" at a very impressionable age, when its evocations of sexuality, violence, and the potential (if not actual) transgression of racial roles and divisions made a

powerful and permanent impact in conservative, segregated Lubbock. In some of Allen's earliest and most formative musical memories, music was articulated with art as well as with the frisson of illicit sexuality. Music, and musicians, could be dangerous, wild wreckers of civilization— especially once rock and roll hit—and the associated images and styles were also salacious and proscribed. For an avid dancer like Terry, rock and roll was the ultimate body music—and completely seductive. At Jamboree Hall he'd often shirk his duties and hide out in a bathroom stall, listening and drawing: "At my dad's dances, I remember hearing that pounding music and seeing these elaborate porno drawings on the bathroom walls—which I later started to draw my own version of in other kids' notebooks, for a quarter—so I guess I always associated making music and making marks as the same kind of act."

The two sensory experiences became inextricable to him: "I always thought that was my first real introduction to music and drawing together, the idea of artmaking in different media at the same time." The pounding throb of a live band's backbeat as heard through rudimentary, often distorted amplification (often an inadequate PA system) and muf- fled through concrete walls, divorced from most of its harmonic and melodic content, was as viscerally somatic and architectural as audi- tory. Accompanying it was a very specific iteration of imagery—the sexually explicit, and anatomically uninformed, drawings conjured and created by sexually inexperienced boys. "I had a brief career as a por- nographer," Terry joked, "though there were several competitors."[11]

IN THE SPRING of 1954, at age sixty-seven, Sled suffered a heart attack, which slowed him down considerably, and from which he never com- pletely recovered. His doctor advised him that, in order to convalesce completely and successfully, he should send Terry away to a sleepaway camp or risk another, worse heart attack. Or in Terry's blunter words, "If you want to live through this summer, you need to get rid of that little sonafabitch." So on June 9, Terry boarded a bus to Camp Davis in Rociada, twenty-seven miles northwest of Las Vegas, New Mexico, for what the *Avalanche-Journal* called a monthlong "camping session."[12] The landscape and location seemed terribly exotic to Terry, and he was excited, if apprehensive, about his first extended trip away from his par- ents. Photographed standing by the bus, Terry is decked out in a slouchy

cowboy hat tipped back on his head, jeans rolled eight inches up his calves, a giant belt buckle, a fringe jacket over a Western shirt, and a shy grin.

His carefully curated cowboy fashion sensibility was in for a rude surprise when upon arrival, all the boys were issued matching white camp T-shirts as uniforms. Activities included horseback riding, rowing, capture the flag, and shooting. It was all utterly alien to Terry and, at least initially, intriguing. For someone who spent so much time outdoors, Terry was a city boy, not an outdoorsman—due more to circumstance than inclination. Other dads took their kids camping, hiking, or fishing, but Sled had never expressed any interest in any outdoor activity other than golf and yard work. In retrospect, Terry suspected this was because his father had endured such a rugged life already—playing ball, hopping trains, doing manual labor—that hiking or sleeping outside felt like a preposterous and counterintuitive leisure activity when he finally had a perfectly comfortable home and bedroom.

One late afternoon at the rifle range, Terry wandered off up a hillside to pee. He soon became utterly disoriented, mystified by the creased, forested mountain landscape. It was so unlike Lubbock, where, as he wrote to his mentor H. C. Westermann in 1979, "the only tree is in front of the courthouse (farmers drove in from hundreds of miles to look at it) and the only mountain was on a postcard up in a frame over the counter in the Mr. Spudnuts shop."[13] The camp was situated in a valley or depression, "like a bowl surrounded by mountains," but he could no longer see it beyond the trees. Terry rambled farther and farther in the wrong direction; each time he caught sight of the camp between the rocks, it appeared more distant. "I don't remember being afraid of bears or starvation, but that feeling of being completely disoriented, that was terrifying to me," he shared with a palpable shudder. "That freaked me out the most. It was like a dream." He spent the night and the next day hopelessly lost, foraging for berries and searching for water, until the second night, when he saw the miraculous flashlights of a search party winking over the mountain. This misadventure traumatized him, and he quickly buried any burgeoning fantasies of cowboying, exploring, or soldiering, and like Sled, he refused for the rest of his life to engage in camping or even hiking, which, he regretted, "played hell with [his] kids."

"My comment about the great outdoors," he told me, "is that I usually limit it to the distance from the pool to the bar."

CHAPTER 5

THE HI-D-HO HIT PARADE

Pink and Black is comin back
For you and me

 —"The Pink and Black Song"

ELVIS PRESLEY FIRST CAME TO LUBBOCK IN JANUARY 1955, AND HE PLAYED there six times through 1956, always at Fair Park Coliseum (except for one ignoble show at the Johnson-Connelly Pontiac dealership), sometimes decamping to the Cotton Club afterward. The first Elvis show that Terry saw was not even a headliner tour but an opening slot for Little Jimmy Dickens, to a rather sparse audience. The King played early singles like "Milk Cow Boogie" and "That's Alright, Mama," both released in 1954. In February 1955, he returned to the Coliseum with Buddy and Bob, Buddy Holly's country duo with Bob Montgomery, and by that October, Holly was opening again with the Crickets. Each concert grew exponentially, attracting a bigger and more frenzied crowd, until Presley's final triumphant Lubbock performance, for an audience of ten thousand at the Coliseum in April 1956, in the wake of "Heartbreak Hotel." Terry was in seventh grade at Hutchinson Middle School at the time, and he distinctly remembers, the day after the show, sitting in class behind a girl who was showing off Presley's debut LP. The iconic cover image—the posture, the suit, the guitar—influenced him as much as the concert to try his hand at rock and roll (as well as record collecting, which became a lifelong hobby).

 Although he always did his bedroom posing and miming with a broom guitar, there was a real piano in their living room, and he begged Pauline

for a lesson.[1] "She taught me how to play exactly one song, 'St. Louis Blues,' and then said, 'That's it—now you're on your own.'"[2] "Blue Suede Shoes," both Carl Perkins's original (released in January 1956) and Presley's cover (released in September), which was played incessantly on KSEL's *The Hi-D-Ho Hit Parade*, made a big impression, superficially because Allen himself, a budding follower of fashion, owned a pair of the eponymous footwear himself—part of his precious arsenal of dancing shoes.[3] But the attraction went deeper. In his 1994 "Self-Interview," Allen writes: "This song had a major impact on me when I first heard it, because it was one of the first songs I was conscious of that did not address your parents, your church, your school, any institutions. It addressed you directly."[4] "Suddenly music became a very important presence in my life," Terry recalled. The newfound urgency resulted in his first original arrangement for piano, a rock-and-roll version of Glenn Miller's "In the Mood."

Sled booked most, if not all, of Presley's Lubbock appearances, and on one of the earliest shows, Elvis and his band—at that point, just the classic original trio with Scotty Moore and Bill Black—pulled up outside the Allens' home on Twenty-Eighth Street and knocked on the door. They had just driven in from Clovis, New Mexico, all piled into a single unremarkable station wagon, pressed against their gear. They'd managed to find their way to Sled's house but needed directions to the fairgrounds for a sound check. Sled and Pauline invited them in for supper. Elvis was not yet the mononymic cultural monolith he would become; twelve-year-old Terry perceived him and his band as polite teenagers, older and interesting, but not terribly exotic or impressive. He'd met many much more famous and flamboyant musicians.

The next time they played Lubbock, Elvis had an entourage and his famous pink-and-white Cadillac, and rabid fans—lustful girls and their hostile boyfriends, steamed the scandalized citizenry—reportedly tore up the touring party's cars in Amarillo. These concerts catalyzed a musical revolution in Lubbock and a moral backlash that included ritual record burnings.[5] Many local artists of Terry's generation—notably the Flatlanders, Bobby Keys, and particularly Mac Davis, who wrote several hits for Elvis, including "In the Ghetto" and "A Little Less Conversation"— revered Presley, and subsequently Holly, and some eventually followed in their idols' more famous footsteps, though only after peripatetic travels

away from Lubbock. But in the immediate wake of the rock-and-roll explosion that Elvis detonated, other, now forgotten, bands were more conspicuous on the local scene. "There was a guy named Jerry Burgess" who provided Allen with something of a musical role model. "There was a band called the Four Teens, with a drummer named Brownie Higgs, Kelmer Key on saxophone, Jerry on piano and vocals, and Joe B. Mauldin—who later founded the Crickets with Buddy Holly, Jerry Allison, and Niki Sullivan—was the bass player. They were the hot teenage band who played covers. Jerry was a phenomenal piano player to me at that time."

In 1958, Terry finally discovered some of the Black artists who were the true architects of rock and roll but whose visibility among white teenagers in West Texas was eclipsed by the fame of their white disciples. That fall, at the beginning of his sophomore year, on a barn dance date with Janita Kinard, he first heard the mesmeric rhythm that would captivate him for the rest of his life. The couple had just settled into a cozy, if itchy, corner nook on the hayride when he heard "Bo Diddley" blaring from a car radio. Released in September 1955, it was not a new song—it was already ancient by pop-music standards—though it may have been new to Terry's social circle, or perhaps his ears were finally receptive to its infectious, syncopated clave rhythm, articulated on Diddley's guitar and Jerome Green's maracas, which became synonymous with the artist's name and the eponymous song. "Bo Diddley" hit Terry with the power of revelation and the force of prophecy. He was transfixed; the scales fell from his eyes (and ears). At that moment, "something changed inside me," he remembers. "Bo Diddley" sounded like a direct broadcast from an alien culture—at that point, the West African, African American, and Afro-Cuban musical wells from which Diddley drank were almost as alien to Allen as the Lubbock Lights—and animated his imagination beyond even the fiery rockabilly and raw sexuality of Elvis and his Sun Records cohort. "Bo Diddley" gave him his "first permission and necessity to play music." That year, Terry had been playing Ersel Hickey's "Bluebirds Over the Mountain" (one of the first records he bought with his own money, and another breadcrumb in tracing his bird fixation) ad nauseam, but compared to Bo Diddley and the thundering rhythms he banged out on his signature box guitar, former fixations like Hickey, Elvis, and Perkins suddenly seemed a little less

cool and a lot less dangerous (and danceable). For the rest of the eve-
ning, Terry, dumbstruck, proceeded to ignore poor Janita, who ceded
her temporary romantic advantage to her friend Jo Harvey Koontz.

From there, Allen's musical tastes attuned increasingly to Diddley
and the three others in his holy tetrad of electric guitarists, Chuck Berry,
John Lee Hooker, and Jimmy Reed. He began buying records more regu-
larly (everything from Eddie Cochran to Jessie Hill) and learned how to
play "Bo Diddley" and "Who Do You Love?," which remain late-night,
after-hours, jam session staples and encore fodder to this day.

IN THE WINTER of 1958, the same year as his Diddley epiphany, Allen's
secret antihero was the psychotic nineteen-year-old Charles Stark-
weather, who, with his girlfriend Caril Ann Fugate, embarked on a
vicious eleven-victim murder spree across Nebraska after fleeing the
Fugate family home, where they'd shacked up for six days after Stark-
weather slew Caril's entire family. The bizarre story, with its potent
whiff of existentialist grotesquerie—Starkweather never provided any
rationale for the killings except "fun"—sparked frantic news coverage
as well as Allen's own *JUAREZ*. Allen remembers a dead- and hollow-
eyed Starkweather—who was handsome in a blocky, broad-faced,
slightly feral way not dissimilar to Terry himself—mugging for the cam-
eras like a homicidal James Dean doppelgänger, a long-ashed cigarette
dangling limply from his lips, as limned in *Dugout*: "his greasy hair and
ducktails and Levi's hanging below his ass and punk collar sticking
straight up with a Lucky Strike burning in his face."

Preachers and parents in Lubbock conflated Charlie's evil rampage
with sinful rock-and-roll culture ("they were exactly what came from
listening to that twisted Commie slave devil music") and teen sex ("his
nasty girlfriend Caril has egged him on with sex . . . laughing like a wild
hyena"). Before the couple's arrest, Lubbock's upright authorities wor-
ried that the duo might head south to the Panhandle. Rumor was that
Charlie had "killed everybody in Nebraska, most of the people in Iowa,
and was presently working his way through Oklahoma . . . headed for
Mexico and looking forward to murdering everybody in Texas along the
way." The Highway Patrol erected roadblocks, and Lubbockites armed
themselves to the hilt. It all hit Terry "way down low inside himself": "It
really connected with rock and roll, the wild romance and danger of it,

making that run with your girl . . . and the incredibly conservative reaction in Lubbock to rock and roll. I can remember in school having my head down on my desk, mumbling, 'Go, Charlie, go!' to myself. . . . It definitely played into Jabo and Chic [of *JUAREZ*] manifesting." Rock and roll, in Terry Allen's teenage world, was inextricable from darkness, danger, and death—and therefore irresistible. He embraced it and never looked back.

IN 1957, SLED Allen announced his cosmopolitan dance, the first of its kind in Lubbock.[6] He booked Ray Charles at the Fair Park Coliseum for the occasion. The year after his "Drown in My Own Tears" and "Hallelujah I Love Her So" singles, Charles, twenty-seven years old, had just released his self-titled debut record as well as an instrumental jazz album called *The Great Ray Charles*. Sled hoped Charles's self-professed greatness would carry the night, proving sufficiently captivating to distract the audience from the very fact of who they were, where they went to school, and who was dancing next to them. The concert's "cosmopolitanism" was a euphemism for its delicate and highly controversial concept: an event where the audience of kids—some adults too, but mostly teenagers, who would shout along more loudly with Charles—would be racially integrated, effectively a night off from Jim Crow. White, Black, and Latin communities would attend together, all under one roof, with no separation by rope, room, balcony, or any of the other usual architectural barriers. Six years after the Lubbock Lights, the cosmopolitan dance promised another, arguably equally exotic, if more terrestrial, alien encounter.

It was more of a publicity stunt than it was a gesture of goodwill or integrationist attitudes. Terry has readily acknowledged that his father, despite effectively, if not intentionally, integrating Lubbock concert audiences for the first time ever, never evolved beyond the deep-seated "separate but equal" segregationist attitudes of his border-state, fence-riding Red Leg Missourian origins. The cosmopolitan dance was ultimately a crafty business decision, a calculated wager. "I think he saw an opportunity, that's all," Terry supposed. It was a historic experiment nonetheless and a risky move for someone doing business in such a conservative and racially entrenched town. Terry suspects that Sled was only able to avoid the wrath of racists and enforcers of piety outraged by

the rock-and-roll brush fire he helped ignite in Lubbock due to force of personality and the momentum of his public persona as a beloved local athlete.

Terry and Jo Harvey attended the cosmopolitan dance with a small gang of friends, a triple date situation. Jo Harvey's best and oldest friend, Janita Kinard, was technically Terry's date that night, though their relationship never progressed beyond cursory and casual, particularly after Terry's Bo Diddley obsession took hold. The tension was palpable. Ray Charles put on an electrifying show, "up there singing his ass off," but few fully enjoyed it, because they spent most of the night surveying each other suspiciously and fearfully and waiting for trouble, or a fight, which never happened. The crowd effectively self-segregated. "There was this huge open floor, and these three little distinct, paranoid knots of people who wouldn't get near one another, just dancing among themselves and watching," Terry laughed. Janita was so ill at ease being in such proximity to Black and Mexican American bodies that "she went into shock and threw up," providing the cosmopolitan dance's most notable moment of real drama and release.

It was the longest interaction that Terry had ever had with Black people, surpassed a few years later dancing with Jo Harvey at the Palm Room in Lubbock, until moving to LA. He had few opportunities to cross color lines that were heavily enforced, both officially and unofficially. Although he regularly observed and interacted with Black performers hired by his father, and loved their music, he was a child, and they were adults; there was a social barrier that Sled did not encourage him to cross.

IN OCTOBER 1959, Sled, on his deathbed, knowing that the end was near, dreamed that his only child would inherit the family wrestling and concert promotion business. Summoned to his father's bedside with a gravity that sank his stomach, Terry listened respectfully to his pitch, a request stained with the frank formality of the dying. Sled had been reduced from 200 pounds to an unrecognizably wan and crooked 130. He resembled an elm root. "He called me into his hospital room," Terry recalls, "and said, 'I have to offer you this. You don't have to take it, but I can put this business in trust. . . . You know it's a good business; you can make a living.'" In a 1976 notebook for *RING*, in which wrestling serves as a central symbolic schema, Allen described the incident, then decades

more recent, in more detail: "He told me it was 'a good living' and that he had been happy for it. He asked me to think about it—but would not hold any feelings against me if I turned it down. I explained to him that I couldn't do that—that I would never know how—that I wanted to do other things (fortunately he didn't ask me what—I didn't know—but I'm sure he knew I didn't know). The last live wrestling match he saw was also the last I saw."

The prospect of remaining in preternaturally flat and featureless Lubbock precipitated a kind of reverse zero-altitude vertigo, an existential unease and stultifying stupefaction. He didn't know what he wanted from life, but, at sixteen years old, becoming a West Texas wrestling and music promoter was toward the bottom of the list, at least on that bright fall day. Anguished by his seventy-three-year-old father's imminent death and addled by the incompatibility of Sled's generous offer with his own uncertain future, hopefully in one of those imaginary elsewheres beyond the bleak horizon, he looked down into his father's searching, hollowed-out eyes and quietly declined the proposed succession, instinctively shaking off his inheritance in a piercing, breathless moment.

In that pivotal instant in Methodist Hospital, he turned his back on his father's legacy and the possibility of a homegrown career in entertainment and finally, formally forswore Lubbock, a place whose absence of natural echo he experienced acutely. His teenaged ears heard nothing native to his hometown that entranced him, that shook his bones, like the dangerous sounds of his idols Bo Diddley and Jimmy Reed did. To be fair, most local musicians left as soon as they could drive—the Hub City is spoked with highways to take you away to anywhere else, to anyone else. Those routes provided the existential exit from West Texas for which Terry longed. Staying stranded on the Llano Estacado felt to him like a death sentence.

Doc Sarpolis and his partners purchased Sled's wrestling promotership on September 2, 1959, expanding their Amarillo empire, and the entertainment industry of Lubbock limped on.

Four decades later, thinking about his elderly father's once powerful body lying desiccated in that bed, ravaged by bone cancer—or possibly, as his death certificate read, multiple sclerosis—he would truss a taxidermy coyote with neon glass tubing, glowing red, as a totemic figurehead to crown a sculptural tableau he called *Ancient*.[7]

CHAPTER 6

CRISIS SITE (ROOM TO ROOM)

She did the Charleston
Called me Kid
Lived in the Bottle
That's where she hid

— "Oh Mom" (alternate lyrics)

SHE'D DISAPPEARED BEFORE ON BINGES, LEAVING HER OLDER HUSBAND TO worry and fret, sometimes for days, hiding behind his newspaper screen on the sofa. But she'd always return, and though the boy suspected something when she locked herself in her pitch-black bedroom, sleeping and smoking behind the perfectly closed curtains, his father had always been present with distractions and detours. Now, left utterly alone in the empty house, the boy ate leftovers—mealy cold fried chicken and pale, sagging Jell-O salad—out of covered glass dishes brought by glassy-eyed well-wishers and fellow mourners. He played piano to fill the silence, though not as articulately or intricately or briskly as his mother. He attended school in a stupor, he listened to his John Lee Hooker records, he drove around town in his customized 1953 Chevy with the radio blasting out the ghosts, he wrote and drew in his notebooks. At night he listened to the pyracantha thorns screech against the windows, the deathless wind rattling the screens and moaning through the metal weather stripping, carrying with it caliche dust and the acrid stench of Lewter Feedlot. And he waited—for her voice, her piano, or for anyone, really, to fill the mute rooms on Twenty-Eighth Street with more

than his father's spectral presence. Despite his friends and girlfriends, he was alone on the hard High Plains and in his own hard head—but not for long.

A 1977 NOTEBOOK reveals that his companion at the movie theater the night his father died, the identity of whom he subsequently forgot, was Betty McAbee, a classmate at Monterey High School. Betty was his "steady" at the time (and a close friend, then and now, of his future wife, Jo Harvey). In the notebook entry, he explicitly mentions her presence at the theater, their silent drive together back to his empty house, holding hands in the car. She attended Sled's funeral at Rix Funeral Home, which despite his familiarity with the establishment in the more rational corners of his memory, Terry recalled decades later, through a distorted scrim of shock and grief, as "an immense empty space, an empty temple" of inert air, the decorous maw of Lubbock. The room seemed to yawn and dilate like the gullet of a dark tunnel as, standing by his father's casket, he glimpsed his friend Jo Harvey Koontz from a distance at the other end of the tunnel. She'd shown up with Lynn Livesey, the Monterey High football player she was dating.[1] It was as if she manifested from thin air. One moment he was staring at the solitary coffin containing his father's corpse in the expanse of a cavernous, empty room—"HE LOOKED LIKE WAX WHEN HE WAS DEAD WAXED BONES i can't remember HE HAD ON HIS SHRINE PIN," he wrote—and the next moment, she appeared like a beacon within a crowd of anonymous gray mourners and their anonymous gray whispers. The congregation sang "The Old Rugged Cross."

After a limousine ride home together from the cemetery, where Sled was buried in a lot he had bought in November 1955, Betty sat with Terry in his living room—if he could stand to call it that—where, to distract themselves, they talked idly about a recent trip to Abilene. Betty was singularly suited to comfort him, having recently lost her own mother. He did not feel comfortable with anyone else during those hard weeks. No one else could possibly understand.

A few days later, after the funeral, still living alone at his house, he went back to see *Tamango*, the movie he'd missed, sitting by himself in a sparsely attended cinema with a Coke and popcorn. A movie addict, he

craved the escapist collision of stories and images and the narcotic dark and noise of Lubbock's fifteen cinemas now more than ever. But for as long as he could remember, movies had flickered incessantly through the magic lantern of his mind, furnishing not only his primary diet of visual culture but also a potent tranquilizer.

Both the swashbuckling *Captain Blood* (1935), an Errol Flynn vehicle about a doctor's slide into Caribbean piracy, and the historical epic *Captain from Castile* (1947), starring Cesar Romero as the conquistador Hernán Cortes, who overthrew the Aztec empire, eventually informed *JUAREZ*, topically and as classic Hollywood storytelling modes to subvert. John Ford's *The Searchers* (1956), which he watched at the State, the same cinema where Buddy Holly and Jerry Allison saw it and borrowed John Wayne's line "That'll be the day" for their hit, was later a reference for *Rollback*, Allen's 1988 collaboration with Bruce Nauman and choreographer Margaret Jenkins. *Wake of the Red Witch* (1948), another, earlier film starring Wayne as a nineteenth-century ship's captain, informed an eponymous song about moviegoing on *Bottom of the World* (2012). In September 1960, he saw *Psycho* twice, the second time with Pauline.

He scrutinized not only the stories and screenwriting but also the scores. He'd later use "T-Bone Tiomkin" as a tongue-in-cheek songwriting and scriptwriting pseudonym, appropriating the first name of blues guitarist T-Bone Walker and the last name of Dmitri Tiomkin, the Russian-born, Oscar-winning composer for films such as *High Noon* (1952) and *The Old Man and the Sea* (1958).

On at least two prior occasions, when his parents discovered his prolonged absence and panicked, Terry had to be forcibly removed from movie theaters by law enforcement. The first time, during *The Man with a Thousand Faces* (1957), the cops escorted him from the Lindsey, tossed his bike in the trunk of the squad car, and drove him home to "waiting faces." Sitting alone now in the diving bell of the Arnett Benson, his numbness gave way to pangs of guilty nausea when it dawned on him that he had been waiting for this trash instead of waiting beside his dying father alongside his moaning, Bible-tongued kin.

The hollow in his chest, voided by despair, gradually filled again with rage, and he had resolved, like his parents in their different ways, to escape those empty flatlands once and for all. When his mother returned,

haunted and broken, to their home, it was his turn to disappear. He avoided the house as much as possible, staying out late driving and drinking beer, dreading the walk through the front parlor to his bedroom. If she was home, he was never quite sure in what state he would find her. If he was home, he was never sure in what state he might find himself.

BLOODLINES II (BARRELHOUSE): UNCLE FATE AND THE TEXAS SHEIKS

There is a river
Run through the mountains
Under moonlight
Hear the song
Of the bloodlines
Gone long before me
Ever after . . . moving on

—"Bloodlines II"

ONE DAY, SOMETIME IN THE 1950S, TERRY'S MATERNAL GRANDFATHER, STEPHEN Anderson Pierce (1872–1968), known as S. A., disappeared. The family, panicked, called the police and initiated a statewide search and, after a few months, resigned themselves to his death. As Allen writes in *MemWars*, they gathered for "an old-time wake with a box-without-the-body. Later, they ate fried chicken and sang some hymns, then divvied up his effects." They even erected a cenotaph for him beside the grave of his wife, Cora.

Six months later, one cool fall night after family Sunday dinner, there was a knock on the kitchen door of Uncle Shorty and Aunt Villa's house in Amarillo: "He had a long white beard, a bedroll, his Bible, and a walking stick. . . . My mother screamed like a banshee." S. A. explained that he'd hitchhiked to Alaska to prospect for gold. "The Lord said there ain't no gold," he revealed, "but there is big, pretty country, and nobody

bothers you," so he'd stayed awhile. He walked through the house, collapsed on the guest room bed, and slept like the corpse everyone had presumed him to be.

Although he was the only one of Terry's grandparents to live long enough for him to know personally, S. A. Pierce's lineage is the least documented and the most convoluted. Due to the proximity of his mother's side of the family, many of whom lived in Amarillo or within a couple hours' drive, Terry spent much more time with the Pierces than the Allens as a child, so we consequently know more about the Pierces as they were during Terry's childhood and more about the Allens before Terry's time.

Whether proactively or simply as a function of her vagabond lifestyle, Terry's mother, Pauline, avoided lending her name to official records, and outrunning government ink trails (and other liabilities) may have been a family tradition among the peripatetic Pierces. S. A.'s people were agrarian highlanders who migrated in packs, by hard portion, out of the Appalachian foothills and mountains of East Tennessee, western Virginia, and West Virginia, moving from the margins of the mountains across the great river to the flatland frontiers of Missouri, Oklahoma, and finally the Texas Panhandle, where they established themselves in and around Clarendon and Amarillo.

S. A. was born on March 28, 1872, in Tate Springs, Tennessee, the child, apparently illegitimate, of John Smith Pierce (1847–1915), a wounded Civil War veteran of the Union Fourth Tennessee Infantry, and a Nancy Hanks, whose identity remains obscure but may have been a relative of his wife, Martha "Mattie" Hanks (1852–1935). He seems to have been born and raised in a separate household from his siblings, fifty miles west of the rest of the Pierces on the other side of Hawkins County. That Stephen may have been born a bastard, an outsider to his own family, raised under a cloud of shame and unbelonging, may explain his disapproval of his daughter Pauline's decisions. Despite his shadowy origins, S. A. was named after his paternal grandfather, a native of adjacent Greene County, Tennessee, a place bristling with Pierces.

As a child, S. A. seems, astonishingly, to have lived briefly in Howell County, Missouri, around the same time that his future son-in-law Sled was born there. On August 12, 1876, Stephen's future wife, Cora Tice, was born a few miles down the road in Hutton Valley. Though they'd

lived in Missouri since Cora's father's (Reuben, 1832–1925) marriage to her mother, Mary Elizabeth "Mollie" Black (1839–1910), in 1857, the Tices had migrated from Tyler County in what is now West Virginia.[1] It's possible that S. A. and Cora met as children in Howell County, since the two families were already in the process of becoming thoroughly matrimonially enmeshed. Two of Stephen's uncles, Fate (1845–1912) and Ivans Brown "I. B." Pierce (1857–1942), married Tice women a decade before he and Cora wed in 1892. (Pulaski Lafayette Pierce, extravagantly named after two heroes of the American Revolution—Casimir Pulaski and the Marquis de Lafayette—owed his nickname, Fate, which coincidentally also became the moniker of Terry's record label, to an elision of "Lafayette.") A veteran, like his younger brother John, of the Union Fourth Tennessee Infantry, Fate wed Frances "Fannie" Eleanor (1866–1931), his second wife, in 1882, in Howell County, after which they moved to Montague, Texas, where I. B. married Lydia Josephine "Lidda" Tice (1864–1955) two years later. Cora was the younger sister of S. A.'s aunts, Fannie and Lidda. By the time she and Stephen wed in 1892, they had joined various other Pierces and Tices in Montague, a town near the Oklahoma border and at the southern terminus of the Chisolm Trail, an important trade route for cattle drives between Texas and Kansas.

Stephen and Cora's eldest son, Guy Smith Pierce (1895–1971), named for S. A.'s father, John Smith, was born a Texan on June 8, 1895, and by 1900, the family was residing in Plano, where Guy's grandfather and namesake was living with his family. Shortly after Guy's birth, after less than a decade in Texas, Stephen and Cora, with numerous other Tices and Pierces, struck out once again in a covered wagon, this time to southwestern Oklahoma, near the border of the Texas Panhandle. By July 1901, they were homesteading in Greer County, where their second child, Ivens Brown (1901–1994), or I. B., given his great-uncle's name with an amended spelling, was born. When S. A. filed a formal claim for the property at the US Land Office in Mangum, Oklahoma, in the spring of 1905, his brother-in-law J. W. Tice and his uncle I. B. Pierce both registered as witnesses "to prove his continuous residence upon and cultivation of said land."[2]

In addition to the continuous cultivation, S. A. served as the postmaster in Hollis in neighboring Harmon County, a position he did not rate highly among his checkered career choices. When he resigned from the

postal service in June 1905, moving his family from town out to their farm, he told the *Hollis Herald* that he felt "almost as he imagines that one would feel when getting out of jail"—the first recorded glimpse of Terry's ancestral sense of black humor.[3] Ironically, S. A. and his family would soon preside over an actual jail.

On August 9, 1904, Pauline Roosevelt Pierce was born in the family's Hollis dugout—a dwelling partially or fully built into a hole in the ground or a hillside, hewn out of the sour earth like a bear den in Plains places without sufficient trees or lumber available for a cabin. She didn't remain in Oklahoma, even in this far western sliver of the state, for even a year. On July 15, 1905, before Pauline's first birthday, the Pierces left Oklahoma, much of their extended family, and their subterranean existence permanently, striking out southeast on yet another long overland wagon journey. Months later, after being waylaid in Bowie, Texas, they ultimately ended up two hundred miles in the opposite direction, in the heart of the Texas Panhandle, only about sixty miles due west of where they'd begun in Hollis.

Today, Brice, Texas, comprises little more than a few gray-faded structures at a desolate crossroads, but it was once home to a small, thriving agricultural hamlet. Then as now, the surrounding area is dominated by the massive JA Ranch, the oldest cattle ranch in Texas, where it probably felt inevitable that S. A.'s sons would work. Guy, whom the other siblings idolized, sported an impressive, enormous tattoo of a longhorn steer on his chest (part of a thicket of ink that his nephew Terry credited among his early artistic influences). The cowboying lifestyle took hold particularly strongly with Stephen's youngest, Blue, before he abandoned it for a less romantic but more stable and less itinerant career in cobbling.

In 1982 in a letter sent to the *Clarendon Press*, Pauline reminisced nostalgically about their farm in Brice Flats, in thrall to the elemental South Plains landscape, virtually unchanged since her grandfathers' generation: "It had a rain water cistern at the corner with a big zinc bucket and a rope pulley to draw the water up . . . and the old gourd dipper we had hanging by the well to drink from. Warm smoke poured out of the roof from that old pot bellied stove inside, where we used cow chips and brush for fuel."

It was here that Pauline's younger sister, Zevilla, and brother Stephen Anderson Jr. (technically S. A. III), who went by Blue, were born in 1906

and 1908, respectively (they died in 2005 and 1992, respectively). By 1920, the family, including teenaged Pauline, had moved to marginally more cosmopolitan Clarendon, the next town north, across the county line in Donley County. Here S. A. turned from farming to wage labor and piecework made possible by a higher population density, working both as Clarendon's town marshal and its cobbler, sometimes at the same time. Apart from a sojourn S. A. would take in Cortez, Colorado, with Blue's family after Cora's death in 1942—where father and son plied their shoe-mending trade together in the same shop, and where young Terry visited—S. A. and Cora would remain in Clarendon for the rest of their lives. Their elder daughter left them behind there as soon as possible.

PAULINE GREW INTO a determined and preternaturally talented woman, who beneath her apparent charm, humor, and physical beauty and grace was at war with her own will. According to her similarly spirited younger sister Villa, S. A. had fostered an antagonistic relationship with Pauline since she was a young girl. In *DUGOUT*, her father's resentment, through Terry's dramatization, begins at her very birth, edging into maniacally misogynistic fantasies of hellfire violence imbued with the dark, illogical grain of sacrificial destiny, or a divine curse.

Although he was not conventionally religious in a churchgoing, dinner-on-the-grounds sense, S. A. was an avid Bible reader and adhered to idiosyncratic, nondoctrinal fundamentalist beliefs of his own, which made room for both Holy Roller evangelical Protestant brimstone and phrenology alike. An imposing man who wore high-top shoes and dime-store browline glasses and chewed Red Mule tobacco, he nurtured an "all-consuming" hatred for Catholics and Shriners (among whom Sled numbered) and felt beset by "illegitimate" kin (among whom Terry numbered). These beliefs coexisted with his own wicked sense of mischief—he liked to sit on his porch and shoot marbles out of a tin can at cats and "a neighbor woman's ass"—as well as a penchant for dramatic and cryptic pronouncements.[4] S. A. did not approve of young Pauline's burgeoning interest in music, dance, and fashion, all signifiers of a wide world of iniquity, racial integration, and effete urbanity beyond the bounds of sleepy, conservative Brice and Clarendon, where the wide-open sky and the endless potential it symbolized were hemmed in by other people's immense ranches and cotton fields. Terry recalled his grandfather, later

in his life, habitually watching TV evangelist and radio Church of God founder Herbert Armstrong, who preached against the consumption of alcohol and tobacco (both of which S. A. consumed liberally) and vociferously decried the dire spiritual dangers of immodest dress, makeup, fornication, and divorce, all those (predominantly female) "spiritual sins" of which Pauline would qualify as serially guilty.[5]

Guy, the Pierce patriarch in waiting, inherited his father's religious fervor and conservatism along with his job as Clarendon's peace officer. (When Terry stayed with S. A. in Clarendon, in his one-room shack on Third Street, less than a block from the jail and courthouse where Guy worked, his aunt Mary [1912–2000], the prison matron, would serve him meals seated beside the prisoners at the same jailhouse supper table.) Terry's aunt and uncles, and even his mother, despite their obvious differences, all feared S. A.'s wrath and looked up to Guy, his eldest son. Guy and I. B. were both venerable veterans, having served in the army and the navy, respectively, during both world wars.

According to *DUGOUT*, Pauline's exposure to the litany of Armstrongian sins may have begun early, when she was barely a teenager. In Allen's fictionalized telling, the She character's initiation into the worlds of sex and alcohol is not consensual but apparently implicated with at least one instance of brutal assault: at thirteen, she awakes in a stable, drunk and "naked . . . spread-eagled in a broken bundle of hay," bruised with "deep red welts," her "bloodied knickers . . . in a wad near a stall." Even if this incident is purely speculative, it's an unflinching and disturbingly clinical portrayal of violence inflicted on a character based on the artist's mother—a chilling example of why "cold-blooded" remains one of Allen's favorite adjectives for describing the art he admires and to which he aspires. By the next year, the wartime summer of 1918, the She character and her sister are regularly sneaking out—"we make the windows slick from crawling out at night," Allen writes luridly—to seek adventure and escape, musical and otherwise, and to test the bounds of propriety.

Later, sometime in 1942, while visiting Palo Duro Canyon together, the She character, now pregnant, confides in Him her history of blackouts, including a few times she woke up beaten and once, for reasons she could not recall, in a Mexico City trailer—having been in LA the night before.[6] "I just couldn't keep doing it," she explains. "I was going to get

killed." She's trying to cut down on alcohol while pregnant, which has its fringe benefits. "Sex is a lot better since I quit drinking," she concedes.

The conservative confines of Clarendon did not stop the real Pierce girls from pursuing more cosmopolitan lifestyles opposed to the traditional values of rural Panhandle Texas. Beautiful, glamorous, and quick-witted, Pauline and her little sister both styled themselves as flappers in their late teens, but Villa was "sneakier" about it. (Terry and Jo Harvey later marveled over photographs of Villa as a young woman, sexily bedecked in scarves, furs, and spit curls—and nothing else.) As the younger sister, she received S. A.'s mercy more often than Pauline, but she also doubtless learned lessons in tradecraft from Pauline's earlier transgressions and punishments. Terry has remarked that, in many respects, his mother and Aunt Villa both chose to remain in the 1920s glory days for the rest of their lives, at least as far as fashion, argot, and cultural perspectives, as if preserving that pre-Depression halcyon era in amber, for better or for worse.

Pauline continued also to play primarily the music of her childhood and earlier generations, a potent mix of rags, blues, early jazz, gospel, and parlor and pop music.[7] Two home recordings Terry made in the 1970s prove what otherwise endures only in the memories of a few surviving family members: Pauline was, in his words, one "hellacious piano player."

From an early age, music offered Pauline both an axis of identity and an escape—from confronting others as well as herself. Terry ventured that his mother "played as self-defense," suggesting that submerging herself in music served as an instinctual attack or retreat, as the situation demanded, to suppress anxiety, communicate nonverbally, or even channel her unsteady rage. There was a desperation in her style. The way she told it, the reason her left-hand playing was so accomplished and nimble—she favored thunderous and muscular bass, even by the bottom-heavy standards of the barrelhouse style she played—was because her childhood piano teacher, who always sat to her right on the piano bench, had terrible bad breath. The fetid smell drove poor Pauline farther and farther left down the keyboard, wiggling away into the lowest reaches of the instrument's range. In *DUGOUT*, her teacher refuses to teach her anything but hymns, and her "hideous breath" is, tellingly, a function of her religious fanaticism—"God is always swarming out her

mouth"—which her long-suffering student can still smell years later whenever she plays above middle C. As a result of this Pavlovian conditioning, the Pauline character's "left hand could raise the dead," though so too "her right hand could make the dead dance." She continued to play sacred music, despite the rancid associations; Terry recalls the strains of hymns ringing out in their home after he went to bed. The *DUGOUT* avatar for Pauline walks in on her father and her piano teacher, "the woman in black from church," in flagrante delicto (as illustrated in prurient, pornographic detail in a drawing by Terry). The narrative chronology suggests that Pauline's discovery of this shameful intimacy may have inspired her pious piano instructor to help Pauline secure a scholarship to an unnamed "music college in Dallas . . . secretly endowed by the Church of Christ," and possibly, as She grimly jokes, the Ku Klux Klan.

Whatever the circumstances, the prospect of university banishment to faraway, comparatively urbane, Dallas must have appealed enormously to the real Pauline. Although no record of her matriculation survives, she always claimed to have attended Southern Methodist University (SMU) in Dallas briefly on a music scholarship, until she was expelled for the unpardonable transgression of playing jazz with Black musicians in a juke joint in the Deep Ellum neighborhood of Dallas.[8] A red-light hotbed of secret Prohibition-era speakeasies, Deep Ellum was home to blues artists like Blind Lemon Jefferson, Blind Willie Johnson, and Lead Belly and a birthplace of boogie-woogie, an up-tempo varietal, once known as "fast Western" or "fast Texan," of the barrelhouse piano style, named for its origins in barrooms and brothels, that Pauline mastered. Neighborhood clubs like The Harlem and the Palace offered a haven for white folks to experience Black culture, out of prurience, reverence, or some combination of the two. Playing with local musicians would have introduced Pauline to new techniques, tricks, and tunes, but her outraged educators and family did not share her integrationist musical enthusiasms, which they saw as a treacherous flirtation with immorality and illegality. "This Jazz is a terrible wickedness," says the dean of discipline in *DUGOUT*, "but a white girl playing it with Negroes is unspeakable!"

Pauline's elaborately collaged but asynchronous scrapbooks from this period reveal a life full of social engagements, romance, and intrigue

as well as a young woman's irrepressible loyalty to her friends and, more variably, fondness for her family, particularly her siblings and their children, all documented extensively in photographs and ephemera captioned in her distinctive left-leaning cursive handwriting. Photos show her looking fabulous and flirtatious, slender and wide-eyed like Terry, posing coyly with a curly bob, a sly grin, and an array of stylish outfits ranging from bathing costumes and sportswear to tweed suits and sleeveless flapper gowns.

Her whereabouts after leaving SMU, circa 1923, and before meeting Sled in 1942, a period of two decades, remain difficult to trace. Terry speaks of these years with admiration, describing Pauline's considerable bravery to leave home and strike out on her own as a single woman. It must have required enormous courage, and she may have felt, like her son would forty years later, she had no other options available to her, that her ardent aspirations could not be achieved in Panhandle Texas. *DUGOUT* adheres, here, to what Pauline told Terry, that after her expulsion and departure from Dallas, she waitressed to fund her enrollment in cosmetology school in Fort Worth, where she also founded her first working band (possibly the Texas Sheiks mentioned in her scrapbook). From that point forward, her cache of annual state cosmetology licenses and beauty shop business cards offers the few concrete clues to track her mercurial movements during these postcollegiate lost years working as a musician and hairdresser. As far as we know, she married at least twice before Sled.

Her trail picks up in California, where in 1923 and 1924 she worked briefly at Harbell Beauty Parlors, in Long Beach. In 1925, she spent some time in Phoenix, Arizona, employed by a "M. La Belle Rhodes, Beauty Specialist" while active on the local dance scene. By the following year, Pauline was living in Colorado; in Denver, according to *DUGOUT* and family lore, she worked "playing an old ragtime upright at the last silent movie house," because "she [wasn't] licensed to do hair in Colorado." Indeed there is no Colorado cosmetologist's license in her extensive collection, though there are business cards from Denver salons. In 1926, Denver cinemas were just beginning to experiment with the sound process, and most theaters still screened silent films exclusively.

In Denver, Pauline met Luther "Lute" Lamb (1888–1955), a civil engineer from nearby Fort Collins, Colorado, sixteen years her senior and

employed by a variety of outfits when he wasn't out of work, which, as the Great Depression grew in severity, he increasingly was. Things moved quickly, and they didn't stay long in Colorado. On January 1, 1927, the Board of Examiners of the Hairdressers and Beauty Culturists of New Mexico signed the first of Pauline's several annual state cosmetology licenses, so she could open a modest "beauty culture shop" of her own in Clovis. She and Lute married in Clarendon a few months later, likely in the spring of 1927. She was twenty-three.[9]

They remained in Amarillo long enough for Pauline to host a radio show on WDAG with a Cora Jane Purberry, specializing in "old-fashioned music." Pauline, ever the hustler, maintained annual cosmetology licenses in New Mexico for the next decade, until 1937, and the Lambs lived in Santa Fe for a few years in the late 1920s. In 1928, Pauline led a band known as Lamb's Night Owls, who played dances in Santa Fe's Sierra Vista Park, and the same year, she earned a police citation from an Officer Manuel Ortiga for an unknown infraction, a violation of an unspecified Santa Fe city ordinance. She saved the citation and posted it proudly in her scrapbook beside a newspaper clipping about her brother Guy, now sheriff of Donley County, busting a record number of moonshine stills—Prohibition was still in force—with forensic assistance from his brother I. B., "the fingerprint expert." Terry suspects that his mother's descent into full-blown alcoholism began around this time, catalyzed by her relationship with heavy-drinking Lute and exacerbated by her subsequent marriage to another man several deeps below her on the Stygian spiral into dipsomania. Like many, Pauline struggled not only with addiction but also with depression; Terry surmises, in light of her extreme behavior later in life, that she may have suffered from undiagnosed bipolar disorder.[10]

She returned to California in 1930, after the onset of the Depression, with Lute in tow and lived there for a dozen years. Judging from the sheer number of home and work addresses they registered, their lives in the Depression-era Golden State were not stable, settled, or prosperous. For four years, they moved around San Bernardino. By 1935, they'd separated, and Pauline held hairdresser and cosmetician licenses in both California, with an address in San Mateo, and in Texas, with an Amarillo address. Her life in the mid- to late 1930s was nomadic and unmoored; she was spending long enough periods back home that she felt the need

to find work there, especially after her mother, Cora, was diagnosed with uterine cancer in 1935. Despite these trips back to Texas, she seems to have predominantly remained in the Bay Area well into 1942, working at department stores like Levy Brothers in San Mateo and Livingston Brothers in San Francisco, with a final stint living in San Bruno in 1940.[11] Lute remained alone in San Bernardino for a while, living as a lodger, while his life unraveled; the census entry for his address as of 1935, in the wake of their separation, reads simply, sadly, "someplace."

At that time, likely either in the Bay or LA area, Pauline met Stanley Ira Allenthorp (1905–1984), the divorced "drunk newspaper man" of *DUGOUT.* The two married on March 18, 1938, when she was thirty-three and he was a year younger, and she moved into his apartment at the inauspicious address of 666 O'Farrell Street in San Francisco.[12] We can only speculate what dissolved Pauline and Stanley's marriage in late 1941 or early 1942, but alcohol seems to have furnished a poisonous solvent. Terry recalled her hinting that her relationship with Stanley was "when she encountered alcohol pretty heavy." *DUGOUT* embroiders the psychic pain with domestic violence: "It went straight downhill for five years. She didn't mind the liquor, even tolerated a black eye now and then . . . but she had despised the jealousy and left." Stanley signed her "Memory Book" on January 29, 1942, with a heartsick inscription: "From 1935 to 1942, The girl I loved—I miss you so much no one will ever know. And there is nothing worth wile [*sic*] any more. Love always, Pop."

By the summer of 1942, Pauline was back in Amarillo, single again and within striking distance of the rest of the Pierces. Her Texas cosmetology licenses for 1942 and 1943 retain her married name of Allenthorp, with her residence recorded at 312 West Ninth Street in Amarillo. That summer her mother, Cora, died of cancer on July 18, and she met Sled.

THE 3701 28TH ST. COWBOY BLUES

It most certainly seems
Some disease of the dreams
Has been goin round

 —"The Wolfman of Del Rio"

"DID I EVER TELL YOU ABOUT MY PARENTS' HOUSE?" TERRY ONCE ASKED ME.

I was born in Kansas and moved almost immediately to Amarillo, where I lived the first two years of my life. And we lived in this house that my parents really liked. So when they sold the house and moved to Lubbock, they took the plans, and when they got enough money, they built an identical house in Lubbock. That's where I grew up. After my dad died, my mother sold that house, and she kind of moved around for a while. By this time Jo Harvey and I had moved to California. Then she ended up moving back to Amarillo, and she moved two blocks away from that original house, waiting for the woman in there to die so she could buy it back. She bought it finally when the woman died. And we would go back to visit, and it was the identical house where I grew up in Lubbock, except it was 113 miles away in Amarillo.

The Allens' short tenure at this Amarillo home accumulated, for Pauline especially, a disproportionate significance to her sense of identity and the story of her life. Perhaps it was the first time she felt she could lay legitimate claim to a house, a physical structure, that truly reflected her

notions of home and a functional, loving family, a fresh start away from Clarendon, Colorado, and California and the anguish those places represented. Perhaps she just loved something about its design or layout. "She was an odd duck . . . a haunted person," Terry shrugged to an interviewer in 2013 by way of explanation. "She was a very sentimental person that way."[1] Whatever Pauline's inscrutable reasons, the house possessed her imagination to the degree that, after returning to Amarillo from Southern California—where she'd lived briefly, once again, in the San Bernardino area—she begged the new owner to sell it back to her. The woman refused, and in August 1963, Pauline moved into a neighboring house at 1300 South Rosemont and waited until the new occupant died two years later, after which she repurchased 1501 South Rosemont.

The Rosemont Street house also imprinted on Terry, one of those houses he revisited in dreams—its floorplan etched in memory, eternal, but its details uncannily modified, adapted to hypnagogic logic—but with an additional disorienting twist. Its architectural identity never felt entirely discrete from its double, the identical replica his parents built in Lubbock in 1950, nine years junior to its elder sibling, where Terry lived for that most impressionable decade of seven to seventeen. When, in 1965, Pauline reoccupied the Rosemont Street house, where she remained until she died, the temporal, spatial, and mnemonic distinction between the two homes became even more porous, as if some banal dimensional wormhole had opened between duplicate wide-lawned midcentury Texan ranch houses. She furnished it exactly the same way as the Lubbock house Terry knew by heart, his memory palace, so when he visited he experienced a keen sense of confusing déjà vu. It was a dream home in two senses: the aspirational (or material) and the oneiric (or illusory)—ideal fodder for artists, mother and son alike.

TERRY'S FOUR EARLIEST memories all suggest trauma, or at least toddling misadventure, reflecting themes that would recur throughout his life: toxicants, physical pain, driving, and the horror of addiction. He remembered falling into a hornet's nest in the backyard of the house on Rosemont Street and being stung multiple times as well as falling on a radiator and watching a waffle-shaped burn mantle his pink baby flesh. One day, riding his cast-iron tricycle down the shallow hill beside the house, his toe got stuck in the pedal, and he sped out into the street in

front of a truck; luckily, the driver stopped in the nick of time, extricated Terry's toe, and helped him back home.

> The starkest memory is when I was maybe two or three, laying in a crib in the dark, and this creature was bending over me. I recognized it as my mother, but it was totally something else. She used to have this big hairy skunk coat, and she was coming in from some party, half-drunk, with the smell of booze on her. She was the kind of alcoholic where, after one drink, it was a physical shift. I was always anxious when they went out, and especially at the holidays. I really cared about my folks, and they cared about me. But there was a lot of space between us. . . . I knew that alcohol had something to do with it.

Elsewhere in his private writings he describes her on that night as resembling a spider ("NONA," his baby speak for "MOMMA") looming ominously over him, her sprung web a halo of black and white skunk hair hovering around her own curls: "HERE COMES MY MOTHER / an unusual odor / bending over / a fiend is eating my bed / vampires freeze the sheet / I am three / COBWEB LIPS / slip the spider . . . and I am afraid of her until morning." Such warped childhood memories assumed the weight and viscosity of subsequent years of retrospective resentments, misunderstandings, and affections, compounded into an oily black resin. (As Allen writes in *DUGOUT*, "in 1945, the first memory crawls up out of the ooze and looks around and starts lying to itself from then on.")

Pauline's undeniable love for her only son harbored jagged streaks of occasional unintentional cruelty, competitiveness, and neglect learned from a life of hardship and an unforgiving father. In twenty years of Terry actively exhibiting his art in galleries and museums before she passed away, she never attended a show. In ten years of Terry actively performing publicly before she died, she attended a single concert at the Cotton Club. "She had a lot of opportunities to see me play," Terry reflected, "but there was something that blocked her; there was a jealous streak, something competitive in her."[2] The inevitable, irrevocable deterioration of alcoholism and aging certainly contributed to her failure to provide consistent parenting. Caring for a child is challenging enough when you have the energy of someone in her twenties or thirties, but

Terry did not leave home until she was fifty-six, grieving Sled, a stabiliz-
ing presence, and descending vertiginously into dissociative behavior
fueled by alcohol. "I don't know if it was the music, if she felt she missed
a chance at fame, or if it was the men, but there was some kind of deep
agony she had about her life," Terry shared with me.

There was rarely a lack of love or laughter between them, however;
on good days, of which there were many, it felt to Terry like a giddily
intoxicating surfeit of both nourished the household. But Pauline, for all
her admirable qualities—her fiery autonomy in the face of repressive
familial and societal forces, the irrepressible charm and sharp wit that
punctured her considerable pain to let the light in, and her ability to
make outrageous convention-bucking and iconoclasm feel natural, inev-
itable, and, most of all, fun—was temperamentally unsuited to certain
of the self-abnegating and authoritative rigors of parenting. Alcoholism
rendered these idiosyncratic shortcomings of maternal character, oth-
erwise probably surmountable, into a quagmire of sinking impossibili-
ties, bubbling with rancor, guilt, and shame.

AS ALLEN APPRAISED it, with considerable understatement, "1959 was a
pretty memorable year for me." Within a few months, he lost his father
and found a path forward, a glimmer of light through the grief and rag-
ing confusion.

It was indeed a defining year for him. He began to wonder if what he
enjoyed doing—drawing cartoons, writing poems, shaping songs on the
piano—was valid, a possible road to pursue away from Lubbock and
into an adult life. He knew, through his father's work, that musicians
could support themselves, if only modestly, and find audiences around
the world. But he never imagined it for himself—artists and musicians
came from other, more interesting places, not from Lubbock, which was
just a place for a passing-through payday—and his mother had provided
a sobering counterexample of the fate that could befall a musician
unable to harness a career for herself.

But perhaps there was hope for him after all. He had begun keeping
journals and notebooks in junior high, and now he began writing itera-
tive self-affirmations in their pages, manifesting potential futures in
text, disappearing down the tripartite rabbit hole of forking paths, much
like he would later test fate by throwing the I Ching:

I want to be an artist
I want to be a writer
I want to be a musician

The order varied: "One would take precedence, depending on what I was reading. . . . I don't know why I thought I could be an artist. I liked drawing, but I never *saw* any art. Music was apparent and everywhere. Writing was an offshoot of reading, which I loved. . . . But you read privately, like it was a weakness. . . . That made it all a little more valuable." It was, at least, a diagnosis of his yearning, if not a proper prognosis of his future. He burned this mantra into his mind, with no conception that he could possibly be all three things or that all three things were in fact one thing, with the right perspective and context.

ONE DAY IN 1959, in his sophomore English class, he was, as had become his habit, furiously scribbling away in a notebook in the back of class while the teacher, Ms. Murphy, was reviewing *Julius Caesar*, that year's compulsory Shakespeare play. Noticing that Terry was distracted and disengaged from her lesson, she pulled the classic pedagogical move of attempting to shame him by sharing what she assumed was an illicit and probably humiliating note.

"Mr. Allen, what is it you're writing back there that is so much more interesting than William Shakespeare? Would you please stand up and share it with the class?"

"Oh, shit, here we go again," Terry thought to himself, flustered but accustomed to getting busted for various classroom transgressions. His heart in his gut, he put down his pen and reluctantly, slowly stood, his notebook clenched in sweaty, ink-stained hands. After a moment of stammering, he began to read, head bowed, eyes glued to the page.

"It was just some idiotic, gibberish, blabbering beatnik poem, some stream-of-consciousness junk," Terry explained dismissively. He was mortified to hear the words coming out of his mouth, where they did not sound nearly as thrilling as they'd looked in his crabbed handwriting. To his chagrin, the keen, declarative twang of his Panhandle drawl sounded nothing like the measured, confident East Coast cadences of the Beat poets he'd heard reciting their poems on recordings or film clips, high and round accents redolent of northern cities and seas.

Then it was, mercifully, over, and that felt, if possible, even worse.

Barely able to raise his gaze from his notebook, he heard only a stunned silence from the class. Finally his eyes shyly met Ms. Murphy's; she was staring right back at him, hands on her hips, squinting in inscrutable appraisal. The slightest hint of a grin flickered across her face before she resumed her stern countenance.

"Keep doing that," she commanded, immediately swiveling back to the blackboard and to Brutus. Terry stood gape-mouthed for several seconds before fumbling back into his seat again.

"It was like being slapped," Terry told me. "It was a total shock to get that permission, that approval to do something you actually felt like doing, something you *had* to do, something so crazy." Affirmation was a novel experience. Nothing like that had ever happened to him in "the torture chamber" (one of his nicknames for Monterey High School in his diary).

IT'S TELLING, OF course, that if, as Terry has repeatedly alleged, his childhood home in Lubbock contained exactly one piece of art, that it was a generic etching of a sailing ship, a briny reminder of the barren sea of grass outside, that ancient ocean, and the maritime tendencies of his mother's family.[3] (One wonders if the etching traveled from the Amarillo house, south across what *DUGOUT* calls "The Sea of Amarillo," to its Lubbock clone, its sister ship, and then back again.) The Pierce men were sailors, with the navy and merchant marine, or both; between his uncles and cousins, they collectively served "in every war in the twentieth century" except the Gulf War. I. B., who worked as a boatbuilder in a shipyard on the Gulf coast after his navy service, and Blue, Terry's favorite uncle, harbored a dream to sail around the world together, and they'd sit around scheming and mapping routes and ports while Terry watched, amazed at the scale of the watery world they described.[4] They told him he could join them as the cabin boy, and for a while he believed that was his fate, a foretaste of Sailor from *JUAREZ*: "All of them grew up on a farm out on the desolate flats of the Texas Panhandle. That's probably why they went off to fight wars on the ocean. Most enlisted men from that part of the world did. Water was definitely an exotic draw when you were raised on a dry land farm, but even more so, flat just seemed to naturally go off to fight on flat. Maybe it's more comfortable to kill somebody or get killed with a familiar horizon in the distance."

Sitting in the dry, prickling grass after Sunday dinners with the Pierces, through the glare of heat and the scrim of airborne dust, young Terry watched these scarred, shirtless men, smoking and drinking in their skivvies and telling "what was surely outrageous lies about various naval battles and loose foreign women." They would "sing bawdy sea ballads and each try to outdo the other by showing off their heavily tattooed bodies. It was a genuine technicolored flex-a-rama." The boy's fascination with their war stories was inextricable from his fascination with the inky iconography that illustrated their tall tales on their bodies, providing clues and cues for their blustery, boozy narration: "panthers, birds, naked hula girls, angels, the rock of ages, longhorn steers with rabbits running out their noses, raging bulls, Satan snorting fire, monkeys, Jesus, snakes, skulls, and hearts wrapped with curly banners saying MOM or JOY or REMEMBER PEARL[5] . . . some etched with machines and others hand-hammered with bamboo needles." These crude, sweaty images, blurred and blued, in addition to his cache of comic books like *Tales from the Crypt* and *Mad* magazine—and the pornographic Tijuana Bibles he found in Sled's sock drawer—were Terry's "first deep seduction into the true passions of the visual arts."

"I think of all these people as stacks of stories," Terry reflected, and with the Pierces it was impossible, and discouraged, to distinguish true stories from fiction. Villa's husband, the "devout drunk and religious depressive" Uncle Shorty, "a dapper little barber" and gambler who plied both trades in "the ornate gilded lobby of the prestigious Herring Hotel" in downtown Amarillo, "The Pride of the Golden Spread," had somehow acquired, possibly in a card game, detailed plats and architectural plans for every major bank in downtown Amarillo. After every Sunday dinner,

> Uncle Shorty would grab a set of those bank plans from his bedroom, take one and spread it out flat on the table, and my uncles and cousins would all circle around like buzzards and diligently, and in great detail, begin planning how to rob it . . . the kind of guns they'd use, kind of dynamite to blow the safe, where they'd get it, masks they'd wear, who'd be the lookout, who'd knock out the guards, cover the terrified tellers . . .
>
> A game.

Like Monopoly or Clue.

I think.

None of them ever actually robbed a bank.

As far as I know.

Billy Earl (1925–1987), Terry's cousin—the only child of Villa and Shorty—was eighteen years older than Terry, born in Clarendon in 1925. He spoke with a pronounced lisp and had learned as a kid to become "quite handy with his fists." After serving in the navy in World War II, he enlisted with the Merchant Marine, and he claimed to have seen every port of call around the world—"and he looked it." Billy Earl introduced Terry to elements of urban culture from his travels, like modern jazz, including Dave Brubeck and, more challengingly, fellow Texan Ornette Coleman. This nonlinear, improvisational "mystery music," and his cousin's stories about frequenting New York jazz clubs, blew Terry's still provincial ears and mind wide open, expanding his sonic syntax beyond the rhythmic and harmonic fences of the well-trod vernacular territories— the domestic lingua franca, and family business, of rock and roll, blues, country, and rhythm and blues—with which he was already intimately familiar and comfortable into freer, more abstract zones. Billy Earl "was also smoking a lot of dope, which was the first time I'd been around that." He offered Terry a connection to Black and Beat culture that was more deeply informed, and lived, than the ersatz poses of Lubbock's short-lived beatnik-and-bongos craze, in which Terry dabbled during his teeth-gritting final years in Lubbock, even briefly sporting a beret and threatening to join Castro's revolution in Cuba.[6]

Billy Earl's son Steaven Earl Lynn (later Payne) (1947–1996), the final tragic casualty in a long line of Pierce veterans, was four years younger than Terry; among that family of much older relatives, they shared youth and wonder. When Terry was ten, Steaven accompanied the Allens on a vacation to New Orleans. It was Terry's first visit to a city that thereafter forever inhabited his imagination with its decrepit, damp beauty, its haunted Caribbean and creole lineage, and its saturation of humid color and horns. Sled shot a photo of the two boys at a hotel, both attired in motley military surplus gear—helmets, canteens, and toy guns. "I look at that photo now," Terry sighed, "and I think about how odd it is, what happened to him."

* * *

THAT SAILING SHIP etching provided something to anticipate on the horizon, a sign of life and mobile culture—not unlike the touring musicians and wrestlers that passed through Sled's arenas: "I always grew up associating music with movement. The bands that I knew came from somewhere else, and they went somewhere else after they played. So it was always in motion. I think that any kind of motion in West Texas is like a drug, because everything is so staid. I grew up with a lot of music, but no visuals. . . . The only museum in town was full of farm implements."[7]

That visual vacuum later informed not only the character *of* his songs but likewise the characters *in* his songs and their stories: "You look at the horizon and it's always about what you *don't* see. It's not what you *see*, because there's nothing *to* see. There's a desperation to be visual when you grow up in a place that has nothing visual." When he introduces his song "The Wolfman of Del Rio," about driving and listening to the howling DJ Wolfman Jack on Acuña border station XERF, he tells audiences that he "grew up in a land that's so flat that on a clear day, if you look hard enough in any direction, you can see the back of your own head.[8] Metaphorically that's true and sometimes for real too." The only indigenous artifacts of material culture in his daily life, other than the sailing ship print and his uncles' tattoos (his beloved comics and movies came from afar) that held particular visual interest for Terry were Pauline's set of china plates with painted birds on them, which hung in her kitchens until 1967, when a house fire she accidentally set—a result of her chain-smoking habit of burning multiple cigarettes at once, and sometimes forgetting where she'd left them—reduced them to potent, feathery ash when the flames spread to the dining room. In *MemWars*, Allen recounts the aftermath of watching his mother sifting through the charred remains: "Just after the fire, when they were oddly still perfectly intact, you reached up from a ladder to take them down off the charred walls and the lightest touch to them collapsed into a fine painted ash across your fingers and face and drifted out across the air, released now, birds of their own, flying into each breath going into your body."

In a 2003 journal entry, he recalls "Momma's bird plates" as "porcelain O's, omens" that "foretold their own collapse, their flutter. They were birds of death. The suicide note of the house." Similar language appears, without the autobiographical tell of "Momma," and with the

qualifying description that the birds were red, in the notes to *DUGOUT*, which describes the boy's bird fascination: "He had developed a necessity for birds. He didn't know where it came from." Not coincidentally, these domestic images and their corollaries—ships, sailors, the sea, and birds of all varieties, sometimes all appearing together—recur as potent symbols in his artwork, beginning at least as early as the early 1970s with *JUAREZ*, Allen's first significant mature body of work and his most enduring (and chronically unresolved). "I've always had a real fascination with birds," he reflected, "not ornithology, but just the idea of them. . . . I think it comes from the bird plates that my mother had, that collapsed into ash."

For Allen, birds are mysterious "ancient souls" imbued with frightening and fragile grace, airborne and evanescent as ghosts, easy to damage and redolent of death, doomed to fall to earth and ash—like Pauline and her plates. They would infect, and inflect, his art and music much like Pauline's alcoholic absence and inattention in the wake of Sled's death infected his soul, injecting "panic and loneliness for three years." She had flown far from Clarendon, alighting for a time in Amarillo and Lubbock, where she nested in relatively stable, if uneasy, domestic peace. When Sled, her anchor to earth, her only ballast, fell into the earth, she just flew away.

LOOKING BACK IN the late 1960s and early 1970s, Terry produced furiously typewritten, raging prose poems, with the word "TEXAS" crudely scrawled across them in pencil, and windows excised through pages like open wounds, exposing underlying pages (concrete-poetry experimentation that suggests self-censorship or redaction). There are scenes that relive and relitigate childhood episodes: confrontations between Sled and Pauline about her drinking; Terry, unnerved and truculently vocal about his mom's mutable behavior, imploring Sled to take him out of the house to play miniature golf when Pauline comes home drunk; Terry guiltily professing his love for his parents and apologizing for his adolescent offenses.

After Sled's death, the scenes shift to a two-person dialogue or interior monologue: Pauline begging Terry to stay home and watch TV with her, hoping he'd stave off the demons driving her to drink and disappear; Terry tortuously deciding whether to go out (and risk returning to an

empty house and a missing mother) or to stay home and be her caretaker and confidant (and almost always choosing the former).

Mom: PLEASE STAY WITH ME TONIGHT AND WATCH THE TV.
Son: I'M SORRY MOMMA I CAN'T I'VE GOT A DATE LET'S DO IT
 TOMORROW NIGHT.
Mom: THIS HOUSE IS SO EMPTY WITHOUT YOUR DAD.
Son: I KNOW I'LL BE IN EARLY.

would she be gone when
he came home . . .
is
she
dead
she was asleep and he woke her up and kissed her and said he was
sorry
he was late she was on the floor passed out he would have
to drag her and undress her wash rag her
head over the toilet she was dead when he came
home she was gone off
with one of them

A clutch of agitated pages imagining grim scenarios of Pauline's violent death and projecting fantasies of his revenge on her suspected enablers ends with a bluntly piteous proclamation of resignation: "MY DADDY IS DEAD AND MY MOTHER IS DRUNK / AND I'VE SEEN IT SINCE 16."

Sometimes a friend would express polite concern or confusion about Pauline's demeanor—the tone or slur of her voice, her air of despondency when asking about her son's whereabouts, the barely perceptible unsteadiness that overtook her usually graceful glide—but she was highly effective at hiding her illness from respectable Lubbock society, usually revealing it only to the dim drinkers' demimonde to which she retreated more and more often. Terry's friends liked her, which made it worse. They thought she was cool and smart, funny and glamorous, which she was, and he knew it, which hurt even more. They wondered why he wouldn't invite them over to hear her play piano, why he changed the subject, why he avoided his own house:

MY BEST FRIEND FOUND ME IN THE LAKEBED WADED UP
WITH THE FROGS
 YOU SHOULD TELL YOUR MOTHER WHERE YOU'RE GOING
 SHE CALLED ME AND SOUNDED STRANGE AND SICK YOU
SHOULDN'T WORRY HER MAN GO HOME
 she's drunk you motherfucker that's why she is sick and strange . . .
 i went to mexico forever

CHAPTER 9

THE ROMAN ORGY

Uh oh, or-gy
Whoa woe, or-gy
Oh oh, night and day
Doin' the orgy in the Roman way

—"The Roman Orgy"

ALLEN CITES HIS ROMANTIC CHILDHOOD ASSOCIATION OF THE MEXICAN border with outlaws, transgression, and revolutionary causes, subjects at the heart of the corrido song form that suffuses *Juarez* the album:

> Mexico was always that distorted mirror. It was where you could go and get everything you couldn't get where you were. . . . You know, bandits going to Mexico to escape the law, joining the revolution. So it was incredibly rich compared to where you thought you were. . . . Liquor, girls—all of that stuff was just right across that line. There weren't any rules or laws or religion or any of that bullshit. I think that had a huge impact on people who had any kind of curiosity or felt restrained where they were.

Of course, the fantastical Mexico Terry envisioned as a teenager, without rules or religion—the "sneaky, unclean world" depicted in the Texas history comic books distributed by Humble Oil, "the most racist, scumbag stuff you could ever imagine"—has never been real. But Mexico was never solely a fantasy for him; the Allens visited border towns together on several occasions. Ciudad Juárez, across the Rio Grande from El

Paso, was about 350 miles and a six-hour drive southwest, and Ciudad Acuña, across the river from Del Rio, about the same distance. There are photos of Pauline posing, grinning wryly, at a border crossing and beneath *papel picado* in Juárez streets.

The international exchange was of course mutual. Lubbock's Latin population was somewhat less separate and more visible to Terry than its more marginalized and slimmer minority Black community. Because of the popularity of *lucha libre*, there was a degree of mixing at Sled's wrestling venues. Mexican kids often worked alongside Terry selling Cokes at matches, and though real friendship would have been frowned on, Terry was at least on a friendly first-name basis with some of them.

Mexican and Tejano music influenced Terry early on: "The Mexican migrants would come for cotton-picking season. There were huge gypsy caravans that moved around Texas. In Lubbock, which was one of the huge cotton areas, the caravan was in the fairgrounds. When I was a little kid I remember walking with my dad through those camps with the smell of food, people cooking, people singing, always a lot of music. That's really one of my first memories of hearing people just sit out and play music together."

"Maybe I romanticized it in my mind, but that's the first time I ever encountered music as a communal force," Terry remarked.

Although it was not one of his father's shows, the great Tejana balladeer Lydia Mendoza, "La Alondra de la Frontera" (the Lark of the Borderlands), played Lubbock in the 1950s, which left young Terry with an indelible love for her music. He has incorporated, and interpolated, her classic songs "Mi Problema" and "Mal Hombre" into *RING* and various iterations of *JUAREZ*.

> There was all the mythology of Mexico in the '50s. As early as junior high, I always saw carloads of kids going down. I probably lied and said I did too, but I didn't [until later]. Mexico was more of an idea than an actual geography. That was true of my whole generation. There were just endless stories and bullshit about escapades. . . . But at the same time it activated the air, the aura, the idea of the place, which was reinforced by movies, books, music, everything. The idea that everything would be all different when you cross that border line. It was a real fantasy. It's almost a cliche.

One of those cars that made regular illicit trips to Mexico was an infamous green Buick, "one of the few cars that would get people from Lubbock to Juárez when I was in high school." He recycled that potent automotive image in *JUAREZ*. Once he was able to drive, teenaged Terry returned regularly to Juárez and Acuña, mostly to score booze when it was too difficult to procure closer to home in Post or Amarillo.

Tellingly, one of the first songs Terry performed onstage on piano, at a fifth-grade recital just after his eleventh birthday, was the hoary old Mexican folk song "La Cucaracha." The next song he wrote, the first original composition he performed formally in public, was entitled "Cuña Town," a broad border fantasia about the freedoms of la frontera to be found in Acuña, which, according to his cousin Jamie Howell, "was the place where all the Monterey High School boys went to get laid for their first time and got thrown out of school for three days." On December 10, 1960, his senior year, he and his buddy Hugh D. Reed performed it at the Monterey Senior Carnival—three times as the closing act for three subsequent shows. Hugh played bongos, and Terry played piano, wearing a sombrero. A classmate named Silvia Ramirez wore a can-can dress and lay on top of the upright piano. "We were perfect. . . . I felt wonderful," he wrote in his diary. The song was not so popular with the faculty, as he recounted, with oddly formal locution, in the aftermath: "I made the mistake of writing a song about a small town on the Rio Grande, which was well liked by my fellow students. When this song was sung at our senior party, I was branded as a corruptionist. They claimed my victim was the entire student body. I made a loud protest before being silenced." Jimmie Dale Gilmore of the Flatlanders caught a rehearsal for this infamous performance, and it changed him forever: "He was already a maverick. . . . I didn't know anybody at that point creating their own music. This night had a profound effect on me. He was doing his own songs—and they were good!"

AFTER "CUÑA TOWN," Terry was eager to return to the Monterey stage. The next day in class, he wrote in his diary, he was "commended all day on the song . . . everybody is nuts about [it] . . . and they want us to be on the Exchange Assembly and we're going to. It's a Roman theme. I found out from Jo Harvey tonight." The following few weeks of the holiday season were among the most eventful and busy—and dire—of his high

school career. He sold a cartoon drawing of Santa Claus in the school Christmas exhibition; finished and submitted an application to Pratt Institute in Brooklyn; and on December 14, helped Pauline decorate for Christmas. While hanging tinsel on the tree, he matter-of-factly "hit [upon] the theme for our song. It's going to be about a Roman orgy. Good, no? I hope we find a good beat and make the assembly. Good luck to us please."

That night, while singing to himself in the natural reverb tank of the shower, he wrote "The Roman Orgy" and another ditty sung to the same chord progression and titled, ominously, "Gouge Eyes," "an original adventure into sex and violence," as he annotated in one of his songbooks. They were his third and fourth original compositions, after "Cuña Town" and his very first, "Rooftop Blues," which he wrote in July 1960 about his summer job working for Hamilton Roofing Co. Roofing allowed him to save up for a new car and for records and booze; he enjoyed occasionally drinking and chatting with his Mexican coworkers, but he hated the grueling hours, the sweltering heat, and the backbreaking labor. His friend and coworker Hugh D. fell off a roof and ended up in hospital the day before Terry penned "Rooftop Blues."

Although the Santa drawing has been lost, it too caused him trouble with the authorities—unsurprisingly, since it depicted "Santa with his thumb pushing in the soft spot of a baby's head [and] said 'Merry Christmas, Baby Jesus.'" Based on contemporaneous drawings, we can imagine the style. Among Allen's archival ephemera is a small portrait in profile of a dopey Roman patrician, perhaps Augustus Caesar himself, titled "Caesar's Palace," likely related to his "Roman Orgy" performance. Rendered as a cartoonish grotesque, equal parts *Mad* magazine, Otto Dix, and William Hogarth, the image is typical of Allen's gross-out, comics-inspired drawings of the era. Already the satirical impulse was strong in him, both musically and visually.

LATE JANUARY 1961 was bitter cold in Lubbock, the wicked South Plains wind blasting snow down University Avenue and blanketing the city. But the atmosphere onstage at Monterey High School on January 25, the final day of the fall semester, was comparatively balmy and Mediterranean. "Rome in Caesar's Day" was the theme of the Monterey Exchange Assembly, a periodic event for local high schools (including, notably,

Dunbar, the Black school) to perform musical, dance, and theatrical numbers. Competition was implicit and unofficial but fierce, following the established lines of intramural rivalries and adjudicated in the court of student opinion. Monterey was still brand new in institutional terms, having opened in 1955, so it was the insecure underdog in its rivalry with Lubbock High.

Terry sat behind the piano, fidgeting and nervously eyeing his friend and classmate David Box, who stood beside him with his Stratocaster. Their performance depended on Terry's lead vocals, pounding piano, and foot-stomping—already characteristic of his burgeoning style—but David was by far the more accomplished and experienced musician. As leader of the Ravens, David had not only recently tracked his original song "Don't Cha Know" at Mitchell's Studio at Lubbock in March, but in August he had also recorded it, along with "Peggy Sue Got Married," in Los Angeles with none other than the Crickets. While Sonny Curtis completed his military service after Buddy Holly's tragic death in a plane crash in February 1959, David was briefly, thrillingly, the heir apparent to Holly, the first person to record with his band in the wake of the accident. Like the rest of the Crickets, David had lived in Lubbock for the formative years of his brief life, and he had a yearning, youthful voice and clarion guitar style eerily similar to Holly's, but his talents transcended mere mimicry. Poised on the brink of success, when he returned to Lubbock after the LA sessions and a short tour with the Crickets, he couldn't help but shyly brag to Jo Harvey Koontz, behind whom he sat in class, poking her in the back and asking her to guess where he'd been.

Terry credits David with his introduction to the notion that someone like them, middle-class kids from Lubbock, could become a professional musician: "David Box was one of the first people I ever encountered who really wanted to be a musician, who wanted to be a rock and roller. He was the first, and about the only, person I ever played music with back then—he was a very good guitar player."

OF COURSE, TERRY admired Buddy Holly, but Buddy was seven years older and dead—his artistry, achievements, and legacy seemed untouchable, despite the fact that Sled himself had booked him for several shows. Terry hadn't paid much attention to Holly while he was alive, and

he wasn't alone in his relative ignorance. Though Holly played locally—at the Hi-D-Ho Drive-In, at a roller rink, and even opening for Elvis at the Fair Park Coliseum (twice)—he famously recorded in Clovis, New Mexico, with Norman Petty (as did fellow Texans Roy Orbison and ex-Cricket Waylon Jennings, from nearby Littlefield) and toured constantly, so he was not exactly a local Lubbock fixture. Plus, Holly had two marks against him, in Terry's musical estimation: he had gone to Lubbock High, and he was white. Despite his myriad academic and athletic frustrations, Terry had school pride. And he emulated Black musicians (especially guitarists with idiosyncratic senses of rhythm) above all others, recognizing that they had, in fact, originated the rock-and-roll revolution—he'd watched and worshipped those legends up close himself, so there was no doubt: "I always thought I played piano more like a rhythm guitar. It was always the guitar players, Bo Diddley and Chuck Berry and Jimmy Reed, that I was most moved by. Those deep rhythms and grooves. Guys like Jerry Lee Lewis and Little Richard, as much as I loved their music, were so phenomenal and untouchable to me as piano players." In *MemWars*, Allen reflects that the same was true of Pauline; her instrumental skill felt unattainable to him. It was the guitarists who most appealed to Terry as storytellers too—especially Chuck Berry, whose sung cadence was perfectly attuned to his guitar rhythms. The guitar seemed to Allen somehow a more reasonable instrumental model for him, if only for its ubiquitous presence in rock and roll, rhythm and blues, and the folk revival at that time. Plus, you could more easily dance while playing it. "I liked to watch [Pauline's] fingers zip up and down the keys," he later wrote, "but my real dream was for a red box rectangle guitar like Bo Diddley. That sound hit like lightning and had gone as straight into me as a direct message from God. But the closest I ever got was a broom, which I pounded for hours, listening over and over to his first record, gyrating and practicing my moves to the mighty 'Bo Diddley Beat.'"

HIS FINGERS GRAPPLED with the piano keys, trying to twist them into what he heard issuing from the guitar fretboards and amps of his heroes; his left hand, like his mother's, grew heavier and more commanding in the bass clef.

A couple of weeks earlier the Box-Allen duo had auditioned together with their frantically percolating take on Bo Diddley's "Who Do You

Love?," which in their rendering was more shambling gallop than sexily syncopated clave. Terry, hunched and bobbing over the keyboard, glasses sliding down his sweaty nose, snarled the vocals, doing his best approximation of bluesman menace.

Today, however, they had a different plan in mind—Terry's idea, but David was game. Even David's mother, Virginia Box, got involved. "That morning going to school," David's younger sister, Rita Box Peak, remembered, "David and my mother looked for just the right flat white bedsheet for a toga and a generous amount of safety pins. I thought this is going to be high drama—and it was."

After David played "Peggy Sue Got Married" and "Don't Cha Know" solo, to rapturous applause from the audience—there was no one on the bill whose skill and confidence could remotely compare with his—he hustled offstage, where Terry was waiting. Both boys hastily doffed their shirts and donned crude bed-sheet togas, emerging from the wings to the audible gasps and screams of the incredulous audience. Terry sat at the piano bench, glanced at David, counted off rapidly, and instead of Bo Diddley, they slammed into a hopped-up, hyperactive tune that they had definitely not played at their audition. They swapped verses and harmonized on the chorus, David's airy, ductile voice weaving around Terry's feral yowl. The lyrics deployed Terry's slim arsenal of Classical historical knowledge (gleaned largely from William Wyler's film *Ben-Hur* and Shakespeare's *Julius Caesar*) in a perfectly idiotic and addictive piece of juvenile doggerel:

> Rome is the place
> Where the orgy is
> They orgy for hers
> And they orgy for his
> They orgy all night
> And orgy all day
> Spend their lives
> Just orgy'n away

The audience erupted in an indecipherable cacophony of cheers and jeers. "It was a big hit with our peers, but not for the powers that be," Terry recalled. In fact, it was "disastrous from an administrative point

of view," and particularly for David. As soon as they stepped offstage and toward the shocked crowd, head basketball coach Gerald Rodgers "grabbed me by my toga and threw me up against the wall and hissed, '*They* may not know what an orgy is, but *I* do! You're outta here!'" Shoulders stinging from the impact with the auditorium's brick wall, all Terry could do was cower and nod. Rodgers, who saw himself as defending the honor and delicate ears of the virginal female student body from such prurient, sex-crazed trash, suspended both boys for three days on an obscenity charge and threatened "to kick [their] asses all the way to Amarillo if [they] came back before then."[1] He lectured them about what a shame it was that "such good minds were wasted on *filth*."[2]

Terry had a history with Coach Rodgers. He was dating Michelle McLeod, whose ex-boyfriend Wilson, a football and basketball player and one of the coach's pets, had been hounding Terry since summer. Finally, outside a sock hop on September 30, Wilson challenged him to a duel. "It was a fast mean fight," Terry assessed in his diaristic postmortem of the clash. The melee was sufficiently public, violent, and protracted that the cops showed up. "Coach Rogers said he would forget it if nothing else happens. I sure was glad I didn't get expelled," he wrote. Jo Harvey, whose cousin had provoked the fight by mendaciously needling Wilson about Terry's purported emasculating insults, took pity on Terry. After dropping off Michelle at her house, Terry went straight to the Koontzes' house after the dance, and "Jo Harvey played nurse"—Nurse Worse to his Dr. Tractor, they joked—"and commiserated with me about fighting a giant." Her tender ministrations that night with ice and washcloth caused them both secretly to question the status of their relationship and their respective dating habits, presaging their future romance.

Three days after the "Orgy," Terry returned to school, officially an outlaw and delinquent in the eyes of the administration, but his reputation as a heroically subversive renegade (or seditious agitator) cemented in the imaginations of his student peers, including future Flatlanders Jimmie Dale Gilmore, Butch Hancock, and Joe Ely. The impact of "The Roman Orgy" extended far beyond those who actually witnessed it—in fact, most people interviewed for this book recounted the secondhand story, the legend, not the actual event itself. "I knew about 'The Roman Orgy,' but I wasn't there," Jimmie and Joe regretfully told me. All three Flatlanders looked up to Terry and David, two years their seniors, from

afar, but they weren't friends. Even Ely, who rode a motorcycle down the Monterey hallways on the first day of his freshman year and was already playing bars and clubs, suspected that Terry occupied a different stratum of cool. Norman Odam, four years Terry's junior, known then as the Hip-Hop Cowboy (for his footwork, not his musical innovations) and later as the Legendary Stardust Cowboy, was only following in Terry's insurgent footsteps when he later caught hell for wailing his deconstructed, one-chord proto-psychobilly songs on the steps of Monterey.

In the aftermath of the Exchange Assembly, "The Roman Orgy" remained etched in the collective memory of Lubbock's youth culture at large, moving through the city as folklore and folk song. For years, into the 1970s, "The Roman Orgy" served as a drinking song for Texas Tech students, fulfilling its proto–*Animal House* promise. Most fraternity revelers were unaware of its provenance, but the first generation of frat brothers learned the song from Terry himself, as he confessed in a songbook annotation: "THE FRATERNITY FLESH IN THE MAROON SOCKS CAN HAVE IT."[3]

Terry's triumph was not shared by David, who was evidently not expecting the outraged faculty response. He already had a promising music career and didn't need this kind of aggravation and infamy. "I think it hit him a lot harder than it hit me," Terry realized regretfully. Disheartened and embarrassed, Box transferred to the negligibly more artistically enlightened Lubbock High School for the remainder of his senior year and, head down, continued his music career, with increasing success outside of his hometown. Artistically, he turned his back on Lubbock.

IN FEBRUARY 1961, among the friends who took a ski trip to a resort in Cloudcroft, New Mexico, on the Mescalero Apache Reservation, where Terry performed "Cuña Town" and "The Roman Orgy" with Hugh D. back on bongos, was Lubbock High student Alton Clayton Black. A local "wannabe gangster" and Starkweather acolyte, Black was nicknamed Jabo; the teenage thug's older sister, Charoletta Jewel, was called Chic. These namesakes of the *JUAREZ* characters were white and not Latin—as far as Terry knew, anyway—but had appropriated elements of Tejano youth fashion and offered the closest analog to real pachuco style, menace, and publicly precocious sexuality that Terry encountered in his social

circle in Lubbock.[4] In a notebook entry written in the midst of his febrile period working on the initial rounds of *JUAREZ* drawings, Terry wrote: "I knew Jabo in Texas. He had a wild dark sister named Chic (probably the first girl in Baptist Lubbock to take her blouse off at party) . . . and, though not Mexican . . . they were both pure 'pachuco.' I could never forget those names."[5] Among Allen's high school notebooks is an abandoned letter on lined loose-leaf paper dated "Sunday – Sept. 16" that reads only "Dear Alton—"

ON FEBRUARY 8, 1961, Terry wrote in his diary: "I am now playing rather regular for David Box, who has recorded several records. I hope to make some money with him but don't know if I'm good enough for the band. We're going to Big Spring this Saturday and cut some dubs for an album. I hope we make good." He was still insecure about his abilities—not so much his stage presence or songwriting, which he sensed were singular, as much as his facility and dexterity on the keyboard—but David didn't seem to mind, despite the fact that he soon moved on to work with Roy Orbison as well as legendary Nashville "A-Team" session musicians like pianists Floyd Kramer and Hargus "Pig" Robbins, either of whom could outplay Terry in a measure.

Sometime in 1961, post-"Orgy," Box managed to borrow an acetate disc recording machine and lug it into his family's living room in Lubbock. These lathe devices, marketed as portable—before the days of viable tape recorders, they'd been used for ethnographic field recording—were bulky and extremely heavy. Terry recalled the one David had as enormous, "as big as a whale" beached in the Boxes' diminutive living room. The two began the day recording at the Box home while the rest of the family was out. Rita returned from school to a surprising scene and mess: "These cable cords were running from the living room to David's bedroom, and vinyl cuttings were everywhere in the living room, and this machine was going, slinging all of these cuttings around, and that's when I first met Terry. The recording was kind of a disaster, as far as I know. And after that, they picked up the machine, all the cords, and left the house. When my mother arrived home from work, she was greeted with a house covered in all those shavings."

A single known recording has survived from that day, a minimalist rock-and-roll take of Lead Belly's "Cotton Fields (the Cotton Song),"

probably modeled on the hit 1960 recording by the Highwaymen.[6] David, who performed the song later at Lubbock High, leads on spare Strat and vocals. Terry is faintly audible above the hiss, yelping high harmony backing vocals and playing some sort of primitive percussion, maybe the bongos that were ubiquitous in Lubbock in those beatnik-besotted days or possibly just slapping his thighs to keep time. It was not a particularly fortuitous beginning to a recording career, but it was appropriate that it was an entirely home-brewed and rather ramshackle affair, on questionable equipment and on Terry and his friend's own terms.

On October 23, 1964, the small prop plane carrying David and several musician friends crashed near Houston, killing everyone onboard. "It was one of those horrible epic ironies," Allen remarked sadly, that, after replacing Holly in the Crickets, David died in the exact same manner. He always told people he wanted to be just like his hero Buddy Holly, and sadly, his wish came true.[7]

BY HIS SENIOR year in high school, living with Pauline, as much as he adored her, had become excruciating, an oppressive trial punctuated by moments of mutual torture. She had begun disappearing on longer benders from which Terry had to rescue her, often putting himself in physical danger. On rainy October 16, 1960, the one-year anniversary of Sled's death, after a visit to his grave at Lubbock Cemetery, Pauline spent "all day drunk and depressed over Daddy" and then vanished again. "It scared me senseless," an exhausted Terry wrote after she finally returned at 6:45 a.m. "I don't know what to do. . . . I'm afraid to leave anymore cause I never know when she'll be home or drunk or sober. I hope, I've got to find an answer soon or I'll just give up. Help Mom, God, please." Three days later, he reported on an unusual day of sobriety and lucidity: "Mother was sober today . . . said she was sorry. I know she can't help herself and I love her so bad it's unusual. It has got to the point of fear for her life. I'm nervous when she's gone at night, now for any reason. I always have a fear that she won't come home and that I will be alone."

As an increasingly depressed and dysfunctional Pauline grew sicker and more reckless, an increasingly despondent Terry grew angrier and more reckless himself. He was forced into a parenting role, calling his mom's friends to track her down, hunting for her at night in his car,

helping her sober up and endure hangovers and withdrawal symptoms, and hiding bottles of liquor he found cached around the house. On several occasions, when she'd been gone longer than a night or two, Terry would knock on the doors of her regular haunts—friends' houses, bars, clubs, and motels—resulting in some perilous encounters with unsavory characters. Once he had to extract her from a Buffalo Lake cabin where she was holed up on a binge. Another time he tried to rescue her from a shady party in an Amarillo hotel room, but he got a flat tire on the way and had to push the Ford home. After every such occasion, he confronted Pauline or wrote her desperate letters, pleading with her to stop, to no avail. "I really love my mom," he wrote. "God, please let us make it, please."

Pauline had become involved with Alcoholics Anonymous, but Terry despised her sponsor, suspecting that for all her sanctimonious piety about a higher power and dry time, this "red head with big tits" was enabling his mother. In a memory poem titled "Blue Mother Monday," written about a decade after the events described, Allen expounds on his mistrust, alluding to an incident when, searching for Pauline at a supposed meeting, he found himself facing down the muzzle of a shotgun.

THEY ALL CAME OVER AND GOT DRUNK AND
dry fucked and wet fucked
AFTER THE <u>AA</u> MEETING WHEN THEY GOT THE AWARDS FOR
DRY TIME
a shotgun pointed right at my head
HE HAD A SHOTGUN
son I'LL GET YOU SOMEDAY I PROMISE
AND I NEVER DID but I will

On December 16, 1960, Terry came home from a party to an empty house. When Pauline finally returned "half drunk," they argued about her drinking and disappearances and his own persistent absence from home. Their increasingly rare intersections had devolved into a cycle of dramatic altercations and recriminations followed by tender reconciliations the next day. But this confrontation, which became physical, was the most traumatic yet.

Two days later, having made up, the two drove to Clarendon, and on the way home, Pauline veered off the road, almost killing them both in a "brush with death" that clearly shook him up. On Christmas Eve, after a visit from his uncle Guy and aunt Mary, who drove up from San Antonio, a drunk Pauline—"HO–HO–HO–Mom got loaded tonight"—nearly caught Terry and Michelle in flagrant delicto, but he was able to sneak her out in time due to Pauline's impaired faculties. "It was funny but scary as crud," Terry wrote, adding, poignantly, "Merry Christmas, Terry. You deserve it."

In the final few days of 1960, Terry's partying reached a fever pitch. He began a heavy daily tobacco habit that continued, notwithstanding numerous failed attempts to quit, well into the twenty-first century. He attended dances, jam sessions, and a wild New Year's Eve bash in Hugh D. Reed's family's disused barn, where he "danced with everybody and got drunk as hell."[8] The night before he had finally, and bitterly, broken up with Michelle—"SO LONG MICHELLE BROTHER I'M GLAD IT'S OVER!!!!"—and went on a drive-in double date with Jo Harvey, overcoming his reservations about dating such a close friend.

"Jo Harvey's a great girl," he wrote. "(I'M FREE!)"

ALTHOUGH ROMANTICALLY DISENTANGLED, Terry was far from free. Lubbock and its perceived limitations, the Llano Estacado and its "vast-illimitable expanse of desert prairie,"[9] all those flatlands snares and obstacles, real and imagined, empirical and metaphysical, inhered in one house at 3701 Twenty-Eighth Street and the sorrow and shame it contained behind its brick skin and the curtain-lidded eye of its cyclopean front window. "I only want to understand Mom better and go to Pratt," he wrote on the final day of 1960. "In case something happens to me this year, Mom remember I love you next to God himself. I hope this is never read, but if it is, Mom keep your chin up and live your own life. I know you can do it. Love, Terry."

"Whatever bullshit I said the reason was for going, the main one was to save my life," Allen asserts in *MemWars*. "I had no clue what would happen, but at least I knew I had a chance if I was in it with Jo Harvey. We always had a lot of nerve together."

What he sought to escape was a secret that only Jo Harvey could unlock.

CHAPTER 10

THE BALLAD OF COLDYLOCKS AND RUBBER LEGS

And when the blue of your eyes
Met my blues down inside
Well I knew . . . that we two could fly

 —"The Thirty Years War Waltz (for Jo Harvey)"

WHENEVER A FRIEND INQUIRES HOW TERRY AND JO HARVEY MET, OR THE circumstances of their unlikely courtship, he has a stock quip ready: "We met when we were eleven, but we didn't screw until we were twelve." If Jo Harvey is present, her typical response is to scold him, with a smile and an eye roll: "*Te*rry!" She's heard it hundreds of times before. The truth is, as is often the case, more complicated and less sensational.

Terry and Jo Harvey met at a dance sponsored by the Rainbow Girls, an organization for the daughters of Masons, held in some forgotten Mason's home in Lubbock. The spoken introduction and first verse of "The Thirty Years War Waltz (for Jo Harvey)"—recorded, as Terry calls out on tape, on "July 31, 1978, Lubbock, Texas"—set the scene vividly: "We were at a dance, and she was with Freddy L., Fat Freddy we called him, and I was with Myrtis M., the Girl with the Snapping-Turtle Spine. You'd be dancing with old Myrtis and have your hand on her back, and two bones would come out and grab your finger and nearly break it off. I met Jo Harvey at this dance. I had a crew cut, a red sports coat, and they called me Rubber Legs."

The details are largely true. Jo Harvey indeed attended the dance with Freddy Love, and Terry was with Myrtis Murphy, who, as the physical obverse of Fat Freddy, apparently did have notoriously pronounced vertebrae, though the bone-breaking threat they posed to wandering fingers was, characteristically, exaggerated. "I wonder periodically if she's heard that record," Terry said. "The snapping turtle spine was real; you could feel every bone in her back dancing with her."

The date of this fateful first encounter remains unverifiable; Terry and Jo Harvey agree they met when they both were eleven years old, which would have been sometime between May 7 and November 2, 1954. However, Jo Harvey remembers the dance occurring in the summer between sixth and seventh grade, which would have been the summer of 1955. She is also adamant that they met right before her family moved out of their home on Avenue L into a new house that her father built at 3104 Forty-Third Street, completed in 1955. If they met in 1956, as the song supposes, they would have been thirteen.

Regardless of when it occurred, the attraction was immediate and animal, but not necessarily romantic, at least not initially or openly. It was, rather, kinetic and aesthetic, the magnetic and mesmeric attraction between two passionate dancers, two young bodies seeking and finding complementary angles and cadences. "We just looked at each other and started dancing like crazy," Jo Harvey recounted wistfully. "He was a great bopper. I danced every single dance with him." (Poor Freddy and Myrtis—hopefully they each found someone else or, perhaps, each other.)

Terry was indeed known as Rubber Legs for his dancing ability and wild rockabilly bop style, all loose legs, double-hinged knees, and hunching and swiveling shoulders. (Already a compulsive nicknamer, he dubbed Jo Harvey Coldylocks for her skinny ankles and chronically slouching socks.) Those early dance lessons and all that piano pounding inspired by Pauline's barrelhouse rhythms had paid off on the makeshift dancefloors of Lubbock homes, cotton fields, school auditoriums, and Sled's hangar. Unlike many of his male peers, who danced reluctantly if at all, and only then out of obligation and hormonal desperation, participating in the primary mating ritual available to young people in the 1950s, Terry danced for the sheer pleasure of moving through space with other bodies. He was, by all accounts, an enthusiastic, energetic,

and idiosyncratic dancer who never hesitated to get on the floor and grab a partner.

And Jo Harvey was the perfect partner for him—another gifted dancer who made a point to learn all the new dance crazes, sometimes from her family's Black maid, who taught her the twist when the craze exploded in 1960. When they met—incredibly, in an antediluvian pretwist world—Jo Harvey still had a round baby face beneath short hair, with apple cheeks and sly, penetrating blue eyes that did not waver when she stared deep into yours (and, in Terry's case, as the song goes, "met my blues down inside") and that squinted when she smiled, both of which happened often. Their compatibility was physical and pheromonal first; only later did they discover the deep connections they shared beyond their radically different personalities and backgrounds—their emotional and creative hungers, their appetites for experience, and, for all Terry's repressed shyness and affected misanthropy and pessimism, for meeting, reading, and learning from other people with a voracious, if sly, gregariousness.

JO HARVEY KOONTZ was born on November 2 (el Día de los Muertos), 1942, in Lubbock, Texas, to Katie Marie Koontz (née Louder) (1920–2011) and Harvey Ely Koontz (1920–1986), both twenty-two years old at the time and married for less than a year. She was named for her maternal uncle Billy Joe Louder (1924–1966) and her father—known to intimates as Daddy Harv—and in the Southern and family tradition, the two names are decidedly one double-barreled first name, like Buddy Holly's Peggy Sue. (She cringes when people mistakenly call her only Jo.)

Unlike Terry, Jo Harvey was coddled by her parents, raised (in her words) "kind of spoiled rotten." The Koontzes weren't wealthy, but they readily made sacrifices for their daughter's happiness, and sometimes just to satisfy, or tolerate, her mercurial whims. "It's kind of pathetic how well I was treated," Jo Harvey told me, with evident gratitude and slight embarrassment. Harvey in particular treated his only child like royalty, with a morning ritual that could not have been more different to the Allens' groggy daily resurrections: "My dad would wake me up in the mornings, with my eyes closed, carry me to the commode, prop me up to pee, and then carry me to the table. Sitting there in front of my eggs and bacon, I would finally open my eyes. He did that until I was eleven."

In evaluating statements such as this one from Jo Harvey Allen, which seem to beggar belief, it is useful to remember that her first film role was as the character known as the Lying Woman, in David Byrne's 1986 film *True Stories*. She claims the title of her breakthrough cinematic part with honor, as an essential aspect of her identity, discerned by David and formulated on film. She learned early the value of embellishment, exaggeration, and, when necessary, downright dissembling. The role fit her like a glove. "A dime once went missing at school, and they suspected me. They called my parents; it was a big deal. My mother said, 'If you confess, I'll buy you a bicycle.' I said, 'Yes, I did it.' I learned early on that lying pays off! I'm not known as the Lying Woman for nothing." Jo Harvey's childhood sense of entitlement, expectation of indulgence, and flair for the dramatic extended to school. She repeated first grade because she couldn't be bothered to learn how to spell her last name. But she implemented her grandma Koontzie's (Minnie Lee Koontz, 1886–1957) country and gospel music appreciation education with panache, convincing her elementary school teachers to accede to an ambulatory concert: "I sang 'Tennessee Waltz' at the top of my lungs with a pump organ in every classroom."

Her likely first missed connection with Terry, the first time we know they inhabited the same room, was the result of her interest in music, encouraged by dancing Grandma Koontzie and her phonograph. In November 1953, for her eleventh birthday, her parents promised their fifth grader that she could invite six friends to join her for any activity she chose. "What I wanted to do was go to Sled Allen's Saturday Night Jamboree. I used to listen to the radio show with my grandaddy every Saturday night. So I got to go out there for the show, and Terry probably brushed by me, serving set-ups."

Her childhood was an exceptionally happy one, and unlike Terry, leaving Lubbock was never a priority for her. Even her teenage years, so fraught for so many, hold for her, amid the inevitable punctuation points of pain and adolescent angst, overwhelmingly fond memories.

When, in the winter of 1957, in eighth grade, she received an invitation from Terry Allen to a dance he was cohosting with three female friends on February 22 at Hillcrest Country Club, Jo Harvey was shocked. Though she counted Terry among her small circle of acquaintances and despite their magical Rainbow Girls connection, they weren't close and

did not socialize at school. She claims that she hadn't been invited to any party or social event in two years. Terry and his cohosts, on the other hand, were photographed for the newspaper, likely due to Sled's community prominence and longtime association with the country club. Thirteen-year-old Terry is pictured grinning, spinning the decorations (hearts and presidential heads for Presidents' Day) dangling from a tiny, emaciated tree.

When Jo Harvey arrived, wearing her best formal, she sought out Terry immediately to thank him for inviting her. He was wearing a pink sports coat, "looking flashy." He seemed somewhat surprised, but pleased, to see her, and she realized in an instant, abashed, that Terry had invited the entire school; she was not a special guest. "He probably didn't even know I went to that school," she joked, chalking up the event, and their repeated collisions on the dance floor, to "fate or predestination." They danced together all night again. But "it wasn't until after that cloud of time when my dad died," Terry recalled, when Jo Harvey intercepted the call and attended the funeral, that they became more intimate with every passing month, until finally each ranked as the other's closest friend of the opposite gender. They began buying each other little gifts, once memorably gifting each other the same John Lee Hooker record, 1960's *Travelin'*.

ALLEN'S SEXUAL AWAKENING coincided with his father's death and with the acquisition of his driver's license.[1] The first page of his 1960 diary (subtitled "HELLAVA YEAR"), the January 1 entry of his oldest extant journal, drives the point home with two parenthetical fragments of marginalia about his primary preoccupations that year, and for some years subsequently: heart-rendingly, "(first year without Dad)" and with horny hilarity, "(I made a vow that I shall fuck this year.)" He struggled to process the former reality for many years. And while it's not clear that he fulfilled the latter solemnly crass resolution that year, he came close, several times remarking that he and his girlfriends "did everything but" consummate their relationships.

When Terry and Jo Harvey began their dating lives, they sought out other partners first, acting as confidants and confessors to each other. Since he was always anxious about going home, especially late at night, and what he might find there, Terry made it a habit to visit Jo Harvey's

house before and after dates for pregame and postmortem analysis and commiseration. Or he'd telephone, and Jo Harvey would "be in the closet, behind the louvered doors with a pile of clothes on top of me to hide, talking to him all night." On the other end of the line, Terry could talk wherever and whenever he liked: "I didn't have to hide anything; my mother didn't give a shit what I did. We had a lot of very long, dissecting-the-universe kind of conversations."

By the spring of their junior year, with various shared dramas and traumas behind them—the cosmopolitan dance, Sled's death and funeral, Terry's fight with Wilson and subsequent convalescence with Jo Harvey—and both in separate dysfunctional or unfulfilling relation-ships, they finally began to see each other in a different light, not only as best friends but also as prospective romantic partners. On April 9, 1960, Terry reported in his journal that Jo Harvey had broken up with Lynn Livesey and had gone on a date with Greg Smith, concluding woefully that "life is one cool mess." On June 24, he articulated the previously inexpressible idea of dating her but dismissed it immediately as too risky to their solid friendship: "I like Jo Harvey, but I don't know, we're good friends." By this point, Jo Harvey's star had risen, and she was running with the popular crowd and actively campaigning to become one of a handful of class vice presidents. In Terry's estimation, "she was like the queen of high school."

PAULINE WAS CERTAINLY still perfectly capable of self-control, turning on her considerable charm when she wanted or needed to do so, espe-cially around strangers. She utterly beguiled Jo Harvey when they first met in earnest at the Allens' house in the early spring of 1961.[2] Terry and Jo Harvey had just elevated their six-year platonic friendship to an intoxicating if vertiginous romantic stratum, and Jo Harvey, possibly one of the least shy, most wide-open people in West Texas, was unchar-acteristically nervous to meet her new beau's mom. She could sense that Terry was too, because he seemed unusually uneasy and indecisive about scheduling the precise hour of supper and the subsequent movie alike. He did not tell her, at that time, that his stress about timing was not gastronomical or logistical, not related to Pauline's work or social schedule, or to the screening times, but strictly about how to navigate the diurnal needle's eye of her sobriety to ensure a pleasant evening with

no undue drama or disappearing acts to ruin their date and spoil their blossoming springtime ardor.

Pauline was shrouded in mystery even when her husband was living and more so now that he was gone. She shared an impressive sense of fashion and glamor with Jo Harvey and her own mother, Katie, an employee at the Lorraine, "the only fancy dress shop in Lubbock," but Pauline's style was always somehow more distant and daring—and more dated too, though in a timelessly classic way, with echoes of a quaint, and to Jo Harvey, antiquated, previous generation, her 1920s and 1930s flapper salad days. Jo Harvey got the sense, in Pauline's proximity, that she was from elsewhere, had been elsewhere, and was headed else- where soon—and that she might in fact be elsewhere at that very moment too. A sense that she'd done things she'd never tell. Behind her winning smile lay sibylline secrets and knowledge from far beyond the mundane bounds of Lubbock. She wore her past like she wore her Christian Dior suits—impeccably and patently, signifying a detached desire, a thor- oughgoing cosmopolitanism and hunger, that did not quite cover her brash dugout-to-Clarendon twang or posture. She shone with an exqui- site ache that Jo Harvey could not quite place. "She was a real beauty, and incredibly talented, such a firecracker, smoking two cigarettes at once and playing that piano," Jo Harvey swooned. "But she was a haunted woman."

On that evening in 1961, Jo Harvey did, however, know a few facts about her new boyfriend's mom: she knew that she was a musician; that she was grieving and had taken Sled's death hard, absenting herself from her previous visibility in Lubbock society, at ticket counters, in venues, and at women's club and church meetings; and that she and Terry loved each other with a ferocity, tenacity, and protectiveness that sounded, from the way Terry had described it offhandedly, slightly intimidating. Jo Harvey recognized the shyness and sweetness behind Terry's teenage bluster and anger, the unshakeable moral and ethical code behind his bravado and despair. She sensed that his sadness and fury were, in some obscure way, not only about having lost his father but also about continually losing his mother, who was, at this very moment, ostensibly fully present, clanging around the kitchen, which smelled divine, and fussing over Jo Harvey, all smiles and arch jokes. Jo Harvey was, almost immediately, at ease and smitten with this beguilingly ele- gant woman floating around her immaculately tidy home, of which she

was clearly, if stoically, proud, smoking cigarettes and frying chicken, ash falling everywhere but somehow always narrowly avoiding the spitting skillet.

Jo Harvey complimented her on the decor and her housekeeping as well as that incredible aroma. She noticed, but did not remark on, the fact that Mrs. Allen had set the table with only two place settings instead of three, as her own mother would have done, adhering to the Methodist propriety of a parental chaperone for two romantically entangled teenagers. Instead, when Jo Harvey and Terry sat down to dig in, Pauline excused herself and withdrew into the other room. Terry's heart dropped into his gut; he panicked through his surgical smile. After a few moments of silence and some awkward glances over their plates, they suddenly heard the piano ring out loudly with a glissando flourish from the living room. Rather than joining them for the dinner she'd prepared, Pauline played a private concert for them, at full volume, "just to entertain us while we were eating," Jo Harvey laughed.

When they finished, Pauline reappeared with her perennial cigarette to clear the table and cut slices of watermelon for dessert. This time she sat with them. Between crunching bites, Terry cracked a joke, and Pauline exploded in laughter. In Jo Harvey's words, Pauline "got so tickled that she spat watermelon seeds all over the wall," spraying her perfect plaster with pink vapor and staccato artillery.

After dessert, Pauline invited Jo Harvey, already a committed clotheshorse and fashion plate through her own mother's influence, into her bedroom to loan her one of her own outfits. The generosity of the gesture, which reminded her of her own mother's clothing loans, sealed Jo Harvey's affection for her soon-to-be mother-in-law: "She insisted she dress me up like a movie star before going to the Lindsey, with her skunk cape, black and white, and a huge skunk muff with a zipper inside for a purse." It was the same skunk cape and muff in which Pauline had manifested above Terry's crib as a boozily vaporous arachnid apparition when he was a toddler, terrifying him. Like her son, Pauline held on to things—physical things and memories alike.

Not long after dinner on Twenty-Eighth Street, the couple attended a show at the Cotton Club and stopped by Terry's house on the way so he could run in and grab something he'd forgotten. "He was taking so long that I got out of the car and looked through the window, and I saw him

trying to get his mother to bed," Jo Harvey recollected. "She had been drinking. He got back in the car like nothing had happened. I said, 'I *know*, Terry.' He thought it was a big secret."

On what they now consider their first official date as more than friends, in January 1961, the young couple had stopped at the Hi-D-Ho for a meal after a movie at the Lindsey, on the way to a party at a mutual friend's house south of town. On the road, Jo Harvey, giggling, dropped her French fries out the window one by one, like a breadcrumb trail down Old 87. "I don't know what she thought was going to happen to her," Terry said ominously.

But imaginary threats loomed. Sometimes Terry would knock on her door, and when she opened it, he'd yell, "RUN!" They'd pile into his Ford and peel out the driveway, burning rubber. "We'd run away like hell from the horror, just run and hide and play all night long," Jo Harvey said. If the moon was full or the weather was mild, they'd circle up with other cars in a cotton field, usually out on Slide Road or Eighty-Second Street, headlights shining and radios blaring in unison, for a dance party in the dirt. Every Friday of their senior year, they played hooky, driving around or going swimming in Buffalo Lake. They'd hold hands and stroll through downtown Lubbock, standing with their chins pressed against the wall of the Great Plains Life building, the tallest in Lubbock, staring up and imagining the impossible height of skyscrapers in New York City, what it must feel like to scale such a fairy-tale tower into the rarefied air of that mythical, exotic citadel of culture.

Finally, in late January 1961, something shifted, or broke loose, in Terry's life. After years of pressure and grief, and in the wake of concatenation of events—Terry's protracted breakup with Michelle, the acquisition of his Ford Starliner, and the fallout of "The Roman Orgy"—the conditions were right for seismic activity on his private Llano. Terry was hanging by a thread, drinking and smoking and flirting with reckless abandon, drag racing in the streets, once narrowly evading a police cruiser in a high-speed chase, on the brink of destruction or transformation. Suddenly, as if his weekend nights had blinked into Technicolor, his evenings with Jo Harvey, first with other friends and couples, and then alone, assumed a new dazzle of exhilaration. They began to refer to trips together to the Lindsey and the Hi-D-Ho as dates, because there was nothing else to call them, no longer any way to explain how they felt

and looked at each other under the glow of neon and the flicker of celluloid. It was a long time coming, but the relationship was not consummated immediately, Jo Harvey insisted: "He'll tell you I was easy, but we had seventeen dates before we kissed! I wouldn't let him kiss me, because Betty was out of town. He hated me! I was always loyal. Finally I just said, 'Poor Betty's not going to have a chance.' He said, 'Fuck you!' and stormed off. . . . Later I really tried to get him to kiss me, and he wouldn't have a thing to do with me." He stormed back a few weeks later and took her to the Red Raider Drive-In. There, on a brisk February night, they finally kissed.

Giddy and inspired now that their romance felt somehow official, he wrote two new songs that month, "Livin and a-Laughin" and "Summer Day," both earnestly romantic. In March, Jo Harvey reciprocated, in speech, what Terry had known in his heart for weeks and had already divulged to her: "Jo Harvey told me she loved me the other night, and I have never felt better in my life." They attended the senior prom together on April 29, 1961, double-dating with their friends Betty McAbee and Danny Harris, Terry's recent confidant on late-night drives through the forever flatness of caliche and cotton.

THEY WERE KIDS, subject to forces beyond their control, and much of their time together was spent at play. Much of that play rehearsed escape from those forces and from Lubbock itself. While Jo Harvey had no strong urge to remake her life or to escape her hometown, family, or school, she was delighted to play along. Terry took these games rather more seriously, as training. As is often still the case with his robust sense of humor and seemingly bottomless well of quips, jokes, puns, and wordplay, there was an edge of keening, a hint of desperation, behind the fun.

Sometimes they got started at school: "In high school, I kept a half-pint of Four Roses in my car, and Jo Harvey and I would go out and drink whiskey at lunch and eat sandwiches in the car. I only had typing class in afternoons, and sometimes I would pass out." Adventures and games aside, it was not easy and never would be. From the start, theirs was a tempestuous romance. His passion sometimes felt like an addiction, and because of Pauline, addiction frightened him. In late 1961, he wrote of his hopefulness for a shared future despite their bouts of cruelty to each other and his own occasional self-loathing: "What do I do? I try to stop

but I cannot. I love Jo Harvey Koontz but I cut her to shreds. I will marry her though, I pray this to God. I will be nice to her and I will marry her. We will be happy and we will have lots and lots of little babies. We will raise all of them to be like her and not like me. We will be happy, so will they."

Although he never relished fighting, Terry began lashing out, sometimes to the point of violence, toward others and occasionally toward his own body. His brawls with peers were generally not particularly serious—brief, scrappy, and soon forgotten and forgiven—but Jo Harvey once watched in horror as he punched a brick wall in desperation and rage, bloodying and bruising his knuckles. On another occasion, he physically assaulted a loudmouthed drunk who was snooping behind his house, probably seeking Pauline. "I just attacked him," he said. "It scared Jo Harvey and me, I got so angry. I was just so lost, after such a drastic change in my family, and everything was on the surface, ready to explode."

Despite some close brushes with juvenile delinquency, he managed to make it through high school and graduate, just barely, thanks in large part to Jo Harvey and her family (and some late-night chemistry tutoring from Pauline). Not only did Jo Harvey stick by him through his clashes with authority figures, she sometimes proudly joined him. One day Terry got kicked out of English class and sent to the principal's office, and Jo Harvey got up from her desk and declared, "Well, I'm going too." When news broke of their relationship, her hard-won high social standing began to slip and falter—she was suddenly on shaky ground at Monterey, especially with the faculty. School had always come easy to her, despite seldom completing the assigned reading; she relied on guidance from "the smart girls" and miraculously managed to earn As even when her informants didn't. (Contrastingly, Terry read voraciously beyond assignments—"he still reads 10,000 books to my one," Jo Harvey claimed—but struggled with grades, largely out of apathy, antagonism, and distractions at home.) "The teachers used to be so sweet to me, but they quit even saying 'hi' when I started dating him," she said. "A lot of people were against Terry."

ONE NIGHT IN 1961 Terry confessed to Jo Harvey his formless but insistent hopes and fears for the future, something he had never articulated

to another person. "He told me he didn't like high school but always dreaded what would happen after school," Jo Harvey recalls. "We had that bond, and he could confide in me."

"I was so comfortable around her," Terry said, "and I'd never felt that way around anyone. She was a total light for me at that time. She wasn't judgmental."[3] One night, he remembered, "we parked in somebody's driveway, in the dark. I told her I was not going to stay in Lubbock, and I didn't want to do anything any of the people we knew were doing. I wanted something totally different, but I didn't know what. Nearly everyone I knew had a plan, and I remember getting freaked out that I had no plan."

CHAPTER 11

CRIB WORSHIP

Ahh but what of Alicia
Espaniola
Fifteen years old
Girl of Mexico

 —"What of Alicia"

WHEN THE GHOSTS OF HALLOWEEN AND EL DÍA DE LOS MUERTOS—AND Jo Harvey Koontz's nineteenth birthday—departed Lubbock on November 3, 1961, they left in their wake an unseasonable chill, with temperatures plummeting to zero degrees Fahrenheit, gusty winds approaching forty miles per hour, and dust devils of powdery snow whirling down the wide streets. Terry and Danny Thompson, a friend (like Danny Parrish) since third grade, sat in Allen's old Ford in the white-out conditions, windshield wipers squealing and banging along to the radio. The two friends watched pedestrians struggle against the wind, leaning into it at impossible comic-book angles to avoid being blown over with their grocery bags, briefcases, and small children.

"Look at these idiots," Terry muttered.

"Look at *us*," Danny replied. "We're still here, sitting and watching them."

"We've got to get where the sun is shining—and soon." Terry put the Ford in gear and crept away through the pale, blustery dusk, with (as he later sang) "snakes in [his] mind."[1] His long, carefully cultivated dreams soon precipitated into an urgent plan of action, abetted by Danny,

college admissions be damned. "We started talking seriously about going somewhere, preferably somewhere warm," Terry said.

HE'D LEARNED TO drive in Sled's 1951 Chevy pickup out in the vast fairground lots of Fair Park Coliseum (where there was nothing to hit), with his dad providing laconic instruction in his usual taciturn manner, a less dramatic and dangerous reenactment of the swimming "lesson" his own father, Samuel, had given him. Finally, after months of aching anticipation, Pauline and Sled gave him a green '53 Chevy sedan with white-fleck upholstery—nicknamed Cowboy Copas—in 1959, at age sixteen, upon getting his driver's license in May of his sophomore year, not long before Sled died. It was a pivotal moment in his adolescence that coincided with a violent hormonal and attitudinal shift in his behavior: "I did pretty good in school up to sophomore year, and then things went south. I got into a lot of fights, not real hoodlum stuff, but edging on it. And I finally got my first car."

Allen customized Cowboy Copas with moon hubcaps and, weirdly, a painted chicken-wire grille, one of his first forays into sculpture. The Chevy broke down constantly, sometimes due to his own idiocy. (In 1960, whiskey-drunk with a carful of friends, he drove straight into a playa lake, the aftermath of a flood near Buffalo Lake that filled a slight dip in the road ahead of Yellow House Canyon's descent—a relatively mild elevation change but a dramatic one for Lubbock—at ninety miles per hour.)[2] Even so, the vehicle provided a long longed-for link to "the outside world and the world of music": "In some sense, my first memory was my first car. . . . The first memory that anybody has growing up in that part of the country is when you get your first car, because there's absolutely no reason to have a memory up until that point."

The hunt for his next vehicle became an all-consuming quest. In early 1961—right in the midst of his awakening romantic interest in Jo Harvey— he acquired what he has always considered his first "real" car, the first he felt he owned exclusively and that fully and reliably functioned, a "cold black Ford Starliner with a 375-horsepower engine and fast as hell." It was a generous early graduation gift from Pauline, who covered half the cost. The Ford's maiden voyage road trip was out to Cloudcroft to ski, with a gang of friends among whom numbered Jo Harvey and,

once again, the mysterious Alton "Jabo" Black, a trip that marked the true beginning of Terry and Jo Harvey's romantic relationship. With red-and-gold-fleck interior upholstery and a longer and leaner sharklike shape that contrasted with the squatter and more muscular-looking Chevy, the Ford was a beauty inside and out. It was the ideal ride for Terry's burgeoning courtship of Jo Harvey—the "old Ford" that "can still fly," full of Four Roses bourbon, in his song "Flatland Boogie" is the Starliner—who herself drove some impressive vehicles, including her own Plymouth Fury. However, when he first picked her up in the Ford, Jo Harvey was not impressed: "He acted so stuck up about his fancy new car I told him I didn't like him anymore. He'd only had it for fifteen minutes, the poor guy!"

Terry's more mechanically inclined friend Duane Hausauer helped hotrod the Starliner with a column speed shift (a "Strainer 370 horsepower stick"). When challenged at the drive-in, Terry began attending weekend races out on Slide Road, a paved farm-to-market road that was usually barren at night. He didn't have much interest or patience in the technical side of automotive devotion, and his driving skills could never match the serious racers, but he was an adrenaline junky for the sensation of speeding down a long, straight, dead-level road at night with the radio at full blast. In *MemWars*, Allen frames the experience in its most succinct and decisive terms: "The sense of hurtling through great black empty space . . . late at night on a dead straight line of asphalt with headlights shining . . . driving a car as fast as it would go . . . and listening to The Wolfman on the radio turned up as loud as it would go . . . is probably where every freedom I most value first began."[3]

Duane and Terry were fast friends who bonded over their need for speed, their shared sense of adventure, and their penchant for getting into trouble. Duane's father owned a print shop in which they manufactured fake IDs for themselves and their friends; Allen's served him well until he turned twenty-one in LA. The two friends made a memorable road trip to the West Coast together in the summer of 1961, a couple months after they graduated, departing on July 10 in Duane's red Chevrolet Corsair, intending to be gone for an entire month. "California, here we come!" Terry wrote in his diary, where he carefully recorded each day's events alongside his reflections and expenses (and dwindling coffers).

In San Diego, they slept in sleeping bags on Mission Beach (ending up with crotchfuls of sand and ants), marveled at Californian girls (they even "got half-horny over a picture on the menu" at a diner), and visited museums, including the San Diego Museum of Art, by far the most extensive and impressive collection Terry had seen. Then, as Terry wrote several years later in a text called "border memory," they "left lubbock with fresh white peroxided hair and bermuda shorts," shooting pistols at cans from the car, and "drove hard south to the long lines of sailor-crammed chryslers waiting for tijuana / young blood."

The cocksure expedition of two young Americans abroad darkened quickly when they were invited to attend one of the city's notorious "donkey shows," and in their naivety, accepted the offer: "suddenly / right there in front of all the parents in the united states / this cab driver says / 'hey! you want to see a beautiful white girl fuck a donkey?'" Titillated and terrified, they drove into the hills of the city, right "into the syphilitic knife-infested-killer-weed-orgy show," ending up at a makeshift brothel. Terry tells the story of what ensued in an episode he titled "crib worship":

> the cab driver escorted us into a larger room and both of us
> shuddered
> stunned-like-ammonia
> from the smell hammer that slapped us
>
> the room was basically square
> near the ceiling
> criss-crossing from the walls
> ropes were strung
> forming cubicles of rectangular webs
> on which
> nasty blankets were hung
> strung down like small billowing walls and forming cloth boxes
> cribs
> exactly the size of the bare mattresses on the floor of each one
>
> the windows were open on opposite sides of the room
> causing the thick space

to flow
gently
like sea

on the floor
 by each mattress
 was a roll of toilet paper
 white
 and when the wind whipped several blankets
 i saw pictures of jesus, children
 and various saints
 safety-pinned on . . .

i considered fainting
 feinting
 but a girl
 the youngest i'd seen
 calmly walked up in a red dress smiling and grabbed my crotch
 "you want to flicky flick?"

 but duane suddenly turned and bolted out the house
 i followed

Petrified by sexual panic, they barely managed to flee the angry cab
driver, who chased them with a "three-penny knife" demanding pay-
ment, until he was set on by a pack of small dogs. When they finally
made it back to their room in San Diego, Allen wrote coolly on the hotel
stationery, "there's no donkey girls in tijuana / just jackasses." His first
encounter with sex workers and extreme poverty, this "spooky" experi-
ence "made a huge impression" on Terry. It also had "an enormous
impact" on *JUAREZ*, providing the model for La Estrella Negra, the
Tijuana whorehouse where Sailor meets Alice, down to the "cribs," the
mattress-scaled cubicles made from blankets hanging from a rope grid,
blowing queasily in the wind (evoking sails and a ship at sea) and poi-
gnantly personalized by the prostitutes with collaged images represent-
ing family, faith, and aspiration.

CHAPTER 12

GONNA CALIFORNIA

Gonna California . . . gonna leave tomorrow
Leavin this town and all of its sorrow
Behind me
Cause my heart's been burned from the lessons I've learned
Behind me

 —"Gonna California"

BACK HOME IN LUBBOCK, TERRY HONED HIS OWN COMPARATIVELY PRIVILEGED aspirations: "Although my ambitions are dream-like, I look forward to a life filled with new ideas, world travel, and family happiness. As a commercial artist, and husband, I hope to turn these ambitions into reality." Commercial art seemed the only viable career path, and it offered an apparently marginally more pragmatic entry point into the arts than so-called fine art. Terry and Danny Thompson, "a phenomenal cartoonist" and fellow member of an art-class "coven of criminals," had successfully rendered and passed off fake bills at liquor stores; maybe they could put their enterprising counterfeiting skills to more ambitious use. Pratt was his only real hope at continuing education, because it was the only art school of which he was aware. But Monterey High School vocational counselors were not well equipped to advise a hopeful art student applying to a New York City institution, and Terry didn't have a clue what kind of application would be competitive.[1] He was not accepted.

Feeling utterly adrift in Lubbock, Terry enrolled at Texas Tech for the fall semester of 1961. He knew he didn't want to be a roofer, and he wasn't eager to find another, more permanent job as a manual laborer, so

what other option was there? Both Jo Harvey and Danny Thompson had decided to matriculate at Tech, which provided impetus and some sympathetic company, as other friends were drifting off to faraway colleges or taking full-time jobs. But the decision was nauseating. As the primary cultural and economic force in Lubbock, Texas Tech and everything for which it stood—from money to politics to football (e.g., "The Great Joe Bob")—was anathema to Terry and his nascent, if overly rigid, value system as an aspiring artist. He prayed his attendance would be only a temporary purgatory.

His hard-won high school diploma having been secured against all odds, and with middling grades outside of an A in graphic arts and a B in painting, on June 1, 1961—proud Pauline kept the program—Terry gritted his teeth, girded his loins, and resigned himself to play the part of dutiful college student. He did not last long. He and Danny took as many entry-level art courses as possible and blew off everything else, skipping classes wantonly. In order to register for studio art classes, the Architecture and Allied Arts Department required students to take architecture classes, which they tolerated, barely. Allen actively looked forward to exactly one class every week, the only academic hours that buoyed him through the single semester he endured at Tech. Fledgling part-time art instructor Paul Hanna taught an introductory drawing class in which, unlike in other classrooms, both Terry and Danny felt comfortable, appreciated, and challenged. Before earning an MFA from Texas Christian University in Fort Worth and joining the Art Department at Texas Tech just the year prior, in 1960, Hanna had served in the army as an intelligence officer. It was an apt background given the intel he provided to his students Terry and Danny—the only piece of salient, practical information that stuck with them through their brief tenure at Tech.

For three years before moving to Fort Worth, Hanna had attended an art school in Los Angeles with a chewy, baffling, and vaguely foreign-sounding name: the Chouinard Art Institute. "It was a huge thing for me," Allen reveals, "when I asked [him] if he knew of a school that was like his class. That was the first bull's-eye on California." Terry had, of course, never heard of Chouinard, but Hanna sang his alma mater's praises, speaking fondly and nostalgically of his exciting time in Los Angeles and what he'd discovered there, how Chouinard's radically open-minded, largely self-directed, European-style curriculum had

cracked open his narrow small-town Texan skull to absorb a wider world of ideas, how its world-class faculty had forged him as an artist. For some unfathomable reason, Hanna had, in Terry and Danny's callow view, squandered his momentum to move to Lubbock—he'd stay at Tech for decades, eventually retiring as professor emeritus—but his seductive stories about life as an artist in mythical, beatnik-teeming California were like catnip to the young men. He convinced Allen and Thompson that Chouinard was a viable, even perhaps preferable, alternative to Pratt, encouraging them both to apply. The weather in LA was certainly more appealing.

They did not require much arm-twisting, even if they had virtually no idea to what, exactly, they were applying. Little did the two boys know the school was already actively fostering many of the future leading lights of a radical new generation of artists thereafter permanently associated with LA.[2] For eighteen-year-old Terry, "Chouinard" was mostly an exotic word that represented a chink in the impenetrable prison of dark associations (and dissociations) that Lubbock had become for him—a sliver of light toward which he resolved himself to scrabble at any cost.

Founded in 1921, Chouinard had quickly become among the most significant and influential professional art schools on the West Coast. It owed its ascendancy and solvency largely to the pagan fantasies and fairy tales of Walt Disney and his animistic critters. Throughout the thirties, Disney lent his animators to Chouinard to teach and to scout talent, hiring numerous students and graduates who went on to animate classic films like *Snow White and the Seven Dwarfs* (1937), *Pinocchio* (1940), and *Bambi* (1942). When Terry and Danny arrived in 1961, the school was in the midst of both fiscal and identity crises, as Walt and Roy Disney, anxious about their investment, guided a controversial merger with the Los Angeles Conservatory of Music, thereby establishing the California Institute of the Arts (better known as CalArts).

Terry, visions of anthropomorphic mice and ducks dancing in his head, worked assiduously on his application over winter break, completing it in the somnolent dog days after Christmas. Though he'd assembled a small but potent group of drawings he'd made in Hanna's class to bolster his candidacy, the actual Chouinard application resembled a correspondence class questionnaire, "like some kind of comic-book art drawing lesson," Terry recalls. "It was a form with four or five pages,

with different slots and instructions to draw your hand, draw your room, draw your house, draw your pet." That was easy enough for him, but one question in the written section stumped him: "It asked, 'What artist has contributed most to the world?' or 'Who do you feel is the most important artist of all time?' Something outrageous like that." Terry sighed, his mind a blank, and stood to grab a drink from the refrigerator. On the way back into the living room, his roving eye chanced on an issue of the *Saturday Evening Post* on the coffee table. Taking up his pencil again, he quickly filled in his answer: "Norman Rockwell." "He was the only artist I could think of at the time," shrugged Terry, and one of the few he recognized by name and whose work he knew intimately and could readily identify.[3] Danny and Terry mailed their applications as soon as possible, on January 2, 1962. Although they had not formally withdrawn from Texas Tech, "neither one of us showed up at school anymore after that."

Allen started writing "Gonna California," a sarcastically sanguine, major-key sequel to the morose "Late 1961 (the 3701 28th St. Cowboy Blues)," right before leaving Lubbock for Los Angeles, as he labored on his application. Superficially a relatively straightforward leaving-town-in-a-hurry song, genre conventions like the suggestion that it's purely heartbreak—via a fictional "little girl" on equally fictional D Street—that's driven the narrator to depart mask the actual unspeakable reasons for "grievin'" that Terry harbored in his broken heart.[4] Jo Harvey's anger at his incessant harping on leaving Lubbock and her own declarations of independence had, however, truly wounded his pride, withering his slim, unrealistic hope that she'd miraculously vow to wait for him. She refused to make the same mistake of assuming exceptionality that she had made almost exactly five years earlier, when Terry invited her—and every one of their classmates—to his Valentine's Day dance.

TERRY AND JO HARVEY have often told the story about how after graduating from Monterey, at the age of eighteen, they flipped a coin to determine whether they'd move to New York or LA, which seemed the two most viable cities to pursue their dreams. And, as Terry puts it, the results were clear: "We got LA."

But in fact the coin flip was likely more performative than prognostic, since, with Pratt out of the picture, the geographical decision was a foregone conclusion. When in December, only weeks before departing, he

finally worked up the courage to broach to Jo Harvey the subject of his impending move to California, she was understandably apoplectic. Although it did not come as a complete surprise—the specter of escape had been in the air for years, and he had been raving about Hanna, Chouinard, and Disney for weeks—the timing was offensively late, sudden, and inconvenient.

Once she broke through a moment of utter disbelief, her fury was trebled by circumstance. Not only was she hurt by Terry leaving her behind, despite his anxious assurances that it was a trial run, with no promise of acceptance to Chouinard, and that he'd return for her, but she could not move to California with him even if he'd invited her (which he had not). Her parents would never approve—she wouldn't approve herself—of moving away with a boyfriend before marriage, and as far as she could divine, no proposal was forthcoming. She was also at a crossroads herself. She had dropped out of Tech not long into her first fall semester due to a bad case of mono, so she had put her own life on hold until her health improved. Terry's elation at his escape only exacerbated her own anxious sense of suspension in limbo. But she swallowed her pride and resolved to bide her time, giving Terry a reluctant and curt blessing to follow his dreams to Los Angeles. She'd return to Tech for the spring semester and see how events unfolded. But she'd be damned if she was going to wait around for Terrence Lain Allen to call on her or to propose. In the meantime, she'd continue her education and date whomever she pleased. "It wasn't a good reaction," Jo Harvey told me, with extreme understatement, of her immediate response to Terry's news.

> I thought he was leaving me forever. I couldn't believe it, but I did understand that he had to go. I drove way out into the country, and I got off the road and drove across these cotton furrows to the middle of a field. Right about sunset, I got out of my car and started screaming as loud as I could. Our friend who lived out there, Hugh D. Reed, saw me out there and heard me screaming. I told him, "Get out of here! I'm screaming, leave me alone!" We were fairly dramatic back then.

Pauline had seen it coming, and part of her had never left California, reciting her adventures and disasters there iteratively in her memory.

She smiled enigmatically, tilted her head, and embraced her only son warmly, wishing him luck and handing him a slip of paper on which she had written some relatives' names, addresses, and phone numbers.

ON THE MORNING of January 4, 1962, Terry and Danny once again sat shivering in the Ford, squinting out the windshield into the pallid glare of another Panhandle blizzard. This time, unlike the similar occasion exactly two months earlier, the car was crammed with threadbare suitcases and cardboard boxes containing hastily packed clothes, books, records, drawings, notebooks, art supplies, and meager provisions for a journey of unknown duration and dimensions. The two boys glanced at each other furtively, unsure what to say to commemorate such a moment, how to acknowledge to each other, and to themselves, their childlike terror and excitement. Terry took a deep breath, revved the engine, checked the rearview mirror, and backed out of Danny's driveway.

They would not hear back from the admissions office until the spring, but the simple act of putting their applications in the mailbox was for them sufficient lure and deposit for them to take the plunge and make the move. Perhaps proximity to Chouinard's campus might influence their chances through some sympathetic magic. For his part, Terry was not going to take no for an answer. He'd figure it out somehow or other and claw his way out of dead-end Lubbock to a life in the arts, even if he had to reapply a dozen times.

"Dave Hickey asked me once what my definition of art was, and I said, 'To get out of town,'" Terry has remarked.[5] By the measure of that admittedly intuitive and immediate response, Allen officially became an artist in 1961, at age eighteen. It was an escape mechanism, an instinctive response to disfiguring loss as much as a chosen vocation: "I never considered that there could be any artists in Lubbock. If you were creative, you had to run as soon as you had the chance; you didn't even think of staying."

HIGH ON EXHAUST fumes, testosterone, and sheer momentum, with no concrete destination, they drove until they could drive no farther, straight to the brim of the North American continent.[6] Two days later and four hubcaps fewer, they parked at Venice Beach and gazed blearily, back and forth, at the swollen, sweating denizens of Muscle Beach and the roiling,

gray Pacific Ocean.[7] "Arriving there was like landing on another planet," Allen observed. They stumbled out of the car, greasy cheeseburger wrappers blowing out the doors like Texas tumbleweeds, and, dropping their sneakers in the sand and rolling their jeans, walked immediately across the beach and off the United States of America's western edge into the frigid sea, "as far away from Lubbock as possible." That night they found a nearby seedy motel to stay temporarily, while they rationed food and scoured the newspapers for jobs and an affordable apartment.

They finally scored a gig selling pots and pans door to door. They attended a marketing meeting in an anonymous office full of ashen middle-aged men in cheap, rumpled suits, where a matronly gray woman solemnly presented them with dossiers containing glossy foldout brochures displaying centerfold photographs of gleaming cookware, like pornography for kitchen fetishists. It was enough to supplement their dwindling savings to pay the first month's rent at an apartment house in Wilshire, at the intersection of South Normandie Avenue and West Eighth Street. It was a dark and dingy semibasement hovel partially below street level: "It was half above and half below the sidewalk, mostly underground, with a high narrow window eye level with the pavement. The very first day we moved in, we were looking out this window, and some guy ran around the corner, and the cops caught him right in front of our window, threw him down on the ground, pounding him into the sidewalk. I remember him looking right at us through the window. It was the perfect introduction to LA."

Face to face with those desperate eyes staring into his, Terry realized he had traveled halfway across the continent—fleeing Lubbock and, as he sang in "Gonna California," "all of its sorrow," "all of the lessons he'd learned," all the "evil and bad" now supposedly behind him—and he'd ended up full circle, reborn back into Pauline's hillside first home in Hollis, Oklahoma, dropped into the dusty trough where Sled had spent all those threadbare years with his teammates. Like his ancestors, responding to the inscrutable call of westward expansionism, he had taken refuge in a subterranean shelter, albeit of the urban variety, but no less the provisional product of destitution and desperation—a dugout.

AROUND THE CORNER, at 3260 West Eighth Street, was one of the city's premier jazz clubs, a mecca for musicians associated with the West

Coast scene. Once he finally had some pocket money to spare on entertainment, the Tiffany Club's considerable charms were difficult to resist, and it was one of the few places in the neighborhood where he felt comfortable drinking and dancing. He'd square his shoulders and try to look stern as he flashed the fake ID he'd made with Duane. He and Danny would nurse the cheapest beers they could buy and surreptitiously gawk at the stars, like Jackie DeShannon, occasionally dropped off in their limos. The Tiffany was a convergence of old and new LA, an admixture of postwar and youth cultures and audiences that heralded the immense changes on the horizon.

One night during that first LA winter, Terry stopped by the club after work, an impromptu indulgence. It was a weeknight with no scheduled show, so despite a couple full tables among a smattering of solitary drinkers, the place was relatively quiet. Suddenly a stool screeched, and a visibly drunk middle-aged man in a disheveled suit lurched to his feet and made a slurred announcement, waving a bouquet of flaccid bills above his head:

"Fifty bucks to anyone who can play the goddamned 'St. Louis Blues'!"

Terry couldn't believe his luck. He'd just unwisely emptied his wallet on beer, and that was still one of the few songs—other than his own, which were shaky enough—that he felt marginally confident about performing in public. The taproot and wellspring of his entire musical knowledge and experience, the official blues of the largest city central to his family history, he'd known it longer than any other, thanks to Pauline. He leapt up, raised his hand like a schoolboy, hustled over to the slim stage, and sat down hard on the cold bench. There, shoulders hunched in his typical piano posture, he froze. The man with the money, now seated again—an obvious relief to his unsteady legs—stared from Terry to his friends with rheumy truculence, as if trying to prove some obscure point.

Terry thought of the masters who'd sat in this very place: Russ Freeman backing Chet Baker, Mal Waldron backing Billie Holiday. He thought of his mother. He flashed to late nights huddled on a sticky hotel bar banquette at the La Fonda in Santa Fe while Pauline played ferociously to kill the chatter and silence the clinking glasses, as if punishing herself and the scant, distracted audience for the unfulfilled promise of her career, smoke billowing from her red lips and rising from an ashtray

beside the keyboard, as if it emanating from the trembling piano itself, a furnace of musical combustion. What the hell did he think he was doing on this legendary stage, fingers hovering over the keys of an instrument animated by so many brilliant players? He was no jazz musician; he could barely manage the simple, dirge-like blues progression the song required. He had never performed for a roomful of strangers. But somehow his fingers fell hard onto a ringing G minor chord—God, that piano sounded good—and the "goddamn 'St. Louis Blues'" filled the uncrowded room. Terry sang its poignant, gloaming lyrics to himself in his head: "I hate to see the evening sun go down . . ."

BECAUSE THEIR APARTMENT lacked a telephone, Terry and Danny spent countless cumulative hours in 1962 on the lobby pay phone in the nearby Hotel Normandie, calling loved ones back in Lubbock.[8] Letters remained their primary form of communication because they couldn't afford long calls or sometimes any calls at all. And some conversations had to be spoken and heard.

The day that Terry finally called to propose, a Sunday afternoon in May, just after his nineteenth birthday, Jo Harvey Koontz had been out waterskiing on Buffalo Lake with friends. Her hair was still damp, the dank tang of lake water still redolent on her. Terry was terrified, naturally, his heart a fist in his throat, despite having rehearsed the conversation for days. He had just received a letter from the Chouinard Admissions Department notifying him that he'd been accepted to Chouinard on a provisional basis—as had Danny—and his future suddenly felt somewhat more tangible and even potentially promising. His grades and portfolio were both too feeble for full matriculation, so he was admitted on academic probation. He took it as a sign that, since he finally had a concrete reason to stay in LA for at least the next four years, now was the time to lure Jo Harvey out, which he knew would require a marriage proposal.

Jo Harvey was not surprised by his fumbling phone call; she'd anticipated it, encoded in hints in his breathless, hilarious multipage dispatches—equal parts randy and profane, fawning and romantic, jealous and grateful for her bizarre care packages.[9] She had continued dating other boys, albeit casually. "What was I going to do?" she asks. "I was still mad for Terry, but he was gone." Before he'd left, Terry had floated

the idea of seeing other people, until he ran into Jo Harvey with another boy at the Hi-D-Ho. "I was hanging onto his steering wheel, and he was pulling on my feet to try to get me out of his car and leave me in the dust," she remembered. "My mother said, 'If a boy ever tried that hard to get rid of me, I would let him.' Everybody said, 'For God's sake, don't let them get married!'" Still, there was no question she wanted to marry Terry—he could be infuriating, but he was the most interesting and unusual boy she knew, and she loved an adventure. So she didn't torture him; she immediately said yes to his faltering question. They were both elated, and for a few seconds, uncharacteristically speechless. She envisioned herself as Sandra Dee in *Gidget* (1959): "I thought oh, this will be fun! I'd marry Terry, we'd go to California, get a place on a beach, sleep in a hammock. We'd cook on a hibachi right on the beach and dig for clams (which we did once, and it was a disaster—they were so sandy and just inedible). I had a coat like Sandra Dee, a white coat with three black buttons, so I was ready. I never once asked Terry what he was going to do, or how we would support ourselves." "She never thought about money, or making a living," Terry grumbled.

They quickly got down to the business of discussing the particulars but misread each other's expectations, the first of several critical premarital miscommunications. Jo Harvey described the confusion of planning a wedding largely by post and phone calls from a hotel lobby: "I do remember there were a lot of conversations about whether we should have a wedding or just run away. My folks offered us money to run away and elope. But I thought that Terry wanted a wedding, and he thought that I did. So we had this big church wedding at 7:30 in the morning. Which was kind of unfortunate, because he was trying to jilt me at the altar."

CHAPTER 13

FLATLAND BOOGIE

Some old Angel from Amarillo
Must be helpin us to hold it on the road

—"Flatland Boogie"

HARSH MORNING SUNLIGHT BLARED THROUGH THE NARROW WINDOW, illuminating the white tile and scrubbed porcelain of the bathroom at Forrest Heights Methodist in Lubbock. It sliced a pale path across the floor and crept across his stiff new leather shoes and up the pant leg of the new navy-blue suit in which he found himself packaged, perspiring and pacing. He pulled at his skinny tie and fussed with his corsage. The musty church smell that he inhaled, with juddering, ragged breaths—candle wax and wood polish, dust and stagnant water, sweat and body odor (some of which he recognized as his own), the decaying scent of nonenal topped with a hint of disinfectant—belied the apparent cleanliness of the holy lavatory, and the nave itself. He abruptly stepped to the outer wall, threw open the window, its swollen frame screeching in protest, and stuck out his head experimentally into the fresh wind and hot glare, like a sailor in a gale, blinking in blind terror. Although it was obvious that his broad shoulders would never squeeze through such a slim aperture, he hoisted himself up level with the sill—just in case there was a way out.

It was Sunday, July 8, 1962, 6:30 a.m., the day of his wedding to Jo Harvey, and Terry was desperate to escape by any means necessary.

A battalion of knuckles beat insistent tattoos on the thin panel door—it sounded like it was ready to rattle off its hinges—in a call-and-response

conversation with the creaking window frame. Terry knew there were four pairs of fists doing the battering, belonging to his best man, Danny Harris, his two groomsmen, Danny Parrish and Ronnie Hall, and his usher, Stanley McPherson. A track star from Hobbs, New Mexico (where Harris also grew up), nicknamed Roadrunner for his extraordinary speed, Stanley "had crazy pin-wheeling eyes, loved Coors in the can, and dipped snuff." Noticing how anxious and squirrelly Terry was getting, a fox at bay, they had feared he might flee at the last minute, so they'd cornered him and pushed him into the bathroom, not considering he might lock himself in.

The mood among the wedding party had shifted in the few hours since they'd all driven home blearily from Buffalo Lake for an inadequate prenuptial nap. The groomsmen had filled their trunks with beer and bootleg whiskey, intending to convoke a bacchanalian bachelor party. Instead, due to poor planning and Terry's reluctance, they stayed up all night, sitting on the hoods of their cars and staring at the lake, slugging whiskey, chainsmoking, and discussing the future, which felt insanely, vertiginously uncertain that night, their bellies full of rotgut booze and butterflies. Only Stanley harbored a coherent plan; he had scored a track scholarship to Texas Western, where, inspired by Disney's animated sylvan idylls, especially *Bambi*, he would study forestry.

The prospect of "going to California," ostensibly for good this time, "to exit Lubbock to that degree, was kind of like going to Mars. And getting married was a completely Martian notion too." They all toasted Terry, the first astronaut of the group (though Danny had recently wed his sweetheart Claudia Keaton, Jo Harvey's matron of honor). Though no one mentioned it aloud, they all privately wondered if they would ever see each other again. In fact, Terry would only reunite with Harris fifty-five years after his wedding. He would never see Ronnie again, nor Stanley, who would die five years later, on September 19, 1967, blown to pieces in a Vietnamese jungle. "We did talk a few times on the phone," Terry said. "One weekend he called and said he'd just gone over to Juárez and gotten totally wasted and had a roadrunner tattooed full length on the calf of each of his legs. Those little bleep-bleep fuckers from the cartoons, he said. But Mexican style. That was our last conversation."

Danny Thompson, who had made it abundantly clear to Terry that he did not approve of the union, was conspicuously absent from the

drunkenly dour company at the Buffalo Lake bachelor's wake. "He was real pissed about not having a car," without which he'd be stranded in Wilshire, Terry explained, but there were other psychological factors at play. The roommates had developed a codependent relationship based on their social isolation, penny-pinching penury, and a daily commute to their assembly-line jobs at an aluminum awning factory—"Rooftop Blues" all over again—in Gardena, fifteen miles south, off the 110. It was grueling, mind-numbing work, and Terry spent as much time as possible off the factory floor and away from the din of the machinery, attending to other, more pressing, private needs. "I would go to the bathroom constantly to write and read letters to and from Jo Harvey," he revealed. "They must have thought I had a terrible problem with my bowels." In reality, he could barely afford to eat, relying on shared lunches from a sympathetic coworker named Billy Dean Turner, "a real tire-tool type guy with a pompadour," an unlikely early friend in LA.

Terry and Danny were on the 110 by 6:00 each morning and back downtown for their respective night shifts at different cinemas twelve hours later. Though Terry's nocturnal career as an usher at the Beaux-Arts Orpheum Theater, which consisted primarily of wearing "a sleazy-ass tux" and "selling popcorn or waking drunks up and making them leave," sometimes verged on hallucinatory levels of tedium—he claims to have watched the 1961 World War II epic *The Guns of Navarrone* five hundred times—it was far more congenial and less dehumanizing than the factory. He befriended his eccentric manager Roger Olett, a portly bibliophile who ranted obsessively about obscure writers and whose gloomy apartment was congested with labyrinthine piles of paperbacks over which he presided like "some bizarre Borges character." Both boys worked until 1:00 a.m., completing a daily fifteen-hour workday, and trudged back to their urban dugout to sleep for four fitful hours. They had three unoccupied waking hours to themselves each day. Exhaustion became a kind of delirious fuel for Allen, instilling a rigorous (and arguably extreme) work ethic that he subsequently applied to his art career.

"By the time I went back to Jo Harvey," he confessed in retrospect, "I was a raving zombie hysteric."

Despite his enervating schedule, Allen did manage to venture out to experience some of what the city had to offer. One day in early 1962, he

drove to the Jewish Community Center on Wilshire Boulevard to see a
performance by the Freedom Singers. After the show Terry had his first
prolonged, serious conversation ever with a Black person—and not just
anyone, but the incendiary, charismatic bandleader himself, Cordell
Reagon, a field secretary for SNCC.[1] As recounted in *MemWars*, the con-
versation was a revelation, politically and artistically. Reagon railed
against "all the nonviolent stuff," advocating that it was "time for Negroes
to rise up and get guns and fight the motherfuckers." Allen, a budding
(and naive) civil rights convert, was stunned. Then Reagon played him a
reel-to-reel tape:

> The voice on the tape sounded like it came right out of the ground.
> It was an old, old voice, but with something else dark and strange
> going on in it. The song was something about a black crow.[2] I'd never
> heard anything like it. Cordell Reagan said it was this young white
> kid who called himself Blind Boy Grunt. . . . [He] said they were
> Protest Songs.
>
> The voice sure didn't sound like any kid. It was high and scratchy,
> and mysterious and ancient, and ugly and hypnotic all at once.

Blind Boy Grunt was an early nom de plume of Bob Dylan, whose epon-
ymous debut album on Columbia Records would be released a few weeks
later, on March 19, 1962.[3] Terry bought it and played it incessantly. Dylan's
figurative, skeletal music, degrees harsher and drier than anything Allen
associated with the polite and bland folk revival he knew, hit with the
force of a dust storm, much like Bo Diddley had a few years earlier. He
couldn't believe that this artist was only two years older than him.[4]

When, before leaving for Lubbock, Terry put down a deposit on a new
one-bedroom rental in an apartment building known, dubiously and
aspirationally, as the Kenmore Tropics, barely five blocks north, Danny
knew the end was near. Feeling slightly guilty about bailing on their dual
dugout for matrimonial bliss, Terry made a point of telling Danny that
he'd always be welcome at the Tropics, that Jo Harvey was a much better
cook than he was, anyway. They remained friends, but it was never quite
the same between them. Danny, feeling both jealous and betrayed, had
lost more than a roommate, and they would never regain the same
degree of intimacy they shared as pioneers in poverty. It was the first

tear of a rift between them that would widen irrevocably over the course of their divergent college and artistic paths, leaving them estranged and Danny eventually isolated in a bitter fog of drugs, depression, and recrimination. Mulish and wounded, Danny stayed in LA when Terry went home that summer to enact his engagement.

TERRY ROLLED INTO Lubbock in late May 1962 after driving straight through from LA, mentally and physically fatigued. He was trepidatious about returning with so little to show for his five months away but hopeful that the excitement of a wedding would forestall the barrage of questions about what he had accomplished and whom he had met in sunny California. After their joyful, febrile reunion, he and Jo Harvey promptly resumed their predeparture cycle of hot and cold swings, with episodes of jealousy and exasperation stoking their passion amid a busy calendar of frothy social engagements. In the home stretch before the big day, as droves of Louders and Koontzes began descending on Lubbock and the preliminary warm-up events began, the situation became stressful for shy Terry, who unlike his fiancée did not relish the parade of frilly tea parties and "epic movie-wedding bullshit."

In early July, less than a week before the wedding, they had their first serious argument. Driving around town running errands for the impending wedding, Jo Harvey saw Terry's Ford parked in the driveway of their mutual friend Sharon Marcus's big house, on the corner of Nineteenth Street and University Avenue. Terry maintained that he had just stopped by to say goodbye before returning to California and that the visit was innocent of any subtext or sneaking. Slowing down to a crawl, Jo Harvey spied him in Sharon's sunroom and "went ballistic." She told her mother that the marriage was off, even if, realistically, "it was inconceivable I wasn't going to fight it out with that man."

They made up just in time for the July 7 rehearsal dinner, at which they sat together, grinning sheepishly at each other over steaks and family chatter, and immediately fell into another argument, this time about their wedding song. Jo Harvey had invited her friend Toby Joe Gilbert to sing Rodgers and Hammerstein's "Oh, What a Beautiful Morning," from the musical *Oklahoma!*. Terry could not abide such saccharine pabulum, "an absolutely absurd idea," and, disgusted, he announced that his own song choice was "What'd I Say" by Ray Charles.[5] He proposed

playing the 45 on a portable turntable, fully aware that was not going to fly but chancing it anyway, delighting in the prospect of scandalizing clergy and congregation. No compromise seemed forthcoming, or even possible, between these two diametrically opposed musical visions. They each stormed off and went to their respective homes, stagecraft unresolved.

Bride and groom both showed up at Forrest Heights on time early the next morning—Terry somewhat the worse for wear in the aftermath of his Buffalo Lake drinking session—if not to wed as scheduled then at least to continue fighting it out in formalwear. They bickered as the wedding guests arrived ("about one thousand of Jo Harvey's closest friends and relatives—and my mother," according to Terry). Jo Harvey won by default.

Incensed, feeling his very artistic identity impugned, Terry threatened to leave right then and marched toward the door and the parking lot, ready to hop in the Ford and burn rubber west on Thirty-Fourth Street, straight out of town and back to LA. Panicking, his groomsmen managed to restrain him sufficiently to shove him into the bathroom, where he remained, seething and frustrated, plotting his self-defenestrating escape, regardless of the laws of physics and the momentum of his undeniable, if vexed, love for his bride.

His head craning out the window, Terry inhaled deeply, the acrid odor of Lewter Feedlot burning his nostrils with a familiar sting he was eager to leave behind once and for all. Smiling, he considered how the smell of real cattle contrasted with the church smell of human cattle. With a sigh, he shut the bathroom window with a bang. He unlocked the door and grinned maniacally at his four friends, waving a white flag of toilet paper in surrender. They had come this far, despite the odds stacked against them as a couple, and he was prepared to capitulate to matrimony.

When Terry caught sight of Jo Harvey in her wedding dress and veiled pillbox hat, his stubborn indignation wilted, *Oklahoma!* treacle be damned. She wore a bell skirt she'd had altered repeatedly, demanding that the seamstress at the bridal shop, eventually reduced to tears of moral outrage at such a licentious length, hem it three times to shorten it sufficiently. The result was daring for Lubbock in 1962, even for a teenaged wedding, and Jo Harvey looked radiant. He walked up the packed

aisle with Pauline, an ambiguous grin on her lips—she had strolled down a few aisles herself—glancing nervously at the crush of perfumed, weepy bodies leaning toward him at each side, as if they might collapse behind him like the Red Sea postparting.

The ceremony was followed by a breakfast in the Colonial Room of the Pioneer Hotel, where the couple had sometimes gone for coffee on Sunday mornings before Terry's departure. They drove there in the Ford, which the bridesmaids and groomsmen had scrawled upon with soap and festooned with streamers and dragging cans. After breakfast, they joined Jo Harvey's family at her home to pick up her luggage and for final farewells, which elicited an emotional scene that agitated Terry. They were all sobbing, and not tears of joy: "When we left Jo Harvey's house, I got upset, because *they* were all so upset. It was like a funeral, with people pulling out their hair and gnashing their teeth. . . . Part of that was just how far away we were going to live, and the fact that I was going to art school. LA was like Satan's den, even then."

They were on the road before lunchtime. As soon as they passed the city limits and lost Lubbock in the rearview mirror, headed southwest on Route 62, he breathed a sigh of relief and whooped out the open window. They were embarking on a new domestic life together, but that could wait—first came the two-week honeymoon they'd planned in order finally to spend some time alone, which had been scarce during the six weeks Terry had been home. The first stop was Brownfield, fifty miles west of the Caprock Escarpment of the Llano, to wash the car and dispose of the rattling cans, and then, for old time's sake, Cloudcroft, New Mexico, where they repaired hungrily to bed, though it was only late afternoon. Before entering their room, they playacted for another couple at the motel, pretending, just for laughs, to be naive newlyweds afraid to sleep together for the first time. They fell into bed giggling and, eventually, slept heavily, awaking for the first time late the next morning as husband and wife.

After stops in La Jolla and San Diego, where Jo Harvey gazed on the ocean for the first time, and Tijuana, where they nervously attended a jai alai match (no donkey girl this time), they arrived at their final destination before Kenmore Tropics: Disneyland. Terry had visited twice before, with his parents and with Duane, but he was eager to share the experience with Jo Harvey. Although Disney's worlds soon curdled considerably for

him, in the absence of any other direct knowledge of art history or contemporary art, the animistic Disney cosmos still represented to him some ideal of stimulating imaginative play, the seductive artistic potential of artifice, illusionism, and theatricality.[6] "We were just kids," he shrugged by way of explaining his delight and ability, before his imminent exposure to Chouinardian anti-Disney politicking, to appreciate the artistry. Jo Harvey found his boyish enthusiasms charming. "Right before we got married," she revealed conspiratorially, "he said, 'I've got to tell you something. . . . I play with little men. Little soldiers. I still like to play with them.'"

"We really were just kids!" she exclaimed, echoing Terry. "He made me cover my eyes until we got into the hotel, and he drew the drapes so I couldn't look into the park. We had color books that they gave us in the hotel lobby, and we laid on the floor and colored—on our honeymoon! That's how young we were, just playing. The next morning he opened the drapes and said we'd be the first to go in and the last to leave, and we'd ride every single ride in the park."[7]

After the fantasy of Anaheim, it was time for another fantasy: cohabitation in the first of their many shared homes. Jo Harvey had never been inside an apartment building before; she imagined something resembling the VA clinic in Lubbock: monolithic, boxy, stodgy, and probably packed full of old, sick men behind its wind-eroded brick walls. What she saw when they pulled up to the Kenmore Tropics shattered her small-town expectations. The midcentury building, only five years old, advertised its own name in jauntily angled red script on its facade. She recalled her favorable first impression of its swinging sixties hipness, one of the few elements of Los Angeles that aligned with her *Gidget* preconceptions: "I was dumbstruck! There were palm trees, colored lights, glitter in the stucco, and a hanging staircase. Terry carried me up the stairs to the apartment. It was only one room, really . . . with orange and turquoise and black vinyl everywhere. . . . We had the most amazing time there."

PART II

THE CALIFORNIA SECTION

Ah but see how the lightning makes cracks in your air
Tearing the clouds, then closing the tear

—"Cortez Sail"

CHAPTER 14

FREEDOM SCHOOL

Cause you got to move
From crayons to confusion
You got to grow up . . . little boy
And be a man

 —"Color Book"

TERRY AND JO HARVEY SET UP HOUSE AND PROCEEDED TO BLOW THEIR SAVINGS as quickly as possible. Including Terry's modest inheritance from Sled, they'd both managed to save what, for them, felt like quite tidy sums, so in the wake of their honeymoon, neither was in a rush to find a job. Instead, they spent their time and money exploring the city and celebrating their newfound freedom. As Jo Harvey puts it, "we high-rolled it for almost one whole year." While they had both grown up in permissive households, the license of living away from the constraints and limitations of Lubbock, and the expectations of family and work, came as a bracing shock to their systems. They had more time and money on their hands than ever before and far more opportunities to spend both. It took a few weeks for them to adjust to the new pace of leisure and luxury, but they managed to make the most of this unprecedented interlude in their lives. They frequented upscale bars like Dino's Lodge—where they saw the Marquis Chimps (actual apes) open for cornpone country-comedy duo Homer and Jethro—and restaurants like the Captain's Table on La Cienega or anywhere where the food was served aflame, a novelty they associated with the height of opulence.

The day they spent their final five dollars at the Ambassador Hotel's coffee shop, Terry began to worry about their drained bank account and total lack of income. During his first provisional semester at Chouinard, he began working at the Aluminum Can Co. (depressingly his second aluminum assembly-line job in LA). After Jo Harvey recovered from a mysterious two-week paralysis of her legs—possibly a psychosomatic reaction to the stress of massive life changes—she registered at Woodbury College of Design to study interior design (eventually working as the personal designer to a gangster's wife) and took a series of part-time telemarketing jobs shilling (in order of increasing strangeness) phonebook advertising, houseplants, and beef. "I had this accent, and people would open up to me" on the phone, she revealed. "Once a man confessed that he'd locked his wife in the bedroom and burned down the house."

The pristine funk of the Halloween-in-Hollywood color-scheme decor of their own home at Kenmore Tropics did not last long, mutating into a different sort of nightmare funk after Terry spilled iced tea on the orange carpet, and Jo Harvey's mother, Katie, suggested pouring some "sweet milk" on the spot to remove the stain. Every day, when they'd return from work or school, the ochre stain had spread, becoming fouler and more rancid. "It just spread like the Blob and covered up the whole apartment," Jo Harvey shuddered, "and we had to move out to escape it."

ON THE FIRST day of his first class, Terry was running late—not the way to make a good first impression as a probationary student, and he knew it. He'd spent the morning gathering all the materials listed on the letter he'd received from Chouinard—charcoal, erasers, various pencils, pens, inks, and brushes—and organizing them in his makeshift art-supply container, an old fishing-tackle box. He had underestimated the time it would take to park and locate the right classroom, so he ended his commute in a sprint down the hallways, anxious and hoping he could slip in and take a seat amid the introductory bustle without his tardiness being noticed. When he burst into the room, out of breath and gazing around pop-eyed, directly in front of him, a dozen feet away, was a completely nude woman contorted into an uncomfortable, and revealing, stance on a model's stand. He dropped his jaw and then his tackle box, in a cacophonous metal-on-concrete "explosion of pencils and shit." All the other

students, seated on benches in front of easels, studiously sketching the model, stopped what they were doing, and dozens of sets of eyes stared at him disapprovingly. A few titters leaked from corners of the room. Mortified, with as much haste as he could muster, Terry gathered his wits and his gear, some of which had rolled to the base of the model's stand, putting him perilously within inches of her impassive bare body. He silently took a seat and then slowly, tentatively, put charcoal to paper, tracing the model's spine down to her hips, his first gesture as an art student. "It took me a while just to get past the total shock of seeing a naked woman," he laughed. "In Lubbock we drew fruit!"

The instructor was a fifty-three-year-old Russian émigré artist named Leonard Cutrow, who had served in World War II, one of several Chouinard professors to share that traumatic, formative experience. Terry would, in his words, incessantly "dog him after class," shadowing him down the halls and peppering him with questions to try to squeeze out of him any indication, any small hint, of how he was doing. He was on edge every day, acutely aware of his ignorance and the precarity of his probationary status, constantly worried about whether he'd eke out the B grade he needed for full enrollment. Cutrow was a brittle eccentric, jumpy and easy to startle when approached after class—in retrospect, Terry surmises that he likely suffered from PTSD. In their final class meeting together, Cutrow announced that everyone had performed adequately and that if they'd attended every class, they'd all get a B on their report cards. Terry, his taut monthslong state of anxiety finally punctured, let out an audible, whistling sigh of relief; he would live to see another semester.

The Chouinard faculty at that time, at least those with whom Allen studied, was, like Cutrow, overwhelmingly male and white, predominantly middle-aged, and primarily engaged, despite the sometimes more traditional nature of their own work, in imparting their laddish love affair with a particular strain of modernist painting. With few exceptions, they evangelized the self-consciously heroic, virile aesthetic and methodology, grandiose scale, and tortuous *Sturm und Drang* ideology of postwar American abstract painting, especially as practiced in New York and especially of the Abstract Expressionist and Action Painting idioms, as typified by artists such as Arshile Gorky, Jackson Pollock, Franz Kline, and Willem de Kooning and theorized by critic Clement Greenberg. Ed Reep, who prided himself on his toughness and was

never without a gnawed, wet cigar clamped between his teeth, epitomized these tendencies—"everything had to be physical, very macho." Terry considered him a blowhard until decades later when he saw the moving sketches Reep had made at the Battles of Anzio and the Bulge, which shifted his perspective.

Allen felt closer to Emerson Woelffer, "a wonderful teacher" for his unorthodox expressivity. A noted AbEx painter in his late forties, the gray-bearded, taciturn Woelffer encouraged his students to work in silence, occasionally offering feedback in the form of sudden explosions of wild gesticulations, "like a dance," accompanied perhaps by a few muttered words, after which he would stalk off to the other side of the studio. This ritualized, aphasic capering was intended, Terry eventually realized, to give his students permission—to leap into the unknown, to bring forth something from nothing, to play. Woelffer's appeal was his rare ability to explain the ineffable challenge of beginning in blankness, the ultimate shared struggle of all artists to reckon with emptiness: "He was the first person I ever heard talk about making a painting of something that wasn't there. He expressed perfectly how I felt, the struggle of an empty canvas, an empty page."

The Japanese American artist Matsumi "Mike" Kanemitsu, another veteran, who had been imprisoned with his family at the Manzanard internment camp, was another influential figure for Terry. One day in class, he unrolled an enormous scroll of butcher paper the length of the entire studio floor, stared at it in meditative silence, grasped an inked brush, then let out a wild scream and scuttled down the length of paper in a crouching, skittering crab dance, leaving skeins of Japanese calligraphy in his wake. He then marked up every miniscule error he'd made with a red pencil, discussing the importance of precision, discipline, and self-critique, even in the context of the most audacious gesture.

EVEN BEFORE HE began to forge his own artistic voice after college, Terry preferred the control, flexibility, and direct contact of drawing, for what to him seemed its lesser emphasis on finality and formality and its closer, more immediate connection to thought and language—to writing. Drawing has always been his primary means of working out provisional ideas in real time in his journals, and it has accordingly always comprised the essential sine qua non medium of his art, its foundation.

Painting, at least as taught at Chouinard, seemed to him overly obsessed with size, scale, strength, masculinity, and surface, and insufficiently entangled with other disciplines he valued, like sculpture, graphic design, theater, music, dance, and literature. Drawing felt more porous, more personal, and more applicable to his interdisciplinary fascinations. "I was so sick of oil painting after school," he related. "I haven't done one since I stepped out of Chouinard."

The curriculum at Chouinard was oriented around studio practice, and students spent long hours in the studios, to which they were granted twenty-four-hour access. Some fellow students slept or even surreptitiously lived in their studios to save rent money. Benzedrine and marijuana were ubiquitous, prized for their boost to nocturnal productivity and creativity; later, LSD became the drug of choice. As with oil painting, Terry dutifully but halfheartedly partook, but he never felt any real affinity for chemically enhanced creativity, at least not yet. As he wrote in a notebook in 1994, with decades of hindsight: "I made brief attempts at being a beatnik and hippie, failed at both. Never liked marijuana, LSD, and that shit. Later I loved pills."

Once Danny and Terry were off academic probation, they both took a series of mandatory classes together, including drawing, painting, and Materials and Methods (which Terry dubbed "Wallowing in Plaster"). But there was very little faculty supervision or discipline about enforcing assignments; students were expected to be self-motivated and self-directed (if not self-medicated) to complete assignments by deadlines. The lessons were intended to instill the importance of artistic behavior—exercises in how to see, think, and work as an artist—over specific artistic techniques. Allen's few remaining Chouinard-era notebooks are peppered with aphorisms and advice lifted from class lectures and critiques, few of which relate to the specific techniques and technologies of artmaking; rather, the majority refer to the broader business of observing, conjuring, and creating:

DISPLAY THE GUTS AND BONES AND BRAINS—CRAWL IN THEM—FEEL THEM—BE THEM
 THINK NOT LIKE MAN, BUT MORON—FIND A FRESH NATURE OF THINGS
 PASSION DOES NOT ALLOW FOR FORMULA

The Chouinard education extended outside the studio into all manner of intellectual and experiential plein air situations far beyond anything Allen could have imagined. Terry found his first-ever art history class revelatory. The instructor was Jules Langsner, a star critic riding high on his fresh lingo of "hard-edge painting," which he deployed to champion an exciting crew of geometric abstraction painters like Ellsworth Kelly, Ad Reinhardt, and Frank Stella. Langsner had been a friend of the novelist Henry Miller, which impressed Terry, who at that time had a firmer, if still rather tentative, footing in the history of literature than the history of art.

The pioneering American Dadaist and Surrealist Man Ray would frequently drop by campus, strolling casually onto its quad, where students and teachers would convene and eat lunch among scattered picnic tables and vending machines. Allen described Man Ray as always nattily attired, cosmopolitan and "surprisingly affable," always ready to hold court and expound upon the life of an artist. He relished imparting nuggets of wisdom to the rapt students who surrounded his picnic-table lectern. Terry took his pronouncements to heart: "He said if you're an artist, you can do anything you want to do; there are no rules. You can paint a picture of a cat, take a photo, film a walk with your girlfriend, anything—you have free rein. But on the other hand, you also are fully responsible for whatever you do. That rang a bell with me: there are no rules, only responsibility."

Terry's second-year art history teacher was Ms. Watson, a former nun, once cloistered in France, who "dropped the cloth, left the convent, came to LA, and became an art critic at the *Los Angeles Herald Examiner.*" Somewhere along the way she met André Breton, author of the Surrealist Manifesto, who introduced her to his circle. Like many Chouinard professors, Ms. Watson taught part time, usually in the mornings, to supplement her career. Unlike most Chouinard professors, she was female, informed by her faith, and more interested in the multimedia, interdisciplinary European artists of Dada and Surrealism (male and female alike) than she was in the macho American Action Painters. She invited artists she knew personally to discuss their work and interact with students, like photographer Harry Callahan and British-born Mexican painter and novelist Leonora Carrington, and extolled the work of German Dadaist and Surrealist Max Ernst, a polymath whose multihyphenate prominence in several

media made a particular impact on Allen. Allen had never heard of any of these visiting artists until they appeared in class looking vaguely European and distinguished, rumpled and bohemian. But they intrigued him more than the abstract painters his other male teachers lionized. The work of Ms. Watson's Dadaist and Surrealist acquaintances, with its absurdist, psychosexual gestures; its emphasis on the primacy of dreaming, the subconscious, and automatism; its embrace of language, narrative, and collage; and its radical politics, appealed deeply to him on a visceral level, in ways he could not yet articulate. As opposed to the painters with whom he studied, none of these visiting Dadaists and Surrealists appeared to define herself as an artist limited to any one medium, discipline, or genre, instead viewing the practice of art holistically and fluidly, as a necessary consequence of, and response to, daily life, psychology, and the culture at large, regardless of what form (or formlessness) her ideas might assume.

Allen's most memorable, and historic, convergence with a legendary modernist occurred in Ms. Watson's class, when she announced that they'd be exploring the work of Marcel Duchamp. Who? Terry and his classmates eyed each other with blank expressions, barely registering the diminutive, formally dressed elderly man sitting behind her, silent, inscrutable, and gray. "'And we're fortunate enough to have Mr. Duchamp with us here today,' she said—and there he was. She showed us slides, and he talked about various pieces, but none of us had any clue who he was. He just seemed like some nice old French guy in a suit." At the end of class, the courtly, diffident Duchamp thanked the students profusely and told them, since they'd been so attentive and kind to him, he would like for them to join him that afternoon for a television interview at the Pasadena Art Museum (now the Norton Simon Museum), where his first-ever museum retrospective exhibition (his first one-man museum show of any kind, in fact) was set to open in a few hours. TV interviews made him nervous, and he would appreciate their presence and support as a youthful tonic. "I could never figure out why he wanted us there," Allen said, but he trusted Ms. Watson, so he accepted this unusual invitation to Pasadena. It was his first visit to the small, up-and-coming museum that would change his life within five years.

After class, Terry and twenty of his classmates traveled to Pasadena, where they watched as a local TV reporter, even more clueless about his

subject than the students, awkwardly interviewed the great French Dadaist, seated across from him at a small table in the middle of the gallery, surrounded by the artist's enigmatic objets d'art, including his "readymades," recontextualized appropriations of banal objects like a bicycle wheel, a snow shovel, an ampoule of air, and, infamously, a urinal (titled *Fountain*). On the table sat a chess board, a potent symbol of Duchamp's artistic practice (he claimed disingenuously to have retired from art to pursue chess) and his relished role as a trickster and provocateur par excellence, the father of conceptual art. After the conclusion of the one-minute news segment, Duchamp again thanked Terry and his classmates, warmly shaking their hands and nodding, after which they wandered around the exhibition, bewildered teenagers at a press preview to which they had been personally invited by arguably the most important artist of the twentieth century.

The show, which reintroduced Duchamp's abstruse career to the United States and the global art world, blew open Terry's mind in ways he could not fully process for months. Allen had no idea what to make of this self-reflexive, recondite art that resembled archaeological or archival relics from the future despite having been made up to fifty years earlier—"it was so vague and obscure compared to the bullshit we were thinking about at the time"—but he left invigorated by the mysterious work and by the curator who had chosen to host a collection so outlandish, so arcane and ineffable.[1] Terry was twenty years old, and he'd already met Elvis Presley and Marcel Duchamp, two of the most influential living artists in the Western world. What had he done himself?

CHAPTER 15

DREAM PEOPLE

So there oughta be a law against sunny Southern California
Yeah there oughta be a law
Against putting the devil . . . behind the wheel

—"There Oughta Be a Law against Sunny Southern California
(Jabo I, II, III)"

AT CHOUINARD, HE FINALLY FOUND HIS PEOPLE, OTHER TEENAGERS WITH
the same roiling compulsions and confusions, the same urgent need to
make marks and to converse about their lunatic dreams and unhinged
ideas. It came as an enormous relief and a balm for the intense loneli-
ness he had felt in Lubbock: "It was like falling into a place I had needed
for so long to feel a part of. Meeting the people there, teachers and stu-
dents, was a pretty profound shock for me: there were so many people in
the same boat I was in. Everyone was very passionate about making
things—you had to be [in order] to survive. I'd never encountered that.
The attitude was: 'Don't fuck around; do it for real.' That permeated the
school from day one." He loved the self-determinative freedom and lack
of structure. Although comics and illustration had initially interested
him in animation and advertising, and he was drawn to the narrative
dimensions of those disciplines, beyond a few mandatory classes, Terry
immediately gravitated to the "fine art" side of the Chouinard fence and
remained there. Danny did not follow.

Despite the strong Disney affiliation with Chouinard, the overall
emphasis (at least in their first two years) on so-called fine art history
and practices as a necessary foundation even for students aspiring to a

career in so-called commercial art rankled Danny. "He just didn't buy it," Terry sighed, meaning the permissive instruction, and in particular the assumption that fine art history, theory, and techniques should inform commercial art, not the other way around. Danny had a point. Although certain students and teachers at Chouinard, Allen included, sought to efface or disregard such distinctions, the fine versus commercial dichotomy, however specious, still obtained then. The dramatic turn that American contemporary art took in the 1960s represented in large part a reverse osmosis, the result of the influence, and appropriation, of the sometimes disdained, second-class commercial and vernacular realms (illustration, film, comics, advertisements, graphic design, folk art, etc.) on, and by, the rarefied fine art realm. Chouinard eventually collapsed under the weight of these widening divisions, and Terry joined the ranks of the anti-Disney cadre, protesting Uncle Walt's meddling and signing inflamed letters to the dean.

What to Terry felt like an undue influence of commercial and corporate concerns was not nearly enough for Danny. He took one animation class at Chouinard and then promptly defected, transferring to the Art-Center College of Design, which, to Terry, seemed its exact antithesis: "highly disciplined and formalized." Their divergent educational paths opened "the second breach," after Terry and Jo Harvey's marriage, in Terry and Danny's relationship. Danny would visit their apartment to criticize Terry's work or drop by the Chouinard studios to harangue anyone who would listen, denigrating everything about the school compared to the ArtCenter, framing his "weird resentment" and jealousy toward Terry as a fierce, if one-sided, collegiate rivalry. Although soon thereafter Danny dove headfirst into the inchoate counterculture's drug-filled deep end, and nearly drowned there, he eventually became a prominent, award-winning animator, in spite of his self-sabotage.

The Allens always felt out of place in fashionable, cosmopolitan Los Angeles—a perennial condition exacerbated by President Kennedy's assassination in November 1963, which ignited a firestorm of anti-Texan sentiment that they experienced firsthand—and they gravitated to their fellow country and small-city mouse misfits, many of whom hailed from the South, Texas, and the Midwest rather than art-savvy coastal metropolises.[1] On the first day of class, waiting in a registrar's line before his humiliating first life drawing class, Terry met another tall, lanky

freshman, who introduced himself as Al. Allen Ruppersberg had grown up in Cleveland, a place nearly as psychically dissimilar to LA as Lubbock. The two became fast friends and comrades; today, Ruppersberg ranks as Allen's oldest living friend and one of his closest. They discovered early on that they shared a wry sense of humor and interest in writing and language, which they incorporated in their respective artwork in novel ways, always pushing each other to take it further. Like Terry and many others with little to no familiarity with contemporary art, Al began art school with aspirations of becoming an illustrator but quickly swerved into other, more slippery realms, exploring environments, installations, performance art, and archival projects, as well as diverse object-making, helping determine the first-generation arsenal of conceptual art's parameters and practices.

As Danny withdrew, Allen made other lasting friends. Within the first few weeks of school, Terry met Doug Wheeler, a painfully shy kid who had grown up in tiny Globe, Arizona, on the edge of the Sonoran Desert.[2] Doug had fled his own Southwestern "cowboy upbringing" in a mining and ranching culture in which he never felt comfortable or completely himself. Another aspiring illustrator who quickly shifted gears, he shared with Terry a distinct unease with the conservative Western environment in which he was raised, despite a love for country music, its primary art form of choice. A shock of recognition passed between them. "Like me, he wasn't a Californian, and I never really connected with that culture either," Doug observed. "Without saying a word to each other, we knew we were kindred spirits." Wheeler would become a central figure of the Light and Space movement. His pristinely constructed sculptures and installations, which investigate the interplay of light, surface, and optical perception, could scarcely be more different from Terry's work, but their respect was—and continues to be—mutually deep.

Ron Cooper, another of Allen's first friends in LA, was the rare native Californian who ran with this gang of miscreants. Cooper was known in those days for his hospitality, hosting ad hoc weekly dinners at his third-floor apartment on Friday evenings before heading out to find the best party, concert, happening, or gallery opening. It was never exactly cozy—he had thrown most of the furniture out the window to make the space more suitable as a studio—but other than Jo Harvey, Ron was one

of the few of their friend group who could approximate a home-cooked meal.[3] Ron's later home, a big Victorian house at 155 North Beaudry Street, provided a central gathering place, clubhouse, and hub for their scene. "It was an open house," Ron explained; Ruppersberg described it as "ground zero for the counterculture in LA at that time." The denizens of this informal club got matching tattoos on their forearms—the Beaudry Rose.[4]

Often present at Beaudry Street, and anywhere he could find illicit thrills and substances, was the inimitable Boyd Elder, one of the few fellow Texans in Allen's Chouinard circle and always the last to leave any party. As soon as the two of them heard each other's West Texas accents—Boyd's people were from tiny Valentine, near Marfa, and he grew up in El Paso with Bobby Fuller, the doomed singer of "I Fought the Law" fame—they felt an "immediate affinity" that sparked a lifelong friendship, though one that was not without its strains. Known by the self-chosen epithet "El Chingadero"—"The Fucker"—the likably roguish Elder easily positioned himself in the epicenter of the LA canyon scene, becoming close with Joni Mitchell, Cass Elliott, David Crosby, and Dennis Hopper. He also befriended the members of a promising new band called the Eagles, who performed in public for the very first time at the 1972 opening of his exhibition *El Chingadero*. Later the Eagles used Elder's painted bull, horse, and bird skulls on three album covers, underpaying him a few thousand dollars for each of the multimillion-selling records.

Surrounded by all these visionary artists and newfound friends, Terry mostly floundered and fumbled through art school. To the extent that traditional grades mattered at Chouinard, he easily surpassed his lackluster high-school report cards, because he was finally actually motivated to push himself to excel. But he was lost in the weeds, especially when, after his sophomore year, the curriculum eased off prerequisites and demanded that students determine their own directions and projects. Perhaps it was a case of overstimulation, a kind of paralysis caused by choice overload, rapid reeducation, and the radical changes in his life. His first year away from Lubbock had expanded and exploded his notions of what art could be and what an artist could do, as well as introducing the challenges inherent in maintaining independence and a marriage, financially and emotionally. Like a Western movie cowboy, he

had been riding toward a false horizon in an idyllic Golden State, and when the sunset backdrop dropped, he discovered that the trail was in fact ersatz, and he was astride a Texan horse in a slick Hollywood studio. He knew that commercial art was not for him, and he knew that he did not want to paint in the cigar-chomping, abstract manner of most of his teachers, but beyond that, he suddenly felt like he knew nothing. At Chouinard, where, outside the Animation Department, narrative art was considered hopelessly outmoded, he saw no sluice for the reservoir of stories inside him, and his own trajectory seemed mired in a slough. "I AM REALLY A WRITER," he insisted in frustration in a journal.[5] "Maybe these notebooks *are* my art," he wrote a few years later.

LITTLE DID TERRY know that a shadow would follow him west, on the trail from Lubbock to Southern California, and in the bewilderment he encountered there amid its reflective unreality of surfaces and sea.

As soon as Terry had returned to California with Jo Harvey, Pauline took her own steps to sever her and her son's connections to Lubbock and the grief and ghosts that lingered there. According to Terry's son Bukka, Manse had "snaked Sled's life insurance," leaving her with little but the haunted simulacrum house at 3701 Twenty-Eighth Street. On August 17, 1962, a month after the wedding, she sold the property to Nick and Lorraine Roberts, husband-and-wife wrestlers who had purchased Sled's promotership from Doc Sarpolis after Terry declined to assume his mantle.[6] After a peripatetic and increasingly desperate few months in Lubbock and Amarillo, staying in dingy rentals and with family, in 1963 she finally packed up and drove to Palm Springs, a couple hours east of Los Angeles, following in her son's tire tracks. She was accompanied by her rebound beau, "an asshole ex-cop" named Jeff. The attraction, as it would be for most of her relationships before and after Sled, was likely predicated on their shared alcoholism and little else. She visited her son and daughter-in-law while they were living in an apartment at 3815 West Eighth Street in Westlake near campus. Wrapped up in their own petty marital dramas, they didn't see the warning signs of her deterioration (which Pauline was no doubt careful to hide).

Returning to Southern California, so close to her former life in San Bernardino, proved Pauline's undoing. Jeff somehow defrauded her of most of her savings, possibly with a female accomplice, as cited in

Terry's brutal "Blue Mother Monday" poem, and vanished. Pauline, in desperate straits both psychologically and financially, plunged into her grief and shame. Her behavior careened from erratic to flat-out dissociative, and she retreated into a fantasy world when she was conscious and responsive at all. According to Terry, the scene in his 1985 long-form narrative audio piece *Pedal Steal* in which friends of Billy the Boy recount his mother's descent into insanity was in fact modeled directly on Pauline's psychological disintegration during this period in Southern California:

> She was too busy bein' nuttier than a fruit cake back in San Bernardino . . . making dream people out of parts of the living room. Sounds like one of those goofy voodoo movies. She'd take chairs and tables and put little useless items on them . . .
>
> Crap like forks and ashtrays or string and sticks and little pieces of hair and cloth. Then she'd give each one a name . . . after some person she knew or some relative of hers. She'd have long conversations with them . . . her doing all the voices like she was playing dolls . . . or making her own Tupperware party or something . . . just nuts.
>
> . . . he sat down and watched her make all these psychological people for a long time. He laughed and said he sat down right on top of this one uncle he hated. He tried to understand why she picked certain useless items to be certain people, but he never could. Mainly though, he kept waiting to see if she'd make him, but . . . of course . . . she never did.

The "dream people" were real enough to terrify Terry. Wrenched with undeserved guilt at having left her behind in Lubbock and not having intervened earlier, Terry called Uncle Blue, his lifeline in Southern California. Blue had a steady job as the supervisor in the cobbler's shop of Patton State Mental Hospital in Colton, just south of San Bernardino, training and overseeing patients to make and repair shoes. Distraught and without anyone else to whom to turn, Terry visited Blue at the hospital and, his guts in knots, watched him work while he explained the situation. "I didn't know it was that bad," his uncle responded when he'd heard the disturbing tale of Pauline's recent troubles. He was eager to help, encouraging his sister to stay with him in Colton until she

recovered. But it got worse. She stayed out all night, as Blue put it in racist dismay, drinking in bars "with [n-words] and Mexicans." He could no longer help her, and the situation rapidly became untenable. He called Terry with a plan. In "Blue Mother Monday," Terry's disconsolate frenzy and fury is palpable:

HE CALLED ME AND SAID SHE WAS CRAZY WE HAVE TO GO TO LAWYERS AND SIGN PAPERS FOR HIM SHE HAS TO BE COMMITTED SHE'S BEEN IN CABAZON AND MET A FAT LADY SHE LEFT HER STUFF THERE THEY'RE ON PILLS TOO SHE'S INSANE DOING THINGS STRANGE WITH CHAIRS IN THE ROOM GET DOWN HERE YOU'RE TOO YOUNG "I HAVE TO BE LEGAL GUARDIAN WE HAVE TO PUT HER IN THE HOSPITAL OR SHE'LL GET KILLED OR GO TO PRISON SHE'S CRAZY"

Having worked at Patton State for so many years, Blue understood the process of institutionalization, so Terry did not have to navigate the impossible situation himself. Blue accompanied Terry to court, where he countersigned the requisite paperwork, since Terry was not yet twenty-one. By the time they dropped Pauline off at the hospital, she was in a state of catatonia.

On August 23, 1963, Pauline's tragic sojourn in California mercifully ended. She returned to Texas, moving into 1300 South Rosemont Avenue in Amarillo, across the street from her Shangri-La of 1501 South Rosemont, the ur-house. She had left the dream people behind for the promise of a dream house. She bided her time for the owner of 1501 South Rosement, an older woman, to die so she could reclaim the house she had once briefly occupied happily with Sled and Terry. She managed, through sheer willpower, to maintain a tenuous grip on lucidity—most of the time. The rest of the time she spent at Amarillo Osteopathic for various undisclosed ailments.

A few days after she moved back to Amarillo, Terry, drained and shaken, began his second year at Chouinard Art Institute.

RED BIRD, BLACK WALL

Rusty wing
A dead dark thing
Crows too loud now
When red bird sing

 —"Red Bird"

"WHATEVER YOU DO, DO *NOT* WEAR THOSE HORRIBLE PANTS," JO HARVEY instructed Terry, looking him up and down. He grinned mischievously and made a resolution to wear the horrible pants, which were made of a striped mattress ticking material as uncomfortable as it was hideous. They'd just left dinner at a beautiful almost-house high up in the Hollywood Hills and were driving home in their battered Volkswagen Beetle. The lavish construction site was the unfinished home of an older couple, Dean Whitmore and Will Huffman, who were renovating and expanding their mansion, adding several additional rooms. Terry had been working for them since he'd completed his junior year at Chouinard, doing light construction, gardening, and handyman tasks. It was a solid, steady summer job that he'd found, like many of his gigs, on the Chouinard help-wanted bulletin board.[1] He and Jo Harvey were "absolutely busted" at this point, and a free dinner prepared by elders was like manna from heaven.

 A week earlier, Terry had been standing around in Dean and Will's living room waiting for Dean to cut checks for him and a few other straggling workers. Restless and bone-tired, he noticed a piano in the corner of the room, traced his fingers down the keys, looked around, and sat

down. He was one of the last laborers left that day, and his employers were out of sight, so there wasn't anyone to bother. Anyway, in his limited interactions with them, the mansion's owners had always seemed kind, if a bit distant. An out gay couple, especially a middle-aged one (Dean was forty-three at the time), was certainly still an astonishing novelty to someone who had grown up in Lubbock. But Terry's time at Chouinard had opened his mind and dismantled his prejudices about other people's private lives and choices of sexual partners, which he figured were not any of his damn business. "What the hell," he thought, and pressed his fingers onto the keys experimentally, letting a few chords ring out in the obscenely large, and largely empty, room. It was a beautiful, rich-sounding grand, hard to resist; these days he was only playing out-of-tune, often ancient uprights, like the one he had acquired for $150, a gift from Katie and Harv Koontz. (The following year, 1966, he abandoned it in his Descanso Street apartment after sawing off its corners to fit it up the stairs, smashing through an exterior wall and triggering a lawsuit in the process; Pauline contributed to its replacement.) In the evenings after work, he'd been writing as much as he could, and he was more satisfied with some of his recent songs than he was with his drawings, which seemed to be spiraling solipsistically into themselves, never expanding into something external or autonomous.

In 1964, after a knock-down, drag-out fight with Jo Harvey, "a free-for-all screaming pan-thrower"—a fairly regular occurrence as he spent more and more time in the studio and away from Jo Harvey, even sneaking out of bed at night to work—he'd written "Red Bird," which he considered his first song worth keeping, the first one "that felt like a real song," and perhaps still his most personally significant. Even though it sounded to him suspiciously similar to Johnny Cash's 1958 hit "Ballad of a Teenage Queen," or perhaps because of it, he recognized its fully fledged nature, and its primacy among all his other songs, almost immediately. "Probably because it's strange," he wrote of its cryptic lyrics about an allegorical red bird prisoner in New Orleans, "I felt great about the song and dumped yards of neurotic agony into it." Jo Harvey lay in bed upstairs in their rental duplex on Benton Way in Rampart Village, where they lived for the majority of Terry's college years, listening to him work it out, her rage settling into curiosity. "Red Bird" was the song that his friends always wanted to hear him play, the undisputed favorite

among his peers. Sometimes he doubted if they knew the names of any of the others.

He liked "Freedom School" too, though he sensed correctly that its context of Chouinard politics might be too opaque to appeal broadly. Provoked by his fellow students' incipient anti-Disney protests, as well as his struggles with his own work, it stands out for its topicality and apparent ambivalence about his education.

Sitting at the piano in Hollywood Hills that afternoon in the summer of 1965, he played neither of those songs, however. Instead, his fingers settled into the opening A major chord of a tune called "Big Time Hollywood Businessman," appropriate, he thought wryly, given the location. He played for a few minutes, pushed back the piano bench, and saw Dean standing in the doorway grinning.

"I didn't know you could play like that. Did you write it?"

After recovering his composure, Terry answered affirmatively and nervously. He hoped Dean hadn't taken offense at the subject matter.

"How'd you like to be on television? I produce a program called *Shindig!*"

Shindig! was a new music variety show on ABC, shot in front of a live audience but heavily edited, that pandered, rather shamelessly, to a teenage demographic in thrall to rock and roll and soul. It was only in its first season, having premiered a year earlier, a last-minute replacement for its predecessor, *Hootenanny*, which had been oriented toward folk-revival fare that was now, at least according to ABC executives, hopelessly passé, having been decimated by the British Invasion. Terry and Jo Harvey had watched *Shindig!* occasionally, though at twenty-two years old, they were already older than the target audience.

"Well, yeah, I'd like that, I guess." Terry squinted and grinned right back, unsure if this was a joke.

Dean invited him to dinner that weekend, where they could discuss the opportunity further, asking him please to bring his lovely wife. Dean's previous familiarity with Jo Harvey was limited to an episode weeks earlier when, on her way to pick up Terry from work, she had stalled their Beetle on the steep, winding road up to the house, slipping backward off the shoulder and denting the car. Frustrated and embarrassed, she leapt out of the vehicle, and she and Terry hollered orders

and abuse at each other at a distance, much to Dean and Will's surprise and amusement.

Over the course of drinks and dinner, Jo Harvey managed, as she often did, to charm her hosts utterly, laying on her aw-shucks confidence, dazzling storytelling chops, and honeyed Lubbock accent as thick as the title of another recent Allen composition, "Smooth Butter Device." Will, who had grown up in the South, was particularly beguiled, resulting in him and Dean protectively taking this young couple of naive West Texans under their collective Hollywood wings, employing Terry more, occasionally feeding them both, and offering nuggets of show-business and life advice.

At dinner Dean instructed Terry to attend an audition a few days later, writing down the address for him. Terry showed up at "some place out on Western Avenue, some little rathole," where he rushed through Lead Belly's "Lining Track" until the casting director told him to stop playing—he'd made the cut. They gave him a date and told him to await future instructions. As producer, the final decision was technically not Dean's, but since Terry was completely unknown compared to the other talent that *Shindig!* was regularly attracting—Sam Cooke, the Everly Brothers, the Beatles, the Beach Boys, the Rolling Stones, the Hollies, and Allen's hero Bo Diddley—it seems likely that Dean had put in a good word to grease the wheels. If there had been any remaining doubts about Terry's viability as a performer, Dean had forgotten them in his and Will's delight at Jo Harvey's dinner performance.

Weeks passed without Terry thinking much about his impending television debut, until the date of filming approached. Filled with dread, he drove to the studio, where he was cursorily introduced to the director, Richard Dunlap, and the host, Jimmy O'Neil, neither of whom appeared impressed with his appearance. He was wearing the horrible pants, which he regretted as soon as he walked on set, with suede Chelsea boots and a dark waistcoat over a light collared shirt. His hair, unruly and densely curly, though still relatively short, resembled, in his words, "a Brillo pad." His heart fell when he discovered that he was the sole novice artist booked for the episode, which would air a few weeks later, on August 4, 1965. His fellow performers included the Righteous Brothers, who would debut "You've Lost That Lovin' Feeling," and the Great Scots, a gimmicky, be-kilted beat band from Nova Scotia whom Terry

regarded dismissively as "some Beatles rip-off group." He was more excited about his female costars: the infectious New Orleans vocal trio the Dixie Cups, of "Chapel of Love" fame, who had recently released their hit version of the Mardi Gras Indian classic "Iko Iko" (Terry was a sucker for New Orleans music), and the languid, radiantly sexy London singer Marianne Faithfull, a protégée of the Stones and their manager Andrew Loog Oldham.

Unsure what to do with himself or where to stand, Terry walked over to the most approachable-looking cluster of musicians he saw, who were gathered around the back line, laughing. Led by Billy Preston, the multi-talented keyboardist, singer, and songwriter who had backed Little Richard and Sam Cooke and would, within a few years, work with the Stones and join the inner circle of the Beatles at the brink of their breakup, the *Shindig!* house band, ridiculously dubbed the Shindogs, also had an integral Lubbock connection, which was, as Allen puts it, "really fortuitous," considering his agitated state of mind. Two Crickets were, respectively, a regular featured player and a steady Shindog: guitarist Jerry Naylor, who fronted the Crickets for four years after David Box's death, and pianist and honorary Cricket Glenn D. Hardin. Naylor immediately shook Terry's hand and set him at ease. The two commiserated about David's tragic death the year before. Jerry introduced Terry to the other Shindogs, an astonishing lineup of brilliant young musicians on the cusp of fame, including, at various times, Glen Campbell, Leon Russell, Delaney Bramlett (later of Delaney and Bonnie), and guitarist James Burton (the only one Allen clearly recalled meeting).

When it was Terry's turn to play, a stage manager told him he would have two minutes to play his two songs and that, due to set changes, unlike the other performers, he would not be joined by the program's famously kinetic, often silhouetted backup dancers. He brusquely pointed out the cameras and the position of the piano. Terry nodded, understanding nothing, sweating through his shirt. He stepped cautiously into the center of the vast stage set, empty except for the absurd piano they'd found for him. An enormous upright with tawdry baroque detailing and filigrees, lit with a spotlight, it looked like it was borrowed from the saloon set of a Western TV series, which it may well have been, in an attempt to provide some visual interest and regional context for this gangly Texan's solo act.

Terry's brief clip, black and white like all the *Shindig!* footage, represents the earliest surviving example of his music as recorded to time-based media, either visual or audio. It begins with the camera on a crane above the shoulders of the silhouetted Shindogs. As it's lowered, the camera tracks across the soundstage toward Terry, already hunched over the meretricious upright, pounding away at "Red Bird," at a tempo even brisker than usual. As the camera approaches from behind, you notice how his vest is awkwardly scrunched halfway up his back. You can hear and see his right Chelsea boot stomping away heavily on the riser to keep time, heel and toe swiveling wildly, the first manifestation of a percussive feature that has plagued many sound engineers and broken many piano pedals over the decades and is still evident in all his music today. As the camera turns to shoot him in profile and then close-up, Allen himself turns toward it in three-quarters profile, alternately smiling and snarling through the lyrics, head waddling and nodding maniacally. He's wearing a harmonica rack, which is suddenly revealed to be jury-rigged with a kazoo, an instrument never again featured in his music, which he toots for an entirety of four measures—four seconds—in a transitional gesture before accelerating the same chord progression and rhythm just slightly and tearing into "Freedom School." The unnatural screams of young girls erupt periodically, seemingly randomly, encouraged by mechanical teleprompters in the audience, and then suddenly subside. They sound like screams of terror, more apposite to horror movie than matinee idol. More kazoo follows between verses, and his voice drops into an occasional growl as he bares his teeth. By the end of this obviously rushed, slightly unhinged performance, Terry, his eyes squinting and bugging behind his heavy black-framed glasses, resembles some demonically possessed avatar of Buddy Holly. Suddenly he stops playing and rotates on his piano stool to the audience, looking abashed and relieved, and very much himself, a shyly smiling twenty-two-year-old young man, slouching with his hands shyly between his knees, drained of all that freneticism, wondering what on earth he is doing there. A title reads, as if by way of apologetic explanation, ". . . THAT WAS TERRY ALLEN." The whole thing is over in one minute and forty-four seconds, safely under the allotted time.

Out in the audience, Jo Harvey was thrilled, beaming with pride, perhaps the only person there who did not need to be prompted to scream

in delight. Sitting right behind her was a smartly dressed British man in his early thirties, obviously not a local or a teenage audience plant. He raved about the performance, exclaiming repeatedly, "This guy's great!" When, following her husband's set, Jo Harvey turned to introduce herself, he cordially introduced himself in turn as Brian. Dean quickly informed her that "Brian" was in fact Brian Epstein, the manager of the Beatles, who was presumably there because of his friendship with Faithfull. He asked Jo Harvey for their phone number, shook her hand again, and told her that he'd be in touch. Elated, Jo Harvey told Terry about the exchange as soon as they had a private moment together. "I told Terry, 'We're going to be so rich!'" They'd only been in California two years, Terry was still in school, and here was their big break. After the shoot wrapped, they drove to Dean and Will's to celebrate and asked to borrow a few hundred dollars—Terry claimed $200, Jo Harvey $500— which they assumed they'd easily be able to pay back as soon as Epstein called and signed Terry. He'd be on TV every week, they were certain. They drove down to Laguna Beach for the weekend and blew the entire loan. Brian Epstein didn't call on Monday. He never would. "Of course, nothing happened," Terry said. He had to pick up extra hours to pay his patrons back.

Exactly one week after Terry's episode was broadcast into living rooms across the nation, a too-common incident of police brutality perpetrated against a young Black man named Marquette Frye ignited five days of riots—sometimes known today as the Watts Uprising—in and around the Watts neighboring of South LA, throwing the city into chaos and racist hysteria. The tumultuous era we regard in cultural historical terms as "The Sixties" had officially arrived in Los Angeles.

THE RUSH OF *Shindig!* and the disappointment of its anticlimactic aftermath impelled him to concentrate more seriously on his songwriting. He secretly wondered if Epstein would have called had he chosen different songs to play, earworms impossible to forget over the course of a weekend. Of course, he didn't have many others from which to choose, at least not any that felt sufficiently current or vital for national television. So he got to work, grinding down pencils to their nubs and emptying pens on pages of lyrics. Through 1966 and 1967, songs piled up, in various stages of completion and degrees of satisfaction. He didn't own a

tape recorder yet, so they all still existed only in lyrical form in note-books and songbooks, handwritten and typewritten, respectively. Most of these mid-'60s songs are built on two, or occasionally three, major chords, alternating riffs, midtempo to positively peppy, with additional changes at turnarounds and choruses. There are seldom bridges or mul-tiple parts. The titles are often amusingly evocative, if sometimes outra-geously florid, and the lyrics tend to be either incomprehensibly bizarre and disjointed or forgettably slight.[2]

He still regularly performs many of the songs he began writing imme-diately following this period, some of which he has recorded more than once, but his pre-1968 songwriting output, much like his visual art out-put of the same era, is notable for its dead ends, entombed (unusually for Allen, who never learned to read music) in sheet music transcribed for an abortive publishing deal and unresolved recording sessions. Other than "Red Bird," Terry would never revisit any song from this stack, allowing them to languish in the past.

WHILE *SHINDIG!* PROVIDED his first glimpse of corporate musical culture in his adopted home, for several months he had already been exploring the fringes of the LA music scene on his own terms—and, for the first time, with musical compatriots. He preferred the LA underground they traversed together to the glitz of the *Shindig!* studio. Comprised of four Chouinardians and a ringer—Terry on electric piano, singer and har-monica player Gary Wong, bassist Mike Murray, "a guy named Wes" on guitar, and Tyrone Swader, the sole non-Chouinard student, on drums—the Black Wall Blues Quintet coalesced in 1965 as the go-to "art school party band" of Los Angeles.[3] Although the band's repertoire was fairly unadventurous and generic for the time, consisting almost entirely of blues standards and covers—"Muddy Waters, Howlin' Wolf, stuff like that," Terry recalled—Black Wall had a diverse presence, culturally and musically, that gave them an edge and distinguished them from other similar outfits.

A Korean American native of Los Angeles, Gary Wong overcame his colorblindness and dyslexia to enroll at Chouinard, studying with Woelffer and Kanemitsu and later becoming an integral member of the surfing and skating communities of Southern California. When the band formed, an Asian American front man was an anomaly in rock and roll

and blues bands, but Wong attacked the Quintet's set lists of predominantly African American vernacular music fearlessly and with inimitable style, cutting quite the imposing figure in his signature black leather trench coat. Terry brought a Texan honky-tonk rhythmic grit to the band, inherited from Pauline, that introduced a South Plains aridity and spatial sensibility to songs more climatically and culturally aligned with the humid currents of the Mississippi River. Allen was primarily the keyboardist, playing a treasured Wurlitzer suitcase electric piano, only taking lead vocals on Bo Diddley's "Who Do You Love?" He never performed any of his original material with the band, still raw after *Shindig!* and concerned his songs were similarly uncooked.

They'd attend concerts together at the Ash Grove—Muddy Waters, Jesse Fuller, John Hammond Jr.—and then, feverish with inspiration, head back to their rehearsal space downtown across from the Olympic Auditorium, playing late into the night, staring out the big warehouse windows at the crowds emptying out from boxing and wrestling matches. The collision of blues, booze, and blood sport reminded Terry of Lubbock, but at a grander scale.

Regardless of what his band was playing, Terry's musical inspirations at the time ranged far beyond the blues. Impresario Elmer Valentine, who had cofounded the Whiskey a Go Go and would later also open the Roxy Theatre (where Allen would play the West Coast *Lubbock* release show in 1979), had launched a new club on the Sunset Strip called the Trip, the short-lived successor to the jazz club the Crescendo, which advertised itself rather pompously as "The New Shrine of Pop Culture." The Trip was promoting a two-week residency, the LA debut, of a new group out of New York, about which only dark rumors and sinister hearsay were circulating through art-world channels, since they had not yet released any music. The band had just recorded the bulk of their debut album the month prior in New York, and while in LA, they were scheduled to rerecord three songs during two days of additional sessions at TTG Studios in Hollywood. But in early May 1966, the record was not yet finished, so few people in LA, and even fewer in Terry's gang, had any idea what to expect.

Billed on posters, illustrated with both Roy Lichtenstein and Warhol imagery, as "Andy Warhol Presents the Plastic Inevitable Show with the Velvet Underground and Nico chanteuse & light shows & curious movies," the show was slated to run from May 3 to May 18, but on its third

night, the Sherriff's Department raided the Trip to quell the purported Warholian vice and perversion on display. Terry and Al Ruppersberg, mostly curious about the Warhol association, caught it on either May 3 or 4. The place was packed with the cognoscenti of the LA underground music and art scenes, including rising stars like Sonny and Cher, Jack Nicholson, and Jim Morrison. The Velvets' soon-to-be labelmates on Verve Records, Frank Zappa and the Mothers of Invention, who were already, in Allen's words, "a whole element" on the LA scene, infamous for their outrageous lyrics and more outrageous shows, opened. Backstage, and possibly also onstage, the musically and culturally incompatible Mothers and the Velvets supposedly traded thinly veiled barbs about each other, fanning the flames of a coastal rivalry that pitted two breeds of disreputable youth counterculture against each other: the hardcore, kinky, speed freak contingent of arty New York nihilists, arrayed in a uniform of black leather and dark sunglasses, versus the peace-and-love hippies of psychedelic Southern California, adorned in feathers and piebald motley.

The Velvets' opposition to the speciously beatific hippiedom of LA, against which Terry's mordant wit and Texan pragmatism had always chafed, proved to be deeper than fashion. Their performance was violent and immediate, as tuned to the gutter as the gallery. Allen always felt that flower power, in the face of the atrocities of racist violence and the Vietnam War flaring throughout the 1960s, lacked voltage. The Velvets seemed to agree, tapping directly into the subterranean and subcutaneous currents of generational rage and outrage but rejecting proselytization and overt politics in favor of a struggle for personal survival, if not enlightenment, by any means necessary, decadent and ascetic alike. Experiencing firsthand the Velvets' notorious John Cale–era sonic onslaught of feral feedback and primal thud, equally informed by avant-garde and minimalist composers and free jazz as it was by doo-wop and rockabilly, and then several months later hearing *The Velvet Underground & Nico*, made Terry a lifelong convert. Together Reed and Cale straddled avant-garde art and popular music in a way he had not previously believed possible.

Since that night in May 1966, Allen has always admired Lou Reed for his "cold-blooded" songwriting and stance, his brutal honesty and candor, proclaiming in a 1989 notebook that Reed "might be the best

songwriter alive."[4] In a 1969 songbook, he typed out the lyrics to Reed's song "Pale Blue Eyes," recently released on the Velvet Underground's third, self-titled record, because: "WHEN I FIRST HEARD IT I WAS SURE THAT I HAD WRITTEN IT OR WAS ABOUT TO. SEVERAL PEOPLE I KNOW FEEL THE SAME WAY TOO. MOST OF THEM ARE GONE NOW . . . TO NEW YORK CITY." Allen learned not only from Lou's lyrics, but later he likewise incorporated into his own music subtle lessons taken from La Monte Young's Theatre of Eternal Music that filtered, through Cale, into the Velvets' sonic assault in the form of drones, ostinatos, and repetition.

Allen recognized in the Velvets, especially in the fertile but antagonistic partnership of Reed and Cale, a striking and subversive example of art music, pop music, theater, and cinema tangling together in an uneasy embrace, a performative gestalt and a sharp streetwise poetic edge that, as a lapsed Beat devotee himself, he found intoxicating. But the most lasting impact of that May night, for Terry, was extramusical. He had never seen a psychedelic light show before—few people had, even in the wake of Ken Kesey and the Merry Pranksters' LA Acid Tests a couple of months earlier—and he was overwhelmed by the sensory overload of the projections, which included slides, stroboscopes, and Warhol's Factory screen tests, accompanying the band's dissonant savagery and harsh poetics. He walked out of the club giddy and a little frightened by what he'd witnessed, resolving to attempt something similarly powerful with his own work.

As affected as Allen had been by his eye-opening experience of Warhol and the Velvets, the Black Wall Blues Quintet was a more modest concern. They played parties, primarily, initially at friends' houses but, as they gained momentum, at other venues as well. Nearly every club already had a house band, so out of necessity and the urgency to play loud and late in front of sweaty audiences, they created their own club, a moveable feast modeled, at a much more modest and manageable scale, on the Exploding Plastic Inevitable and similar events that blurred the boundaries between concert and happening. The band began renting an Elks Lodge, "a beautiful old hall," across the street from MacArthur Park, for twenty-five dollars a night, hosting dances and inviting other bands to join the bill. They memorably played with Love and the Leaves, among many forgotten LA bands, opening the night and then closing

with a drunken late-night set after the headliners finished. Admission was a dollar, which helped with rent and pocket money. Black Wall's most memorable gig was in 1966, in the ballroom of the Hollywood Knickerbocker Hotel. The vibe was perfect: it was one of those nights when the band was fully locked in, and the packed room vibrated with dancing, blissful bodies. But the evening had a dark denouement for Terry, immediately presaged by a sinister cinematic portent:

> I remember sitting at the bar during a break between sets, and the guy next to me was the horrible redneck guy in *To Kill a Mockingbird* [James Anderson, who played Bob Ewell], the one that Boo Radley kills . . . the real villain. I was sitting right next to this guy. He talked exactly like the movie . . . I think he lived in the Knickerbocker. . . . That was also the night that Danny Thompson had his breakdown. He came to the show wearing a sailor suit and captain's hat, with a completely painted face, like someone had a seizure while painting him. Everybody was worried about Danny, and right after that, he disappeared.

A few days later, Terry called around desperately looking for anyone who had seen Danny and finally located him at an LA County jail. He had gone to a restaurant, ordered an enormous meal, walked up to the counter, and instead of a wallet pulled out a pistol, placing it pointedly on the counter and smiling. When Terry visited, Danny was catatonic. Allen called Danny's dad Goldie in Lubbock, who bailed him out and brought him home, where he spent several months on the psych ward of Lubbock Methodist Hospital. When Terry visited him there on a trip home, Danny, conspiratorially whispering the details of his ploy, revealed that he was "drawing his way out" of institutionalization. The doctors had attempted some primitive art therapy with him, and Danny immediately took advantage of the situation to outwit them, making a disjointed, disturbing image of a deconstructed haunted house that every day in subsequent iterations he rendered more tightly and cheerily, until it resembled what he knew they wanted to see. The ruse worked, and Danny returned to LA, but he never truly recovered.

Despite their peaks, the Quintet suffered a rather ignoble end following double debacles in late 1966. First Terry and Jo Harvey's VW bus (the

Beetle's successor), full of the band's gear, including all their amps and Terry's Wurlitzer piano, was robbed outside their apartment at 3279 Descanso Drive in Silver Lake, across the street from the summit of the Music Box Steps, while he ran upstairs to grab something before driving to rehearsal. Wracked with guilt, Terry struggled to replace the equipment, stretching himself extremely thin financially in the process. He had not yet paid off the Wurlitzer, and he had to buy a second one to play the gigs they'd already booked, so for a year and a half he paid installments on a ghost piano. Meanwhile, in its death throes, the band soldiered on aimlessly for a few months, until a Chouinard friend named Mike Peters, who had decided he was the Quintet's manager, hatched a harebrained scheme that finally sounded the knell. Peter's dancer girlfriend had secured a gig in Puerto Rico for which she required a backing band, and she felt the Black Wall Blues Quintet would serve nicely in this capacity. One night at rehearsal, Peters took everyone's measurements and, the following week, presented them with "these weird, matching monkey-suits." Terry "reacted pretty violently" in opposition, and Gary and Tyrone backed him up, complaining about the indignity of the costumes and the suggestion that the great Black Wall Blues Quintet would ever accept a subordinate role as frilly backup to a dance troupe. The band broke up that night.

CHAPTER 17

THE NOUVEAU LIP POSSE

Hey remember all those
Psychedelic nights
When your head came loose
And floated into the lights

—"After the Fall"

AS HIS BAND WAS DISINTEGRATING, TERRY'S ART FINALLY BEGAN TO INTEGRATE, once again with a little help from his friends. Like many of his classmates, by the beginning of his senior year, in the fall of 1965, Terry had begun to feel increasingly disillusioned with Chouinard as an institution. The school's financial indebtedness and thrall to Disney, as well as what he and his friends perceived as some of its faculty's departure from Madame Chouinard's vision and capitulation to the artistic conservatism and pandering demanded by Disney, dismayed and finally inflamed them. They wrote letters to the dean and the editor of the school publication and published a newsletter to which Terry contributed protest screeds and poetry. Entitled *Fuck Mickey* and likely penned, at least in part, by Terry himself—his manically punning voice reveals itself plainly at points—this anti-Disney broadside caustically accused legendary animator Don Graham, Ed Reep, and new dean James Jackson as the worst offenders, beginning with a diagnosis of Chouinard as "in its death throes," and continuing to indict the Happiest Place on Earth: "If you want to know what is wrong with the country today, look to Disneyland. The Western Saloon doesn't sell liquor, the quaint American town doesn't have a section on the wrong side of the tracks. The railroad

doesn't have union problems, the castle doesn't have serfs. In short, [Disney] is illustrating a giant Lie. A lulla lie for an asleep public. The public is waking up." Beside its final, fiery passage calling for "a more progressive education . . . that deals with the contemporary world" is a drawing of Mickey Mouse French kissing Donald Duck. Terry claimed the cover was more graphic, a depiction of the two Magic Mice, "Mickey and Minnie, fucking."

Ultimately, Allen and his friends took matters into their own hands and provided their own progressive education. They had begun to spend more time at the Pasadena Art Museum and at the La Cienega galleries, the haunts of a curator who would take a keen interest in this group of disgruntled but promising young art students.

WALTER HOPPS HAD curated *By or of Marcel Duchamp or Rrose Sélavy*, the retrospective Terry had attended with Ms. Watson's class.[1] It was an ambitious and auspicious first museum exhibition for Hopps, who had recently come to helm the Pasadena Museum of Art as curator and subsequently assumed its directorship. A year before Duchamp, in the fall of 1962, Hopps had mounted *New Painting of Common Objects*, the groundbreaking (if blandly titled) first museum survey of Pop Art painters, featuring, among others, Warhol, Roy Lichtenstein, Jim Dine, Wayne Thiebaud, and the soon to be ubiquitous young Oklahoman prodigy Ed Ruscha. Hopps's daring stewardship, which helped reinvent the American art museum as a viable space to show contemporary art, introduced Terry to the work of, among others, Kurt Schwitters (in another pioneering one-person show), Allan Kaprow, and Jasper Johns (he remembers a gaggle of elderly ladies circling Johns's *The Critic Smiles*, a 1969 sculpture of a toothbrush with human teeth as bristles, in flummoxed confusion).

Hopps had recently left Ferus Gallery, which he'd founded in 1957 with his wife, art historian Shirley Hopps, and budding art-world bête noire Ed Kienholz, who departed a year later to concentrate full time on his unsettling sculptures and installations. Ferus Gallery, arguably more than any other institution (with the possible exceptions of Chouinard and the dive bar Barney's Beanery), was instrumental in transforming Los Angeles into a viable home for contemporary artists and art, slowly dismantling its underdog status as a supposed cultural wasteland of

hollow Hollywood gloss. Until its closing in 1966 and dissolution into the Irving Blum Gallery the following year, for a decade Ferus anchored the LA contemporary art scene from its location at 723 North La Cienega ("The Swamp") Boulevard (*Artforum's* headquarters were upstairs), launching the careers of a staggering array of artists—almost all of whom were, it must be noted, white and male—associated with the so-called Cool School and defining many of the aesthetic and conceptual aims of the LA scene that birthed the loosely affiliated Light and Space, Finish Fetish, and, to a lesser extent (because it was always more associated with the Bay Area), Funk art movements. In the years before Allen arrived in LA, Chouinard served as a feeder school and recruitment center for Ferus, much the same way it did for Disney, though drawing decidedly from the "fine art" segment of its student body.

July 9, 1962, the day Terry and Jo Harvey woke up in Cloudcroft after their wedding, Warhol's solo exhibition of Campbell's soup can paintings opened at Ferus—the first time they'd ever been exhibited as a series—catalyzing a Pop revolution among Terry's future peers at Chouinard and beyond and finally firmly putting Ferus, and LA, on the art-world map. Allen first visited Ferus in 1965 for Ed Ruscha's third solo show there, a series of paintings of birds metamorphosing into pencils, which hit Terry, an avowed lover of both birds and pencils, right in the gut. By then every first-Friday opening at Ferus and the other galleries popping up on La Cienega had become an unmissable event for Allen and his cadre.

Because he did not graduate until 1966—and perhaps because even his early work was radically different from most of the Ferus group's—Terry was a couple of years late to the party, but he managed to coast on its fumes, especially those that powered Hopps's tenure at the Pasadena Art Museum. Allen would come to know the ex-Ferus crowd well, especially its cofounder Hopps, who became a key supporter and mentor.

More than their art, which, with few exceptions—notably Kienholz, John Altoon, and painter and musician Lynn Foulkes, to whom Terry was occasionally compared—bore little resemblance to his own, the Ferus artists' attitudes, early successes, and congeniality toward younger artists undoubtedly influenced Allen. Several of them—notably Robert Irwin, Larry Bell, and particularly Ruscha, all slightly senior Chouinardians—became mentors, briefly, and then several years later,

friends, permanently.[2] When, after graduating from Chouinard, Allen taught drawing at the Pasadena Art Museum, his class followed that of John Altoon, who had attended Chouinard in 1950 and still occasionally taught there. Altoon, an intense personality of the same World War II generation as many of Terry's other teachers, had managed to move beyond the self-imposed limitations of his Abstract Expressionist peers with his delicately rendered figurative and biomorphic paintings and drawings, which demonstrated an idiosyncratic mastery of line and color from which Terry blatantly cribbed. "He'd recently had a nervous breakdown," Allen recalled, "but I'd go to his class, take extensive notes, and then do the exact same thing in my class." After a struggle with schizophrenia—Larry Bell described his friend as "possessed by real demons"—Altoon died of a heart attack in 1969 at age forty-three, his enormous promise unfulfilled.[3] Though the gallery had closed a few years prior, his passing marked the true end of the Ferus era. "If the gallery was closest in spirit to a single person," Irving Blum, one of the Ferus partners, remarked, "that person was John Altoon—dearly loved, defiant, romantic, highly ambitious—and slightly mad."[4]

Of all the "slightly mad" artists associated with Ferus, it was cofounder Ed Kienholz whose art and stance most directly impacted Allen's own. Kienholz, though shrewd and fully aware of his position in the art world, presented himself as an art-world outsider, building a persona as a humble blue-collar mechanic and carpenter, a laborer and craftsperson. It was a guise of guileless that Allen would occasionally adopt as well—when it was to his advantage. Kienholz's challenging and frankly confrontational artwork, as it developed from figurative sculptures into found-object assemblages, human-scale tableaux, and eventually room-size installations, ranged from merely irascible to outright raving, its scuzzy surfaces as texturally gnarly and encrusted as its content was scatological and sordid, its brutality a mirror for its viciously satirical sociopolitical critiques. He tackled topics untouchable at the time in mainstream museum-bound contemporary art, courting controversy by depicting sex workers in a brothel (*Roxy's*, 1961), the aftermath of a squalid back-alley abortion (*The Illegal Operation*, 1962), casual drunken sex (*Back Seat Dodge '38*, 1964), the stigmatization of mental illness and the abuse of institutionalized patients (*The State Hospital*, 1966), and most horrifyingly, a racist lynching (*Five Car Stud*, 1972).

* * *

HOPPS HAD AN open-door policy in his museum office, so one day, thoroughly disenchanted with Chouinard and approaching desperation, even openly discussing the possibility of dropping out together, Terry and Al visited the dapper, bespectacled curator and confessed their desire to quit school, rent studios, and launch their professional careers. Their mentor encouraged them instead to finish their final year and get the diplomas they deserved, which they would need if they ever needed or wanted to teach (the last thing Terry or Al thought they wanted or needed). But in the meantime, he suggested that they marshal their funds to open their own cooperative gallery to show their work, in effect fostering their own art scene and hopefully attracting some attention, and maybe even money, to help them strike out on their own after graduation.

The plan sounded sensible to Terry and Al, so they gathered some of their simpatico classmates and rented a space at 733 Western Avenue in East Hollywood, and Gallery 66, named for the year, was born. There was never any intention for the project to develop into something more than temporary; one year would suffice. During the span it stayed open, they managed to maintain regular hours of 10:00 a.m. to 5:00 p.m. on weekdays and Saturdays—unless the assigned minder didn't show up due to school assignment stress or hangover.

The untitled inaugural exhibition of Gallery 66, known informally as *16 Artists*, to differentiate it from subsequent shows, the majority of which featured either three or sometimes two gallery members only, featured work by Allen and Ruppersberg as well as their fourteen founding cogallerists: Bob Bigelow, Gil Brown, Leonard Castellanoes, Bobby Clark, Padraic Cooper, Wataru Hiramatsu, Teruku Hiramatsu, Jack Kling, Jan Levison, Frank E. Malcolm, Ted Nagashima, Mike Peters, John Schroeder, and Gary Wong.[5] Membership was fluid; Terry's non-Chouinardian friends Greg Card and Doug Edge were also involved at various points. Collectively, the Gallery 66 group called themselves the Nouveau Lip Posse. The promotional poster mailer for a later group show consisted of a large photograph of a woman's tan-lined ass with a small star-shaped sheriff's badge suspended at the apex of its crack, emblazoned with a pair of nouveau puckered lips—a callipygian provocation to kiss their asses.[6]

Gallery 66 was not entirely a hip, irreverent cult of youth or an exclusively student-oriented club, however; the Posse did recognize, and occasionally pay tribute to, their forebears and teachers. According to the inaugural press release for *16 Artists*, Mike Kanemitsu, "a noted New York 'first generation painter' [who] has been instrumental in the initial planning and development of the Gallery," donated some pieces to help raise money. Various other established LA artists, drawn mostly from the ranks of elder, appropriately anti-Disney Chouinard grads and faculty still in the good graces of the Posse, such as Altoon, Connor Everts, Joe Funk, Stephan Von Huene, and Woelffler, exhibited with Kanemitsu at Gallery 66's second show, the rather more conventional *Drawing and Print Invitational* of fifteen artists. Walter Hopps served as the patron saint, critic-at-large, and eminence grise of the space, providing not only art-world legitimacy and imprimatur but likewise direct—and always rigorous—feedback about the constituent artists' work. He would occasionally call Allen in the middle of the night to tell him he would be stopping by the gallery in an hour or so, perhaps around 3:00 a.m. Allen would ring the other Posse members, and whoever could be roused would meet down on Western Avenue for the "night raid" critique. "He'd come in like a spy," Terry remembers, "wearing a trench coat and a hat, incognito. He'd stalk around, look at everything, and then storm out, saying, 'All of you can do better than this!'" More detailed notes would come later; for example, Hopps once told Allen, when he saw the influence of R. B. Kitaj in his work, that he should already have surpassed him.

These informal critiques were particularly important for Allen, who felt a special connection to Hopps, his first curatorial mentor and the first nonartist art-world figure who recognized something special in his work. Terry admired Hopps's nonconformist attitude and stringent, obsessive perfectionism—he was known to fuss over gallery installation details, muttering censure to his preparators: "Wrong, wrong, wrong!"— and respected his background and perspective as well, which intersected with his own interests. Hopps had come up in the Californian Beat scene, and his artistic sensibility was fundamentally informed by music, particularly West Coast cool jazz. Hopps appreciated and championed the work of polyglot artists with an encyclopedic bent and a dedication to the literary, the absurdist, and the darkly humorous—Duchamp, Joseph Cornell, Robert Rauschenberg—so he, in turn, appreciated

Allen's ambitious, intertextual art, which beginning with Gallery 66 was already attempting to knit together obscure narratives, symbolism, and representational imagery. As responsible as any other single figure for demonstrating the viability of Los Angeles as a center for contemporary art, Hopps was an important and powerful person for Terry to have in his corner.

When Allen's three-person Gallery 66 show opened on May 23, a few weeks after he turned twenty-three, he had only exhibited in one other noncollegiate group show, a charity benefit for SNCC, in February 1964, at the Westside Jewish Community Center. It ran for an underwhelming single week. So he was determined to make his small-group Gallery 66 debut count. In promotional photos for the exhibition, Terry, in blazer and shades, alternately slouches against an ornate wrought-iron gate outside the space and peeks up from a subsidewalk basement, with fellow artists Padraic (or Patrick) Cooper and a mod-attired Gary Wong, who resembles a Korean John Cale. A postcard close-up of Allen's face, in high-contrast black and white, shows him smiling maniacally and wearing Lilliputian welder's goggles, looking like a crazed starship trooper or competitive swimmer (he liked the image enough to reuse it for the poster of his first solo show). Allen's three-man Gallery 66 show also provided his first opportunity to exhibit a complete body of new work outside the confines of the Chouinard campus, viewable by the public (or at least those who appreciated the prankish mailers and could find the unassuming address).

The series he showed—a set of pieces that "overtly violated everything [he] had been taught"—comprised the first body of work, "colorful, flat, Pop-ish erotic image drawings" that he felt confident about truly calling his own. There were thirteen pieces in total: a print titled *The Tongue with the Silver Pud*, available in a limited edition, accompanied by twelve drawings rendered in colored pencil, pastel, press type, and various other emphatically unpainterly media, not on canvas but on modestly sized, decidedly unheroically scaled sheets of paper. Each drawing was priced at seventy-five dollars, a not inconsiderable sum to Terry at the time (the print was twelve dollars). Although few images and studies remain—swarming with sexy cephalopods, aroused anthropomorphic forms with trembling tongues, foraging phalli, and lubricious orifices engaged in contortionist coitus—the vivid titles alone betray

some of the salacious content, as well as the narrative subtexts, heavily influenced by comics and surrealism.[7] Certain pieces suggest the artist's roots, familial and geographical, like *Tornado "T" and the Day Burns Boys* and *My Twin Brother, Who Lives at Night, and the Picture of His Mother, Shrieks*. (Terry has occasionally used the "twin brother" character to poke fun at his supposed double identity as visual artist and musician.) Confectionary and geographical themes thread through several images: *Little Candy Connie's Precious Pie Machine*; *Map*; *Sugar Bird Pie and the Marching Cookies*; *Surplus Meat Map*; *California Pops, Plum Drops, and the Cherry South*. *All-American Lay-Her Cake* was, in Terry's words, a "USA-shaped cake with candles in the shape of pricks," particularly memorable because it furnished his very first sale, to his friend Marie Greco (later Botnick), another fellow Chouinard student. "I loved his sense of humor, that's what drew me to it," she explained.

One piece in particular foretold things to come. *Apparatus for Catching and Suspending Hogs* was inspired by a series of schematics Allen had found in a 1948 book called *Mechanization Takes Command* by architectural historian Siegfried Giedion. Within this eight-hundred-page tome, Giedion features illustrations from patent filings and abattoir technical manuals depicting elaborate machines for catching and slaughtering pigs, as well as cleaning, scraping, disjointing, and weighing their carcasses. The one from which Allen lifted the title of his drawing, dated 1882, includes a grim caption that reads: "The hog M acts as a decoy for the others, and much time and labor are thus saved."[8] "It showed," Allen described, "how these hogs were suspended on this scaffolding, and then these hooks went around their feet and turned them upside down. Then their throats were cut." Giedion argues that Cincinnati's nineteenth-century pork-packing industry effectively innovated new, advanced industrial assembly-line technologies in its slaughterhouses because such mechanized devices, despite their enthusiastic patent filings with their florid Victorian graphics, did not actually function efficiently, or even sometimes at all. The killing machines were failures. Butchery, it seems, is one realm in which human beings still hold the advantage over machines. What Giedion deems "the birth of the modern assembly line" he posits was the direct result of the intractability of pigs: "Even when dead, the hog largely refuses to submit to the machine."[9]

Allen has never been able to explain precisely what attracted him to the image, or why, in a subsequent iteration in 1969, it resurfaced in a drawing that, for no reason he could understand then or now, he called *The Juarez Device*, the first visual artifact of his *JUAREZ* body of work. Perhaps it was the intersection of mechanized precision and brutal violence, the charnel-house automation of death and transformation into industrialized product, that connected to the iterative, cyclical violence of his own *JUAREZ* cycle of slaying and transfiguration, as inchoate or subconscious as it might then have been. In *The Juarez Device*, the pigs transmogrify, temporarily, into their human butchers: "I changed the drawing so they began to be people-hogs, then when they turned upside down, they became rocks or trees or bushes—they became natural elements." It was the first glimmer of *JUAREZ*, a project that manifested like sourceless smoke, a vaporous dream vector that would, in the artist's words, "haunt" him for the rest of his life.

With these new drawings exhibited at the co-op gallery he'd cofounded, Allen finally found a voice and an embryonic style that suited his narrative explorations. The Allen-Cooper-Wong show closed on June 11, 1966, a freighted date. The very next day, Terry and many of his fellow Posse members graduated from Chouinard. At the time the diploma felt about "as worthless as toilet paper," an anticlimactic technicality with only the flimsiest relevance to his future. He and his friends had already moved on, feeling they'd learned what they needed, eager to start their professional careers as practicing artists, Disney animators, or, if all else failed, teachers. A few Gallery 66 shows followed, but without the social and academic adhesive of Chouinard, the Nouveau Lip Posse gradually drifted apart and disbanded, just a month or so shy of their expiry date. The final, eponymous show closed in October of 1966. Their grandiose plans, outlined in a nine-point memo by Cooper, to publish a manifesto, solicit support and solo exhibitions from established older artists such as Barnett Newman and George Herms, and organize a *Young Los Angeles Artists from Gallery 66* show at David Stuart Gallery in LA (and also hopefully somewhere in New York), went uniformly unrealized.

At the time of his graduation, Terry and Jo Harvey's income was sporadic at best, and now he was saddled with $1,250 of student loans—thankfully, he had earned a full scholarship for his final two years at Chouinard—in addition to the debt to his bandmates for the stolen

equipment. The situation felt hopeless, the all-too-common trap so many art school graduates fall into when forced to reckon with what Allen has called the "withdrawal from the sanctity or the womb, of mama, of school. . . . It's that first year when you come into the reality that you've got to make a living and step into the world."[10] The uncertainty and lack of training about how, exactly, to establish an art career in pragmatic terms sinks fleets of graduates every year: "That year after art school is the most dangerous. . . . Suddenly you have no peers to talk to every day, no facility or equipment to use every day. There's a lot of casualties."

CHAPTER 18

ENTERTAINING THE ANGELS

Ahhh . . . you better look good
Yeah . . . you better act right
Cause the Art Mob's out tonight

— "The Collector (and the Art Mob)"

"THE WAR BLEW EVERYTHING OPEN," TERRY HAS OFTEN OBSERVED. ANY sense of complacency that the Allens and their social circle had harbored clarified into horror (at the interventionist injustice of the conflict's rationale and the death toll on young Americans and Vietnamese alike) and terror (of the draft and becoming another statistic).

It took Terry much longer than it took many of his peers to open his eyes. Due to his family's robust history of military service, a juvenile patriotism indoctrinated in Lubbock's school system and churches, and a general lack of comprehension of the situation thousands of miles away, Allen did not necessarily oppose the war in its early years, accepting it as a distant inevitability promising vague nationalistic benefits having to do with eliminating the supposed scourge of Communism. In the summer of 1964, when President Johnson authorized the deployment of US combat troops to Vietnam, Allen briefly considered enlisting. Compared to a career in art, the military seemed a viable and stable job prospect, and he was still not immune to the stirrings of patriotic duty— nor to an opportunity to goad Jo Harvey and observe what her reaction might be to such a proposition. His status as a married man had pushed him "back a slot" in the early rounds of the draft, and then he earned an education deferment for his four years in college. But within weeks of

his graduation, by the time the summer of 1966 had officially begun, he received a draft notice letter forwarded from Lubbock—he was now 1A, fully eligible to serve. Suddenly the war felt much closer and much more frightening.

Unlike many of his friends, Terry had not done anything to avoid conscription to date, and he was not going to start now. "To be honest, while [the war] was going on, I didn't think about it that much," he told his friend Dave Hickey in 1993.[1] While the Allens were living on Descanso Street in 1966, Terry's second cousin "Little" Steaven visited, "all clean-cut in a uniform and beret," nervous and excited about shipping out from San Pedro with the Green Berets. At seventeen, heartbroken after breaking up with a girlfriend, Steaven had impulsively begged his mother to sign his enlistment papers so he could escape his provincial hometown and his heartache. He went from winning high school science fairs in Texas to earning medals for valor in jungle combat in Southeast Asia. Terry, who'd always felt far more fraternal affection for his young cousin than he ever did toward his actual half-brother Manse, from whom he was now fully estranged—more out of distance and irreconcilably different perspectives on their family than malice—could understand Steaven's hunger to leave everything behind, like his father Billy Earl had done before him.

A year later, Terry's attitude changed starkly and irrevocably. "I didn't have any great aversion to the war until my friend Stanley got killed," he recalls. "That was such a shock, the first time it was real, despite all the news." On September 19, 1967, Stanley McPherson was killed in action in Biên Hòa province, his body rent by a Bouncing Betty S-mine, obliterated by "multiple fragmentation wounds." He was reportedly identified by the Roadrunner tattoos on his dismembered calves, one of the few remaining intact pieces of his ruptured corpse. The news scarred Terry and everyone who'd loved Stanley back home in Lubbock and Hobbs. His friend's ruined, riven body haunted his dreams, eventually transubstantiating into his radio play *Torso Hell* and multiple *YOUTH IN ASIA* artworks.

Steaven, on the other hand, survived his service in corporeal form, returning wounded and highly decorated. But when Terry and Jo Harvey next saw him, in Berkeley in 1970, after he'd been to Amarillo on leave between tours, his spirit, in addition to his heart, was irrevocably

broken. Their houseguest was no longer the bright young science-fair champion full of irrepressible energy and teenaged enthusiasms. Now his grasp on his own identity and even material reality seemed tenuous, disjointed. Steaven paced around their apartment manically "like a caged animal," strung out on a cocktail of pills, while Jo Harvey attempted to calm him down and engage him in quiet conversation. At a diner with Terry, he experienced a hallucinatory breakdown that unnerved his cousin. In 1991, Allen told the story to Hickey:

> The waitress came up and put a bowl of peas on the table. These are just green peas, right, but my cousin suddenly disappears—I mean he just literally dove under the table and wouldn't come up. I didn't have any choice but to crawl down there after him. "I don't wanna look at any dead eyes!" he said. "I don't want to see any more dead eyes!" he kept saying, and I just sat down there with him, trying to coax him back into the world and gesturing like mad for the waitress to get those damned peas away from us.[2]

His marriage in shambles, his mind shattered, Steaven finally confessed that he was ready to desert. Through antiwar activist connections at the University of California, Berkeley, Terry set him up with an underground railroad guide for draft resistors and AWOL soldiers fleeing to Canada. At the last minute, Steaven changed his mind and disappeared, resuming service for a second tour. In the middle of a firefight in the sweltering jungle, in a morass of mud and blood, he received news from a commanding officer that his wife, son, and daughter—along with his wife's new boyfriend—had been in a terrible car accident. His wife and daughter were dead, his son permanently crippled.[3] In less than twenty-four hours, he was standing outside his empty house in Amarillo in a blizzard. He never recovered from the trauma. Addicted to the precarity and adrenaline rush of combat, and with nothing left to lose in life, he signed up for a third tour. By Christmas in Amarillo, at the urging of family and friends, he had reconsidered once again. On their way back to Berkeley after the holidays, Terry and Jo Harvey dropped Steaven and a buddy outside Santa Rosa, New Mexico, where they planned to hide out in the mountains until the war was over. Like everything in Steaven's life since enlistment, the ploy was an abject failure;

his friend was apprehended on a foray into town to scavenge food and supplies, and they were both thrown into the stockade. Due to his impressive, decorated service record, Steaven got off with a general discharge and returned to Amarillo to live in Billy Earl's trailer on the plains. From then on, it was, in Terry's words, "just a slow death from the war; he never got it back together." On top of the pills, Steaven became involved in nonprescription drugs, first mildly, growing marijuana under the trailer, then getting strung out on cocaine.

Throughout the 1980s and into the 1990s, in his *YOUTH IN ASIA* body of work, Terry drew heavily from his experiences of Stanley's death and Steaven's death wish. Speaking to Hickey five years before Steaven's passing—but with the distinct foreknowledge it was imminent—Terry offered context to the diner story: "That's what *YOUTH IN ASIA* is about—that kind of residue and those kinds of experiences. In one sense, they're incredibly intriguing and horrifying events—specific traumas, you know—but at the same time, they're really just stories about the consequences of betrayal—about a culture that betrays its children. You don't have to be the veteran of some war to understand that."[4] As he has remarked to me on more than one occasion, "I wasn't in the *war*, but I was still *in* the war—everyone was." From his perspective, Vietnam represents the defining trauma of his generation—the generational, cultural corollary to his father's death and his mother's psychological decline, the defining traumas of his personal life—and out of grief and guilt alike, he would return to it in various ways throughout his career, until finally compelled to visit Southeast Asia in person (twice).

He admits, of course, that his wartime experience was heavily mediated and not in any way equivalent to the experiences of veterans or Vietnamese citizens. In his conversation with Hickey, he condenses it into a single image, describing those years traveling back and forth between LA and Lubbock in an old pickup truck, "driving through the desert, listening to rock 'n' roll and monitoring the jungle war on the radio. That, basically, was my Vietnam War experience—the American Southwest overlaid with rock 'n' roll and news from Southeast Asia." Whether or not you accept his provocative premise (or wording) that those who stayed at home were somehow still "in the war," it is not unreasonable to suggest that the Vietnam War did indeed introduce a malign, evil climate to the United States, that the populace was "infected with

the atmosphere," as he puts it. *YOUTH IN ASIA* traffics in the atmosphere of the aftermath, that traumatic "residue" more than the war itself, of which Allen is careful not to claim firsthand knowledge.

IN 1966, HOWEVER, beyond what he heard and saw on the news, Terry still remained largely blissfully ignorant of the true and lasting repercussions of the US engagement in Southeast Asia, or how it would infect not only the nation but his own life and art. His primary concern was finding a job, any job, as quickly as possible; he and Jo Harvey were surviving on canned food, and the situation was tense. He had resorted to desultory film-industry gigs that barely paid, like "gray-fill" extras parts in TV ads, including a Chevy commercial where he appeared as an anonymous body in the crowd. In desperation he even considered grad school as a way to forestall the inevitable, applying to the San Francisco Art Institute. The Admissions Department, however, was not interested in Terry's Gallery 66 work: "I got back a scathingly chickenshit letter that said, basically, we don't show work like this, and we're not interested in this kind of art. It looked as if someone had taken a ball peen hammer to my box of slides; it was completely crushed. I was so pissed that I didn't apply anywhere else." The letter, dated April 6, 1966, reads: "The Committee feels that the qualities which the program is best able to encourage are not present in your work. Therefore, the program will not be of sufficient benefit to you. For this reason, your application was not approved."[5]

With grad school off the table, Allen applied to a local elementary school teaching job through the US Poverty Program, which was only too happy to hire him, given the lack of eligible teachers. He was assigned to teach third-grade English at the Ninety-Third Street School in Watts. Sundered by violence and razed by the riots a year earlier, the neighborhood of Watts was in crisis, including its public schools, from which teachers were quitting or transferring at an alarming rate. Terry wrote to the Lubbock draft office, explaining the situation, and waited several weeks for a response, "sweating it all summer." Finally he received a letter, which he opened with trembling hands standing in the kitchen of their leaky apartment at 2453 North Beachwood Drive in the Hollywood Hills, where they had recently moved. The draft office had confirmed his reclassification; once again, he was safe. Even then, while he recognized

his tremendous good fortune—dumb circumstantial luck, really—and was certainly not eager to carry an M-16 into the jungles of Southeast Asia, he was not categorically opposed to the war in principle, not yet.

Although he was a voracious, some might say compulsive, reader and writer, Terry had not the foggiest idea how to teach the English language and literature to an overcrowded class of impoverished third graders, many of whom could not yet read. When he showed up for his first day of class in September 1966, he discovered that every one of the thirty students' faces gazing up at him from their mismatched, broken desks— some sweetly and expectantly, some suspiciously or truculently, most blankly—was Black or brown, and in the wake of the Watts Uprising, they were understandably disinclined to trust a young, bespectacled white man who called himself an artist. After the first few days of class in September 1966, he decided to ignore the lesson plans and curriculum— which he did with relative impunity, since the school district was so disorganized and understaffed—instead trying, in spite of an administration that vacillated between apathy and outright hostility to its student body, to get these kids excited about language and reading. He stationed a student as a guard at the classroom door to warn him of any approaching administrators.

He played them records, mostly jazz, blues, and rock and roll—Little Richard and Bo Diddley were favorites—and they talked together about the stylistic differences, about the evolution of American pop music, about what the lyrics meant to them. "They were totally locked into Elvis Presley, they'd seen all those goofy movies, but they didn't know his music," Terry recollected, "so I played them lots of Elvis records." His brief tenure in Watts was a transformative experience and probably responsible more than any other period in his young life for forging his liberal—and over the years, increasingly leftist—political consciousness, a consciousness often at odds with the country music establishment and sometimes also with the values of the art world, despite what it might profess publicly. Jo Harvey remembers the emotional release of his final day of class, when Terry dissolved into a puddle of guilt and grief at his own implication in systemic racism and his tenderness for his young charges. "They were a beautiful bunch of little people, man," he told me, expressing regret that he never saw them again and that he did not do more to help them in their short time together.

* * *

TERRY'S TEARS ON his last day of teaching his third-grade class weren't strictly about those thirty children. That very same June day Jo Harvey went into labor with their own first child. From the moment they'd married, the Allens had wanted kids; Terry recognized fatherhood as a possible way to redeem and reverse some of the trauma of his own childhood. After four years of the couple trying unsuccessfully, a charitable Beverly Hills fertility doctor named Dr. Fox finally put them on the right track. One day in September 1966, having carefully monitored her ovulation, Jo Harvey sped across town, stood beneath the second-story window of the Black Wall rehearsal space, and screamed at the top of her lungs: "Terry, get down here immediately—we have to screw *instantly*!" He obeyed.

On June 24, 1967, the second day of the Summer of Love, within twenty-four hours of Terry crying on their bed about children that were not his own, his eldest son Bukka Cain Allen—named after both bluesman Bukka White and Herman Hesse's affirmative interpretation of the biblical Cain in his 1919 novel *Demian*—was born at Cedars of Lebanon Hospital, while Terry fretted in a waiting room, "cranking cigarettes."

Within a few months after Bukka was born, they began trying for a second child, figuring they should strike while the iron was hot. By New Year's Day 1968, Jo Harvey was pregnant again, and Bale Creek Allen— his given name a derivative of Beowulf—was born on September 21, only fifteen months after his brother, once again at Cedars of Lebanon, with Dr. Fox attending.[6] Back in Texas, Allens and Koontzes were united in their vocal disgust with both their grandsons' unconventional names.

In a well-intentioned but somewhat dubious decision, Terry and Jo Harvey chose Danny Thompson as the godfather of both boys, a largely "honorary role," according to Terry, given Danny's drug and psychological problems and general unreliability by that point, but a symbol of their deep friendship, even if it was marred. In a congratulatory letter to Terry on the occasion of Bukka's birth, Danny wrote from his exile in Lubbock: "Your letter was the most exciting thing that's happened to me in months . . . if you don't let me be a godfather I'll kill you."

By the time Bale was born, they were living in a small Mission Revival–style shotgun, built in 1923, at 1152 North Gardner Street in West Hollywood, their final home in LA, where Terry wrote many of the

songs that would seed his catalog for decades, especially his first three albums, *Juarez, Lubbock (on everything)*, and *Smokin the Dummy*. He kept promising Jo Harvey they'd find another place, somewhere safer for the kids, who kept trying to toddle out the door and toward busy Santa Monica Boulevard. But they never were able to get enough money together to move, so they remained there for two more years. Despite their financial and practical stresses, which became much more acute now that they had two infants, it proved to be a highly productive time for Terry. In a weird coincidence, the couple's sudden fertility corresponded with the beginning of an incredibly fertile period for Allen's work.

TERRY DECIDED ONE day toward the end of 1966, after beginning his stint at Ninety-Third Street Elementary, that, even if he was stuck teaching for the rest of his life, he must produce a fully realized body of work, one that he could finally stand behind, something stronger and more cohesive than his Gallery 66 drawings. He had recently visited a Chouinard classmate named Gonzalo Duran in his studio above a movie theater (he paid rent in-kind by changing out the marquee letters as needed), where he was producing an astonishing volume of exciting work. It put Terry to shame and prodded him to get to work.

So he chose an arbitrary subject off the top of his head—"like a good Texas boy," he would illustrate the Bible, the most basic, hackneyed, and predictable subject for an artist from the Bible Belt, and the foundation for nearly a millennium of European art history. What could be more staid and straightforward? He might as well start from the beginning of Western art history (as taught at Chouinard, at least), from rock bottom, ground zero—or from the celestial heights of the empyrean, depending on your perspective, with nowhere to go but down. It was a placeholder, at least initially, a whimsically conceptual academic project to keep him busy on evenings and weekends. As it happened, shortly after beginning the untitled Bible series in earnest—he started in early 1967 and finished a year later, in early 1968, with, depending on the source, either fifteen or sixteen total drawings—the work quickly veered away from his nominal subject matter but retained an identifiable format and style. As he put it in a work binder, "Rapidly (and fortunately) it became something else. I never even got through Genesis."

In 1967, he'd landed an earlier piece in his first proper juried exhibition outside of Chouinard. His acquaintances and soon-to-be friends Ed Ruscha, painter and sculptor Billy Al Bengston, and ceramicist Ken Price curated a group exhibition at Cal State College in Long Beach titled, rather unassumingly, *Small Images*. Allen's entry, *5-4 Note of Mouse . . . and Make It* (a late entry in the Bible series, now completely voided of scriptural content) resembles some kind of Dadaist Mickey Mouse schematic of obscurely tongue-in-cheek annotations in handwriting, type, and press type. Its diagrammatic nature suggests a flowchart or technical drawing explicating a cryptic system or device, offering a foretaste of features found in Allen's memory-machine drawings throughout his later career. It was, appropriately, an ambiguous artifact of his involvement in Chouinard students' anti-Disney picketing, marking his first-ever piece seen outside art school as a clear product of the foremost triumvirate of his formative institutional artistic influences: Disney, Chouinard, and Ferus.

Ostensibly biblical drawings like *Coat of Arms* (featuring a coat with dozens of arms, crotchless panties, and elongated human nipples extruding wormily from a bra), *Babylon Superman, or Honky-Tonk Sodom Jamboree* (with caped crusaders, the "S" for Sodom, waging a firefight above a city, while a giant cow's pendulous teats take root above a fleshy city in surgical sectional), and *Entertaining the Angels* (in which a punctured heavenly vitrine leaks clouds on coat-hung wardrobes), all from 1967, are dense, dynamic, and colorful, with "tight renderings of boxed vignettes fractured in surrealist arrangement."[7] Their mannerist sexual fixations and manipulations, neosurrealist absurdity, and sly staginess—they are all contained by or spilling out of drawn vitrines—and strong underground comics' influence allied them with contemporary work by the Chicago Imagists, the so-called Hairy Who group of loosely affiliated Art Institute of Chicago grads, particularly Jim Nutt, of whom Terry was ignorant at the time but came to admire (and eventually meet). Allen's emerging style of exquisitely rendered, comics-inspired mayhem, with its archly salacious psychosexual preoccupations and vibratory psychedelic overtones, apparently developed independently of his slightly senior counterparts in Chicago and the Bay Area. "That was just the nature of the language I found to finally say something worth saying. It was always about looking for a language and

holding true to it, trying to find a voice and hold it. That was the first series that I felt was a real body of work," Allen said.

When he had about a dozen of these horny, hyperactive images, rendered in oil pastels and colored pencil, he decided it was time to take them to "the best galleries in town, starting at the top and going down." So in the fall of 1967, chip already firmly positioned on shoulder, he schlepped his portfolio up and down La Cienega, asking strangers to look at his strange pictures. The first stop was David Stuart Gallery, where the Nouveau Lip Posse had hoped to show. Just as Stuart himself had emerged from his office to greet Terry, the actress Eva Marie Saint walked in, and Stuart fawned over her, murmuring, "Oh, Eva!" They vanished into the back room, and the receptionist told Terry to come back another time.

Next was the Nicholas Wilder Gallery, which had opened in 1965. "Renowned as a debonair figure with a taste for scotch and chili dogs from Pink's, a renowned hot dog stand on La Brea Avenue," Wilder was instrumental in discovering Bruce Nauman and showing him before any other commercial gallery.[8] Terry had no idea who Nauman was—few did in 1967—but he knew Wilder had a reputation for recognizing young talent, and the art world of LA was a much more accessible place then, so he waltzed right in and asked to see Mr. Wilder. Coincidentally, his friends Ron Cooper and Bill Pettit were already there, which was somewhat awkward; Terry hoped he would not have to hustle in front of his peers. He laid out his drawings on the floor as instructed and waited for Wilder to complete a series of interminable phone calls, and then for Cooper and Petit to leave. Finally, the gallerist shook Terry's hand and scrutinized his drawings in complete silence. Finally, he pronounced, "I'm not going to show these . . ."

Terry's heart fell. This sounded like the rejection letter from the San Francisco Art Institute. A sigh escaped through his forced smile. "Oh, OK, well . . ."

"But somebody needs to," Wilder finished.

Over the course of the next two hours, the voluble and generous Wilder gave Allen an impromptu, gossip-filled debriefing and primer about the LA gallery scene. He suggested taking the drawings to Riko Mizuno and to Eugenia Butler—one of them might be interested—"but whatever you do, *don't* go to Blum." This was puzzling. Terry of course

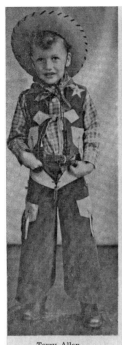

TERRY SAYS:

For Real Entertainment See

WRESTLING

Every Wednesday Night

At Sled Allen's Arena

Phone 2-9221 — 606 Texas Avenue

Terry Allen

"Real Entertainment": An advertisement for Sled Allen's Arena starring four-year-old Terry, 1948. *Courtesy of Terry and Jo Harvey Allen.*

Pauline, Terry, Sled, and their dog Rags at home in Lubbock, Christmas 1953. *Courtesy of Terry and Jo Harvey Allen.*

"The goddamned 'St. Louis Blues'": An early portrait at the piano. *Courtesy of Terry and Jo Harvey Allen.*

A portrait of the artist as a young man. *Courtesy of Terry and Jo Harvey Allen.*

Pauline at her piano, with her bird plates, January 1960. *Courtesy of Terry and Jo Harvey Allen.*

"Rooftop Blues": Terry (seated) with his fellow roofers John Cummings and Hugh D. Reed, summer of 1960. *Courtesy of Terry and Jo Harvey Allen.*

Newlyweds Terry and Jo Harvey in Lubbock, honeymoon bound, July 8, 1962.
Courtesy of Terry and Jo Harvey Allen.

"Red Bird den": The Allens in their Benton
Way apartment in LA, c. 1964. *Courtesy of*
the Southwest Collection/Special
Collections Library, Texas Tech
University, Lubbock, TX—Allen
Collection, box 82.

A Lubbock boy looking for the back of his own head: Terry in Los Angeles during his art-school years. *Courtesy of Terry and Jo Harvey Allen.*

With Black Wall Blues Quintet frontman Gary Wong (and "Fuck Mickey" vending machine) on the Chouinard campus, 1966. *Courtesy of the Southwest Collection/Special Collections Library, Texas Tech University, Lubbock, TX—Allen Collection, box 232, file 13.*

In Plummer Park in Los Angeles with Bukka, Bale, and Jo Harvey, c. 1970. *Courtesy of the Southwest Collection/ Special Collections Library, Texas Tech University, Lubbock, TX—Allen Collection, box 82.*

Live at the grand opening of *Al's Grand Hotel*, Los Angeles, May 7, 1971 (Terry's twenty-eighth birthday). *Photo by, and courtesy of, Gary Krueger.*

At the Pismo Beach Hotel for their tenth wedding anniversary, the first such periodic celebration, July 1972. *Courtesy of Terry and Jo Harvey Allen.*

"Writing on Rocks across the USA": In the Mojave Desert with Bale and Bukka, on the road between Fresno and Lubbock, where they collected four rocks, one for each family member, later incorporated into tattoos and jewelry, early 1970s. *Courtesy of Terry and Jo Harvey Allen.*

Family portrait in Paris, September 1977, during the Biennale. *Courtesy of Terry and Jo Harvey Allen.*

"War Waltz": Jo Harvey and Terry at Caldwell Studios in Lubbock during the recording of *Lubbock (on everything)*, July 1978. *Courtesy of Terry and Jo Harvey Allen.*

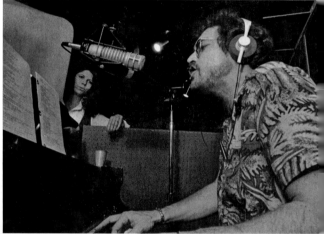

The original Panhandle Mystery Band at Caldwell Studios, summer of 1978: Kenny Maines, Lloyd Maines, Terry, and Curtis McBride. ("The Only Mountain in Lubbock" looms to the right.) *Courtesy of Terry and Jo Harvey Allen.*

"Truckload of Art": Terry performing in the bed of a pickup truck for Creative Time's *Art on the Beach 1* series, with the World Trade Center towers looming above, Battery Park, New York, August 28, 1978. *Courtesy of Terry and Jo Harvey Allen.*

Jo Harvey's portrait of Terry for the back cover of *Lubbock (on everything)*, 1979. *Photo by Jo Harvey Allen, courtesy of Terry and Jo Harvey Allen.*

Stubb's BBQ, Heart & Soul of Lubbock, TX: With Stubb and Terry's tribute drawing at Lubbock Lights gallery, April 1979. *Courtesy of Terry and Jo Harvey Allen.*

"There will be no bad talk or loud talk in this place": Lloyd Maines and Terry at Stubb's BBQ in Lubbock at the *Lubbock (on everything)* release show, April 1979. *Photo by Milton Adams, courtesy of Joe and Sharon Ely.*

"Precious objects are scattered / All over the ground": In Lubbock with the Cadillac Fleetwood he traded for his drawing *Cadillac Heaven*, 1980. *Courtesy of Terry and Jo Harvey Allen.*

"That'll Be the Day": Crashing the Monterey High School graduation dance at the Cotton Club in Lubbock with Joe Ely and Linda Ronstadt, May 1, 1982. *Photo by Milton Adams, courtesy of Joe and Sharon Ely.*

At the Tornado "Mud" Jam,
May 2, 1982. *Photo by, and
courtesy of, Sharon Ely.*

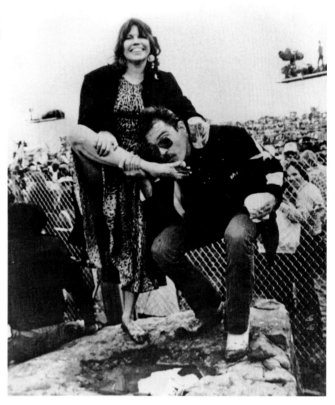

The Silent Majority: With Nancy Reagan at the Awards in the Visual Arts reception, Washington,
DC, May 7, 1982 (Terry's thirty-ninth birthday). *Courtesy of Terry and Jo Harvey Allen.*

"My Country, 'Tis of Thee": In character as a ghost GI on the set of *Amerasia* in Thailand, with Surachai Jantimatawn of Caravan, December 1983 or January 1984. *Courtesy of Terry and Jo Harvey Allen.*

Jo Harvey as the Lying Woman with director David Byrne on the set of *True Stories*, Dallas area, fall 1985. *Courtesy of Terry and Jo Harvey Allen.*

In concert at the Cricketers in Kensington, London, April 26, 1986. *Photo by Dave Peabody, courtesy of the Southwest Collection/Special Collections Library, Texas Tech University, Lubbock, TX—Allen Collection, box 105.*

The Creatures of Snot: Terry, Mike Henderson, and William T. Wiley at Cuesta College Art Gallery, San Luis Obispo, where they collaborated on an exhibition titled *Out of Time*, January 1988. *Courtesy of the William T. Wiley Estate and the Wiley family.*

With David Byrne, Kris McKay, Lloyd Maines (with the infamous "Jell-O Bowl," or cümbüş), and Will Sexton at the Hit Shack in Austin during the *Human Remains* sessions, September 1995. *Courtesy of Terry and Jo Harvey Allen.*

"Maybe these notebooks *are* my art." *Photo by Jo Harvey Allen, courtesy of the Southwest Collection/Special Collections Library, Texas Tech University, Lubbock, TX—Allen Collection, box 106.*

Los Dos Rockin' Tacos: Terry and Guy Clark. *Courtesy of Terry and Jo Harvey Allen.*

"My ego / Ain't my amigo / Anymore": Reprising his iconic *Lubbock (on everything)* portrait thirty-four years later, 2013. *Photo by, and courtesy of, Peter Ellzey.*

"Sailin' On Through": At Arlyn Studios in Austin during the *Just Like Moby Dick* sessions, May 2019. *Photo by, and courtesy of, Barbara FG.*

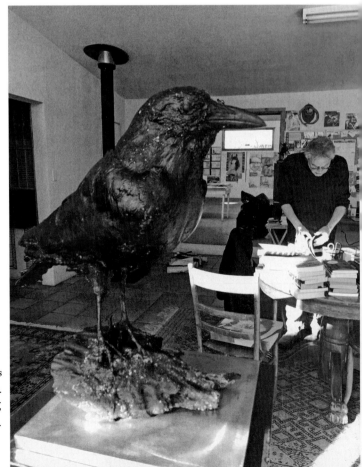

With *Caw Caw Blues* in his studio, Santa Fe, January 2020. *Photo by, and courtesy of, Sylvie Simmons.*

was familiar with Ferus through Hopps's former involvement, and he knew that Ruscha and Bell, whom he looked up to, both showed there. He could never determine if there was a rivalry between Wilder and Irving Blum, who after closing Ferus had opened his own eponymous gallery and married Hopps's ex-wife Shirley, or if he sincerely felt that Blum would not appreciate his work:

> So of course I walked right out of Nick's gallery and across the street to Irving's gallery. . . . He was yammering away on the phone and hung up. I introduced myself, he looked at the drawings, never said one word, and went back to his desk. He called the Pasadena Art Museum and asked for Jim Demetrion, the acting director after Walter Hopps. Irving said, "There's a guy here who needs a show." He gave me Demetrion's phone number and said, "Call this guy when you get home." So I called Jim. That was my first show. They squeezed twenty of my drawings in a little room not much bigger than a closet, in between two galleries.

Allen and Demetrion came to terms on dates and a selection of works in November 1967, and the resulting show, *Drawings by Terry Allen*, would open on August 6, 1968. The Pasadena Art Museum show comprised sixteen drawings (advertised in local press as gouaches, they were in fact all mixed media) from the so-called Bible series, thirteen completed in 1967 and three in 1968, all of which, by the time the show opened, had already been exhibited, along with five additional 1968 pieces, in Terry's first solo show in a commercial gallery, which, in an unexpected twist, predated the museum exhibition, which had been confirmed first.

Private galleries are always more nimble than museums, so as it turned out, Allen did not have to wait long to encounter the grim reality of his limited early commercial prospects. Before the Pasadena show opened, gossip of Terry's peculiar drawings spread quickly via Hopps, Blum, and Wilder to a young dealer in San Francisco named Michael Walls. Walls, who owned a small gallery at 561 Clay Street in San Francisco, immediately reached out to Allen—the first extant letter dates to October 11, 1967—and moved quickly to poach him from Pasadena, hurriedly mounting a perfunctory preview show of the Bible drawings in

the spring, to Demetrion's likely annoyance. Walls wrote to Terry regularly, in a treacly vernacular of ingratiating flattery, gratuitous name-dropping, and obscure and unrealistic promises of sales and checks. Terry liked Walls personally and was grateful, but, sensing some less than scrupulous salesmanly tendencies, and unsure how to communicate with an art dealer, he kept a circumspect distance, sometimes letting Michael beg for a reply—"WRITE, Goddam it"—before responding. *Drawings* ran from May 14 through June 8 at Michael Walls Gallery, promoted by a mailer with the Gallery 66 image of Allen in welding goggles and a Cheshire grin.

At the opening, a young man walked up to Jo Harvey and offered some unsolicited commentary.

"Wow, this guy's *definitely* on drugs, right?"

She smiled. A few minutes later he ventured, "Do you know the artist?"

"*Intimately*," she said with a wink.

Walls had a keen eye for talent and an ambitious vision for his gallery's program, everyone said so, and his shows were well reviewed critically. But Allen would soon realize that his business acumen was lacking, his books perennially in shambles. Walls evidently managed the gallery in a chronic state of financial distress, illiquidity, and overextension, never paying Allen on time, if at all, and often running low on funds for such routine tasks as framing the work he was showing. Allen was barely known in LA and an even darker horse in San Francisco, and only two drawings from *Drawings* sold, for $125 each—*Stuck*, *Upon the Rainbow Trail* to Roger Chouinard of Santa Monica (an artist whose surname reveals his allegiances) and *Submarine Bed Dive* to Joan Jacobs of Beverly Hills. Walls himself, out of guilt, pity, or a desire to retain Terry on his shoestring roster of artists, did eventually, in February 1969, buy *Entertaining the Angels* for $120, 40 percent under the new, post–Pasadena Art Museum list price of $200, but still a princely sum to the Allens.

Entertaining the Angels was also the piece chosen to illustrate a bemused review of the show by Palmer D. French in the November 1968 issue of *Artforum*. French, sounding hopelessly square, acknowledges Allen's "precocity of graphic dexterity as well as of graphic wit in a style owing much to such by-products of the Hippie subculture as the Zap Comics and their prototypes in 'camp' psychedelic posters."[9] He goes on,

rather perceptively, in a marble-mouthed torrent of tortuous clauses, to describe how

> Allen elaborates a slapstick Surrealism of funky Freudian fantasies, inhabited by tube-tentacled, cloth-limbed schmoos in grotesquely obscene postures, and abounding in youthfully audacious funk-slapstick imagery, such as water-closet interiors with fixtures and appurtenances grotesquely askew, various comic-biomorphic abominations, including reptilian phallic and visceral shapes, scatological blobs and the like, all frequently set against blue skies and cotton clouds in jocular paraphrase of the impossible perspectives and improbable juxtapositions of interior and exterior vistas found in historic Surrealist painting.[10]

It was Terry's first proper review in a nationally, and increasingly internationally, prominent publication, and he couldn't argue.

The August 1968 Pasadena show (which closed, after a weeklong extension, on September 8) followed exhibitions by Wayne Thiebaud, Dennis Hopper (with his literally explosive piece *Bomb Drop*), Terry's friend Doug Wheeler, and Frank Lloyd Wright. Demetrion may have sandwiched Terry's drawings, as a space-filling afterthought, somewhat unceremoniously in a cramped, glorified, thirteen-by-sixteen-foot vestibule between two other galleries, but those galleries, and the museum's other salons, were inhabited by an extraordinary array of objects by Larry Bell, Wallace Berman, Helen Frankenthaler, Jasper Johns, Ellsworth Kelly, Roy Lichtenstein, Morris Louis, Kenneth Noland, John McCracken, and José de Rivera. Terry most vividly remembers his drawings hung next door to a selection of shadowbox assemblages, each a dollhouse-scaled miniature microcosm of their creator's arcane mystical and alchemical visions, by one of the twentieth century's most uniquely compelling and elusive artists—Joseph Cornell.

The same set of drawings earned an offhanded mention in the October 1968 issue of *Artforum*, ahead of the following month's more detailed analysis of the earlier Walls show. Alongside more extensive descriptions of shows by Beaudry Street regulars Terry O'Shea, Doug Edge, and Jun Kaneko, critic Fidel Danieli describes Terry's images as "formal, ritualistic, and sinister in their bulky bound figures with tubed

interconnections."[11] The *Pasadena Independent Star-News* filed a much longer, and far less literate, review likening the drawings to children's coloring books (no insult to Allen, a new father and fan of coloring) and ending with a zinger: "Me? Color me unimpressed."[12]

The windfall opportunity of solo museum and gallery exhibitions, the stellar company, and the modest critical response thrilled Allen, who immediately set to work making plans for his next body of work, which would begin from a more personal place than the Bible.

SNAKES IN THE PIE

Yeah I'm just a country boy without angels
Ahhh just a country boy without gold

—"New Delhi Freight Train"

A MONTH LATER, BACK IN AMARILLO, A "MRS. OLIVER LEE DAUGHERTY, 62" also made the papers, but for reasons ruinous rather than generative. On March 16, the *Amarillo Daily News*, under the headline "SAVE WOMAN FROM FIRE," reported that Mrs. Daugherty "may have been saved by injuries by a 7-year old boy."[1] First-grader Steve Steele, walking down the street with a friend, was the first to notice smoke pouring out of the garage of 1501 Rosemont Street. After his mother and a neighbor knocked frantically on the door for several minutes, a dignified middle-aged woman answered and cordially invited them in, oblivious to the flames engulfing the kitchen and licking around the seams of the garage door. They managed to pull her out of the house by her arm, and after talking to the police for several minutes, she departed in a car with her sister, Villa. The article noted that "investigating officers said they are not sure who Mr. Daugherty is, but he is believed to sell mobile homes."

Mrs. Daugherty was the former Pauline Allen. She and Oliver had married on October 15, 1966. Born in 1911 in Hope, New Mexico, Oliver was seven years Pauline's junior, and in Terry's estimation, fathoms beneath her in every conceivable measure. Allen never had much use for Daugherty, tolerating his presence in his mother's life and home with thinly disguised disdain. A Baptist, Oliver had found Jesus in recovery, and most of his surviving writing—letters to Pauline and Terry and Jo

Harvey, poems, and songs—revolve around the stuttering axes of faith and addiction. The fire, caused by Pauline's characteristically cavalier habit of keeping multiple cigarettes burning in various ashtrays while drinking, destroyed the house's kitchen and garage, which contained "a late model car" as well as all of Sled's belongings. Oliver was not home, but a lifetime of things that Sled had accumulated—letters, photos, mementoes—were reduced to greasy gray ash. When he visited Amarillo in the aftermath, Terry rescued Sled's misshapen, molten 1925 Spalding Trophy, one of the few of his father's personal effects to survive in any form.

This was only the first of two fires to ravage Allen's archives during his LA era.

BY EARLY 1968, Terry and Jo Harvey had settled into their final LA abode at 1152 North Gardner Street, near Plummer Park. There, everything changed for Terry; he struck a wellspring of creativity that did not relent for years. As revealed in his notebooks, the decade between 1968 and 1978 sowed the seeds for many, if not all, of his most important later bodies of work, including *JUAREZ*, *Anterabbit/Bleeder*, *YOUTH IN ASIA*, and *DUGOUT*, as well as many of his most iconic songs.

In most cases, Allen's 1968–1978 ideas were fragmentary and partial, embryonic—a dream, a lyric or line, a flash of images, a metaphor—and often he did not return to them seriously or systematically for decades. Many died on the vine in the pages of his workbooks. But they just as often sparked or sustained projects years or even decades later, suddenly resurfacing like ancient ruins from a dry lakebed. Because they were often rudimentary and unfinished, there was often evident a curious bleed from one project to the next. None was discrete; all of the aforementioned cycles of work overlapped in that decade of journals, informing each other in their infancy, recombinant and permutational, awaiting resolution. Anything could happen. Sailor from *JUAREZ* might wander into a navy node of *YOUTH IN ASIA*; *Bleeder* might drip down into a *DUGOUT* hole. It was at this point when his work in different media began finally to rhyme, echo, and modulate, and he began considering how to position his polyphonic visual ideas, songs, texts, and theatrical concepts in conversation and harmony with each other.

He had begun writing more, keeping more regular notebook entries—
though not the diaristic, day-by-day blows he had abandoned after high
school and only resumed later—but also venturing into texts that might
stand on their own as distinct works. A film producer he'd met through
an animation student at Chouinard suggested that Terry write an ani-
mated film treatment inspired by "Red Bird," which he finally did in
1967, a decision that was, in Terry's estimation, "totally economically
driven," and a total nonstarter as well. *Red Bird (a film)* unspooled into
a short script, a fever dream set in the 1920s French Quarter of New
Orleans and consisting mostly of stage direction interspersed with
song lyrics and minimal dialogue—abstract, surrealist, and utterly
uncommercial.

He recorded some music for another film producer named Harold
Nebenzal, who instructed him to play "about ten minutes as fast as you
can, whatever you want," and then heard nothing about it for a year.
Finally, Nebenzal invited him to the premiere, where Terry and Jo Har-
vey sat behind actor Sam Jaffe. The film was *All the Loving Couples*, a
wife-swapping skin flick in which a group of suburban swingers arouse
themselves, in a meta twist, by watching porn films together, one of
which is soundtracked by Terry's frenetic, honky-tonk improvisation.
Nebenzal next commissioned Allen to write a Western, offering $100 for
a treatment. Terry produced an uncompromisingly ludicrous and plainly
unproduceable low-concept (literally) surrealist lark (or as he puts it, "a
monstrosity"). A prankish, proto–*Blazing Saddles* genre satire, *Snakes
in the Pie, or Up the Lovely Ladies and Down the Other* follows the
rough contours of a generic Western plot, with stock characters who all
"crawl around on their bellies" throughout the film, slithering through
studio scenery cacti and tombstones. It ends with apocalypse, the most
compelling part of the muddled, manic script: "The sun falls down and
the desert turns black." Nebenzal paid Allen an additional $50 for a
rewrite and "translation"—"into the language of snakes," Allen specified
pointedly—for the clueless studio execs who would theoretically read it.
He never contacted Terry again.

Much of what Terry produced during this period was similarly theat-
rical and highly experimental in nature, though little was actually per-
formed. When narratives exist, they unfold in fractured, nonlinear, or

recursive ways. Many appear designed, if not explicitly to shock, then to challenge normative moral assumptions. While some were clearly private exercises, many were intended for public consumption. "The Baby: A Sado-Maso Drama Nonsense Murder" was written in longhand in a notebook, though the long poem "A Pleasant Day Pursued," dated October 9, 1967, felt to its author sufficiently polished to submit to the *Paris Review* for potential publication (it was summarily rejected). Both boil with explicit sexuality and violence, filtered through a surrealist lens.

On December 8, 1967, Allen performed two one-act, one-night-only plays in the basement of the house of former Chouinard student Dennis Remick. The invitation featured a drawing of menacing figures in various states of deliquescence, mutation, and bondage with a series of ambiguous headlines.[2] But the audience could never have been prepared for the spectacle of sheer abuse unleashed on them over the course of these two bizarre, ritualistic forays into morbid prophecy and over-wrought art historical pedagogy. In *20th Century Pronto, Arrived (or, An Unroll Funeral for the End of the World)*, Terry played the titular oracular character Pronto, a kind of zombie Tiresias. In pantomime, accompanied by a tape of all the dialogue, sound effects, and music (including Bo Diddley's "Congo"), he hurled filthy, prurient imprecations at audience members.[3] Then came the equally grisly, but rather less humorous, augury portion of the evening: "I wore a wig and painted my face white. . . . The gist was a prophecy. I pointed this stick at each person in the room and told them all how they were going to die."

Dialogues in Drag . . . A Satire was only marginally less confrontational, starring Terry as the Queen of Speak, wielding a giant cloth penis and introducing and interrogating various local artists and art-world figures. The script dramatizes Allen's own experience with LA gallerists and lampoons artist friends. He would never again take the stage as a performer in such a visceral, actorly way. But the experience served as an initiatory ritual, "awakening him," as he later told Michael Walls, "to the possibility of theater as a way of combining narrative and visual elements."[4]

"In a way," Terry mused, "that night was my only real theater training."

Less bombastic are the "object books" or "object novels" that Allen began making in 1967, among which the first and most formative was *Heaven and Earth*. Like the performances and scripts, these artist's

books—bound or unbound sheets containing text, image, and collage elements arrayed in a more minimal, controlled environment than his notebooks—gave Allen license to experiment further with combining the narrative and visual aspects of his practice. Housed in a wooden box, *Heaven and Earth* is at once an art object, an early example of LA conceptual art, and a wordless text comprising one hundred pages, each containing a small square excised from a photograph and mounted in a single adhesive photo corner. Fifty images are supposedly celestial (clouds, stars, the moon, etc.), and fifty are terrestrial (earth, soil, plants), though, as miniature, closely cropped and textural details, it is often impossible to tell one from another. It is a catalog of creation, distilling the world into one hundred tokens of elemental power.

WHILE POSTCOLLEGIATE TERRY dabbled in pornographic soundtracks, surrealist Western film treatments, and artist's books, he was also writing songs at a prolific clip, including many that he would parcel out among his first few albums and that would match his visual art in ambition. In early 1968, he embarked on an intermittent and truncated career as a recording artist, an indentured prologue to his later independent recording career, that, for the next seven years, unfortunately yielded only disappointing if not frankly disastrous results, most of which remain unreleased.

Through Dean Whitmore, Terry had met David B. Nelson, a small-time music publisher, aspiring A&R rep, and general industry hustler with two modest publishing outfits, BNP Music and Four Star Television Music, which controlled the rights to a few dozen songs total.[5] Nelson bought some of Terry's early drawings and professed to like his songs, suggesting they make some demo recordings on spec to drum up potential interest from labels or other artists interested in covering them. Terry, flattered and always grateful to meet someone who seemed to place his art and music on equal footing, agreed. After transcribing lead sheets for Allen's entire repertoire to date, Nelson enlisted a composer, arranger, and conductor named George Tipton, a rising star a decade older than Terry known then for his early collaborations with Jan and Dean, Harry Nilsson, and Leonard Nimoy. (In 1973 Tipton would compose the score to Terrence Malick's film *Badlands*, inspired, like *JUAREZ*, by the violent exploits of Charlie Starkweather and Caril Ann Fugate.)

Over the course of two days, April 15 and 23, 1968, at Wally Heider Recording, Los Angeles, Allen laid down at least nineteen takes of "Gonna California" and perhaps seven of "Color Book," two older songs he felt would complement each other on his aspirational first single. The latter is a thumbnail portrait of a thirty-three-year-old mama's boy artist still living at home in "eternal puberty," whose mother demands he "move from crayons to confusion . . . grow up, little boy / and be a man," a fittingly faux-naive match for the A-side, written on, and about, the eve of his departure from Lubbock (and Pauline and Jo Harvey) for LA (and art school). "I never could think of any verses as good as the first one," Allen confessed.

Co-producers Nelson and Tipton brought in a band of seasoned, and visibly bored, session musicians, including accomplished guitarist Mike Deasy of the Wrecking Crew.[6] Allen, who found it challenging enough to play in a group setting with friends in the Black Wall Blues Quintet, was completely out of his element among these professional strangers. He was a nauseated bundle of nerves. On the surviving tape either David or George begs him over the control room mike to loosen up: "Try and relax a little bit, Terry." They reminded him repeatedly, and with increasing annoyance, not to bob his head, keeping his mouth trained at all times a demure distance from the microphone, and not to tap his boot audibly, severely cramping Terry's style and stymying his performance. "They might as well have put me in a straitjacket," he recalled with enduring frustration. "It was unbelievable bullshit."

Despite Terry's considerable discomfort, he finally did capture some acceptable, if stilted, takes.[7] Nelson sent dubs of the tape around to various labels, but there were no bites.[8] Undaunted, Nelson, Tipton, and Allen continued to collaborate on demo sessions, logging a few more days at Wally Heider over the course of the next year, well into the summer of 1969, as Terry completed batches of additional songs. These dates were no more comfortable for Terry as far as freedom of movement, but at least he knew what to expect; plus, he was no longer expected to play with strangers or to do endless takes. The remaining recordings, comprising more than thirty unique songs (some afforded multiple takes), are all solo performances, all of which remained unheard until the cassette *Cowboy and the Stranger*, released in the summer of 2019.[9] He consistently sounds like he is rushing to get the songs down

before the tape runs out or Nelson and Tipton kick him out of the studio, mechanically announcing the titles at the beginning of each take, with occasional nervous guffaws and bashful apologies ("George, you can take out the 'goddamns'").

In the spring of 1968, Marie Greco's fiancé Bruce Botnick, a recording engineer and budding producer who coproduced Love's 1967 master-piece *Forever Changes*, invited Terry to the sessions for the Doors' third album, *Waiting for the Sun*, which was released just three days after the Botnicks' wedding (which the Allens attended and at which the Doors performed). Terry was impressed by the state-of-the-art TTG Studios, which were unlike anything he'd ever seen, and Bruce's skill and ease in helming them, so unlike Nelson and Tipton's approach. He noted a stark contrast between the slickly professional setting and the voluptuary rawness of the band behind the control room glass, cruising like sharks in an aquarium: "It was this incredible paradox, seeing these absolute savages playing and gyrating inside this pristine spaceship."[10]

In June 1968, before "Gonna California" and "Color Book" had been pressed to vinyl, Allen completed a rash of songs at which he had been chipping away for months, most of which he would soon abandon. Most appear on the Nelson/Tipton tapes or on home recordings he had begun to make on a consumer reel-to-reel recorder he kept in the back room at Gardner Street with his piano. Some litigate his relationship with Jo Harvey, like the flirtatious "Baby, How I Know" and the melancholy and revealing "Opposite Wing."[11] There's the vicious SoCal satire "County of the Oranges," about a "middle class fascist suck" and his family. In its lyrics and music alike, "The Pink and Black Song," like "The Hokey-Pokey Drive-In, or Mogul of Carhops" and "Nouveau Queen" before it, both embraces and satirizes 1950s nostalgia and Terry's not-so-halcyon days as a teenager. Allen composed two particularly ambiguous oddities titled "You Can't Swim Here (Not When There's Fishing), or the Waters of Freud" and "City of the Chimes" on express orders from Nelson, who attempted to pitch them to a mysterious "Italian with a lot of money but a shitty voice" looking to cut a single, whose name Terry never learned and who hated the songs, screaming at Nelson in disgust and thereafter reportedly returning to Italy, never to sing again.

Among the songs from the summer of 1968, some endured and por-tended the future, such as "Ain't Got Nobody, and That's Enough," begun

in 1966, which, slightly reworked and retitled, and inserted within a narrative context that did not yet exist in any coherent way, became "Border Palace" on *Juarez*. "Cowboy and the Stranger" depicts the final moments of a dying cowboy's life, his memories and sensations, as he lies in the dust watching a Bible-toting stranger steal his horse and ride off, having offered no succor. It ends with a yodel that serves as a death rattle.

After finishing it, Terry contemplated its consequences in a notebook: "My show in San Francisco will come from this song. . . . It has something to do with the end of the cowboy . . . the end of the range and the bottom of the world. My mother's in it too." This is not only the first mention of the connection between the song and his upcoming solo exhibition of the same name but also the first appearance of the phrase "the bottom of the world," a psychogeographical designation that refers simultaneously to the Global South, the bottom bits of any given continent (often Mexico) or of our planet as a whole, and to an interior hell of subjectivity—the bottom of the glass, rock bottom—Dante's "lowest deep" of the soul. The line would recur periodically in his writings until finally landing as the title and title song of his 2013 album.

"New Delhi Freight Train," Allen's most well-known and frequently covered song aside from "Amarillo Highway," represented the improbable collision of several divergent events and people. On June 6, 1968, almost exactly a decade before the recording of *Lubbock*, a friend who studied animation at Chouinard was visiting the Allens, back in the world after a harrowing year stationed overseas, bearing firsthand witness to the brutality and trauma of war. He had been drafted, declared himself a conscientious objector, and served as a medic in Vietnam. "Then he was stationed in a burn ward in the Philippines as a nurse for his last six months," Terry said:

It was the day after Bobby Kennedy had been shot at the Ambassador Hotel. . . . Everybody was really upset about it. I turned on the TV, and *The True Story of Jesse James* [1957], with Robert Wagner and Jeffrey Hunter, was on. We started talking about India, and how Gandhi had stopped the empire by getting his people to lie on the train tracks. The conversation around Kennedy and war and peace and protest continued, with Jesse James robbing trains and blowing up banks in the background. Periodically they would break in with

the latest on Kennedy's worsening condition. . . It came out of those multiple climates at that particular time. It's one of those songs that couldn't have been written other than right then at that moment when it happened.

It was, in its way, both a product of its time and an anomaly—a topical protest song, although an unusually cryptic one, couched in the historical violence (and antiviolence) of colonial India and the American West.

Written in 1969, "Truckload of Art" had a similarly serendipitous but circuitous LA infancy before appearing on *Lubbock*. It is an early example of Allen's songwriting taking a sudden, welcome turn into harder, leaner territory, the surrealist tinge of his language rendered more ductile, more adaptable to broader humor and legibly pointed satire, while retaining its essential weirdness. The enduring occupational anthem of art handlers everywhere, "Truckload of Art" pits East Coast artists against their Western "ego counterparts," those "snotty surfer upstarts," but the attempted cultural colonization ends in disaster and conflagration. On its way from the Big Apple to California, the eponymous "Art Ark" runs off the road and bursts into flames, and "precious objects are scattered/all over the ground," the art now embedded in the environment instead of a gallery, and without an audience. So much for Manifest Destiny.

"Truckload of Art" references not only contemporary art history but likewise the history of country music, with a yodeling tribute to Jimmie Rodgers and sly nods to Roy Acuff's 1938 "Wreck on the Highway" and Little Jimmy Dickens's 1966 novelty trifle "Truckload of Starvin' Kangaroos." In their melodic contours and cadence, the yodels specifically resemble those in Tex Owen's 1934 cowboy classic "Cattle Call"—or one of its many covers, like the famous versions by Eddy Arnold and Slim Whitman—closely enough to count as an affectionately unhinged caricature. In an early demo recording of the song, Terry even barks out an ad-libbed aside about "little Eddy Arnold in the truck."

The Nelson and Tipton cut of "Truckload of Art," the first known recording of this song, reveals itself, like so many of these compositions, as fully formed and intact even in its infancy. In this plainly satirical song, Allen is acutely aware, in May 1969, of the art world's now firmly established coastal rivalry, and he positions himself—geographically,

artistically, and temperamentally—on the receiving, underdog (or "Golden Bear") western end of the failed art invasion and colonization.

Other songs unspooled across 1969 at a rapid pace, demonstrating Terry's increasing ambition and mastery of his craft. Written in January 1969 "under mind-expanding and/or mind-dismembering circumstances," the epic narrative ballad "Roses Red Roses," a brutally violent Western tragedy about the travels and tribulations of a gunslinging Shawnee "girl of mystery" who "fires her long rifle at the sun going down," remained, until the *Cowboy and the Stranger* cassette, unrecorded ("ancient and buried") for fifty years. (His producers likely did not have patience for an eleven-minute demo.) "The Beautiful Waitress," written in September, was likewise unrecorded, possibly because Allen recognized that, unlike its sculptural counterpart, it remained unfinished.[12] While all the verses and the chorus are intact, including the "cracker crunch" refrain, the song's best part, the story recited at the end that gives the object of the diner's perhaps unwarranted flirtatious attention the undercutting punch line and last laugh, was appended a few years later in Fresno.

Most if not all of Allen's other 1969 output was apprehended at Wally Heider under the vigilant (if impatient) supervision of Nelson and Tipton. "Arizonia Spiritual," one of Allen's first explicitly religious songs, shares its title with a drawing and its extrasyllabic state name with a lyric on *Juarez*. It likewise shares with his greatest "gospel" songs a reverence and wonder couched in unrepentant blasphemy.[13] "Roll Truck Roll" and "The Night Cafe," a diptych of automotive dramas, offer counterpoint perspectives on the labor cultures of trucking and food service. Both, along with "Cajun River Roll," another tune from 1969, would appear on *Smokin the Dummy* eleven years later (curiously, *Dummy*, Allen's third album, contains several songs older than those on either of his first two albums). "Cocaine Cowboy," yet another number destined for *Dummy*, is a riotous, satirical character study of an addict that Allen would avoid performing for years, queasy about its popularity with children, who never failed to snort along with him on the verses.

CONVINCED THAT THE full-band recordings of "Gonna California" and "Color Book" still represented their best chance at landing a label or a potentially lucrative cover by another artist, in late 1968 Nelson guided

Terry through the mastering and production processes, arranging to press one thousand copies of a 45 rpm seven-inch vinyl single, five hundred labeled as "promotional copies" and five hundred without that designation, for Allen to distribute, sell, or give away as he saw fit. Terry finalized the label materials the same week that Bale was born in late September. Early the next year, while awaiting the pressing, he prepared a printed insert he titled "The Terry Allen Year Book," with an arch autobiography.

On a visit with Nelson and Tipton to A&M Records, Allen spied a Herb Alpert gold record framed on the wall and decided that was the perfect way to immortalize his first recording. He inquired where such gilded mementoes were manufactured, and in 1970, when he had some extra cash, he ordered one himself, framed it, and hung it up at home, calling it *Sonshine, 1960–1970*, its title, flanking the word "Self-Portrait," engraved on a bronze plaque. In a tribute to his young sons, the orange label listed the (imaginary) record label as Bale Creek, catalog number 101, and the fanciful publisher as Bukka Cain, ASCAP. "People were *very* impressed," he commented snidely. The gold record was also a memorial to itself—and to Terry's abbreviated early recording career—because when the pressing of the workaday black PVC version of the single was completed in early 1969, almost no one heard it. Before he or Nelson could even pick up the pressing from the plant, it was almost entirely destroyed, while still sealed in its factory cardboard boxes, in a warehouse on Sunset: "This is God's truth, there was a guy floating around Hollywood called the 'Hollywood Arsonist'—he was starting fires in places around Hollywood and Sunset Boulevard. And he set one of his fires literally on top of my stack of records that had just been pressed." Allen was able to salvage between fifty and eighty intact copies from the charred and melted remains.

IF, ON AN afternoon in late 1969, you walked into Al's Café, an unassuming neighborhood joint with understated signage at 1913 West Sixth Street in Los Angeles, a couple blocks off MacArthur Park, you would have encountered a small and fairly typical, if somewhat oddly appointed, American diner. The fare, however, was anything but familiar, featuring largely inedible conceptual menu items apparently created by a sadistic (or Postfuturist) chef preoccupied with the flavor notes of stone and

polyvinyl chloride. Depending on your budget, you might order "three rocks with crumpled paper wad" ($1.75), "simulated burned pine needles à la Johnny Cash, served with a live fern" ($3.00), or perhaps "Al's Burger," made of "Sky, Land, and Water" ($1.75). The "Blue-Plate Special," prepared by a guest chef, was an envelope containing an artist bio insert and an overcooked 45 rpm, seven-inch single, its label singed and smoke-stained, its surface melted and warped such that it was not only indigestible but also, if you took it home in a doggie bag, certainly unplayable.[14] This was Terry Allen's "Gonna California / Color Book" record, accompanied by *The Terry Allen Year Book*.

Al's Café was a temporary environmental installation and participatory performance piece by Terry's close friend Allen Ruppersberg. Terry shared Ruppersberg's devotion to diners, which appear throughout his work in all media. While Terry lived in LA, he and Al were obsessive Denny's habitués, meeting there almost daily to talk, share ideas, smoke, and drink coffee and sometimes just to silently scribble in their respective notebooks. The diner was a refuge for Terry to concentrate on his work away from the distracting noise of family and home. During one of those Denny's sessions, Terry suggested that his record would make a great menu item for *Al's Café*, "an instant collector's item." Al wholeheartedly agreed and enthusiastically accepted the scorched, foul-smelling donation. *Al's Café* would be only the first of a handful of Ruppersberg works that featured, documented, or were somehow inspired in some sidelong way by his friend Terry.

In December 1969, Terry wrote a song in tribute to his friend's breakthrough installation titled "Al's Cafe," which he planned to perform in the café, as he wrote in a songbook, "for my final song of a concert a la carte." Unfortunately, before he had the opportunity, the police shut down the café, which had become a busy hangout spot for young LA artists, for serving alcohol without a permit.[15]

RAWHIDE AND ROSES, COWBOY AND STRANGER

Ahh a cowboy is lying
Under the final sky
Yeah the cowboy is dying
Under a vinyl sky

—"Cowboy and the Stranger"

THE DIVISION OF LABOR THAT ESTABLISHED ITSELF IN THE ALLEN HOUSE-
hold, at least throughout Bukka and Bale's childhood, was traditionally
gendered and of its time, but Jo Harvey very much owned her decision to
stay home, which she still celebrates, and when challenged vigorously
defends. Back then, she "*only* ever wanted to be a mother—I hate that
women feel they have to say that word 'only,' or use that terrible phrase
'*just* a mother.' Having children is the most creative thing I've ever done."
One summer day in 1968, Terry, perhaps to distract and provoke her, or
to challenge her to follow her demonstrably rich talents as a storyteller,
invoked the terrible phrase—he suggested that being "just a mother"
might be "boring" for her. "So without thinking about it," she explains, "I
announced that I'd be going to radio school and walked out the room.
The next day, Terry hadn't forgotten. He asked, 'So are you still going to
radio school?' I said yes, and he said, 'Forget it, I just got you your own
show!'"

Rawhide and Roses originally aired Sunday mornings from 7:00 a.m.
till 10:00 a.m., from the summer of 1968 through the summer of 1970, on

KPPC-FM 106.7 (and its AM corollary), broadcast from the basement of the Pasadena Presbyterian Church.[1] It was a country music show (broadly defined) produced and largely programmed by Terry and hosted and helmed by Jo Harvey, making her, by most reckonings, the first female on-air country music radio DJ in history. "Well, it was kind of a novelty then," she demurred.

Similar in format to Bob Dylan's *Theme Time Radio Hour* forty years later, the surviving recorded shows are loosely themed: tractors, trucks, weather, water, Texas, "old and new songs" (investigating traditional material, folk songs, and covers), honky-tonks, birds, beautiful women. Jo Harvey not only announces the artists and songs but also tells discursive, infectiously charming stories about her family, Lubbock, and her life in LA.[2] Although she sketched out certain stories and segues in advance, and Terry wrote the show's introduction, musician bios, and brief sections on musical and cultural history, her seemingly improvised non sequiturs often have the power of poetry—"I *love* it when I feel like an animal," she giggles during the episode about animals. (She laughs a lot throughout the shows, charming and disarming her listeners.) In another episode, she talks about asking to buy a portrait of Huey Long off the wall of a filling station café in Louisiana, to the waitress's abject horror.

After choosing the weekly theme, the Allens would often visit the UCLA archives to research, and sometimes borrow or transfer, old recordings. They began preparing in earnest for each week's show on Friday evening or Saturday morning, and sometimes Terry, in a fit of deadline-deadeyed inspiration and frenzy, would spend all of Saturday night in the studio, sleeplessly pulling records and plotting his playlists, an experience he relished. They invited musicians to visit them at KPPC on the mornings after their Saturday-night shows, often at the Ash Grove or Troubadour, and soon labels and managers began soliciting the Allens directly, adding their names to guest lists every week and sending them piles of promo records.

One Sunday morning, they picked up Ramblin' Jack Elliott, one of Terry's musical heroes, from the home of Dan Blocker, the actor who played Hoss Cartwright on the TV show *Bonanza*, to interview him on air. Doug Kershaw and Linda Ronstadt were both guests; Jo Harvey

recalls that when Ronstadt was on the show, the two of them "just gig-gled together the whole time and didn't even play any music." Jo Harvey recorded an interview with Mother Maybelle Carter. Terry, an avowed fan of the International Submarine Band, had John Nuese on the show and interviewed his ex-bandmate Gram Parsons at the Chateau Mar-mont. *Rawhide and Roses* was allegedly the first radio show in LA to play Willie Nelson, helping break Nelson in Southern Californian mar-kets ahead of his move to Austin and his transformation from a success-ful songwriter with a rather disappointing and indistinctive recording career into the patron saint of so-called outlaw country. On one occasion Taj Mahal joined the Allens in the studio before appearing on Bernie Pearl's *Nothin' But the Blues* program, the taping of which followed theirs. Also on the Sunday schedule was *The Firesign Theatre Radio Hour*, a surrealist comedy troupe show, a precursor of *Monty Python's Flying Circus*, which sometimes featured the Holy Modal Rounders, with future playwright Sam Shepard on drums, as its house band.

The vibe at KPPC was communal and celebratory, a tight-knit com-munity of hip young people coming together to share music with the hungry listeners of Los Angeles. "The marijuana smoke was so thick," Terry recalled, "you couldn't tell if you were outside in the smog or inside in that fog." There was a DJ couple from Lake Charles, Louisiana, who cooked up big pots of jambalaya and gumbo most afternoons to share during and after their show, satisfying everyone's munchies. Sometimes the Allens invited the KPPC gang back to their house for a DJ dinner on Sunday evenings, usually spaghetti or beans with ham hocks, followed by Jo Harvey's famous peach cobbler.

That first summer of 1968, around the same time he wrote "New Delhi Freight Train," Terry penned a text called *The Jesse James Year Book*, an interpolation of spurious biography with contemporary settings and Allen's own personal history that inspired *The Terry Allen Year Book* accompanying promo copies of the "Gonna California / Color Book" 45. The project, intended as a weekly episodic segment of *Rawhide and Roses*, never got off the ground, however, mostly because Terry "couldn't write that fast." (A similar fate befell a collaboration with the Magic Theater when a broadcast of William Burroughs reading *Naked Lunch* raised the hackles of the FCC.) The first episode, the only one that

actually aired, begins with some background material: "Jesse James was born in 1953 in Arizona . . . three miles from Tempe. His father was an Indian agent for the federal government, and his mother was a Cherokee squaw educated at Vassar. The James family lived in a dugout." James then proceeds to travel to LA, and, of course, to Amarillo and Lubbock.

THE TIMING OF Jo Harvey's declaration of broadcast aspirations was fortuitous, because even before either of them had ever spoken a word or played a song on air, Terry had already independently embarked on a new and lucrative freelance career in radio promotion, an opportunity that led to *Rawhide and Roses*. Approached, likely via Nelson/Tipton connections, by the owner of The Music Hall, an influential record store on the corner of Sunset and San Vicente, kitty-corner from the Whiskey a Go Go, to help with creating local promo spots to air on KPPC, Terry enthusiastically agreed. The Music Hall hired him to write, and later to produce and record, radio advertisements for new and upcoming records as well as the occasional concert or film in which they had a promotional stake. While cutting some early ads at the studio, the station manager told him that they'd recently lost a DJ and asked if he had any interest in hosting a show, since there was an open slot. "I guess they had confidence in my ads," Terry suggests. "Or they were just stoned, like everybody else." When Jo Harvey exasperatedly disclosed her desire to go to radio school, she had been reading and hearing his Music Hall spots for a few weeks, so her proclamation didn't come out of nowhere.

Eventually, Bob Krasnow, the founder of Blue Thumb Records, recruited Terry as an in-house promo copywriter, and through Krasnow, Allen began working for Spot House, a firm that produced promos for larger labels like A&M, broadcast nationally. He graduated from copywriting and recording spots himself to producing recording sessions with voice actors like Wink Martindale in A&M's posh studios. Curiously, his pay increased inversely as his duties became fewer, until he was able to charge $100 per script or print ad copy and another $100 per recording session, eventually invoicing a Jack Schnyder at A&M for a $500 monthly retainer, more money than he and Jo Harvey had ever seen. The spots, which ranged from ten seconds to a full minute, allowed Terry to hone his on-demand writing chops with brief, rigidly formulaic texts that

deployed his outrageous wordplay for promotional ends, teaching him the potential commercial value of brevity and how to sell "highly stupid" sloganeering, ambiguously bawdy punning, and "double-entendre bull-shit" to square executives seeking validation and buy-in from the counterculture.

Over the course of the next year and a half, he wrote, and in many cases also produced, spots for a wide variety of artists and records both legendary (the Band, the Beatles, the Byrds, Johnny Cash, Aretha Franklin, the Grateful Dead, and Jimi Hendrix) and lesser-known, such as Earth Opera, the Crazy World of Arthur Brown, the Deviants, Dillard and Clark, the Silver Apples, the Delta blues artists on the Blue Thumb *Memphis Swamp Jam* compilation, and personal favorites like Love and the Velvet Underground ("probably the most dangerous group in the world," whose second album *White Light/White Heat* "makes the Marquis de Sade look like a waterhead"). His record collection and musical knowledge grew to encyclopedic dimensions, as he and Jo Harvey accumulated thousands of free albums from labels interested in their services.

One of Terry's personal favorites, a memorable spot for Captain Beefheart and His Magic Band's second album, *Strictly Personal* on Blue Thumb—the predecessor to sawtoothed, futurist-blues masterpiece *Trout Mask Replica,* an enduring inspiration to Allen—offers a prime example of what was earning him the highest piecework pay of his life so far.[3] It features Terry's goofy Seussian narration (riffing playfully on Beefheart's own illogical beat-blues lyricism) dubbed over the sound of hysterical laughter, which he elicited by pinning Jo Harvey to the ground and tickling her relentlessly.[4]

As in all of Allen's activities during this time, there exists ample evidence of him working out ideas in language and lyrics even in the midst of these rote, overtly commercial gestures. Just because it was a routine, tossed-off work-for-hire gig between drawing exhibitions, recording demos, and *Rawhide and Roses* sessions did not mean it had to be a waste of time. On August 28, 1969, in copy advertising the film *Midnight Cowboy,* he conjured a line that transposes Texas geography into gerund patois: "Honky Tonkin' the High Country and Pan Handlin' the Blues." A year later, he would recycle and reshape the second clause into a key line in the second verse of arguably his most famous song, "Amarillo

Highway." On December 6, in print ad copy about the Flying Burrito Brothers, a koan that would become critical to the enigma of *JUAREZ* (when reversed and trimmed) first manifested in written form, as if from thin air: "It'll Make Today's Tamale Taste Like Tomorrow's Rainbow."

That month Terry would write a few more spots—for records including Fairport Convention's *Unhalfbricking* and Waylon Jennings's *Don't Think Twice*—before he and Jo Harvey took an overdue holiday together, a road trip to New Orleans, their go-to budget vacation destination, to celebrate the end of the year and their new life as up-and-coming celebrity underground DJs (and simultaneously to avoid a forecast earthquake).[5] They dropped off Bukka and Bale with the Koontzes in Lubbock on the way. When they returned, the promo job had completely dried up, and the Allens were back to square one. Their radio show continued for several more months, but behind the frosted glass of those A&M windows, the music industry had shifted. The labels decided they did not need to pay outside producers for promo spots when stations were happy to plug their releases for no charge. "The stations blew us out of the water by doing it for free," Terry explained.

Rawhide and Roses had lasting repercussions for both Allens. Their entrance into radio came as FM broadcast band stations were becoming increasingly popular and culturally relevant. Though still dwarfed by AM corporate power and listenership, FM stations, through a proliferation of AOR ("album-oriented rock") and free-form programming in stereo, catered to youth and countercultural audiences. Those new, vocal audiences took notice of *Rawhide and Roses* and especially its vivacious young host, whose voice was so unlike others heard on radio, and in particular country radio. Jo Harvey struck the perfect balance among the respectable gentility of a Texan ingénue, a countercultural edge, and feral, sexy wildness. The show became an underground phenomenon in LA, leading to some interesting invitations, Jo Harvey remembers: "At that point, because of the radio show, I was asked to do a film. It was called *The Last Movie*, with Dennis Hopper and Kris Kristofferson. They went to Peru and were wild and crazy—this was after *Easy Rider*—and we all thought this movie was going to be the best movie that ever came down the pike. I had these little kids, so Terry said, 'I'll keep the kids, and you go for two months, and it will be okay.' I knew it wouldn't be okay, so I didn't go." Hopper and his production team

approached Jo Harvey because of her DJ persona; she and Jack Nicholson, who appeared alongside Hopper in his film *Easy Rider*, had recently met and chatted at a party. But they would also have been familiar with Terry's artwork, at least in passing, given Hopper's engagement in the LA art world, including the La Cienega galleries and the Pasadena Art Museum, where his show preceded Terry's by a few months. Jo Harvey did not regret her decision to pass on *The Last Movie*, though as a result, she would not appear in her first feature film for another fifteen years.[6]

DURING THEIR FINAL years in LA, at the height of their minor fame as KPPC DJs, Terry and Jo Harvey found themselves often surrounded by strangers. They were seemingly on every guest list in LA and could attend nearly any concert or film in town for free but could rarely afford a babysitter, so they often spent nights apart from each other, exacerbating the turbulence and jealousy that roiled beneath their marriage even at the best of times. Few among their new social circle were married, and fewer had kids, so they were constantly explaining themselves, caught in a push and pull between domestic and familial obligations and peer pressure to party. They found themselves swept up in the tornado of a new "fast life," which, while exciting and glamorous, obscured themselves from each other and from themselves. They felt their identities slipping. On Saturdays after the show, their home, according to Jo Harvey, "would fill up with hippies and entertainers." Scantily clad young women Jo Harvey had never met would leer at Terry or, much to her horror, offer to bathe the kids while she prepared her peach cobbler. "Everybody was hitting on Terry and on me," Jo Harvey declares. "We weren't in a happy place dealing with all that." The heightened sexuality of the environment infected Jo Harvey's style too: "I went from wearing short gloves and a girdle to false eyelashes on the bottom, a headband with Coke bottle lids on it, blouse unbuttoned to the waist, and a miniskirt with my ass hanging out," she sighed wistfully. "I went nuts."

Bedrock vestiges of the socially conservative Lubbock girl occasionally revealed themselves through the accreted sediment of hippie adornment (she remained a clotheshorse, so her wardrobe, split between her older and newer styles, became schizophrenic). When Andy Warhol's retrospective opened at the Norton Simon Museum (the rebranded Pasadena Art Museum) in the spring of 1970, of course the Allens were in

attendance. Terry remembers that Warhol fussed over Jo Harvey in her Lubbock formal finery, the polar opposite of grayscale Factory fashions: "He asked her to be in a movie, gave her his address and number. She was thrilled. Afterwards she would tell all our friends about it, and they would say, 'Oh, Jo Harvey . . .' She'd never seen a Warhol movie. So we went to a Friday-night screening of his film *Blowjob* [1964], and she decided real quick that she was not going to be in any Warhol films. She's got some letters from him." The Allens remained close with the Chouinard crew of Ruppersberg, Cooper, and the Beaudry Street milieu, but they began spending more and more time with music industry insiders and Hollywood actors. New friends rolled up to their modest, shabby shotgun house in brand-new Mercedes-Benzes while Bukka and Bale circled on Goodwill tricycles.

To escape the cramped quarters and bustle of their own home, they began retreating to the home of their welcoming and generous new friend Peter Duel, who lived up on Glen Green Terrace in the Hollywood Hills. A handsome actor with chiseled features who had gotten his start with a recurring role on the TV series *Gidget*, Duel rose to stardom through his starring role on the sitcom *Love on a Rooftop*.[7] But the role for which he is primarily remembered was the notorious outlaw Hannibal Heyes in the Western television series *Alias Smith and Jones*.[8] The home of this Hollywood cowboy provided a refuge and a sense of insulation from the pressures and the less savory strangers invading the Allens' lives. Despite Peter's own open-door policy, his house was larger and more comfortably furnished, and his numerous hangers-on and hasslers never demanded anything from the Allens, who could help fend them off when necessary.

Duel, in turn, appreciated the Allens' creativity and honesty, their lack of regard for his fame—they met before *Alias Smith and Jones*, before he was a household name—and, perhaps, the helpful character research their Texan accents and backgrounds provided for his signature role (he himself had grown up in Rochester, New York). Unlike others in their scene, Peter did not merely tolerate but loved kids and enjoyed playing with the boys; Bukka still harbors dim but warm memories of flying a kite with Peter in the park. Duel regularly asked the Allens to housesit when he was away filming on location, and they were only too happy to inhabit temporarily his much more generous accommodations.

Jo Harvey also befriended Duel's girlfriend at the time, Kim Darby, before her success with *True Grit* (1969), the Charles Portis adaptation in which she starred opposite John Wayne. Drawn to the stories they told about acting—and able to see beyond Peter's constant anguish about the quality of the roles he was offered—Jo Harvey decided she wanted to become an actor herself. (She also began painting and writing poetry during this period.) Peter introduced her to his agent, convincing him to take her on.

"We became very close friends," Terry said quietly of Peter. "He's kind of a typical Hollywood story: he wasn't happy being on a TV show and wanted to be a serious movie actor. He was trapped in his own fame in a way—couldn't go anywhere without being dogged by people. But he played it too; it was that damned-if-you-do, damned-if-you-don't kind of deal." Jo Harvey remembered Peter walking into their living room and breaking into tears of frustration and anxiety at his inability to avoid the claustrophobic throngs of fans and press. Duel attracted stalkers, who followed him everywhere, accosting him in restaurant restrooms and mobbing him at the horse track. The Allens were staying at his guesthouse when his contract for *Alias Smith and Jones* was renewed, and they watched him weep over the news. He felt like a prisoner in the role, an imposter who would never have an opportunity to prove his true talent in films and theater.

The mythology of the reluctant, depressive Western actor Duel was a probable inspiration for Leonardo DiCaprio's character Rick Dalton in Quentin Tarantino's 2019 film *Once Upon a Time in Hollywood*.[9] Tarantino's film climaxes in a flame-throwing finale involving the Duelesque character and the Manson gang, a lurid cinematic exaggeration of a very palpable fear that Terry and Jo Harvey themselves experienced firsthand.

ONE NIGHT IN early 1969, after a rare evening out at the movies together, having managed to secure a babysitter, the Allens returned home to find all the lights on and the stereo blaring. Alarmed, since the boys should have been asleep already, they walked through the place to the back room, Terry's studio, where they found a young woman sitting barefoot on the floor, playing their records, a pair of expensive-looking cowboy boots beside her. Evasive and dead-eyed, she would not answer their questions—they suspected she was high—except to clarify that the

boots were not hers. They asked her to leave and walked her to the door, bewildered. She left without complaint or explanation, walking out onto the street barefoot, leaving behind the boots.

She had apparently been following Duel and staked out the Allens' house as a location he regularly visited, identifying Terry and Jo Harvey as trusted friends in his inner circle. When they left for the evening, she convinced the babysitter that she was a close friend of the family and would take over minding Bukka and Bale. She sat down and waited for Peter to appear, which of course he never did. Later, the Allens recognized her as Susan Atkins, aka Sexy Sadie of the Manson Family, who participated in eight of the murders.

On another occasion, in the spring of 1969, while they were staying in Peter's guesthouse on the hill behind his house, Jo Harvey entered the main house to retrieve a poetry manuscript that she had left there for Peter to read. Once again, she encountered a young woman sitting on the couch alone, in a dirty T-shirt and ragged cutoff jean shorts. At Peter's that was not as unusual; he often left keys for friends while traveling, and he had a wide circle of acquaintances and employees. Jo Harvey—who would talk to anyone—engaged her in conversation, asking how she knew Peter and how long she'd been staying at his house. Her responses were vague, squirrelly. She changed the subject.

"Well, I'm not staying long, anyway. I'm about to leave, actually. I'm hitchhiking to New Mexico."

"Alone? Oh, don't do that, honey," Jo Harvey protested. "That's too dangerous. Can't you ask a friend to go with you?"

"*I'm* the one *they* need to worry about," she replied with a vacant, menacing grin, pulling a knife out of a scabbard tucked into the waistband of her shorts. She stared at the blade for a moment, weighing the weapon gingerly in her palm, then slowly walked out the front door, knife still in hand. Jo Harvey closed her mouth, breathing heavily, and ran back to the guesthouse to tell Terry what happened. Later that summer, following the Manson murders, they were able to identify the intruder as Catherine Share, aka Gypsy of the Family, who was eventually convicted of witness intimidation. The run-in spooked Jo Harvey enough to avoid being alone at any of her famous friends' homes ever again. Once, while staying at Darby's house shortly after the murders, in the summer of 1969, her mind began racing through the connections the

Family had made between her, Peter, and acquaintances in the music scene and at the *Los Angeles Free Press*—and she realized that Kim might be on their list too. She leapt out of a bubble bath, hastily dressed, and rushed to her car to race home.

WHILE TERRY WAS consoling disconsolate screen cowboys and avoiding serial-killing strangers, he was also working on his new body of work, *Cowboy and the Stranger*—the first piece of which, completed in October 1968, *Prologue . . . Cowboy and the Stranger*, Peter Duel purchased (along with *Harmony Sovereign*, from 1970).

Allen began conceptualizing the structure of the piece and making preliminary drawings in August 1968. The twenty other works in the series he completed in 1969, with the exception of *Tear*, the lone straggler in 1970. The untitled biblical series may have been, in Allen's estimation, his first "real" body of work—like "Red Bird" was his first "real" song—but it was a dead end, a cul de sac on which he did not bother building, departing from the nominal subject matter before he even finished the group of drawings. In contrast, *Cowboy and the Stranger* was his first body of work to open a path into a set of working methods, media, materials, and coherent conceptual concerns that would sustain his art for years. (It is also the first body of work for which he kept a surviving dedicated sketchbook, instituting his lifetime habit of regular journaling, which continued unabated after this point with few and rare lacunae.) Simultaneous with Allen's liberatory embrace of the erotic in his art was an embrace of his West Texan roots and the deconstruction of tongue-in-cheek Texan tropes; together the two changes catalyzed a transformation of his art, foliating a heraldic system of symbols through his entire career.

Threaded through and bound together with a skeletal but sufficient narrative based on his song "Cowboy and the Stranger," the series incorporated, along with the mixed-media drawings with collage and sculptural elements (decals, photographs, and small found objects), recordings of his original songs, texts, and even an abortive idea for a theatrical production involving the "characters" mentioned in the drawings: Ed, Larry, Waco, Winnie, Roses, and Mo. It was his first work of conceptual art and his first gesture toward Gesamtkunstwerk—a total artwork that integrates multiple forms. The drawings are all uniform in size,

twenty-nine inches high by twenty-three inches wide, and rendered with a labor-intensive, media-specific process that he developed for the project:

> I started working with oil pastels, Dr. Ph. Martin's dyes, and color pencil. . . . Martin's was a very intense dye, with especially bright reds and deep purples—highly concentrated, but they faded very fast. So I would silhouette an area I wanted to work in, and then I'd go in on top of it with color pencil and pastels, draw into the color field. . . . When I sprayed it, the dyes would come up, it would shift and become a very intense beautiful color. Most of *JUAREZ* is also done with that method.

COWBOY AND THE STRANGER opened on February 4, 1970, at Michael Walls's new three-thousand-square-foot gallery space at 900 North Point Street at Ghirardelli Square in San Francisco, just a block from the waterfront and across the Bay from Alcatraz Island.

The drawings were framed in clear Plexiglas boxes, two of which, *The Arizonia Spiritual* and *Unveiling the New Dallas Comanche*, sprouted additional Plexiglas protuberances from the surfaces of the frame—echoing the biomorphic excrescences and tumescences in the imagery of the drawings themselves—that contained totemic objects related to the narrative, such as dirt and feathers. Inspired by, and existing in a clear lineage with Dadaist gestures such as Kurt Schwitters's *merz* works and Duchamp's *Large Glass*, while also resembling Catholic reliquaries, these "extension boxes" later became a central characteristic of the *JUAREZ* works as well, projecting the story away from the wall and into the room in sculptural relief, as if offering museological, forensic, or sacerdotal "evidence" of the story, and its ambiguous crime, in pristine vitrines.

That crime, or transgression, at the heart of the minimalist *Cowboy and the Stranger* narrative—the Bible-thumping stranger's motiveless theft of the expiring cowboy's horse, his callous refusal of mercy for the cowboy's plight—likewise presages the collision between Sailor and Alice and Jabo and Chic that defines *JUAREZ*. Both stories convey the approach, convergence, and departure, in death, between two characters (or sets of characters). Two stories, or vectors of mythic potential,

pass through each other like clouds, eliding and moving on, changed, toward unknown destinations. As in *JUAREZ*, interior monologue renders dialogue superfluous. There are no words spoken between cowboy and stranger; only the horse is exchanged, and the cowboy carefully notes his desert surroundings as he dies. The characters, like the *JUAREZ* quartet, are conceptual devices, "climates" or "atmospheres" in counterpoint, more generic ghosts—relics of genre, artifacts of action, vapor trails of pain—than actual human people with distinct identities and intentions.

The images in these twenty-one works deemphasize human figures, favoring a panoply of symbols and iconography related to the American Western genre of music, fiction, and film: cowboy hats, pearl-button shirts, chaps, boots, lassoes, pistols, handkerchiefs, horses, steer skulls, cacti, tornadoes, and even, humorously, tacos, chili dogs, and beans— all in various states of dissolution, molting, or permutative mutation, bearing the sutures of recombinative graft. One drawing is titled *Lash Lorraine*, in honor of Western film star Lash LaRue. *Boot* depicts two cowboy boots, each toe tipped with lips, with a bare-assed cowboy inside one of the shafts; it is captioned "To: Ramblin Jack . . . From 10:00 til 1:00 (Girltalk at the Paradise Lounge)."

Somatic anxiety, the threat of violent, vaguely erotic disintegration, reigns. Body parts, such as hovering nipples or nodules, presented as surgical specimens, or disembodied hands with feathered, pointing fingers, outnumber intact bodies. As in *JUAREZ*, when a full human figure is glimpsed, we never see its face. They're drawn from behind, obscured by a blowing bandana or bulbous, polymeliac cacti. In *Prologue*, the cowboy's head has devolved into a jumbo set of grotesque, gummy wind-up teeth chomping into a deflating phallic frankfurter. What remains are not names or faces but the detritus of the aftermath, the story's searing but fading afterimage, the perverted evidence and artifacts of the experience—the mottled memory in a perpetual state of becoming, feebly flickering into focus, transubstantiating faintly into calloused flesh.

In keeping with the violent Western vignette the song and the drawings dramatize, the drawings depart in important ways from the Bible studies, retaining their humor but incorporating even stagier framing apparatuses that foreground their artificiality. Scaffolding, latticework,

curtains, rigging, and containers abound, as do diagrammatic captions and matrices resembling musical staff lines or comic-book frames, all of which serve to organize the images spatially within theatrical proscenia or musical, analytical, and pseudo-scientific schema. The effect is to remove the pictorial content from the strictly representational, as if setting it in quotation marks, captioning the evisceration of livestock with a clinical dissection of nostalgic Western mythologies.

Cowboy and the Stranger represented Allen's first resolute, and earliest publicly exhibited, attempt to combine music and image in nonillustrative counterpoint. ("It's the way I work," Allen sighed. "I end up making a drawing or song, and the next thing I know I'm into this hell-factory of making stuff from every angle.") Three drawings included tape reels affixed with glue to the back of the Plexi frames, containing recordings of songs related to the visuals.[10] Terry called them "paper listening movies." At the opening, Allen provided matched musical accompaniment for various drawings. He wheeled a piano around on a rolling platform (a miniature stage echoing the stages in the drawings) to various pieces to perform different songs in "conversation" with them.

Even at this early date, the intention was not for the songs to explicate the images or vice versa, but for the two simultaneous statements to catch fire by friction or sympathetic magic: "I never thought of them as in any way illustrative of each other. It's like they were two parts of the same idea, but at different sides of the room, and you were in the middle, putting it all together—or not." In retrospect, he came to view this element of *Cowboy and the Stranger*'s primitive interdisciplinarity as an unsuccessful, if necessary, experiment.

The cowboy theme permeated the promotional materials and the opening. The exhibition announcements featured the photo of Allen as a kid in his full cowboy outfit, ready for his wrestling ring cameo in Sled Allen's Arena, printed in monochrome sepia ink beneath rope script lettering advertising *The Terry Allen Cowboy Show*. With more time for advance planning and promotion, the show was better attended, and sold marginally more, than Terry's previous exhibition with Walls. In slides of the opening, attended by an incongruous mix of men in dark suits and hippies playing their parts in cowboy hats and floral-print dresses, Jo Harvey sits beside her husband on the roving piano bench, smiling broadly, her hair down. Terry, wild-haired, wears a vest under a

generously fringed suede jacket, leaning into the Western theme. A tall potted cactus stands in the middle of the room, with a crushed Coors can in its sandy soil.

The exhibition featured not only the *Cowboy and the Stranger* series but also a few other stray works, including an early sculpture, involving a transistor radio in a guitar case on the floor, titled *Lucky's Last Song*, and *The Juarez Device*, finished on August 17, 1969, a refinement and enlargement of *Apparatus for Catching and Suspending Hogs* and an attempt to apply the *Cowboy and the Stranger* materials methodology to a larger-scale drawing.[11] Perhaps an ineffectual hog-killing machine felt like an apt metaphor for the cycle of violence on the Mexico-US border, or the abattoir of the Vietnam War. Perhaps it was the formal beauty of the technical illustrations and their balletic processes that appealed to him. Perhaps it was the emotionally detached diagrammatic captions and Giedion's drily macabre humor in describing a hog corpse's mutiny against the machine, its resistance to technology. Though Terry had no idea at the time, recognizing its enigmatic presence but uncertain what it augured, *The Juarez Device* was the first visual work of the *JUAREZ* series.

In the summer 1970 issue of *Artforum*, the critic Jerome Tarshis dug into the Michael Walls show with a mix of complimentary acuity and sarcastic bemusement. He noticed the theatricality and artifice of the pictorial space of the drawings while snidely observing how Terry's aspirations as a songwriter and his Texan identity seemed alien in the New York art-world context, sounding like the coastally prejudiced critics Allen lampooned in "Truckload of Art."[12] It was only the first of innumerable reviews and commentaries apparently bewildered by Allen's interdisciplinarity. When the show ended on February 28, after only three weeks, Allen felt deflated and exhausted, which would become a familiar sensation for him after projects ended. He was pleased, with some reservations, at the response to the show but somewhat self-conscious at how gallery viewers and press had pigeonholed him as a Texan artist engaged with regional themes, even if subversively or transgressively so. As he wrote in a sketchbook: "Now everybody thinks I'm a cowboy. Fuck that. I'm a dog."

He was already casting past the breakers for the next story to reel in. On the very same page as the aforementioned canine reflection is a

drawing of a mountain range that alternates peaks and pillows beside the annotation "the Montezuma denial." It is the first instance of a recurring image in *JUAREZ*, the pillow in the mountains (reproduced in one of the lithographs boxed with the original limited-edition LP of the album), accompanied by the Aztec emperor who also recurs in the series. A week later Terry made preliminary notes for a drawing called *Mastoid Neon*, a precursor work to *YOUTH IN ASIA* that he would not actualize for several years.

CHAPTER 21

AMARILLO HIGHWAY TO CORTEZ SAIL

I ain't got no blood veins
I just got them four lanes
Of hard . . . Amarillo Highway

— "Amarillo Highway (for Dave Hickey)"

ALTHOUGH TERRY STILL ANTICIPATED AND RELISHED THE VISCERAL RUSH he experienced every time he ascended the caprock of the Llano Estacado, passing from eastern New Mexico into West Texas, accelerating into the void of the High Plains—a potent, head-cleaning cocktail of lucidity, nostalgia, and apprehension at returning to his home terrain— the eighteen-hour drive between Los Angeles and Lubbock had become mind-numbingly familiar over the course of nine years of regular visits home. But this trip, in August 1970, was different. They were leaving Los Angeles for good this time, and Terry was despondent and indignant.

Squinting into the rising sun and simmering with bitterness, he drove a U-Haul truck packed tight with all their worldly possessions, which didn't amount to much. This truckload of art did not even contain a piano. In a fit of performative rage, Terry had taken an axe (borrowed from Al Ruppersberg) to his piano, a gift from Pauline, determined, like a jealous lover, that if he couldn't have it, then no one would. Al, who was helping carry boxes, as were Peter Duel and his girlfriend Dianne Ray, watched in some alarm at the violence with which his friend attacked the instrument he loved and at which he had spent so many nights composing, and which now splintered, clanged, and vibrated beneath swings of the hacking blade. "It frightened Bukka and Bale to death," Al

remarked. Beside the Captain Beefheart *Safe as Milk* sticker, Terry had pinned a small photo of himself as a child onto the wood on the left-hand side of the instrument, a target for his first strike. As the soundboard collapsed, a fugitive Mickey Mouse button rolled into a dusty corner, where it languished. Gary Krueger, who had photographed Terry playing the piano, documented the wreckage the next morning, with Terry standing beside the butchery, brandishing his borrowed ax maniacally.

After replacing a broken axle on their VW bus near Needles—Terry so agitated that "I thought [he] was going to impale himself on a cactus," Jo Harvey giggled—they powered through high winds, rain, and lightning to Albuquerque, where they arrived after dark. (The lyrics of "Cortez Sail" describing "leavin LA on a cloudy day" and lightning "tearing the clouds" across a bruised sky are autobiographical.) The unexpectedly crowded parking lot of a Holiday Inn was strung with festive lines of bunting like a used-car lot. The desk clerk informed Terry that the motel was unusually busy because it was hosting a morticians' convention, but they were in luck—there was one room remaining. Terry backed up the U-Haul from the check-in lane and tore down all the streamers in a wet tangle of flags. In the lobby their dog Sunshine promptly took a steaming shit on the carpet.[1] After a sleepless night—Jo Harvey was spooked by the presence of all the undertakers, wondering if they'd brought their work with them—they finally rolled into Lubbock County the next afternoon, rattled and grumpy. On the outskirts of town, Terry pulled off the side of the road and paced.

"What's wrong, Terry?" asked Jo Harvey. "Oh, God, is there something wrong with the truck? We're so close!"

He stared at her glassily, breathing heavily, and spoke quietly and measuredly: "I can't do it. I can't go back there. I can't live there again."

Jo Harvey hugged him and convinced him to get back behind the wheel. Her parents had generously already rented a house for them at 3501 Thirty-Fifth Street, which they now saw was a typically low-lying pile of blandly ranchy, midcentury bricks with few distinguishing characteristics. When they pulled up, the Koontzes were standing in the driveway waiting to meet them and help unload. When they tumbled out, Jo Harvey's uncle, hands on hips, remarked loudly to Terry, "Well, now you can actually go to work!" Terry gritted his teeth and blinked.

As it turned out, the uncle was right; as much as Terry dreaded their return and despised their time there—"Lubbock seemed like a horrendous end of the world to me then"—in the absence of all distractions, and fueled by spite and ambition to leave as soon as possible, the six months they stayed turned out to be a highly productive and pivotal time for his art and music.

BY THE EARLY summer of 1970, Jo Harvey was at her wit's end. She was fed up with the cycle of jealousy between her and Terry, the ubiquitous drugs and casual sex that surrounded them. She feared, and foresaw, a spiraling descent into a lifestyle that felt incompatible with the health and security of her young family and, of which, if she was honest with herself, she had to admit she did not truly approve. When she looked in the mirror, she didn't like what she saw anymore. Unlike insomniac, workaholic Terry, Jo Harvey has always been a heroic sleeper who works in bursts—she claims to have, on at least two occasions, hibernated for three or more days straight—but no amount of makeup could conceal the dark circles under her eyes. Terry felt it too, how fatigued and stretched-thin they were, pulled in every direction but toward each other. But he was more easily enchanted, and for longer, by the milieu into which they'd wandered and the access they'd been given, by virtue of their youth, beauty, ease making friends, and talent, to the LA demimonde of artists, movie stars, and musicians. His career benefited from that propinquity, whereas Jo Harvey had yet to embark on an enduring vocation beyond her family, her primary concern. The cultish, operatic violence of the Manson slayings, and their brushes with two Family members, unsettled them. The confounded anticounterculture media frenzy in the murderous aftermath cast a pall on the city and their community, and the Allens felt they were in danger of succumbing, suffocating. They no longer felt entirely safe at their own house, or at the home of Peter Duel, whose depression was steadily deepening.

The final straw was the smog, a more visible pall on the city. Air pollution had become an omnipresent concern and a serious health hazard in hazy Los Angeles. Jo Harvey began experiencing respiratory problems, falling prey to fits of nausea and vomiting; she would suddenly retreat to a friend's bathroom or pull over to the side of the road on a drive across town. One Sunday morning over breakfast, the Allens read a study published in

the *Los Angeles Times* predicting that young children who lived in LA consistently for eight years bore an exponentially higher risk of developing asthma and emphysema. Their neighbors on Gardner Street had two young boys a couple of years older than Bukka and Bale who were plagued by pneumonia, their little lungs poisoned and shriveled by the noxious air.

Jo Harvey began weighing their options. She drove Terry and the kids out to a brand-new tract home development in Simi Valley. "A neighbor asked me what I wanted from life," she remembered. "I said, 'I want Little League ball games,' and it was then that I realized I better get out of there." There were no Little League players or parents among their crowd, but she knew where there were plenty of both. One Sunday morning in June 1970, she confronted Terry with an ultimatum: They could not and would not stay in LA. They would leave in two weeks, and Lubbock was the only logical landing pad, at least in the short term.

Terry, partially out of legitimate resentment and concern about his art career, which finally seemed to be gaining momentum, and partially out of inertia and his impulse to play devil's advocate against any new plan Jo Harvey hatched, refused. He railed against leaving LA, and Lubbock was the last place in the world he would go—even remotely entertaining the prospect felt like a capitulation, a cowardly rout and an admission of failure.

But realizing that Jo Harvey would leave with Bukka and Bale, with or without him, he acceded. He knew, deep down, that she was right. He was only able, after months, slowly to shed his veil of stubborn reluctance, and in retrospect he grudgingly grew to appreciate her unilateral decision to force his hand: "We were just really burnt out. It would have wreaked havoc on our family if we'd stayed there."

THE ALLENS ARRIVED in the immediate wake of the multiple-vortex Lubbock Tornado of May 11, the most destructive tornado in Texas history, which killed twenty-six people and caused approximately $150 million in damage. The devastation was, justifiably, all anyone could talk about, and Terry carefully cataloged the outrageous accounts and legends of casualties, true and folkloric alike—including a holocaust of ballistic prairie dogs—that people recounted to include later in song and story.[2] Two days after the tornado, in nearby Amarillo, Pauline was arrested and placed on probation for drunk driving.

Ironically, since Allen had no reliable income sources or financial prospects and felt crippled by apathy, regret, and debt, his new lifestyle in conservative, supposedly wholesome Lubbock, surrounded by in-laws, regressed into something at least superficially more degenerate than it had been in Los Angeles, that infamous den of iniquity. They survived on their slim savings and the meager support they were periodically, reluctantly, compelled to accept from family. Since Terry was unwilling to concede to any comfort that might threaten permanent residence, and unable anyway to afford any furnishings that hadn't arrived with them in the U-Haul, their rental house, bigger than any space they'd occupied in LA, contained very little furniture—very little, in fact, of anything. They consolidated everything of value—some choice pieces of art by Terry, Jo Harvey, and other friends; posters; records; and books—in one room, placing pads on the floor and hanging Jo Harvey's scarves around like pennants. "We smoked dope in there and listened to music," Terry recollected unfondly. Some rooms remained completely empty. Terry and the boys played a frantic, lawless variety of indoor soccer-cum-squash in the barren living room, streaking the walls with skidmarks. Once, while Jo Harvey was in the bathtub, Sunshine began agitatedly scratching and barking at the bathroom door. Exasperated, she grabbed a towel and opened the door to discover that Bale had parked his toy steam shovel on the wood-burning stove, setting the room ablaze with a spray of molten plastic.[3] In the den, the only object other than a sad, sunken couch was a sculpture by a friend from Chouinard: a bright orange propane tank sporting welded steel appendages and covered in gnarly, matted junkshop furs. A local mother forbade her children from coming over to play with Bukka and Bale after one of her kids dutifully reported to her that the Allen home contained an orange bomb wrapped in human flesh.

Every day, while Jo Harvey wrangled the kids, frequently depositing them at her parents' place, Terry, a Lubbock Bartleby, morosely partook in a daily ritual of sloth and existential resistance. In the morning hours, he sat on their lone couch, sullen and silent, with a notebook on his lap, chainsmoking, and watched *The Newlywed Game*, *Let's Make a Deal*, and *The Dating Game*, which he dubbed the Holy Trinity, or the American Trilogy: "Jo Harvey's mother thought this was pure lowlife behavior, which I suppose it was. It proved to her everything she thought all along

about me." At noon, he would drive out to the provisional and charmless studio he'd rented just northeast of town at 806 East Idalou Road, a decrepit cinderblock garage between a gun shop and a café. The neighborhood, even now, is a wasteland of derelict buildings, empty lots, and general desolation, the ragged fringe of Lubbock's grid, on the edge of Queen City, which traditionally housed Lubbock's Black community.

Every day Terry would eat lunch, cheap and homely but "fantastic downhome cooking, fried chicken and mashed potatoes and gravy" at the diminutive, rundown café, owned by an older woman named Ms. Vera Hall. He never saw anyone else in there and suspected he may have been Ms. Hall's sole customer. The proprietor of the gun shop was another story, a surly crank from whom Terry kept a cautious distance. The frieze of his firearms business was emblazoned with a hand-painted sign warning that "THIS BUSINESS IS PROTECTED BY SNAKES," a threat that was, incredibly, true. Before locking up and leaving each night, the owner, like some Harry Crews character, would reach into a tangle of rattlesnakes he kept in a terrarium, pulling them out one by one to fondle them and release them gently onto the floor.[4] "Sometimes," Terry shivered, "he would forget to gather them up and put them back again in the morning, so it was pretty hairy." The crumbling cinderblock walls of his studio were riddled with holes, and Terry lived in fear of a venomous visitor slithering in.

BASED ON THE promise of his Michael Walls and Pasadena Museum shows, Riko Mizuno of Mizuno Gallery in Los Angeles had already offered him another solo exhibition in November 1971, so he was working toward a deadline and what he hoped would represent a triumphant, if temporary, return from his exile in the wilderness. Unmoored in his hated hometown and desperate to make use of his time, Terry managed to begin and complete several key works. The return to Lubbock signified a retreat for him, a defeat at worst or a depressing rearguard action at best. He intended to make it count.

An admitted workaholic with a rigidly disciplined schedule, he carried his obsessive studio habits with him to Idalou Road. As a teenager in Lubbock, he had often held two jobs and sometimes worked (or wandered) all but three hours a day; exhaustion came to function as a heady fuel for him. In California, he had barricaded himself in his studio all

night, every night, barely sleeping except for periodic thirty-minute cat-naps.[5] Paraphrasing Flannery O'Connor's comments on her writing practice, he explained, "when it happens, I want to be there—so I make myself go to the studio every day," outlasting bouts of boredom or unproductivity with stamina and sheer tenacity: "I've never victimized myself with blocks. . . . There are a lot of doors into making things, when it's the only thing you care about, other than family. It's not a career; it's a way you choose to live. Your time shifts to that."

True to its noir nature, *JUAREZ* was born in that dilapidated cinder-block room, while rattlesnakes hissed behind tumbledown walls. In the Idalou Road studio, all within the span of a few months toward the end of their stay, once he'd built up sufficient steam and anxiety, Terry revisited his drawing *Aztec Vendetta*, which he had aborted on Gardner Street in November 1969, and completed *Border Vows* (on October 30, 1970) as well as two pairs of linked drawings and songs, *The Cortez Sail*/"Cortez Sail" and *Dogwood*/"Dogwood"—the two drawings finished on November 17 and December 8, 1970, respectively—among the most symbolically fecund of the original *JUAREZ* series and among the most enduring and curiously constructed of all Allen's songs. The intricate, iterative process he had developed for making these new drawings was so tedious that he had to take regular breaks to stretch his hands and rest his eyes. The old upright piano the Koontzes had bought and helped him install in the studio presented the obvious opportunity to do so. "I've always thought the physical action of drawing and playing piano are related," he has reflected. If Allen's studied simultaneity of media can be said to have begun anywhere, at least as far as regular habit and rigorous practice, it was in Lubbock in August 1970, in the concurrent creation of these two pairs of drawings and songs.

The drawings grew songs that birthed the story's elemental personages, solidifying the *California Section* of the tripartite geographical structure of *JUAREZ* (after which this book is structured). Jabo, Chic Blundie, Spanish Alice, and Sailor were conjured as smoke, sparked by memory, and transfigured in the forge of imagination. However, the quartet is not comprised of actual human characters, as Allen has long insisted, but rather faceless archetypes or disincarnate energies in motion: "I never thought of the characters in *JUAREZ* as actual flesh-and-blood people, as much as I thought of them as climates, emotional

214

OF ART

climates or atmospheres in a state of dispossession, always in motion. They were constantly shape-shifting and changing and colliding with one another, moving through these geographical focal points."

These four "climates" would consume Allen's art and music in near totality for more than five years, until the end of 1975, when he exhibited all three completed, and previously separately shown, sequential parts— the *California Section*, the *Cortez Section*, and the *Juarez Section*— together as the *JUAREZ Series* at the Contemporary Arts Museum Houston and pressed the first editions of the *Juarez* album. But unlike his other bodies of work, which effectively ended after the circle-closing and summing-up of a retrospective exhibition, *JUAREZ* uncannily persisted. Allen has observed that every few years "it rears up," demanding revisitation, reinterpretation, and expansion. For five and a half decades, it has served as the elusive, enigmatic axis mundi of his art. Never discrete or static, its ceaseless undertow continually accretes a growing constellation of new meanings, mutations, and manifestations, defying linearity and finality. As such, *JUAREZ* has provided the indelible blueprint for all Allen's Gesamtkunstwerk strategies: "It became the underpinnings for the way I've worked since then—using language, using songs, using images, in whatever direction they have to go."

The mysterious, self-generative genesis of *JUAREZ*, much like the purported "simple story" of *JUAREZ* itself—the dramatic personae and narrative kernel of which amount to fewer than two hundred words— emerged from a mysterious fog of what Allen calls "floating facts" and circumstances: "The whole thing came in a very mysterious fashion to me, out of nowhere, and I think I've always grappled with it." The jangling nerves, stupefying boredom, and sheer mortification of being back in Lubbock triggered the fantasies—of violence, of escape, of Mexico— he'd nurtured there as a teenager. There was, of course, precedent in Allen's personal life for the ideas and images that presented themselves— the green Buick, the nicknames Jabo and Chic—as well as the themes of compulsive driving, bilious sex and violence, and bodily transmogrification that already permeated his work. When pressed, "I can go back and nitpick through my memories on where some of those images came from," Allen admitted. "Sailor was obvious, and the whole tattoo thing; my whole mother's side of the family are navy people. My grandfather

used to be a cobbler in Cortez, Colorado, and I spent a few summers helping him there. I remember the *feel* of that place."

In a sense, with these new songs and drawings, and the story evinced through them, Allen was finally writing that letter to the real Jabo, Alton Black, the one he had addressed and abandoned back in 1961, right before he left Lubbock. A line the witchy rock-writer Chic sings in "Writing on Rocks across the USA" resonates as an apt description of its composer's defensive position in wind-abraded Lubbock: "I scribbled down some of the mysteries / And I stopped that howling wind."

During his six months in Lubbock, Terry had only a dim and distant sense of what he was creating. He was operating on instinct, but he was also following predetermined structures, modalities, and goals. The first, pragmatic, impulse was formal, an experiment in applying the distinctive working process he had applied to *Cowboy and the Stranger*—the tight and detailed rendering with Martin's dyes, pastels, and colored pencils, the collage elements and Plexiglas extension boxes—to a larger scale and a more prolific series. The second impulse was narrative, an attempt to develop a more compelling strategy of storytelling through the coincidence of thematically interconnected images and music, without relying on illustrative modes or physical proximity as he had in *Cowboy and the Stranger*. "I realized what I really wanted to do was tell stories," he has said. In this new body of work, he sought to provide more space, and trust, for the viewer/listener to traverse the unresolved spaces between story and song, to navigate the lacunae between static drawings and durational time.

He had already completed *The Juarez Device* and "The Juarez Device (aka Texican Badman)," the drawing and the song, but they were unrelated in his mind, until it occurred to him to combine them under the same title in August 1970. Between them, "The Juarez Device" now suggested an evocative working title. He had not yet articulated, to himself or to anyone else, what exactly the title meant, how precisely the two pieces related to each other, or how they could provide a prologue to, or foundation for, a larger body of work. At forty by thirty inches, the drawing was the largest piece he'd made with these materials (and in fact one of the largest drawings or works on paper he'd ever made). A story slowly coalesced through the careful accumulation, in his sketchbooks, of

isolated and gradually interwoven representational imagery; symbols, iconography, and heraldry; lyrics and concrete poetic experiments; characters and structural elements—historical and geographical, narrative and numerological. In the process, he clarified the nature of *The Juarez Device* itself, what that title, and its surrealistic metamorphosis of Giedion's hog-killing machine, might mean. By foregrounding the slaughterhouse source material, Allen ensured that very seed of the series was bloodroot.

A page in one of his folders of loose notes from this period contains a collage of diagrammatic and text elements: a gray photocopy of Giedion's diagram is labeled, with ransom cut-out text, as "Rio Grande," with "USA" to the north and "Mexico" to the south. Each hog, trussed and bound for slaughter, is labeled as either "water," "earth," or "air," moving toward "mirror," their demise. This schematic functions as a skeleton key to *The Juarez Device* itself. The finished 1969 drawing does include, between its "Figure 1" and "Figure 2" sections of assembly-line carnage, a small gray outline of the river, but the rest of the colorful, coded composition is denser and more difficult to decipher. The upper apparatus, Figure 1, contains a lumpen clot of pillowy biomorphic forms on all-fours, each composed of one of those three classical elements, outfitted in cowboy hats, handkerchiefs, and boots. Sleekly stylized fish and birds leap and flutter, like chrome dreams, out of the water and air figures, respectively, and a cactus sprouts from the central earth figure's rocky back. The Figure 2 apparatus spills them sloppily down a mechanical ramp into a void off the frame, as their cowboy accoutrements shake off and their bodies deliquesce into vividly disemboweled piggy viscera. Each figure portion of the drawing also contains a grotesque supine creature, an observer or operator, that resembles a giant, obscene pinto bean with cowboy-booted legs akimbo, displaying a tubular orange and purple torso rent with sexually suggestive orifices, fissures, and slits that appear alternately as vulvas and eyes.[6] Each pinto lure lies in a mountain landscape, perhaps the Franklin and Juárez ranges spanning the real-life cities of El Paso and Juárez.

The plain paper study makes plainer the conceit of *The Juarez Device*. It also helps elucidate "The Juarez Device (aka Texican Badman)," a song Allen composed by appropriating (apparently inadvertently) the opening chord progression, waltz rhythm, and tempo of the

narrative border ballad "El Corrido de Gregorio Cortez" (specifically as recorded by Pedro Rocha y Lupe Martínez in 1929). Cortez was a real-life Mexican American folk hero (1875–1916) falsely accused of horse theft, persecuted, and hunted by the Texas Rangers for his shooting, in self-defense, of a sheriff. Allen recontextualizes this folk song of Tejano resistance with lyrics from the oppositional Anglo perspective of a stereotypical border-crossing, pistol-packing, thrill-seeking weekend outlaw in search of ill-gotten lucre, tortillas, and a "fine señorita" to buy, by violent means if necessary. The brief song, though sonically seductive and couched in romantic and humorous language, is a biting satire of colonization and tourism, though it is seldom heard that way. Allen's diagram discloses what he has otherwise never explicitly stated: the "device" of *The Juarez Device*, the drawing and the title of what would become the first song on the *Juarez* album, is in fact the US-Mexico border itself. The Juarez Device is *el matadero de la frontera*, the abattoir of the borderline, that arbitrary, historically unstable, false partition between two entwined peoples, two mutually reflective nations. (Poet and theorist Gloria Anzaldúa, whom Allen has quoted, has vividly described la frontera as *una herida abierta*, "an open wound."[7]) To pass through the Juarez Device is to pass through the looking glass, and to risk evisceration—and environmental collapse, the spoilage of air, water, and earth with gore.[8]

As he writes in his *Juarez* artist's book of 1975, a 160-page typewritten and collaged document that he photocopied and bound in an edition of approximately a dozen and gave to interested friends, art dealers, and curators, the US-Mexico borderlands, and specifically the border between El Paso and Ciudad de Juárez, are "an irresistible mirror, using America's secret reflection of itself as bait." (Although a handful of the duplicates survive, in the late 1970s the actor David Soul, of *Starsky and Hutch* fame, who had designs on a film adaptation, borrowed the original *Juarez* book and never returned it, earning the eternal ire of the entire Allen family.) Listening to *Juarez* the album or following its annular tale through its various visual manifestations, we too pass through the looking glass into Allen's fictionalized, filmic interior world, casting mirrored glances across the mythic Southwest, limning and effacing the boundaries of the borderscape. In the metaphorical cosmology of *JUAREZ*, the border is both a killing machine and a looking glass: a

mirrored meat grinder. (Decades later, Allen would propose a public artwork that involved installing enormous mirrors on each concrete bank of the Rio Grande, manifesting the border-mirror metaphor—El Paso and Ciudad Juárez as grotesque twins—into literal materiality and recursive reflections.[9]) *JUAREZ* deploys a whole host of doubling devices, dualities, double entendres, doppelgängers, and other mirror play in its every aspect and iteration, which Allen lists in his notebooks and the 1975 book.[10]

Terry was continually analyzing and documenting the work and its progress as he created, edited, and revised it. He filled the earliest pages of the first of the notebooks dedicated to the project, which he maintained throughout the six months spent in Lubbock, even before arriving. The very first page, dated July 9, 1970, contains the first fully recognizable iteration of the wooden question mark, the dogwood tree, "sinking into its own period," which, with its leg extended into a pachuco cross, became the central motif of the drawing *Dogwood*.[11]

From the earliest stages, he adhered to a rigorous structure that helped organize the narrative along a traditional dramatic arc and render it legible. Behind all its ciphers, cryptograms, and abstruse hidden messages, coded into the work like evidence of its central murder, *JUAREZ* is indeed "a simple story." And in a surprisingly categorical statement, Allen adds in his project notebook that "THIS IS A TRUE STORY." The appearance or possibility of verisimilitude, or at least the desire for the work to be interpreted through a lens other than that of folklore or mythology—which, early on, at least, he worried was too quaint, or insufficiently serious—has been a recurring concern for Allen, despite the story's obvious kinship to magic realism, folk narratives like badman legends and trickster tales, and even Jungian archetypes. At least through the 1980s, he consistently objected to exclusively mythopoetic interpretations of the text.

For such a fertile haunting, the actual narrative of *JUAREZ*, at its unadorned core, is as deceptively "simple" and archetypal as advertised, inviting such folkloristic and mythopoetic readings. Its inherently elliptical nature allows endless revisions and permutations; it is, as Dave Hickey has suggested, a palimpsest.[12] The geography and momentum of the narrative, driven as it is by motion between locations, are as important as the actual events. Although it is evident that,

as Terry told me, "the story grew as the piece grew," revealing itself piecemeal with the completion of each new piece of the puzzle, it is remarkable to see how much of what we now recognize as the central themes of the series exists in that very first notebook. The central narrative is not fixed—it shifts, expands, and contracts in different iterations over the decades—but a consolidated summary of the primary characters and plot points is instructive before delving further into details and variations.

Sailor, a twenty-three-year-old serviceman from Abilene, on leave from the navy in San Diego, meets Alice (aka Alicia or Spanish Alice), a nineteen-year-old cantina waitress and sex worker, in a Tijuana bar known as La Cervezería las Golondrinas. (In some tellings, Jabo is already there, disappearing when Sailor arrives.) Repairing to a brothel called La Estrella Negra, Sailor and Alicia "get drunk, fuck, and cry-to-believe together." She is desperate for a way out of Mexico, and the two impulsively elope, crossing the border and driving, in a green Buick, to Cortez, Colorado, to honeymoon in "a small rundown mountain" trailer. "At exactly the same time," Jabo, "a Juarez-born pachuco" and his "LA girlfriend" and "pachuco queen," the chameleonic *bruja* and prophetess Chic Blundie—"an enigma, rock writer, and occasionally ... Jabo himself"—decide to return to Jabo's hometown by joy-riding his motorcycle (his "little Crucita") up to Cortez. They depart on a Sunday. For some unexplained reason, perhaps to evade the law, since Jabo has, in some accounts, just stolen a car, robbed a liquor store, and murdered someone that very day, "they go north to get south." In most longer iterations of the story, including the album, radio play, and theater piece, on the way to Colorado they rob a filling station ("Aztec Auto") in Arizona (or "Arizonia") and set it ablaze.

In Cortez, Jabo and Chic encounter Sailor and Alice, entwined in marital bliss in their trailer, argue for reasons unknown, and kill them, leaving their bodies and stealing the Buick. A "passing motorist" discovers the bodies at 8:00 a.m. on a Sunday. After a shootout with police at Shiprock, New Mexico, Jabo and Chic dump their victims' belongings in the desert outside a small town called Love Test, where they engage in ritualized sex while "jackolopes watch." "Objects of a massive statewide search," they flee to Juárez, where they finally part, both literally and metaphorically, resuming their individual and separate

forms—something they are perhaps only able to enact by magically assuming the identities of their victims Sailor and Alice. Jabo's tattoos begin to fade, replaced by Sailor's. He goes to a club in Juárez called Melodyland "to sit and talk and drink and dance and long for LA." Later we glimpse him on the border bridge that spans the Río Bravo/Grande, standing above the Juarez Device itself, dressed in Sailor's naval uniform, before he vanishes. Chic changes her name to Carlotta—in the radio play, the same name as Alice's mother, which inks itself above Chic's left nipple, an immaculately conceived tattoo—and she wanders down the Avenue of the Sixteenth of September, where she too disappears.

Although they appear only in nonlinear fragments, kernels of this elliptical double-murder ballad, or corrido (from the participle "to run," apt for a road story like *Juarez*), are already there in inchoate, rough outline form, even in Allen's first Lubbock-era *JUAREZ* notebook. But they are buried within a mountain of extraneous material, to the extent that the process of revelation appears to have involved a gradual excision and extraction more than the slow accretion of additional details that Allen himself has described. The gang's all there: Sailor, Alice, Jabo, and Chic. But they seem to have begun life with somewhat more banal human baggage, before Allen eliminated some of those personal details, stripping them down to streamlined signifiers, effacing their histories and reducing them to atmospheres. Why Alice? "It rhymes with 'palace,'" he writes, at one point specifying that her last name was perhaps Domínguez, an idea that he immediately dropped, preferring to stay on a more mysterious first-name basis. Where did Chic get the strange last name Blundie? It happened during the writing of the song "Dogwood." "A ludicrous pun on *Dagwood and Blondie*," the comic strip, suggested a correspondence between "Dogwood" and "Blundie," he reveals. He discloses, before abandoning the idea in favor of retaining her inhuman enigma, that Chic is white, not Tejano or Mexican like Jabo. There is a rough sketch of Jabo and Chic "screwing" (as specified in a caption) in front of purple mountains, on a musical staff, with a rainbow (no tamale yet). Elsewhere, Allen draws Jabo and Chic from the back, making the beast with two backs, while sutured together on his motorcycle, "swimming in one body" (an image that became *Loteria . . . in Memory of Wings* and informed the song "The Radio . . . and Real Life": "And baby when I'm on

top of you / You gonna be on top too.")[13] Even this early, they are not discrete beings, and their faces are hidden. In the mathematics of this myth, "Sailor + Alice = 2," but "Jabo + Chic = 1."

Other keystone elemental images of the story populate this early notebook's pages as well: Jabo and Chic's pachuco cross tattoos; Alice's whorehouse "crib," modeled on the primitive rope-and-sheet rooms Terry saw in Tijuana; a couch or bed with a grave and shovel in it; "Blundie's vanity" (which would become a construction in the first series); "fish eating birds and turning into fish"; the Gonorrhea Madonna (an epithet associated with an ambiguous photo of a young woman, possibly Alice); the Anima Sola or Anima del Purgatorio (the Burning Woman) and La Calavera Catrina (the skeletal symbol of el Día de los Muertos); and the trailer (in an early telling, it is Sailor's momma's, stolen from her and abandoned in Cortez). Some images, like the cactus with transplanted human genitalia or the song "Big Balls in Bethlehem" (a goof on Bob Wills's double-entendre hit "Big Balls in Cowtown") would not make the cut.

Likewise, linguistic themes arise in the *JUAREZ* urtext that endure throughout its iterations: the repetition of the "Fuck – Cry – Kill – Believe" litany, "Pinto[s] to Paradise," "A High Mountain's Eye," and "writing on rocks," among others, though all largely divorced from context, just as scrawled slogans. Geography suffuses *JUAREZ* from its inception. The story, the songs, the drawings, and the installations all contain roadmap-folding cartographic conflations, elisions, epentheses, and inversions—"they go north to get south," "Texican," "Arizonia," *Stat Eline,* "crashin' the state lines," and so on—so it is unsurprising to find in the Lubbock sketchbook maps of California, Texas, the Four Corners (where Colorado, New Mexico, Arizona, and Utah state lines crash in a cartographic crucifix), and Mexico, some with the characters' circuitous routes drawn on them, as well as landmarks of significance to Southwestern indigenous peoples. Shiprock (a monadnock in the Navajo Nation of New Mexico) and Montezuma Castle (a cliff dwelling site in Camp Verde, Arizona) are both within a few hours' detour north and south of the long drive from Los Angeles to Lubbock.

The triangle formed by tracing the characters' combined route from Tijuana to Cortez to Juárez—Sailor and Alice's path to their honeymoon and their killers' escape route—would feature in several drawings, and Terry would even ink it on the inside of Jo Harvey's nude bent leg,

photographs of which ended up in the pieces *From Root to Ruin* and the "codex" or "index" piece *History House*: "I remember thinking how interesting it was that Cortez, Colorado, is in Montezuma County. I drew a line from Cortez to Mexico City (Tenochtitlan) to Madrid, and then I drew a line from Tijuana to Cortez to Juárez, and it was the same angle—the exact same angle. So it was things like that that began to inform the piece." The triangle itself, repeated in *Writing on Rocks across the USA* and elsewhere, also resembles an Aztec pyramid. The cartography of *JUAREZ* catalyzed its own private numerology and mathematics, some inspired by Aztec numerology and some just invented or determined by Oulipian rules or chance procedures:[14]

> I used references of six. . . . If I had a choice in the measurement of something, I would choose six inches over seven or five, just because "Juarez," "Cortez," "Sailor," and "Alicia" all have six letters. Six became an element in the work, even though I've never given a whole lot of credence to that stuff. But when you make that choice, then things start showing up, you know? I'd done a drawing of these bound figures that are sitting on the cross in *Dogwood*, and I found the exact same images in an Aztec codex. Those things can become potentially weird, but they are also sometimes the only things that tell you if you're on the right track.

These numerological rules, arbitrary or otherwise, embedded themselves in the visual work especially, which often contains numerals and mathematical references.

The mirrored geometries of geography that Allen embedded within the songs and drawings of *JUAREZ* also activate resonances of the historical violence and suffering that are perpetuated and reenacted, hundreds and thousands of years later, within the action of the story, and within the violence and suffering of the Juarez Device. Among the works that Allen completed that summer in Lubbock, *Dogwood* and *The Cortez Sail* reverberate with moments of historical upheaval: the crucifixion of Jesus Christ and the arrival of the conquistador Hernan Cortés to Mexico with "a Spanish Christ . . . alive on his lip," respectively. Both accompanying songs are constructed from multiple parts, lyrical and musical, suddenly swerving into surprising new territory with a chord or key

change or a lyrical shift in perspective, as if stitched to a separate story or narrative voice. "This was the first time I'd experienced thinking that I was writing two or three songs and realizing I was just writing one," said Allen. It was an approach that he would revisit elsewhere on the album *Juarez*—and throughout his catalog. He played "Cortez Sail" first for Jo Harvey in his studio, beery and teary after stumbling around Lubbock Cemetery unable to find his father's grave, "crying there . . . on the plots, drunk in the grass and listening to Webb Pierce snarling yodels on the radio from the [VW] bus." Later Al and actress Ronnie Troup visited the Allens in Lubbock, on a cross-country drive in a rented yellow Mustang, and he played it for them.

"Writing 'Dogwood,'" he wrote thirty years later, "saved my life." Originally titled "Dogwood Tree, or Jabo at Golgotha," the song contains both "Lament" and "Appeal" sections, the former sung from the perspective of the dogwood tree felled to build the crucifix on which Christ was crucified, and the latter sung from the perspective of Jabo, appealing to Chic to join him on his joyride to Cortez and on to Juárez, crucified together upon his motorcycle La Crucita. "Cortez Sail" bookends and elides the story of Cortés's bloody colonialist conquest of the Aztec Empire, the middle section of the song, with Jabo and Chic's drive back to his home in Juárez (and, by the transitive property, Terry and Jo Harvey's drive back to Lubbock). Both Cortés and Jabo are armed and dangerous, prepared for slaughter, but in slaying Sailor and Alice, Jabo symbolically enacts revenge on colonizers like Cortés and their collaborationists.

The complementary drawings share this multipartite, modular structure. *Dogwood* the drawing consists of a doubled image—another mirror—with the descender and tail of a question mark reflecting, or metamorphosing into, a crucifix. In its structural symmetry, with text inverted on its lower half, it is also an ambigram, equally legible when the picture is flipped, with the cross on top and the question mark on the bottom. Above the roiling sea in the drawing *The Cortez Sail*, where a skeletal fish devours a bird and a sacred heart bearing the pachuco cross frays and flaps in the wind, the central sail image, a portal or mirror, frames a second, land-bound scene of "the high mountain's eyes," containing the other classical elements of the Juarez Device, air and earth. Allen charts the characters' triangulated routes through miniature map fragments in the picture's marginalia.

Border Vows opens a dialogue with the preexisting song "Border Palace," depicting Alice, reclining on her bare crib mattress at La Estrella Negra in Tijuana, as a raven-haired skeleton—one of the few times a character's face is depicted, albeit as an orgasmic cranium—in a coital embrace with, or violent subsumption of, Sailor, who has metamorphosed into water, his sailor's cap bobbing on his flooded form beneath leaping fish, his totem. In "Border Palace," Sailor's "skinny body . . . slip[s] like a knife into her perfume"; in the corresponding drawing, Alice possesses the agency, penetrating Sailor with her bony limbs and liquefying him.

IN NOVEMBER 1970, the Dale Buckner Advertising Agency hired Allen to produce radio jingles for Lubbock Power and Light.[15] Terry drove out to "some sleazy-ass recording studio in Dallas" to record a satirical, sixty-second, full-band gospel number, complete with a hired choir and lyrics about "people power" and "turning on."[16]

Even by the standards of the time, it was rather tame, but many conservative Lubbock listeners heard it as "hippie drug music making fun of Jesus" and canceled their service. Buckner's secretary transcribed a ranting, vitriolic call from Sanford Columbus Whitacre of Whitacre and Law Architects:

> "Don't like that [n-word] music, all the white people in town are mad." Says he is going to call everyone who has bought a home from him and change them over to SPS.
>
> After approx. 5 minutes, admitted he was drunk!

The rancorous racial climate in Lubbock had not changed since Terry had left.

THAT SAME MONTH, while wrestling with Sailor, Alice, Jabo, and Chic in his studio on Idalou Road, Terry received a serendipitous visitor.

Hailing from Fort Worth, Dave Hickey was an emerging enfant terrible of the art world—critic, essayist, curator, and dealer—five years older than Terry. Hickey was in the process of curating an exhibition called *South Texas Sweet Funk* at St. Edward's University in Austin

and paid Allen a studio visit to see his work. It was a lark, a low-stakes detour while in Lubbock visiting his in-laws. Terry had known Hickey's then-wife, Mary Jane, slightly in high school, and Jo Harvey, they discovered later, was Dave's double second cousin ("I can't explain what that is," the normally voluble and erudite Hickey demurred). Hickey, who with Mary Jane had opened the influential but short-lived gallery A Clean, Well-Lighted Place in 1967 in Austin, had no particular confidence that Allen's work would merit even an hour, but it was an excuse to get out of the in-laws' house. Terry and Dave were only dimly aware of each other by emergent mutual reputations as formidable art-world outsiders.

When Dave parked his car in the dusty lot on Idalou Road, Terry spotted an acoustic guitar in the backseat and asked if Dave played; neither knew that the other wrote songs. Terry invited him to bring it into the studio—just as a wicked sandstorm rolled in from the east, bruising the horizon and darkening the studio doorway:

> I started playing my songs on an old upright I had in there, and he sang his songs. I don't think we ever mentioned art, but he put the *Dogwood* and *Border Vows* drawings in that show. Each of us was just so knocked out about meeting another person with a similar Texas and art background, writing their own songs out in the wilderness. There was a horrible sandstorm that day, and a lot of dirt was coming in under the doors, so we were kind of playing against the wind. Shortly after that, he wrote a piece for *Art in America* called "Earthscapes, Landworks, and Oz" [1971], which was one of the early articles about land art. He introduced it with printed lyrics to "Truckload of Art," and then he mentioned that my studio was on the Amarillo Highway.[17] It wasn't; my studio was on Idalou Road, which went to Idalou, not Amarillo. . . . That helped trigger the song "Amarillo Highway." I was working on the idea already, but that's where the lyric "High straight in Plainview / Side bet in Idalou" came from. Then I dedicated the song to Dave, just because of that screw-up on his part.

It was a breakthrough—the place Terry so scorned inspired what would become his most renowned song. (He got to work on it right away but did not complete it to his satisfaction until 1973, in Fresno.) And in

Hickey it produced one of Allen's greatest friends and foils over the years, the critic who most lucidly apprehended his work, even through its periodic inscrutability, and wrote about it more imaginatively and astutely than anyone else. Until their fortuitous meeting in 1970, as far as their careers were concerned, Hickey and Allen had both been "playing against the wind," but Hickey became an early and enthusiastic advocate for Terry. Even so, the friendship was always a fraught one, a fractious and captious fraternal bond grounded in bickering and sublimated competition as much as affection.

Hickey's seminal *Art in America* essay ends with a piquant description of the day they met: "Terry is banging his piano, and beer cans are dancing atop it; the wind is banging signs and doors, and the November sky is full of local topsoil. Everyone in the room is laughing to hold back tears of sublime self-pity as Terry plays 'A Truckload of Art.' It is more than the paranoia and bathos of the song; there is an authentic ambivalence between a commitment to technical Oz and the sepia-tone city outside."[18]

SOUTH TEXAS SWEET FUNK, though somewhat equivocally received and reviewed at the time, proved influential both in determining Hickey's aesthetic concerns as a curator and critic and for forging friendships and community between its constituent artists, including Allen. *Artforum* struggled with the concept of regionalism in contemporary art, venturing somewhat squeamishly that narrative might provide a through line: "Common ground lies in the implication of a story-telling line, a puckish continuity in which each of the works might present some ongoing predicament, urgent or irrelevant, peopled by congenially assorted randy and quixotic subjects discovered askew in miscast materials."[19] Hickey sounded tentative about the regionalism implied in his own show's title, allowing only that "the show *does* define, in an embryonic way, a regional sensibility."[20] ("Artists have to come from *somewhere*," he supposed.) *Artforum*'s intrepid critic-at-large Martha Utterback, bold enough to travel all the way to Austin, seemed mystified by Terry's forensic riddling, presuming that, in Texas, "you would search hard for serious tampering with occult mystiques: nobody's taking time to consult the I Ching along Terry Allen's Mexican border."[21] (In fact, Terry did consult the I Ching to guide choices in his work.)

Two fellow artists in the exhibition became dear friends to Terry over the years: self-described "Florida cracker" Jim Roche, whose colorful, folk-inflected sculptures; maniacal shamanic-satirical performances of cretinous, sometimes vilely hateful Southern grotesques; and motorcycle-mapping mythomania Terry found hilarious, and Luis Jiménez, an El Paso–born artist whose large fiberglass polychromed figurative sculptures with Tejano themes Terry adored. This was the first time Allen shared a gallery space with either future comrade.

Terry and Jo Harvey grew to love Dave, despite and in fact because of his irascible nature and impossible artistic standards. But they worried, as they aged, about his poor health and embrace of dysfunction, his predilection for positioning himself in opposition to everyone, including, it sometimes seemed, himself. They admired his brilliance, his keen eye, and his preternatural facility with language, but they also soberly assessed its psychological and emotional cost. "Dave's the most emotionally nonfunctioning person I've ever known, like a teenager in an adult body," Terry told me before Hickey passed away in November 2021. He sighed. "But he's also a good and true friend."

For his part, Dave loved the Allen family and commended, apparently against his better judgment and personal taste, Terry's "high mimetic and proto-mythic" art about the West, particularly the "formal ingenuity of the rendering" and other "technical maneuvers." He praised Allen as a "Renaissance person . . . the art world's 'leading exponent of the 'Post-Modern Operatic'—the Master of Impure Spectacle," who tackled conceptualism with dexterity and old-fashioned ingenuity, "renowned for his effortless command and outrageous combination of disparate genres and media, according to the task at hand."[22] But he harbored reservations about what he perceived as the work's essential theatricality; its autobiographical, figurative, and narrative qualities (including "that *folklore* that started with *JUAREZ*"); and an unseemly preoccupation with Mexican culture.

"But I don't know any other artists that are like him," he confessed. "Terry lives the square life in order to write about un-square things. I live a messy life and write about square things—abstract paintings, mostly. . . . He's one of the more rational people I know, but I always felt he was being pushed in the direction of psychosis in his work. Terry is probably a sane person who grew up in a crazy environment." Up until

Dave's death, they spoke regularly on the phone, teasing each other through laughter (usually) and spite (sometimes). Beneath the caviling born of their affection, and beyond Hickey's perhaps disingenuous claims of befuddlement at his friend's motives, he was ultimately clear-eyed about Terry's work.

"I think the way I would describe Terry's process or project," he ventured in our final conversation before he died, "is an effort to force the unthinkable, the untouchable, and the unreachable into a kind of symbolic language."

A CLEAN RECORD AND
NO COWBOY MUSIC

Yeah a truckload of Art
Is burning near the highway
Precious objects are scattered
All over the ground
And it's a terrible sight
If a person were to see it
But there weren't nobody around

 —"Truckload of Art"

SHORTLY AFTER MOVING INTO THEIR NEW APARTMENT, THE BOTTOM FLOOR of a Victorian house at 2163 Vine Street in Berkeley, the Allens discovered that there was a man wearing only a loincloth residing in the tall tree in their front yard. "He had long hair and a beard and lived on a little platform up there," Terry claimed. "We couldn't figure out what he did, or how he survived. We figured he came out at night and ate dog shit. He would never speak to us, or to anyone, as far as I know. Very shifty. But you have to consider the times." It was a few days after New Year's Day 1971, and those were indeed shifty times in the Bay Area. Upon their arrival in Berkeley, the Allens' VW bus was immediately robbed, their belongings tossed with sparkling shards of glass. Anti–Vietnam War protests in Berkeley had reached a fever pitch, resulting in several violent incidents—notably the riots in People's Park in May 1969, the subsequent occupation by the National Guard, and the infiltration of the antiwar movement by local law enforcement and shadowy federal

operatives. During orientation on Terry's first day as a guest artist lec-
turer at the University of California, Berkeley's Art Practice Department,
his fellow faculty members warned him that half of his students might
be on the FBI's payroll as informants.

He witnessed at least three more riots in the single semester that he
worked at Berkeley. In March, on the first day he allowed himself a
proper break from his intensive teaching and studio schedule, he
walked right into a demonstration gone wrong: "I stepped out on Tele-
graph Ave. and . . . somebody grabbed me and pulled me into a book-
store. They handed me a wet towel and told me to lay down because of
the tear gas." As a benefit of Terry's new employment, Bukka and Bale
had enrolled in the university's prestigious and exclusive nursery
school program for the children of professors. Jo Harvey loved the pro-
gressive curriculum, but shortly after the riot that Terry witnessed, a
nearby protest bombing, an unnervingly regular occurrence, rattled
the school building (luckily, no one was injured). After that, the Allens
kept their heads down, only going out when necessary. Terry would
occasionally call home and warn Jo Harvey to stay in because of clouds
of tear gas drifting through a particular neighborhood. The waning
war's presence, reminders of its terrible toll, were ubiquitous. One of
Allen's colleagues in the sociology department was a veteran who had
been horribly disfigured in Vietnam. "He had no nose, no hair, no ears,"
he shuddered. "He taught his class under a big photo of himself in uni-
form before he was burned."

A fellow art professor, the printmaker Karl Kasten, generously
allowed Terry to set up a makeshift studio in his university office—
just a drawing table tucked into a crowded corner—where he spent
long hours toiling on the *JUAREZ* drawings. But even this hideaway
did not feel entirely safe. "I remember working at night there, and
sometimes I'd get spooked," Terry explained. "You'd hear weird sounds.
That climate was so scary and foreign to us after Lubbock." They did
not stay long enough to settle in fully, and they traveled back to LA on
several occasions, so the Allens felt like perpetual outsiders in the Bay
Area, nearly as alien as they'd felt in Lubbock.

LEAVING LUBBOCK IN early January 1971 had been an effortless decision;
Terry was ready to accept any escape route, and when he was contacted

about a semester-long visiting artist position, he accepted it immediately. At Berkeley, Terry once again was part of a community of artists ensconced in academia, but this time he was on the smug institutional side of the chess board instead of the disgruntled students' side. The decision to teach was strictly mercenary—and monetary—a survival mechanism. Beginning in 1968, he had in desperation applied for a number of university teaching jobs. He saved rejection letters from USC, the San Francisco Art Institute (again), the University of Judaism in Los Angeles, Cal State LA, and even his alma mater Chouinard (which had begun by then to use CalArts letterhead). When Berkeley responded with an offer, he jumped on it. "Getting into teaching was like falling into a hole with a little money at the bottom," he cracked.

Amid the frustrations and aggravations of university employment, he found pleasure in aspects of the job. He enjoyed his time spent in the classroom with students, but he grew to dread the myriad and mounting peripheral responsibilities of university pedagogy: the grading, the endless paperwork and meetings, all of which he viewed as a perverted professionalization and bureaucratization of art: "The idea of art taking place in such a structured environment—you're dealing with a basic absurdity, if not a hypocrisy." He feared catching the ubiquitous virus of creeping careerism and complacency that he felt plagued many of his colleagues, so he held departmental chairs and deans at an arm's length, determined not to lose his appetite for his studio practice and an increasingly busy exhibition schedule.

Through his association with Michael Walls and the Pasadena Museum, Allen showed work, primarily from his Bible, *Cowboy*, and *JUAREZ* series, at a number of group exhibitions throughout 1970 and 1971. Jim Demetrion, the new director at the Joslyn Art Museum of Omaha, included Allen in *Looking West 1970*; other Western-themed shows included *Made in California* at UCLA and *The 73rd Western Annual* at the Denver Art Museum. There were retrospective and survey exhibitions like the *1970 National Drawing Exhibition* at San Francisco Museum of Art; the oddly titled *The Sixties, Where It Was* at Quay Gallery, also in San Francisco; *Continuing Surrealism* at the La Jolla Museum of Art; and the *National Invitational Drawing Exhibit* at Southern Illinois University in Carbondale, where Ferus associate and Los Angeles County Museum of Art (LACMA) curator Henry Hopkins

and Ed Ruscha served on the selection committee. (Allen won the Purchase Prize, and the university bought his *Cowboy* piece *Winnie Over Half-Way Cross* for $500.)

Despite his reservations about his new employer, Allen did fraternize with certain colleagues, including assemblage artist and sculptor Bob Hudson and ceramicist Pete Voulkos (both of whom would become long-standing friends) as well as Voulkos's apprentice Ron Nagle, also a songwriter and musician of note. Terry met H. C. Westermann, albeit only in passing, at the older artist's university exhibition; they would not become close for several more years. Perhaps his most influential encounter in Berkeley was with Charles Amirkhanian, an electroacoustic composer from Fresno who introduced Allen to the world of contemporary classical, avant-garde, and so-called new music: composers like John Cage, Steve Reich, and Philip Glass, and American eccentrics Conlon Nancarrow and Harry Partch, whose compositions harnessed collisions of avant-garde and vernacular techniques.[1]

During his brief tenure at Berkeley, Terry's most important musical accomplishments were writing "Four Corners" and "The Radio . . . and Real Life." The former (originally titled "Visions of Cortez") was an anomaly; he felt the developing *Juarez* cycle of songs required an "intimate moment" between Sailor and Alice in the trailer. "That's actually the only *Juarez* song that I wrote because I felt it needed to be in the piece," he revealed. "The rest of them came more mysteriously and placed themselves in the sequence." In his journal, he wrote that, pleased with the final product, he immediately played the song for Jo Harvey and friends before leaving for a night out: "They all liked it . . . but were ready to go. Lyrically I feel the song is one of the best I've ever written. . . . But musically . . . it either needs more instruments or a more clever piano player." The sentiment that the *Juarez* songs lacked something in their minimalist arrangements recurred for decades, leading Allen to record various new versions with full bands.

Because there was no piano in their Vine Street apartment, and his studio was a stopgap shared space, Terry spent a great deal of time alone in the music department practice rooms. In March, he recorded eight demos there: rough-and-ready versions of "Red Bird," "Gonna California," "Truckload of Art," "The Night Cafe," "The Beautiful Waitress," "Cowboy and the Stranger," "The Pink and Black Song" (specified as the

"short version"), and "Late 1961." He dutifully mailed a copy of the tape to Jean Milant at Cirrus Editions as payment for the *Pinto to Paradise* print he made there, which depicts the eponymous bean motif in an easy chair tethered to a lasso, floating above a desert landscape and jukebox labels for the same eight songs. Allen's poet pal Jim Brodey also received a copy, which he passed on to Doug Sahm of the Sir Douglas Quintet, who raved about it and passed it on to his label, Mercury-Smash. (There was talk of a meeting, but nothing transpired.) Another copy went to the home of Earl McGrath in LA, accompanied by a self-effacing apology for Terry's substandard gear: "Please forgive the quality of this tape—my machine is fucked up—the piano is fucked up—and not to mention me." He went on to apologize for his vocals, corroded by a cold: "Forgive this flaw. It's just another in a long line of events that I call my life."

McGrath had recently visited the Allens in Berkeley, where Terry had played him these and other songs live in the same practice room. Earl had become a regular correspondent and an umbilical source of au courant dispatches from the heady music and art scenes back in LA. Terry could not have asked for a better inside man and cicerone in LA than McGrath, though it turned out that he could have found a more sympathetic, and certainly a more seasoned, record label executive. Although he deliberately eschewed household-name and headline status, preferring to remain "famous to the famous but unknown to the general public," McGrath had risen to become what writer Joe Hagan has called "a secret handshake" among the elite insiders and intelligentsia of contemporary art, film, literature, and music in New York, LA, and Europe.[2] A friend to everyone from poet W. H. Auden (who introduced him to Frank O'Hara) and artists Warhol and Cy Twombly (each of whom dedicated works to him) to Joan Didion (who dedicated her 1979 collection *The White Album* to him) and Mick Jagger (who hired him, despite a complete deficit of relevant experience, to head Rolling Stones Records), he was the rare creature as comfortable, respected, and well-loved among the literati as the glitterati, able to move with ease between disparate cultural (and countercultural) milieus. "Earl was less a professional than a human lightning rod for interesting people," Hagan writes.[3] McGrath's ascent seems to have been fueled by sheer willpower and a keen intelligence alloyed with an excess of charm and ribald humor. His marriage, in 1963, to Italian countess Camilla Pecci-Blunt, certainly

helped grease, and finance, a fleet of wheels on the way up, and the two of them remained dedicated to their compound status as an iconic bicoastal power couple until Camilla's death in 2007, despite McGrath's abundant rumored affairs with men.

Terry met Earl in early 1970 at one of the regular card games at the Beaudry Street house. "He was an awful poker player," Terry huffed—perhaps, in retrospect, an ill omen for his dubious propensity as a producer and businessman. But like so many others, Allen was drawn to McGrath's lightning-rod presence and the wealth and cachet, cultural and financial, that he wielded so nonchalantly. He was impressed with Earl's effortless glamor—always dressed elegantly and eccentrically, he cut a foppish figure—and grateful for the introductions, access, and air of mentorship that his older friend facilitated. Terry and Jo Harvey began spending a lot of time at the McGraths' decadent home, always a site for interesting encounters, like breakfast with Didion.[4] "He'd have these afternoon soirees where there'd be some eighteen-year-old musician on the edge of OD'ing in one room, and outside Joseph Cotten and Patricia Medina would be strolling through the lawn," Allen told the *New York Times*.[5]

McGrath sussed Allen's artistic aspirations and blue-collar work ethic immediately. After hearing him play, Earl impulsively offered Terry recording and publishing contracts with his brand-new label, the cheekily named Clean Records. Terry instinctively trusted and respected Earl and so immediately acquiesced, becoming one of McGrath's very first signings after Hall and Oates. It was a decision Allen would soon come to rue—and for years to come.

Clean was primarily a vanity project for McGrath, a hobbyist diversion bequeathed to him, seemingly as a lark, by the legendary Ahmet Ertegun, cofounder and president of Atlantic Records, where McGrath briefly served as vice president. With a clever soap bar logo designed by McGrath's pal Larry Rivers and a clever motto to match—"Every man is entitled to a clean record"—Clean was more of a conceptual art project than a functioning record label. Ertegun was right to value Earl's discernment, his penetrating eye and ear for talent, and McGrath did discover, and occasionally, if negligently, cultivate, a handful of artists who would go on to achieve fame elsewhere, like Lubbockite Delbert

McClinton of Delbert and Glen. But he had no head for business, and no earthly idea how to produce or market records. In fact, Clean only ever released a handful of actual records.

Nonetheless the label paid for a piano rental while the Allens were back in LA, staying at Duel's and regrouping after Terry's Berkeley teaching gig ended. The instrument was delivered to an office studio Al Ruppersberg had generously loaned Terry. That summer Allen endured some thoroughly unpleasant session hours for Clean, another "strait-jacket" situation: "I did actually go into the studio and record solo for Clean Records, and it was terrible. . . . 'Don't move your head! Don't stomp your foot!' . . . I felt like I was hamstrung again. Even though I'd signed a contract with them . . . the record never came out, never came close even to being started. Plus my publishing was tied up." Terry's reels for Clean apparently languished in Earl's closet for forty-five years, evidence of a "phantom record" that never manifested, thereby impris-oning Terry in his contractual terms, to his enormous frustration and consternation.

His May 5, 1971, contract with Clean was in fact technically a con-tract with parent label Atlantic, on Atlantic Records letterhead and written by its lawyer John Gross. The terms specified an ostensibly modest one-year contact term with Atlantic, but closer reading reveals the deal's essential snare: the term would be renewed until Terry deliv-ered an approved album, with an automatic extension of sixty days for each "record side" (that is, each song, or "side" of a theoretical seven-inch 45 rpm single) he was unable to deliver, up to forty-eight additional sides total. When, after the desultory July 1971 demo sessions, they abruptly stopped giving him studio time, Allen had no way to fulfill the obliga-tions of his contract, no exit strategy other than waiting what amounted to nearly nine years for its eventual expiry—or risking a lawsuit. Signing this "idiot sheet" in a flush of excitement—his first record deal, shep-herded by a friend and mentor, with the blessing of one of the undisputed titans of the recording industry—soon consumed him with regret. He took the modest advance, as he explains it, because he and Jo Harvey needed the money, which did not last long: "The Clean deal was one of those things that you sign your name to, so you can live through the summer, then starve to death the next five years."

* * *

THEY SURVIVED THE summer, thanks to the advance but also to return jaunts to LA, vital pressure-relief valves. Terry's exiles in Lubbock and Berkeley had afforded him time, and in the case of Berkeley, a bit of money, to concentrate on completing the first group of drawings (and accompanying songs) comprising the *California Section* of *JUAREZ*, as well as the preceding *Prologue* (containing *The Juarez Device* itself, alone) and the *Intermission* (again with only one work, *The Dos Equis Novella*)—ten total drawings and constructions. He finished only in the eleventh hour. In January 1971, writing in a journal after arriving in Berkeley, he fretted that he had no studio, a show due in March, and only "3.5 drawings." While working tirelessly on the drawings, which he completed in an extremely compressed and frantic two months, he also wrote incessantly, compulsively: poems, songs, daily reflections, complaints, notes on Mexican and pre-Columbian art and New Mexican geography, punches landed per round in Muhammad Ali and Joe Frazier's "Fight of the Century," measurements of how quickly the elevator in his university building took to ascend and descend on different days. Finally, he finished, making a minor repair to *The Cortez Sail* and applying final decal text to all the pieces before packing them up in the VW bus for yet another drive south along the Pacific coast. He sometimes felt, like Jabo and Chic, that they'd gone north (to Berkeley) to get back south (to LA).

For this first group of *JUAREZ* works—which he prayed would help finance the two consecutive sections—Terry ventured away from Michael Walls, much to the dealer's chagrin. Although he liked Michael personally, he did not have an exclusive relationship with him, and he wanted to show his work in LA again. Plus, he could not turn down an offer to exhibit at Mizuno Gallery. "She's a whole other mythology," Terry told me about Mizuno, who had been a regular visitor to Gallery 66. "She was a real character, a true heart . . . a very straight-ahead, good person." Born in Tokyo in 1932, Mizuno had moved to LA in the 1950s to study ceramics at Chouinard, after which she presided over three influential galleries, beginning with Gallery 669 (her address on La Cienega), initially in collaboration with Eugenia Butler but thereafter under her own name.[6] She inherited various established Ferus Gallery artists, such as Larry Bell, Robert Irwin, Ed Moses, Ken Price, and Billy Al Bengston,

and even showed works on paper by the novelist Henry Miller, whom Terry met in the gallery. But, as a successor to Ferus, her focus was on providing a space to nurture young artists, especially those with ties to LA. Terry was flattered to be on Riko's roster and under her wing.

She managed to come to a mutually beneficial arrangement with Michael Walls, coordinating the loan of a couple of works and shared investment in promotion and marketing. For his part, Walls exposed an ugly racist streak during their negotiations, mocking Mizuno's accent and occasional grammatical slips in a conspiratorial letter to Terry.[7] Several of the surviving announcements for the show—featuring a triptych of Gary Krueger's photos of Terry seated at his LA piano, from the back, pre-ax murder—include his gallery name and address on them in addition to Mizuno's.

JUAREZ Series: California Section opened on April 6, 1971, at the Mizuno Gallery, still located at 669 North La Cienega Boulevard. The opening was a riotous occasion, according to Terry, a real "blowout." He performed songs from *JUAREZ* as well as some other selections, frustrated how at gallery performances, regardless of the artworks on display, "people always wanted to hear other songs." Art audiences have always had trouble appreciating his music within the same context as his visual art: "Maybe it's the nature of the music, the limitations of my accent and my playing," he supposed, as opposed to musician-artist peers like John Cage and Laurie Anderson. Even Riko, politely intrigued, never feigned any real affinity for the country bearing of his songs. Allen once received a postcard from her, while she was visiting Hawaii, with a terse travelogue: "Great here, no cowboy music."

The original concept for "The Radio . . . and Real Life" entailed a bit of performance art, but at its very first performance at the Mizuno Gallery opening, Terry had to improvise when his key prop, a "live radio to click on and off during the performance," didn't appear: "Greg Card was supplying the radio, and I was going to turn it on loud and sing over whatever crap was playing . . . but he showed up late and I had to improvise . . . imitate the radio . . . with tongue clicks." He closed with a truncated, two-verse version of "Truckload of Art," always a crowd pleaser for rowdy gallery crowds with alcohol in them. The libations (which Terry specifically requested) were appropriate for the content, and the crowd's reaction was enthusiastic: "They were all drunk on tequila and

Dos Equis and applauded wildly," he wrote. Still unaccustomed to solo public performance, especially after a year away from LA, it felt as if "years of solitude dissolved into three minutes of endurance (and/or indifference)." The hangover was nasty: "Riko passed out at the opening. I remember looking in the window from the street while smoking a cigarette. . . . All the pictures were hanging cockeyed, there were bottles on the floor, people lying around wasted. We went in and laid Riko on the cot, picked up all the bottles, and tried to clean up. She actually sold some things though!"

A few of the sales were insider deals: Riko herself bought *Couch*, an image of a couch frame containing an Aztec pyramid, volcanoes, cancerous cacti ventricles, and fish (later purchased by AT&T); Walls bought *The Cortez Sail*; and McGrath bought the assemblage *Blundie's Vanity*, in typical fashion choosing the most outrageous and baroque piece in the show, featuring an ofrenda of botánica figurines. Chicago collector and curator A. James Speyer bought *Border Vows* and *Dogwood*. One of the more surprising things to sell was the especially abject *The Dos Equis Novella*, a TV dinner plate garlanded with withering message-in-a-bottle condoms, to Leonard Holzer, who took delivery of the piece without paying: "I remember he did not send me a check for the measly $800, or whatever it was. And this guy was just stinking rich. I called him so many times, I must have spent $200 on phone calls to get the $800 check."

The show closed on April 30, after a mere three-week run, but that was enough to make an impact, especially among other artists. Allan Kaprow mailed the exhibition invitation back to Terry in Berkeley with a handwritten note: "Thanks for the marvelous show!" Back home in Berkeley, he received congratulatory phone calls from Ed Ruscha, Larry Bell, and Billy Al Bengston. "That really meant a lot to me," Terry confided, "and I'm sure Riko encouraged that."

CHAPTER 23

WILLIN'

And LA she waits
Like a poisonous snake
Coiled up with her diamonds in the Hills

 —"The Heart of California (for Lowell George)"

TECHNICALLY CLEAN AND ATLANTIC PARTIALLY FULFILLED THEIR END OF
the bargain one week later by recording Terry's live performance at the
opening festivities, on May 7 (his twenty-eighth birthday) and 8, 1971, of
Al Ruppersberg's most recent conceptual art enterprise. *Al's Grand
Hotel*, a two-story craftsman house in Hollywood, expanded the *Al's
Café* concept, staging a fully operational boutique hotel populated by
Ruppersberg's artworks and installations, open to visitors and paying
guests for six weeks. You can tell, listening to the Wally Heider Mobile
Studios Unit recording of Terry's concerts, that the room is full of friends
already familiar with at least some of his songs, since they request
"Truckload of Art," appropriate for the event and clearly a favorite
among the crowd of artists and dealers in attendance. "I originally wrote
it for Tina Turner," Terry announces before playing "Funky Mama," elic-
iting Jo Harvey's giggling protest—"No, you *didn't!*" McGrath introduces
one of Allen's sets in his reedy voice.

Allen plays twenty songs over the course of three short sets, the sec-
ond of which is largely dedicated to compositions that would appear on
Juarez four years later.[1] He also plays three songs each that would
appear on *Lubbock (on everything)* in 1979 and *Smokin the Dummy* in
1980, showing the extent to which he had already written and honed

much of his classic repertoire.[2] Of particular interest among the other pre-1968 songs performed is the anomalous "Off Malibu," an uncharacteristic elegy for a surfer—Terry personally found surfing preposterous—admired by ex-surfer Hickey and dedicated to his Chouinard classmate and friend, the troubled painter and surfer Mike Balog, "and all the other surfer boys and girls."[3]

THE FACT THAT the label's tapes of the performance promptly disappeared thereafter was contractually irrelevant. (They'd eventually be released, in 2011, as *Live at Al's Grand Hotel, May 7, 1971*, on the Ruppersberg-affiliated boutique label Orion Read.) Terry remained hogtied by his Clean contract, legally unable to release or even publish any music under his own name (enter his alias T-Bone Tiomkin). He continued working on songs for *Juarez*, slowly losing faith that anyone would ever hear them in recorded form. The experience soured him on record labels for decades: "After that, I never pursued any record company deal again. I realized if my songs were ever going to get out in the world, I would have to do it myself."

Perhaps too charitably, Terry never blamed Earl, who seemed too good-natured and easily distracted to have maliciously duped him. McGrath professed ignorance and impotence, or sidestepped the conversation, when Allen repeatedly asked him to amend or release him from the contract or, at least, help him cut a proper record to release. Terry suspected the real culprit was Ertegun, though he probably only had the faintest notion of who Allen was.[4]

OF ALL THE introductions occasioned by Terry's friendship with Earl McGrath, one proved especially rewarding. In the summer of 1970, not long before the Allens left LA, at a party at the McGraths' house, Terry met an upcoming songwriter and multi-instrumentalist named Lowell George. George had formed a new band called Little Feat after Frank Zappa had fired him from the Mothers of Invention over an indeterminate disagreement about Lowell's classic song "Willin'," with its lyric abut "weed, whites, and wine" (a point in his favor, as far as Terry was concerned, recalling the Velvets' total destruction of the Mothers at the Trip back in 1965). Lowell was preparing to record Little Feat's 1970 self-titled debut album for Warner Brothers Records, which contained "Willin'" (featuring Captain Beefheart and the Magic Band fugitive Ry

Cooder on bottleneck guitar). Terry and Lowell, both navigating what seemed then the respective brinks of their institutionally sanctioned musical careers and prospective first records—of course, George would outpace Allen almost immediately—hit it off.

Lowell invited Terry to jam with Little Feat, a somewhat unnerving prospect for Allen, rattled by his horrendous studio experiences and, years after the dissolution of the Black Wall Blues Quintet, still acutely uncomfortable and unpracticed playing with other musicians, especially those who weren't already friends. He was at the time definitively (and defiantly) not the jamming kind.[5]

But the convergence worked, largely due to George's generosity of spirit and his band's phenomenal musicianship. The session featured the original quartet incarnation of Little Feat, with George on guitars and vocals, fellow Mothers of Invention refugee Bill Payne on keyboards, Roy Estrada on bass, and the great Richie Hayward on drums. Lowell and Little Feat's sturdy, expressive writing and expansively funky sense of rhythm were a revelation and inspiration to Terry, whose own piano rhythms were still rutted in rigid cadences. Although they never played together thereafter, Terry's decade-long friendship with Lowell was formative, instilling a degree of newfound musical confidence.

George encouraged Terry to play some of his own compositions, which he loved enough to offer producing a record. He was particularly taken with "New Delhi Freight Train" and asked if Little Feat could record it themselves for their forthcoming album. When Terry complained about his contractual commitments to Clean, Lloyd offered to wait until the publishing portion of the contract expired so Allen could collect his full share of royalties: "Almost to the day my contract was up, he called and said they wanted to do 'New Delhi Freight Train.' . . . He never asked for a dime of any of my royalties. 'New Delhi Freight Train' and 'Amarillo Highway' are the two songs that I've consistently gotten royalties for; a lot of people have covered them. I always thought that Lowell bailing me out like that was a great act of generosity."

ALTHOUGH TERRY STILL regards his impotent tenure with Clean Records as an unmitigated disaster overall, it did produce at least one enduring recording, albeit, aptly, one of which we can hear only a compressed, brief snatch. Following the "Truckload of Art" demo produced by Nelson

and Tipton, another, somewhat less germinal version, featuring some special guests, appeared (rather incompatibly) in filmmaker Monte Hellman's cult classic 1971 road movie *Two-Lane Blacktop*, starring James Taylor and Beach Boy Dennis Wilson as cross-country hot-rodding heartthrobs, each appearing in their sole cinematic roles as actors. Terry's first (and only) official studio session as a Clean recording artist featured, surprisingly, Don Everly of the Everly Brothers singing harmony and James Burton, a master guitarist who had already backed Ricky Nelson (who later covered "New Delhi Freight Train"), Randy Newman, and Buffalo Springfield and would go on to play with Gram Parsons, Joni Mitchell, Emmylou Harris, and Elvis Presley, among legions of others. Allen had met Burton in passing on the set of *Shindig!*, and he had hung out with Everly at a McGrath party. Everly, who had recently started collecting Cool School artists—like Ruscha, Joe Goode, and Billy Al Bengston, who designed the cover of Everly's self-titled 1970 album—had reservations about the lyrical content: "I remember Don Everly being nervous about it, because he was starting to collect art, and he thought maybe I was making fun of art, and I laughed, 'You're fucking right I'm making fun of art!' There was a lot of self-consciousness and paranoia in California about New York artists, because LA was just starting to exert itself as an artistic community at that time."

In a handwritten annotation in one of his songbooks, Allen expands on the anecdote, revealing that both he and Don were drunk, which might have contributed to his discomfort about the perceived disparagement of his new artist friends: "He couldn't decide if I was putting them down or not . . . of course I verified his worst suspicions because we were drinking Southern Comfort."[6] In the final cut of *Two-Lane Blacktop*, "Truckload of Art" is only barely and briefly audible, just an isolated yodel on the stereo of Warren Oates's yellow GTO while it's parked at a filling station. "These are good records," the anonymous character played by Laurie Bird comments blandly of the fictional cassette on which the song supposedly appears, before replacing it with a Kris Kristofferson tape. It's easy to miss, and we may never hear the whole take, because the tapes have apparently been lost.[7]

DURING THE SUMMER of 1971, the Allens returned from Berkeley to LA once again, for three months this time, staying with Peter Duel for one

last time. Toward the end of the spring term, the University of California, Berkeley's Art Practice Department had officially notified Terry that they lacked sufficient budget to extend his guest lecturer position another semester. There was no longer anything anchoring them to the Bay. But word had spread about the Mizuno show, and he finally faintly sensed that there might be a way to make a proper living through art. Almost immediately after Berkeley's notification, he received a letter from California State University, Fresno (known colloquially as Fresno State), inquiring whether he might be interested in teaching there for the 1971–72 academic year. The prorated annual salary of over $7,000 was a fortune to the Allens (over $50,000 annually, adjusted for inflation in 2024).

He suspected the pedagogical profession, at least within a university context, was one for which he was plainly temperamentally unsuited, and he worried about losing his edge, his studio time, and possibly his mind as a suburban academic. But for the sake of his family, he simply could not refuse the salary, so ultimately the decision was a foregone conclusion. For better or for worse Fresno represented, finally, the escape they had sought from LA but that had so far eluded them in Lubbock and Berkeley. But in the meantime, they decided to enjoy themselves in the company of friends for one last spell in LA before heading north and inland to the perceived badlands of the Central Valley.

From June through August, Terry set up his third consecutive, and short-lived, provisional studio of the year, working out of one of Al's studios, an office space complete with private-eye pebbled-glass windows in a creaky old building at 7505-7 Sunset. The studio floors were stained with puddles of Wesson oil, the residue of Ed Ruscha's 1969 film *Premium* and the accompanying photobook *Crackers*, which document his enaction of Mason Williams's 1964 absurdist comical essay "How to Derive the Maximum Enjoyment from Crackers in Bed," which instructs readers to coax their dates into a motel bed full of salad and then to soak both date and salad with five gallons of their favorite dressing. It was here, in Al's salad-stained private-eye office, where Terry wrote "Flatland Farmer" and "Blue Asian Reds" (about the pill-addicted widow of a soldier killed in Vietnam, inspired by the notion of Stanley McPherson's grieving widow, Quita, whom he'd never met), both of which would find a home seven years later on *Lubbock (on everything)*.[8] He struggled

with "The Great Joe Bob (a Regional Tragedy)" too, to which he did not return in earnest until 1973, in Fresno. The frustration was largely situational and contextual. LA held too many distractions—"everybody was going to the beach every day"—in opposition to the laser-focused Lubbock content of the song, about a wayward Texas Tech football player gone to seed and ensnared in a life of crime. Fresno, Terry would discover, was an environment far more similar to his hometown.

Aptly, he spent the final days of residence in Los Angeles working on a drawing he called *Red Bird*.

CHAPTER 24

FRESNOIA

A hot icepick's in the side of my head
Stuck in a spot that's always red
I need codeine or it will spread
Across my face, all over my head

—"Headache"

THE HEADACHES BEGAN SHORTLY AFTER THEY MOVED. "WHY THEN, I HAVE no idea—probably just because I went to Fresno," he chuckled bitterly. At first they were isolated incidents, terrifying because of their severity but usually mercifully fleeting after their piercing onset and clashing climax. Their quarter-hour duration could feel like an eternity, because they debilitated him physically and mentally, rendering him a raving, or alternately comatose, pain-zombie. He was always so relieved and eager to resume whatever he had been doing—eating a sandwich, preparing for class, chasing the boys around—that it was initially easy, after a headache passed, to deny its brain-rattling hold on his daily life, to want to forget it and move on, reclaim his day. They began as infrequent events, possible to compartmentalize as freak occurrences, minor occasional obstacles he could surmount. But with each passing month, Terry experienced the incapacitating headaches more regularly, sometimes ten episodes on particularly bad days, until, by the mid-1970s, they effectively took him hostage for fifteen years. He described the sensation viscerally in a 1983 text called "My Headaches (a Theme by T. Allen)":

motherfucking hideous hideous terror vomit pain green white
nightmare burn-shove in upper right side of face jam-jabbed jab jab
ram & jabbed & cracked broke off in head & left forever to murder-
ous rip tip ice pick needle explode inject sulphur hell balls lightning
spike furnace veins shriek phosphorous splits napalm scream gut-
ted hammer slam hurt fry fry death jump all over face sinus cheek
jawbone melt skull bubble pit eye runny clear boiled puss blooded
razors teeth eat eat gnaw gouge & rumble death throb slits hell hell
wrath / not tumor cancer . . . but hate attack from god.

Finally he relented, and, taking advantage of his university medical
insurance—a luxury and a primary motivation for taking the job—he
began to consult various doctors, who diagnosed him with cluster head-
aches. Out of stubbornness and a degree of superstition, he initially
refused a brain scan, but he did eventually submit to tests and prescrip-
tions. (When Terry claimed that moving to Fresno "basically saved our
lives," he meant medically as well as psychologically and financially.)

He drew "cluster pain charts" that resembled demonic phrenological
charts—his grandfather S. A. would have approved—and wrote exten-
sively about the experience, noting the unsettling warning signs: prick-
ling, needling sensations across his scalp and face, tingling lips and
jaws, and nasal and eye discharges that presaged the onslaught, within
a matter of minutes, of "a storm of burning needles and swirling acid
flying all over inside of the head—a hurricane with no calm—fire storm"
or "firenails (as in a nuclear furnace) hammered into your face." Curi-
ously, these excruciating headaches seemed to coincide almost exclu-
sively with moments of calm and respite, not with stressful events, at
least not directly. They seemed never to occur while he was in the studio
working or otherwise engaged in an activity that required intensive con-
centration, focus, or creative flow. In fact, as he discovered later, when
he was able to will himself to work through the pain, the skewering
headaches sometimes subsided.

For most of the seventeen years the Allens lived in Fresno, during
which Terry was plagued by these headaches, the only treatment offered
him was a powerful narcotic, Fiorinal #3, the brand of which most often
prescribed was Fiorinal Codeine Watson 956. These jaunty half-yellow,
half-blue capsules contained the opioid painkiller codeine and fiorinal, a

blend of aspirin, caffeine, and a medium-duration barbiturate butalbitil, similar to phenobarbital. Like many sedative-hypnotics, butalbitil is known to be addictive in many cases, and codeine, like all opioids, is of course highly addictive. Fiorinal codeine was first prescribed to Terry sometime in the mid-1970s, and by the 1980s he had fully succumbed to its power, in the thrall of the little blue-and-yellow pills. It was a vicious cycle of dependency: when he began to feel strung out, he would try to kick cold-turkey or wean himself off the prescription, and as soon as he did, the headaches would return, worse than ever. Eventually he got to a point where he would "use any excuse to take it," secretly attributing his compulsive productivity in the studio, as well as his inspiration, to his carefully timed regimen of medication, which he would stockpile and parse out as needed: "All of the '80s I was on that stuff, all through working on *YOUTH IN ASIA*. At certain points I was so strung out, I thought I could use it to open up things in my work. . . . I would save pills for later, going out to the studio and taking them in the morning, and I would have thirty to forty-five minutes of supreme awareness. I can't say it was negative from a work point of view. But it was a weird tool, and then it became a weapon I would use against myself."

He remains warily and grudgingly affirmative about the drug's potentially positive effect on his art and music—at least for a time—but unequivocal about the physical, psychological, and emotional ravages it wrought on him and his family, especially throughout the 1980s, when he was most thoroughly chemically saturated and suffering through his greatest physical and psychological torments: "I was trying to be resistant most of that time, to figure something else out. It was wreaking havoc on our family, but not particularly on my work. Which is an odd thing, because I've always made such a connection between family and work—they're so interdependent to me." After largely avoiding drugs throughout his immersion in the orgiastic milieu of the '60s, he was eventually undone by just what the doctor ordered, prescription medicine to treat a neurological affliction. Ultimately, Allen told me, "the headaches—it was like a whole world." That world, not coincidentally, was coextensive with the oft-derided city of Fresno, a headache-hell Allen would call Fresnoia.

ON SEPTEMBER 2, 1971, the Allen family left Los Angeles once again, driving the four hours northwest to Fresno, into the unknown of the

Central and San Joaquin Valleys. They settled into a modest rental home at 909 East Fountain Way in a nondescript, tree-lined neighborhood between Tower District and Old Fig Garden, nestled between train tracks two blocks to the west and an irrigation canal two blocks to the north.

Once again there was not sufficient room for a home studio, and Terry had become accustomed to working elsewhere, putting some distance between himself and the distractions and clamor of home, so he searched for a rental. The place he found was not particularly convenient, but it was larger than any of his previous spaces and, most importantly, cheap, due to its condition and unusual site—inside a "real funky old dark" cinderblock warehouse outbuilding, once a garage, in the middle of a ramshackle boatyard at 3434 Belmont Avenue. (Landlocked and surrounded by boats, he reflected, was the perfect place to complete *JUAREZ*.) The building was windowless except for a meager office antechamber with a glass-panel door that provided almost no useful natural light. The surrounding neighborhood was a crucible of gang activity, drugs, and crime.

Money remained tight, and Allen fell behind on rent. However, in May 1972, he received welcome news of a windfall, an artist fellowship from the National Endowment of the Arts in the amount of $7,500, more than his annual salary—"a handsome sum" in the estimation of Michael Walls, who, in one of his cloyingly conspiratorial letters, regaled Terry with behind-the-scenes NEA machinations, intimating that he might somehow be partially responsible for the award. The truth was that several panel members were friends, allies, and established or emerging supporters of Allen.[1]

The boatyard, an anomaly in the neighborhood, had been robbed repeatedly, and the kindly landlord, Manny, warned Terry, as an Anglo outsider in a heavily Chicano community, to watch his back. For a while he was lucky, but one night in 1973, the inevitable occurred—someone broke into the studio, smashing the glass: "They came in and stole my record player and other stereo equipment and some tapes. . . . But obviously when they broke in, one of them had cut themselves, because there were spots of blood all over the floor. And they pulled my drawings out and looked at them, because there were little spots of blood on one drawing too [*The Cortez Slab*], and then they very carefully put the covers back on them and put them back where they got them . . . it was very

bizarre."[2] Shaken by the break-in, Allen took action to engage positively with the community in which he was apparently an unwelcome, or at least unknown, interloper and target, to introduce himself and announce his benign intentions. He posted fliers around the surrounding blocks announcing that he would teach a free art class for local children every Saturday morning henceforth that he was in the studio and that anyone was welcome to stop by and draw with him. The first day ten kids showed up, some with their parents, leery but curious. Terry's clearly unthreatening, open-hearted manner, sense of humor, and rapport with children quickly set their minds at ease, because he "never had any more trouble after that."

MANY OF HIS colleagues, and even longtime residents he met, despised Fresno—like the metal sculptor Allen Bertoldi, "who cussed it constantly."[3] But Terry and Jo Harvey appreciated their new home's unremarkable nature, its plainness and flatness, topographically as well as culturally, which reminded them of Lubbock. Terry was also a fan of the local diner and café culture, writing giddily in a notebook, shortly after their move, that "not only are there 4 Denny's here, there is also a Zenny's!"[4] Still, the low municipal self-esteem bothered him: "It was the first time I had lived anywhere, even Lubbock, where the people who lived there expressed such disdain for where they were living. Why the fuck don't you move then? It was odd, like a civic neurosis. People were always so apologetic for being from Fresno. In the quality-of-life ratings for California, Fresno was always next to last, just above Bakersfield. But Jo Harvey and I loved it! We were thrilled to live in the worst place in California."

In many ways Terry preferred the serenity and informality of his Saturday-morning classes in the boatyard to his official duties at Fresno State, but slowly he found his tentative place within the Art Department. Much as he had done in the neighborhood of his studio, he achieved a functioning detente by laying bare his intentions. His focus would remain on the students and his own work, not the bureaucracy or careerism of the academy. For the first few years, "I never felt inhibited by the school," he said. "I taught what I wanted, when I wanted, and I was very productive. I finished up *JUAREZ* and started all the *RING* stuff while teaching." And in the classroom, he shone, imparting his own subversive versions of the challenges and exercises in freethinking

250 TRUCKLOAD OF ART

posed by his own teachers at Chouinard. A signature assignment was to instruct the students, in a still life or life drawing context, to look hard at the object or body in front of them, and then—without moving—to draw the other side of it, the side they could not see.

There was plenty, unfortunately, that Terry could not himself see; the machinations of the department remained frustratingly opaque and obtuse. The first few years at Fresno involved, each semester, an exasperating game of brinkmanship between Allen, the department chair, and the dean to allocate funding to promote him beyond "Lecturer E" class, the equivalent of adjunct professor, where he had landed as a default after his first semester as a guest lecturer—and that actually entailed taking a pay cut. He sought promotion to assistant professor, with its attendant higher salary, more robust benefits, decreased scrutiny and oversight, and lighter class load, for two years before the department granted it in 1974.

Luckily, he found some excellent allies as soon as he arrived, such as Greek American sculptor Stephen Antonakos, known for his pioneering use of neon. The older artist and his second wife, Naomi Spector Antonakos, opened their home and hearts to the Allens, becoming some of their closest local friends and colleagues on campus and off. In turn, the large gestural neon wall piece Stephen gifted them became "the heart of the house" in both the Allens' Fresno and Santa Fe homes.

Many of Terry and Jo Harvey's social interactions revolved around the English department, which hosted "such a fertile influx of literary people that it was the most exciting place to be." Allen befriended English professor George Lewis, a fellow Texan and a friend of Dave Hickey who taught creative writing. In 1974 they collaborated on two projects together, a concrete poetry "novel" titled *Z-Rocks* (a pun on "Xerox"), which contained photocopied images of objects alongside cut-up text, and *Cocaine Cowboy*, a play inspired only in name by Terry's song. Terry designed the costumes, which involved elaborate masks and prosthetics to transform the actors into characters like Charlie, the Cocaine Cowboy (played by Terry's student Al Hatter), a giant ambulatory nose wearing a cowboy hat—like Gogol's Kovalyov if he had been a Texan ranch hand—and Amanda (played by Jo Harvey, in her first theatrical role), in a mask of high-piled blond curls, constructed of "two Dolly Parton wigs sewn together."[5]

It was during this period, through his English department friends, that Terry discovered Malcolm Lowry, a major influence throughout his work; read the work of French philosophers and critical theorists such as Georges Bataille and Michel Foucault; explored the modernist theatrical works of Eugène Ionesco, Alfred Jarry, Bertolt Brecht, and Antonin Artaud; and learned of the contemporaneous works of avant-garde directors Richard Foreman and Waco native Robert Wilson: "I was really interested in Guy de Cointet, the Living Theatre, and Jean-Jacques Lebel.[6] It was a desperation to find out about people and read more about theater. . . . I think part of it was the excitement of those ideas slammed up against the conservative environment I was finding myself in." Another part of it was that in the art world at that time, despite the opening up of performance art, "'theatrical' was still thought of as a disparaging word," much like "narrative," the qualifier so often applied to his art. Terry was perversely attracted to the unfashionability of theater, though he admits that he was then more interested in theories of theater and performance, as they might be applied to his percolating ideas about installation art, environments, video art, and artifacts, the "residue" of ritual or narrative action—like wrestling—more than the actual experience of writing or witnessing a stage play. He took it out on his students and colleagues, mounting modest, one-off, one-person performances, readings, and performative lectures like *Cowtown, American Sadness*, and *The Plateaus of Perception (for Robert Irwin)*, also known as *The Levels*.

During those early years in Fresno, Terry also revisited his artist's books, after discovering like-minded artists whose investigations of word and image intrigued him: on the literary side of the equation, French writers like Alain Robbe-Grillet, Roland Barthes, and the Lettrist International, and on the visual art side of things, Lawrence Weiner and John Baldessari, whom he befriended. For a few months in 1973, he embarked, in the same conceptual concrete-poetry-and-collage vein of *Heaven and Earth*, upon a grueling "novel a day" project. Since critics and curators kept harping on the narrative nature of his work, and he himself continuously wondered if the core of his art was in fact writing, he might as well try his hand at novels. *Homage to Alfred Jarry*, arrayed with clouds of excised words—reminiscent of fortune cookie slips or ransom notes—contains references to Jarry's life, work, and words. A

Juarez book contains loosely collaged constellations of scraps of type-written text, schematics, and clippings of pornographic images. *Memory House* contains what appears to be a found photograph of a crime scene but is in fact a still from a forgotten B-movie, showing the body of a murdered woman lying in a living room. The photo is surrounded, once again, by a swarm of paper shreds containing typewritten times of day, "torn out and pasted on there like someone had cut their face shaving," as Terry described the effect—evidence with no context, memory unmoored from any discernible affect.

Other Fresno friends included the poet Philip Levine and his wife, Franny, consummate entertainers who hosted parties, readings, and sometimes impromptu concerts at their home. Philip was, in Terry's words, "an old Commie, obsessed with the Spanish Civil War." Levine helped activate Terry's nascent political consciousness, though his work, unlike Levine's, would only rarely reflect political or topical concerns in an overt manner. (Jo Harvey studied poetry more formally with Levine.) The literary scene into which he'd wandered, comprised mostly of older writers, seemed "on the cusp of the old beatniks," and, his Beat ethic reignited, he hungrily absorbed the personal introductions and book recommendations. In exchange, he provided his new friends with access to a younger, hipper milieu of visual artists and musicians, particularly those whom he invited to visit Fresno State.

Levine arranged for campus visits and readings from poets like Mark Strand, Richard Hugo, W. S. Merwin, and Gerald Stern, which inspired Allen, in collaboration with his officemate Charles Gaines and Allen Bertoldi, to launch a more formalized guest artist program. With Fresno so removed from the epicenters of contemporary art, they felt bringing practicing artists (and some curators) to campus would inject much-needed vitality into the studio art program. They invited a host of fascinating artists from a range of disciplines—many of whom were friends or acquaintances wondering why Terry had chosen to settle in Fresno of all places—to spend a week sitting in on classes and interfacing with students, most of whom, Terry presumed, "were baffled by these artists—as they should have been."

Among the roster of guests were Chuck Arnoldi, Richard Artschwager, Vija Celmins, Robert Grosvenor, Jene Highstein, DeWain Valentine, dancer, choreographer, and filmmaker Yvonne Rainer (with whom Jo

Harvey fruitfully studied), Al Ruppersberg, and curator Marcia Tucker—
an impressive list that unfortunately failed to impress the unenlightened
departmental administrative figures. The sculptor Richard Nonas, who
was living with Laurie Anderson at the time, visited as well, which is
how the Allens met Anderson. Their chemical connection, as two artists
involved equally in visual art and music—much to the mystification of
curators, dealers, and critics—resembled two dogs sniffing each other:
wary and then affectionate, relieved to find another similar creature.

One of the first artists Allen arranged to visit, in September 1974, was
Chris Burden, whose controversial performances involved extreme
feats of endurance and self-inflicted physical harm. Burden arrived in
Fresno on September 23, exactly five months to the day after his piece
Trans-Fixed, in which his attorney "crucified" him on a Volkswagen
Beetle, nailing his hands to the roof. He attended his lecture wearing a
suit and tie, his hands only recently healed from their puncture wounds.

Terry, Gaines, and Bertoldi judged the guest artist program a wild
success, and many of their students, though thoroughly confounded by
these dispatches from the bleeding edge of the art world, relished the
visits. But according to Allen, the rest of the faculty, and particularly the
conservative administration, did not approve of visiting "lunatics" like
Ruppersberg and Burden. It was, in Terry's words, "typical institutional
idiocy," a perfect example of what he feared he'd encounter as a full-time
professor. The department killed the program after about three years.
"That really soured me for the rest of my time there," Terry confessed.

To make matters worse, in 1976 the department began cracking down
on faculty members accepting visiting artist gigs at other institutions or,
indeed, working off-campus at all. "When I was invited as a guest artist
for a lecture somewhere else, or even to travel to Landfall Press or some-
where else to do prints, they always threatened to fire me, every single
time. . . . Finally, the year before I quit, they passed a rule where no one
could travel." Some of these draconian new policies were a result of
statewide and federal Reaganite economic and political pressures. Fel-
low faculty members were cowed into submission, scared of making a
false step. "It was an oddly slack-jawed climate," Terry reflected to me.

After the dissolution of the guest artist program, Terry resolved not
to stick his neck out anymore; from then on, he would teach his classes
to the best of his abilities but not take any extracurricular risks, instead

channeling his professional energy and extra time into his own studio practice. He participated nominally, and usually negligibly, in departmental business and politics, doing the barest minimum to collect his paycheck, extend his family's medical insurance, and ensure a safety net, dedicating the maximum possible number of hours a day to making his own art and music. Once he was finally eligible for a sabbatical in 1977, he extended it for as long as he could, effectively vanishing from campus and departmental life but maintaining the most tenuous tether of official connection in order to prolong the health insurance policy, without a salary: "I just kind of reached the end of it. I really strung them out. . . . They kept my name on things, and I was officially on faculty, but they would hire five people for whatever they were supposedly paying me." This attenuated ghost sabbatical lasted an incredible five years, until Allen and Fresno State finally cut ties permanently in 1982.

CHAPTER 25

EXTRAORDINARY REALITIES

And if you never let
That honky-tonk
Jukebox
Sing for you
Manhattan Bluebird
Girl . . . you missed your song

—"Manhattan Bluebird"

IN THE EARLY HOURS OF DECEMBER 31, 1971, WHILE DIANNE SLEPT, A BULLET from Peter Duel's .38-caliber revolver shattered his skull, then a window, and lodged in the glitter-stucco carport across the street. He died immediately as a result of what the coroner reported as "cerebral destruction." He was thirty-one years old. Duel had been struggling with clinical depression and alcoholism, and his death was ruled a suicide. But some close to him, including his brother and Jo Harvey, believed, because his death came so suddenly and without any warning, known trigger, or note, that it was more likely an accident, or even possibly foul play.

"Peter was one of those people that you kind of expected the worst," Terry sighed, "so we were surprised, but not shocked, by what happened." In a letter to friends, Terry imagined the scene with grim humor and in lurid color: "PETER . . . DRILLING HIMSELF NAKED UNDER SIX DAY OLD CHRIST LIGHTS."[1] In a more sober moment, he wrote in a journal about his difficulty coping with the loss of a fellow artist and its repercussions on his own sense of mortality and urgency about his legacy ("constant and consistent bouts of breath and energy and vision").

Terry even connected Duel's suicide with his own twin-house upbring-
ing in Texas, "his duality."[2]

Having just moved to Fresno, the Allens were devastated by the news
of Peter's passing, which felt like a tragic epilogue to their years in LA,
which they so closely associated with Duel's generosity and friendship.
Peter was the first of three loved ones to die by his own hand on New
Year's, permanently marring the holiday for Allen.

ONLY THREE MONTHS after moving to Fresno, on December 18, Allen's
second solo museum show opened at the Museum of Contemporary Art
Chicago, a coup that helped support his case for a more permanent pro-
fessorship. MCA director Stephen Prokopoff, who curated the show, had
studied art at Berkeley and was known for championing artists in Allen's
orbit, like Robert Irwin, Jim Nutt, and Richard Artschwager. *Terry
Allen: Mixed-Media Drawings* was another nondescript exhibition
title, but the work was exceptional, even by the standards of the MCA,
with its daring curatorial program and links to the Chicago Imagists.
The exhibition included thirty-seven drawings, twenty-one from *Cow-
boy and the Stranger* and fifteen from *JUAREZ*, including two (the
related *Stat Eline* and *Stateline Motel*) from the *Cortez Section*, still in
progress. By positioning the two related bodies of work in conversation
within the same gallery context and playing tapes of his songs related to
each body of work aloud in the same space, the exhibition offered, for
the first time, some perspective on Allen's project, his approach to
extended narratives and what he was still calling "paper listening mov-
ies." He deployed that phrase, belabored in various newspaper reviews
of the exhibition, in his notes in the exhibition catalog, his first dedi-
cated publication. More like a pamphlet than a catalog, the six-panel
foldout includes an essay by Prokopoff, which ends with a zinger: "Mem-
ory and history become legend and legend becomes personal imagina-
tion. Interpretations circle each other warily under 'blood-red skies.' Is
it the sunset of the classical Western denouement or the neon glare from
a local Burger-King?"[3]

On the subject of food, in a December 9 letter Prokopoff had regret-
fully declined Terry's now traditional request to serve tequila and beer,
because the bar would be located, "for space reasons," upstairs, accom-
panying the other exhibition opening that night, *White on White*, which

necessitated serving "something white." This gimmicky exhibition, comprised entirely of white artworks by heavy-hitters and blue-chip artists—most of whom otherwise had nothing to do with each other—was, perhaps creditably, a crowd-pleaser, and the museum dedicated most of its promotional and budgetary resources toward it, neglecting the weird "cowboy pictures" downstairs. During the opening on December 17, from 5:00 to 7:00 p.m., museum patrons flocked to the bustling *White on White* opening, where all the booze and food was located: "They had white punch, White Russians, and a white cake—and on top of this cake, there were little live white mice with rhinestone collars, with tiny chains connected to a pole in the middle of the cake. Surely they must have had something on top for the mice to shit on. . . . I don't know, I didn't eat any cake. Everyone was dressed in white, in white tuxes and evening gowns—except the staff, who were all Black, also wearing white. They were the only black in the whole place." Few people ventured downstairs to see Terry's show, at least during the opening event.

Terry's uncle Guy, Pauline's brother, had died ten days earlier in Kerrville, Texas, so Terry arrived already somewhat rattled and on edge. The subfreezing weather that weekend didn't help his mood. In his sparsely populated gallery, he gradually turned up the volume of his tape to ear-splitting levels, which didn't help foster attendance, and spent the evening wandering around, taking advantage of the open White Bar, with Jo Harvey, Billy Copley, and Michael Walls. Walls had been instrumental in scoring the show for Terry and helping arrange loans and shipment of his pieces from various collectors and galleries, an increasingly complicated procedure now that he had begun selling and exhibiting work around the continent.

At the packed after-party at Prokopoff's house, the Allen party, conspicuously polychromatic, gingerly picked their way from room to room among the throngs of white-clad bodies. The critic Robert Pincus-Witten, an editor at *Artforum*, was seated on the floor of the front room. Walking by, "Jo Harvey accidentally speared him right in the middle of his hand with her high heel, and he shrieked like a banshee. She was very apologetic—we were all half-looped by that point in the night—but I was really proud of her."

Artforum once again did not cover Allen's show, and the critical reception to Terry's Chicago museum debut was decidedly mixed, more

so than any previous press. Local artist and radio critic Harry Bouras rhapsodized about the drawing *Boot* for thirty minutes on WFMT, playing a selection of Allen's songs from a tape borrowed from the MCA.[4] The *Herald* and the *Des Moines Register* were rather more noncommittal and equivocal. In a hard-nosed and humorless piece for the *Chicago Tribune*, which reproduced *Boot* (apparently a favorite for Chicagoans), Jane Allen—in Terry's first unambiguously negative review by a professional art critic—decried what she saw as the hipness, maximalism, and literary aspirations of Allen's work and, by proxy, his personal character and entire generational cohort of "West Coast, literary, post-Pop" artists.[5] She grumbled about the apparent inaccessibility, inscrutability, and impenetrability of Allen's "heavily footnoted" art, citing the problem of its essential conceptual nature, its arcane relationships to "the paraphernalia of popular Western culture," most egregiously the genre of "folk epic" and the uncouth Western "ballads which he writes and composes himself."[6] Despite this multipronged panning, Allen's MCA show marked the beginning of a career foothold in Chicago, which would become, along with Kansas City—and the California triad of LA, San Diego/La Jolla, and the Bay Area—unexpected epicenters of Terry's artistic and musical activity over the next two decades, his midwestern Florences.

JUST AS ALLEN was establishing himself in Chicago, he also made his New York museum premiere, with inclusion in two separate shows, within the span of a single year, at the venerable Whitney Museum. This initial splash, while impressive, did not create permanent ripples in New York, where assorted gallerists, curators, and critics, when they were not themselves clumsily contributing to such misperceptions, struggled to dissociate him from ascribed affiliations with unmodish ideas about regionalism, autobiography, figuration, and narrative, or to sufficiently address (or dismiss) perennial concerns and confusions about his work's untoward imbrication with country music and theater.

Allen's introduction to the art world of New York, which seemed to him cloistered and provincial compared to LA, was almost entirely the result of the tireless support of one brilliant friend, the second, after Mizuno and shortly before Claire Copley, in a significant lineup of women curators and dealers (also including, among others, Paule

Anglim, Betty Moody, and Kimberly Davis and Lisa Jann of L.A. Louver) who believed in Allen's work and pushed to advance his career, often having to tack and paddle hard upwind of current trends. Or as she herself wrote, likewise deploying a marine metaphor, Allen "refused either to defend himself against or resign himself to prevailing art tides"—so his art-world supporters were likely to get wet.[7] Terry met Marcia Tucker, one of his most ardent and articulate champions, in LA during those limbo years between the Allens' imminent departure and their permanent settlement in Fresno, when she visited his studio. With Jane Livingston, Marcia cocurated Bruce Nauman's landmark early retrospective, and first major museum exhibition, which opened on December 19, 1972, at LACMA before traveling to the Whitney and elsewhere. She introduced Allen to Nauman at the LACMA opening, though they did not properly get to know each other until a few months later, in 1973, on one of Terry's first trips to New York, when the three of them sat on the floor of Tucker's apartment, listening ad nauseam to the Nitty Gritty Dirt Band's instrumental version of the Fred Rose instrumental "The End of the World," featuring Doc Watson and Earl Scruggs.[8] Thereafter until her untimely death in 2006 at the age of sixty-six, Marcia and her husband, Dean, provided the Allens with a reliable place to stay in New York.

Born in 1940 in Brooklyn, Tucker was a fascinating alloy of both insider and outsider in the art world, a whip-smart, self-made intellectual whose precociousness, toughness, and outspoken nature endeared her immediately to Terry, along with her keen eye, knack for critical writing, and deep-seated love of country and folk musics (despite her own admitted tin ear). By the age of twenty-two, she had managed to get fired from the Museum of Modern Art (for refusing to sharpen pencils for despotic curator William Lieberman), after which she served as amanuensis and secretary for Noma Copley, the stepmother of the Allens' friends Billy and Claire, in which role she met, and charmed, W. H. Auden, Duchamp, and Warhol, among other artistic luminaries. By the age of thirty-seven, in 1977, she had also been fired from the Whitney Museum (for her controversial exhibition of Richard Tuttle's wispily ephemeral, and apparently infuriatingly casual, sculptural works) and had founded the New Museum, a laboratory for cutting-edge, diverse, often socially and politically charged art by underrecognized artists.[9]

Tucker, beloved by artists but still viewed with suspicion by many institutional types, appreciated Allen's conceptual approach to narrative and his ambitious attempts to braid together the plastic and performative strands of his art—even if she didn't always get it. He viewed her as the heir apparent to his similarly open-minded, intellectually curious curatorial mentor Walter Hopps: "Their focus was so much more on the intent, the process and the passion, the intangibles behind the object instead of the object itself. That happened in the '60s, the collapse of object worship, but then by the '70s, people didn't know what to do with it—how do you sell circles in wheat or a ramp made out of rocks? . . . Walter and Marcia irritated a lot of people with their openness, what they promoted, how they didn't place restrictions on the work according to medium or fashion." As an amateur and enthusiastic participant in the theater arts herself—she dabbled in everything from dance to stand-up comedy to a capella singing (with her ensemble the Art Mob, named for one of Allen's songs)—the idea of visual art and theater cohabitating, cross-pollinating, and mutating did not bother her in the slightest. It felt to her, as it did to Terry, like a natural postmodern evolution that simply returned to modernist theatrical projects from the Ballets Russes to Dada performance, an era before the squeamishness of postwar Puritans from Abstract Expressionists to Minimalists. Tucker was one of the few art-world figures who acknowledged and described certain of the essential qualities of Allen's art across all disciplines: porosity and interpenetration, multimodality and recursivity in both form and content. Before most, she apprehended and applauded the inherent theatricality of his artistic endeavors. Comparing Allen to his beloved Malcolm Lowry and the Argentinian metafabulist Jorge Luis Borges, she was also one of the first and only critics to recognize the significance of his notebooks, their status as a locus of meaning and a branch of his artistic practice (she was also one of the very few granted access to those pages).

In a 1980 essay for *Artforum* titled "TERRY ALLEN (on everything)," she went so far as to suggest provocatively that his art, in its "multidimensionality" and "self-referential, circular quality," might have more in common with "the isomorphisms of advanced science, computer technology, higher mathematics, canons and fugues, Zen koans, and recent literature and film than with the world of fine arts as we know it."[10] She

quoted Allen's own arch take on the necessity of embracing ignorance as a sine qua non for any inquiry, whether scientific or artistic: "If you're an artist, you're usually only interested in what you don't know and can't find out." (Also, "you usually have an ugly car," he added.)[11] Tucker continued: "This is perhaps one of the reasons that Allen's work, when it was first seen in New York in [January] 1973, was confusing to an audience who insisted on knowing whether he was a songwriter or an artist; only a few people seemed to notice, or care, that the characters and incidents in the songs and drawings were related."[12] As an associate curator at the Whitney Museum, Tucker told Terry that she put his seven-and-a-half-foot-wide *California Section* triptych *Sailor . . . and the Cortez Premonitions*—containing three stages of Sailor and Alice's brief honeymoon: "On Perfect Highway," "The Paranoid Hotel," and "Paradise Valise," the latter a suitcase containing a ship—in the 1973 Whitney Biennial precisely because she did not understand it: "She liked it, but she didn't know why. . . . She was one of those people, like Nick Wilder, who when she saw something really odd, ugly, or stupid, got instantly interested and curious about it."

If Allen's contribution to the Biennial—or to *Extraordinary Realities*, another 1973 Whitney group show curated by Tucker's boss Robert Doty—sparked the general public's affection or curiosity, they kept quiet about it, communicating mostly with shrugs and raised eyebrows.[13] "Marcia always laughed" about having to select just these three contiguous *JUAREZ* images for a broad survey like the Biennial, because, out of context with other works and the songs, "people were completely bewildered by them—they had no idea what they were about or why they were there." For her, that was the point—not obscurity or difficulty for its own sake, but, in her words, Allen's work "remained outside the mainstream by virtue of its unexpectedness, its multiplicity (the idea that content could be expressed in any form within the artist's imagining), its humor, and its relentless and ironic dissection of American mores."[14] She sought to remedy that exclusion.

A VERY PARANOID SITUATION

He don't make no money . . . Awww
But I'll tell you . . . that boy can
Out sing
Out pick
Out play
Out drink
Out pray . . . and out lay
Any of them Nashville stars

　　—"Flatland Farmer"

THE DRIPPING SPRINGS REUNION AT THE HURLBUT RANCH IN DRIPPING
Springs, Texas, in the Hill Country just west of Austin, was intended to
be "the redneck Woodstock," a similar celebration inverted and domes-
ticated for the shitkicking, short-hair, bootcut set. Dave Hickey's cousin
was among the promoters, but Dave himself was largely responsible for
booking and corralling the artists, stage managing the show, and even-
tually, paying the performers, some out of his own pocket. When Mike
McLaughlin called Allen in Fresno, he poured it on with a hard sell,
telling Terry that he'd follow Merle Haggard and could even set up a
"picture booth" to sell his drawings.

　　As it turned out, Haggard didn't even play, but Hickey's curation was
impeccable. The lineup represented an astonishing cross-sectional
revue of intergenerational country music giants, beginning on Friday,
March 17, 1972, with Bill Monroe, followed by Charlie Rich and Buck
Owens. The rest of the weekend featured a whole host of legends, includ-
ing Tom T. Hall, Roger Miller, Sonny James, Loretta Lynn, Earl Scruggs,

Hank Snow, and Dottie West. Roy Acuff, Tex Ritter, and Nashville DJ T. Tommy Cutrer served as masters of ceremonies. The younger generation was represented by Kris Kristofferson, Waylon Jennings, and Willie Nelson, who had just moved from Nashville, still in his relatively clean-cut, prebraids incarnation ("no beard, with a Dutch-boy haircut under a golf cap"). Annie Leibovitz photographed the festival for *Rolling Stone*, her portraits unfortunately accompanying a snide and condescending dispatch of complaints about the weekend by Grover Lewis.

Although by financial and organizational metrics, it was a complete and utter fiasco, Dripping Springs helped break what later became known as the Outlaw Country scene, which, to his abiding chagrin Hickey inadvertently helped name with his 1974 essay "In Defense of the Telecaster Cowboy Outlaws," and to legitimize Austin as a viable epicenter of country music.[1] Hickey had purposefully booked a cadre of exciting, up-and-coming young songwriters, the wild vanguard of the emergent so-called outlaws, who were reinventing country music in their own ragged, hirsute image, simultaneously progressive and regressive, incorporating rawer production and elements of rock and folk in order to provide meaningful contrast—and a sense of continuity—to the more traditional, Opry-establishment stars, creating what Terry perceived as "a very paranoid situation": "It was all very tense, because it was the first gathering in Texas where the hippies and the rednecks were in the same audience. . . . They were so afraid of what might happen that they had the Texas Rangers completely ring the entire area on horseback. Every fifty yards or so was a Ranger with a shotgun . . . just waiting for something to bust loose. Nothing happened though; everybody was too stoned and drunk." The festival organizers, expecting audiences of 200,000 over the course of the weekend, went overboard with aggressive security measures, as touted in the *San Marcos Record*: "Patrolling the area will be an estimated 123 security men, forty perimeter riders, and numerous highway patrolmen. Also on the site will be two helicopters."[2] But due to a failure of promotion and marketing and the unknown, remote location, barely anyone showed up, with estimates ranging from a low of perhaps only 700 souls on opening night—when Terry played— to a generous estimate of 10,000 on Sunday. Most attendees and performers agree the actual figures were much lower, likely a few thousand each day at most. Those who did attend seemed to get along, if warily.

Terry and Jo Harvey met up in Texas with a motley crew of friends composed of various LA and New York artists, dealers, and actors, including Ruppersberg and Ron Cooper, and their equally remarkable dates. Terry's old Chouinard classmate Billy Copley was in town visiting his sister, Claire, who had just recently moved to LA and was dating Al. The Allens had met Claire at one of many long nights at the Palomino Club in North Hollywood, LA's premium country music venue and a popular hangout for their circle of friends.[3] The Copley siblings were the stepchildren of jeweler Noma Rathner and the biological children of her husband, the artist, collector, gallerist, patron, and polymath William Copley (also known by the pseudonym CPLY, as he signed his eccentric and erotic figurative paintings), who, in both New York and LA, moved among the inner circle of the Dadaists and Surrealists who had made such an impression on Allen's art education: Cornell, Duchamp, Ernst, Man Ray, as well as Westermann. Claire, who did not yet have any children of her own, bonded with Bukka and Bale, often babysitting and going out of her way to entertain them extravagantly, flying kites and even helping Jo Harvey with housework. (When Claire opened the Claire S. Copley Gallery in 1973, becoming, after Riko Mizuno, one of the most visible and influential women gallerists in Los Angeles, it was a foregone conclusion that she would show Terry's work.) The company also included the actress daughters of legendary filmmaker Sam Peckinpah, Kristen (who was dating Billy) and Sharon (who was dating Ron).[4]

These various parties descended in pairs on Austin from California, where they crashed on the floor of Hickey's by-now-defunct gallery. Dave caught Jo Harvey doing her makeup one morning in a reflective black Ad Reinhardt piece; he was "furious and highly offended," Terry cracked. Al and Claire drove in from LA in Al's 1967 Ford, and Cooper drove from LA to Texas with his buddy Jim Ganzer, the surfing legend and fellow artist who was a prototype of Jeff Bridges's character The Dude in *The Big Lebowski*. Boyd Elder had given them a tip that there were peyote fields in Starr County, where they occupied a few days tripping and puking before continuing on to Austin and Dripping Springs. They spent all day and night on the festival grounds, which Claire described as a wasteland, "just a caliche dust bowl, disgusting."

The Reunion was a signal event for its younger artists in particular, positioning obscure artists like Terry, Lee Clayton, and, in a ground-breaking early appearance, Billy Joe Shaver, whom Hickey called "a fucking genius," alongside the respectable elders. Hickey reflected on his cavalier strategy, all instinct and opportunity: "They all got famous afterwards, and the world discovered Billy Joe Shaver and Terry. I had a reservoir of young songwriters like Terry and Billy Joe, and when there was a hole in the schedule, I would send one in." Terry, who was virtually unknown, followed Charlie Rich, a veteran of Sun Records who was already a major Nashville star (and troublemaker); the sozzled Rich dozed in his Cadillac until the moment he stepped onstage and then returned to the car—and his slumber—immediately following his set. "I was absolutely terrified," Allen said, "because I'd never played in front of that many people." Earl Scruggs dispensed a backstage pep talk: "Look, you don't know any of those people. . . . What you *really* have to worry about is playing in the front room for your in-laws." "Somehow I got through it," divulged Allen. "I played 'Amarillo Highway' for the first time in public, and maybe 'Lubbock Woman,' some of those songs on the first side of *Lubbock (on everything)*, which were all new songs at the time."

Cooper distinctly remembers Allen sitting hunched over the upright piano playing "Flatland Farmer"—likely also for the first time in front of an audience. When Terry staggered off the stage in a brown study of distraction, unsure what he had even done, the audience applauded tentatively, Jo Harvey kissed him, and Dave nodded and slapped him on the back. Gradually he recovered sufficiently to enjoy the rest of the festival. Shaver's lean, yearning songs of faith and desolation fell from the stage like "lightning bolts," hitting with the force of revelation. After a long, congenial conversation with Jo Harvey, who was on assignment to interview him for KSAN, Waylon played "The Last Letter," a song Terry loved. "Waylon and I were having a great old time talking," explained Jo Harvey. "And then he said, 'I'm sorry, but I should go, I've got this dumb interview to do.' After that I just couldn't tell him it was *me*. So I stood him up!"[5]

The festival itself may have been dusty and dirt-clogged, but the aftermath was even messier and more chaotic. It soon became clear that due to expenses exceeding ticket sales—to Terry it seemed there were as

many musicians and guest listers in the audience as paying attendees—
there was no money to pay the artists; the weekend had incurred enor-
mous losses for everyone. Only a couple of seasoned veterans like Roy
Acuff and Hank Snow, burned too many times to count and likely sens-
ing the chaos and impending shitstorm, left the ranch with any money in
their pockets, because they had demanded payment in advance. Dave
panicked. A few charitable artists forfeited their fees and walked away,
vowing never to work with any of these amateurs ever again. "I did my
best," Dave reflected about the Reunion, "but a lot of guys didn't get paid.
I gradually paid some of them, the ones that needed it most, out of my
sock. I know for sure that I paid Terry and Billy Joe."[6]

Willie Nelson left inspired despite the debacle. In his sniveling article
for *Rolling Stone*, Lewis recounts asking Nelson if he'd return next year
should the Reunion become a recurring event. Willie considered a
moment and asked, "You mean if the same people was runnin' it, or
somebody else was?"[7] He did in fact return to the ranch the following
summer, commandeering and transforming the festival into Willie Nel-
son's Fourth of July Picnic, ongoing annually to this day.

ON MAY 31, 1972, a few weeks after his twenty-ninth birthday, Terry
received confirmation of his approval for a loan of $2,500 from the First
National Bank of Lubbock. With it, and some leftovers from the NEA
grant, he and Jo Harvey bought their first home of their own, a 1955 bun-
galow at 735 East Fedora Street, Fresno, with an overgrown, tree-shaded
yard, only a few blocks away from the Fountain Way rental. They filled it
with art, much of it by their friends. The boys shared a room, which,
primarily through Bale's efforts, they gradually transformed into a teen-
age analog of Kurt Schwitters's *merz* installation environments. "There
was no privacy," said Bale. "It was transparency amok. And it was an
open-door policy, with friends and neighbors coming in and out all the
time."

In July 1972 the Allens inaugurated a periodic tradition of gathering
to mark milestones of their marriage. They celebrated their ten-year
wedding anniversary by inviting all their closest friends from around
the country to join them for a multiday party in Pismo Beach, on Califor-
nia's Central Coast. This was the first occasion of several anniversary
bashes to come, taking place in various settings throughout the

Southwest and Mexico, and erratically at irregular intervals, whenever the spirit struck. At some point these anniversary conclaves assumed a slogan: "It's amazing how long two people can misunderstand each other."

They reserved every room at the Pismo Beach Hotel, "a cockroach-infested flophouse right on the beach," for what turned out to be a couple dozen guests, an "onslaught of hippie idiots." Claire Copley reminisced that it was "one of those endless herding-cats weekends, completely unorganized and completely fun. Their parties were never orchestrated, which was what made them special." Al served as documentarian, toting his Brownie Hawkeye everywhere. As the photographer he was absent from his candid, informal snapshot portraits, which he repurposed for *Where's Al?* (1972), with purposefully banal fictional dialogue about his purported whereabouts captioning a wall grid of approximately three hundred photos.

he: Where's Al?
she: Maybe he stayed home to read.
he: What's he been reading?
she: Things on Houdini.[8]

It became one of Ruppersberg's signature works.

The Allens' lives felt, finally, almost stable, at least as far as domesticity and family. There were trouble and strife ahead, but in Fresno, frustrations aside, they had found a safe, humble home. In October 1972, Terry wrote "The Thirty Years War Waltz," a future-memory ode to matrimony, as a present for Jo Harvey's upcoming thirtieth birthday. With a healthy dose of humor, the ballad traces the arc of their relationship from their meeting at age eleven and imagines a retrospective consideration of a thirty-year partnership. "At the time I wrote it," he joked, "the idea of being married thirty years was like, who would be that stupid to live that long and be married that long?" At the end of the recorded version of the song, Terry begins cracking up, at once undermining and ennobling its sincerity.

CHAPTER 27

MYTH MY ASS

Ahhh Colorado
Affectionado
Out of Texas
Yeah down to Mexico . . . up San Diego
California
Arizonia
Yeah to 1 2 3 4 corners of . . . Colorado

 —"Four Corners"

WHEN PAUL SCHIMMEL, JUST SHY OF TWENTY, FIRST WALKED INTO WHAT HE described as the Allens' "very sweet postwar bungalow" in 1974, he was surprised at the dissonances it contained: the trappings of a wholesome, if somewhat cramped, middle-class family domicile; the prominent artwork by friends like Antonakos, Ruppersberg, and Ruscha; the refrigerator-posted schedules of a professional academic; the entropic lairs of two young boys; traces of Texas among Jo Harvey's vestigial regalia of her former life in LA as a "goddess and rock star"; and what felt to him like Terry and Jo Harvey's simmering unease with their new, stable life in Fresno. He had seen some of Terry's work through his friendships with Michael Walls and Claire Copley, but he had never met him and knew little about the Allens other than basic geography.

He sensed tension between the two, Terry with his more established but still precarious career and Jo Harvey, who was just embarking on her own artistic journey, both torn between Texas and LA and now stuck in a "backwater" that was not so different from Lubbock. To Schimmel, Terry was pacing like a caged lion, working frantically to complete his

JUAREZ Series and to make peace with his new home: "They were try-ing to convince each other that this was the right thing to have done. It was an interesting and stressful moment in their relationship. . . . Even to me, at age nineteen, you could tell he was freaking out." Schimmel himself was freaking out, having been thrown into the deep end of museum curation. He was ambitious and bright but understandably intimidated by Allen. Terry's first impression of this young emissary from the Contemporary Arts Museum Houston (CAMH) was not imme-diately favorable. He saw Schimmel as a New York City greenhorn whose cultural privilege blinded him to his own greenness and prejudices. But on offer was a solo museum show at one of the more interesting progres-sive contemporary art museums in the nation—and certainly in Texas—an opportunity to exhibit his entire *JUAREZ Series* at once, in sequence, with his songs, as he intended it to be experienced, instead of parsing it out piecemeal as he had been doing for pragmatic and financial reasons. So he could not afford to alienate this kid—not that he didn't try: "When Paul first came to Fresno, he told me that he'd been promoted by Harithas and was curating the show. He said, 'I'm the youngest museum curator in America.' I said, 'Well, quit the fuck acting like it.'"

Schimmel was a protégé of James Harithas, a former curator and (for a nine-month spell) director at Washington, DC's, Corcoran Gallery (where he was replaced by Walter Hopps). When Harithas left Syracuse Univer-sity to take a job as CAMH's second director in 1974, Schimmel followed. Having recently christened a forbiddingly blocky and metallic new Gun-nar Birkerts building with a controversial 1972 exhibition titled *Ten*, in which Ellen Van Fleet's *New York City Animal Levels* unloosed a cock-roach infestation and killed a clowder of cats, CAMH was in an embattled position, both financially and institutionally, having just lost its short-lived founding director Sebastian "Lefty" Adler in the postpestilence backlash.[1] Out of desire and necessity—the museum was plagued by funding woes—new recruit Harithas transformed the museum into a ragtag laboratory for developing Texas talent and rethinking the role of a contemporary art museum, with a new focus on Texas artists (including Latin and Black artists) and video art. (One such artist was Townes Van Zandt, whom the Allens first encountered playing at a CAMH opening.)[2]

Terry benefited from this wholesale wild-style museum makeover, landing two major shows at the museum before Harithas's firing in 1978.

In Schimmel's telling, Harithas handed him the *JUAREZ* exhibit primarily because, while he admired Allen's work, he preferred not to deal with him professionally: "I'd never heard of Terry. Jim said, 'You're both young—you should do the show.' It was an assignment. I'd worked on a number of other exhibitions with Jim collaboratively, but this was the first one where he said, 'It's yours.' He recognized that Terry is a total control freak, so leaving him with an inexperienced curator would be the best thing." For Schimmel, the learning curve was steep. His relationship with Allen could be at times mutually antagonistic, but it was also mutually respectful and grew over time into a cautious professional friendship. The precocity that got him the gig was also a liability, especially in terms of his views about the art world beyond LA and his hometown of New York, where he had grown up in a family of collectors of rare books and art.

Allen's connection to LA and his enduring currency there—despite the new attenuation of two hundred miles' distance—were what excited Harithas most, but he also understood the institutional significance of keeping things local to placate the board and donors and ensure continued funding. As much as he himself admired the *JUAREZ* works, Schimmel discerned Allen's value to the museum as "a real Texan who was not just stuck in the bayou." However, he worried, considering the dense narrative nature of Allen's work and the necessity of contextual and explanatory wall text, that "Texans are not big readers . . . they have the attention span of gnats."

Luckily, as he demurred, "as a curator, there wasn't much to do" when it came to mounting the *JUAREZ Series* (a highly relative statement). Allen had devised a rigorously established sequence, so Schimmel's duties were largely logistical: determining how to fit the pieces, some sprouting unwieldy extension-box dioramas, in the correct order on the space's three long primary interior walls; how to program and ensure the mechanical function of the "orientation room," an antechamber that featured a slide projector that displayed images mechanically triggered by a reel-to-reel machine playing the songs from the *Juarez* album, recently recorded but still not available as an LP; overseeing the writing, design, and publication of the catalog, Allen's first full-length publication; and assisting Harithas with the planning of the exhibition opening and concert on November 7, 1975. Another primary responsibility was

managing Allen's expectations and strain, which involved delegating responsibility, often away from Terry himself. "I remember that he was drinking a lot to deal with the stress," said Schimmel.[3]

WHILE SCHIMMEL AND Allen were plotting the culminating, compiled *JUAREZ* retrospective, Terry was still hustling to complete the constituent sections, progressing chronologically and episodically through the timeline of the "simple story" as if illustrating the stations of the cross or involute comic-book frames. After the premiere of the project with the *California Section* at Mizuno Gallery, Terry had returned to the fold of Michael Walls for the subsequent two exhibitions, perhaps against his better judgment. Allen could be loyal to a fault, and he was grateful for Walls's support, his willingness to take a risk on his work, and the undeniably salutary effects their relationship had on his career. However, unignorable cracks were beginning to show in the edifice of Walls's business, and despite respectable sales and interest from other curators, dealers, and especially artists, each of the subsequent *JUAREZ* installments at his galleries yielded diminishing returns as far as critical reception and public visibility as well as disintegrating trust between artist and dealer.

Comprising eleven pieces, one more than the *California Section, The JUAREZ Series: Cortez Section* opened at Michael Walls's new gallery space at 8404 Melrose Avenue in Los Angeles on May 19, 1973, two weeks after Allen's thirty-first birthday and over two years after its predecessor at Mizuno Gallery. This second group of works correspond with the climactic episode of the story set in Cortez, Colorado, where the marauding Jabo and Chic murder the honeymooning Sailor and Alice in their trailer. Matching the high drama of the narrative's violent inflection point, these pieces are among the most formally ambitious and materially multifarious of the series. The earliest works in the section's sequence, and the first that Allen finished, incorporate more two-dimensional collage elements amid the diagrammatic compositions, particularly, as in *Wind and Distant Engines*, postcards of southwestern sites and scenery, some of which are referenced in the songs and drawings. *Devine Port*, the only *JUAREZ Series* piece Allen referred to explicitly as a sculpture, disembarks entirely from the picture plane, drifting into a full-on assemblage composed of found, manipulated, and built objects:

model couches, battleship postcards, a letter, branches. Despite its sculptural status, it was still exhibited against a wall, like a high-relief work. The *LA Times* reviewed the *Cortez Section* equivocally and somewhat impatiently, "annoyed at all the allusive complexity," suggesting that "Allen's considerable talents are excessively restricted by ordinary graphic media."[4]

As early as 1973, Walls began to show signs of troubling possessiveness (and sexism). In a letter written after the June 16 closing of the *Cortez Section* show, he wrote dismissively of Claire Copley, who had recently opened her gallery and had expressed to both Walls and Allen her desire to show Terry's work, with no self-awareness of his own lack of business acumen: "Needless to say, she will never be much of a business woman."

Eighteen months later, on November 9, 1974, the *Juarez Section* opened at yet another Michael Walls Gallery location, this time at 429 West Broadway in New York, saddled with the somewhat ponderous and clunky title *Terry Allen: "The Juarez Chapter" of "The Juarez Series."* There were once again eleven pieces, all completed in 1974, now forking into two formal tributaries, with some of the works retrenching into the stagey surrealism and bold colors of his earlier work, albeit more highly refined, ramping up the graphic density to an amphetamine frequency, while others surveyed new, more desolate landscapes that seemed to reckon with the textures and spaces of minimalism, largely voided of all pictorial and illusionistic concerns. What binds these final, seesawing works together is their shared foregrounding of magic, spells, and alchemical processes (e.g., *Tragic Magic* and *Loteria*), as the four characters—the Four Corners—metamorphose in the Ovidian sense, coalescing, mitosing, and eventually disappearing.

Most spectacular was *Melodyland*, a forty-by-ninety-inch triptych in which the left panel, *Radio*, contained exactly that, in a Plexi box, and the right, *Piano*, was buttressed by a three-dimensional piano frame on fire. The center panel, *Gonorrhea Madonna*, was built around a large hand-tinted photo of a young girl, her awkward stance and deer-in-the-headlights expression—an admixture of naïveté and experience, decency and damage, anxiety and arrogance—offset by a coy grin and adult evening wear. This provocative image, used repeatedly throughout *JUAREZ*, is in fact eleven-year-old Terry himself, in drag

for a Halloween Carnival "style show and beauty contest," a fashion show benefit at M. C. Overton in which he placed third. Standing in his sixth-grade classroom, he's wearing a wig, dress, and jewelry borrowed from Pauline. ("I think I am utterly devastating, don't you," reads a caption in a family photo album.) "It had such a weird presence to me, I thought it would be perfect for *Melodyland*," he explained. "That kind of androgynous innocence and idiocy. . . . It adds another possibility to *JUAREZ*, a possible personal dimension. Chic is described as sometimes Jabo himself. So there is that doubling."

On the morning of the opening, Terry and Jo Harvey stepped into Michael Walls Gallery to find all these pieces leaning against the bare white walls. The show was opening at 11:00 a.m., in a couple of hours, and nothing, not one picture, was hung. Michael was nowhere to be found. Finally, they spotted him levitating outside the window. He was standing perilously poised on the narrow ledge, four floors above Broadway and its throngs. "He was one of those people, who, when he got to New York, started to kind of unravel," Allen reflected. "There was paint around the edge of the windows, and he was very meticulously scraping off this paint from his window. It was more than just a priorities collapse. Marcia Tucker came early, and she and Jo Harvey and I hung the whole show just in time for the opening." Later that evening, Terry performed in the gallery on a piano that Walls had rented for the occasion. The program was billed as *Songs from the California and Cortez Sections of the Juarez Series*, since he was still working on the final songs from the *Juarez Section* of what he hoped would soon become a record.

"He sold that show really well," Allen acknowledged, "but I had a lot of problems getting my money from him. . . . Michael would take money he made and dump it back into the gallery and not pay the artists, which unfortunately was a common thing then. I never thought of him as a crook; he was just kind of mindless. But he pulled some questionable things, as far as saying he would send a check, and you never got it, saying it was in the mail—classic stuff."

SCHIMMEL DESCRIBED THE CAMH opening exactly a year later as "a blockbuster" and "a real *opening*," in the sense that it not only marked the first public access to the exhibition, but it likewise cracked open and exposed the socioeconomic fissures of Houston. This was by design:

"The whole art world was so segregated then, and Harithas spectacu-
larly blew it all open." Schimmel watched the wealthier white patrons,
the traditional museum crowd of trustees and collectors—many fueled
by oil money—bridle and flinch at their fellow museumgoers: "I do
remember rich white folks from River Oaks were shocked, like, 'Who are
these people, why are they here, what the fuck is my money going to?
What is this drunken, drug-addled party with Chicanos and Blacks get-
ting fucked up and trying to fuck our white daughters?' . . . Texans can
be really racist."

Depleted and drinking, relieved that it was done and half-dreading,
half-anticipating the inevitable renewed haunting by Sailor, Alice, Jabo,
and Chic, the pull of the *JUAREZ* undertow, Terry remembers that night
in slim shards. Considering his state of mind, "he probably enjoyed the
opening less than anyone," Schimmel admitted. He played a show off-
site, in a University of Houston classroom, concurrent with the exhibi-
tion: "Terry is a professional. He could have played to an audience of five
hundred back then, but this was art-world bullshit, maybe thirty or fifty
people, tops. He was not happy with the mixing board, the speakers, the
shape of the room. . . . It was very important even for that small audience
to understand the music stood on its own, that it was not an illustration
for the paintings or vice versa." The performance, broadcast on Houston
station KPFT, did not suffer from the desultory circumstances. If any-
thing, it imbued his set with an apocalyptic anger that suited the songs
and startled the meager audience: "He fucking mauled the piano on Jack
Daniels . . . like a wrestler."

MICHAEL WALLS ATTENDED. His participation had been critical in secur-
ing loans and providing provenance and documentation of the pieces,
and he was a close friend of Schimmel. Even if Allen understood that
Walls's financial malfeasance and mendacity were more the result of
feckless blundering than outright treachery, when he spied his dealer
across the gallery, he bristled and steamed. He glowered across the
room at Walls, who smiled as if nothing had happened in the intervening
year since his dance on the precipice of Broadway.

"I thought at the time he had a lot of nerve coming, because he owed
me for two years of work," Terry fumed. He marched over and demanded
his long-overdue check, and Walls, cornered with no excuse or escape

route, wrote him one then and there in the gallery, still smiling, promising more later. "That ended my relationship with Michael," Terry grumbled. "I don't think I ever saw him again after Houston. But I did finally get my money."

Allen and Schimmel had worked together tirelessly on the final details of the installation, with the "orientation room" presenting particular technical difficulties with timing the slides to the songs on the looped forty-three-minute tape. In one of his journals, Allen fretted about how to balance image and audio aspects:

> Is there a way to perform the music and visually show the work, while maintaining the independent and collective nature of both—equally and at a maximum energy?
>
> If you confront a complicated visual experience and at the same time have access to a more simplistic and familiar audial experience, you are (in all probability) going to gravitate to the simpler audial—if for no other reason than to escape the more complex and demanding visual experience.

ARTIST AND CURATOR locked horns, largely good-naturedly, about the catalog. Ultimately Terry, too distracted by his other obligations, reluctantly had to cede control to Paul and the designer Stephen Walsh, and he conceded that the final product was a success.

The text comprised four essays—a brief introduction by Harithas and longer texts by Schimmel, Walls, and Dave Hickey. Only Hickey, in his oddly noncommittal and uncharacteristically tentative piece, his first dedicated to his "old friend" of five years, admits failure and "come[s] clean at the outset," writing "I don't understand it. Its ramifications go ripping beyond my comprehension; its illusions ring bells outside my hearing; and its specifics exist in a detail too microscopic for my perception."[5] He protests rather too much, making some incisive observations about the series's status as "a collection of fictive artifacts . . . [that] needs to be approached as an archeologist might approach any artifact, with an eye to sorting the actual event from the object."[6] But he ends his essay equivocally, musing that "somehow arising out of this intersection of wastepaper, rockabilly, and gorgeous icon, there is the intimation of a tragic event which is both private and perpetual."[7]

Walls ends his essay with a suspicion that suffused the subtext of *JUAREZ*, peaking around the CAMH exhibition:

> Indeed, might not an artist who has a manifest interest in identity transfer and who made a drawing almost ten years ago entitled "My Twin Brother—Who Lives at Night" invest elements of his personality and his personal history in an Abel/Cain, Jekyll/Hyde, or Sailor/Jabo dramatization? Is Jo Harvey, the artist's wife, mother of his children, and muse, the provoker—the woman in green shoes—Chic? Is the artist himself Sailor—the misplaced innocent, or is he Jabo—capable of music and of murder? . . . or is he both characters? Perhaps.[8]

In conversation, Schimmel seconded this conjecture: "I was impressed with how he would create alter egos and characters and write them into *JUAREZ* as a way of talking about himself . . . writing himself into it all. It was very clear that these characters were autobiographical, that they were him and Jo Harvey. The notion of their journey was a reflection of Terry and Jo Harvey's journey." Terry and Jo Harvey chafed at such characterizations, both the gauche idea that fictional characters must represent or resemble their author and the sexist intimation that Jo Harvey (her green shoes aside) was merely a muse, a passive voice rather than an active agent in her own and her husband's art. On the eve of the opening, Jo Harvey received an unexpected gift that disturbed her:

> All our friends were coming into town for Terry's show. I was paranoid, because I didn't know what people would think about it. I thought they'd attach it to Terry and me. Some of those characters were just the wind. Do people think I'm Alice, or do they think I'm Chic? I have to admit, there was that paranoia. . . .
>
> We were at the hotel, and a big bouquet of roses was delivered to our room. I can't remember if it was addressed to Chic or Alice on the card, but it freaked me out so much. And Terry said, "Well, you're neither Chic nor Alice. You might be a little bit of both of them."

The cover of the catalog did not do much to dispel the idea that the artist's personal life informed *JUAREZ*. It was a split image, two

black-and-white photographic portraits of Terry: on the left, the *Gonor-rhea Madonna* image of him in drag, and on the right, a picture of him grinning slyly, cigarette in mouth, straw hat on head, shirtless, fingers stained with nicotine. Shot by Jo Harvey, this arresting, ambiguous image, more closely cropped to remove Terry's fingers and chest, would appear as the cover of the original editions of the *Juarez* record. But this was the first anyone had seen this photo, because the album was not yet available—a source of anxiety for Terry throughout the preparations.

IN 1973, JOHN DOYLE, a gallerist in Chicago, had featured Allen in his *Opening Exhibition* of his new gallery and invited Jack Lemon, a master printer who had founded Landfall Press at 63 West Ontario three years prior. Intrigued by his work, Lemon invited Terry to his shop, inaugurating a decades-long collaborative and business relationship that would quickly flower into their cofounded and jointly owned record label, Fate Records. He'd recorded the *Juarez* album in the summer of 1975 with the intention of including it in the *JUAREZ Series* exhibition, but the pressing was not yet ready, in part because, as their inaugural release on the Landfall (thereafter Fate) label and the first LP either of them had ever produced and manufactured, he and Lemon had no idea what they were doing. The "orientation room" was always a compromise to showcase the songs. Not only would the vinyl LP have provided an affordable artifact for visitors to take home with them to listen at their leisure, but it would have represented the thirty-sixth piece in the show, preserving a multiple of six appropriate to the private numerology of *JUAREZ*.

Like the last page of Terry's Xeroxed 1975 *Juarez* book, the *JUAREZ Series* catalog's final page, after *The End*, reads simply "Myth My Ass," a rejoinder to all those past reviews that described *JUAREZ*—reductively, in Terry's mind—as a "folk epic" or mythographical. If intended as a preemptive response to reviews of the series exhibition, it failed. Those reviews were not forthcoming.

SIX MONTHS AFTER the show closed, on June 15, 1976, an art-handling truck picked up all but three of Allen's pieces from the museum: *Blundie's Vanity*, the *Melodyland* triptych, and *Booth*.[9] The next day, the rain began, rapidly inundating the museum with nine feet of water. Any

works on paper or canvas, including Terry's last pieces and hundreds of others, dissolved, blanched and swollen, accreting into pulpy masses. Multihued mold and fungi bloomed and proliferated on every surface.

After *Border Vows* and *Aztec Vendetta* both burned in mysterious conflagrations at their respective owners' homes, the *JUAREZ* casualties due to elemental disasters now totaled five.[10]

EL CORRIDO DE JUAREZ

Well the Juarez mountains
They're rising up high
Trying to touch
Some of that Texican sky
And the El Paso range
It's rising up too
Trying to hook
Some of that Mexican blue
Ahhh
But just like me and you
They're just passing on through
One another

 —"La Despedida (The Parting)"

THE GENESIS OF *JUAREZ*, A QUINTESSENTIAL ALBUM OF THE SOUTHWESTERN United States and the Mexico-US borderlands, and one of the most critically lauded concept records of all time, can be traced not to some Tijuana bordello, East LA liquor store, El Paso hotel room, or Juárez club—all key locations in its story—but rather to the deep, unnavigable white-out drifts of a Chicago blizzard. Jack Lemon had invited Terry to collaborate on some prints at Landfall Press, which piqued the artist's insatiable curiosity. His experience with the highly technical, specialized, and increasingly esoteric world of printmaking was limited to a single class of tentative experiments at Chouinard and a brief affiliation with Cirrus Editions in 1971.[1] Terry knew that Jack had worked with several artist friends he admired and trusted—Robert Arneson,

Bengston, Ruscha, William T. Wiley, and most impressively, the elusive elder statesman H. C. Westermann—among many notable others. So in the winter of 1974, the novice printmaker, to expand his toolbox and repertoire of skills and media, flew to Chicago.

During that first visit, Terry and Jack completed two lithograph editions together. *Texas Goes to Europe* is a comical grafting of Texan sites, cities, and luggage items onto a map of Europe. *Yellow Man's Revenge*, a version of the diptych *Yellow Man* that Allen retroactively incorporated into the *Cortez Section* at CAMH, was yet another iteration of his drag portrait, an additional interpolation of his personal history into *JUAREZ*, with a two-sentence story about Sailor's (or Terry's) childhood testicular mosquito bite, and his mother's (or Pauline's) racially charged warning that his skin might turn yellow. "The great Yellow Man returns as the Gonorrhea Madonna," he wrote in a notebook—corrupted and transmogrified by a bite, if not by an insect then perhaps by the succubus Chic. A persuasive case can be made for Yellow Man/Gonorrhea Madonna as an avatar of any, all, or none of the four characters; they are a symbolic, composite incarnation of all the characters' fluid identities and genders. The two editions took two weeks to complete and involved a crash course in a variety of printing techniques.

After establishing some ground rules, Terry and Jack got along famously. Allen respected Lemon's focus and rigorous work ethic as well as his fierce loyalty to his artists and friends, which cemented his trust in the master printer: "Jack ran his shop like the Marine Corps or a prison sweatshop . . . exactly what I needed at the time." Having been burned by his business dealings with Walls and concerned about Jack similarly overextending himself, Terry wanted as little money to change hands as necessary. Allen stipulated that, in lieu of paying for Lemon's time and services, he would prefer to split every edition he printed at Landfall fifty-fifty, and Jack could show and sell his share however he liked. Lemon assented.

One night, Terry stayed at Landfall after Jack went home to his family, working late with his new friend's blessing and a spare set of keys. A blizzard blew in, and by the time Terry was ready to leave, he opened the door to a wall of snow blocking any egress and spilling into the shop. He was snowed in: "Jack and [his wife] Ethel called and said they couldn't get in. So I ended up sleeping on the press. I had beer, pretzels, and

peanuts, which is pretty much what I lived on then anyway. I was snowed in the whole next day, and they came to rescue me the next evening."

At the end of his frigid midwestern jaunt, Terry had booked one of his now regular visiting artist lecture gigs at Northern Illinois University in DeKalb. Jack, possibly out of blizzard guilt, decided to join him. Terry had already played him several of his songs in the shop and had explained the Clean contract and his frustrated attempts to record an actual album. Jack, a music enthusiast, and a country music fan in particular—Chicago's Double R Ranch saloon was the "unofficial Landfall clubhouse"—was intrigued.[2] In DeKalb, Allen showed slides of the *California* and *Cortez* sections of *JUAREZ* and played a tape of the related groups of songs.

Sitting there in the dark lecture hall surrounded by college art students, eyes closed, it all clicked for Jack. He suggested that they collaborate on an edition of prints to accompany a record comprised of all the *JUAREZ* songs. Terry agreed that it was a fine idea, and the ideal complement to his upcoming exhibition at CAMH, provided they do it all themselves and informally. He was completely disillusioned with the music industry and wanted no part in any more crippling recording contracts, Clean be damned—no more songwriting pseudonyms, no more stockpiling tapes no one would ever hear.

Of course, neither of them had the foggiest notion how actually to proceed with the recording, record-pressing, and distribution variables of the endeavor, all of which, in those days, posed significantly more considerable barriers to amateur entry. After shaking hands, they each began making phone calls to friends, gathering intel and calling in favors.

ENTER LIL' GEM E. HOWL, Terry's nickname for his "cousin"—actually Jo Harvey's second cousin—Jamie Howell, also known as Jimmy. In 1975, Howell was living in San Francisco and working with Jefferson Airplane, which two years earlier had bifurcated into Jefferson Starship and Hot Tuna. Howell, a guitarist, served as road manager for all three bands, as well as A&R man for Grunt Records, their in-house label, distributed by RCA. Officially there was no recording budget available—Jack and Terry had managed to scrape together a measly $500—but Howell was one of the few music-industry insiders whom Terry felt he could trust.

He was family (technically, by marriage), he would work for free (mostly, or so he said), he could keep his mouth shut (hopefully) in case of any Clean contractual heat—unlikely, since McGrath had seemingly all but forgotten about Allen—and, most critically, he had access to a world-class facility, Wally Heider Studios in San Francisco. What he did not have were any real qualifications as a record producer, but since Terry and Jack had zero experience operating a record label, that felt apt, a perfect match of innocence, ignorance, and—Terry's word—idiocy.

Before Allen left Fresno for San Francisco, his cousin informed him that Grunt had booked Studio A at Wally Heider's around the clock. The studio, located at 245 Hyde Street, was, in the summer of 1975, already legendary, the source of iconic records not only by the Airplane and company but also by a whole host of other monumental artists across genres—the Byrds; Creedence Clearwater Revival; Crosby, Stills, Nash, and Young (collectively and individually); Herbie Hancock; Gram Parsons—but with a focus on California countercultural country rock and folk rock.[3] Most meaningful to Allen was the fact that John Lee Hooker had recorded *Endless Boogie* there.

Jamie knew that no one, Grunt-adjacent or otherwise, had any interest in occupying the space during the late-morning dead zone following late nights of recording and revelry, so all three studios—A, B, and C—were usually empty between nine and noon every day, sometimes longer. They could sneak in surreptitiously under the cover of daylight—anathema to the nocturnal Airplane crew—and record for free, and no one would ever be the wiser. As Terry recalled, "The idea of coming in first thing in the morning after waking up was like a nightmare. So we stayed up all night so we could *get ready*." It is difficult to imagine Allen spitting out those violent lyrics before lunch—the studio's signature multicolored lights muted, the water-filled echo chamber room tenebrous—but it's also somehow appropriately perverse.

IN EARLY AUGUST, days before Terry drove the three and a half hours to San Francisco to meet up with Jamie, he got an unexpected shot of confidence regarding his songwriting prowess and prospects. It may have been—to use one of his favorite words—a fluke, but it was an encouraging fluke, especially in such proximity to his recording sessions for his first album.

Hickey had become more entrenched in Music City, and along with songwriter Marshall Chapman, whom he was dating at the time, he had begun hanging out with country star Bobby Bare.[4] While snowed in at a motel somewhere in Kansas, covering a country music package tour for *Penthouse*, Hickey played Allen's embryonic demo of "Amarillo Highway" for Bare—"just a reel-to-reel work tape that I'd cut in my living room," said Terry. Bare adored it and decided to record it, along with "High Plains Jamboree," Terry's poignant portrait of a troubled but stoic Lubbock couple, and two of Dave's existential rodeo songs, for his 1975 RCA album *Cowboys and Daddys*.[5] Allen, a longtime Bobby Bare fan who had seen him live at the Palomino Club, was thrilled.

Bare's high-profile covers precipitated the need for Allen, ignorant of the arcane details of music publishing, to get his business affairs in order so he could collect royalties. Bare connected him with the band Dr. Hook's publisher, and Terry named his publishing company "Green Shoes" after the green high-heel platforms he bought for Jo Harvey, which appeared repeatedly in his artworks and songs (including "Street Walkin' Woman" on *Juarez*). The first time Terry heard one of his own songs on a radio show he himself didn't program was when he accidentally tuned into Bare's "Amarillo Highway" midsong while at the drive-in window of a liquor store on the Tahoka Highway outside Lubbock.

IN THE STUDIO, just a few days after the Bare deal was finalized, Terry and Jamie got to work. They had resolved to keep the arrangements minimal out of necessity; there was no money or time to hire or rehearse a full band, and Allen's primary aim was not sonic variety but, rather, "making the piece one coherent thing, not just a series of songs." While planning their guerrilla sessions, Jamie and Terry both realized that a drummer would only cause problems, for two reasons. First, recording drums was complicated. Second, and more urgently, Jamie was aware that Terry's idiosyncratic, divergent sense of rhythm, crookedly honed over years of playing alone, would flummox most drummers. "If you listen to *Juarez* carefully," Howell noted, "you'll hear that every once in a while, a passage that you expect will be four bars long will be five, or four and a half." Later Terry always heard more varied, full-band instrumentation for this set of songs in his head, consistently revisiting them

on subsequent albums. In retrospect, he was never entirely satisfied with the minimalist arrangements on *Juarez*.

Working with in-house engineers Ken Hopkins and Jeff Husband, Terry and Jamie completed all the basic upright piano and vocal tracks within a few mornings, and Jamie called in three local musician friends for overdubs. Howell tasked guitarist Peter Kaukonen, known for his own band Black Kangaroo and his fine work with the Airplane bands, Link Wray, and Johnny Winter—he is also Airplane lead guitarist Jorma Kaukonen's younger brother—with the parts he felt required a blues inflection. Greg Douglas (or Douglass, after he added a surplus "s" to his surname) played guitar with Hot Tuna, Van Morrison, Peter Rowan, and the Steve Miller Band (he cowrote "Jungle Love") and excelled at major and melodic styles, so he tackled many of the parts that required a Tejano feel. Diane Harris, married to Heider engineer Mallory Earl, provided backing vocals on "La Despedida."[6]

Recording, mixing, and mastering spanned scattered dates throughout August 1975.[7] Allen was petrified most of the time, riddled with anxiety and self-doubt. They recorded a few takes of most songs, primarily due to Terry's vicious self-critique and difficulty inhabiting the songs vocally. He struggled when overdubbing vocals atop audible guitar overdubs. He rushed through takes, chastising himself, on a yellow legal pad of session notes, to take it easy and "try to be <u>objective</u>":

Sing the song, don't try to be a singer . . .

Don't be just dumbfounded at hearing other instruments than yourself! Listen to it. . . . You don't have to scream and pound so hard. RELAX! . . .

Slow down and believe in the ego-magics.

The annotations for individual songs, on Mickey Mouse stationery, are among the most amusing:

On "Dogwood," Terry wrote: "Pause like a meditator before the 'religious' anomalies." Jamie added, "Preach it, bro!"

About "Honeymoon in Cortez": "Sounds like stabbing" (apparently a positive attribute).

Regarding "Writing on Rocks": "Galveston itself is fucked."

The mixing notes for "Cantina Carlotta" are the most outrageous: "The song has to be raunchy and rackety—I'm not Mel Tormé. Carlotta is a whore, remember 'D STREET, THE BROWN HOUSE' in Lubbock. It needs that DOUCHE DUST COME CRUST <u>SMELL</u>."

The notes divulge a heretofore unknown edit to the album. Terry cut one track, a two-second spoken declaration, from the sequence. In a symmetrical echo of "Today's rainbow is tomorrow's tamale," the riddle he intones at the end of side one, Allen originally intended the spoken line "Myth my ass" to conclude the second side of the record. He decided against it, probably because it would have been too deflating a postscript after "La Despedida."

They ran out of money at the final session, unable to extract the mastered tapes from the studio. It's not clear if there were additional incidental costs they needed to cover, if the engineers asked for a higher fee, or if someone caught wind of the sub rosa sessions and demanded payment.[8] Whatever the case, Jack Lemon, whom Allen had tracked down in Kansas City, received a frantic call in late August: "Terry was still in San Francisco, and he called me and said, 'They're not going to let me out of here unless you send me some money.' . . . So I went to see Jim Morgan, and I played some of Terry's songs for him in his living room. He had never heard of Terry, but he just reached into his pocket and pulled out $500 in cash and gave it to me. I wired it to Terry right away, so he could get out of that place." The eccentric Kansas City arts patron, collector, and gallerist Jim Morgan, the kind of person willing to bail out an artist he had never met, whose work he had never previously seen or heard, on the paltry strength of a few demo recordings and a friend's good word, became, along with his wife, Myra, with whom he had cofounded the Morgan Gallery, a major, benevolent presence in Allen's life—diehard benefactors, dedicated collectors, and loyal friends.

BACK HOME, THE "ransom" paid and the masters in the can, Terry and Jack had to figure out what to do next. Allen was still in a state of mild shock that, against all odds, they'd pulled off the recording, mixing, and mastering and smuggled the tapes out of San Francisco. In a letter to Jamie, he thanked him effusively, writing, "I've been listening to 'La Despedida'—over and over—dumbfounded that it sounds as good to me

as it does . . . makes me want to sell everything I own for studio time (2 hours)." He was hooked, a complete reversal of his previously bitter attitudes to recording.

Allen mailed the tapes to a pressing plant recommended by the engineers at Heider's, Phillips Recording Company in Richmond, Indiana, ordering one thousand copies. They knew that in addition to the limited-edition set of the record and prints, however that might manifest, they wanted to release a more widely available regular vinyl LP edition. They got to work right away on the album design and packaging, more familiar territory, with assistance from Jack's upstairs neighbor Bob Feie, who implemented the technical aspects of the jacket and label layout.

On January 15, 1976, the test pressings finally shipped to Jamie at Grunt and to Terry at the Fort Worth Art Museum, where he was working on his first sculptural installation, *The Paradise*. In February, the standard LP edition of *Juarez* was finally complete, though the aftermath was somewhat anticlimactic. When asked about the record's official release, he demurred: "I can't say there *was* a release; it was more like an escape." Having missed the chance to premiere the record and prints at the CAMH exhibition, which had closed on December 8, Allen was forced to wait for his next solo show in May 1976 at Claire S. Copley Gallery.

The format that Terry and Jack chose for the limited Landfall edition of *Juarez* was, for the time, novel: a box containing the *Juarez* album on a vinyl LP, accompanied by ten album-sized (twelve-by-twelve-inch) prints: six lithographs known as the *Juarez Suite* and four prints containing text only, comprising a title card, "The Characters," "A Simple Story . . . ," and credits. Both the box and the LP featured on their respective covers Jo Harvey's black-and-white portrait of Terry smoking, wearing a straw hat and no shirt, grinning enigmatically like a degenerate Mona Lisa, but on the box cover, the image was reversed horizontally. The lithographs pulled at Landfall developed directly out of the larger-scale *JUAREZ Series* works; Allen excised and excerpted symbolic details, adding marginalia: "I wanted the prints to be the same size as an LP, so they would all fit in one box. The images were edited out of the different sections of the drawings—the bed with the heart, the cantilevered bed, the bed with the grave in it, the trailer room, and so forth." He listed the "meta four"-ical motifs in a journal:

Study for the Juarez Suite: Six Meta Four Incidents
1. Pillow in the Mountains
2. Room with Horns
3. Bed with Heart
4. Bed with Ditch
5. Ditch with Heart
6. Heart in the Mountains

In the final version of the sixth print, it's been retitled "Pillow in the Mountains II," this postmurder, postmetamorphosis pillow is aflame, tucked between livid bloodred peaks. Allen drew all six images on a single large lithographic stone, amplifying the degree of difficulty exponentially—he had to ensure every image was perfect (no do-overs on individual segments)—before printing it (in ink with glitter details) on approximately twenty-four-by-thirty-six-inch sheets of Special Rives BFK paper and then hand-tearing them into their constituent LP-size panels.

The iterative process of building up the prints in layers is evident in the heavily annotated images—lyrics, captions, corrections, and errata—linking the prints more closely to his notebook investigations than the pristinely finished, larger *JUAREZ* works in Houston. Allen finished the lithographs on September 15 and headed home to Fresno, but Jack did not complete pulling the entire numbered edition of fifty until April 1, 1976. As promised, the Morgans bought twenty-five of the fifty-box edition, keeping the operation afloat financially.

MEANWHILE, TERRY AND Jack haphazardly shipped out records, first mostly to friends and dealers—Ruscha, Artschwager, and Denver and Betty Peckinpah were at the top of Terry's list for early shipments—and then through a primitive Landfall mail-order system. The trickle of mailings elicited a thin trickle of positive press, which took months or even years to emerge, and most of which mentioned that the album was virtually impossible to find. Proper distribution was not forthcoming, and no one at Landfall really knew what to do with the record other than to sell it in their shop and wait for people to call or write and place orders. For years, *Juarez* languished in semi-obscurity. But it managed eventually to find its circuitous way onto the turntables of some unexpected fans in

Allen's old Hollywood stomping grounds. In addition to David Soul—
who became an unwelcome admirer, given his theft of the original
Juarez book—Jack Nicholson and Steve Martin were also professed
fans of *Juarez*, though Terry only heard so secondhand through mutual
acquaintances. Once George Carlin called the Allens' home in Fresno
out of the blue to tell Terry how much he loved both *Juarez* and *Lubbock
(on everything)*. (Terry was out, so the comedian spoke to a slightly
suspicious Jo Harvey.)

Realizing that Landfall lacked the channels for distributing records,
Jack, Ethel, and Terry decided to create a separate business entity, dis-
tinct from Landfall, to move the album into the world, clearly a necessity
if they ever hoped to release anything else. On a drive from Fresno to
San Francisco to visit Bill Wiley, they tossed around ideas for names—
Four Deuces, American Fate—finally settling on Fate Records, "one of
the weirdest record companies that ever existed," a conceptual art proj-
ect disguised as a label.

After the release (or "escape") of *Juarez* in 1976, Allen began to
receive more offers to perform his music on the gallery and art institu-
tional circuit, "the only way for most people to hear the songs" and to buy
the album—directly from the source. His milieu would not include music
venues or festivals for years yet; until 1979 and *Lubbock (on everything)*,
the audio components of *JUAREZ* circulated almost entirely within the
confines of the art world. The Morgan Gallery, the Claire S. Copley Gal-
lery, and other sympathetic dealers picked it up, and eventually it ended
up in various art museums, archives, and private collections. After
Allen's participation in the 1977 Whitney Biennial, Marcia Tucker began
stocking the LP in the museum's shop, which helped sales considerably.
Eventually, after pressing and shipping two thousand additional copies
of the stand-alone LP (three thousand total), Fate reissued *Juarez* in
1980, to capitalize on *Lubbock (on everything)*, with a plain, stark black
cover—"I don't know why we did that; I guess a combination of expedi-
ence and cheapness"—followed by a replica 1991 CD edition.

JUAREZ THE RECORD, the set of songs as fixed in recorded media, finally
unveiled for audiences—for people outside Allen's inner circle—the actual
core story of *JUAREZ* with its visceral violence, raw sexuality, anticolo-
nialist overtones, and black humor sheathed in folkloric antinomy.

In October 2016, five months after the record's reissue by Paradise of Bachelors, Dan Fox, coeditor of the art magazine *Frieze*, proclaimed *Juarez* "a singular moment in the history of country music" and "one of the most singular and underrated works in the history of US conceptual art."[9] Indeed, it stood alone, upon its 1976 release and to this day, as a singular example not only of a (nominally) country music concept record but likewise as a work of conceptual art itself, a keystone example of vernacular modernism. *Red Headed Stranger*, Willie Nelson's 1975 masterpiece, recorded seven months before *Juarez*, represents, in terms of cinematic scope, Western narrative ambition, structural and thematic cohesion, and spartan sonics, the only legitimately comparable precursor or analog in the realm of country music. *Red Headed Stranger* was far from the first concept album in country music history—it was not even Nelson's first—but before *Juarez* no country concept album, and vanishingly few (if any) albums of vernacular American music in any genre, could claim any substantive art-world resonance.[10] *Juarez* represents, of course, just a single articulation of the multivalent *JUAREZ* mythos, something much vaster and more nebulous, a mythic cipher of the chthonic American Southwest and borderlands, that fossilized dreamscape of dead oceans and slaughtered civilizations, fissured by cloven canyons and vanishing-point highways. But without *Juarez*, the album, it is difficult to make the corresponding case that *JUAREZ*, the broader body of work, stands as such a landmark of conceptualism. The album, more than any other single iteration or articulation of *JUAREZ*, is integral to its art-historical legacy.

Art admirers and music fans alike who were unfamiliar with Allen, or had only seen the *JUAREZ* artworks, were granted access to a more ostensibly personal, familiar, and accessible articulation of the story, packaged in the digestible quanta of country songs. *Juarez* presented *JUAREZ* as an audible tale told by a master storyteller rather than a series of mythographical artifacts, hieroglyphs, and fragments of poetry on a picture plane. The album, structured itself like a traditional Tejano corrido—framed by an introductory salutation or metanarrative statement of storytelling intent ("The Juarez Device") and a final farewell, or *despedida* ("La Despedida")—finally articulated and elucidated the story in a more direct way, proving the potential immediacy and power of Terry's approach to narrative art.[11] It was both capstone to the first

generation of *JUAREZ* and a Rosetta Stone to decipher and render legible the oft-maligned opacity of the visual art. As music *Juarez* also inhabits time, a critical dimension for a story that contains and manipulates historical time, folding the conquest of Cortés into a murder in twentieth-century Cortez. As Allen wrote at the time, "A drawing is 'over' when you finish it . . . in many ways . . . a song has just begun (if you perform it). And vice versa?"

Although we might interpret the violence as intercultural or (as Dave Hickey suggests) intergenerational, Jabo and Chic's motive for the murder of Sailor and Alice is never revealed or unraveled, nor is it meant to be—that occlusion, that vacancy, *is* the story.[12] The murder itself lacks a song or dialogue to explicate it; there is just the diegetic crash of a storm brewing and shattering glass (lifted from sound effects records) where the confrontation between the couples should be, at the end of "Honeymoon in Cortez." No real climax or catharsis clarifies the carnage in that Cortez trailer. When, in "La Despedida," we leave Jabo in Melodyland, the bruja Chic has disappeared into Carlotta ("d'nada," nothing), and "there ain't no God at all / Just some jukebox down the hall . . . playing the blues."

"Not only are there no happy endings," Hickey proposed of his friend's art, "there are no endings."[13] The record keeps spinning; only a song remains. Music might sustain us, just maybe, against the vacant sea.

EVEN BEFORE *JUAREZ* was released, Allen was already making speculative track lists for a follow-up record called *Lubbock* (not yet everything), another album titled after a city. The title existed at least two years before the concept tightened and the shape, structure, and track list cohered. He'd escaped *JUAREZ* for the time being but was already fretting the next thing: *RING*. "It is difficult to suddenly shove my head into a new body of work," he wrote. "I don't think I operate that way, but I'm not sure."

CHAPTER 29

SNUFF QUEEN IN PARADISE

They met out on the highway
At the Paradise Motel Lounge

—"High Plains Jamboree"

THE HANDHELD CAMERA TRACKS BACK FROM THE OPEN DOOR OF A MOTEL room to find Jo Harvey, backlit in silhouette by the harsh parking lot daylight, wearing (in her words) "a sleazy kimono," black wig piled high into a mountainous, drag-inflected beauty-pageant bouffant, applying elaborate makeup. It shakily pans to the bathroom, past pantyhose and underwear hanging to dry, slowly circling around to where instead of a bed, a horse stands on plastic sheeting, right behind Jo Harvey's shoulders, chewing her wig.

They'd asked permission to use the room, which the artist Joe Ferrell Hobbs had rented. The motel manager was surprisingly philosophical about turning one of his rooms into a temporary stable, replying to Terry, "Why not? Horses are cleaner than most of the people that stay here."[1] Jo Harvey was not so sanguine. Terrified of horses and of her cinematic debut, before the shoot she vomited in the room next door, collapsing on its bed, praying its occupant would not return. The resulting fifteen-minute color video, titled *Snuff Queen* (a reference to the slang term for a country music groupie) represents a first within a first for Terry. A component of his first sustained, dedicated foray into sculpture—which, audaciously, comprised an ambitious, large-scale environmental installation in a museum—it was also the first real foray

into video (and filmmaking more generally) for both Allens (and probably the palomino too).

The Fort Worth Art Museum had invited eleven artists—including Hobbs, Lubbockite George Green, Red Grooms, video artist Andy Mann, Robert Rauschenberg, and photographer Garry Winogrand—to attend Fort Worth's Seventy-Ninth Annual Southwestern Exposition and Fat Stock Show in late January 1975, granting them full access, "behind-the-chute passes," to observe the inner workings of the rodeo and the daily lives of its cowboys, cowgirls, clowns, and contractors. The artists then met with museum staff to select spaces in the museum in which to install rodeo-inspired work they would create, over the course of the next year, for an exhibition coinciding with the Eightieth Exposition, which shared a parking lot with the museum, as part of a broader "celebration of that religious event."

The show, which opened on January 25, 1976, only one month after the closing of the *JUAREZ Series*, was called *The Great American Rodeo*, and Allen loved it. He relished the opportunity to conduct in-depth research in his home state, among artists he respected—he particularly enjoyed getting to know the two photographers, Mann and Winogrand—and the luxury of a generous budget and an entire year to prepare a commission. He was so excited about the experience that, shortly after returning to Fresno, he wrote "Helena Montana," his punning, menacing version of a rodeo song, which he performed at the opening.[2]

Allen's piece *The Paradise*—a reference to "the Paradise Motel Lounge" frequented by the two lovers of his song "High Plains Jamboree"—was the largest and most adventurous work he had ever attempted, an extension of his *JUAREZ* "extension box" dioramas into human-scale architecture. The sculptural environment conflates and collapses what Terry imagined as the three primary spaces the typical hard-living, itinerant rodeo circuit rider inhabits: a lurid honky-tonk club and a cheap, seedy motel room, bisected by a rodeo arena. In contrast to the Eastern and Northern artists in the show, who were fascinated by the novelty of the equine and bovine spectacle, "I had grown up around those images, so I wanted to do something much more internal," Terry said. As he wrote following his rodeo immersion, "There are things that are unique about it, but it's the things that aren't unique that are the most interesting."

Viewers approached the installation through a twenty-five-foot-wide oyster shell "parking lot" in front of a wide pink wall, bedecked with a red neon sign reading "The Paradise" in script, a planter box below filled with cacti, pink plastic flamingoes, and fake palm trees—foreshadowing the "plaster palms" of "Oui (a French song)," which he wrote immediately thereafter, in February, to play at the Whitney Museum, at Tucker's invitation. Two upholstered vinyl doors, designated "Lounge" and "Motel" in more neon, led inside a bricolage of contiguous but disjunctive rooms. A garish corridor with zebra-print congoleum flooring ended at a jukebox—the panel of which read "Desperate Rooms"—containing forty-five honky-tonk singles, sourced from Sumter Bruton's local record shop.[3] A white fence separated this honky-tonk hallway from a dirt-filled rodeo arena hung with red, white, and blue bunting, in the middle of which stood a bed with a shovel shoved into a dirt-filled grave dug into its mattress. Turquoise shag carpeting led to a generic motel room assemblage, where a small television atop the dresser showed *Snuff Queen* on a loop.[4]

"That was a critical show in a sense for me, as far as dealing with a space *being* a piece, the idea of a room as an event," he told me. "It was the first time I thought of an installation . . . like walking around inside of a brain." In a coeval notebook, he observed, with the satisfaction of a quiet epiphany, that "theater is a justification to combine" media—drawings and songs, sculptures and videos—the excuse and raison d'être he'd been seeking to create "theatrical residue." Because it contains the potential of geography and motion, privileging "movement through a room," theater could provide "a unifier on a general level" for his simultaneous visual, musical, and narrative impulses.

CHAPTER 30

A STORY WHICH SWALLOWS
ITS OWN TALE

Well it's only fair
When you hear yourself swear
Baby I'm sorry, it'll never ever happen again

— "Room to Room"

IN MARCH 1976, WITH A MAY SHOW AT CLAIRE S. COPLEY GALLERY LOOMING, Allen started to panic. He was formulating a few different projects at once, all largely text-based, none of which seemed to be bearing anything but the most rudimentary, bitter fruit. Finally, he managed to produce three pages of typewritten text, a story he called *The Evening Gorgeous George Died.*

The stark tale of two anonymous characters, another "simple story," begins with an ambiguous epigrammatic prologue: "We are all re-living the future, consequently . . . all art is viewed from behind." "He," a struggling writer "from a family of sports promoters"—wrestling promoters, specifically—is married to "She"; they have no children. Their relationship, corrupted by his addictions to alcohol and gambling and her paranoia, devolves into mutual accusations of infidelity. She discovers his sexual fantasies recorded in his notebooks, and shocked, begins keeping her own diaries. Their respective fantasies are activated, actualized, and perpetuated through their mutual suspicion and jealousy, both professional and personal:

He accused her of having affairs he had already finished.

In return, she accused him of having affairs she was still just planning . . .

She hated his fantasies, but used them well as a motivation for her own reality.

He hated her realities, but used them well as a motivation for his own fantasy.

He stops writing anything but angry letters and telegrams, inheriting her sensitivity and paranoia, and She begins writing, usurping his words. Having thus merged or traded aspects of their identities, the couple separates. As He disappears on Mexican benders, her career takes off, and She is published. On the same day both her father and Gorgeous George the wrestler die (December 26, 1963), He finally succeeds in committing suicide. Years later, She writes an acclaimed story, adapted and serialized for TV, called "The Evening Gorgeous George Died," the nature of which is unspecified. She remarries and fades into obscurity.

Inspired by Malcolm Lowry's novels *Under the Volcano* and *Dark as the Grave Wherein My Friend Is Laid,* as well as Roland Barthes and Alain Robbe-Grillet, Allen deployed this spare narrative of dissolution as the basis for his next body of work, dissecting, deconstructing, and enacting the text of this "warfare of words" in various ways—as he puts it, "taking that story and running it through all its possibilities." He called the resulting multipartite body of work *RING,* a reference to the circularity of the story as well as to the wrestling rings and wedding rings that encircle the marital combatants. As he explains in the 1981 cumulative catalog, the text of the three-page story "is the base from which the entire *RING* piece evolves out of and revolves around."[1]

This was a different kind of narrative art, an experiment in generative linguistics and narrative permutations that is sometimes as much about the language as its visual manifestations. By leaning into the text itself—the actual letters, punctuation marks, and words contained in the story—*RING* dramatically departs from the pictorial density and palette dazzle of *JUAREZ*, blanching his earlier style of its illusionism and ripe color, resulting in objects, often sculptural and monochromatic

or grayscale, that more often resemble concrete poetry or minimalist art than anything he had attempted to date.

In his journals, Allen could not help, with some apprehension, but compare the strange new objects he was rushing to construct in his studio in the spring of 1976 to *JUAREZ* (his "declaration of independence" as an artist) and *The Paradise*: "Like *JUAREZ* it *is* the story. It is not *about* a story. . . . It is a cold and paranoid violence compared to the heat in *JUAREZ*. . . . Much of it came from the rodeo piece *The Paradise* . . . the first time I really dealt with actual human scale and space."

RING RANG CLEARER autobiographical resonances than *JUAREZ*: wrestling as a family business, writing as a competitive sport between spouses, marital strife and jealousy, Mexico as a site of escape or exile, and corrosive alcoholism—an incendiary conjugal cocktail as devastating as napalm.

The work that Allen installed at the Copley Gallery in May was shockingly reductive, in the context of the artist's usual maximalist style. He completed it in his studio on May Day 1976, noting with some anxiety that the experience was anticlimactic and muted compared to his usual feelings—relief, pride, *l'appel du vide*—upon finishing a body of work. "For the first time," he wrote, "there is a lot less to look at in a lot of ways." What there was to look at was an installation of discrete domestic elements: four sculptures, each accompanied by a framed page of story text (the prologue was allotted its own page), hung at awkward heights to prod readers into assuming wrestler-like poses, with a corresponding drawing on the opposite wall of the gallery. Three of the sculptures were boxy, gray tableaux that resembled the ghosts of home furnishings, which served both as artworks as well as pedestals for found objects of mysterious import. A vanity held a lamp and a framed photo of S. A. Pierce playfully menaced by dwarf wrestlers; a broken glass, ashtray, and a mirror sat on a narrow bar; and on a low platform stood a dollhouse-scale wrestling ring with a wedding band placed in its center. Each furniture tableau was almost entirely devoid of detail and ornamentation, its provisional plywood form coated in the viscous (and highly toxic) metallic paint Sculpmetal, which Allen liked for its "eerie, floating sense," especially when lit with colored lights. The final

sculptural object was a bird cage containing a black bird, a reference to the He character's auditory hallucinations.

Neither audiences nor critics knew what to make of this strange new work, especially given its somewhat muddled presentation at Copley Gallery alongside *JUAREZ* works, including the *Suite*. The announcement mailers featured the cover photo of *Juarez*, and the opening, on May 10, 1976, three days after Terry's thirty-third birthday, was billed as a record release party in addition to the debut of *The Evening Gorgeous George Died*. Allen played a show the night of the opening at Improvisation West on West Melrose Avenue, which until 1974 had been the Ash Grove, and, since *RING* did not have songs explicitly connected to it, performed primarily *Juarez* and future *Lubbock* songs.[2]

William Wilson, the same *LA Times* critic who reviewed the *Cortez Section*, also covered *Gorgeous George*, much more favorably—it reminded him of "a Harry Chapin lyric." He marveled at Allen's "goggling galaxy of superior gifts" but worried that "the fact that he can do so many things is almost a curse," suggesting, like so many others would, that Allen's true calling, as a visual artist who was also a writer of songs and stories, was filmmaking.[3]

ON SEPTEMBER 19, 1976, Danny Parrish died. "My oldest friend is dead," Terry wrote. "He was one of three people with the same name who remained in pieces all over my mind."[4] An incipient project titled *Jackalope* became *Bleeder*, a veiled biographical tribute to his late hemophiliac friend (or his fictional shadow). Of the two remaining Dannys of Terry's childhood triumvirate—Thompson and Harris—one more was likewise doomed.

The following month, still mourning, Allen traveled to Valle Crucis, North Carolina, for the Southern Rim Conference, a gathering, organized by Appalachian State professor Bill Dunlap, of Southern artists and sympathetic curators: William Christenberry, William Eggleston, Jane Livingston, Jim Roche, Paul Schimmel, and James Surls, among others. Allen, never one to abandon an opportunity for a nickname, called this orgy of drunkenness, philandering, pistol-shooting, and all-around chaos Camp Death. Marcia Tucker and Terry attempted to keep each other out of trouble.

Tucker, who would later write an essay for the 1981 *RING* retrospective catalog titled "THE RING: A Story Which Swallows Its Own Tale,"

included *Gorgeous George* in the 1977 Whitney Biennial, one of her final gestures of kindness to Terry before the museum fired her. While installing the piece in February 1977, Terry visited the gallery next door, where Bruce Nauman was carefully positioning the heavy steel floor elements of his *White Breathing*. Terry spotted H. C. Westermann standing by his three sculptures, talking to Dennis Hopper, and he inserted himself in the conversation. It was his first proper chat with the man who would become his foremost artistic mentor.

Born in 1922, Horace Clifford Westermann, known to friends as Cliff, was over twenty years older than Terry, old enough to be his father (though still a decade younger than Manse), and their relationship fulfilled the paternal void in Terry's life. A veteran of World War II (as an antiaircraft gunner aboard the USS *Enterprise* in the Pacific) and the Korean War (as a marine infantryman) as well as a railroad gandy dancer, professional acrobat, and master carpenter, the ropily muscular Westermann was heavily tattooed in a sailorly style, with the sea-legged bearing and intricately purpled skin of the Pierces. His art's deep engagement with the sea, its satirical critique of the twin American imperialist follies of expansionist war and global capitalism, and its hilarity in the face of death, influenced Terry and his work enormously. He admired Westermann's blue-collar work ethic and fluency in the bawdy patois of roustabouts and sailors—a vernacular, both linguistic and artistic, that he deployed to infiltrate the art world with his drolly seductive drawings and wooden sculptures. The trick, for Westermann, a vernacular modernist, was in the translation, inhabiting two artistic languages at once and thereby addressing multiple audiences. Terry observed and absorbed his friend's two-tongued sleight of speech.

The two men maintained a lively mail correspondence but never again met in person. Westermann and his wife, Joanna Beall, on their way home from Marfa to Connecticut, were in Lubbock on the night of Terry's only concert that Pauline ever attended. But they missed each other, death ships in the night.[5] Instead of spending long overdue time with his hero, Terry drove Pauline back to Amarillo, and Cliff and Joanna hung out with Jo Harvey, Katie, and Harv, a fellow carpenter.

MESSAGES FROM WRESTLERS IN HELL, the third episode of *RING* (but the second shown) was ill-fated from its troubled genesis, and Allen remains

unsettled by it. He had been invited to exhibit in the Tenth Biennale de Paris, and flush with his positive Whitney Biennial experience, he took the opportunity to debut a brand-new installation at the Musée d'Art Moderne de Paris at the historic Palais de Tokyo—and to take Jo Harvey, the boys, and their babysitter, Karen Tanaka, on a much-needed family vacation. Nothing went as planned, but they still managed to enjoy themselves thoroughly on their first visit to Europe.

Upon arrival, a Biennale curator gathered the American artists and announced that she regretted to inform them that the total budget for per diems was twenty-five dollars—to be split among all of them. The artists pooled their funds, siphoning off their artwork installation stipends to supplement living expenses. They found moments of fugitive fun on the cheap. At Brasserie Lipp (the haunt of poets Verlaine and Apollinaire), Terry and Jo Harvey sketched the tattoos—tornados on their ring fingers, four dots (or "rocks," signifying their family unit), and, for Terry, a pachuco cross on his right hand and an ouroboros bracelet on his wrist—that, on September 19, 1977, after a brief wedding vow-renewal ceremony, the artist Ruth Marten inked in indigo in the museum. Jo Harvey's tornado "wedding ring" was "longer and more elegant than mine—which is coiled, appropriately, more 'up-tight,'" he wrote.

Terry intended *Messages* as an elaboration and abstraction of *Gorgeous George*. The installation featured similar Sculpmetal furniture-set tableaux—with a larger wrestling ring set piece—but tilted and skewed, injected with shots of color, and enhanced with infernal red lighting. The accompanying texts were excised of words, stripped of story, leaving only punctuation marks, with arrays of symbolic objects, lights, and a cassette soundtrack of "pedestrian sounds" (breaking glass, birds, traffic noise, dragging furniture) filling the absences like pus in abscesses. He had distilled the narrative down to a negligible grit and stain, devoid of visual pleasure or discernible emotional context—"just a bunch of leftovers, really." He disliked *Messages* as soon as he completed it, barely in time for the opening, with scavenged tools. In retrospect he considered this third episode of *RING* "a tautology, something that has absolutely no meaning, no connection to anything else." However, the process of making it and realizing that emptiness, gazing into the void he had created, satisfied some necessary (if rancid) curiosity, even if he disowned the actual artworks. "It was not well received at all,"

he reflected to me. "People picked up on the odd malignancy of the piece."

The months spent preparing *Messages* had been sleepless ones, and sometimes he felt that, between lack of rest and appetite, exacerbated by the vicious cycle of headaches and pills, he was dancing on the precipice of psychosis. "Someone told me I looked tired today," he wrote. "I haven't slept in four months." He recorded murderous fantasies and deranged daydreams in his journal. The American Cultural Center, which was supposed to serve as a basecamp for American artists and was exhibiting *Gorgeous George*, closed at three in the afternoon every day, when the aloof staff would wheel banks of desks and telephones into the gallery space. The center never hosted any events, unlike other countries' counterpart embassies' cultural organizations, which threw lavish self-congratulatory cocktail parties. "We'd get mysterious calls on the hotel phone," Jo Harvey recalled with a shiver. "There was always a Citroën parked out front, with a guy sitting in it at all hours." They discovered later, after similarly disheartening experiences at other international exhibitions, that the network of American Cultural Centers was allegedly a CIA front. The sinister resonances of espionage and suppressed violence suited the malevolence and paranoia of *RING*.

Before flying home, Allen played a concert at Galerie Farideh Cadot, which was showing some *RING*-related study drawings—his first performance for an international audience, unfamiliar with both country music and English. "It was the first time I encountered people who didn't understand what the hell I was singing," he laughed. "The only song they responded to was 'Rendezvous USA,'" because of its doggerel French lyrics.

CHAPTER 31

A DUET OF FALSE EVIDENCE

But me and you we're not to blame
Love always returns from where it came
Back to black and in the end
It's all the same

—"Back to Black"

IN THE WINTER OF 1978, BACK IN HOUSTON, JO HARVEY PUT ON A BLOOD-flecked mask, and Terry removed one.[1]

Round one: Lights up on a wrestling ring furnished, in one corner, with a chair and a small table holding a typewriter and lamp, and, in the opposite corner, an unkempt bed and suitcase spilling vagrant debris. In the domestic corner, a woman in a clear plastic mask, the faceless face, dressed smartly in a dress and red scarf, examines a photo of dwarf wrestlers, reads, types, and does her toilette, applying perfume and nail polish. Round two: A masked man, the heel, smokes and drinks on a bed as rumpled as he is, fondling playing cards, postcards, and women's undergarments. Round three: Two luchadores, a man and a woman, step through the ring ropes, standing as silent sentries before grappling and slow-dancing around the furniture.[2] Round four: Masked woman and man surreptitiously investigate each other's corners and letters, as the wrestlers observe, arms crossed. Forty minutes into the one-hour performance (or match), the woman and the man, accompanied by disembodied amplified voices—"secret readers"—read a story about He and She. Round five: The wrestlers reengage, their holds and throws increasingly vigorous and fatiguing, while the secret readers recite romantic

bromides. The masked couple embrace, finally, and fall to the mat, defeated in death or ecstasy. Lights down, no winner declared.

THE EMBRACE . . . ADVANCED TO FURY, Jo Harvey's first widely seen stage performance and first proper artistic collaboration with Terry, opened on January 12, 1978, in a nondescript warehouse on the outskirts of Houston, starring Jo Harvey opposite local actor Brett Cullen as He and Terry and Vicki Duffey as the secret readers. Terry hand-built bleachers for the audience and secured a wrestling ring through Houston promoter Paul Boesch, a veteran of the same Texas circuit Sled had worked decades earlier. Boesch, with help from the fabulously named fighters Joe Pizza and Tiger Conway, helped Allen hire two professional wrestlers, Maria DeLeon and Sammy Jones, for the performance:

> [Boesch] totally reminded me of my dad. His desk was a shambles, just covered with stuff: junky trophies, piles of muscle magazines, and these incredible pictures of him and midget wrestlers. . . . It dawned on me that I was doing exactly the same thing my dad did. I was putting on this spectacle for people in a wrestling ring. . . . That's what art does—it takes you into these weird circles back into yourself . . . places you never in a million years thought you'd ever go. So I *did* end up being a wrestler promoter after all.

With *The Embrace,* the second episode of *RING,* Allen finally accepted, temporarily and on his own terms, Sled's inheritance, the family wrestling business.

The occasion for the premiere of *The Embrace . . . Advanced to Fury* was *American Narrative/Story Art: 1967–1977,* another exhibition at CAMH, which opened on December 17, 1977. Once again curated by Allen's young advocate Paul Schimmel, under the direction of Jim Harithas, this survey featured forty-three artists, many of whom Terry handpicked himself. Schimmel explained that Allen, personally invested in this opportunity to vindicate his and his friends' decade of engagement with narrative art in the face of near-constant curatorial and critical disapproval or dismissal, took the reins and led the charge. "Terry was really the central figure," Schimmel told me. "No Terry, no narrative show. He was the excuse and the opportunity to do the exhibition."

Tensions between curator and artist mounted, particularly when it came to artist selection and budget. Terry wanted to emphasize the underrecognized West Coast, Midwest, and Texan artists in his circle, those whom he felt had explored narrative dimensions in art earlier than the East Coast establishment, those overexposed "enemies from New York." Allen's proposed budget for *The Embrace* performance alone exceeded what Schimmel had allotted for the entire exhibition, so they haggled endlessly about money. When agreed-on payment was not timely, Allen snapped and confronted Schimmel: "I pushed him into a broom closet and told him if I didn't get my check, I was going to kill him. That's the only curator I ever actually threatened to kill."

The story staged in *The Embrace* was clearer, starker, and more widely relatable than anything in *RING* to date, and "Jo Harvey was fierce, she was inventive, and she owned that fucking piece," Schimmel exulted. By subtitling *The Embrace* "a theater occurrence by Terry Allen," the artist claimed an equal footing with the lineage of Dadaist theater, Samuel Beckett, and Artaud, as well as more recent developments: the procedural, metanarrative fictions of Robbe-Grillet; the theatrical work of Peter Brook, Richard Foreman, and fellow Texan Robert Wilson (whom he had recently met); and Richard Schechner's writings on "environmental theater."

In addition to the performance, Allen showed all new pieces: two large mixed-media constructions from *Fighters of the Darkness*, the final episode of *RING*, still in process, *Notations from THE CROSSING* and *Red Mail/La Dama*, as well as five verbosely metacritical drawings of silhouetted, cartoonish figures from a new series titled *Object/Dramas*, shown as a larger group in 1980 in *Terry Allen (part of and some in betweens)* at the Baxter Art Gallery at the California Institute of Technology and never revisited thereafter. The *American Narrative/ Story Art* catalog includes an early version of Marcia Tucker's *RING* essay and a ten-inch flexidisc record with recordings of Allen's "The Collector/Art Mob" (recorded in Fort Worth in 1973, featuring Hickey on handclaps) and "Writing on Rocks across the USA," alongside tracks by other artists in the exhibition, such as Laurie Anderson, Dennis Oppenheim, and Jim Roche.

The exhibition traveled to New Orleans and Santa Barbara, but the Allens only performed *The Embrace* again in Berkeley at the University

Art Museum, in October 1978, and one final time in Kansas City for the 1981 *RING* retrospective at the Nelson Gallery/Atkins Museum. For these subsequent performances, Brett Cullen, in the role of He, was replaced by the curator Jock Reynolds, whom the Allens had befriended through his stewardship of the San Francisco performance space 80 Langton Street, which had hosted a notoriously cacophonous artists' jam session, circa 1977, featuring Terry, Bill Wiley and Mike Henderson on guitars, Richard Shaw on banjo, the poet Michael McClure reading, and Bruce Nauman on fiddle, an instrument on which he had only the most tenuous grasp. In early 1978 Jo Harvey had written to Reynolds asking to perform her first one-woman play there, listing as her qualifications *Rawhide and Roses* and her domestic discipline—having "scrubbed the bathroom floor over 1000 times," she was ready for the spotlight. Reynolds, charmed, became an ally, booking Jo Harvey in April and Terry for several solo shows. An autobiographical "poetry performance" (as it was described on invitations), Jo Harvey's *A Moment's Hesitation* evolved from her work with Philip Levine and Yvonne Rainer and featured a striking (and acrid) shoe-burning scene. Soon thereafter, Jock starred in the video version of *The Embrace*, shot in Berkeley and exhibited numerous times, often on a monitor in a miniature wrestling ring.

Terry struggled with the final installment of *RING*, *Fighters of the Darkness*, throughout 1978 and 1979, revealing it in stages at a series of solo gallery shows.[3] "The worst (most frightening) aspect of this work is its rigidity," he fretted in his journal, worrying about the fourth episode of *RING* manifesting as a "silent blood bath" or, worse, betraying its bloodlessness. This new group of bricolage works returned to the relative safety of representational imagery and identifiable symbolic systems, providing some ballast to the conclusion of the *RING* cycle. Some, like *Notations from THE CROSSING*, *Desires from a Duet of False Evidence*, and *Dark as the Friend Wherein My Grave Is Laid* ("a reversal for Malcom Lowry"), with its Mexican map and high-heeled sandal, could easily be mistaken for late *JUAREZ* pieces. Letters from He to She, dispatches from His dissolute exile in Juárez, populate these epistolary works, surrounded by lucha libre imagery, playing cards, and birds, suggesting the interior landscape of the He character's febrile, mezcal-mutated mind. If *Fighters* betrays a measure of strenuous

overcompensation for the unmoored and vaporous linguistic qualities of *Messages from Wrestlers in Hell*, it also provides the most immediate and visually satisfying chapter of *RING*.

IN RECLAIMING THE ring as a performance art site for enacting marital drama and alcoholic trauma, Allen was both memorializing and subverting his parents' relationship to wrestling. His *RING* notebooks outline these tensions. In one, he enumerates a list of rules for living that relate directly to *RING* and the legacy of Sled and Pauline:

> Never believe that anything you might do can prevent an alcoholic from drinking—especially if that person is of your own blood.
> Never try to be a respectable person . . . because the weight of respectability is death and everything below that is lobotomy.

Having broken with his family and his hometown by pursuing the life of an artist, but thereafter settling in Fresno for the sake of a secure, middle-class family life, he had been wrestling for years with the mask of respectability, donning and doffing it with schizoid frequency. By mounting a masked play about a troubled marriage marred by alcoholism, in a wrestling ring, and using his grandfather's image in the work, he had dropped any lingering pretense that his art was not sometimes autobiographical or that, as an artist, he had left his past in Lubbock behind. *RING*, with its "weird circles back into" himself and his past, became an important step toward *Lubbock (on everything)*.

CHAPTER 32

THE ONLY MOUNTAIN IN LUBBOCK

My ego
Ain't my amigo
Anymore

 —"My Amigo"

EVEN WHILE LIVING AMONG THE LUSH VALLEYS, SCENIC MOUNTAINS, AND urban gridlock of the Golden State, the wide-open Panhandle landscape loomed large in the language and imagery of the songs Terry was writing, which he described in terms more cinematic than sonic: "The wind and the dirt are etched into West Texas music." In July 1978, he hoped to etch that wind and dirt into the grooves of a second record. The result ranks as his most widely known, critically acclaimed, and arguably most approachable album.

Although in retrospect he could not have made *Lubbock (on everything)* anywhere else, in many ways Lubbock was the least likely place in the world for him to make a record, or to make anything, including amends: "My life changed drastically after my father died. . . . I used Lubbock as a scapegoat—like a lot of young kids do—just to propel me out of there as quick as I could go. . . . I never really knew Lubbock until I went back to record *Lubbock (on everything)*. I'm still a little surprised at myself, because at the time I had built up such a backlog—a catalog— of negatives about Lubbock and Texas and where I came from." He was thirty-five and a father himself—Bukka was eleven; Bale, ten—with a fledgling art career but few musical prospects, when he returned to make his second record. Little Feat released their languid, stately take

on "New Delhi Freight Train" on *Times Loves a Hero* in April 1977, and along with Bobby Bare's covers, it had helped raise his songwriting profile and publishing income.[1] But for those familiar with his name, Terry Allen remained an artist who coincidentally wrote and sang songs, to the satisfaction of some (artist friends and the most intrepid record collectors) and the mystification of most (most gallerists, curators, and critics).

The summer of 1978 was of course not the first time a retreat to Lubbock had provided a perspective, or "undertow," that catalyzed his work. But this trip was different from the one the Allens had taken eight years ago. The context—the company, his collaborators, the overall climate—had changed, realigning his attitude toward the city he'd fled twice.

IN LATE 1977, as he was finalizing his contributions to *American Narrative/Story Art*, Terry continued to compile track lists for the imaginary record he called *Lubbock*, which after a few cuts—such as "Late 1961," "Cocaine Cowboy," "Opposite Wing," and "Helena Montana"—had largely solidified by late spring of the next year. As he closed the circle of *RING*, he had begun casting I Ching coins to help inform decisions about his art, including how to pursue a *JUAREZ* screenplay (thwarted by the fallout with David Soul), the formulation of rudimentary early concepts for *DUGOUT* and *YOUTH IN ASIA*, and approaches to recording a second album. "I had a fantasy," he explained, "of cutting some of it in LA with Lowell [George] producing; cutting some of it in New York with Laurie [Anderson] producing; and cutting the Lubbock-oriented songs in Lubbock with whoever I could find to work with." Apparently, no auspicious studios or producers manifested through the hexagrams. George was consumed by touring, and he never even asked Anderson: "In addition to being broke, I was blocking myself with these geographical fantasies."

AFTER A FEW months of floundering frustration, in December 1977, just before heading to Houston, a windfall and a phone call reignited the project and provided some geographical and conceptual focus. First, Allen was awarded his second NEA grant, a $10,000 surprise that he claims "just came in the mail" with no warning or foreknowledge that he had even been nominated. Then his new acquaintance Paul Milosevich—a Coloradan painter who had, rather anomalously, moved from Southern

California to Lubbock and tracked down Allen (and a copy of *Juarez*) after Bobby Bare had divulged to him that he was among his favorite new songwriters—telephoned Terry in Fresno and suggested a new plan.[2] Why didn't he come out to Lubbock and meet Joe Ely?

By 1978, the slight, slyly serene Ely was beginning to make a name for himself in the wake of his 1977 self-titled solo record for MCA. Fresh from eye-opening UK tours with Carl Perkins and Merle Haggard, during which he had befriended the Clash, with whom he later toured and recorded—that's Ely singing Spanish backing vocals on "Should I Stay or Should I Go?"—Joe was back in Lubbock, working with "a hot band" that included accordionist Ponty Bone, fiery lead guitarist Jesse "Guitar" Taylor, and multi-instrumentalist and pedal steel virtuoso Lloyd Maines. Though Ely had lived in Lubbock since age twelve, Terry had never met him—Joe was four years younger—but he remembered Ely's fellow Flatlanders Butch Hancock and Jimmie Dale Gilmore hazily from high school. Paul gave Terry Joe's and Lloyd's phone numbers as well as the number of local studio owner, saxophonist, and producer Don Caldwell. Terry called Don and told him he had twenty-one songs to record and "needed a hell of a deal." Don, charmed by Allen's audacity but dubious of his solvency, agreed. Able now to invest some NEA money in the project, Allen convinced Jack Lemon to cover the studio costs, in the form of a $4,000 loan (essentially a recording advance).

As soon as the Allens hit the Lubbock Loop, Terry's anxiety about what exactly he'd gotten himself into, and with whom, escalated, manifesting as a pall of superstition, sentimentality, and nostalgia. He grew gloomy and quiet, and Jo Harvey worried. He haunted the cemetery, visiting the graves of Sled, Danny Parrish, and Buddy Holly at least three times within the first four days in town. He returned two days later, hands shaking at the wheel, with Bukka and Bale, who traced their little fingers over the gravestone of the grandfather they never knew, and again the following day with Jo Harvey, who wept. "Bloodlines run deep," he reflected in his journal. "I love those little boys . . . they help me through it in a way their age does not yet allow them to know." Allen felt an irresistible urge to make a rubbing of Holly's grave; he listened to his music every day "like it holds the secret." He threw the I Ching and considered calling Lowell and Richie of Little Feat for moral support, Bruce Botnick for engineering and production advice, and Laurie Anderson for

guidance on what the hell to do with a fiddle player, a specimen of whom he'd heard might be present at his sessions. Ultimately, he consulted other oracles instead: he listened compulsively to Townes Van Zandt and read Italo Calvino's novel *Invisible Cities* (among which, to him, Lubbock ranked).

The fog gradually dissipated and lifted, once again through the intercession of Milosevich. First Paul introduced him to venerable barbecue joint proprietor and chef Christopher B. "Stubb" Stubblefield. An eccentric man of giant stature and spirit, Stubb owned an eponymous institution at 108 East Broadway on the east side of Lubbock that incubated the local music scene. In 1973, five years after founding the compact restaurant, which until then had catered almost exclusively to the local Black community, Stubb, cruising Broadway in his Cadillac—arrayed with a line of candles on the dashboard to supplant the busted defroster—picked up a young white hitchhiker and invited him into the premises for a barbecue sandwich. Lubbock native Jesse "Guitar" Taylor, who resembled, in Terry's words, a "total tire-tool savage," a tattooed greaser whose fearsome appearance belied his tender heart, had never considered patronizing this inconspicuous Black-owned business in segregated Lubbock's Queen City, but he was immediately smitten with Stubb's smile, his cooking (honed as a mess sergeant during the Korean War), and the alluringly dilapidated atmosphere. Despite curtains that were nailed to the wall (to prevent diners from using them as napkins) and a hand-lettered sign that read, "There will be no bad talk or loud talk in this place," Taylor recognized performative potential in Stubb's cramped, crowded space. Although completely deaf in one ear and half-deaf in the other, Jesse was a gifted, and earsplittingly loud, guitarist.[3] Through this pair's unlikely friendship, the humble barbecue spot began hosting a legendary Sunday-night jam session that eventually attracted venerable blues artists like Muddy Waters and Bobby "Blue" Bland, country stars like Johnny Cash and Tom T. Hall, and Texan upstarts like Stevie Ray Vaughan and Taylor's bandmate Joe Ely.[4] In the process, it became "one of the first integrated, colorblind places in Lubbock."

For Terry, Stubb was "a real figurehead who was always on the periphery when that record was made. He was a very important element and presence for me." That summer, the Allens visited Stubb's "pretty much every day." Terry's appreciation for Stubb's generosity and beatific

attitude, his poetic malapropisms and piles of exquisitely smoked meats, catalyzed a mutual love—one of the defining friendships of Allen's life—that endured until the older man's 1995 death in hospice, at which Allen kept vigil.

In his notebook, Allen mentions this memorable meeting, noting that he'd encountered Stubb, "a Black man with crooked teeth who gave me a hat and a t-shirt." That evening Allen and Milosevich drove even farther east to an after-hours speakeasy called TV's, another Black neighborhood hangout of which Terry was completely unaware. There he met Ely, and the two played pool and jukebox records late into the night, cagily sizing each other up.[5] Ely invited him to see his band play the following night at Coldwater Canyon, a honky-tonk south of town.

Terry was booze-sick the next morning when he met Don Caldwell for the first time at his studio and played him some of his songs, "zombie-style," the coppery tang of bootleg whiskey, smoke, and TV's pork chops coating his throat. He hit it off with Don immediately, remarking on his elfin qualities—his "lived-in face," "goofy little cap," and the flapping "pointy bat-wing collars" of his "incredible disco shirts"—as well as his "lowdown" saxophone playing. He promised to return the next day.

ON TUESDAY, JULY 18, the Allens dropped Bukka and Bale off with the Koontzes and checked into a gnarly sinkhole-prone hotel on barren Thirty-Fourth Street that they referred to as "The Na-na-nameless Hotel" (the owner stuttered), inhabited by Mexican migrants and day laborers working at the pungent cottonseed oil processing plant across the street. They promptly divided their tiny room in half with masking tape on the floor to designate their separate studio zones. ("Need breathing room in the blood chamber," Terry explained in his journal.) It's a suitable symbol for their working relationship as artists: contiguous but contentious, affectionate but antagonistic, separate but sharing borderlands.

A few nights earlier, on Saturday night, July 15, Terry had gotten his first taste of the Ely Band's invigorating musicianship, and when he arrived at Caldwell's studio the next day, hungover again, he was determined to harness their powerful rhythmic and harmonic engine.

Gifted pedal steel, dobro, and slide guitarist Lloyd Maines, a congenitally congenial Lubbock native from a large musical family hailing from nearby Acuff, had just celebrated his twenty-seventh birthday. Thanks

to Milosevich, Lloyd had already spoken to Terry on the phone, surprised to hear "a guy who had a stronger West Texas drawl than me, so we hit it off immediately." He had also, thanks to Paul, heard *Juarez*—reportedly racing into the studio control room to turn down the volume during the smutty "Positions on the Desert" segment so as not to offend the delicate ears of the young women present—but he had no clue what he was getting himself into. Although a seasoned session musician at Caldwell's and an exceptional instrumentalist with his family band the Maines Brothers as well as the Joe Ely Band, he was primarily accustomed to playing covers and running local gospel studio sessions.

Lloyd stood by the grand piano in Caldwell Studios while Terry played every single song in sequence, an unusual working method that informed later collaborations as well. He recalled the memorable moment he first heard Terry's songs with a breathless wonder that belies his otherwise mellow, stolid demeanor:

> Terry walked in the front door wearing a pair of snakeskin boots and carrying a bold leather-bound notebook full of songs. . . . When [he] first sat down at that 5'8" grand piano and played his songs, I remember how those songs hit me. Every one of them was riveting and different from each other, but had this common thread weaved inside every lyric line: West Texas Panhandle sandstorms, tornados, The Bible Belt, The Hi-D-Ho Drive-in, honky-tonks in a dry county, blood, and love. . .[6]

Lloyd had never heard anything like them before, nor had his bassist brother, Kenny, who "fell in love with every song," a first for the twenty-four-year-old studio vet, whose wide smile was so permanently plastered throughout the sessions that Terry teased him for flaunting "rented teeth."

They began tracking the next night, the evening of Monday, July 17, cutting both "Amarillo Highway" and "High Plains Jamboree," the first two tracks on the album, and proceeding through each subsequent song in nearly exactly Allen's predetermined track sequence, with only a couple deviations, over the course of the next two weeks. Terry's tooled-leather portfolio, floridly inscribed as "The Terry Allen Silver Dollar Songbook," mapped the album's symmetrical structure of song groupings: exploring

Lubbock through landscape and portrait songs, on the first vinyl side; on the second, critiquing the art world; and then, following an intermission of comical songs related to food, drink, and drugs, concluding side three with two songs about war. The fourth side lands squarely on the back of Terry's head, with the final four deeply personal autobiographical songs.

"Lloyd Maines is a genius," Terry flatly proclaimed in his journal after that first session. Although he felt "a little stiff up front," things loosened, and by the end of the final tracking session, when they cut "Thirty Years War Waltz," the final full-band tune, Terry "could barely stand up." "There was something comfortable to me about playing with Texas musicians," he reflected, "who came up listening to the same stuff that I had, and in that same kind of geography, which I do think plays a big part in how you write." In contrast to the dawn chorus of *Juarez*, the sessions were largely nocturnal, beginning late in the afternoon and lasting into the early morning. Between Lloyd and Kenny and regular visitors, a family atmosphere pervaded the sessions from the first night: "About three in the morning there was a pounding on the door, and in came Stubb. He had every conceivable kind of barbecue with him, sacks full of it: ribs, briskets, links, everything, to give to all the musicians. That was classic Stubb. I don't know how many gigs we played all over Texas, and you'd turn around, and there was Stubb with a big grin and a pile of barbecue with him, and he had driven all the way to feed everybody." The night mystic fiddler Richard Bowden, a longtime vegetarian, first arrived for the *Lubbock* recording sessions, having hitchhiked from Austin, he was so famished—and so charmed by Stubb—that he dove face-first into the pile of meats. "It was worth it," he said with a twinkle.

Jo Harvey would stop by in the afternoons with Bukka and Bale, damp and sunburned from a hot day at the Seahorse Pool, in tow. Bukka, more inclined toward music than Bale, was mesmerized by "hearing that magic" in the studio and listening to rough mixes on cassette at the Koontzes'. He played his very first show at an evening jam session at Stubb's that summer, sitting in with the band on a boogie, nervous and elated as Terry beamed. Milosevich remembers watching Lloyd's daughter Natalie Maines—later of the (Dixie) Chicks—not quite four years old, toddling around the studio, "soaking it all in."

Terry spent July 22 with Pauline in Amarillo, a rainy day he summarized as "wet miles, vodka smiles—numb in the hard kitchen of

remembering." Back in Lubbock, he got as "drunk as possible with Paul, but not enough." He was vigilant about protecting Bukka and Bale from seeing their grandmother in that state. "I remember going to visit Pauline a few times, getting out of the car and getting right back in and driving back to Lubbock," Bukka said.

WITH HIS CHARACTERISTIC patience and affability, Lloyd convinced Lubbock's finest players to participate, calling on a wide variety of local musicians to contribute. The original roster of the ever-shifting Panhandle Mystery Band—the mystery of which, Terry joked, "is who *isn't* in it"—coalesced over the course of recording:

> [Lloyd] knew Curtis McBride, kind of an itinerant car dealer and drummer, and brought him in. . . . Kenny Maines, Lloyd's younger brother, had come back from Vegas with a show band that hadn't panned out too well. The core band was the four of us—Lloyd on all the guitars, Kenny on bass, Curtis on drums, and me on piano. . . . It was the first time I met Richard [Bowden], who ever since has been a mainstay in the band and a great friend. All the horn players came in later. Jesse Taylor came in and played that great flatpicking part at the end of "Flatland Farmer." Joe Ely played harmonica on "New Delhi Freight Train."

Since Allen had left town, Lubbock had become a "really musically incredible place," with many musicians (Curtis McBride's car dealership side hustle aside) "actually making a living playing clubs" like the Main Street Saloon and Fat Dawg's. "All those credits on the record," Allen affirmed, "were local working musicians, with the exception of the Monterey High School marching band and the 'Lubbock Symphony'—which was four people. . . . On a whim, we thought, why don't we get the marching band to come in to play the Monterey school song at the end of 'The Great Joe Bob'? So we called them up, and these kids came in; every one of them played out of tune, and it was *perfect*." A photo shot over Terry's left shoulder shows him hunched in a demented conductor's pose, waving a cigarette butt as baton. Several of the backup singers were receptionists at the studio. Tommie Anderson was "a terrific jazz trumpet player who had a surveying business next door to Caldwell Studios," and

Luis Martínez, "a real tasty guitar player," lent his Wes Montgomery jazz stylings to "Cocktails for Three."

Playing with this group proved a revelation to Allen, both musically and personally. "I could sing and pound the piano, and I had a few ideas for different instruments with different songs, but I had no experience of when things should come in or go out," he confessed. Maines astutely assessed the situation and promptly assumed the role of primary arranger and engineer, despite up until that point having produced very little. *Lubbock* became Lloyd's first significant production credit, though ironically, he shared it with about forty other people. The record jacket lists Maines and Caldwell as recording and mastering engineers, and Jack Lemon is recognized as executive producer (for his financial contribution), but the production credit reads "Produced by: everyone on this record." Despite articulating Allen's single-minded, meticulously plotted vision, the album was truly a collaborative effort in its execution.

Beyond the bonhomie and musical magic, which Lloyd regarded as "dream work" and Bowden considered "life-changing," there was an assortment of technical complications and compromises to overcome. Terry regularly played irregular measures—sometimes intentionally, sometimes not—and often counted inconsistently from take to take, adding or dropping beats or bars, a by-product of being largely self-taught and having written, performed, and recorded almost exclusively as a solo musician. ("I suppose you could call it eccentric playing, but it was basically probably just ineptitude," he shrugged.) When Lloyd, a stickler for timing and tuning, tentatively mentioned it, Allen's blithe response was one Maines still laughs about: "Relax, man—it's music, it ain't math."

It became obvious on the first day of tracking that Terry was a more vigorous pianist than Lloyd and Don were accustomed to recording. Their willingness to accommodate his style came as an enormous relief to Terry. They even miked the piano lyre, treating his pedal-stomping boot as a second bass drum. To contain the power and reverberation of his mighty left hand, Terry and his new band built a mountain: "There was a beautiful grand piano in the studio, but they had a hard time miking it; I play loud, and the sound went all over the place. So they piled a ton of foam rubber on top of me, the piano, the mics, everything, to baffle the sound, so they could control it. . . . I started calling

Caldwell's 'the only mountain in Lubbock.'" The conditions may have been preferable to the straitjacket restraint of the Clean sessions, but they were as preposterous, and symptomatic of a ramshackle studio environment. Terry, who had very little studio experience of any kind, was more amused than irritated: "The mic stands might fall apart in the middle of a song. They'd hit 'Record,' and I'd have to push the tape against the heads on the machine and hold it when we were doing over-dubs, so that Caldwell could use both hands on the board. It was kind of a clusterfuck as far as equipment goes. But it was also the most open and incredible experience. Like being around old friends you've known your whole life."

While Lloyd has occasionally regretted the record's lack of fidelity—partially a by-product of the studio's mixing boards, which were intended for radio, not studio recording—the most persistent and substantive audio issue occurred not during tracking or mixing, which effectively captured the wild spirit of the performances, but during final mixdown to the quarter-inch tape reels used for mastering and manufacturing. Due to a motor malfunction and a faulty back torque, the studio's tape machine ("a lemon," according to Caldwell) did not run at a consistent speed, so the final master tapes were flawed in insidiously arbitrary ways. Despite Terry's fingers on the tape head, every song was rendered variably out of tune, on all copies of the master tapes and on all subsequent releases until the 2016 remastered reissue—some pitched slightly sharp, some slightly flat, often waywardly drifting pitch over the course of a single track.[7]

Despite the plague of equipment problems and the liberal consumption of libations from Pinkie's liquor store, the sessions proceeded surprisingly efficiently. Lloyd has long insisted that basic tracking by the core quartet was completed in two days. Terry claimed that's an exaggeration: "I think the whole record took about two weeks. But it was fast, and there wasn't a whole lot of overdubbing. That was the first time I'd ever overdubbed myself—vocally, anyway. I think 'Truckload of Art' was the only song I did, so I could hit those high-pitched yodels." The surviving tracking sheets and invoices, supported by Terry's and Paul's diary entries, suggest sessions that spanned a full five weeks. They recorded the core band, with live vocals, from July 17 through July 31, with weekends and a few other days off, for a total of at least seven full

days (or nights) spent tracking. Several more days of overdubs and mixing followed, concluding with a final master on August 24.[8]

THE BLISTERING ROAD-HOLLER "Amarillo Highway (for Dave Hickey)" kicks off *Lubbock* with a faux-macho character study, an unreliable local narrator. The album version of the song serves as a self-conscious parody of the "outlaw" image and swaggering honky-stomp sound then being peddled by Waylon, Willie, Billy Joe, Tompall Glaser, and company. It constitutes a playful burlesque of male Texan bravado and machismo, its posturing and its props, with an arch wink that many contemporary listeners continue to miss.

The night they recorded an accelerated final take of "New Delhi Freight Train" was particularly memorable for Terry: "Everybody was in an anxious, elevated state, I remember, trying not to blow it. It became the longest track on the record, and we just kept playing it, because we liked what was happening so much. You can hear me laughing all over the end; I was lost in it." It is not the only song that articulates the passing of time by manipulating the structure, tempo, and duration of the performance itself. "The Wolfman of Del Rio" tracks the two characters' voyage into adulthood and the maw of nostalgia by transitioning to a completely different chord progression three minutes in. The final verse's harmonic changes mirror the characters' changes, as "they circle one another / armed with the lives from their past." "For a long time I thought the coda at the end of the song was another song entirely," Allen reflected. "It wasn't until on a random fluke I put them together that I realized, *now* it's a song." On "The Girl Who Danced Oklahoma," a dilatory bridge marks the march of years with an extended two-chord vamp, an instrumental ellipsis so hiccupingly repetitive it might almost be mistaken for a skipping record instead of a segue:

> "The Girl Who Danced Oklahoma" was about time, what time does to people. I think it's also about nerve, about the courage to go somewhere else, to be someone else. . . . There are those long repetitious chords that happen between the first part of the song and the last part, where at the end of it I say, "And ten years later. . . ." We've actually played that instrumental section for ten, twenty minutes, where everybody takes a ride through time in the middle of it. Then

there's this woman who is all different at the end of it . . . a farm girl dancing naked. Free maybe . . . free, but probably crazy too.

After his exodus in California, he himself felt "free, but probably crazy too." Lubbock had transformed in the interim, evidently, but so had he:

When I actually got there and recorded, the experience was so amazing for me on every level as far as the musicians and people I met, it changed everything. It really wasn't until we were listening back to the whole record after we'd just mixed it that I realized these songs I had written about that place were actually affectionate toward it and the people there. My feelings about Lubbock were so internally different than the attitude I had been expressing externally. And it was kind of shocking to me, because I suddenly realized how much I actually cared about the place, and how important it was to me and what I did.

CHAPTER 33

THEM OL' LOVE SONGS JUST KEEP COMIN' ON & ON & ON

Well
I just left myself today
Hell
I couldn't wait to get away
There's still a smear
Across the mirror
That I have been
But it won't
Reflect on me
Again

 —"I Just Left Myself"

IN ITS FINAL FORM, *LUBBOCK* MOVINGLY REFLECTS ONE OF THE WEIRDLY wrenching (or reassuring) processes of adulthood, the realization that you have been irrevocably shaped by your past, your hometown, and your family, whether you like or it not—no matter how much you might, like Jesse James in "New Delhi Freight Train," "welcome the run from what [you] done"—and that you can either reconcile with that happy and horrid fact or continue to wriggle strenuously away.

With these twenty-one songs, written more than a thousand miles and half a continent away in California, Terry shifted modes from the sordid, violent mythology of *Juarez* to piquant prodigal-son satire that perfectly conveys his mordant wit. As Terry told me, revealingly, about songwriting, "If it's not a lie, it's probably satire." Satire and sarcastic humor suffuse West Texan culture, and for Allen, when deployed

properly, they provide a standard of aesthetic quality. "I've always thought of the *Lubbock* songs as mostly satirical," he clarified. Moreover, "I've always thought of pretty much *everything* good I've ever done, or anybody else has ever done, as satire." The trick to teasing is walking the tightrope between provocation and adoration.[1] It is on his second album where Allen first achieved that precarious counterpoise, which has characterized his career since. It may be satire—at least until the final few songs, which take a turn toward the nakedly personal—but Allen is also deeply compassionate toward his subjects, even when they are ridiculous or pathetic. *Especially* when they are ridiculous or pathetic—and at their most vulnerable—these all-too-human characters come alive. *Lubbock* exposes an accidental capitulation to home, to rootedness, and to love.

It's fitting that the penultimate song on the album is Jo Harvey's. Her contributions to *Lubbock* are undeniable and indelible. She not only sang backup and shot the iconic jacket photos of Don Caldwell's uncle's red vinyl chair—embellished with cartoon cactus, yellow ashtray, and whiskey bottle—and Terry hiding behind his hands, but she effectively single-parented Bukka and Bale while Terry worked in the studio.[2] In the most evocative and beautifully composed photo surviving from the sessions, Jo Harvey leans over a pegboard wall toward the "mountain," captured in mid-coo while Terry snarls in mid-howl over the grand piano. Her left-hand ring finger sports a small inky smudge, easy to miss unless you know what it is—the matching Parisian tornado tattoo that she and Terry share in lieu of wedding rings, an abiding symbol of their devotion, another freak force of nature. *Lubbock (on everything)* is, among other things, a chronicle of the first two decades of their long love story.

These love songs do not lie. Allen's 1986 sculpture *Them Ol' Love Songs Just Keep Commin' On & On & On* [sic] is his monument to venerable Lubbock venue the Cotton Club, but the title's sentiment likewise describes *Lubbock (on everything)*, his labyrinthine memory palace to his hometown.[3] On *Lubbock*, the satirical impulse never eclipses the humanizing impulse; it is, instead, an engine of empathy. The Great Joe Bob and the narrator of "Oui (a French Song)" both give up their dreams, of football and "sculpturing," respectively, for different kinds of prison. While Joe Bob "traded in the pigskin / for the penitentiary," a literal jail, the protagonist of "Oui" wonders if it's true that "it's pathetic / when

you give up your aesthetic / for a blue collar job in the factory," a sad assembly-line simulation of sculpture: "puttin' plastic leaves on the plaster palms." Both characters are archetypes, but not stereotypes. Terry is not so much lampooning brutish jocks and depressed struggling artists as he is tapping into the complex circumstances that created and undid them—even when those circumstances may not have been entirely legible to the songwriter at the time: "I have an entire drawer full of clippings people have sent me of the same story as 'The Great Joe Bob'—a football hero robs a liquor store and goes to the pen. There were a couple of specific high school football players that I thought of when I was working on that song, but it's not about the people as much as it's about that circumstance." Similarly, although "Lubbock Woman" later "became almost an iconic character," Terry "wasn't thinking of a particular person or anything when [he] wrote it." She is, notably, one of many strong female characters that inhabit *Lubbock*. Allen agreed but demurred regarding the significance, explaining that "those are just the people that live in those songs."[4] But even in "The Beautiful Waitress," a song that can elicit cringes from contemporary listeners more sensitive to the pervasiveness of sexual harassment and the toxicity of the male gaze, the subject of the narrator's diner fantasy gets the last and best line. According to Terry, "The spoken part about drawing horses is almost verbatim an exchange I had with a waitress in Fresno."

In the liner notes, Allen dedicates the record to his mother and the memory of his father. He thanks a prodigious list of people and places, concluding with gratitude for "Jo Harvey, Bukka & Bale, highways and a flat horizon (best of the best)." But he also includes an unusual epitaph-as-epigraph in the form of three in memoriam curses, or, as he calls them, "the three 'fuck yous,'" memorializing his three departed friends Stanley (*"fuck viet nam"*), Peter (*"fuck hollywood"*), and Danny (*"fuck bad blood"*), damning the causes of their untimely and tragic deaths and providing a key that helps unlock the record's hidden dimensions of grief.

Everything, Lubbockites will tell you—Dallas, Fort Worth, Austin, San Antonio, Marfa, Albuquerque, Santa Fe, Oklahoma City—is about a five-hour drive away. True to its title's winking, extravagant ambition, *Lubbock (on everything)* not only summons a city on the High Plains but likewise attempts to encompass everything, sublime and banal

alike, in a great, untidy embrace: love and heartbreak; marriage and its (dis)contents; family and childhood; driving and travel; the art world and its classist contortions; booze and pills; sports and play; agriculture and foodways; the ambitions, failures, frustrations, and satisfactions of labor and art; crime and war and violence and peace; the mirages of memory; the passing of time; and finally, poignantly, the dissolution and disappearance of the self.

With the album's final movement, its reckoning with identity ends, having come full circle from "Amarillo Highway," whose narrator has denied his own humanity with the bravado of nihilist momentum and rejects any hope for salvation or transcendence. He has resigned himself to the vicissitudes of fate, shackled to the midnight road and the five-hour intervals between the Hub City and everywhere else. Eighty minutes later, the scouring winds of the Llano Estacado, that echoless void of home and horizon, have abraded that machismo to reveal the unguarded vulnerability of "I Just Left Myself," whose narrator finally achieves an escape from himself—an insubstantial, spectral self that was only ever "a mirror" anyway. "I didn't float," Terry sings, "I didn't fly / I did not transcend," accompanied only by his piano (the rest of the Panhandle Mystery Band has been stripped away too, for the only solo performance on the record). Is this freedom or surrender, apotheosis or oblivion? Terry appraised "I Just Left Myself" as "a cosmic existential joke." Like many of his jokes and his lyrics, it is rendered visible, and risible, only through the context of its darkness—backlit, a constellation perforating the clear night sky over the High Plains, a matrix of pale stars by which to navigate that boundless sea of grass.

WHEN THE SESSIONS wrapped, Terry and Jo Harvey flew to New York City. They stayed with Marcia, who had booked Jo Harvey to perform *A Moment's Hesitation* on September 12 at the New Museum. Terry was busy preparing for his own performance. For its first annual Art on the Beach series, Creative Time, a nonprofit dedicated to commissioning site-specific art in public spaces, invited him to play an outdoor solo show on August 28 at the future site of Battery Park City, then still a sandy landfill. When he arrived he found a pickup truck with a battered upright piano in its bed, which staff informed him would serve as his stage—a truckload of art and a touch of Texas in the Battery dunes.

Bemused but game, he complied, performing for an audience of about fifty, with the Lower Manhattan skyline, including the World Trade Center towers, looming above him, a dramatic incongruity immortalized in photos. In retrospect, he suspected the staging was well-intentioned if condescending, "a typical Easterner's ideas about what somebody from the West should do—like Marcia making chili with potatoes in it." Terry flew home, and Jo Harvey stayed behind to complete a brief off-Broadway run of her play. He mailed her a pair of silver rat earrings as amulets to ward off the "flying verbal cheese" of uncomprehending male New York theater critics. Home alone, he struggled with reentry into Fresnoia; as he wrote to Paul, "I miss Lubbock a lot (and I never thought I'd say that again in my life)."

THE FIRST TIME the Panhandle Mystery Band performed Allen's songs publicly as a named unit, beyond the informal jam sessions at Stubb's while recording, was in Chicago on November 13, 1978, immediately before Terry's *Fighters of the Darkness* opening at Nancy Lurie Gallery, at an unlikely venue: the improv comedy theater Second City. It was the first of three shows celebrating *Lubbock (on everything)*, though the album was not yet available to buy. At Landfall a few days before the show, Terry first saw the finalized album design and layout.

Exactly five months later, when *Lubbock (on everything)* was finally released as the first record on Fate Records, the Allens returned to Lubbock. Terry exhibited a series of twelve Lubbock-related drawings at Lubbock Lights, Debbie Milosevich's gallery on Avenue Q.[5] Stubb's was the obvious venue for the April 13 and 14, 1979, hometown release shows for the record.

Ron Cooper helped produce the final concert in the trio, booking the Roxy in LA on October 22 and cooking cauldrons of green chili. The show was a trial by fire for nineteen-year-old Donnie Maines, Lloyd and Kenny's younger brother, who made his debut as the Panhandle Mystery Band's drummer that night, replacing Curtis McBride. Right at the driving climax of "New Delhi Freight Train," Donnie ruptured the bass drumhead with the backline wooden beater at the exact same moment that Terry, in the first instance of a series of such massacres, smashed and dislodged the lyre of the piano with his stomping boot, sending pedals and splinters skidding across the stage. While the band continued to

play, Allen crawled beneath the piano to try to fix it while Donnie's drum set collapsed, "pieces exploding and flying everywhere, like we were all attacked by 1000 Pygmy spears."

HOME AGAIN IN Fresno after his victory laps, it seemed initially that little had changed. Fate continued to struggle with distribution, so both his records remained "nearly impossible for people to get" except through mail order. But there surfaced, eventually, encouraging signs that people were listening. Joe Nick Patoski covered the album and Stubb's show for *Texas Monthly*, and college papers and music periodicals began to file reviews. Country comedy duo the Geezinslaw Brothers released a cover of "High Plains Jamboree," produced by Bobby Bare. The broad-minded bluegrass musician Peter Rowan recorded live versions of four *Juarez* songs at the Armadillo World Headquarters in Austin, released in 1981 on his album *Texican Badman*. The Crickets began playing "The Great Joe Bob" in concert. Bonnie Raitt inquired about an opening slot on her tour, but Terry, in a self-sabotaging fit of pique, turned her down, immediately regretting it. The sculptor DeWain Valentine gave a copy of *Lubbock* to the director, playwright, and screenwriter Joan Tewkesbury. She immediately approached Terry about collaborating on a screenplay and music for a film (never produced) titled *Venice, Texas*.[6]

In August 1979, Allen wrote to Westermann that Fate was pressing a second thousand copies of *Lubbock*. In November, he returned to Lubbock to play the raucous Anniversary Jam benefit for Stubb's BBQ at the Cotton Club. At their Kansas City show a week later, during the runs of *Fighters of the Darkness* at the Morgan Gallery and Jo Harvey's play *Duckblind*, the Panhandle Mystery Band shared marquee billing at the Uptown Theater with Count Basie and Muddy Waters, much to Terry's delight.

THE RECORD GRADUALLY rose to prominence over the course of the early 1980s, through years of word-of-mouth fandom, grassroots touring, and rapturous reviews. The Panhandle Mystery Band tapped into the Lubbock musicians' booking networks, expanding Terry's orbit beyond the well-trod museum and gallery circuits.[7] Even if Allen's music is more accurately described as art-country, *Lubbock (on everything)*, considered by many to be the urtext of alternative country, sowed the seeds of

that scene's emergence a decade later. His intellectually tough trans-
mutation of honky-tonk's flinty foundations into something stranger and
subtler dismantled the notion that country music as a form is fossilized,
fixed, or inherently conservative.

Lloyd, Kenny, and Donnie all credit Allen with opening their eyes to
the viability of writing and performing original compositions and
demonstrating the full capacity of country music to accommodate
highly idiosyncratic personal and literary lyrical dimensions. "Until I
started playing with Joe and Terry, I didn't realize that West Texas peo-
ple even liked hearing bands doing original music," Lloyd confessed.
Kenny agreed: "Terry not only changed me, but the entire complexion of
music in Lubbock. Ely had been instrumental in creating a different
energy for Lubbock music, but Terry took it and did a total transforma-
tion." *Lubbock (on everything)* permanently altered the artistic aspira-
tions and literary ambitions of songwriters in Lubbock, across Texas,
and, eventually, far afield. It's no accident that Lloyd went on to play
pedal steel on classic alt-country albums like Uncle Tupelo's *Anodyne*
(1993) and Wilco's *A.M.* (1995) and to produce Richard Buckner—in
addition to working with artists such as Ray Wylie Hubbard, Jerry Jeff
Walker, and the Chicks.

For Terry, the most significant legacy of the record is the relation-
ships it fostered: "With those guys, it was like meeting a new family. I'm
an only child. I never had any brothers, but they became my brothers."

I KNOW SOMETIMES A MAN IS WRONG

Shakin his hands
On the mountain
Yeah he did what he did
Then he run and he hid
His blood bubbled up
In the fountains

—"Lonely Road," from "Billy the Boy"

IN JANUARY 1986, THREE EUCALYPTUS TREES, DEAD AND VENEERED IN lead, were craned and installed on the campus of the University of San Diego. When they began to speak and to sing, among their voices was David Byrne's. The head Talking Head had contributed a song called "I Know Sometimes a Man Is Wrong," expressly written for the project and recorded with a choir of insects and birds as "the musical and rhythmic bed."

Trees was Allen's first public art commission and the institution's fourth, between works by his two friends Robert Irwin and Bruce Nauman. Terry's loyal friend and supporter Mary Beebe, who had hosted him at Portland Center for the Arts in 1981, had, even before taking the helm of University of California, San Diego's, new Stuart Collection of public art, successfully advocated for his commission, overcoming the reservations of an indifferent board. Terry, at best suspicious and sometimes outright disdainful of public art—solicitations of which he had successfully evaded for years—was originally dubious of the proposition. Despite his reservations, Allen harbored deep appreciation for

vernacular architecture and the built environment, enumerating to Beebe, in a proposal letter written on December 7, 1983—the day before he flew to Bangkok on a life-changing journey—some sentimental examples of public art he did value:

> About the only things "outside" I like are the Buddy Holly statue in Lubbock, the little life-size bronze kid on the sidewalk eating a hamburger in front of McDonald's in Kansas City, the Eye-Full Tower, the Lincoln [Memorial], the memory of my 1953 green Chevrolet half-sunk in Buffalo Lake in Lubbock, the Great Plains Life building in Lubbock . . . stuff like that. I think my aversion to it has usually been because of inbred resentments to horizon obstruction.

"Public art is for the birds," he insisted to Beebe. "When I go outside, I don't want to look at art, I want to look at nature." So Allen and university staff selected three nonnative eucalyptus trees from a campus grove earmarked to be cut down for future construction. Under the clever engineering and fabrication supervision of the Stuart Collection's Mathieu Gregoire, they felled, dismembered, segmented, pressure treated, and sutured back together the chosen trees, inserting hidden speakers into two of the three. Terry then hammered and nailed sheet lead, like an armored bark, onto the preserved eucalyptuses. (Visitors are welcome to scratch graffiti into the lead flesh, scarifying it to silver before it oxidizes and is reinscribed.)

The *Poetree* broadcasts poems and spoken-word pieces by, among others, Roxy Gordon, Philip Levine, and Joan Tewkesbury, punctuated by field recordings: Navajo chants, Aztec poems, whale songs, duck calls, the roar of a Grumman F-14 Tomcat. A hundred yards away, the *Song Tree* plays a selection of music—much of it recorded specifically for *Trees*—that Allen solicited from family and friends old and new, including, in addition to his new friend Byrne, Laurie Anderson, Dave Alvin, Jacki Apple, Caravan, Joe Ely, Butch Hancock, Mike Henderson, Dave Hickey, and Lloyd Maines. (Terry contributed his own "I Love Germany" and "Loneliness," two recent songs for stage productions.) The *Tree of Contents*, which stands in front of the library and is stamped with the names of every collaborator and contributor, is silent, eternally mute.

Beginning in 1990 with *Corporate Head*, a collaboration with Philip Levine, Terry would embark on more than a decade of high-profile, intensive—and often fairly lucrative—public art commissions, facilitated first by his new manager Wanda Hansen and then by his new gallery L.A. Louver. The pieces, reliant on relationships with foundries and engineers, required enormous time investments, but they helped pay the bills. They also allowed Allen to insert his work into the public consciousness, to play with audience interactivity and expectations, and to engage with communities and environments in different ways. With *Trees*, when it came to public art, Allen discovered, sometimes a man is wrong. It was a lesson he would learn repeatedly and painfully throughout the 1980s, a decade that secured his artistic legacy but nearly destroyed him in the process.

THE DECADE HAD begun joyously in Lubbock. At the stroke of midnight on January 1, 1980, at the Elys' inaugural New Year's Eve concert at Coldwater Country, the audience parted, and Jo Harvey stood on her head, exposing, as the layers of tulle drifted down like petals, a large red "80" stitched in red sequins across the bottom of her panties. Terry recorded two new songs at Caldwell's, "Cajun Roll" and "Whatever Happened to Jesus (and Maybeline?)," which interpolates Chuck Berry's automotive lament (one of only two covers in Allen's catalog) within a skewed gospel song of his own devising, releasing them as a seven-inch single on Fate. In April, Terry traded a drawing titled *Cadillac Heaven* to a collector for a white 1971 Cadillac Fleetwood.

By 1982, he had once again attempted to clear the horizon of obstructions. No longer able to justify his five-year sabbatical, Allen called a family meeting to discuss his decision finally to leave Fresno State. Jo Harvey and Terry had begun to travel more extensively, often separately; Jo Harvey was more involved in her own theatrical work; and Bukka and Bale—now high schoolers—were far more independent. Unencumbered by even a phantom day job, he suddenly found himself with more freedom and time than ever to stretch the tentacular strands of his art in multiple exploratory directions.

With, he hoped, fewer seismic changes as he entered his fortieth year, Terry's private life now aligned itself temporally with the duration of each of his public creative projects. Throughout the 1980s, he was

completing—and releasing, premiering, and exhibiting—interwoven work in every medium so rapidly and coextensively, at such a fever pitch of synchronous, pill-facilitated productivity, and with so many new collaborators, that a strictly chronological accounting would be disorientingly scattered and incoherent. How he survived the decade in real time beggars belief.

DESPITE ITS PLAYFUL qualities and its status as symbolic signposts to a new era in his career, *Trees*, with its somber gray skin and its chorus of voices living and dead, inherited a degree of the funereal circumstances that surrounded Allen. As the breakneck pace of his professional life seemed to be approaching escape velocity, his family was bombarded with an improbably rapid and unrelenting succession of deaths that left Terry alternately depressed, debilitated, and manic—at times nearly unhinged by grief and exhaustion. On February 26, 1986, while Jo Harvey was rehearsing for a performance in Lubbock, her father, Harv, collapsed in his driveway and died. On April 23, while Terry was in London, minutes before playing the first show of his first international tour—his first tour anywhere—his friend Boyd Wright unexpectedly dropped dead in his kitchen. Two days after Boyd passed, so did Allen's cousin Billy Earl ("jazz and love," he wrote in his journal). During that same spring season of death, Bale's friend died in a car accident, and Julie, the girl Bukka loved, was shot in the head by her father, deranged by jealousy, after he'd murdered her mother and her little sister, whom he shot in her sleeping bag in a tent in the family's yard.

A series of contemporaneous triumphs during the same two months of 1986 counterbalanced these tragedies, an emotional whiplash. On April 1, Terry opened a letter declaring him the recipient of a prestigious $25,000 Guggenheim Fellowship, a complete shock. Within the next two weeks, he was in San Diego to celebrate *Trees*; at Wright State University in Dayton to create, in collaboration with art students, an installation and performance titled *Ohio*, about the death of Hank Williams; at Theater Artaud in San Francisco for a dance piece he'd soundtracked; and then off to Britain to tour with a borrowed British band.

In July, routed by grief, the Allen family, with Boyd's two sons, fled to Oahu, where the collectors Laila and Thurston Twigg-Smith loaned them their home on the North Shore, which Terry described as "the most

beautiful and comfortable place I've ever been," in time to celebrate their twenty-fourth wedding anniversary.[1]

With the luxury of placid Hawaiian hindsight, Terry realized that the pileup of losses had begun at the very dawn of the decade. Lowell George had died of an accidental cocaine overdose on June 29, 1979. Allen's exuberant exchange of letters, artworks, and music with Westermann ended abruptly with his friend's death on November 3, 1981. "The animal has come for Cliff," Terry wrote.

CHAPTER 35

SOME KIND OF DEMENTED BELL, AND ASSORTED OTHER UNPOPULAR STYLES

Smokin the dummy
Piss in the wind
American music
Play it again

　　—"Smokin the Dummy"

IN A FEBRUARY 1981 LETTER TO WESTERMANN, WRITTEN SHORTLY AFTER THE late-1980 release of his third album, *Smokin the Dummy*, Terry explained the genesis of the album title and artwork:

MY KID BUKKA GOT A CHARLIE MCCARTHY DOLL FOR CHRIST-MAS ONE YEAR WHEN HE MADE UP HIS MIND HE WAS GOING TO BE A VENTRILOQUIST. HE IMMEDIATELY PAINTED IT UP TO LOOK LIKE A VAMPIRE. . . . AND I JUST AS IMMEDIATELY PUT ON A PAIR OF JO HARVEY'S SUNGLASSES AND THE SLEAZIEST JACKET I COULD FIND (western slime) AND SAT FOR FAMILY PHOTOS. . . . ANYWAY, I BLEW RINGS OF SMOKE ON THE DUMMY AND BUKKA SAID I WAS SMOKIN THE DUMMY.

　　I GUESS IT RANG SOME KIND OF DEMENTED BELL . . .

Cliff died shortly after receiving this letter, enclosed with a *Smokin the Dummy* LP, the minimalist black jacket of which Allen suggested that he fold into a jaunty cardboard hat if he didn't like it. That response was unlikely, since Westermann loved Terry's music, calling *Juarez* "the

finest, most honest and heartfelt piece of music I ever heard."[1] In October 1979, he had sent the Allens a sculpture—"the greatest honor I could ever hope to have," Terry wrote—a small, exquisitely constructed wooden cooler that snugly contains a six-pack of Pearl Beer, the classic Texas brew cited in "Amarillo Highway."[2]

Recorded at Caldwell Studios during July and August 1980, exactly two years after *Lubbock*, the feral follow-up is less conceptually focused but more sonically and stylistically unified than its predecessor. It's also rougher and rowdier, wilder and more wired, and altogether more menacingly rock and roll. In the years since *Lubbock*, the Panhandle Mystery Band had coalesced through their periodic performances, honing their sound and tightening their arrangements. Terry sought to harness the high-octane power of this now well-oiled collective engine to overdrive his songs into rawer and rockier off-road territory.

Allen was feverish for several studio days, suffering from a bad flu and sweating through his clothes, which partially explains the literally febrile edge to his performances, rendered largely in a perma-growl. He stomped the pedals off Caldwell's piano during the session. Alongside the stalwart Maines brothers and mainstay Richard Bowden (who contributed not only fiddle but also mandolin, cello, and "truck noise theory," the big-rig Doppler effect on "Roll Truck Roll"), Jesse Taylor supplied blistering lead guitar, on loan from Joe Ely (who played harmonica). Taylor's kinetic blues lines and penchant for extreme volume were instrumental in pushing these recordings into brisker tempos and tougher attitudes. During a studio break, Terry painted the band's faces like Bob the Dummy, hoping to use the photos he took for album art or publicity photos. But when they realized the resemblance to Kiss, "it made [them] all want to vomit."

Like the album title itself, the songs on *Smokin the Dummy*, culled from a decade and a half of songbooks, ring various demented bells: a rabid "Cocaine Cowboy," a stately "Red Bird," a glowering "Helena Montana." The tracks rifle through Terry's assorted obsessions—especially the potential energy and escape of the open road, elevated here to an ecstatic, prayerful pitch—and are populated by a cast of crooked characters: truckers, truck-stop waitresses, convicts, cokeheads, speed freaks, greasers, holy rollers, rodeo riders, dancehall cheaters, and sacrificial prairie dogs, sinners seeking some small reprieve, any fugitive

moment of grace. The album, like the lead track "The Heart of California (for Lowell George)," another driving song, is dedicated to Terry's recently departed friend, who shares the dedication with Suzanne Campbell Harris, an artist Allen met in Paris who also passed in 1979.

Critics paid attention more quickly and consistently this time. *The Village Voice*, making unusually apt connections between Allen's art and music, proclaimed *Smokin the Dummy* "some of the strangest art-rock you ever heard . . . desperado dadaism."[3] Russ Parsons of Terry's hometown paper the *Avalanche-Journal* compared the record to *The Grapes of Wrath*, calling it "masterfully done" and "one of the best albums [he'd] heard in a long time, period. . . . Dazzling." He issued a warning to Lubbockites that "it's going to offend some people, like the best rock and roll should."[4]

AS THE PANHANDLE Mystery Band launched into *Smokin the Dummy*'s frayed "The Lubbock Tornado (I don't know)," days ahead of the twelfth anniversary of the real thing, the bruised sky opened, and a deluge of rain inundated Buddy Holly Park and its audience of forty thousand—Allen's largest yet, exponentially—strafing the stage of the third annual Tornado Jam festival, organized by Joe Ely, this year also featuring Linda Ronstadt, Joan Jett, the Crickets, the Maines Brothers, and the Joe Ely Band. Lloyd's picks sluiced through the groove between the twin necks of his pedal steel. Richard dumped a pailful of water out of his fiddle, and sparks arced between Jesse's guitar and his amp.

Terry had also played the previous Tornado Jam, the most memorable moment of which also involved immersion—a local kid accidentally capsized her lawyer father's Rolls-Royce, reportedly the only one in Lubbock, in a playa lake in the park. But May 1, 1982, the night before this year's so-called Mud Jam, exceeded even that local legend. After a Panhandle Mystery Band rehearsal, the Maines Brothers were booked to play a Monterey High School graduation dance at the Cotton Club. Following the rowdy and ravenous consumption of beer and barbecue at Stubb's, Terry, Joe, Linda Ronstadt, and her piano player Bill Payne—also a member of Little Feat—crashed the dance, taking the stage to play several songs. In the middle of a spirited rendition of Holly's "That'll Be the Day," with Terry singing backup and playing tambourine, the club's manager unceremoniously shut off the power,

and the room went dark, despite Joe's protestations. Ronstadt, according to Sharon Ely, was delighted at the lack of recognition from the audience and her summary expulsion from stage, both foreign experiences for her at the height of her fame.

Six days later, on his thirty-ninth birthday, dressed in his best post-professorial semiformal wear of blazer, jeans, cowboy boots, and a massive Panhandle Mystery Band belt buckle, Terry nervously watched Nancy Reagan mincing ever closer, while a bomb-sniffing dog surreptitiously pissed on a sculpture in the corner. One of ten American artists chosen to receive a $10,000 grant in the Awards in the Visual Arts program's inaugural round of funding, he was standing in a receiving line at the National Gallery of Art in Washington, DC, to meet the First Lady. The Secret Service had allotted Terry three minutes to chat with her and explain *The Embrace* video. "She said, 'I'm so sorry I don't have time to watch the whole thing.' To which I replied, 'Well, the show is up for three months; why don't you come back when you have more time?' She smiled at me with a look like, of all the things she was never going to do, that was the top of her list. She was whisked off."

IN JULY, THE usual suspects descended on the down-at-the-heels De Vargas Hotel in Santa Fe for the Allens' twentieth anniversary convocation.[5] On the evening of the eighth, in his resonant bass, Stubb, the master of ceremonies, introduced what would become the Allens' traditional anniversary concert. After a raucous Panhandle Mystery Band set—with a set-break boogie by Bukka and Stubb's discursive "Summertime" and "Stormy Monday"—Ely played as well as the Albuquerque band the Planets, whose Lubbock-bred drummer Davis McLarty would later assume the drum throne in the Panhandle Mystery Band in addition to serving as their booking agent. At a raucous Planets club gig the next night, after singing an impassioned version of "The Thrill Is Gone," Stubb's dwarf sidekick Little Pete stage dove into the arms of curator and writer Ron Gleason. During their customary set-closing medley of Buddy's "Not Fade Away" and Bo's "Who Do You Love?," Ely followed suit, running across the stage and leaping into Terry's arms, both men toppling over a pedestal table onto the floor, still laughing.

It was in this affectionately debauched milieu that Terry began recording a new record six weeks later, on August 24, 1982. On his

manifold fourth album, Allen contemplates kinship—the ways sex and violence stitch and sever the ties of family, faith, and society—with skewering satire and affection alike. *Bloodlines* compiles thematically related but disparate recordings from miscellaneous sources both historical and theatrical. It was recorded at Caldwell Studios in scattershot sessions spanning August 1982 through January 1983, and released in June 1983 on Fate, dedicated to Westermann and Jim Morgan, who had died in a motorcycle accident a year earlier. At Morgan's memorial service, Terry was too emotional to sing "Red Bird," Jim's favorite, but the band played a memorable concert that night: "It was crammed with people, outrageously drunk and stoned. That was the first time I ever remember playing when it felt like everything was going to come unhinged, and the room would self-destruct. The energy was so desperate."

By comparison, the recording process felt like a diffuse slog.[6] Despite Terry's frustration with the protracted timeline and anxiety about the correspondingly higher budget, the production on *Bloodlines*—courtesy, once again, of Lloyd—is slicker, cleaner, and more dynamic than prior efforts, and it reached a broader audience than ever before.

Bloodlines was the first of several subsequent albums to revisit selections from *Juarez* with full-band arrangements: a comic take on "Cantina Carlotta" and a road-rage, burnt-rubber rendition of "There Oughta Be a Law against Sunny Southern California" featuring Jesse, in his final Panhandle Mystery Band recording, on "asphalt vendetta guitar" (Maines Brothers guitarist Cary Banks deftly handled lead guitar elsewhere). Terry wrote two songs for plays: the Pasadena idyll "Oh What a Dangerous Life" for Joan Hotchkiss's 1982 play *Bissie at the Baths* (produced by Tewkesbury) and the gospel-coughing hymn "Hally Lou" for Jo Harvey Allen's 1983 eponymous performance piece, in which she played the titular revival preacher. The irreverent hellfire-hitchhiker-on-highway ballad "Gimme a Ride to Heaven Boy" (featuring Ely), in which Jesus steals the narrator's car and beer for a joyride to the hereafter, became a fan favorite. Written, as Terry explained to Westermann, "one night late in-between commin [sic] home somewhere between Los Banos and Chowchilla," Terry completed the final verses in a Texas Tech practice room the day they recorded it.

Prologue ... Cowboy and the Stranger,
1969
Mixed media on paper
38 ¼″ × 31 ¼″ (framed)
From *Cowboy and the Stranger*
© *Terry Allen*
Courtesy of *L.A. Louver, Venice, CA*

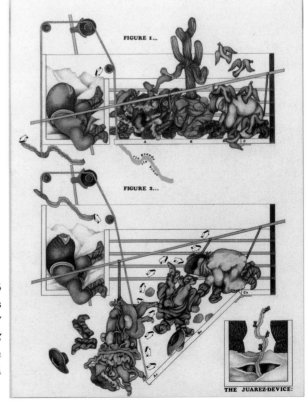

The Juarez Device, 1969–1975
Mixed media on paper and plexiglass
40″ × 30″
From *JUAREZ*
© *Terry Allen*
Courtesy of *L.A. Louver, Venice, CA*

The Cortez Sail, 1970
Mixed media on paper
40″ × 30″
From *JUAREZ*
Collection of Michael Walls
© *Terry Allen*
Courtesy of the artist

Melodyland—"The Radio,"
"Gonorrhea Madonna," and
"Piano," 1974
Mixed-media triptych
(destroyed)
40″ × 90″
From *JUAREZ*
© *Terry Allen*
Courtesy of the artist

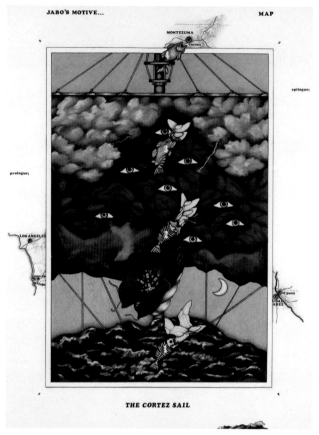

The Paradise (exterior installation view), 1976
Multiple-environment, two-room, multimedia installation with video and jukebox (site-specific, permanently dismantled)
42′ × 21′
Fort Worth Art Museum, Fort Worth, Texas
© *Terry Allen*
Courtesy of the artist

The Evening Gorgeous George Died (installation view), 1976
Mixed-media installation
Dimensions variable
From *RING (Episode I)*
The Belger Collection, Kansas City, Missouri
© *Terry Allen*
Courtesy of Claire Copley

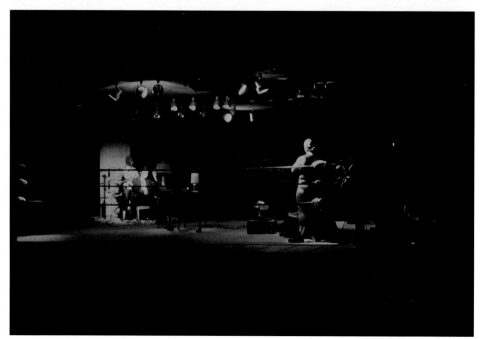

The Embrace (Advanced to Fury), 1978
Still from the second run of the "theater occurrence," University Art Museum, Berkeley, California,
October 13–14, 1979; featuring Jo Harvey Allen as She (right corner, partially obscured), Jock
Reynolds as He (left corner), Sammy Jones and Maria DeLeon as wrestlers (standing), and Terry
Allen as the secret reader (not pictured).
From *RING (Episode II)*
© *Terry Allen*
Courtesy of the artist

Desires from a Duet of False Evidence, 1978
Mixed-media triptych
40″ × 117″
From *RING (Episode IV: Fighters of the Darkness)*
Collection of Mr. and Mrs. Eugene Aron
© *Terry Allen*
Courtesy of the artist

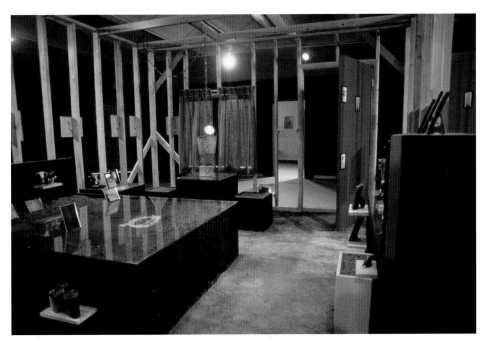

BILLINGSGATE (a motel) (interior detail), 1982
Mixed-media installation in room constructed with 2″ × 4″ studs (permanently dismantled)
8 ½′ × 12′ × 20′
© *Terry Allen*
Courtesy of the artist

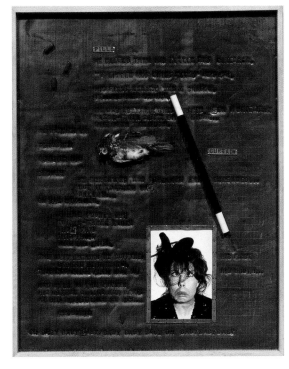

Pills, 1982–1983
Mixed media on lead
25″ × 20″
From *Anterabbit/Bleeder (a biography)*
© *Terry Allen*
Courtesy of the artist

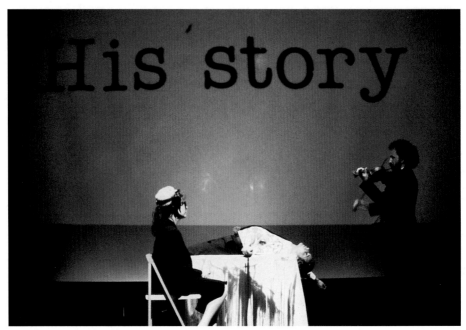

Anterabbit/Bleeder, 1983
Still from the theater performance, Sherwood Auditorium, La Jolla Museum of Art, La Jolla,
California, April 19 and 21, 1983; featuring Jo Harvey Allen as Woman (pictured, left),
Sean Sullivan as Bleeder (center), and musicians Richard Bowden on violin (right) and
Lloyd Maines on pedal steel and guitars (not pictured).
From *Anterabbit/Bleeder (a biography)*
© *Terry Allen*
Courtesy of the artist

China Night
(front installation view),
1985
Three-quarter-scale-
room multimedia
installation with audio
270″ × 164″ × 96″
From *YOUTH IN ASIA*
Collection of the
Museum of
Contemporary Art,
Los Angeles, California
© *Terry Allen*
Courtesy of the artist

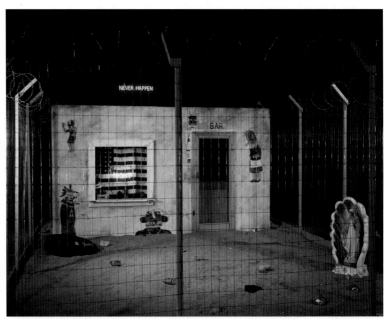

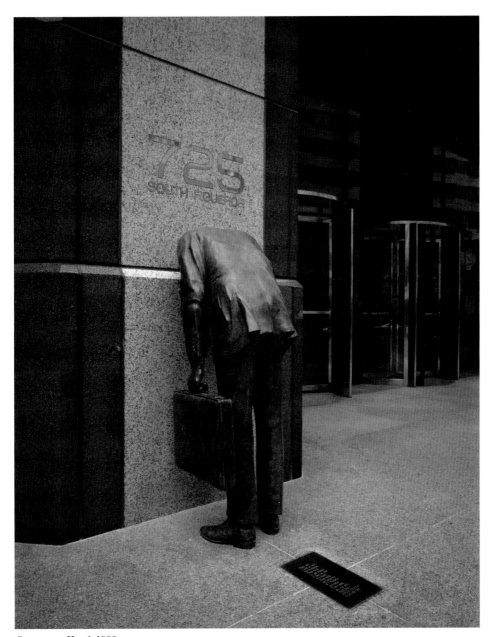

Corporate Head, 1990
Bronze, with poem by Philip Levine
30″ × 22″
Citicorp Plaza "Poets' Walk," Los Angeles, California
© *Terry Allen*
Photo by, and courtesy of, William Nettles

Quack Buddha, 1991

Pastel and gouache on paper

30″ × 22″

From *YOUTH IN ASIA*

Collection of Cynthia Jurs and Hugh Wheir

© *Terry Allen*

Courtesy of the artist

Sneaker, 1991
Mixed media
52 ½″ × 37″ × 7 ½″
From *YOUTH IN ASIA*
© *Terry Allen*
Courtesy of L.A. Louver,
Venice, CA

Melodyland (interior
detail) from *a simple
story (Juarez)*, 1992
Three-quarter-scale-room
multimedia installation
with audio and video
(site-specific,
permanently dismantled)
Dimensions variable
From *JUAREZ*
Wexner Center for the
Arts, Columbus, Ohio
© *Terry Allen*
*Photo by, and courtesy
of, Fredrik Marsh*

Chippy, 1993–1994

Still from the work-in-progress theater performance, American Music Theater Festival, Plays and Players Theater, Philadelphia, Pennsylvania, June 3–5, 1993; written by Terry Allen and Jo Harvey Allen; music composed by Jo Harvey Allen, Terry Allen, Joe Ely, and Butch Hancock; scenic design by Terry Allen; costume design by Sharon Ely; directed by Joan Tewkesbury; conceived and performed by (pictured, L–R): Joe Ely, Jo Carol Pierce, Barry Tubb, Sharon Ely, Jo Harvey Allen, Terry Allen, Butch Hancock, and Jimmie Dale Gilmore.

Courtesy of the artist

Cross the Razor/Cruzar la Navaja, 1994
Temporary, participatory, site-specific
public installation with vans and
soundsystem
Dimensions variable
InSITE 94, Border Field State Park,
San Diego, and Playas de Tijuana,
US–Mexico border
© *Terry Allen*
Courtesy of the artist

Ancient (DUGOUT I, Stage 1), 2000–2001
Mixed-media assemblage
97″ × 96″ × 78 ¼″
From *DUGOUT*
Tia Collection, Santa Fe, New Mexico
© *Terry Allen*
Courtesy of L.A. Louver, Venice, CA

Colorado and Prohibition are in full swing.
She is 28 years old at the piano.
She has long black hair and a red
sequin dress.
The speakeasy is full of ballplayers.
Her band is long gone.
She is smoking a cigarette and plays
alone in the lounge.

Full Swing (DUGOUT I, Set IV, #3), 2001
Pastel and ink on paper
30 ½″ × 22 ½″ (framed)
From *DUGOUT*
© *Terry Allen*
Courtesy of L.A. Louver, Venice, CA

Infinite (DUGOUT I, Stage 6), 2002
Mixed-media assemblage
156″ × 180″ × 120″, variable
From *DUGOUT*
Collection of Laura Donnelley
© *Terry Allen*
Courtesy of the artist

Ghost Ship Rodez, 2008
Still from the work-in-progress theater performance, Massachusetts Museum of
Contemporary Art (MASS MoCA), North Adams, Massachusetts, January 25–26,
2008; featuring Jo Harvey Allen as the Daughter of the Heart.
From *Ghost Ship Rodez (The Momo Chronicles)*
© *Terry Allen*
Photo by, and courtesy of, Kevin Kennefick

Momo Chronicle II: Angels (Interlude/Birds set), 2009
Gouache, pastel, colored pencil, graphite, press type, and collage elements on two panels
46 ½″ × 56 ½″
From *Ghost Ship Rodez (The Momo Chronicles)*
© *Terry Allen*
Courtesy of L.A. Louver, Venice, CA

Ghost Ship and *Momo Lo Mismo* (left and right, installation view), 2010
Mixed media with video and audio
Dimensions variable
From *Ghost Ship Rodez (The Momo Chronicles)*
© *Terry Allen*
Photo by Robert Wedemeyer, courtesy of L.A. Louver, Venice, CA

Road Angel (installation view), 2016
Bronze with audio and light
65″ × 181″ × 81 ½″
Collection of The Contemporary Austin – Betty and Edward Marcus Sculpture Park at Laguna
Gloria, Austin, Texas. Commission, purchased with funds provided by the Edward and Betty
Marcus Foundation, 2017.2.
© Terry Allen
Photo by Brian Fitzsimmons, courtesy of The Contemporary Austin

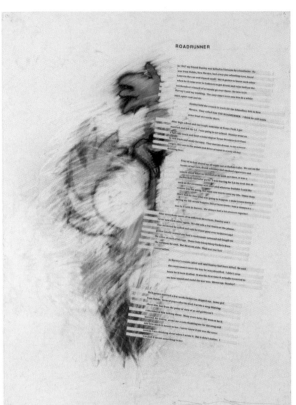

Roadrunner (MemWars), 2018–2019
Mixed media on paper
30″ × 22″
From *MemWars*
© Terry Allen
Courtesy of L.A. Louver, Venice, CA

Storm on the Ghost of Jimmy Reed
(MemWars), 2019
graphite, pastel, gouache, colored pencil,
press type, and collage on paper
30″ × 22″
From *MemWars*
© Terry Allen
Courtesy of Nina Johnson, Miami, FL

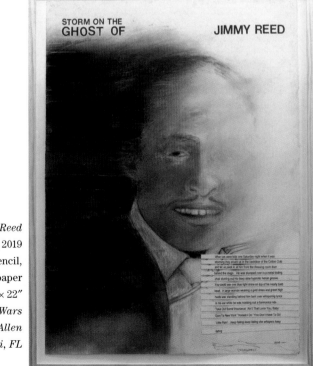

Dave Hickey, whose cantankerous but big-hearted presence haunts the periphery of *Bloodlines*, considering the dim commercial prospects of the record, quipped, "I've never heard such a consistent assortment of unpopular styles."[7] Hickey's doubts notwithstanding, critical recognition was effusive, if limited. In a 1984 review, the *Los Angeles Herald Examiner* called Allen "one of the most compelling American songwriters working today . . . making the most unique art-pop of our time," elsewhere comparing him to not only Moon Mullican and Jerry Lee Lewis but also the Velvet Underground and Philip Glass (probably the only time that unlikely quartet has ever appeared together in one sentence).[8] By 1983 Allen's records were gaining a fanatical word-of-mouth following that had begun to circulate downwind, and underground, of the rarefied air of the art world. His audiences had begun to include outsized contingents of potters and bikers, due, respectively, to enthusiastic ceramicist friends and an unexpected endorsement of *Smokin the Dummy* in *Easyriders* magazine.

Lloyd Maines wept when Terry first played him "Bloodlines," the poignant eponymous ode to the arteries of ancestry and landscape, which sounds as ancient and eternal as a psalm. But that didn't stop him from complaining about having too large and unprofessional a chorus on the album-closing extended version. Twenty-five friends and family members packed the studio that day, including Hickey, Joe and Sharon Ely, and Stubb. "Bloodlines II" represents the recorded debuts of the Allens' sons, Bukka and Bale, as well as Lloyd's eight-year-old daughter, Natalie Maines—a true testament to the power of blood.

CHAPTER 36

HEARTS BECOME ROOMS

An Helena Montana
Beats hell-in-a-city . . . gone cold
An Calgary's like Calvary to me
And Fort Worth . . . it ain't worth a damn

　　—"Helena Montana"

FOR HIS NEXT SOLO SHOW, *ROOMS AND STORIES*, WHICH OPENED AT THE LA Jolla Museum of Contemporary Art on April 16, 1983, Allen reprised two previous large-scale sculptural installations—both built anew after the dismantling and self-destruction, respectively, of the originals—and debuted an ambitious third body of work.

BILLINGSGATE premiered on May 27, 1982, but its genesis dated to the previous May, when, two weeks after Terry's anticlimactic encounter with Reagan, the Yellowstone Art Center unloosed him on Billings, Montana. For three days, strung out on codeine pills, he obsessively recorded his observations and interactions at diners, barrooms, oilfields, and sites such as Little Bighorn Battlefield, Yellowstone Kelly's gravesite, and the Crow Reservation. The aggregate of this solo fieldwork, eclipsed by his own pitchy and narcotized psychological state, described the overriding desolation and degradation of the place, a disturbing, end-times coda of the cowboys-and-Indians myth of the American West, where colonizers and colonized merged into an abject state of desperate poverty, self-loathing, and mutual suspicion. Unsure how to order his chaotic impressions, he decided to present his stay itself as a narrative, a demented ethnographic travelogue.

The result, constructed a year after his visit, was the sculptural installation titled *BILLINGSGATE (a motel)*, a meticulously measured, museological replica of his room at the Imperial Inn in Billings, with framed text of his stream-of-consciousness field notes and forensic photographs of all its contents, down to each ashtray and soap dish, alongside artifacts he'd scavenged. All the furniture was, similarly to *Gorgeous George*, reduced to geometric forms but filled with Montana dirt and positioned within a skeletal architecture of pine-stud scaffolding, a room without walls. The result was as stark and unsettling as a crime scene, eliciting "paranoia inside the room, voyeurism outside it," in Allen's estimation. "I thought it was very successful."

In *ORNITHOPERA*, first exhibited in a fall 1981 three-man show titled *The Southern Voice* at the Fort Worth Art Museum, with Vernon Fisher and fellow Camp Death survivor Ed McGowin, three live hens, a rooster, a crow, and a raven—tended by a veterinarian from a local zoo—inhabited a coop containing dioramas depicting blasphemous Christian themes and representing Southern states. The birds molted (feathers drifted floors away into an office photocopier), engaged in noisy territorial squabbles ("those black and white tensions were what the piece really was about," said Terry), and defecated voluminously (despite Herculean janitorial efforts, the acrid, noxious odor was overpowering, "just horrendous").[1] Here, finally, was the ultimate, malign manifestation of Allen's bird obsession—the unholy resurrection of Pauline's bird plates. "At the opening," Terry recalled, "a woman came up to me after diligently examining the chickens and said, 'They're so realistic!' I was dumbfounded."

ONCE AGAIN A young, inexperienced curator inherited an Allen retrospective exhibition following the abrupt departures of predecessors.[2] This time, it was Lynda Forsha, who visited Allen in his new Fresno studio at 1900 North Echo, across from Fresno High School, where he had been working since June 1981. A former ice cream parlor and dance studio, its "marbled pink-swirl paneling with gold flecks" betrayed its past. The density of materials blanketing every surface was "kind of scary" to a curator focused on Minimalism. "It blew my mind," Forsha reflected. "It was so all-encompassing and expansive, it really broadened my understanding of what art could be." It only got scarier—the

show opened to protests from animal rights activists; one day she opened the museum refrigerator to find a baggie of diced snake meat, raven food.

Anterabbit/Bleeder (a biography), which occupied Allen from 1981 to 1983 before occupying the third room of *Rooms and Stories,* deploys fact and fiction, from his childhood friend Danny Parrish's life and far afield, to explore the nature of biography and history, the ways our language and memories fail and fool us with their feeble reenactments and fractured transmissions of the past, filtered through our myopic present. "History, events, images, memory, and hallucination dissolve into one another," he later explained, "and invent Bleeder's life and mythology."[3] Terry considered it his first sustained foray into biographical strategies, at least insofar as they were applied to a "real" person, an important preliminary project to the more personal *DUGOUT*: "I used stories that were true, stories that were fabricated, built characters that were not true based on some characters that were true. It was the first time I dealt with real biographical information and tested the idea of what a biography was."

As in *RING,* each of *Bleeder*'s three iterations was, as Allen writes, "generated by and developed from the text of the same story," which appeared on the art objects exhibited in the museum gallery (cartoonish mixed-media drawings based on Parrish's juvenile sketches, collages on text-stamped sheet lead panels, and another cage tableau containing a bloodred wheelchair and live parakeets); as the script for a theater piece starring Jo Harvey, Sean Sullivan as Bleeder, and live doves; and finally, in 1990, as the script for a radio play broadcast on NPR.[4] A soundtrack, incorporating Panhandle Mystery Band recordings of "Rock of Ages," "Auld Lang Syne," and Allen's own "Gimme a Ride to Heaven Boy," as well as a selection of traditional Aboriginal, Pygmy, and Hawaiian music, threaded through each installment as score and accompaniment. The theater piece, performed on April 19 and 21—with Terry, Lloyd Maines, and Richard Bowden playing onstage, alongside a hired magician and hula dancer—necessitated lugging heavy, literally leaden sculptures from the upstairs museum galleries downstairs to the museum's stage each night to serve as set pieces.

In 1990, Helen Thorington of New American Radio, which from 1987 to 1998 commissioned more than three hundred experimental works for

radio, approached Terry about writing and recording a new piece. Since the script for the theater piece already existed, *Bleeder* seemed a relatively manageable story to adapt for radio. According to Terry, when she first heard *Bleeder*, Thorington "became infatuated with Jo Harvey's voice," and while no footage exists of the La Jolla stage play, Jo Harvey's audio performance, playing four aspects of the Woman character who cocoons Bleeder with involute narration, is indeed indelible, virtuosic.

Memories are hemorrhages, *Bleeder* suggests, that stain our speech, our stories, and our mark-making with Rorschach bruises of untruths, exaggerations, and fantasies. Projected text—spoken by Allen himself in the radio play—introduced this premise onstage, a key to unlock much of his work: "History exists temporarily, and people take place. Events are carried away to different directions through the mind, as images. Images dissolve across the passage of years, into memory. Stories are told; songs are sung. Hearts become rooms set aside. And hallucination begins."

Dave Hickey wrote one of his most personal and polyphonic essays for the *Rooms and Stories* catalog, foregrounding his friendship with Terry with arch autobiographical asides, pileups of intertextual allusions, and second- and third-person voicing. He completed the piece in a marathon multiday session fueled by amphetamines, crashing in a museum office, armed with a typewriter, a toothbrush, and little to lose. The essay ends with a prognostic admonition, addressed to the artist, the writer, and the reader alike: "You never forgot the things art and language had made you do, the times they had betrayed you, so you could make them set you free."[5]

CHAPTER 37

NOBODY'S GOIN' HOME

Yeah the ones that are gone now
Are the ones that remain

　　—"The Burden"

ON DECEMBER 8, 1983, THE DAY AFTER PROPOSING *TREES* TO MARY
Beebe, Allen left behind a bubblegum Buddha to fly to Bangkok. Only
days earlier, at the Center on Contemporary Art in Seattle, he had com-
pleted the installation of a sculpture titled *Youth in Asia* (a pun on
"euthanasia"), one of the earliest articulations—and the largest yet—of
the eponymous body of work, a project that endured from 1982 through
1992 and eventually encompassed nearly three hundred works in a vari-
ety of media. The kernel of the idea had appeared as early as March 1977,
in his notes about a "monolithic piece" about Vietnam, never realized, to
be titled *Aftermath*. In its ultimate array, *YOUTH IN ASIA* addresses
the posttraumatic legacy of the Vietnam War and its toll of violence
through various lenses, including Vietnamese, Thai, Cambodian, Lao,
Chinese, and French cultures in Southeast Asia; American Indian,
Latino, Mestizo, and Chicano cultures in the American Southwest; the
iconographies of Buddhism and Christianity; and the global imperialism
of the United States and—its comic symbolic corollary—melting and
molting Disney cartoon characters, an indictment of the "bogus inno-
cence of those fairy tales" foisted upon the generation who fought the
Vietnam War.[1]

　　The namesake installation features a dramatically lit lead facade of a
guard tower, encaged behind a fence, that blares American music

recorded in 1968 (Hendrix, Creedence, Joplin, et al.).[2] As in *Bleeder*, Allen chose sheet lead as a material for its tactility and suggestion of corporeality, its "weird, flesh-like quality," as well as its toxicity; throughout *YOUTH IN ASIA*, lead bears an added resonance as a primary constituent of bullets. This stagey scene is presided over by a Buddha statue sitting on a map of Southeast Asia and covered with multicolored welts of bubblegum. For Terry, the gum—chewed by the artist himself and supplemented by museum staff and friends wherever the piece was installed—evoked a range of associations both historical/political (teenaged soldiers, American imperialism) and formal/conceptual (French Postimpressionist painting, specifically Pointillism, as a symbol of French colonialism; the texture of burn scars on human flesh) that would recur throughout *YOUTH IN ASIA*. Flying into Bangkok at night, Terry noted the prismatic neon glow of helical Thai script blanketing the blinking cityscape. It reminded him of "an old Buck Rogers movie about landing on Mars"—and of his bubblegum Buddha back in Seattle.

In June 1983, Fate Records had received a letter from Munich filmmaker Wolf-Eckart Bühler, inquiring about the possibility of Allen soundtracking a film about expatriate American veterans of the Vietnam War living in Thailand. Bühler pitched *Amerasia* as a docudrama that would follow actor John Anderson, playing a PTSD-stricken Black American veteran named John Scott—a lightly fictionalized version of himself—on a trip back to Thailand fifteen years after his final tour. Scott's story would thread through cinema verité footage shot by the master Dutch cinematographer Robby Müller, a collaborator of the German director Wim Wenders, whose films Allen admired. The opportunity to join Bühler's crew on location for a six-week shoot was enormously attractive to Allen; not only would the production company pay Terry's travel, lodging, and studio costs, and a $5,000 fee for licensing the resulting recordings, Allen would retain all copyrights to the resulting music. Bühler, a *Juarez* fanatic, even encouraged Allen to release the recordings himself on Fate. It sounded too good to be true, and it turned out that it was.

Before he left, Terry consulted his friend Ron Gleason, a Vietnam vet who had served in the New Mexico Air National Guard before establishing himself as a public and private curator, alternating posts at the University of Texas at Tyler and the collection of the Atlantic Richfield

Company (ARCO). (ARCO purchased Allen's five-panel 1983 memorial piece *The Box*, which includes a fictionalized "redacted" transcription of a visit to the home of a family resembling Stanley McPherson's, who show their imaginary guest a Polaroid of their son's dismembered legs, "laying in a cardboard box . . . those big Juárez roadrunners all covered in goo.") Over the course of a concentrated multiyear correspondence, Gleason became Terry's principal informant on the perspectives of US veterans, facilitating feedback, introductions to fellow vets, and a syllabus for their informal but intensive two-man reading group, all of which impacted the content of *YOUTH IN ASIA*. Synthesizing these myriad sources, the perspective of *YOUTH IN ASIA* is polyphonic and parallactic, aiming for what Allen has called a "universal aftermath voice." According to Gleason, Terry's humility in assuming strictly a position as "an observer in the aftermath," a raconteur or ethnographer who never claimed lived experience or authority, rendered the work honest and relatable to veterans.

Once in Thailand, Allen, who had agreed to serve as a dialogue consultant—helping to interview American veterans and "translating" for the German crew—realized that Bühler, as a result of his anti-Americanism and "dogmatic Marxist views," had been "deceptive about his motives": "He had this idea that all these Americans were cocaine cowboys and thugs, drug runners and human traffickers, Yankee imperialists running amok in this beautiful, idyllic country. But we got over there, and his premise fell apart. . . . So the drama got pumped out of his movie." All the expat American veterans Allen met recounted similarly sad, ordinary stories of deflating domestic tragedies, occasionally redeemed by love. Some men had discovered that they no longer had a home in the US and returned. An American Buddhist monk described knocking on the door of his former house, long since abandoned by his family, as "the emptiest sound he'd ever heard," a tale eerily similar to Terry's cousin Steaven's. Others feared how their Thai or Vietnamese wives and children would fare in the racist, violent United States and remained, integrating themselves into Thai society.

Although the expats Terry encountered did not support Bühler's agenda, the poverty, brutality, and degradation he witnessed undeniably surpassed anything he'd experienced. The crew spent Christmas Eve shooting in a Patpong brothel so vast and industrialized that customers

used binoculars to scrutinize and select numbered women arrayed like cuts of meat on bleachers behind glass, inspiring Terry's song "Display Woman/Displaced Man." He ate Christmas dinner at infamous expat bar Lucy's Tiger Den, incorporating the meal into the song of the same name. On the ride home, his taxi driver stopped because the road was blocked by a corpse, and gunmen interrogated him as Terry quaked in the backseat. Allen spoke with families whose children had been sold into sex slavery and visited a Catholic orphanage where Vietnamese American children mobbed him, asking if he was their father. He impetuously considered adopting one boy, emotionally telephoning Jo Harvey, a procedure that involved waiting in line for hours, to discuss it with her ("Bring him home!" she exclaimed).

At a café a couple days after arriving, Terry met a group of ragtag musicians whom Bühler introduced, much to his surprise, as his soundtrack collaborators. Caravan was a notorious band of Thai and Lao renegades, led by songwriter and guitarist Surachai Jantimatawn, credited with innovating the *phleng phuea chiwit* ("songs for life") genre of protest music that, utilizing both traditional *mor lam* melodic approaches and Western instruments (often acquired from American GIs), advocated for democracy and the rights of the working class. Blacklisted and censored by the Thai government for their Marxist ideology and activism, Caravan had survived for years as exiled maroons and outlaws in rural Laos. To Terry, jetlagged and intimidated, they still "looked like wild men out of the jungle—which basically they were." Apprehensive but resolved to seize every opportunity to learn, he accepted their impromptu invitation to a concert they were playing that night at a university. "The minute we got out of town," Terry chuckled, "they pulled out an enormous case of dope and cranked up Eric Clapton; smoke was billowing out of this beat-up van like Cheech and Chong."

Hours later, after outwaiting an elephant-related traffic jam, Terry stood atop a blistering rooftop in the jungle, palm fronds swaying by his feet, accompanying Caravan on his dinky battery-powered Casio keyboard for an audience of twenty thousand students and political radicals swarming and shouting in the dark below. The show lasted six hours.

As relations between Bühler and his crew unraveled, Terry distanced himself, living and touring with Caravan for over a month. When he sang "New Delhi Freight Train" the crowd "would always go apeshit," because,

as a local journalist explained, he was "committing treason," an activity with which they were intimately familiar. Caravan's fans recognized "Jesse James" as a fellow outlaw, an agrarian dissident. Allen, costumed in piebald, threadbare fatigues to play the ghost of an American GI in the film, looked the part himself, resembling Dennis Hopper in *Apocalypse Now*.

Despite the language barrier, Allen and Jantimatawn quickly established a pidgin of speech, gestures, and drawings that allowed them to forge a remarkable musical dialogue; they played together for hours every day. Terry's big scene in *Amerasia*, shot on the grounds of a spookily and inexplicably empty hotel in a jungle clearing, entailed a campfire "song duel" between him and Surachai as his spectral counterpart, outfitted in a motley of traditional Hmong garments and the customary Vietcong "black pajamas." They had composed a moving arrangement of "My Country, 'Tis of Thee," transposed to a minor-key Casio riff, with Jantimatawn singing his own ingenious call-and-response Thai lyrics, which not only rhyme with the original English words, but also, in the tradition of *mor lam*, match or mimic the meter, cadence, and phonetic shapes of Terry's vocal. This remarkable creole performance, which furnishes the most compelling scene in the film and the final track on the *Amerasia* album, poignantly subverted Bühler's concept of ghostly sonic warfare with a testimony of cross-cultural adaptation, accommodation, and integration—postwar discourse, and even reconciliation, beyond the grave.

Allen and Bühler began arguing as soon as the shoot concluded. Terry staged a revolt when he noticed, in a rough edit, that documentary footage of "these grotesque fat white guys" hassling Thai sex workers in a Pattaya bar, framed in the script as vile American vets, were in fact German tourists. He threatened to drop out of the project and to disallow his music from being used if Bühler did not cut the scene (he complied). The film's central conceit fatally compromised, and funds for postproduction nonexistent, *Amerasia* faltered, and after a handful of European festival screenings, it finally fizzled and faded away.

LAST OF THE ORIGINAL GHOST LINE

He listened for his mother from
The other side of the grave
But the more that he listened
The less she had to say

—"Houdini Didn't Like the Spiritualists"

WHEN TERRY RETURNED HOME ON JANUARY 27, RAGGED AND EXHAUSTED, San Francisco Airport security subjected him to a body search—"they tore me down from every angle but didn't find anything"—after which the harassment Jo Harvey had been experiencing while Terry was abroad (calls from federal officials asking questions, theft of their mail and garbage) thankfully ceased. After his jungle sojourn with Caravan, California felt "like an acid trip, seeing so many people overwhelmed with glut." Jo Harvey, dressed up in lipstick, heels, and a leopard-print dress for the occasion, drove him immediately to meet her parents in Pismo Beach, an unwelcome detour that left him feeling "like [he] was going to go stark raving mad"—an attitude that she quite reasonably resented.

Readjustment to life in Fresno took several strained months, and Terry and Jo Harvey made a pact never to spend more than two weeks apart from each other at a time. It was too hard on both of them. Terry, as Jo Harvey explained, still wrestled with feelings of abandonment from his childhood, and they both sought to avoid the jealousy and single-parenting stresses that extended separation invariably elicited. He discarded the old journals he had filled with his most venomous excoriations

of his marriage, "the last reminders of the 60s and early 70s . . . the meanest sections," and began wearing his wedding ring again, promising to renew his commitments to Jo Harvey and the boys.

ON MAY 17, 1984, ten days after Terry's forty-first birthday, he and Jo Harvey were in London, awaiting a flight to Paris, where they planned to stay again at Hotel La Louisianne before continuing to Lyon for a site visit. His first solo exhibition in a European museum, *Sprawl/Prowl/Growl: A Geographic Survey of Works by Terry Allen*, which included the *Youth in Asia* installation, was scheduled to premiere in October at Espace Lyonnais d'Art Contemporain (ELAC).[1]

Shortly after the Allens arrived in London, their host gravely informed them that a tearful Bukka had called with solemn news from Aunt Villa: after a series of hospitalizations and surgeries dating back decades, including a mastectomy in 1975, Pauline had died at 11:15 that morning at Country Club Nursing Home in Amarillo. At seventy-nine, her body had finally succumbed to the ravages of cancer and alcohol. It was, as Terry wrote several hours later, "a terrible numb day," protracted into a numb week. He flew from Gatwick to Amarillo, via New York and Dallas, on the next available flights, arriving May 18. Bereft and depleted, he and Jo Harvey, who arrived on a later flight, slept in that "house designed for panic," as he once wrote, now "stripped bare, pillaged" of Pauline's presence, in the bed in which Bale had been conceived. Bukka described to me the wake:

> I remember being in Pauline's house for the wake and looking for my dad. . . . He was in her bathroom in the back room. I remember hearing terrifying noises coming out of that bathroom that I've never heard from another human being before or since—moaning and screaming, these ancient, awful sounds of sadness. He completely lost control in there, purging. . . . And then he suddenly came out; he'd composed himself, and he was there for us. But I'll never forget how that incredible sadness and rage came out in sounds that were not human . . . I've never talked to my dad about it.

What was left after that inhuman howl was a curious hollowness. Terry had feared his momma's death, her final abandonment of him, for

so long that he perceived her irrevocable absence now, and his own aching grief, less as the desolation he anticipated and more as another in a long series of vacancies.

Pauline was buried on May 21 in Llano Cemetery in Amarillo. The ceremony registered only as a blear of tears, a triplet of banality—"'Rock of Ages' . . . a Bible verse and AstroTurf"—except for one grim detail he recorded: "The image of her in the coffin . . . Oliver patting her cheek and her head moving down through her body like a piece of cordwood, I will never forget. The horror in my mind is that was her, is her now."

Terry's relationship with Pauline's widower Oliver had always been stony and mutually suspicious, but Terry managed to convince him to add a critical epithet to her grave marker:

Pauline Pierce Daugherty
August 9, 1904–May 17, 1984
A Great Piano Player

TWO DAYS LATER, the Allens returned to Fresno. Two days after that, Jo Harvey left to perform *Hally Lou* in San Francisco. It was difficult for Terry to admit relief and release, but through the veil of mourning, everything looked different to him: "Even Denny's has new cups," he noted glumly in his journal. In Thailand Terry had played a ghost soldier, but his half-brother Manse, an actual ghost soldier, shell-shocked and shamed into withholding affection, had died of cardiac arrest in 1980 at age sixty-seven. "I'm the last one now of the original ghost line," Terry reflected. His headaches increased in frequency, and the pills only exacerbated his isolation and anomie.

In a dramatic reversal of his recent resolution, Allen began idly pondering moving away from his family and renting a live-in studio—possibly in Fort Sumner, New Mexico—to escape the escalating cycle of jealous battles with Jo Harvey. He assumed her actorly aspirations, which he still denigrated as fantasy, stoked their clashes. "I don't like that profession," he wrote. "I admire it, but I don't care to be around it as a lifestyle." (In the aftermath of Pauline's death, he did not care to be around anyone.) He claimed in a journal that Jo Harvey inspected his hotel rooms for unfamiliar pubic hairs, paranoidly seeking evidence of a dalliance: "For years, she has cut off every female friendship I have, and

I've let her get away with it," he complained in a journal, sounding para-noid himself. Like Jabo, he took off alone to Rosarito, Mexico, alone to mourn, to "sit and talk and drink and dance and long"—for something.

SPRAWL/PROWL/GROWL, AS WELL as a successful but one-off show of other early *YOUTH IN ASIA* work at Gladstone Gallery in New York, were secured and overseen by Wanda Hansen, previously of Hansen-Fuller Gallery in San Francisco, where Allen had shown twice.[2] Hansen had transitioned from gallerist to artist manager, representing Bill Wiley and ceramic sculptor John Mason, and in early 1984 she began assidu-ously courting Terry as her third artist. Flattered by her interest, impressed with her ambitions and connections, and overwhelmed with managing his own business affairs, schedule, and correspondence, especially in the wake of Thailand and Pauline's death, he assented to a deal wherein she would take a 10 percent cut of his annual income—art only, not music—or the equivalent value in his artwork. For years Wanda capably facilitated and orchestrated all of Terry's exhibitions and com-missions, including shows with Paule Anglim, a well-established Québe-coise dealer with an esteemed San Francisco gallery known for championing Beat and conceptual artists, his friend Betty Moody in Houston, John Weber in New York ("a deadend passionless situation" that was "like showing at a pet cemetery"), and L.A. Louver in Los Ange-les. These professional satisfactions proved temporary.

In Paris, following the opening of *Sprawl/Prowl/Growl*, the worsen-ing situation between Jo Harvey and Terry came to a head. Irate after an inflamed public fight, Terry emptied his pockets of all worldly posses-sions, throwing his wallet, pocket change, jacket, scarf, and notebooks on the street. He fled, flying home cold, broke, and alone, leaving Jo Harvey at La Louisianne. Stranded in LA for a night on a layover, he rang up Al Ruppersberg at 3:00 a.m., desperate for a ride and a bed. Al hung up on him, and Terry slept at the airport. A decade later, at a party in New York, Terry and Jo Harvey, laughing, told this story to the Buddhist psychiatrist Mark Epstein, who published it (without names) in *Oprah* magazine as a marital example of "a cyclic process of rupture and repair."[3] Neither of them could remember what they were fighting about.

CHAPTER 39

DUMBO MEETS RAMBO

Yeah display woman
Displaced man
Gonna spend your life in Dis' play land

—"Display Woman/Displaced Man"

THE SUITCASE THAT SAN FRANCISCO AIRPORT SECURITY HAD DISSECTED was crammed with fragrant clothes, still stained with jungle soil, that cushioned exotic artifacts of unknown but suspicious sonic provenance, requiring inspection and interrogation of their owner, who patiently identified a free-reed bamboo mouth organ known to the Lao as a *khene* (Anglicized as "can"), *trupbra* and elephant-skin drums, cymbals and bells—all parting gifts from Surachai—and a tape reel containing five songs cut with Caravan over the course of one long, humid night at 722 Studios in Bangkok. Terry had battled bitterly with Bühler, who had apparently intended only to cover studio costs, to extract even modest fees for Surachai and his bandmates Mongkol Utog, Tong Kran Tanaa, and Veerasak Suntohnsri.[1]

On January 3, 1985, a year after returning from Thailand, Allen toted these fragile souvenirs from Fresno to the small cinderblock outbuilding behind Caldwell Studios to build the soundtrack to *Amerasia* with the Panhandle Mystery Band. Despite the gulf between languages and lived experiences, the Maines brothers felt an instant kinship with the sounds they heard; unforeseen familiarity stripped the recordings of their foreign novelty. "When we put on those tapes and tried to get the vibe of Caravan," Lloyd remembered with awe, "they sounded almost

like bluegrassers to me. The acoustic guitar guy was playing exactly how I would have played it." Allen tasked Kenny, who played harmonica, with learning the can. After hours of practice, lips numb over his rented teeth, he worked out a coarse-grained arrangement of "My Country, 'Tis of Thee."[2] On the album sequence, it follows Allen's scene-setting opening-credits narration—a rewrite of Bühler's stiff, ideological "manifesto"—over synthesized chopper thrum, foreshadowing the final track, "Let Freedom Ring," Terry and Surachai's retitled duet of the same song.

Beyond mixing and mastering by Lloyd and engineer Mark Murray, the five short songs recorded in Bangkok remained largely untouched. The Panhandle Mystery, deploying a mix of their own instruments and the Thai arsenal—as well as, on "Nobody's Goin' Home (Friendship High-way)," a 1971 Cadillac brake drum—appended seven additional vocal songs and four brief instrumentals, capturing a singular, highly percussive and synthetic sonic palette to which they would never return. While both the English and Thai lyrics are direct and unadorned—sloganeering in the original Gaelic sense of "battle cries"—the music and production are experimental and exploratory in a way Allen's visual art, theater, and radio plays often are but his song-based records usually are not.[3]

As an exercise in musical translation and displacement, *Amerasia* is jagged and coltish and often as ill-fitting as Terry's borrowed fatigues, charged with the spirit of new wave and postpunk, a function of his recent listening habits and the album's composition on the jungle-thrashed Casio synthesizer, now too battered and wheezing to ship to Surachai as he intended.[4] Although it indulges in righteous rage and skewed political protest (from both North American and Southeast Asian perspectives), the dominant mood of *Amerasia* is a keening, dizzy dislocation and disorientation, a fascinating if sometimes awkward bri-colage of cultural signifiers in which the mournful memory of war fades into phantasmagoria. Buddha and Jesus may get wasted together on SangSom rum in "Lucy's Tiger Den," but as Terry sings on "The Burden," enlightenment evades us all, and the sleep of reason produces monsters: "Believe we're learning / But we're just dreaming to death."

After interminable delays awaiting a film distribution deal that never materialized, Fate finally released, with a cocredit to Jantimatawn and Caravan, the *Amerasia* soundtrack almost three years later, in November 1987, on cassette and vinyl.

* * *

DESPITE ITS ORIGINS as a soundtrack to a dance performance, *Pedal Steal*, Terry's first long-form narrative audio piece, served as the template for his four subsequent radio plays—collected on the Grammy-nominated 2019 compilation *Pedal Steal + Four Corners*—including *Bleeder*.[5] The project originated when Lloyd Maines invoked the name of Wayne Gailey on the very first day of recording *Lubbock (on everything)* in the summer of 1978:

> Lloyd told me that this guy had been an incredible pedal steel player in New Mexico. He was one of the first people Lloyd had ever heard, and seen, play that instrument in a psychedelic rock-and-roll context. Gailey would be playing at a little country bar somewhere up in the New Mexico mountains, and they'd be playing just flat-out country stuff, but as soon as some pretty girls would walk in, he would take off into a wild Hendrix flight. I think that jarred Lloyd into how he was playing with Ely, and taking off with Jesse on those incredible rides that they took.

In 1985, Terry learned more about Gailey from Roxy Gordon (First Coyote Boy), the magnetic but troubled Choctaw and Assiniboine poet, journalist, activist, artist, and musician Allen had met in Fort Worth through Sumter Bruton, and who had written about the steel player's black magic of desert blues.[6] (Allen dedicated the 2006 Sugar Hill reissue of *Pedal Steal* to the memory of Roxy, who died in 2000.) Fascinated, he began writing the songs that became the "Billy the Boy" cycle that features prominently, though piecemeal, in *Pedal Steal*. First conceptualized and named in a 1976 notebook, the character Billy the Boy now emerged from the conflation of two antiheroes of New Mexican infamy: Gailey and the legendary outlaw Billy the Kid, whose stories intersect in Santa Rosa: "I was using that old classic Billy the Kid legend and slanting it against the climate and culture of early '70s New Mexico. I used Gailey as a pivot point, thinking about a band in that period of time roaming around the southwest playing these shit gigs."

Around the same time, on the recommendation of the executive director of her dance company, San Francisco choreographer Margaret Jenkins reached out to Allen about a potential collaboration. Neither

was previously familiar with the other's work, and it wasn't necessarily an obvious match or a natural fit, as far as aesthetics or personalities. Nevertheless, the Brooklyn Academy of Music (BAM) liked the idea of pairing these two "Western" artists who both lived and worked in California but represented radically different creative milieus and practices. They invited Allen and Jenkins to premiere a collaborative piece for their 1985 season, and after meeting at Wanda's home in Sausalito, Terry "flat-out wrote the script . . . as a sound piece."

In July 1985, six months after tracking *Amerasia*, he recorded *Pedal Steal* at Caldwell Studios with the Panhandle Mystery Band and a variety of guests. Rolling Stones saxophonist Bobby Keys (also from Lubbock) and Don Caldwell (who also coengineered and coproduced) played a sax-duet arrangement of the hoary standard "Sentimental Journey." During Billy's funeral scene, Sharon Ely, as Billy's widow, read from an actual found postcard from Granite Gorge, in the Grand Canyon. Butch Hancock dryly voiced a character and led the band on the morbid country classic "Give Me Flowers (While I'm Living)," a favorite Panhandle Mystery Band encore that also concludes Terry's 1999 album *Salivation*.

All the dialogue other than Jo Harvey's narration is voiced by a Greek chorus of musicians and nonactors, who remember and misremember anecdotes and evidence of Billy's life and death, conjuring the dead, as we all do, to keep them alive. That suits the multivalent, folkloric nature of the text, wherein no single voice (or dancer) is stable, but each embodies multiple characters. The piece was assembled as a collage, using the techniques of film sound editing and analog electronic music. *Pedal Steal* took form as country-concrète composition, the master tape of which served as the soundtrack of each performance of the dance piece: "Each of the people I brought in to read became a strip of tape, until we had the floor and every horizontal surface in that studio covered with numbered strips of tape. When we'd finally finished recording everything, it was like putting a dismantled sculpture together. It was all cut and spliced by hand. It was tactile."

Terry also took on responsibility for art direction for the performance—designing the set, costumes, and projections—for which he won the New York Dance Critics' 1985 Bessie Award a year after its October 1985 debut at BAM's Next Wave Festival. The dancers performed around a

structure designed to look like the graffiti-covered shell of the screen of an abandoned drive-in movie theater called The Beauty, as viewed from the back.[7] Frontal and rear slide projections allowed for the layering of photographs made by Douglas Kent Hall in collaboration with Allen. When dancers moved in front of the screen and onto platforms behind the backlit screen, the lighting stimulated spectral double shadowplay. "One of the things that I was thinking about," Terry elucidated, "was the idea of images coming out of a movie and becoming real and walking around and then going back into the movie, characters who could break continuity but keep moving through another space."

He issued very specific instructions for costuming the six dancers (one of whom was Jenkins herself): "Imagine yourself in Clovis, New Mexico, in 1972, Saturday night, about three in the morning at Denny's. Go in there and take everybody's clothes off of them—that's what the costumes should be." Jenkins recalled that the only point of real conflict during their collaboration involved a sequence in which a character shot a pistol. Allen insisted they use a real gun and actual blanks. She outright refused—"we're dealing with real bodies here!" she protested. "Terry was not happy; it was not a nice moment."

Like his songwriting, which only nominally fits within the realm of country music, Allen's long-form narrative audio works (of which *Pedal Steal* was the first) and his works for radio (his approach to which evolved directly from *Pedal Steal*) appropriate the general form and format of the genre of popular radio dramas—monologue, dialogue, songs, interstitial instrumentals, and diegetic sound cues within a roughly thirty-minute running time—but transform them into something much denser with meaning within a postmodern art context. These works, each of which is couched in one of Allen's bodies of interdisciplinary art, serve as a ligament between his music, writing, visual art, and theatrical work and as a bridge to Jo Harvey's writing, theatrical work, film work, and acting.

ALLEN AND JENKINS'S collaboration was sufficiently fruitful for them to work together again in 1988 on another production, titled *Rollback*, named for a deceptively difficult horseback riding maneuver that Terry's friend Bruce Nauman had recently mastered. The laconic Nauman and voluble Allen had grown closer through mutual admiration, shared

senses of humor, and more recently, proximity, both living in Sante Fe County, New Mexico.[8] Nauman designed the set around two upstage screens on which he projected video footage of him executing rollbacks— looped, inverted, and color-shifted to green and pink. The dancers moved asynchronously with the video, at Terry's suggestion, striking poses and hand gestures adapted from "the incredible ballet-like motion of the Comanches moving in the hills" in John Ford's film *The Searchers*. Allen and the Panhandle Mystery Band once again recorded the soundtrack, a mix of languorous instrumentals and vocal numbers—including a version of "Home on the Range," accompanied by Joe Ely—and a furious drum solo by Davis McLarty, in his first session with Allen, that echoed the earsplittingly loud drum solo recording that Nauman insisted blast over the house speakers before the performance, which premiered on March 22, 1988, at the Kimo Theatre in Albuquerque.[9] "Bruce always wants to irritate you right off the bat," said Terry, "which I admire."

Of his projects with Jenkins, Allen realized in retrospect that "it was all struggling toward a theatrical idea, more than it was about a soundtrack or even an installation."

IN 1986, TERRY was again called out of the blue by a female Californian artist he had never met. This time it was Jacki Apple, who invited him to make a radio piece for *Soundings*, the weekly one-hour radio program she hosted and produced on Pacifica Radio KPFK. Fresh from the success of *Pedal Steal*, Terry took her up on the offer immediately.

Allen was actively exploring digital instruments, which, for reasons of touring convenience, tuning reliability, and sonic flexibility, gradually supplanted acoustic piano to dominate his live performances (and eventually recordings) in years to come, especially once he settled on his preferred Roland models. The E-mu Emulator II, however, was an early 8-bit digital sampler and synthesizer that used floppy disk storage—a very different instrument than Terry had ever used on a recording but one that dominates *Torso Hell*. He recorded the soundtrack at Caldwell Studios, with some additional tracking at STRS Studios in Fresno. Terry and Jacki would perform his script live on air, so he had to estimate the approximate durations for each of the twenty instrumental tracks he recorded and hope they more or less matched the rate they read the script live while the tape played back on air.

Dave Hickey best summarizes the story itself, which Allen conceived as a "radio movie," or a horror film treatment for radio, about a Vietnam vet:

> He has been the victim of a direct artillery strike in Vietnam that has resulted in his becoming a quadruple amputee. Further, his blown-off arms and legs have been inadvertently reattached to his buddies, who were victims of the same explosion. They have all returned to the States: the buddies to their previous lives, the hero to a "torso hell," in the custody of his heartless aunt and her punk son in a boarding house in New Mexico. The aunt and her son keep the hero alive to collect his government disability; and to amuse themselves, they torture and abuse him. The hero . . . having no place else to go, goes deep "into himself" and through "mind control" summons up his buddies and his absent limbs, calls them to him. Finally, in an ultra-violent scene of reunion and revenge, the torso reassembles itself into a "whole man"—enacting a powerful and perverse ritual of resocialization.[10]

This narrative unfolds with a weirdly subjunctive logic and momentum, as if a screenwriter is breathlessly pitching to a movie producer, while the Emulator buzzes, drones, and arpeggiates in the background. The script is notable for its lacunae, its conversational contingencies, as curious for what it specifies as for what it excludes, qualifies, or speculates on. It leaves nearly every detail of direction and dialogue open to the listener's imagination. Terry and Jacki's live vocal performances, which maintain the odd flubbed line and imperfect transition, reinforce this impression of gaseous mutability, of someone speaking this terrifying and hilarious story into existence on air.

Torso Hell is, then, a ghost story in both content and form. It shares the extreme violence and sexuality of its pulp inspirations but presses into the realm of absurdity and metafiction, serving simultaneously as a parody of trashy B horror flicks, ponderous Hollywood Vietnam movies, and Disney fairy tales, and as a vicious commentary on war and its endless rhetorical wake, the ways we abuse, exploit, and ignore our veterans while spouting inane pieties about honor, service, and patriotism. "Dumbo meets Rambo," Terry suggested.

In 1987, a year after its broadcast, the performance art journal *High Performance* released a limited-edition cassette of *Torso Hell* (HP013), with the play on its A-side and the instrumental tracks only on the B-side. The cover features a black-and-white reproduction detail of Allen's 1986 monoprint *Mickey Bob Death* (aka *The Red Letter*), which depicts a sinister, molten Mickey Mouse among Chinese characters from the I Ching (*grace, peace, the abysmal*) and a scrawled "1968." In the radio play, Apple's character suggests that the film should begin "like an old Disney movie, that paintbrush going over the screen in big sweeps, making a full-size cartoon of the jungle, then transforming it into the real thing." Disney's goons appear on a large triptych also entitled *Torso Hell* and incorporating the text of the script (as well as *Mickey Bob Death*), some of it stamped into lead, a toxic Vietnam Memorial.

As a visceral articulation of *YOUTH IN ASIA*, *Torso Hell* the radio play serves as the audio soundtrack to the sculpture *Treatment (Angel with dirty tracks)*, an upright typewriter-headed kachina figure complement to Allen's 1989 supine *Big Witness* and a further facet of the *YOUTH IN ASIA* firmament of damaged ghosts, fallen seraphim, and violated corpses.[11] For Hickey, *Torso Hell*, considered alongside its sculptural counterparts *Big Witness* and *Treatment*, "present us with two rather bleak options for the reassertion of the human bond: hopelessness and transcendental violence, which are, in effect, the same option."[12]

After *Torso Hell* aired, producer and director Roger Corman called to inquire about acquiring the rights for a film. Allen declined. "I said, 'No, you're supposed to listen to it, not look at it.' It'd be bad enough to listen to, much less see it." More notoriety followed when "Jesse Helms put it on his Top Ten hit list of things to be avoided at all costs on radio. I was very proud of that."

ON APRIL 23, 1986, at the Half Moon in Putney, a venue in southwest London, Terry sat dumbstruck under the bar, "trying," as he put it, "to comprehend what was going on." In thirty minutes, he was scheduled to play the first show of his first tour with a proxy Panhandle Mystery Band, equipped with just two days of rehearsal, that included England's premiere pedal steel session player BJ Cole (whom Terry had nicknamed "Dr. Cyclops," for his thick glasses), Bryn "the Destroyer" Burrows (a

Keith Moon disciple known for dramatically destroying his drum set onstage), and fortissimo guitarist Barry Martin (dubbed "The World's Most Unique Midget," for his height). Martin worked for Making Waves, the label that had released *Bloodlines* in the UK.

Terry had just gotten off the pub's phone with Jo Harvey, who delivered tragic news: their friend, the artist Boyd Wright, only forty years old, had unexpectedly and suddenly died of a heart attack. Eerily, Wright had recently delivered a beautiful handmade dining room table to the Allens' home, on the bottom of which he'd carved, in deep relief, a large, leering skeleton. Bale had planned to apprentice with him in his woodshop.

Terry wandered outside to smoke, gasping the damp London air. His substitute bassist Pete Dennis followed him, and when he saw Terry's stricken expression, he wordlessly embraced him while Allen wept. They'd met only three days ago. After a "crazy gig," the Clash's Joe Strummer engaged him in conversation, but Allen remained in a state of stupefaction and delirium that night and for the remainder of the tour.[13] "I have never been so stunned and upset. Out of nowhere—again, the monster looms," Terry wrote that night. "Fucking falling to pieces . . . very depressed and trying to hide it." Three days into the tour, the Chernobyl disaster occurred, threatening to poison all of Europe and casting a literal pall over the trip.

THE BATTLE OF SANTA ROSA

The Moon is made out of paper
Torn paper
Like old rags

—"Pataya" (Surachai Jantimatawn)

IN A DEATH-HAUNTED VOID OF PERSONAL LOSS AND GRIEF, FAMILIAL rupture and repair, *YOUTH IN ASIA* took shape in its mature form, filling psychic vacancies with the loss and grief of two nations as told through a selection of individual veterans' stories. The true subject of *YOUTH IN ASIA* is not war but life after death—the terrestrial possibility of carrying on living after witnessing and enacting appalling carnage, as most easily epitomized by war. "I'm not a Buddhist, though maybe just saying that means I am," Allen has equivocated.

The original cover image of the album *Amerasia* is a detail from *The Battle of Santa Rosa* (1984), a monumental leaden triptych tableau, at the center of which, atop the green baize of a miniature pool table and in front of a chewed-bubblegum crucifix, sits a black Buddha statue, facing away from the viewer and tilted at a precipitous thirty-degree angle, its orientation inspired by Bangkok's Temple of the Reclining Buddha. Now etiolated from battleship gray to albino due to its installation outdoors at the Honolulu Museum of Art, *The Battle of Santa Rosa* is one of several *YOUTH IN ASIA* works that elide Southeast Asian and southwestern US (especially New Mexican) geographies in a Laos/Taos nexus, a Land of (Dis)enchantment: *Buddha of Las Cruces, Bearing Straight at the Club Cafe (Mexican Shepherd Boy), Storm on the Ghost Train . . .*

Laos, New Mexico (all 1984); *Hope* (a reference to the New Mexico town), *The Blue Hole* (1986); *The Fall of Amarillo* and *Truth Are Consequences* (both 1988). Santa Rosa is where Terry dropped off Steaven in 1970, a deserter in the desert, and the town (and its Club Café truck stop) assumed a symbolic power as a way station on the Allens' long drives on Route 66 between LA and Lubbock, listening to news of the war on the radio.

Nowhere is this bizarre intercontinental elision—a return to the cartographic conflations of *JUAREZ* on a global scale—more palpable than in the pivotal 1985 installation *China Night*, which premiered at the Fresno Art Center on September 14, 1985, before exhibition at Documenta 8 in Kassel, Germany, in 1987, and acquisition by the Museum of Contemporary Art, Los Angeles, the following year. *China Night* consists of an uncanny three-quarters-scale cantina, what Allen has described as an "adobe rathole bar," transplanted to the nightmarish netherworld of Laos, New Mexico, where it has been shrunken, gutted, and transmogrified, like a piece of architectural taxidermy, and painted with kachinas.[1] Allen explained the seemingly incompatible jumble of cultural signifiers that appear as an archaeology of migration: "The whole piece was about the Southwest, the aftermath of the American Indians and Hispanics that had gone off to war, courtesy of the USA, to visit their ancient relatives in Vietnam, who had thousands of years before crossed the Bering Strait and come down through the Americas and become what we call Native Americans. So it was like a return home in a perverse way." The fence encaging the property is topped with barbed and razor wire, and a bathtub Madonna stands in the bar's sandlot amid detritus—crushed beer cans and cups, cigarette packs and butts, a tire, a pair of dice, pill bottles—supplied by Allen during the build and by guests at the opening. Behind the building, through the flag-blinded looking glass, things get weird.

The back wall of the bar is missing, and the interior is inverted, with a *Gorgeous George*–style set of stylized bedroom furniture on the ceiling. On the dirt floor is a conclave of plaster lawn figurines: Snow White in whiteface, representing the pure (and Puritanical) self-image of white America (Terry considered plastering her in white bread but resisted), and the Seven Dwarves, faces and hands painted yellow, representing the Vietcong and the North Vietnamese Army, surround neon text

reading "THERE IT IS," a soldierly idiom for death.[2] This sinister tableau implicates Disney iconography—and more broadly, American pop culture—in the symbolic reinforcement of US jingoism, imperialism, and war-mongering propaganda. But it also pointedly references "Disneyland," a notorious open-air brothel, catering to US soldiers, at An Khe Plaza, twenty-five squalid acres of "boum-boum parlor" cubicles surrounded by concertina barbed wire—a Vietnamese La Estrella Negra.

The soundtrack to this fantastic abomination is an hour-long tape of Terry, Ron Gleason, and Roxy Gordon recorded on the afternoon of the exhibition's opening. Their deadpan Texan- and New Mexican–accented voices are juxtaposed with late '60s American rock, pop, and country songs popularly associated with the era, as well as Tejano music and Montagnard (indigenous highland Vietnamese) chants chosen for their sonic resemblance to Navajo and Hopi songs.[3] The three friends alternate haltingly reading the often violent, sexually explicit texts that appear in scarified matrices of symbolic objects and images embedded in the poem constructions and lead reliquaries of early *YOUTH IN ASIA* works. The Fresno Art Center published a *China Night* companion chapbook, printed in a seven-by-five-inch format to resemble Vietnam-era military manuals, containing these "poems of disorientation," as Gordon describes them in his powerful essay about his time in Fresno.[4] They include accounts of veterans' postwar suffering—drawn from interviews, letters, historical research, and fiction—interspersed with lists of absurdist ritual commands designed, perhaps, to jolt oneself out of posttraumatic stupor, such as this one from *Bearing Straight at the Club Cafe (Mexican Shepherd Boy)*, inspired by Steaven's diner breakdown:

Sit in booth
Drink coffee

listen

Look at peas
Tiny dead eyes

eat them

Light cigarette
Break match

smoke

Watch salt
Behind it

wait

Smell cordite
Don't blink

see jumping demons

Open pants
Get under table

see gum

Hear song
Hold penis

sing along

flyin purple people eater

TABLES AND ANGELS culminated the second phase of YOUTH IN ASIA works—compiled in *The Fall of Amarillo*, Allen's first solo show at L.A. Louver in Venice, California, which opened May 28, 1988—much as *China Night* culminated the first.[5] An early example of social practice or participatory art, *Tables and Angels*, installed in the fall of 1987 in a defunct drugstore in Washington, DC, for *War and Memory*, an ambitious interdisciplinary program curated by Jock Reynolds for the Washington Project for the Arts, consisted of a long "boxcar structure" with a row of cubicle cages containing forsaken diner booth tables and benches—the site was a defunct drugstore—at which visitors were

encouraged to sit and talk, their private conversations camouflaged by the stereo soundtrack of helicopter rotors. "The space 'whooshes' and pulses like a giant lung," Allen wrote, with occasional jarring musical interruptions. Many people left mementos and messages, transforming the piece into a modest, temporary adjunct to the Vietnam Veterans Memorial. It was an attempt at making work that was deliberately communicative instead of cloistral and self-referential. Even "haunted visions require absolute clarity," he declared in a journal. "They are haunted because they are clear. . . . I have never felt the necessity for clarity before as strong as this."

After a trip to MARS, the Museum and Archeological Regional Storage facility in Lanham, Maryland—an immense, *Raiders of the Lost Ark*–style warehouse for the national museums—where they examined the manifold items left by mourning visitors to Maya Lin's 1982 Vietnam Veterans Memorial, Terry and the Flatlanders were given the audacious and daunting task of writing a new national anthem for *War and Memory*.[6] They had never written together before. "The disciplining of our four strange minds was just about a zero possibility," Gilmore said. "But it was an amazing experience." "We ended up locking ourselves in a hotel room in downtown DC for a week. . . . At the end of which we'd written *ten* national anthems," claimed Ely. They ultimately abandoned them all, instead ending their concert on November 13, 1987, at the Smithsonian National Museum of Natural History's Baird Auditorium, under a flock of taxidermy birds, with their nomination for a new national anthem: Woody Guthrie's "This Land Is Your Land." "How do you improve on that?" Terry asked.

BIG WITNESS (LIVING IN WISHES), the final large-scale installation of *YOUTH IN ASIA*, first exhibited at the San Francisco Art Institute in the spring of 1989, was equally haunted but less generous than *Tables and Angels*, closed to seated contemplation and hostile in its confrontational irony. Expectations were high. Terry had been the cover model of the January 1989 issue of *ARTnews*, standing in his studio, wearing a blue work shirt and jeans, beside his pink, bubblegum-lumped piano and the headline "TERRY ALLEN: TRUE GRIT." He got some "weird looks at the art supply store" but, otherwise, thought little of the attention until he received the Adaline Kent Award for California artists in advance of *Big Witness*.

A monumental, blockheaded robot-kachina figure—in the accompanying military manual–style chapbook, Hickey describes it as "the terminal artifact of Pop Modernism: a Donald Judd Transformer Toy"—the titular "Big Witness" lies supine, "trapped in his furniture," doubly entombed within a chicken-wire ghost couch within a chicken-wire ghost house. A monotonous audio collage of excerpts from driveling self-help audiobook cassettes and insipid New Age music blares relentlessly from speakers inside the Witness's metal body. "That was the most sadistic piece I've ever done, especially for the poor guards," Terry admitted apologetically. "That relentless litany of self-help was a total prescription to turn someone into a serial killer."

WHEN TERRY ARRIVED at the Southeastern Center for Contemporary Art (SECCA) in Winston-Salem, North Carolina, in October 1992, to install his *YOUTH IN ASIA* retrospective, greeting him in the gallery was a coil of writhing copperheads. Conditioned to perceive portents by the I Ching throws that informed his decisions about *YOUTH IN ASIA*, he shivered at this serpentine ill omen. Similarly inauspicious was the Halloween opening date for the exhibition and concert. The show looked stunning in the museum, "one of the best installations of my work" to date, but almost no one saw it. Beyond the Allens and a smattering of friends and representatives from funding foundations, the opening was sparsely attended, though Allen enjoyed hosting gallery talks for local veterans. Despite a budget of over $200,000, SECCA had grossly underpromoted the show, and although it traveled to museums in Fort Worth, Newport Beach, and Honolulu, it never quite recovered from its initial flaccid impact.

Sneaker (1991), the final *YOUTH IN ASIA* piece, completed after a nearly two-year hiatus working on public art commissions and bronzes, serves as an empty epilogue to the project, much like the anticlimactic coda of the SECCA retrospective itself. The lead-stamped yellow text, flanking two Oxford shoes affixed to the surface of the piece, is a transcription of a newspaper article about a man who, through years of VA psychiatric treatment, claimed the squeak of rubber soles horrified him, because it conjured the memory of the sadistic guards' shoes while he was a POW in Vietnam. When he died, his wife discovered he had fabricated his life story for decades; he had never served in the military at all.

By 1991, in the wake of the Gulf War, it seemed to Terry that, for the US government and much of the public, the horrors of Vietnam had been officially forgotten and effaced, relegated to the distant fantasy of history as the United States rocketed headlong into yet another intractable foreign conflict.[7]

LOOK WHAT WAITS BEHIND THE GLASS

In Europe you're up to your ass
In the mirror of everything past
But look what waits behind the glass

 —"I Love Germany"

IN APRIL 1984, THE MONTH BEFORE PAULINE DIED, JO HARVEY WAS ON THE campus of California State University, Fullerton, for a performance of *As It Is in Texas*, a comedic standup revue of characters from her one-woman plays. The night before the show, she returned to her hotel, where the desk clerk informed her that she'd received multiple messages from someone named David Byrne, a name she did not recognize. "I thought, 'Who in the world would track me down to this crummy hotel? He's got to be some weird stalker.' I had a stack of McDonald's hamburgers with me, and I wrote his number on the bag. But as soon as I got back to my room, I wadded up his number and threw it out and locked the door." The next morning curiosity got the better of her, and she uncrumpled the greasy sack and called the scrawled number, demanding, "Who is this, and why did you call me?"

"Hello, my name is David Byrne," enunciated an oddly formal voice. "We have some mutual friends."

"My God, the oldest line in the books," Jo Harvey grumbled to herself. "He sounds like some kind of killer!" Byrne asked to meet her at her performance that night and inquired about the location of the theater.

"I'm sorry, I can't *begin* to tell you," she drawled cautiously.

They did in fact share a notable friend. Byrne admired Joan Tewkesbury's writing and had "tried to rope her into" helping with the screenplay for his first film. She declined, but when David mentioned that the film would be set and shot in Texas, she insisted that he meet Jo Harvey and Terry immediately. Byrne took her advice, bought all of Allen's records, and "suddenly," he said, "I was obsessed with all Terry Allen's songs."

That night after the show, as Jo Harvey mingled with audience members backstage, a slender, severe-looking young man in a white suit approached to introduce himself. By this time, David was already "addicted to Terry's music," and now he considered himself a fan of Jo Harvey too.[1] "I was knocked out by her show," he told me. "It was moving and funny." He was making a movie, he ventured tentatively. Would she like to be in it? He thought, after seeing her inhabit so many characters, that she could probably play any number of parts.

Still floating after her performance, Jo Harvey did not register the name, and he did not look familiar to her. Who was this guy? His awkward affect clashed with her pathological gregariousness, and still suspicious he was a stalker, she grilled him.

Unimpressed that he "had made a few music videos," she finally agreed to read his screenplay. As he walked out, the awed theater staff interrogated her—did she know with whom she'd been chatting? "Wait, the *real* David Byrne? The actual 'Psycho Killer'?" she responded incredulously. She was familiar with Talking Heads' records through Terry but had no idea what their front man looked like. She hollered after him, "Thank you for coming so far to see me!"

A few weeks later Jo Harvey called David to discuss her participation. Byrne's then wife, the costume designer, artist, and actor Adelle Lutz—whom Terry later nicknamed "Boney," his version of Bonny—heard his side of the conversation. "What's wrong?" she asked, when David, looking "sort of ashen," hung up the phone.

"Jo Harvey thinks she's going to play *all* the parts in the movie. You have to talk to her!"

According to Lutz, "She'd told him, 'So I can do the Lazy Woman like this, the Lying Woman like this . . . Then for the Lonely Bachelor . . .' She had this whole elaborate scenario worked out, like she was Peter Sellers or something."

During a dinner with Byrne and Jonathan Demme, Jo Harvey bravely announced that, despite her reservations about playing the male parts, she believed she could pull off the preacher if she slicked back her hair and parted it in the right way. "Jonathan just dove under the table laughing, like he couldn't believe the gall!" she giggled. David stammered, "Um, maybe on this movie, just pick one character, and on the next one you can do them all?" Eventually Jo Harvey settled for a single role in what became *True Stories*, playing the Lying Woman ("no stretch," smirked Terry, "which she will readily admit").[2]

It was her first film role as well as David's directorial debut, a crash course in cinema for them both. Byrne allowed her to improvise and write some of her own dialogue, shared dailies with her, answered all her questions in his sometimes inscrutable manner, and even invited Bale to appear in a bit part as a farting teenaged lover. Jo Harvey shared with John Goodman a memorably mendacious tall tale–telling scene concerning her amputated talismanic tail. She befriended her castmates Spalding Gray and Pops Staples: "I loved Pops. We'd run errands together. I'd turn up the radio as loud as I could in my new Audi, with the windows down, and we'd sing along at the top of our lungs to Bob Seger." One night, she joined an impromptu hotel-room gospel-singing session with Pops and Mavis. Jo Harvey was in heaven—her cinematic dreams were coming true.

WHILE JO HARVEY was busy lying on celluloid, Terry was in South America. On September 23, a week after the opening of *China Night* and a month before the premiere of *Pedal Steal*, he was in Brazil for the Bienal de São Paolo, one of three American artists invited by the United States Information Agency (USIA), "a long-defunct clandestine branch of the CIA," whose visa stamp in his passport allowed him to breeze through immigrations and customs lines for years. Lonely and jealous, he reflected bitterly on the distance between him and Jo Harvey, writing: "I'm in São Paolo. She's in Dallas. She is trying to be a movie star. . . . I'm happy she is getting a shot at it—but I will not live that way."

On the drive from the airport, the docent assigned to pick him up explained that three months earlier, her husband, who worked in a university forensics lab, had helped authenticate the recently discovered remains of Josef Mengele, the so-called Angel of Death of the Third

Reich, who had conducted horrifying experiments on prisoners at Auschwitz II–Birkenau. Mengele had fled Poland to Brazil after the war; in 1979, he drowned while swimming in the sea near Bertioga with his grandchildren and was buried under a pseudonym. Fascinated by this grim story and the presence of Nazis living incognito in São Paolo, Allen quickly reimagined his loose installation concept under a new title: *Secreto Engel (Stations)*, combining the Portuguese word for "secret" and the German word for "angel."

He constructed a dead-end hallway between two long walls, which he plastered and painted a pale, sickly institutional green—"I've always hated that color," he noted with disgust—installing a sound system in each. One blasted militaristic German music and the other blared Brazilian music, both at earsplitting volumes, like walking "inside a boom box." Museum staff "hauled in this incredibly beautiful blood-red clay from outside the city and packed it a foot deep on the floor."[3] At the end of the hallway, in a dimly lit red alcove, Allen placed "a little altar" that held an aquarium. He purchased a pig's heart at a butcher shop around the corner from his hotel and sunk it in the aquarium, "bleeding and bubbling" and blackening the water.

The atmosphere was nauseatingly oppressive. Although museum staff replaced the heart weekly with a fresh organ, the aquarium continuously emitted a fetid stench. The gallery remained unpleasantly clammy due to the damp clay, which hundreds of high heels perforated during the opening. Presidente José Sarney, surrounded by an entourage, stuck his head into the door of the space and, sickened, loudly announced that it was time to decamp. Allen ranks *Secreto Engel* as perhaps his most overtly hostile artwork: "The smell of blood was amazing with that overpowering sound and humidity. The piece worked on a lot of levels for me—it was visceral, that presence of death and evil."

IN FRESNO ON New Year's Eve 1985, David Byrne's own heart sank. The Allens had invited him and Adelle to their home for the holiday, a celebration that became a treasured interwinter tradition. Like all musicians who visited, David was expected to swap songs with other guests in a "guitar pull," a custom that caused him crippling anxiety: "I gather in Texas, it's a normal thing to gather in a house, around the hearth, and play songs round robin. The idea isn't to do a show, just to exchange

material. I tried to play a Richard Thompson song, but I couldn't remember the words. I couldn't even remember the words to a Talking Heads song." "We don't do this in New York," he confessed to Terry.

Although they'd met before briefly, the occasion was the first time David and Terry had spent any extended time together. The two could hardly have been more different culturally and socially, an unlikely collision of personalities and art-rock and art-country attitudes. They were so dissimilar that their mutual fascination was almost anthropological. "Terry noticed my differences immediately, and he teased me relentlessly," David laughed. "It was awkward," Terry said of their first days together. "David used to be much more bashful and shy. Boney is such an easy person, and David is the absolute opposite, at least then. He had absolutely no concept of small talk—any attempt just died on the vine. As long as it was about your work, art or music or film, he'd talk your arm off—his curiosity was so immense. I liked that. But otherwise you'd think he was oblivious to what was going on."

Their differences proved superficial. The two polymaths knew and admired each other's work, and cruising around Fresno and in Terry's studio, they slowly bonded over their shared interdisciplinarity and disregard for specious boundaries between media and genres. They also recognized each other's essential deep-seated shyness and hunger for friendship and collaboration. David was still editing *True Stories*, and they drove to San Francisco together so Terry could record a single line of voiceover, as an off-screen journalist who salaciously asks John Goodman as Louis Fyne, "Hey, Louis, where you goin' on your honeymoon?" (Terry takes pride that his voice is "the only really pornographic thing in a very clean movie.")

When the clock struck midnight on New Year's Eve, both couples marched outside, parading around the block, banging pots and pans, and bellowing "Auld Lang Syne." They cemented their friendship on the drive back to LA. Terry played *Torso Hell* for David, who loved it. He asked Terry to help him with a song for *True Stories*. Allen's first of three cowrites with Byrne—his first-ever cowritten song—was a challenge due to their contrasting compositional processes: "He sent me a cassette with a song called 'Blue Gallop.' I was mystified. It was a quirky melody, but what threw me was he sang this bizarre Arabic-sounding yodel on top of the music, where he wanted lyrics. He said, 'Where I

made those noises, you can put words.' I thought, 'Man, this is *fucked*; there's no way I can do this.'" Inspired by New Orleans music and Byrne's recent horn-heavy score for Robert Wilson's *The Knee Plays*, Terry wrote "Cocktail Desperado" and recorded it at Caldwell's with his go-to Lubbock horn section.

"Eventually he became a person I feel very comfortable being uncomfortable around," Terry remarked of David. In 1997 he wrote, "I've really got 3 friends off/on my mind. Dave [Hickey] is my phone friend, David [Byrne] is my fax friend, Bruce [Nauman] is my quiet faxless phoneless friend."[4] David's appreciation for the Allens transcended admiration for their art:

> Beyond their wonderful work and creativity, I was very inspired by how they had found a way to integrate those things with how to be a family. You don't often see it. Often the creative person will divorce that from the family life. . . . There's a sense that one's creative work is a solitary investigation—that you have to be a person living on the edge in order to be an authentic person and artist. There's a myth that family life doesn't fit into that. . . . So I took hope from what I saw in their household.

The sentiment was sincere and binding: when David and Adelle's only child, Malu, was born in 1989, they asked Terry and Jo Harvey to be her godparents, a responsibility they've taken seriously, regularly hosting Malu in their home. When Malu had her own baby, Bo, in 2018, the Allens gifted her the antique black pram in which they'd rolled Bukka and Bale up and down the hills of LA five decades prior.

WHEN BYRNE AND Lutz first visited Fresno, the Allen family's lifestyle of interpenetrating artmaking and everyday existence had reached a new zenith of collaborative energy. In late 1986 they were tweaking a family theatrical production they had premiered in June for the Washington Project for the Arts in DC. Chaotic and discursive, improvisatory and constantly, captiously evolving—"we'd stop in the middle and bitch at each other," Terry claimed—*Do You Know What Your Children Are Tonight?* was, other than the typing (for which Terry was individually and irritably responsible), a fully collaborative and democratic, if often

disorderly, family affair. "A hodgepodge of images and ideas," the show was a raw exploration of the family dynamic throughout the course of a single turbulent day, anchored in songs. Bukka had recently recorded a clutch of tunes with Lloyd, which he performed in between Terry's own songs and Jo Harvey's riotous monologues and mugging. Bale played drums onstage for the first time ever.

"There was a lot of profanity—every subject was wide open as far as sex and violence," Terry explained. Both boys spent significant portions of the show in their underwear. This frankness reflected the Allens' wide-open and dichotomous parenting style, which was both wildly permissive and completely uncensored, as far as cultural consumption, creative expression, and candid conversations, and quaintly old-fashioned and traditional, exhibiting what Bukka termed "a West Texas conservative strain." According to Bale, "they gave us complete freedom to express ourselves—our hairstyles, clothes, and bedrooms were our domain." But the Allens also espoused what Bale described as fundamental "Norman Rockwell family values: we eat dinner together, we have family discussions, we pray." (While Terry was, in Bale's words, the "enforcer" as far as general discipline, Jo Harvey was the one to regulate religious observance.)

The Allens encouraged their children not only to make art but also to engage proactively and altruistically with the world. "The idea of expressing your pain and then stepping outside of yourself," that "there are things happening on planet Earth other than what's going on in your own head, in your own trauma," seemed to Bukka an example of Terry's insistence on modeling "the antithesis of narcissism": "Whatever trauma and heartbreak he experienced as a kid, when he could make up for it in his own family, he did. He made a conscious effort to give us what he didn't have."

The Allens' home, filled with art and visiting artists, was a haven to the boys' teenaged friends, who could count on Terry discreetly to bail them out of jail in a pinch—usually in exchange for chores—when they could not call their own conservative parents, and "a devil house," to those same parents, who flinched from its disconcerting decor of red neon and ubiquitous skull imagery. Every surface of Bale's small bedroom in Fresno, an art environment in its own right, was plastered with objects and images, including silicone novelty breasts and skin-mag centerfolds, like a horny adolescent *Merzbau*.[5]

"It was a pretty insane experience," Terry said of *Do You Know What Your Children Are Tonight?* "It was so well received that we were dumbfounded." By the time they reprised the play in January 1987 in San Francisco, the boys were arguably too old and independent for their roles, beyond that "perfect cusp physically and mentally" they had inhabited in DC. Having survived an arrest for shooting mailboxes with a friend on the cross-country drive from Fresno to Boston, Bukka was already living on his own and studying at Berklee College of Music. After a spell waiting tables and pursuing acting in LA, Bale soon joined his brother in his Fenway loft, enrolling at the School of the Museum of Fine Arts, each child pursuing one of their father's two primary disciplines—and excelling.

JO HARVEY, ALWAYS attuned to signs and omens, wrestled with several in Minneapolis in the fall of 1987. She and Terry were in town rehearsing for *Leon and Lena (and Lenz)*, an adaptation of German dramatist Georg Büchner's obscure 1836 play *Leonce und Lena*—a comedic satire disguised as a fairy-tale romance in a fantasy kingdom and the first in a string of elaborate, professional theater works on which the Allens collaborated. Their own relationship was no fairy-tale romance. "Terry and I were going through a really difficult time," Jo Harvey sighed. As she pursued her acting career, Terry likewise began to gravitate toward theatrical projects, galvanizing a long-simmering interest and seeking opportunities for proximity to, and collaboration with, his wife. As his work approached an operatic pitch—beginning, more than ever before, to integrate his songs, prose and poems, and sculpture in a theatrical context—so did their marriage.

For the first time since shortly after their wedding, panicking about having accepted a role as Dolly Parton's sister in a sitcom, Jo Harvey experienced a paralysis in her legs that only dissipated when she backed out of the show. The series was never greenlit. Years later in a journal, Terry reflected, with some embarrassment, on his "codeine drama display" in Minneapolis following a blowup with Jo Harvey, when he seriously injured himself with a blade. The incident scared him, but other, external perils awaited. Crossing a busy street one day, an enormous wayward crow nearly crashed into his face, barely knocking him out of the path of an onrushing truck that had run a red light. In the dilapidated twin towers of grim brick on Oak Grove Street, in which the cast and

crew stayed for three months of rehearsals and performances at the Guthrie Theater, Jo Harvey experienced a disturbing vision: "One morning I got up really early, just at dawn, and looked straight across at the identical ninth-floor window. Standing up against the window was a woman in a blue dress. All I could see was her neck to her waist. Right above her on the roof was a crow, so it looked like her head was a crow. I'll never forget that image. I went over and knocked on that door. No one answered. A janitor said, 'Honey, no one has lived in that apartment for a long time.' Strange things were happening."

Director JoAnne Akalaitis, cofounder of experimental theater company Mabou Mines with her collaborator and ex-husband Philip Glass, had recruited Allen as the production's composer. (Byrne had introduced her to Terry's music, and Lutz was the costume designer.) Hiring Allen was, according to Akalaitis, a "package deal"; Terry told her that if he was going to spend months in Minneapolis, she would have to find a part for Jo Harvey. Although Terry's duties officially encompassed only music, Akalaitis was highly receptive to his ideas, many of which she incorporated in the production: Americanizing Leonce's name to Leon, Americanizing the script's royal families into corporations, and conceptualizing a floating Studebaker containing a special-effects lightning storm inside its cabin, devised by lighting director Jennifer Tipton.

In addition to selecting relevant recordings from his catalog, Allen wrote the sour doo-wop "Oh Mom" (a thinly disguised ode to Pauline), "Oh Tired Feet" (using lyrics by Büchner), and, while in Germany for Documenta, the sinister, squirmingly ambiguous anti-Nazi satire "I Love Germany," which CalArts grads Jesse Borrego and, in an early role, Don Cheadle, a Latino and a Black actor, sang in transgressive duet ("it was phenomenal," remembered Allen):

I love Germany
I don't care what they've done
It's no different really
Than what anyone else has done
It's just rich men having fun[6]

Leon and Lena (and Lenz) opened on October 17, amid the charged atmosphere of the Black Monday stock market crash and the Twins

winning the World Series (during intermission Cheadle announced the scores).

WHILE *TREES* OCCASIONED a professional rebirth in public art that sustained his practice for years, in his personal life Terry was plummeting toward rock bottom. By the end of 1987, five years from the military matrimonial milestone of "The Thirty Years War Waltz," he was mired in a deep depression, an existential dread attributable to addiction, midlife crisis, empty-nest syndrome, and marital strife. Jo Harvey had rented an apartment in Santa Monica in which to stay while auditioning, and the physical distance exacerbated the psychological distance, mutual suspicion, and lack of trust between them. His journals reflect his gloom. He wrote on Thanksgiving, "Jo Harvey is not my friend. That ended when we married." Jo Harvey told Terry that a psychiatrist she consulted suspected that he was mentally ill and likely suicidal, warning her that he might kill himself and leave a note blaming her.

Recognizing that, regardless of how much they still cared for each other beneath all the reckless behavior, they were "just torturing each other," he considered seeing a therapist himself—"hard as nails for me, because I've never believed in them"—but days later changed his mind. He described wanting desperately to "make things right" in his marriage, but he had no notion how constructively to direct such a desire, what strenuous shape his love and hope could possibly take to displace the spite and sadness. He reminisced about their first visit to Paris a decade ago, how tender they had been with each other, lying naked in Hotel La Louisianne. He considered fixing his teeth and shaving his trademark mustache, but he didn't yet have the fortitude to remake his face or his life.

On New Year's Eve 1987, "the last day of the year—a bad year and a great year," exhausted and overwhelmed by looming deadlines and his own voracious ambitions, he took refuge in a small black Moleskine. "I'm tired, but it's bad on top of that. It's a day that's numb," he reckoned. "I'm supposed to make a giant sculpture. . . . I'm supposed to write 5 million songs," he wrote in despair. "Just this week." The breakneck pace of his work threatened a mental and physical breakdown. Fatigue had become a defense mechanism, a way to distract, anesthetize, and isolate himself. Time itself was out of joint, ebbing, "dripping off like

God's flood." He was forty-four years old, and mortality was on his mind. "She constantly tells me she's 45," he wrote bitterly of Jo Harvey, "as if that means anything. . . . I don't give a fuck about age as long as I can die fast—not like some turtle trapped on his back in the back room. 45 is a joke . . . unless it's a pistol (and it's <u>one</u> <u>potent</u> pistol!)."

Although throughout the 1980s he had periodically tried to quit both drinking and smoking, aware of their destructive effects—the specter of Pauline hovering above on vodka fumes—he always relapsed. He was now agitatedly smoking three to four packs of cigarettes a day. More worryingly, after fifteen years of habitual use, the fiorinal codeine pills had begun to poison his perception, unloosing frenzied flutters of hallucinations. The clarity the pills had once provided had clouded, the stamina now stunted. His insomnia was chronic. Noting with clinical detachment how the drugs had decreased his appetite, leading to weight loss, he observed that "if you are what you eat, then I'm approaching nearly nothing." As 1987 collapsed into a new year, and on the brink of collapse himself, Terry wrote unsparingly of his addiction and his unhinged state of mind.

> I got headaches
> I got drugs
> I take the drugs even when my head's fine
> (Whose head is fine?)
> They make me nervous
> So I take them to relax
> I took so many once I had spiders in my eyes
> When I laid down I had spiders on everything
> (I don't mind spiders—I know a lot of them)
>
> I hear voices.
> No sweat.
> They're pretty realistic.
> (I wish they'd give me some ideas.)
> Sometimes they hum.
> Actual melodies.
> But nothing I can use.
> I heard all the tunes before.

My mother's dead.
My father's dead.
My wife and I don't get along so hot.
We go different ways.
My kids are gone but they call once in a while.

I don't know about Jesus
I can't figure that out

I feel like an orphan sometimes
A real old orphan

He knew something had to change. He knew sometimes a man is wrong. But how to make it right?

PART III

THE SANTA FE SECTION

meanwhile,
Duck talking to the sky:

Hello Daddy
Hello Momma
Hello old friends
Angels of the mystery
Flying out flying in
There ain't no way
That's the way it goes
And heaven is just an adjustment
That moves on down the road.

 —"Salivation"

CHAPTER 42

BIG POOL IN AGUA FRÍA

I know you don't understand this
But I think you have a death wish
Even though I know you do not want to die

　　—"That Kind of Girl"

IN JANUARY 1989, AFTER SEVENTEEN AND A HALF YEARS IN FRESNO, Terry finally left the Golden State for good.[1] For the past three months he had been living like an itinerant critter, sleeping on the floor in the empty house on Fedora Street or in his studio at Echo and Normal, where he would wake to the chatter of high schoolers bustling out of buses across the street or the bagpiper who played Sunday mornings to spite the Mormons. "I used to sit on that step," Terry said, "looking at that Mormon church and the high school, and just longing for a vista, seeing a plain or mountains, anything but what I was looking at . . . I despised that view."

Every few weeks he drove from Fresno to Santa Fe to check on Jo Harvey, who was managing the renovation of their new home and construction of his new studio, with the express intent of framing a new view. They had moved out of their Fresno home on September 2, 1988, after the emotionally difficult process of dismantling Bale's ludic bedroom. While Terry remained in Fresno, simultaneously working in and packing up his studio, Jo Harvey followed the moving truck one thousand miles southeast to the old capital of Nuevo México. Ten days later, when she awoke alone in the dusty adobe construction site they had purchased in Agua Fría, a rural village five miles southwest of the Santa

Fe Plaza, just beyond the city limits, she telephoned Terry excitedly, exclaiming, "You're not going to believe this, but there's snow all over the ground!"

When Terry rolled into Agua Fría in January 1989, it was snowing again, but rather than reflecting the rarefied morning mountain light as it had for Jo Harvey in September, this snow cast a milky pall of terror over his passage. He was driving a U-Haul that contained his entire studio—another truckload of art—while his friend David Dowis, a doctor, drove Allen's truck behind him.[2] The ride was harrowing, because of the inclement weather but also because Terry, left to his own devices in Fresno—and understandably anxious about the move—was chemically impaired. "It was a terrifying drive," he shivered, "because I was ripped out of my gourd on pills." Drug-addled and sleep-deprived in Flagstaff, pulling out of a Denny's, he accidentally banged the truck into drive instead of reverse and, lurching forward, peeled an awning off the car park with the cab. Passing through Gallup, the self-proclaimed Heart of Indian Country, its red rock cliffs now blanched, he tuned into a Navajo Nation station that cataloged snowstorm casualties and portended further doom. "They were reading out a list of names of the dead frozen to death that week," Terry recollected. "It seemed like an unbelievable number." When he and David finally surfaced from the whiteout and pulled into the property, Terry, trembling, tumbled out wild-eyed, falling to his knees into the snow, surprised he had survived. Against all odds, some old angel had helped him hold it on the road.

"That was the day I ended my career as a dope addict," he said. "I remember thinking, 'This is it—I've had it,' and I dumped all the pills out into the toilet. That was the last bottle I ever had." The next day, restless, bone-weary, and aching on a flight to Detroit, where he was expected to install *Them Ol' Love Songs* at the Cranbrook Museum and, through some miracle, to perform, he discovered that he was experiencing the first symptoms of withdrawal. Worse, once he was back in New Mexico, the headaches, ever opportunistic, returned with a vengeance, perfusing the opioid void and pinioning him to his drawing table. On one notable occasion shortly after their move, when he felt the onset of a headache, he returned to his new studio and doggedly "drew the headache . . . and literally it went away." When he rose to walk back to the house and finish his dinner, the skewering, blazing pain immediately

returned, nearly knocking him off his feet. He staggered back to his table and made another drawing, and the headache retreated yet again. This pattern recurred ten times, "until I was so exhausted, I couldn't draw anymore. . . . The drawings are hard for me to look at now because they're such souvenirs of that pain."

To Allen's new Santa Fe doctor, this story, with its intimation that Terry had developed some degree of control over the clusters, suggested a link to a seizure disorder, and he prescribed him Depakote, an anticonvulsant used to treat epilepsy, bipolar mania, and migraines. "It was the first time I was given a drug that was a nonnarcotic," he specified. "I don't know how much good it did." It did seem to alleviate his agony somewhat, at least temporarily. By that point, he was willing to try anything to tame the pain, including alternative remedies he had previously mocked. Acupuncture, to his astonishment, helped considerably. Gradually over the course of the next year, the headaches faded and became less frequent, until, finally, by the mid-nineties, they rarely occurred at all outside isolated inky spells. "But the horrible thing is," he acknowledged ominously, "they can come back any time."

That threat has kept him working to ward off that day. In the fall of 1989, following a cluster headache relapse, he memorialized his headache decades by beginning work on a monumental drawing depicting a giant blue-and-yellow Fiorinal #3 capsule floating in water like a sinister life raft. He titled it *Big Pool*, another pun, on "pill." "I regard it as a tombstone to my medication and addiction experience of twenty-some years," he pronounced. He discovered later that the very culture—in both senses of the word—of the place to which they had moved had likely contributed to his recovery. Traditional Santa Fean cuisine privileges the famous Hatch green chile, an extract of which—capsaicin—was an emergent treatment for cluster headaches. "To this day, I still crave green chiles and jalapeños," he said. "And we did find out later that some of the nasal sprays that they use for cluster headaches are 40 percent chile."

BY THE MIDDLE of 1988, both Terry and Jo Harvey were, by their own admissions, feeling "crazy as hell, in our mid-life crisis period." With Bukka and Bale in Boston and Terry long since separated from the university, no ballast remained for them in Fresno. For the sake of their

marriage and Terry's mental and physical health, they needed a change. The two of them hit the road together in their truck for a month, like a couple of teenagers, seeking a sympathetic domestic situation "somewhere in between LA and Lubbock," while Terry played sporadic shows throughout Texas and New Mexico.

Terry and Jo Harvey's road trip ended in Santa Fe, a city that, at least by geographic reckoning, lies much closer to Lubbock than LA, unless perhaps measured in psychic distance, hippie reckoning, or topography (it's the country's highest-altitude state capital, nestled like a pillow in a valley surrounded by mountains).[3] When in the late afternoon they pulled into town hungry, they inevitably headed to El Farol, the tapas restaurant and "old bohemian hangout" on Canyon Road. A couple hours before the dinner rush, the place was empty until a local glass artist named Paul White strolled in. They got to talking about real estate, and White described the ragged, bare-bones property he had purchased in 1982 and was gradually expanding from a modest original house into an aspirational artist's compound, including a skeletal studio structure— coincidentally, the exact same weird property the Allens had noticed on the way into town. Six years into the ambitious project, he was overextended and clearly relieved to meet a couple sniffing around for land. He gave them the key and encouraged them to go check it out for themselves that evening.

Hard on a winding, largely uninhabited, sporadically paved road, they found a sprawling "adobe shell" with several outbuildings in a state of apparently perpetually ramshackle construction. The rear of the property offered an elevated southern prospect through open sagebrush desert, pleated with arroyos, over the western reaches of the city toward Albuquerque. To the east rose the Sangre de Cristo Mountains, in the northern stretches of which lived the Hermanos Penitentes, a Catholic cult that practiced ritual flagellation and crucifixion, and farther to the west lay the Jemez Mountains, with their hot springs, ancestral Pueblan cliff dwellings, and Los Alamos, home to a different kind of death worship. It was love at first sight. Jo Harvey "peed horizontal out there on the gate by the moonlight to mark our territory, like a lion." They flipped a coin the next morning to decide what to do, just as they had flipped a coin twenty-seven years earlier in 1961, to decide whether to escape from Lubbock to LA or to New York. It came up heads—again.

With Terry tidying up in Fresno and traveling constantly, Jo Harvey enthusiastically took command of the ongoing renovation and expansion of the property. She recruited and helmed a skeleton crew of local migrant workers, ex-cons, and moonlighting prison guards. She recounted, eyes wide and eyebrows raised, how one day laborer stopped by late one night "with a six-pack and a hogleg shotgun," supposedly to keep her safe and protect the unlockable house. He presented her with a teddy bear and professed his undying love. Jo Harvey thanked him, nervously smiling and playing along until she was able to usher him out into the pitch dark of the desert.

EASING THE POTENTIAL discomfort of a middle-aged move to a new city devoid of friends or family, a readymade social scene already awaited them in Sante Fe.[4] The Allens discovered that, unbeknownst to both parties, Joan Tewkesbury had moved there the very same week they had. The Allens played poker with artist friends Larry Bell, Ron Cooper, and Bruce Nauman—Jo Harvey thrilled to be the only woman tolerated at a table thick with smoke and machismo—all of whom lived within a ninety-minute drive.[5] At a local opening, Terry met gallerist Dwight Hackett, who invited him to visit his foundry, the Art Foundry, to cast some bronzes, initiating a long-standing friendship and business relationship. Although "it was the last thing [he] was considering at the time," Terry revealed, Hackett's invitation opened the door for Allen to make his first bronze work the following year. After a long day working at Hackett's foundry, Allen and fellow artists like Nauman, Kiki Smith, and Lynda Benglis would repair to nearby dive bar Tiny's Lounge to drink and dance to the house band, a cop combo called Gun by Day, Guitar by Night.

Soon after arriving in Santa Fe, Terry won a call for artists commission for a public artwork to install on the "Poets' Walk" of Citicorp Plaza in LA, where artist and poet pairs were tasked to collaborate. Allen landed on a drawing of a life-size businessman, briefcase in hand, his head embedded in the polished stone facade of the bank located in the plaza. Unsure how to realize the concept technically, he called up Hackett to take him up on his offer, and after some scale hijinks—a confused fabricator first made a monumental "King Kong–size" twenty-foot-tall mockup—they found an actual lawyer to model. Allen patiently learned how to make a realistic figurative sculpture out of armatures and clay and

how to use a clay positive to cast a bronze replica through the lost-wax process. He fell for the new challenge to the extent that his daily studio schedule gradually shifted permanently from late nights to daytime foundry hours to accommodate the numerous bronze projects that followed.

He called the piece *Corporate Head*, with an accompanying eponymous poem about having "a head/for business," by his old friend Philip Levine inscribed on a plaque on the ground, forcing you to assume the same vulnerable bent-over position as the figure to read it.[6]

The 1990 piece raised healthy hackles from all quarters, even from Kathy Lucoff, the art advisor facilitating the project, who assumed it maligned the bankers, realtors, and titans of industry inside who paid her bills. In fact, many bank bosses found it hilarious, though a later tenant threatened to move if it was not removed—until it was selected as a Top Ten LA site to visit by Gray Line Tours, "right up there with the Pacific Ocean and Disneyland," at which point the vocal opponent backed off. "I loved sitting and watching people react to it," Terry laughed. "The first response is that it's just comical, but then it forces you to examine the absurdity of yourself and your own body. Every one of those figurative bronze bodies and busts was *me* at some point." The piece has weathered decades of controversies and surrounding construction. "Even with skyscrapers all around it," Terry observed, "it immediately dominated the confluence of those spaces, and it still does."

The following year Allen reprised *Corporate Head*'s head-in-a-hole concept with a commission for Oliver Ranch, the sculpture park that Steve and Nancy Oliver were developing on their hundred-acre sheep ranch in Geyserville, seventy miles north of San Francisco, and which now boasts site-specific works by Andy Goldsworthy, Ann Hamilton, Bruce Nauman, Martin Puryear, and Richard Serra, among others. Over the course of 1991 and 1992, Terry fabricated two bronze figures, extensions of images that first appeared, beneath Dopey the Dwarf, in the Disney-delirious 1989 *YOUTH IN ASIA* piece *The Credits*, captioned as "mom and dad": a standing man leaning back with his head completely stuck in the trunk of a tree, his pants around his ankles, and a woman bending over, her head swallowed by a large rock, her skirt flying up to expose her ass. Although Steve Oliver originally worried that Terry's proposal ridiculed him and Nancy, Allen explained that, like *Corporate*

Head, it was intended as satire of the human condition, the limits of human communication, since "everyone's got their head up something, ass or otherwise." He wasn't making fun of the Olivers any more than he was making fun of himself and Jo Harvey. To prove it, the Allens recorded a soundtrack, broadcast from speakers in surrounding trees, of the two of them walking around his studio reciting a hysterical soap operetta "translated" into babbling, glossolalic gibberish, while Richard played "Moon River" on fiddle. The final work, titled *Humanature,* became a favorite for visitors to Oliver Ranch, not least because of its salacious selfie potential.

WHILE THE MOVE precipitated Terry's cold-turkey cessation of opioids, mitigating a central source of domestic discord, it stoked other pressures. Manifesting the chemical shift in his brain over the spring and summer of 1989, his body metamorphosed. He gained weight. He grew a ponytail for the first time since the early 1970s, and most dramatically, he shaved his trademark mustache, shocking his visiting sons with an unrecognizably bare face in an unrecognizable, bare house.[7] In the absence of pills, to divert lingering unmedicated headaches and quell withdrawal symptoms, he began drinking more. If he was mercifully unshackled from narcotics and relieved to have escaped the dead end of Fresno, he was also drunker and more irritable more often.

"How much of a toll has this move taken," he wrote in April, complaining about the difficulties of adjusting to a new studio environment. Their dog Sluggo died, joining a dozen other deceased Allen packmates and predecessors. Terry and Jo Harvey argued about the seemingly endless renovation and its costs—the furniture, the appliances, the paint colors, the pumice fireplace and bancos. "She thinks geography is a solution," he wrote, when in fact they both had believed that ruse. While it catalyzed undeniable improvements in their daily lives and working environments, Santa Fe ultimately represented a change in scenery more than a lasting solution to the strains on their marriage.

Once the house and studios were reasonably habitable, Jo Harvey resumed traveling for auditions and shoots. In the previous year she'd scored small parts in the 1988 films *Tapeheads* (starring John Cusack and Tim Robbins) and *Checking Out* (with Jeff Daniels). She flew home early to Santa Fe from the Georgia set of Joan Tewkesbury's *Cold Sassy*

Tree, leaving her salty costar Faye Dunaway to shoot reverse shots of their scene together with Joan as a surrogate for Jo Harvey. Terry continued to disapprove of her film career, both because he thought the work was beneath her talents, and that she should only be performing scripts she wrote herself or his own work, and because he hated how it took her away from home and back to LA. They fought about that too.

One time Jo Harvey was preparing to fly to LA to audition for a role, and Terry complained once again that she shouldn't waste her time auditioning for other people's lame commercial pictures. She drove away fuming but, suddenly contrite, turned around halfway between Santa Fe and the airport in Albuquerque. She saw Terry's clothes strewn all over the house, and after a few moments of slow-motion heartrending anxiety, thinking he'd killed himself in despair over their argument, she finally found him despondent, sitting on the stairs completely naked except for sunglasses. "So I took off my clothes too. We made up. We went at it like crazy! . . . And then afterwards, Terry made reservations at a restaurant for that night, and I remember him saying, 'I hope you take reservations for naked people, because we're never wearing clothes again!'"

In their tempestuous marriage, such moments of joy regularly punctuated (and arguably perpetuated) the pain. But as the years passed, Agua Fría mellowed the Allens, and their commitment to each other was renewed and deepened. In July 1990, Terry described in a journal that he was "going through this stage of trying to be a decent person," mentioning, ostensibly dissonantly, that he had made another "asshole drawing." He was being literal. It was one of a handful of such pieces he had drawn over the years, a self-effacing, crass image he had originally given to Jo Harvey to lampoon their shared obstinacy: "a drawing of two little assholes, His and Hers" with the caption "It's hard to tell one asshole from another":

> I did an expanded version of that, a large drawing with very tightly, carefully rendered little assholes. I remember [art dealer] Diana Fuller just went through the roof, saying "I'm not showing this!" I said, "Well, I'm not going to show if you don't. So I put it right in front of the elevator. The first guy who walked out of it said, "I want *this*," and bought it, the first piece that sold from the whole damn show. . . . Bukka and Bale proudly told all their friends, "My dad sold two assholes for thousands of dollars!"

CHAPTER 43

POSITIONS ON THE DESERT

There's an old shoe
Out on the highway
Tells us of the wilderness of this world

 —"Wilderness of This World"

DAVID BYRNE VISITED THE ALLENS AGAIN BETWEEN CHRISTMAS 1989 AND New Year's 1990, a period when Terry was struggling with what he felt was anemic artistic output that he attributed to the turmoil of upending and moving his studio; his withdrawal from Fiorinal codeine; pressures and unreasonably specific and superficial requests from dealers, collectors, and Wanda (more birds, fewer rats, no taxidermy, no swear words, no swastikas—"NO DICE!" he replied); and some semiserious histrionic castration anxiety ("Jo Harvey wants my dick in a box"). While their respective families celebrated more traditionally, David and Terry holed up in snowbound Santa Fe working together on drafting a script and production ideas for a potential *Juarez* musical theater work.

Although neither had any affinity for traditional musical theater, this challenge was both compulsive artists' shared idea of a merry Yuletide season. Terry had recently won a fellowship from the Wexner Center for the Arts at Ohio State University in Columbus to develop an exhibition to open there two years later, an ample runway to plan something substantial. He hoped to develop stage set concepts for his *Juarez* theater work in the gallery setting and asked David for assistance formulating the staging and the filmic elements he envisioned.

The concept, according to Byrne, was to render the narrative "a little more explicit than what you got listening to the record." The silence of the onstage characters once again presented a problem. "We sat down every day over the holidays. . . . I had all my notes and drawings on the wall," Allen recalled. "David had a laptop, and we just started from the beginning, with the songs. . . . But when Boney read it, she said it needs some dialogue." After three years of correspondence and conversation, they would finally land on a workable draft in February 1993.

"*JUAREZ*," TERRY WROTE in late 1990, while working in his Santa Fe studio simultaneously on *Big Pool* studies and rewrites of *Pioneer*—a theater piece he and Jo Harvey were formulating with the Paul Dresher Ensemble—"has always been a great wilderness inside myself where things happen (as opposed to the one where things don't)." Soon, and for the next four years, he was engaged with the first formal, sustained, and public explorations of that wilderness in over a dozen years, in the form of five different but profoundly imbricated iterations of the cycle: *Positions on the Desert, Reunion (a return to Juarez), a simple story (Juarez), Voices in the Wilderness*, and *Juarez* the musical.

Of course, in Terry's private life of the mind, *JUAREZ* had never entirely dissipated, manifesting periodically in workbooks and texts and regularly on set lists. In 1978, he had written what amounted to an elaborate, distended treatment (or a malnourished screenplay) for a potential *Juarez* film, consisting almost entirely of stage direction tracking the simple story's atmospheric changes and geographic movements—more meteorological exposition of the narrative's four "weather systems" than a proper script: "It was all images and motion, literally like a movie of the album. The characters were so enigmatic, you never got to really see them. You might see a close-up of an eye, a mouth, a hand, or something like that." He set the screenplay aside when he realized that he was unable to write dialogue for, or even photographically reveal, the elusive quartet of climatic noncharacters. As early as October 1989, Allen had written a treatment for a theater piece:

> A panoramic drama set in the Southwest, utilizing onstage characters, film, and both live and taped music. It will have a bilingual script in Spanish and English and be approximately one hour and a

half in length. Its time period is "the present" and its locale is "The Border," cities, highways, and geographical areas of the United States and Mexico (Tijuana–San Diego, Los Angeles, Cortez, Colorado, El Paso–Juárez) that suggest a cross-cultural tension of history, imagery, iconography, music, and lifestyles.

In February 1990, Allen and his photographer friend Douglas Kent Hall road-tripped through the Southwest, tracing the triangulated courses and collisions of Sailor, Alice, Jabo, and Chic. Allen used some of Hall's black-and-white photographs—four portraits of roadkill, one trailer, and one elderly woman, "barely five feet tall and outlandishly beautiful," who ran a cervecería in Tijuana and whose powerful presence and "incredible haunted expression," an undefinable "universal face," fascinated him—in a gridded series of six lithographs collectively titled *Positions on the Desert* (1991), after Jabo and Chic's performative fornication scene. Terry's scrawled annotations surrounding the images expand the *JUAREZ* cosmos, introducing Lydia Mendoza lyrics, La Cervezería las Golondrinas, the Beer Bar of the Swallows ("a swallow is a bird, and you swallow the beer"), the whorehouse La Estrella Negra, the line "Elvis and Jesus walk[ing] arm-in-arm across the clouds," and La Malinche, Cortés's enslaved Nahua interpreter, advisor, and consort, abandoned by the conquistador after being forced to betray her people (an avatar, arguably, for the "witness" Alice, collaborator with Sailor, a hapless symbol of US imperialism).

These new *JUAREZ* pieces were exhibited in 1991 at both L.A. Louver and Gallery Paule Anglim—by now his two primary galleries—with a miscellany of other pieces: *Big Pool, Sneaker, Portrait* (a sheet lead relief of a swastika overpainted with a yellow smiley face), and several new life-size bronzes, disembodied body parts meticulously rendered and imbued with jokey one-liner critiques of power. Businessmen's busts are defaced—sometimes literally, with faces sloughing off or inverted—by baseball bat blows to the back of the head (*National Pastime*), by a swarm of suffocating ties (*Tie*), by zippered lips and jaw (*Smile*), and by an Oxford gag (*Shoe*). These disfigured, broken heads—many life-modeled by Hackett—were at once formal studies in a painstaking traditional technique widely regarded by contemporary artists as an archaic headache and themselves metonymic personifications of Terry's own

actual headaches. He cast his own teeth and hands (*Shake*) and even his own ass, left hollow as a fruit bowl and mounted on a thumb inserted into the asshole (*Hitch-Hiking to the Capitol*).

In March 1991, Dave Hickey curated *The Artist's Eye: Terry Allen*, with Dave and Terry selecting ten works from the collection of the Kimbell Art Museum in Fort Worth to hang beside, and in dialogue with, Allen's own pieces, including *National Pastime*. Terry sabotaged "one of the best art days [he] ever had," spent cheerfully exploring museum storage with Dave, by insisting that his own *Aparté (rat talk at the sonic)*—a 1988 *YOUTH IN ASIA* collage that juxtaposes Mickey Mouse, a turtle in a rice hat, an upside-down image of a swooning woman (a redrawn detail from Jean-Baptiste Greuze's 1777 painting *The Father's Curse: The Son Punished*), and an actual taxidermy rat dangling from its tail—must hang beside Louis-Léopold Boilly's 1812 painting *Portrait of Monsieur G. Giving His Daughter a Geography Lesson*, which Allen, to audible gasps, grabbed and flipped upside down to echo his own piece, scandalizing museum director Ted Pillsbury and even, fleetingly, the usually iconoclastic and unflappable Hickey.[1] Kimbell staff, guards, and even visitors repeatedly, surreptitiously, righted the painting throughout the show's run. Allen called weekly to ensure it was re-inverted. "For five weeks that painting was spinning on the wall like a propeller," he chuckled.

AT THE BRATTLE Theater in Cambridge, Massachusetts, a theatrical adaptation of *JUAREZ* played two nights only, March 21 and 22, 1992. It was tentative and flawed, falling once again into the trap of rendering visible and corporeal that which Allen staunchly believed was neither. The premise was, at least, promising. As stated in the program notes, it was "the first attempt to investigate *JUAREZ* as a live theater production," working from the script of the recently recorded radio play *Reunion (a return to Juarez)*, another commission from New American Radio for NPR broadcast.

If *Bleeder*, their previous radio play, drips like blood, *Reunion (a return to Juarez)* is tidal, oceanic. Despite the action taking place largely in the deserts (ancient oceans) of Southern California and the Four Corners states, the piece begins and ends with the sound of waves and gulls, returning a composite Sailor/Jabo to the sea and "the perfect

ship," suggesting that even the militarized Pacific of the World War II–era US Navy is more truly pacific than his bloody future. *Reunion* offers a retelling of the cyclical tale, denuded of much of its original musical context but with a new score and fresh narrative details, furnishing more information about the various locations, the courtship of Sailor and Alice, the crimes of Jabo and Chic, and the dissolution of distinct identities between the two couples. There is a lot of tattoo talk, a complex extrapolation of a single isolated lyric from the crucifixion ballad "Dogwood."[2] (As Dave Hickey observes, in Allen's 1990s *JUAREZ* works, tattoos function as metaphorical inscriptions and reinscriptions of the story's map-obsessed illogic.)[3] The Fates as tattoo artists stitch character to character, state to state, nation to nation, sewing them into a tangled skein of scars. "Perfect skin gives people ideas," the narrator warns. Sailor dreams his tattoos sink beneath his skin to infect his blood, and he reflects on the similarity of a map to "the best tattoo he ever saw," a net completely covering a man's body, with birds trapped beneath frantically struggling to escape, "like every WISH he ever had was busting loose inside of him."

After the murder, Jabo and Chic escape wearing Sailor and Alice's clothes, and Sailor's tattoos (the "ships on his arm") appear on Jabo, possibly poisoning his cruelty with compassion. Chic transforms into Carlotta—the name tattooed "above her left nipple," now revealed as Alicia's mother's name too—and Jabo eventually assumes the identity of Sailor, or *a* sailor, staring into the water of the Río Bravo at "the perfect ship."[4] *Reunion* takes the additional, explicit step, only hinted at in the original album, into the cinematic territory of shape-shifting David Lynchian doppelgängers. "The two stories"—that is, the two couples—"collide and pass through one another." Although it featured new instrumental arrangements of three songs from the *Juarez* album, much of the incidental music was new, based around a new song entitled "El Camino."[5]

Anticipation for the 1992 theatrical adaptation performance, *Juarez: A Work in Progress*, was high, with seasoned director JoAnne Akalaitis in the audience as well as David Byrne, with whom Terry was becoming increasingly involved, both as collaborator and confidant. Jo Harvey, fresh from her memorable turn as the "Women's Awareness Teacher" in *Fried Green Tomatoes*—"I was the first person in the world to say 'vagina'

out loud in a major studio film!" she liked to remind people—starred as La Malinche Blanca ("not forgotten, nor forgiven for her betrayal"), the omniscient narrator and sole actor. The set was minimal, just a few pieces of furniture, and this time Richard and Donnie joined Terry and Lloyd to provide live music. Lloyd, fascinated by the Allens' process, observed that "the way they come to an agreement is perfect and painful. Painful to watch but perfect in the end."

As the storyteller and medium for all four characters, Jo Harvey had a lot on her plate. During the climactic murder scene, she was supposed to fire a pistol loaded with blanks. But during a fumbling costume change assisted by Bukka's girlfriend, someone forgot to lock the chamber, so at the dramatic moment when she held up the gun, all six blanks fell out and clattered to the floor. Panicking, Jo Harvey shouted "BANG! BANG! BANG!" At the time, she "thought it would help the play": "Afterwards Terry said I might as well have shot him in the heart. It was really sad. You know when a man is so done in and wrung out, all slumped over from behind? That's how Terry looked on his way to the hotel, just like a man drained of every good thing in him."

"It was such a fucked-up mess, it was unbelievable," Terry concluded. In retrospect, he realized that the play's problems were more systemic than the misfire he unfairly blamed on Jo Harvey: "It never was right, it never seemed to make sense at the time. I mean it's typical of *JUAREZ*— it's *never* been right. It's never even been about that. It's just this presence that just keeps kicking my ass."

TERRY WROTE AND recorded the *Reunion* script not only for the New American Radio piece itself but also as the soundtrack for an upcoming exhibition. Only a few days after the Brattle debacle, he traveled to the Wexner Center for the Visual Arts at Ohio State in Columbus, Ohio, to mount *a simple story (Juarez)*, his most ambitious and logistically complex gallery or museum exhibition to date, which opened on April 10, 1992, with a conversation with Dave Hickey, who also wrote a keen catalog essay. The piece showcased three new large-scale sculptural installations, each representing locations in the story: *Melodyland*, an architectural conflation of the Tijuana bar where Sailor and Alice meet with the whorehouse where Alice works and the club in Juárez where Jabo broods after Chic disappears or dematerializes; *Stations*, the

filling-station site, sometimes known as "Aztec Auto," of one of Jabo and Chic's apocalyptic crimes and consequential conflagrations; and *The Perfect Ship*, the trailer in Cortez where the murder occurs, here cradled within the wooden frame of an ark and containing a floating, white, mummy-like figure.[6]

Constructed with assistance from three carpenters and fabricators, *Melodyland* and *Stations* were both, like *China Night*, built at an uncanny three-quarters scale, whereas *The Perfect Ship* featured an actual thirty-eight-foot 1946 aluminum Cherokee Jetstream that Allen bought from a friend of Texan actor Barry Tubb. *Melodyland*, again like *China Night*, consisted of a false scrap-wood facade of a cantina, emblazoned with its title in neon overlapping the Elvis and Jesus poem, behind which Allen lovingly created Alicia's brothel "crib." Live parakeets presided over the bedsheet walls, which were pasted with, as Allen writes in the catalog:

> Postcards . . . milagros . . . a dried hummingbird . . . little scraps of paper and flowers . . . posters and tear-outs from fashion magazines . . . beauty tips and shoes . . . snapshots . . . teen angel . . . the Pope . . . TV celebrities and saints . . .
>
> a picture of her mother.[7]
>
> She says her name was Carlotta, and she disappeared years ago in Guadalajara.

A Polaroid in Alicia's crib reveals Carlotta as the Tijuana cervecería owner in Hall's photographs—La Malinche.

Stations, installed in the Wexner's black box theater and viewed from above, was comparatively impenetrable, a fortress-like jewel box surrounded, once again echoing and extrapolating *China Night* and *The Paradise*, by a gravel lot littered with cigarette butts, broken glass, and other highway detritus, an inert roadside tinderbox shrine to petroleum awaiting the climactic shoot-out. The crime scene of *The Perfect Ship* was likewise hermetically sealed, like, as Rosetta Brooks writes in her feature-length *Artforum* review of the show, a "sci-fi sarcophagus" for the oversized plaster cadaver, a composite of Sailor and Alice, whose perfect skin flickered with video projections that resembled animated tattoos.[8] In the radio play script, reproduced and amended in the catalog

for *a simple story*, Jabo and Chic's cataclysmic violence hits with the
force of a tornado, shattering the trailer into a ruinous charnel house—
another manifestation of the Juarez Device:

> Inside
> The trailer
> Is demolished . . . debris, torn sheets, scattered canned goods,
> gutted pillows, chunks of raw meat, jagged glass, plates, cups, bot-
> tles, black vegetables, twisted knives, spoons, condoms, forks, bro-
> ken tables, lamps, chairs, holes in the walls, torn linoleum, scorched
> carpet, pictures wrecked and askew . . . shambles.
> Flies on everything.

ALL THREE TABLEAUX glowed and flared with video elements, onscreen
and projected, shot in various seedy Juárez bars and on the road with Jo
Harvey and Santa Fe filmmaker Gay Dillingham, who installed a
360-degree rotating camera tripod, like a swivel gun mount, in the bed
of Terry's pickup truck. On the Juárez–El Paso border bridge, they shot
Jo Harvey's feet walking back and forth in her green shoes, kids begging
for and catching tossed change beneath in their "catch wands," and
migrants brazenly crossing the river into the United States on makeshift
inner-tube flotation devices—a poignantly (and pitifully) contemporary
iteration of "the perfect ship."[9]

Reunion and the Dillingham footage were repurposed for the
soundtrack to the exhibition *Voices in the Wilderness*, which involved
car stereo tape decks and speakers wired to, and blaring onto, the sur-
faces of *JUAREZ*-related paintings (sfumato southwestern landscapes
like *Montezuma 6-Castle* and *Shiprock* that split the difference between
Caspar David Friedrich and Ed Ruscha) and sculptural artifacts and
props (an inner tube and plywood "perfect ship," a large rock, a shoe, a
welded cage in the shape of a head containing a video monitor). Opening
in November 1992 at Gallery Paule Anglim, *Voices in the Wilderness*
deployed sparsely collaged audio in a manner similar to *Messages in
Wrestlers in Hell*, and with a similar sense of acute anxiety and impend-
ing doom, as if attempting to defibrillate and reanimate these insensate
artworks and artifacts, with cheap car stereo speakers, into the realm of
theater, or dreams, or history.

* * *

THE WEXNER EXHIBITION *a simple story* developed not only as a stand-alone exhibition but simultaneously as a series of set concepts, studies for the staging of the *Juarez* musical that Allen and Byrne had finally begun considering more seriously as a real production. David loved Terry's miniature cardboard design maquettes of each tableau on display at the Wexner, suggesting they could use them in the play itself. While they could not realistically detonate and rebuild a human-scale gas station onstage night after night, they could suspend a filling station maquette in the dark, a floating architectural puppet in the manner of Southeast Asian shadow plays. "And then when Jabo and Chic speed away, we can blow it up!" Byrne, as Allen remembered the conversation, announced excitedly.

"What do you mean, 'blow it up'—like, with explosives? Every night? How would that work?" Terry wondered.

"Oh, don't worry—in the theater, you can blow up anything. You just can't let it hit anyone in the eye."

Since the fall of 1991, they had been pitching *Juarez* to theaters and performance spaces including the Brooklyn Academy of Music (BAM) and the Wexner while awkwardly attempting to negotiate contractually their respective roles and financial stakes. On October 25, 1991, Allen wrote Byrne to clear the air and ask him outright to direct the play himself. Terry felt more comfortable assuming the roles of art director, cowriter, composer, and set designer anyway:

> I think the nature of the piece demands one director, film and stage, otherwise it could turn out being just a film with stage stuff in front of it or vice versa . . .
>
> I mentioned us being "co-directors" because everybody seemed to be getting nervous over "designations." I don't really care who's called what . . . I have actually worked with people before in conflicting and nerve-wracking situations without going for knife or gun. . . . I want to work with you on this, David, and have never thought whatever differences between us would be anything but an asset.

David agreed to direct and enlisted producer Linda Goldstein of Original Artists to help form their own production company for the show, Juarez Bros. A second in-person writing session happened over the

1992–1993 winter holidays, followed in the summer by yet another research trip to Ciudad Juárez, this time with David. Byrne recalled "driving around, going to shantytown houses made of cardboard and pallets, seeing dive bars and whorehouses."

The project took concrete shape through long-distance correspondence over the course of 1993, primarily in the form of hundreds of now-faded, brittle faxes. Terry's missives were addressed to "DB" or a variety of punning aliases: Dizzy Bell, Doodle Bug, DBalm, DeBris. Set in 1961, the year Terry and Duane visited Tijuana and Terry left Lubbock for LA, the script is narrated by Carlotta and woven around Allen's songs from the 1975 album, with a few additions.

The title of the new song "Wilderness of This World" references an actual note left in Allen's room by a motel maid, also incorporated into the radio play. During a visit to Santa Fe, Byrne contributed a minor chord substitution to the composition.[10] "I was always fascinated by the single shoes you see out on the highway," Terry reflected. "It's always one, never a pair. . . . There's something so lonely about that image."

The Juarez Bros. giddily discussed personnel and casting ideas. They agreed that Jennifer Tipton was the obvious choice for lighting designer, and Boney of course would design the costumes, although, as Terry stipulated: "I GET TO DO THE TATTOOS. I'M ART DIRECTOR, REMEMBER?" They considered Rosie Perez and Rosie Flores as potential Alicias and Dwight Yoakum as a possible Sailor. They tentatively agreed that Lucinda Williams could make a great Chic/Carlotta, though they also floated fellow songwriters Syd Straw or Courtney Love as options. Could Jesse Borrego or Alejandro Escovedo pull off Jabo?

Jedediah Wheeler of International Production Associates (IPA), who produced the Serious Fun! Festival at Lincoln Center, eventually came onboard as the executive producer of the production, securing financial commitments from the Alley Theater in Houston and Joe Melillo of the Next Wave Festival at BAM, for a total $350,000 budget. In November 1993, Wheeler proposed an ambitious timeline, beginning with previews at the Alley in August 1994, followed by a world premiere in Zug, Switzerland, on September 1, a subsequent seven-week US tour (including the opening slot at Next Wave), and further pending European dates. David and Terry enthusiastically conferred about a *Juarez* cast recording, a book, and even the feasibility of a television adaptation.

Then as quickly as it seemed to be cohering, everything crumbled. Wheeler and Goldstein both raised concerns about the potential distraction of *Chippy*, the other upcoming musical theater production in which Allen was involved, slated to open in June 1994 at the American Music Theater Festival (AMTF) in Philadelphia, as well as David's musical and touring commitments following the release of his fourth, self-titled solo record. David proposed postponing the production a year until 1995, to which Terry reluctantly agreed. Wheeler and the various financial backers balked. While in Honolulu in December 1993 for a site visit ahead of the *YOUTH IN ASIA* retrospective's appearance at the Contemporary Museum there, Terry heard definitively from David that he would not be able to direct *Juarez* in 1994; his schedule had become too oppressive. Without Byrne's timely participation, the project was simply not viable; Terry's name was not sufficiently recognizable to secure funding for such an experimental work.[11]

On February 1, 1994, after the "Honolulu *Juarez* Shakedown," Wheeler officially backed out, citing his and Goldstein's exasperation with the principal Juarez Bros.' intractable schedules, his unwillingness to postpone and risk losing momentum, and the difficulty of his "capitalization" efforts during a recession and amid a rampant reactionary backlash against arts funding. Skittish about schedule changes, the unproven nature of the play, and the partnership of its cocreators, both BAM and the Alley reneged on their original offers, leaving IPA without "the resources to raise the funding needed."

There was more to the story of the play's disintegration than finances, however. In addition to his concerns about perceived similarities to David Lynch's 1990 film *Wild at Heart*—despite the genesis of *JUAREZ* more than two decades earlier—Wheeler had consistently expressed reservations about the moral ambivalence and existentialist desolation of *Juarez*, the unabashed absence of any "moral" or resolution to the story and the uncommercial lack, unlike Lynch's film, of any redemption or hope for the characters in the final act.[12] "There was always that push on the part of Wheeler," Allen explained, "to somehow make it a morality play . . . and the Hispanic aspect of the piece was also getting nerve-wracking for everyone." Due to the frenzied debate about NAFTA, signed into law in 1992 and effective January 1, 1994, an unease about Mexico permeated the US press, signaling the dawning of a new hysterical era

of racially tinged divisiveness around immigration across the United States' southern border. A musical about border violence by and toward Mexicans felt ill-timed. Despite Allen's reservations, Byrne, in a conciliatory attempt at contemporary political relevance, had inserted an entire scene around what Allen called "the bastard song" of *Juarez*, "Cantina Carlotta," in which an exploitative tourist businessman shamelessly debases himself in Tijuana. David also suggested using a sample of Ross Perot's voice decrying the evils of NAFTA and the imminent danger of a "giant sucking sound" of jobs and businesses "going south."

After a couple more months of attempts to jump-start *Juarez*, Terry gave up, defeated and embittered at having to abandon a dream project. David apologized repeatedly, concerned, despite Terry's assurances to the contrary, that he blamed his perceived lack of focus for the failure of *Juarez*. Any temporary, and mostly imaginary, concerns about respective resentments regarding the play's demise faded quickly. The only giant sucking sound Terry heard was the wasted years of work, and a portion of his confidence, going down the drain. Like Sailor, he felt like "every WISH he ever had was busting loose inside of him."

BUNDLES FROM HEAVEN, PARCELS FROM HELL

Too many cigarettes
Too many cheap regrets
Too much whiskey
But I'll never fret
I got money to burn
Fate with a capital "F"

—"Fate with a Capital 'F'"

TERRY SITS AT THE PIANO, IN HIS UNDERWEAR, UNDERSHIRT, FEDORA, AND shoes, his smoking fingers plunking out a new tune on the stained keys of a crooked upright. Meanwhile, across the dirt-caked floor, on a wrought-iron bed, Jo Harvey luxuriates in a negligee, Terry's sole listener—until Butch Hancock, also in his skivvies, crawls out from underneath her. The two men trade slugs from a whiskey bottle and caresses from Jo Harvey, until, as Terry and Sharon Ely blithely dance, Jo Harvey delivers a soliloquy about turning Butch's "dick rotten to match his little bitty black heart"—while she and Butch pantomime doggy-style coitus.

In the next scene, titled "Dick Tracing" (a pun on Dick Tracy), Jo Harvey and Sharon Ely sit downstage giggling while snipping out paper-doll penis portraits of their lovers and offering commentary: "They're all so different—like snowflakes!"

Joe Ely, Butch Hancock, and Barry Tubb sit in washtubs, and Jo Harvey douses them with water, soaking the dirt floor to mud slicks. Tubb, a rodeo champion bull rider before *Top Gun* fame, lassos her, laughing

licentiously. Mr. Jukebox, a honky-tonk haunt hovering nearby, played by a pale, wraithlike Jimmie Dale Gilmore, regales them with "Morning Goodness," a joyful ode to the rejuvenating properties of morning sex that Butch Hancock wrote at the Allens' home in Santa Fe while doing his taxes.

IF *JUAREZ* ULTIMATELY proved too hard a sell to the musical theater world, it's a miracle that *Chippy: Diary of a West Texas Hooker*, an unabashedly raunchy reverie based on the 1930s diaries of the eponymous, real-life sex worker, featuring simulated onstage sex, sexual violence, and syphilis, was ever produced.

Other, smaller constituent collaborations had preceded, but the "Lubbock cabal" of seven—as Robert Earl Keen has called it (others, mostly journalists, have referred to the group of friends as the Lubbock Mafia or the Lubbock Mob)—had never all worked together collectively and would never do so again. In 1986, *The Allen/Ely Project* at the Southwest Craft Center in San Antonio had featured a black velvet fashion show benefit, orchestrated by Sharon Ely, and a junk shop student assemblage installation titled *Revelations*. Just months before *Chippy*, in March 1993, *Amarillo Highway (and Other Roads)*, a musical and spoken-word revue starring Terry, the writer Michael Ventura, Butch Hancock, Jesse Taylor, and Charlene Hancock (Tommy X.'s wife, no immediate relation to Butch) of the Supernatural Family Band and the Texana Dames, risked destroying the historic Paramount Theatre in Austin by driving Ventura's beloved green 1969 Chevy, Baby, onstage.[1]

THE ROOTS OF *Chippy* were in a separate Terry–Jo Harvey collaboration: *Pioneer* arose from an invitation from composer Paul Dresher, whose eponymous ensemble was preparing a third installment of his *American Trilogy* of music theater works. Collaborating with actor Rinde Eckert, the Allens wrote the script, which pits Jo Harvey's Widow against male assailants including Columbus, President McKinley, and Admiral Peary—among the vicious colonialists and imperialists Allen's songs "Yo Ho Ho" and "Big Ol' White Boys" satirize. Terry designed the set, a series of ingenious modular "couch" sculptures that were reconfigured as mountains, ice floes, a stagecoach, and a phone booth. Other than Jo Harvey, the cast and crew of eleven, including director Robert

Woodruff, was, according to Terry, "the most macho confluence of sleazy people," and they bullied, demeaned, and condescended to Jo Harvey relentlessly. Opera singer John Duykers's character rapes Jo Harvey's character at the beginning of the play, so "it was a very tense situation every show; that physical contact kept the whole piece on edge the whole time."

After rehearsals in Oakland and the opening at the Spoleto Festival in Charleston on May 26, 1990, Terry left Jo Harvey to complete the run, returning home.[2] Once he was gone, Duykers, ostensibly in a half-witted attempt at method acting, allegedly began to enact the assault on Jo Harvey both on- and offstage, terrorizing her and subjecting her to nightly verbal abuse and physical intimidation. Woodruff, apparently playing along with the childish method marginalization of the cast's sole woman, remained aloof, and Dresher failed to intervene. Terry immediately called an emergency production meeting of the core team of eleven and booked a one-day return trip flight from Santa Fe to San Francisco. "I stood up and calmly said, 'If any of you ever touch her or threaten her again, I'll kill you.' Paul, for the only time, said, 'You better listen to him.' I just unloaded on Duykers, said that I've been around that kind of macho bullshit my whole life, and it was never going to happen with Jo Harvey."

The Allens understandably remained conflicted about *Pioneer*, which received largely positive if somewhat bemused reviews from the *New York Times* and the *LA Times*, which called it "a delirious sort of postmodern vaudeville."[3] They were proud, at least, of their individual and collective contributions and Jo Harvey's tenacity and fortitude in an impossible situation that endured for nearly two years of periodic runs. When Nigel Redden, the director of the Spoleto Festival, left the organization in 1991 to direct the Santa Fe Opera, he made a point to call the Allens, having admired *Pioneer*. Over dinner at Tiny's, Redden asked if they had any other theatrical projects in mind that he could help facilitate. Terry replied that, since *War and Memory*, they had occasionally discussed with their friends from Lubbock the possibility of collaborating on a stage production related to West Texas history and music. (Gilmore takes credit for first suggesting a multidisciplinary Mafia collaboration.) The next day Redden called and told them he had secured funding from the American Music Theater Festival (AMTF) in

Philadelphia, for which he served as artistic consultant. And so *Chippy* was born.

WITH HANCOCK, ELY, and Gilmore all touring, Jo Harvey on set, and Terry consumed with the *Juarez* musical and multiple other projects, it took until 1993 for the entire group to gather, with fellow Lubbockite playwright and songwriter Jo Carol Pierce, at the Elys' home outside Austin to begin brainstorming.[4] They covered Joe's pool table in paper: research material about Texas in the 1930s, the seeds of songs and stories, outlines for scenes, snatches of dialogue, Sharon's costume sketches, and Terry's design drawings. The Allens carried this pile of unprocessed notes home to Santa Fe to assemble a script, while all parties continued to collaborate by fax, phone, and mailed cassettes. The development process occurred concurrently with the soon-to-be-forsaken *Juarez* musical, though on a more tightly compressed schedule.

The AMTF commission had remained amorphous until Sharon Ely's friend Joe Sears, one half of the duo of comic dramatists responsible for the *Greater Tuna* plays, popular satirical portraits of a small, fictional Texas town, casually inquired if she "knew anybody that might be interested in some old hooker's diaries." Understandably intrigued by such a prurient offer, Sharon connected Sears with Jo Harvey, who pored over two stacks of journals, one titled *Bundles from Heaven*, the other *Parcels from Hell*, each bound with ribbons, their contents themed and compiled accordingly. Within their voluminous pages, their author, a woman who only identified herself by her nickname, Chippy, recounted, with candor and humor and in exacting, sometimes salacious detail— "she was one of those savants that could remember numbers, dates, birthdays, hotel room numbers, and song titles," Jo Harvey said—her life working as a prostitute in Depression-era Texas, including Lubbock. "I've slept with over 6000 men," she wrote, naming honky-tonk musicians, roughnecks and oil barons, judges and lawyers, cops and criminals— "and every single one of them was a chickenshit."

Sears had acquired the diaries from a historian in Wichita Falls named Barbara Ledbetter, but their provenance remains murky. Ledbetter never clarified how she herself had obtained the notebooks, and when pressed to divulge whether she was a friend or relation to the author, the circumspect Ledbetter always demurred. She eventually let

slip that she also owned Chippy's bed, leading the Allens to speculate that she may have been a lover—Chippy was openly bisexual—or even, perhaps, Chippy herself. Was Chippy even a real person, or an elaborate historical forgery? After exhaustive negotiations, tinged by her deep suspicion of the Allens but tempered by her avarice, Ledbetter agreed to license Chippy's story to Jo Harvey in exchange for 10 percent of all profits.

Those profits proved marginal. Jo Harvey spearheaded and impelled the project, in which she starred as the eponymous character, bringing to the role her trademark vinegar-and-honey mix of sass and sweetness. Although it became more complex with each run, incorporating additional video and set elements—including an infernal oil derrick—Terry, who also played the character Ghost, designed the set around the deathbed from which Chippy, in conversation in 1967 with her interlocutor and friend Barbara (later renamed Doris), played by Jo Carol Pierce in a dark suit, recounts episodes from her life. The surface of the stage itself, covered in four thousand cubic feet of dirt nearly four inches thick, grounded the actors and the songs in native soil and sepia haze, providing a constant reminder of the elemental landscape of West Texas.

Directed by Joan Tewkesbury, the show premiered as a work in progress, following a frenzied but fun-filled two-week workshop, on June 3, 1993, playing three nights of the AMTF's CrossCurrents program. The cast stayed at the Barclay Hotel on Rittenhouse Square in Philadelphia, where at night they would gather around the lobby piano for boozy jam sessions, which on one memorable occasion included David Byrne, visiting with Boney from New York, accompanying Terry, Jimmie Dale, Joe, and Butch. Some nights they rented a limo and cruised around Philadelphia in full costume—the men in suits, suspenders, and hats, the women with spit curls and bobs—as Jo Harvey puts it, "playing gangsters."

Delighted with the show's promise, AMTF producing director Marjorie Samoff officially added *Chippy* to the festival schedule for the following year. But everyone's elation about the workshop production, imperfect but pure, lasted only a few months. On February 2, 1994, the day after Jed Wheeler withdrew from *Juarez*, Allen wrote: "Today I found out Joan Tewkesbury may pull out of *Chippy*. Jimmie Gilmore <u>was</u> pulled out last month." (Both departed due to preexisting commitments.) Then Sharon Ely, who designed the brilliant original costumes

and played Chippy's sister Ruth, quit abruptly. Although the Allens have always maintained that *Chippy* was a fully collaborative affair, as the scriptwriters and liaisons to the producers, the festivals, and the financiers, they necessarily but reluctantly assumed a de facto leadership role that, amid the all-consuming work schedule and draconian deadlines, they did not always adequately communicate. According to Joe, as tensions mounted, relationships splintered, wreaking havoc on his personal life: "It pulled everybody's life out of circuit, and all kinds of hell started raining out of the skies. Me and Sharon broke up [temporarily], Terry and Jo Harvey almost did. . . . If it hadn't been for the music, well, that grounded it for me. I loved the songs, but the stories themselves were not so fun to live through."

"When Joan pulled out, it changed, left us rudderless," Terry said. Tommy Lee Jones expressed interest in directing, but at a songwriting session at Joe's, Jones and Allen began arguing about whether it was appropriate or anachronistic to include video in a play set in the 1930s. Ely could not believe what he was seeing: "They got to yelling, and pretty soon, I looked up, and they were out in the front yard at midnight, and they had their dukes up and ready to fight. I thought, 'Is this really happening? Tommy Lee Jones and Terry Allen are going to get into a fist fight?' They jumped on each other a few times, and we pulled them apart. Tommy Lee looked at us and said, 'Fuck all y'all!' and drove off."[5]

The ambitious budget that the Allens had negotiated to keep so many touring musicians off the road allowed them to hire, in lieu of the irreplaceable Gilmore, the honky-tonk revivalist Wayne "The Train" Hancock, whom Ely felt would be perfect for Mr. Jukebox ("He sounds just like Hank Williams," he told Terry), and songwriter Robert Earl Keen, an avowed Allen fan who had recently covered "Amarillo Highway." Each appears on one song—all they had time to prepare—on the cast soundtrack album. The unfairly forgotten *Songs from Chippy*, recorded in the winter of 1993 at Joe's Spur Studios and released (only because of otherwise impossible deadlines) by Disney-owned Hollywood Records, includes two strong new Terry Allen compositions, "Back to Black" and "Angels of the Wind," as well as a melancholy, mature version of "Gonna California," reframed as a Dust Bowl exodus ballad, among several cowrites.[6]

Samoff, keen to capitalize on the success of *The Best Little Whorehouse in Texas* (on which, ironically, Sharon Ely had worked as a

costumer), brought in a new costume director, a new set designer to assist Terry, and a new director, Evan Yianoulis. The cast missed Sharon and hated the new costumes, and despite the new crew's best intentions and obvious competence, the refreshed and expanded cast, higher production values, tightened script, and additional songs, the AMTF show that, after extensive rehearsals at the University of Texas at Austin, opened on June 4, 1994, at the Plays and Players Theater—coextensive with an exhibit of *Chippy*-related artwork by Terry, Joe, and Butch at the Fleisher/Ollman Gallery—felt sanitized and limp compared to the original. "All of the really funky honesty of the initial piece was lost," Terry said. But because of their inexperience with major musical productions and the frantic pace of the production, everyone reluctantly acquiesced to the changes.

It did have its moments. Jo Harvey was sensational, fully inhabiting the role. Lloyd, Richard, and Davis—with Dave Heath on bass—joined the cast as the onstage band, the Sunshine Boys. Terry, Butch, Joe, and Robert Earl Keen, in their underwear and boater hats, performed an outrageous barbershop quartet arrangement of the filthy toast "The Rotten Cocksucker's Ball."[7] Press was generally positive, and audiences were modestly sized but enthusiastic. The after-parties and the concerts at the Old City folk club the Tin Angel were notoriously bacchanal. ("The drinking after those shows was unprecedented," observed Keen, whom Allen had nicknamed Rekage.[8] "Doing *Chippy* was one of the highlights of my life.")

The authorities at the John Jay Theatre at Lincoln Center in New York, where *Chippy* played for four nights, starting on July 27, 1994, as part of the Serious Fun! Festival, prohibited the full depth of the stage dirt treatment, allowing only a dusting. Although the sold-out audiences erupted into standing ovations every night, once again, the Lubbock Mob had little time to savor their success. David Richards, writing for the *New York Times*, savaged the piece in a condescending, prudish, and scathingly personal review, effectively scuttling the entire enterprise and dashing the possibility of additional touring and the film adaptation that the Allens had planned. Although he praised Terry's set design and the songs—surprisingly, considering an apparent complete ignorance about country music and Texan culture—Richards compared *Chippy* unfavorably to *The Best Little Whorehouse in Texas*, calling it "a

somewhat grittier enterprise that is no less calamitous in its down-home fashion" and maligning the entire state of Texas for exporting only "oil, beef, and bad musicals about prostitutes." More viciously, he described Jo Harvey in baldly sexist, body-shaming terms: "A hefty woman with protruding teeth, a flat, twangy voice, and no particular stage presence, Ms. Allen would do nicely enough in small, eccentric character parts. But she's hardly in a position to carry a musical, not that there's much musical here to carry." Beyond any reasonable critiques, Richards, in his provincial Northeastern chauvinism, clearly did not comprehend the historical, musical, or contemporary art contexts of the piece and did not even pretend passing familiarity with the work of any of the prominent artists involved. He was unable to discern that, with its dirt-carpeted stage and sculptural props, and its foregrounding of song styles and traditions alien to normative Broadway-style musicals, *Chippy* more resembled a living installation or piece of performance art than *The Best Little Whorehouse*. One can only assume it would have been more sympathetically received and reviewed had it premiered in Texas or in an art-world context.

"That ended it," Terry sighed. "We were all gutted."

To add insult to injury, Barbara Ledbetter, whom the Allens had flown to each iteration of *Chippy*, never expressed anything but scorn, suspicion, and disgusted disappointment for the play and the artists, pedantically haranguing the Allens about its inaccuracies and threatening multiple frivolous lawsuits. It cost Terry and Jo Harvey $8,000 in legal fees to extricate themselves from the relationship, after which neither had the stomach to revisit the project. When she died in 2007, Ledbetter took the true identity of the woman known as Chippy with her to the grave.

This time, Jo Harvey's paralysis was a paralysis of her spirit and confidence, not her body. Devastated, she withdrew. After appearing in *The Client* in 1994 with Tommy Lee Jones—a staunch supporter and loyal friend of the Allens even though he liked to tell people that Terry "fired" him from *Chippy* ("which is true," Terry averred)—she avoided acting gigs and, more worrying to Terry, her own writing, for two years. As much as Terry complained about Jo Harvey's acting career, its potential cessation alarmed him more.

CAPTAIN ZERO AND THE SHAKING MAN

Hey I don't need no chickenshit business man tellin me what to
Even if you ain't got no business same thing goes for you

 —"Gone to Texas"

THE DEMISE OF CHIPPY IN NEW YORK DID ENGENDER ONE POSITIVE CAREER development to compensate for Terry's depression. At Robert Earl Keen's invitation, Barry Poss, the cofounder of Sugar Hill Records, traveled from Durham, North Carolina, to see the play.

A native Ontarian who had quit his graduate fellowship in sociology at Duke University to explore the world of Southern traditional music, Poss worked at the venerable County Records before launching Sugar Hill with David Freeman in 1978. Bald and mustachioed, the genial Poss was quick-witted and quick to laugh, with an intelligence and appetite for knowledge that ranged easily from academic to vernacular realms. Despite Allen's mistrust of record labels and executives, he and Barry got along famously. Somehow Barry seemed different, more grounded, more business savvy, and more sympathetic to the literary dimensions of Allen's songwriting. Poss was already familiar with Allen's music and art through Guy Clark, Butch Hancock, and Townes Van Zandt, all of whom—despite their own irascible, fiercely independent, and anti-authoritarian inclinations—had released records on Sugar Hill, the label that, at Poss's helm, had grown to represent the vanguard of the burgeoning Americana scene.

At dinner after the show, Barry and Terry retreated to the back corner of an empty dining room and struck a handshake deal to reissue

Terry's Fate Records catalog as well as at least two new records. Allen signed a contract and accepted an advance from Poss in October 1994, sealing the fate of Fate Records and launching the era of Terry Allen as a Sugar Hill recording artist.

Sugar Hill promptly paid Allen's agreed-upon advance, but Poss earned the nickname "Captain Zero" when he misunderstood the price of a *Chippy* study drawing he bought from Terry, leaving off a zero on the check.[1]

BY THE TIME Fate drifted into a state of indefinite dormancy in early 1995, the label had been stagnating and struggling for years. Other than managing mail-order and freight shipments and assisting with layout, Jack Lemon had become far less involved in the label after *Bloodlines*, and by the end of the 1980s, Fate was entirely in Terry's hands, much to his distress. Lemon and Allen's agreement was to split all net profits fifty-fifty, but they were both seriously overextended with their other careers, and Jack admitted that the label's finances may have been inadvertently mismanaged along the way. Shortly before the Allens moved to Santa Fe, Lemon and his lawyer visited Fresno to untangle their legal relationship, after which they slept on the floor in the bare studio next to Terry's piano. Terry claims that over the course of their ten-year partnership, he never saw any profits from the label. "I never got a dime, so what I got out of it was Fate," he explained. "I never really had a clue how it worked, and I never particularly wanted to. I just wanted to make records and have somebody else figure out what to do with them." When he moved his art storage from Fresno to a new facility in Albuquerque, unwilling to deal with the "storage nightmare," he jettisoned boxes of *Lubbock (on everything)* into a dumpster.

The first Fate release without any involvement from the Lemons or Landfall was 1993's *The Silent Majority (Terry Allen's Greatest Missed Hits)*, subtitled in the liner notes as "a compilation of: out-takes, in-takes, mis-takes, work tapes, added tos, taken froms, omissions and foreign materials." The cover boasted a photo of Terry chatting with Nancy Reagan taken in 1982, and the back cover featured only the stark faux-surgeon general's alert "WARNING/for ALL REASONS," a play on the comically vague billboard that once stood outside Lubbock exhorting passing motorists to "Visit Lubbock/For All Reasons." Allen recorded

four of the "foreign materials" tracks in Chennai, India, with classically trained Carnatic musicians, in January 1995, while traveling with Jo Harvey, Bale, and Byrne: "Yo Ho Ho" and "Big Ol' White Boys" from *Pioneer* (subversively appropriate selections, given their colonialist content), "New Delhi Freight Train" (an obvious choice), and the mournful "Hearts Road," which Allen has never recorded or performed since. Typical of this chaotic and improvident journey, he had to smuggle out the tapes.[2]

Terry dedicated *The Silent Majority* to Bale and his new wife, Jennifer Attal, who married, after a courtship of eight months, on November 7, 1992. Terry, delighted, promptly nicknamed Jennifer "Jenni-Cat" and, on the last day of 1993, enlisted her to take the reins of Fate, which he officially registered as a Travis County, Texas, business in January 1994. Jennifer managed Fate admirably from Austin and assisted with Allen's music career generally, until her own career in education and her growing family consumed her schedule. On October 11, 1994, Terry wrote in his journal, "Leaving for Austin today for birth of our new grandbaby— Bale and Jenni-cat's kid. What will they name him? Can't wait!" Two days later, he entered a joyous update: "Sled Harvey Allen born today at 4:49 pm . . . the most incredible wonderful thing I ever saw." Terry and Jo Harvey were beaming, ecstatic about their first grandchild and touched that he was named for both their departed dads. With Jennifer focusing on her own work and family, Terry stretched thin with public art projects, and Sugar Hill commandeering his forthcoming musical efforts, the arrival of Sled and Harv's infant namesake aptly heralded the final months of Fate, which by early 1995 was effectively shuttered.

JENNIFER HAD ASSUMED the management of Fate from Matt Ashe, Wanda Hansen's son, who, according to Terry, during his brief tenure— before Terry summarily fired him—bungled affairs spectacularly, losing album stock, digital masters, and artwork and print materials. Ashe's dismissal coincided with his mother's sudden and dramatic defenestration from the Allens' life, the consequence of a shocking betrayal that shook their world and from which it took three years to recover.

On the October morning in 1993 when Terry was preparing to install his new public art commission on the grounds of the Yerba Buena Center

for the Arts in San Francisco, he embodied the title of the piece. *Shaking Man* was another businessman figure—again modeled by Dwight Hackett and again unintentionally resembling Ronald Reagan—smiling and holding a briefcase in one hand and offering his other to shake, his limbs, face, shirt, and tie all fissured in triplicate, "shaking" as if frame-frozen in eternal motion judder. Requiring a three-part wax mold, it was the most complicated bronze cast he had attempted to date and, for that reason, the first he cast at the Walla Walla Foundry in Washington, which housed a larger cauldron and offered more affordable rates.

A month prior, the Allens' accountant had contacted them, hoping to clarify what looked like a discrepancy between Terry's reported annual art income and Wanda's commission, which raised concerns. Had Terry really made that much in 1992?

"Hell, no," Allen answered.

"Well, then we have a problem."

Terry clenched his jaw, and he felt that old familiar anger, the fire that had stoked his art since Sled's death in 1959, flare again in his gut and wick into his chest. He flashed to a recent incident when Hansen had confronted Jo Harvey about spending too much money on flowers, demanding she stop immediately, because they could not afford such profligate expenditures. Jo Harvey adores fresh flowers, and she has always bought them to adorn their homes, even when they were broke. The Allens were incensed—they understandably felt that setting household budgets and blaming Jo Harvey for financial shortcomings overstepped the bailiwick of an artist manager. "That was the first inkling," Jo Harvey said, that something was amiss, but Terry, dependent on Wanda, chose to overlook it.

Since they had begun working together a decade earlier, as Terry explained, the "deal" had always been that Wanda would be entitled to 10 percent of his annual art income, or the equivalent in-kind value in his artworks, in exchange for her undeniably valuable assistance. Fate Records remained a separate concern, and Terry's income from music gigs was similarly siloed. Over the years, however, he had become comfortable and complacent, trusting Hansen to cut checks to pay bills out of his personal checking account, to which he granted her full access. Eventually, Terry came to believe that she was helping herself to what seemed like an unlimited expense account, traveling "high on the hog in

hotels," commissioning up to half of his live performance fees as well as helping herself to artworks. As he began accepting more public art commissions, which involved complex contracts and sometimes massive sums of money changing hands for foundry and fabrication budgets, it became harder for him to monitor his finances. Taking advantage of the situation, Hansen reputedly played fast and loose with the bookkeeping. The Allens and their accountant were ultimately able to sort out and document all the discrepancies, and on October 1, Terry took a dossier of bank statements, receipts, invoices, tax returns, and other evidence to San Francisco, where he knew Wanda, who lived nearby, would attend the installation of *Shaking Man.*

Nauseated and nerves jangling, Terry was barely able to hold in his rage during the *Shaking Man* event, at which their shared artist friends Bruce Conner, Bob Hudson, and Bill Wiley (one of Hansen's other clients) were all present. He swallowed his choler until his lunch date with Wanda the following day. The confrontation itself remains a crimson blur, obscured by a veil of fury, but Wanda was unable to defend herself to Terry's satisfaction. He informed her that he had rented a U-Haul and that the next day he would forcibly remove all his work from her office and drive it 1,200 miles back to Santa Fe, after which he intended never to speak to her again.

He never recovered everything, and it took years to regroup and repair and nurture business relationships after the catastrophic loss of correspondence, slides, and financial records. In the wake of the split, he received letters from some of his dealers, confessing their relief. They had never particularly enjoyed dealing with Wanda—or, to be fair, the firewall of any artist manager—and missed their personal interactions with Terry. Back home in Santa Fe, bruised by the betrayal of someone he considered a friend, Terry seethed, exorcising his ire with private, therapeutic studies for the vengeful *Managerial Series (for Wanda Hansen)*.

OTHERS SLOWLY FILLED the void of trust and delegated duties vacated by Wanda. Barry Poss and his staff at Sugar Hill inherited the mantle of Terry's music career, gradually, over the next ten years, licensing and reissuing Fate's back catalog on CD, including titles that had never appeared in that format in the United States (*Lubbock,* in 1995) or

anywhere (*Amerasia*, in 2003), sometimes with new cover art and liner notes. While Allen later regretted a few of the expedient, cost-cutting measures—like omitting "High Horse Momma" from *Lubbock* to avoid having to manufacture a double-CD set and combining *Smokin the Dummy* and *Bloodlines* on one 1997 omnibus CD, without "Cocaine Cowboy"—overall Sugar Hill's reissue campaign achieved its goals. The reissues made his albums far more accessible in the CD era, introduced his music to a much larger audience, reintroduced him to the emergent Americana music press and radio format, and maintained momentum before, in between, and after the two new albums he cut for his new label. The advance from Sugar Hill, paid exactly a year after Terry's breakup with Wanda, was a critical bailout after a "murderous year" spent scrambling to plug the financial drain caused by *Chippy*, the demise of Fate, and the alleged managerial embezzlement.

On the art side of the equation, Kimberly Davis, the director of L.A. Louver since 1985, began assuming some of Hansen's former responsibilities, including helping propose, plan, budget, and orchestrate Allen's increasingly ambitious and lucrative public art commissions. She and Terry were already congenial collaborators, but the tender years following the rift with Wanda deepened their professional partnership and cemented L.A. Louver's status as his primary gallery, the most willing to invest consistently and substantively in him and his work. With Kimberly's assistance, Terry was about to undertake three of the most logistically complicated, politically fraught, and controversial public art pieces of his career.

CHAPTER 46

THE FEEL OF THE DEAL FROM BEHIND
THE WHEEL

We all got missing parts
Right from the start
We got to live with

—"Peggy Legg"

EVERY WEEKEND FOR FIVE WEEKS, BEGINNING ON SEPTEMBER 23, 1994, TWO superannuated vans parked on each side of the border, one in San Diego's Border Field State Park and the other in Playas de Tijuana, separated by a fence and concrete pylon erected by the Eisenhower administration to symbolize the friendship between the United States and Mexico (the "ultimate irony prick," Terry called it). On either edge of this chain-link demarcation, US soldiers were erecting a ten-foot-high border wall constructed of Gulf War–salvaged steel sheets, which resembled, to Allen, "big rusty razor blades," originally used as airplane tarmacs—"so symbolically hideous." A sign on the side of the vans read, in English and Spanish:

WELCOME TO ALL PEOPLE
　　YOU ARE CORDIALLY INVITED TO CLIMB UP ON THIS VAN AND SPEAK, SING, PLAY MUSIC, ETC.—**FREELY**—WHAT IS IN YOUR HEART AND ON YOUR MIND **TO/AT/FOR** THE OTHER SIDE.
　　CROSS THE RAZOR

THIS IS OFFERED WITH THE HOPE THAT WHAT HAPPENS HERE MIGHT ENCOURAGE INCREASED UNDERSTANDING AND COMMUNICATION BETWEEN THE **PEOPLE** OF THE UNITED STATES AND MEXICO.

The piece, *Cross the Razor/Cruzar la Navaja*—the "razor" as Juarez Device—was Allen's contribution to *inSITE94*, a collaborative exhibition involving thirty-eight US and Mexican institutions and comprising seventy-four site-specific artworks in both cities, mounted in the midst of the furor of California Proposition 187, which would have denied social services to undocumented immigrants. The piece, Allen's most clearly social practice–oriented, most utilitarian, and most overtly political piece, devoid of the aesthetic concerns of *Trees* and *Tables and Angels*, evolved from an initial 1993 proposal to erect monumental mirror-walls, instead of motor vehicles, to reflect each other across la frontera into recursive infinity. The final installation transcended and breached that symbolic border mirror sonically: "It was pretty interesting, the whole thing, because of the eloquence and dignity of the people, especially on the Mexican side—what they had to say about the fence and about relations between gringos and Mexicans. A lot of musicians made use of it to get up there and jam. One time there was a big mariachi band on the Mexican side and a jazz band on the US side."[1]

Cross the Razor required extensive permissions from and logistical coordination with a thicket of bureaucracies: both federal governments, California and Baja state governments, both cities, and US National Park and beach commissions, all facilitated by Lynda Forsha, who had curated *Rooms and Stories* a decade earlier. At the end of the exhibition, the vans were donated to an elementary school in Tijuana. "I think my piece is [the] best thing I've made in a while," Terry wrote in his journal. "FUCK THE BORDER$."

"If they're going to build a wall on the border," he has since argued sarcastically, "they should build it high enough to keep the birds out too."

CROSS THE RAZOR followed *Notre Denver*, Allen's first public art commission for an airport, which afforded a foretaste of the bureaucratic boondoggle of the border installation, but with a tragic and sinister aftertaste. The public art selection committee for the new Denver

International Airport included, along with Mary Beebe, a nun, which partially inspired Terry's proposal of two bronze gargoyles installed in the baggage claim area, those "cathedrals of anxiety." Allen modeled the beasts' heads and wings on images of actual grotesques and their bodies on photos of the foundry manager's twelve-year-old son, who posed squatting in a Samsonite suitcase in his underwear. Upon opening in 1995, the immense airport was plagued with problems and soon became a lightning rod for conspiracy theories and folklore about its underground tunnels, implicating the Illuminati, aliens, and Satanists. The *Notre Denver* chimerae, misinterpreted by ignorant religious zealots as "effigies of Satan" instead of the spiritual protectors of churches they historically represented, were immediately implicated in the bizarre furor, relocated several times before being joined in 2019 by a wise-cracking animatronic gargoyle, some publicist's misguided attempt to lean into the controversy. "There's my little dance with the devil," Terry laughed. "One of them."

The airport's public art program veered from controversy to catastrophe in 2006. Terry's friend from Landfall Press days, Luis Jiménez, embroiled in a protracted battle with airport administrators about the nature and location of *Mustang*, his sculpture of a thirty-two-foot-tall rearing blue stallion with glowing red eyes, would often stay at the Allens' home while traveling home to Hondo, New Mexico, from Denver. "He actually said to me at one point, 'This piece is going to kill me,'" Terry gravely recalled of his discouraged friend, who seemed utterly exhausted by the ordeal. Soon thereafter a segment of the massive fiberglass horse fell on Jiménez's leg, severing an artery in his thigh. He bled out in his studio and died. The airport art commission asked Allen if he would finish the piece. "I said no," he hissed. "At the memorial service, I told them they should take all the parts of the unfinished piece and lay them out there by the runway as a memorial to Luis. That irritated a lot of people from Denver. They gave speeches about how wonderful Luis was and never mentioned the hell they put him through or how he died. I couldn't help but remind them."

Allen's next major public art commission—in his estimation, the most surprisingly controversial piece of his entire career—forced him, again, to rethink the utility, ethics, and value of public art. A reprise of his *Tie* and *Shoe* busts, the bronze businessman of *Modern Communication*

stands outside the Fire and Police Communications Center in Kansas City, Missouri, fingers in his ears, blinded by his flapping tie, and muzzled by his own shoe (poor Hackett left the studio that day with the taste of leather in his dry mouth). Incited by local press coverage, this goofy, gently satirical figure, a *Homo sapiens* trinitarian descendant of the proverbial Three Wise Monkeys, managed to offend everyone who saw it, particularly city officials, and periodic flareups continue to this day, much to Allen's bemusement: "I don't think it's one bit more moronic than I am; that's how I feel everyday about communication, my own included."

THE SEPTEMBER 8, 1995, dedication of *Modern Communication* fell in the midst of recording sessions for Allen's first stand-alone, non-soundtrack album of new songs since *Bloodlines* in 1983. Titled after a sticker that Terry spotted on a coffin being unloaded from an airplane onto the tarmac—"HUMAN REMAINS / HANDLE WITH EXTREME CARE / FINAL DEST: _____"—and that he reproduced in the liner notes booklet, superimposed on a detail of a crime-scene photo from Fresno (previously used in *RING*), *Human Remains* is, appropriately, preoccupied with both death and the failure of modern communication. "Obviously it's what's left from a dead person, but it's also the opposite— 'a human remains,'" he explained. "The dead leave behind not just their corpses but also the living bodies of their loved ones. In the liner notes, I thanked everyone I could think of that was still alive."

Like *Bloodlines*, *Human Remains* pulls from a dozen years of songs, reaching even further back to *Juarez* with a full-band rendering of "What of Alicia," and features tunes written for the *Juarez* musical ("Wilderness of This World") and *Chippy* ("Back to Black" and "Little Sandy," about two "Sandys": Chippy's dead baby and a West Texas dust storm). Terry discerned echoes of *Lubbock (on everything)*, describing *Human Remains* as a sort of shadow of, or mature sequel to, the earlier record in terms of overarching narrative and thematic concerns as well as character studies, specifically portraits of women. "That Kind of Girl" and the fan favorite "Peggy Legg," inspired by the true story of a woman who lost her leg in the 1995 Oklahoma City Bombing (voiced by Jo Carol Pierce), reprise similar sentiments in "Lubbock Woman" and "The Girl Who Danced Oklahoma."

Sugar Hill's budget allowed him, for the first time, to tailor production at multiple studios. This time, under Lloyd's supervision as coproducer, Terry, Lloyd, Kenny, Donnie, and Richard recorded the basic tracks at Caldwell's and then moved to Austin, overdubbing at the Hit Shack and mixing at Cedar Creek. The Hit Shack sessions featured a wider range of guest players than ever before, an all-star cast of twenty-four that included not only stalwarts Jo Harvey, Joe Ely, Jesse Taylor, and Ponty Bone but also—joining him for the first time in the studio—David Byrne, Lucinda Williams, guitarist brothers Charlie and Will Sexton, bassist Glenn Fukunaga, and Bukka and Bale.[2] Terry was relieved that Poss, his new label boss, effectively granted him carte blanche on the album's production, only offering substantive opinions on the track sequence (which he ignored). However, he later regretted allowing Sugar Hill, in exchange for that artistic freedom and those generous budgets, to own the masters of both *Human Remains* and *Salivation*, the only two records the rights to which he does not control—and perhaps not coincidentally also the first two since *Lubbock* that did not share title credit with the Panhandle Mystery Band.

The sonic palette and arrangements on the record are more varied and ambitious than any Allen recordings since *Amerasia*, seamlessly including horns (on the raucous cover of Byrne's "Buck Naked," about which David was initially ambivalent, given its funereal context) and even bagpipes.[3] Lucinda Williams, whom Terry had met at Stubb's in 1980 around the time she recorded her sophomore album *Happy Woman Blues*—on which she asked him to pound piano (his schedule prohibited it)—sings on four songs. "Room to Room" reads as a portrait of a couple, perhaps the same couple from "High Plains Jamboree," but in fact, Allen claimed, it "came overtly from the experience of waiting for my mother to come home" after drinking—"that night anxiety." Allen instructed Byrne to "play like you're just getting ready to throw up," and his subtle "nausea guitar" destabilizes the song, jaggedly underlining the desperate edge in Lucinda's voice.

The Allens had known guitar prodigy Charlie Sexton since he was thirteen years old and playing with the Eager Beaver Boys and the Ely Band, before he toured with David Bowie in 1987. When Bukka and Bale moved from Boston to Austin in 1990, they befriended Charlie's younger brother Will, a unique guitarist and songwriter in his own right, whose

tense, knotty guitar style—which Terry described as "going right up to the edge of a cliff"—is as curiously eccentric as his brother's spare and slim-fingered textural elegance. Charlie played painterly slide on "What of Alicia," another revisitation of *Juarez*, and Will cowrote the World War II disaster-ballad broadside "Galleria dele Armi."[4] *Human Remains* ends with "Flatland Boogie," Terry's ode to Jo Harvey—and to the spirit of Pauline, that "old Angel from Amarillo"—a quarter century after writing "The Thirty Years War Waltz," and four years past that imaginary three-decade matrimonial benchmark. It is a fitting finish for such an album so generously engaged with friends and rooted in family.

THE MONTHS AFTER the album's recording and release were darkened by grief. On New Year's Eve 1996, Terry learned that his cousin Steaven had finally died that morning after drowning in his own vomit, the attenuated end of his thirty-year "slow death." He was forty-nine.

The next day, Guy called to tell him that Townes Van Zandt had also died. Terry had played a show with Townes only two months earlier. At nine the next morning, Van Zandt appeared with a half-full wine bottle in hand, grinning and wearing "goofy moccasins." Terry embraced him and bid him what proved an appositely poetic final farewell: "See you when the wind blows."

Surrounded by human remains and remaining humans in mourning, Allen finally quit smoking. Although he relapsed several times over the next few years, especially when traveling, he could strike off another vice from his dwindling list.

The wind continued to blow.

TERRY DEDICATED *HUMAN REMAINS* to his grandson Sled and to Stubb, to beginnings and endings.

In the final days of May 1995, the Allen family took shifts by the bedside of Stubb, who was dying in hospice care at his glitter-spangled home. "It was almost like an installation, people coming and going, playing the original jukebox from Stubb's," Terry recalled of those difficult days in Austin. For three days Terry kept vigil with club owner John Kenyon, a fellow disciple.

Stubb passed on May 27. At his funeral at the Greater St. Luke Baptist Church in Lubbock, John and Terry both served as honorary pallbearers,

along with Joe, Jesse, and Paul Milosevich. Terry, Joe, and Jesse sang "Amazing Grace" over Stubb's body. "He had his hat on in the coffin," Terry chuckled, "but they cut the back off of it, so he could lay flat. We were all looking at that half-hat and elbowing each other." Walking out of the church, Paul and Terry discussed the need for a memorial to Stubb on the razed site of his Lubbock restaurant, which had moved to Austin in 1986.

Jesse, whom Stubb had picked up hitchhiking decades earlier, forever altering the landscape of Lubbock music, was the last to leave the grave. "I remember he put his hands on the casket and said, 'I'll see you later, old buddy,'" said Terry. "Which I assume he did."[5]

CHAPTER 47

AIN'T NO TOP 40 SONG

There's a creature coiled inside
Been wantin out three hundred thousand years

—"The Show"

WHEN JOHN KENYON WAS DEVELOPING A CONCEPT FOR HIS NEW NIGHTCLUB on Lower Greenville in Dallas, he immediately called Allen to ask him, in exchange for a $16,000 fee and a partnership stake, to design the interior. The club would be called the Red Jacket, an homage to the 1960s supper and soul music club previously at the location, which Kenyon had frequented as an awed teenager. Allen reveled in the opportunity to create a public art environment beyond the deadening claws of municipal bureaucracy (other than L&I), an installation in a vernacular space for dancing and concerts instead of behind the white-columned prison bars of a precious gallery or museum. "The only difference," he reckoned, "between a museum and a nightclub is the uniform the guards are wearing." He proposed and, with help from photographer Christina Patoski and her husband, saxophonist Johnny Reno—dedicated midcentury kitsch collectors—implemented a radical meta-vision: "a nightclub about the idea of a nightclub," steeped in local history and folklore.

The Red Jacket, which opened on February 4, 1996, contained several distinct spaces and discrete bars, which Terry conceived as stage sets arranged around a sunken marquis-diamond-shaped dance floor with a two-hundred-person capacity. Tiny's Bar was a tribute to the Santa Fe institution, with one of Tiny's actual accordions on display and boxing always on the TV; the Pig Bar was upholstered in pigskin, adorned with

neon pig signs from barbecue joints. Kenyon hired the most massive bartender he could find to preside over the Pygmy Bar and a dwarf luchador to sleep beneath the stairs. The Razor Room hosted charity gambling; the Stairways to Heaven and Hell, with blue and red paisley carpets, flanked Purgatory on the way to the Slime Pit.[1] On dance and DJ nights, five go-go cages hosted dancers. In a dubiously legal stroke of genius, microphones in the men's room were wired to speakers in the ladies' room, so women could eavesdrop on the action. The Red Jacket's totem, a red-dyed straitjacket, hung above the door. In Allen's estimation, "it was like a funhouse full of drunken creatures."

When Kenyon expanded the club next door into a new adjacent space, he called it the Ruby Room in tribute to Jack Ruby, the Dallas gangster who owned rival club the Carousel and, on the night before he killed Lee Harvey Oswald, allegedly crashed the original Red Jacket and threatened to burn it down. Allen once again designed the décor, installing a morbid array of large photographic details of the murder. The Ruby Room's opening celebration in August 1998 showcased the actual pistol, carried on a red velvet pillow, with which Ruby assassinated Oswald, as well as performances by legendary strippers Shari Angel and Candy Barr, who had danced at Ruby's Carousel Club.

Terry played the Jacket on several occasions, including twice with Billy Joe Shaver and Guy Clark. "I took Guy there after we played at the Lakewood Theater," said Terry. "There was pounding disco, go-go dancers, people playing poker, lurid red lights, and we were looking down at the insane sprawl from Heaven. Guy just looked at me and said, 'You're a crazy sonafabitch.' I told him he was such an anomaly that he fit right in."

TERRY HAD FIRST met Guy Clark in 1986 at the Kerrville Folk Festival. They got to talking and ended up sidestage, getting "drunk as skunks" on whiskey and "carrying on" rowdily while Peter, Paul, and Mary (the male two-thirds of whom were thoroughly unamused) played "Puff the Magic Dragon" to "thousands of stoned hippies." They watched a cloud "grab the moon like a claw" and cracked up. Guy's friendship proved a reliable balm for the rest of his life, despite his occasional curmudgeonliness.

Terry and Guy bonded in earnest on tour in Italy with Dave Alvin, Tom Russell, Peter Case, Butch Hancock, and Guy's son, Travis, in December 1995. Allen also befriended Alvin, who in an essay for the

Sugar Hill reissue of *Juarez* reports watching in astonishment as, during "Who Do You Love?," Terry lifted an electric piano over his head—"like the angry Moses on Mount Sinai," Alvin writes—and smashed it violently to pieces on the floor in "righteous fury," a crazed look in his eyes and a smile of satisfaction on his lips.[2] "It was a rented piano, and only three keys worked—*plink, plink, plink*," Terry rationalized.

Shortly after they returned stateside, Terry and Guy began touring as Los Dos Rockin Tacos, named for a Mexican restaurant in Santa Cruz. The dopey name—for many years they both signed all their correspondence to each other "Taco"—belied a deep bond and mutual respect. According to Clark's long-suffering sideman and close friend Verlon Thompson, Terry was the only person in the world whom the notoriously cantankerous Guy allowed to tease him, criticize him, and "metaphorically slap him around": "Guy was one of those tigers that would look for a weakness in his opponents. . . . Terry didn't have any of those weaknesses, and he didn't give a shit about Guy's crankiness. Most important of all was that Guy truly admired Terry's art and his talent, his brilliance and intelligence, his uniqueness and his weirdness. Terry's confidence and sense of humor completely disarmed him. He realized he had finally met his match."

In early July 1997, Guy, and in a rare appearance, his wife, Susanna, attended the Allens' thirty-fifth-anniversary festivities in El Paso and Juárez, along with nearly one hundred others—including Cormac McCarthy—who descended on a club called Wild Hare's Booze and Adventure.[3] "It was a real mob, lots of people we hadn't seen in years—like a wild reunion of old Chouinard days," Allen said wistfully. Blissfully ignorant of the mounting violence in the wake of a cartel boss's assassination, Joe Ely spent much of his time blithely wandering the abandoned streets of fear-stricken Juárez in a mariachi costume.[4]

THE PUN "SALIVATION" for "salvation" first appeared in a notebook, beside a drawing of hotel ice machines, in October 1989, and in January 1998, Terry chose it as the title of his next record. He decided to follow the critical success of *Human Remains* with something no one following his career to date could possibly expect from him: a gospel record, or, as Poss put it, his "twisted take on the obligatory country gospel album." Allen was feeling more sanguine than usual about the prospect

of recording, and with the encouragement of Byrne (whose suggestion of incorporating a gospel choir he did not take), he zealously followed the title's trail to Calvary.

After the modest success and renewed recognition afforded by *Human Remains*—which some critics framed as a comeback album— he was in a position to take a musical risk, regardless of some trepidation on the part of his new label. In September 1996, after an appearance at the Buddy Holly Festival in Lubbock, Terry, Richard, and Bukka (playing accordion for the first time in public) had embarked on a two-week tour of the UK and Ireland, the abridged Panhandle Mystery Band's first trip to Europe, which was a resounding success.[5] The BBC1 DJ Andy Kershaw, former host of *The Old Grey Whistle Test*, aired a session with "America's greatest songwriter" that he judged one of the most thrilling nights of his program. On March 21, 1997, Terry appeared for the first time on *Austin City Limits*, an overdue recognition of his under-the-radar influence on Texas music. Six months later, he was inducted (or "indoctrinated," as he put it) into Lubbock's West Texas Walk of Fame.[6]

Along with his increased visibility in the music industry, Allen's finances finally had begun to stabilize, thanks to a steady stream of public art paychecks. A commission for the George Bush Intercontinental Airport in Houston, *Countree Music* was his most technically challenging public artwork yet, comprising a 3,500-square-foot terrazzo floor embedded with a map of Earth, skewed and twisted to position Houston at its geographical center. Growing from Houston's coordinates is a twenty-foot-tall bronze tree cast from a real oak felled on his friend James Surls's property. Allen collaborated on the work's sonic elements with Joe Ely and David Byrne, composing, improvising, and recording a selection of quirky, largely electronic instrumental tracks at Ely's studio over several days in December 1998. While working on this soundtrack, Terry and Joe, habitual and reckless bonfire enthusiasts, experimented with some indoor burning. Terry had been working on a series of cattle brands with different imagery and text: skulls, crosses, "CONTROL," "ALL ARTISTS TRY TO BE GOD AND WILL BURN IN HELL," and a double-ended brand with a swastika on one end and "BUSH" on the other, which he gifted to Natalie Maines in the wake of her 2003 Bush-critical controversy. When he branded the doorframe to Joe's studio

with "IRONY," it immediately burst into flames, sending everyone run-
ning for water, beer, or anything wet to douse it.

Lyle Lovett loved *Countree Music* so much that he called Terry as
soon as he first encountered it, solidifying their heretofore casual friend-
ship. They'd met under unusual circumstances in 1993. Julia Roberts
(another Barry Tubb connection) had invited the Allens to dinner in
Santa Fe, and when they arrived, Café Pasqual's was completely empty
of patrons except for Roberts; her new husband, Lovett; and a crew of
bodyguards. Since then, Lovett had occasionally sat in with Los Dos
Rockin Tacos, but experiencing Terry's visual art in person was a reve-
lation to the younger musician.

PREPRODUCTION WORK ON *Salivation* began in earnest in August 1998,
while the Allens were on Mount Desert Island off the coast of Maine,
staying in a house supposedly haunted by a Captain Allen. Marion Boul-
ton "Kippy" Stroud, the mercurial pharmaceuticals heiress and gener-
ous arts patron who founded the Fabric Workshop and Museum in
Philadelphia in 1977, had invited the whole Allen family to her Acadia
Summer Arts Program. (Until her death by suicide in 2016, they joined
Stroud at "Kamp Kippy" a total of seventeen times, ensuring an annual
family vacation.)

Coproduced once again by Lloyd and Terry, but recorded, beginning
in mid-September 1998, at Cedar Creek in Austin (where the rest of the
band lived), *Salivation* was Terry's first album made entirely outside
Lubbock.[7] Davis had permanently inherited the drum stool from Donnie,
Glenn Fukunaga returned on bass, and Marcia Ball and Ian Moore
guested, on vocals and guitar, respectively, on the ferocious murder
meta-ballad "Ain't No Top 40 Song." Charlie Sexton contributed guitar as
well as, for Middle Eastern flavor on "The Doll," bazouki and cümbüş, a
banjo-like Turkish instrument Terry dubbed the "Jell-O Bowl." Sexton
also brought a harmonium from India for Bukka and Terry to play.

The sessions were bedeviled by calamities, all of which hit while
recording the cheeky carol "X-Mas on the Isthmus." First Bale contracted
viral meningitis and was hospitalized. While Terry stayed bedside with
Bale at St. David's South Austin Medical Center, Boyd Elder sped to the
Albuquerque International Sunport in his "shitty Mercedes"—at speeds
exceeding one hundred miles per hour—to deliver a distraught Jo Harvey

to a lecture to which she'd committed in Santa Fe. When Guy arrived to sing and play guitar on "X-Mas on the Isthmus," Terry, who had just received an anxious call from Susanna, informed his friend that his mother, who had been ailing, had succumbed. "I got it in my head that this song was jinxed," Allen said. "We're being sacrilegious, and now I'm getting fucked over." Jo Harvey worried about the impiety of the *Hally Lou*–style sermon she delivered on "The Show," a cutting music-industry allegory that casts Jesus as a coke-addicted promoter and that Terry considers "one of [his] greatest missed hits." Eventually he "goaded her into it."

In the middle of the blaspheming, button-pushing album hangs its hinge, "Red Leg Boy," a touching elegy to Terry's dad, Sled, his Missouri roots and his baseball career, adorably introduced by Terry's grandson Sled. In spite of Poss's (and many other people's) protestations and bafflement, the lead track "Salivation" concludes with Terry reciting a coda in a florid Donald Duck voice, as if possessed. Terry explained this bizarre choice as a reference to glossolalia, and more generally to the "garble of deep religious feelings" and the "deep melancholy" of commemorating lost loved ones. Lloyd remembered his friend's more direct and emotionally devastating explanation in the studio: "He said when he first wrote that, he did the duck voice to avoid getting too emotional. When we heard it, we thought it was funny and crazy at first, but then we realized he's doing it to not break down thinking about his parents. From that point forward it became sort of scary."

Although he denigrated the demonic duck talk as "art pretense," infuriating Allen (who in response accused him of running a "hillbilly label"), Poss found the final album overall "cynical, wicked, delicious . . . a grand morality play." He was duly punished for his support. Sugar Hill received a flood of hate mail from devout followers of the label, which had released numerous bluegrass gospel albums over the years, with accusations of Satanism and other unholy, unwholesome, heretical, and antibluegrass intentions. Much of this reactionary outrage, Allen admitted in retrospect, was probably due to the album cover alone, which depicted a leering, dewy-eyed, obscenely amateurish painting of Jesus, looking "like he had a big wad of snuff in his lip," that Bale found in the Austin junk store Uncommon Objects: "That shut down a lot of conversation before it got started."

TRUCKLOAD OF ART

Two days before the album's release, Terry played at South by Southwest for the first and last time, wearing a "white suit to feel like [a] revival preacher" and accompanied by Marcia Ball and David Byrne. Because of scheduling constraints, he was "thrown off after a few songs," furious and frustrated. On March 23, 1999, the actual release date, he played a fundraiser for the Stubb memorial at the Red Jacket with David and Lucinda, whose spare, plaintive version of "Bloodlines" had recently appeared on Allen's soundtrack for Jane Anderson's Showtime film *The Baby Dance*, starring Laura Dern and Stockard Channing and produced by Jodie Foster.

Allen and an ad hoc committee managed to raise $300,000 for the Stubb memorial over the course of five years playing benefit shows and selling bricks with donors' names on them. By then, in February 1999, Terry had already begun working in his studio on the clay figure of Stubb. Once it began actually to resemble his departed friend, he worried about more metaphysical matters: "To come in at night and see that presence was very spooky. It was hard to work on somebody like that who I had known and cared about and who had died. I swore I'd never do it again." He cast the bronze statue at Shidoni in Santa Fe along with a plate containing a massive pile of "every conceivable kind of barbecued meat," which he grilled himself, for Stubb to hold.[8]

ON THE LAST day of 1998, Bale found the desiccated corpse of his parents' dog Queenie, one of a pack of beloved canines they owned at the time, at the edge of their property, beneath a tree. "It looked like she'd been shot in the stomach," Terry wrote. She had been missing for six weeks, and he suspected a vengeful, dog-hating neighbor had murdered not only Queenie but also several other local dogs. Charlie and Bale helped Terry load her rigid body into a sack.

Terry returned to the house, agitated and cold, stomping off the snow, to find Guy Clark, among several holiday visitors that year, warming his cowboy boots by the woodstove.

"Some sumbitch shot my dog," Allen managed to croak.[9]

"Well, let's write a song about it!" Guy responded immediately, leaping to his feet. They got to work.

They argued about whether "liked" or "loved" was the appropriate verb. "Guy said, 'You can't *love* a dog; that's the wrong word.' I said, 'You

better believe we loved her. That might be the only thing we ever really do love purely, an animal. Anyway, why does every song you write have to have an old man in it?' Guy got so mad when I said that."

Bickering aside, the chorus of "Queenie's Song" was easy to resolve:

> Queenie's getting buried
> It's time to dig the hole
> New Year's Day in Santa Fe
> Broke mean and it broke cold

CHAPTER 48

THE SEA OF AMARILLO

Angels of the wind
Do they fly by desire
Or do they fall like a stone
Through the dust to the fire

 —"Angels of the Wind"

IN THE BACK ROOM OF HIS STUDIO, TERRY STOOD FACE TO FACE WITH A coyote. He had bought the taxidermy canine on a whim from a junk shop while at Kamp Kippy in Maine—"this thing doesn't belong here; it belongs to the West," he reasoned—and had it shipped to Santa Fe in late 1998. It never failed to unnerve him when he encountered its amber eyes and bared teeth shining in the dark. He began to dream of and draw a coyote wrapped in red neon: "I thought of what happened to my dad when he got bone cancer—this wild, living creature suddenly restrained and bound. I was thinking about disease." He sketched familiars for his parents' afflictions:

CANCER, (LIKE) A RED FACED COYOTE
ALCOHOL, (LIKE) A BLUE RAT

(But do not confuse cancer with headaches.)

He had been wrestling with *DUGOUT* for nearly two decades off and on. When Bukka and Bale turned fifteen, in 1981 and 1982, the same age he was when his own father was hospitalized, Terry suddenly started

hemorrhaging stories about his family, as if they might otherwise fall into oblivion with him. But he still had nothing finished to show except a couple of songs (most recently "Room to Room" and "Crisis Site 13" from *Human Remains*), and more substantively, a radio play.[1]

Dugout, Allen's third and final radio play commissioned by New American Radio, was broadcast by NPR-affiliated stations in 1993, seven years before the first physical artworks related to the *DUGOUT* cycle were completed and exhibited. It shares the ambition of *Pedal Steal* and the other *Four Corners* works, but the chronology feels, if not exactly more linear, then more easily decipherable. The emotional syntax and psychological register are more approachable, less dizzyingly antic and omnivorous. Jo Harvey and her mother, Katie, their voices difficult to distinguish, narrate, with an introduction and interjections from Terry. The radio play concentrates on the fictionalized avatars of Allen's parents and grandparents, stopping before the extensions into Allen's own childhood, and the midcentury Cold War and science-fiction contexts, that *DUGOUT II* and *III* present. Terry composed the music with Lloyd, though many of the recurring motifs are deconstructions of traditional songs, like the spiritual "In the Sweet By-and-By" and Pauline's favorite, "St. Louis Blues." The gestures of subjunctive direction in *Dugout* refer not to forking-paths filmic potential, as in *Torso Hell*, but to the inherent subjectivity and entrenched flaws of memory. ("If there's sound, it's a piano.") Though it contains its share of strident sex and violence, *Dugout* maintains some of a child's innocent awe at his parents' bedtime stories, even if the child himself invented them: "Truths, half-truths, half-lies, lies . . . now I don't even remember which is which," Terry shrugged.

Allen labored on *DUGOUT* off and on over the course of the next decade. "The radio show really triggered the piece," he reflected. "Then I got the idea of trying to expand it into drawings and constructed images. But it took a while to assimilate all of that." He accelerated his efforts in the late 1990s, in an era when he was simultaneously busy with music, public art commissions, and new activist and charitable causes. He had been struggling to move beyond purely pictorial and illustrative articulations of his parents' story into something more urgent and immediate, more universal and symbolically viable. "I want it to be as raw as a car wreck," he wrote in his journal. The taxidermy coyote found a home in a piece he completed in 2001.

Ancient, one of *DUGOUT*'s six weathered-wood tableaux assemblages or "stages," frames two paintings, of a wild sea and a tornado, behind collapsing folding chairs and slates containing the story of a 1959 afternoon in the backyard of Twenty-Eighth Street, shortly before Sled (He) leaves home for the hospital. As Pauline (She) examines her husband's hands, "huge and gnarled . . . ancient," He tells Her, in language Pauline recounted verbatim to Terry:

"I was thinking about all of it.
Ever damn second.
How I wouldn't trade any of it for nothin.'"

Above, at the end of a pirate-ship plank, prepared to jump off, skulks the coyote, tied in glowing orange neon, unbroken and restive but bound: bound like Sled by pale cicatrix, by guilt and grief over a shadow family; bound like Pauline by an unslakable thirst for impossible peace, by a ravening hunger for the stillness of embrace. Father and mother, coextensive in a coyote, both bound by light.

EARLIER THAT YEAR, the first time he played Nashville, at Caffè Milano with Guy, a country music rite of passage even for a Texan, Terry met Emmylou Harris, who cooked them dinner and swapped songs with them. Terry immediately took to her, sensing her sincerity. (The admiration was reciprocal: in 2010, she wrote "The Ship on His Arm," inspired by his *JUAREZ* print.) She asked him to participate in Concerts for a Landmine Free World, a series of benefit concerts she was helping organize to raise awareness about and money for the international campaign to ban and clear landmines, cofounded by the dynamic activist Bobby Muller of the Vietnam Veterans of America. Terry, recognizing that his participation in the cause represented a critical, political coda to *YOUTH IN ASIA*, immediately accepted, feeling, as he wrote, "honored."

After flying to LA on December 2 for his first Landmine gig, nervous because he did not know anyone but Emmylou and Guy, he joined a rotating cast of musicians involved with the organization, including Kris Kristofferson, John Prine, Gillian Welch and David Rawlings, Patty Griffin, and Bruce Cockburn. The next night he performed at University of California, San Diego, with Emmylou and Guy, as well as Mary Chapin

Carpenter and Steve Earle, both of whom became friends. He played "Peggy Legg," an irreverent but joyful portrait of a dancing amputee that injected some absurdist humor into an otherwise bleak subject. (It became an obvious anthem for the organization.) Terry took Clark and Carpenter across campus to see *Trees*. "I think that's where he got the idea of putting his ashes in one of my pieces," Terry later realized. "So I royally fucked myself there." Earle, a visual artist himself who was somewhat familiar with Allen's work through their mutual friends Guy and the artist Tony Fitzpatrick, immediately gravitated to Terry, peppering him with questions in his unspooling, staccato conversational style. "Now that John Hartford, Guy, and Townes are gone," Earle testified twenty-two years later, "Terry's the last of my teachers."

Selling scarves woven by Cambodian landmine victims was Loung Ung, a twenty-nine-year-old Cambodian American activist, born in Phnom Penh, whose parents and two sisters were starved, disappeared, and killed by the Khmer Rouge when she was a child. (She later told her story in two riveting memoirs.) That night, after talking with Terry, she invited him and Carpenter to join her on one of her regular fundraising trips to Vietnam and Cambodia. Once again, Terry could not say no; he had been angling to return to Southeast Asia for years, Jo Harvey had never been, and he sensed it was his duty to close the circle of *YOUTH IN ASIA* by aiding those maimed in the war's aftermath.

On February 3, the Allens flew to Hanoi via Hong Kong and spent two weeks traveling with Ung and Carpenter through Cambodia, visiting clinics and silk-making centers for landmine victims in Siem Reap, Phnom Penh, and rural villages near the Vietnamese border. They visited Angkor Wat, once a Khmer Rouge stronghold riddled with landmines, and the Củ Chi Viet Cong tunnels under Ho Chi Minh City, near where Stanley was killed in action. Terry performed at a bar in Phnom Penh, playing a "funky piano" and "sweating profusely because of the humidity, bitching endlessly about the heat." Sitting across from him was a little Cambodian girl. "She didn't have a drop of sweat on her," Terry observed, "and she was just staring bullets at me. Finally she said, point-blank, 'Why don't you just *control* yourself?'"

He was barely able to control himself during an emotionally devastating pilgrimage to Tuol Sleng, a notoriously brutal Khmer Rouge prison camp located in a former school. "Experiencing that horror did

something to me that I'll never get over," he avowed. Ung was unable to enter the museum; it was too painful. When Terry emerged, he walked over and silently hugged her, an embrace she has never forgotten: "People looked at me with pity, and pity does not solve problems or change the world. Pity makes me feel smaller. I wanted allies! Terry never pitied me. I felt a sense that he respected and valued my strength. . . . The way I see him—I can't stress this enough—is like a Care Bear, shooting out rays of love and laughter."

When Ung married in 2002, Terry offered to walk beside her:[2] "Knowing my parents died in the war, Terry offered to walk me down the aisle. He was the one and only person who offered. I remember it to this day. . . . Terry saw the daughter in me." Witnessing the Allens' marriage up close—their commitment despite occasional cruelty—helped her accept marriage as a vital bond in her own life: "I'm the first woman in my family to say no to arranged marriage. . . . I saw, in their marriage, how having love in your life and staying together does not make you less—it makes you more." Terry never expected any closure to YOUTH IN ASIA. The pain of losing Stanley and Steaven would never entirely recede. But after befriending Loung, he got closer.

DUGOUT UNEXPECTEDLY PROVIDED a similar sense of resolution and reconciliation. When she realized, after the radio play, that DUGOUT was revealing itself as yet another long-haul cycle of work for Terry, Jo Harvey grew nervous: "I was very worried about him delving into all that history. I was so afraid that it would throw him into the depths. But it lifted something that had been in there forever since I had known Terry. He became so much lighter, and he had invented the sweetest memories. . . . He spun all the things he didn't know into a beautiful, compassionate story about forgiving his mother, rather than staying angry." By encoding and embodying his stories in words and in objects—and in his own person in songs and onstage—his own grief and actuating rage gradually ebbed. Ironically, at the time, Jo Harvey was working on Homerun, a performance, and later a book, of interlocking poems and stories of her own childhood that premiered in 1997, marking the return of her inimitable idiom and presence to the stage—much to Terry's relief and delight.

Unlike other projects, which he generally showed piecemeal, only after a decade of work did Terry finally begin to exhibit elements of DUGOUT. The delayed gratification was made possible in part by upfront

funding from Peter Goulds of L.A. Louver and Ted Pillsbury of Peters and Pillsbury Fine Art, who formed a partnership with Allen to implement *DUGOUT I, II,* and *III.* In May 2002, ten days after he turned fifty-nine, Terry premiered *DUGOUT I,* its five wood-and-neon stages (the sixth was not yet finished) each recounting an episode from the relationship of Him (Sled) and Her (Pauline), corresponding to six sets of eight drawings—His with crude printed text and dark wood frames, Hers with cursive script and polished light wood frames—all of which collided in a helical reverse chronology with the radio play as a soundtrack. *DUGOUT I* next appeared in November 2003 at the Austin Museum of Art, in nearly complete form. *DUGOUT III: Warboy (and the backboard blues),* the theater piece interpolating Terry's childhood, starring Jo Harvey, with live music provided by Terry, Lloyd, and Richard, developed over multiple iterations as a work in progress at the Dallas Museum of Art in 2002, the Lensic Center in Santa Fe and the Palm Springs Desert Museum in 2003, and, finally, the Austin State Theater in January 2004.

On September 13, 2002, Terry was killing time at the bar of the ZaZa Hotel in Dallas before the opening of *Faith and Superstition,* a show at Pillsbury and Peters in which both Bale and Jo Harvey were exhibiting work. Jo Harvey was driving from Marfa, and unable to get in touch with her, he grew increasingly panicky, knocking back drink after drink. By the time she arrived, he had switched to coffee, but it was too late. Unable to walk or see straight, mortified at his impairment being discovered, at the opening he just "leaned against the wall the whole time." He fell hard in a heap and broke his thumb: "I had a hard time getting back up. That was the final humiliation. I realized, I can't do this anymore; this is no good. I didn't drink anything for about five years, and not much for a few years after that." Mortified, he knocked on his sons' hotel rooms to inform them of his decision, to which he adhered, with a few slips, for several years. Jo Harvey credits his willpower: "Without those pills, Terry was drinking too much, and it was hard for us. Then he just announced he wasn't going to smoke or drink period one night, and he didn't. . . . When he got off codeine, the doctor said it would be impossible without being committed to the hospital. But he did it on his own. He's very strong-willed. . . . He does exactly what he says. If he told you he would do something, you can count on it, period. He's like that."

Eventually he resumed drinking wine—Malbec remains a favorite—but beer and hard liquor, with the rare exception for a special occasion,

were permanently excised from his life, and his attitude toward alcohol shifted irrevocably. In the summer of 2003, during the stressful final push to prepare *Warboy* and combat the Austin State Theater's lame attempt to withdraw from its commitments, he experienced mysterious chest pains and slept in a hospital bed for the first time in his life (it was acid reflux). Jo Harvey was also struggling with heart palpitations, which required an ablation to resolve. "This is the worst month of my life (isn't it?)," he wondered in his journal. When he threw out his back the next month and his friend Dr. John Jackson (a proctologist whom he called "Butt"), visiting for the Fourth of July, suggested Vicodin or Darvocet, the shadow of the old fiend, opioids, spooked Jo Harvey, who understandably panicked. "Jo Harvey is going ballistic paranoid dramatic over even the mention of codeine," he wrote. "Codeine + fiorinal = paradise straight to hell."

IN A SOMEWHAT disorderly but still impressive logistical accomplishment, all three movements of *DUGOUT* coalesced in Los Angeles in early 2004. On February 28, *DUGOUT II (Hold On to the House)*—a reprise of the architectural interior tableaux first explored in 1976 in *The Evening Gorgeous George Died*, blank minimalist furnishings here appearing with projections, props (lamp, basketball hoop, a giant inflatable *Warboy* doll known as *Little Puppet Thing*, and a second taxidermy coyote)—opened at the Santa Monica Museum of Art. A week later, the complete *DUGOUT I* installation opened at L.A. Louver, and *DUGOUT III* premiered at the Skirball Cultural Center, recorded for L.A. Theatre Works' weekly NPR show *The Play's the Thing*.

The masterstroke of presenting three simultaneous projects in the city where Terry had attended art school and launched his practice attracted more press recognition than any of his art endeavors since *YOUTH IN ASIA*.[3] *DUGOUT I* was awarded second place in the Best Show in Commercial Gallery category by the International Association of Art Critics (AICA) Award.[4] Although still after all these decades dubious of Allen's theatricality, *Artforum*'s review was circumspectly affirmative: "Allen's work is like a collection of great country tunes—able, in a way that feels both familiar and mysterious, to tell about what could be specific torn hearts, dashed dreams, or troubled times, while situating these tales within broader human themes."[5]

CHAPTER 49

DAUGHTER OF THE HEART

Do they dream of Hell in Heaven?
Do they regret how hard they tried
And wish now they'd been much more sinful
Then repented just a minute before they died?

—"Do They Dream of Hell in Heaven"

JO HARVEY HATED ANTONIN ARTAUD. OR RATHER SHE HATED INHABITING HIS febrile mind. It was June 2006, and she was grateful to be in Lyon, France, workshopping a new theater piece. After rehearsing and writing all day, she and Terry were presented with a fabulous meal, after which they would retire to their beautiful room in an ancient monastery. A circus encampment had parked outside their window, and Romani fiddle music emanated every night from its ring of caravans through the spring air. "It was a very romantic period," Terry said. "Wine and cheese and candlelight, an incredible view out the window, and we were working like dogs every day. But Jo Harvey was having such problems with the material."

The material was undoubtedly challenging. Terry had been interested in influential French modernist playwright, actor, artist, and "Theater of Cruelty" exponent Antonin Artaud since seeing his gaunt, haunted face, crowned with a massive, cetacean forehead, staring from a photograph on the cover of the copy of *Artaud Anthology* that Lawrence Ferlinghetti, at the counter of City Lights Bookstore in San Francisco, gifted him in 1965. (Realizing Terry was penniless, the poet grumbled, "Just take the fucker!") Beyond his radical theatrical ideas,

Artaud represented, for Terry, a means of "cutting through the bullshit to reality and clarity"; a kind of holy madman, he was one of the artist forebears Allen credits with granting him permission to become an artist himself. Artaud was also, like Terry, plagued by headaches, a result of childhood meningitis. That enormous skull contained vast reservoirs of pain.

Ghost Ship Rodez, the play that the Allens, with musical support from Richard, were developing in Lyon, investigates the true story of Artaud's descent into insanity after attempting to return an artifact he believed to be Jesus's staff, inherited by St. George, to Ireland. After suffering a psychological collapse and striking a Dublin policeman with the saintly stick, Artaud was deported to France. *Ghost Ship Rodez* attempts to harness and articulate the hallucinatory interior monologues of Artaud during the seventeen days in 1937 that he endured chained to a cot, raving, in the hold of the freighter *Washington*. In France, he lived out his final decade, the most prolific era of his life, in various hospitals and sanatoria, including the Rodez asylum.

Jo Harvey, outfitted in a red wig and corpse-clown makeup, starred as the polyphonic Daughter of the Heart, a medium or narrative antenna for various characters, largely women, who offered testimonies on Artaud, a hive of consciousnesses colonizing his mind. However, Artaud's violent, unhinged behavior, heroin abuse, and obscenely psychosexual and scatological writings—he was in the habit of drawing magical "spells" in his own bodily fluids—repulsed her, and she found herself unable to access her character's claim to his interiority. She seriously considered faking a heart attack to avoid performing. One day, standing in the wings during her performance at Festival Les Intranquilles, she witnessed the prop Staff of St. George move, scrabbling along the stage, seemingly by its own volition. She gasped, and empathy for Artaud and his broken mind seeped past her defenses. Years later, she judged *Ghost Ship Rodez* as "the most meaningful project" of her career and still choked up telling the story: "It was an interesting thing to become friends with a dead madman."

GHOST SHIP RODEZ followed *VOIDVILLE*, which used the plays of Samuel Beckett to consider the agonizing contemporaneous US military engagements in Iraq and Afghanistan:

After a big project [like *DUGOUT*], I feel depressed and empty. So naturally, to avoid depression, I started reading Beckett, which is of course hilariously depressing. Also at the same time, the Abu Ghraib torture story was happening. They played into each other with that body of work—with madness. I made drawings that responded directly to Beckett and the news. Of all my work, *VOIDVILLE* is probably the most of a bastard. It's totally its own thing. I don't think I ever sold one piece out of it.

Terry showed *VOIDVILLE* first, with his cattle brands, in November 2004, at Paule Anglim, and then a year later at the Mermaid Arts Center in Bray, County Wicklow, in Ireland, Beckett's nation of birth.[1] Characterized by large, colorful drawings derived both from pop-comic and art-historical precedents (some pieces vaguely resemble Philip Guston's late work) and incorporating three-dimensional assemblage elements and props, *VOIDVILLE* is indeed an outlier in Allen's oeuvre. As simultaneously an homage to modernist art and literature, a pictorial political protest, and arguably his most painterly body of work, it is both unusually specific and unusually opaque, formally and conceptually. In both its rendering techniques and its unflinching mortification and scarification of human bodies—articulating Beckett's damaged *Endgame* characters and their defective and unfinished bodies with the torture victims at Abu Ghraib—*VOIDVILLE* bridged *DUGOUT* and *Ghost Ship Rodez*.

GHOST SHIP RODEZ (THE MOMO CHRONICLES)—Artaud referred to himself as the Mômo—a fourth volume of Allen's fictionalized biographical works (following *RING*, *Bleeder*, and *DUGOUT*), occupied the Allens for the second half of the aughts, incorporating sculptural video installations and drawings in addition to the performance. Terry began *Ghost Ship Rodez* as a psychological maritime fantasy that braided Artaud's story with the similarly seafaring character of Sonny Boy, based on Allen's cousin Billy Earl. He hammered out a preliminary script on a two-week stay in Guanajuato, Mexico, before flying to Lyon.

In Lyon—around the same time Jo Harvey experienced her vision and resulting epiphany about Artaud—Terry abandoned the Sonny Boy thread, realizing that shoehorning the two characters and time periods together, while conceptually and personally appealing, ultimately felt

contrived and muddled. Artaud's story and presence could survive on its own without a post-*DUGOUT* hangover tether to Allen's family. The piece refocused with precision on those seventeen days at sea, becoming a contained, fictional-clinical case study of Artaud's delusion, delirium, and derangement, unmoored from land and sanity.

Days after returning from Lyon in early July 2006, the Allens drove to Marfa, the art-world outpost of two thousand souls in ravishingly desolate West Texas, about an hour's drive from the Mexican border, to celebrate their forty-fourth wedding anniversary with, among numerous others, the Elys, Hancock, and Barry Tubb.[2] New celebrants included Bobby Muller of the Vietnam Veterans of America and a twenty-five-year-old songwriter and ex-rodeo bull rider named Ryan Bingham whom Terry had recently met through Tubb while playing at the Gage Hotel in nearby Marathon. "I was knocked out, just dumbfounded by how good his songs were," said Terry. The Marfa party was Ryan's introduction to a whole host of older mentors and new friends, including Guy Clark and the artist Kiki Smith. Like many younger artists, Bingham gravitated to Allen's gruffly avuncular humor and paternal presence.[3]

One evening the Allens strapped a Wonder Woman blowup doll to the front of their pickup and drove out to a property north of town, past the cemetery, owned by Barry, empty but for an Airstream trailer, to cook barbecue and dance. Everyone parked their vehicles in a circle, turned on their radios, and kicked up the dust with their boots into the headlights' beams, where it mingled with the fragrant barbecue smoke, like they had done as teenagers in Lubbock. Joe Ely danced so hard on the hard dirt that he reportedly limped for weeks. "All of a sudden," Jo Harvey recalled, "walking across this field out of the dark came Guy and Susanna. She was in [a] long white muumuu and black glasses." She had been in bed for a long time, shattered by losing her best friend and "soulmate" Townes Van Zandt, so no one expected it. "She was like a vision," Jo Harvey swooned. "An angel." This magical emergence from the gloaming was one of Susanna Clark's final public appearances.

Other old friends were present in spirit—in fond talk—if not physically. Marcia Tucker, whom the Allens had last seen at the final performance of *DUGOUT III* at CalArts' REDCAT theater, had hoped to attend, but she was not feeling sturdy enough to travel. Her daughter, Ruby, arrived without her. Three months later, Marcia passed away. At her

Buddhist memorial service, Terry wondered, staring at the "box of Marcia," who had been so "true and full," a "beauty of big bulging laughing eyes and glitz," if her tattoos survived in her ashes, rendered in some subtle, chemical way. Guy followed up with his own bad news: he had lymphoma. He began to mention, with increasing frequency and urgency, Terry's responsibility to incorporate his ashes into a sculpture. Terry brushed it off as usual.

On January 8, 2007, the Allens bought the old whorehouse in Marfa (long since decommissioned) but sold it three years later. "I loved that green floor," Jo Harvey recalled, with a wistful sigh.

They continued to refine the script of *Ghost Ship Rodez* together, and while in Puerto Vallarta in March 2007 at collectors' Karen and Robert Duncan's residency program, Terry started the related drawings that he showed later that year at Dwight Hackett Projects in Santa Fe. They returned from Mexico in time for Bukka's wedding, on April 27, to singer-songwriter Sally Semrad, to whom he had proposed a few weeks after the Marfa convocation.

That September, a year after the Lyon workshop, the Allens joined Dave Alvin, Butch, Tom Russell, and others on a weeklong Tarahumara Roots on the Rails Mexican train tour from Nogales to Copper Canyon, an intimate locomotive concert series for passengers willing to pay the $4,790 fare. At Copper Canyon, on a break between train-car performances, Allen visited a humble Antonin Artaud Museum and asked the Tarahumaran people he met "if they'd ever heard of a crazy Frenchman who lived with their parents or grandparents and did drugs in the '30s. None of them had ever heard of this guy; they looked at me like I was insane." Despite the failure of his ethnographic research, the journey provided fodder for the next iteration of *Ghost Ship Rodez*, which they undertook as artists in residence at Mass MoCA in North Adams, Massachusetts, in January 2008, when he and Jo Harvey workshopped the further installments of the performance.

Terry spent the two-year interim between the Mass MoCA workshop and the culmination of *Ghost Ship Rodez* working on related drawings and sculptures and beginning to explore the songs and images that would comprise the *Bottom of the World* album and prints. He also became embroiled in two bizarre copyright disputes. First, Bukka discovered that the San Jose Museum of Art was selling miniature

Corporate Head figurines manufactured without permission. Then after seeing Terry play in the plaza in Santa Fe, the actor Val Kilmer invited the Allens to visit his property. When Kilmer asked them to join him for dinner, "Jo Harvey said, 'I'm sorry, we'd love to, but we're already going to dinner with some friends tonight.' He said, 'You couldn't possibly have any friends more interesting than I am.' And Jo Harvey said, 'Oh, honey, just about *all* of our friends are more interesting than you are.'" She may have been right. Years later, Kilmer discussed buying one of Bale's bronze tumbleweed sculptures, decided they were out of his price range, and proceeded to make his own nearly identical sculpture—plated in twenty-two-karat gold—which he allegedly attempted to sell for $150,000. Bale threatened to sue him for copyright infringement, and Kilmer settled out of court in 2019.

Terry, similarly engaged with bronzed botanical specimens, installed *Tennessee Leaf*, another large-scale public sculpture, at the Hunter Museum of American Art in Chattanooga, in April 2010; thereafter, his industrious public art production slowed. Allen's family both expanded and contracted during this period. On July 11, 2009, as Terry recorded in bold pen strokes, filling an entire page of his journal, the Allens' third grandson, Kru Westermann Allen—named for Cliff—was born to Sally and Bukka. The first song he ever heard was "Bloodlines." Bukka, who had been actively touring with the Bodeans, Joe Walsh, and the Chicks side project the Courtyard Hounds, took a break from the road, and his relationship with Sally began to falter around the fault lines of parenthood and mental strain. Bale and Jennifer, drifting apart, announced their own separation in December. Both couples endured unhappily for years before finalizing their divorces—Bale and Jennifer in 2012, Bukka and Sally in 2015—wracked on what Terry in his journal called "the bitter wheel."

Distressed about the pain in which his sons, daughters-in-law, and grandsons found themselves, Terry blamed himself, turning the bitter wheel of his own past. "I think it might be me who brought about this— me over the years carrying anger and rage and bad climates," he wrote in anguish. He and Jo Harvey had continually exorcised their mutual anger and jealousy, for better or for worse, and had managed to achieve a hard-won clarity and fastness within the tornado turmoil. They had survived the worst of it. When they awoke together on their forty-eighth anniversary, July 8, 2010, they "just looked at each other and laughed,"

giggling uproariously under the sheets. Was it decision or destiny that had brought, and kept, them together? Did it matter anymore?

THE SET OF the completed *Ghost Ship Rodez* theatrical production, which opened at the Lensic in Santa Fe on April 9, 2010, featured as a centerpiece a spare, hanging knot of spars and rigging meant to suggest the *Washington*. In addition to the drawings presented concurrently at the gallery show at SITE Santa Fe were two striking puppet-inspired sculptures that stand among Terry's most singular and accomplished three-dimensional pieces. *Ghost Ship* comprises a set of sail-screens mounted on raw wooden sticks (or staffs) as mast and booms, on which video of Jo Harvey flickers, suspended over a bare metal cot placed on a ship shape traced on the ground in open books. *MOMO Lo Mismo* is an anthropomorphic robot, a giant maritime marionette constructed of hinged steel bars, rigging, and six flat-screen monitors—one each in the position of head, torso, hands, and feet, each containing a video detail of Jo Harvey's face (eye, red lips, nose)—trussed at multiple points through a ceiling grid and tied off to cleats on the floor. In 2011, an exhibition that collected all of Terry's plastic artworks related to the project traveled to L.A. Louver and Paule Anglim.

The Allens performed the play one final time at Theater Artaud in San Francisco, but it was not exactly a triumphant homecoming to the namesake venue of their tortured subject. Terry had hoped for a stronger reaction, positive or negative, than the lukewarm bafflement *Ghost Ship Rodez* elicited, even among those he loved. There was, he wrote, "a strange silence among some friends about the piece—notably Bruce [Nauman] & Susan [Rothenberg]. . . . People are evidently disturbed by it."[4] In March 2012, he privately despaired in his journal, temporarily surrendering to self-doubt: "Sometimes I think I'm just pretending to be an artist." By the summer solstice, he resigned himself and retired the body of work completely.

On June 27, 2012, Susanna Clark, still in mourning, having never recovered from losing Townes, whom she openly called her "second husband," fifteen years prior, also resigned herself and retired her body to oblivion. "Susanna Clark, our old crazy friend, died last night," wrote Terry. "Guy called at 4:00 this afternoon. Devastated behind the front. We are too." Danny Thompson killed himself two months later, shooting

himself in the heart on August 20, the eve of his seventieth birthday. He
had left an uncharacteristically sober and pacific voicemail for Terry
only days earlier, sending his love; Terry did not return the call in time.
His death, Terry wrote, "will be a haunting to me the rest of my life. . . .
We coerced and propelled ourselves out of [Lubbock] with a burning
desire, in a blizzard, on January 4, 1962."

CHAPTER 50

THE BLOOD ANGEL AT THE BOTTOM
OF THE WORLD

Emergency human blood courier
Headed south down to Mexico
Where there's been a whole lot of bleeding
An gonna be a whole lot more

—"Emergency Human Blood Courier"

IN HER HOSPITAL ROOM, JO HARVEY FLOODED HERSELF IN HEALING LIGHT
and waited for her blood to be drawn. "I'd meditate and say my prayers,"
she said. "I washed myself in lavender light daily." When the phleboto-
mist arrived, "she was real gruff and kind of severe," Terry remembered.
"Then she stopped what she was doing," looked at Jo Harvey, and she
grabbed her and shook her and said, "'Praise Jesus—you do not have
cancer! Say it!'" Jo Harvey, rarely at a loss for words, stared up at the
nurse, backlit by fluorescents, in silent disbelief.

"Say it! 'I do not have cancer.'"

"I . . . do not have cancer," Jo Harvey intoned flatly. The nurse smiled
and nodded gravely.

"I called her the Blood Angel," Terry said. "I'd say, 'Jo Harvey's going
to the Blood Angel today.'"

When the Blood Angel left the room, Jo Harvey swooned.

IN 2011, TERRY plumbed the bottom of the world and stayed there for
three years.

"In the lowest deep, a lower deep": Allen had Milton in mind when he wrote and recorded the album released in 2013 as *Bottom of the World*, his first album of new song-based recordings in fourteen years, since *Salivation*. A set of songs as dark and bleak as *Ghost Ship Rodez*, though as always, never without their sense of macabre humor, it recalls *Juarez* both for its stark, minimalist arrangements and the suite of large-format prints that accompanied its original limited-edition release. Recorded slowly over the course of several sessions spanning 2010 to 2012, the charting of *Bottom of the World* bookended Jo Harvey's May 2011 diagnosis of ovarian cancer, forever carrying that black terror with it—"I've never been so frightened," Terry wrote at the time—and informing its stately and somber mood. Allen had written all the songs before the diagnosis, but the resulting album was retroactively flattened by grief and dread, seeming eerily to prognosticate and parallel Jo Harvey's condition.

When Barry Poss sold Sugar Hill to the Welk Group in 1998 and retired, Allen found himself in the awkward and rather absurd position of losing not only his primary champion at the label but also his back catalog licenses and access to his *Human Remains* and *Salivation* masters, which transferred to the corporation that accordion impresario Lawrence Welk founded in 1964 to sell resort timeshares. The situation ratified all his worst fears about record labels. Although he liked Poss's successors well enough, in Barry's absence he perceived a gradual deprioritizing of his music and a diminishing of attentions as Sugar Hill diffused its management and diluted its identity into the larger corporate concern. When in October 2008 label reps informed him that they would offer a maximum $15,000 budget for a third album, he balked and decided he would ride out his license and not release any more music with Sugar Hill, abandoning a nearly completed reissue of *Rollback* (originally released by Fate, with *Pedal Steal*, on a 1988 CD).

The decision to self-fund and self-release the new album lent itself to the spare, mostly acoustic production—spacious, drumless, hearkening back to the sonic world of *Juarez*—that he had originally envisioned for *Salivation*, albeit through a process more disjointed and scattered, and less immediate and focused, than he would have liked. He began in July 2010 with the folio of prints, an edition of thirty, comprising one large double-sided lithograph of illustrations and handwritten annotations on

sheet music for each of the album's eleven compositions. Terry and Jack Lemon, who had moved Landfall to Santa Fe in 2004, shot each "Queenie's Song" print with a Winchester rifle, leaving a bullet hole in the same location across the entire edition. It would be the final collaboration between Allen and Lemon, who has since largely retired.

For the album cover of *Bottom of the World*, Terry took a different tack, using a black-and-white photo of an artifact from *DUGOUT*, a simple wooden chair with ten piano keys, D to B, arranged on its seat, an homage to Pauline. The lost-key image also evoked a contemporaneous excursion. In September 2010 (ironically, the same week he broke a key on his keyboard), Terry recorded the sound piece *For Beginners (instructed piano)* for Bruce Nauman, in which he haltingly repeats a series of arduous finger-contorting intervals on piano, exacerbating his arthritis. "I'm not sure I want credit for that," he joked to Bruce of the final product.[1]

Allen recorded the entire album at Screen Door Studios, Bukka's home studio in Buda, Texas. The skeleton crew band included Lloyd, Bukka, Richard, Sally on backing vocals, and Bukka's friend and bandmate Brian Standefer, who also engineered and mixed, on cello. The quiet, dry, close-miked recording, lack of rhythm section, and emphasis of Lloyd's levitating steel guitar and dobro achieved a consistent intimacy and weightlessness new to Allen's catalog, baring the breath around the words he sang with more poise and precision than ever and setting off the sinking sensation elicited by the pensive lyrics.

The album pulls songs from a variety of sources, including *Juarez* (the mood-setting opener "Four Corners"), *DUGOUT* ("Hold On to the House"), *Ghost Ship Rodez* ("Do They Dream of Hell in Heaven"), and *Chippy* ("Angels of the Wind"). "Do They Dream of Hell in Heaven" and "Emergency Human Blood Courier" rank among Allen's most compellingly morbid songs (and song titles), though both are freaked with grim gallows humor. "Queenie's Song" appeared in Allen's own tender rendering a decade after Clark first recorded it for his 2002 Sugar Hill record *The Dark*.

In the wordy "Wake of the Red Witch," the album's most complex and lyrically accomplished song, Allen dredges submarine memories of his childhood moviegoing disappearances into fiction—"Hide in a movie / You can't tell / If you're on the earth / Or in a diving bell"—with scenes

from specific John Wayne films, with ringing resonances of death, Sled's in particular. *Wake of the Red Witch* terrified Allen as a kid, especially the final scene, when the water rises in Wayne's antique diving helmet as he slowly drowns, an image that haunted his nightmares for years. The song that shares its title uses John Wayne, his roles, and his problematic legacy to comment on cinema in general, the passive practice of spectatorship, sitting in the dark with your eyes and ears open and surrendering to the tide of light and sound and story. In a self-referential lyrical twist, Allen begins the song with a line about "modern dancers" and how *The Searchers* inspired the choreography of *Rollback*. "I wish I'd thought of that song then," he told me, "because it would have worked perfectly in *Rollback*." In retrospect, Terry regards "Bottom of the World," "Wake of the Red Witch," and "The Gift" (a chilling rumination on the insidious disease of privilege, inspired by Bernie Madoff) as harbingers of his next album, still another seven years away. "The way the lyrics worked with the music" heralded "the first move toward *Just Like Moby Dick*."[2]

"Covenant" fulfills Terry's tenderhearted tradition of ending his albums with a song for Jo Harvey (arguably two, since "Sidekick Anthem" might address a friend, relation, or lover). It shares its title with a performance that debuted on June 21, 2011, just ahead of the Allens' forty-ninth anniversary, at Oliver Ranch. A collaborative theater piece that surveyed their individual careers and their long relationship, *Covenant* premiered in Ann Hamilton's *Tower*, a structure resembling a World War II coastal guard tower but containing a unique double-helix pair of staircases. One staircase held the audience, and the other was occupied by Lloyd, Richard, Bukka, and Brian Standefer, staggered vertically, with Terry and Jo Harvey at the base of the tower, on a platform suspended over water. Acoustically and visually the experience was, for Terry, "remarkable, just because of the nature of that architecture." The next day, he wrote that "Jo Harv gave one of her great performances in the tower yesterday. Stunning to watch and listen to."

However, in hindsight, he reckons that *Covenant* wilted outside the hothouse environment of the tower. "To me it's the weakest piece we've ever done," he proclaimed. "I think it's because of everything going on in our lives then, with Jo Harvey's cancer scares. It was disjointed, overly sentimental. . . . It never had that coherence and cold-blooded necessity that a piece needs to work." Jo Harvey noted that younger audiences

responded most to *Covenant*'s depiction of their marriage, even if she and Terry found it too soft-hearted: "We weren't happy about it. We were worried about me dropping dead! It's hard to put mean things in there when you're worried about somebody dying. Our kids loved it. . . . A lot of young people loved it. . . . But we both felt uneasy about it being so personal. We were just so stressed about my health at the time."

ON AUGUST 17, 2011, after an interminable series of tests and biopsies, Jo Harvey underwent surgery to have her ovaries and fallopian tubes removed. The reprieve of her remission was brief. Three years later, on November 13, 2014, she underwent a hysterectomy during which doctors confirmed that the cancer had spread to her uterine lining. Since then she has been cancer-free, as predicted by the Blood Angel. Both the recording of *Bottom of the World* and the writing and run of *Covenant*, some performances of which they had to cancel for medical reasons—"I've never cancelled anything, but putting Jo Harvey in jeopardy makes the choice simple," Terry wrote—existed in this tenebrous limbo of medical unease and grief, sleepless nights and radiation side effects.

Bottom of the World was released on February 5, 2013, following Allen's first solo New York show in years, a survey titled *Ghosts: Works from* Dugout, Ghost Ship Rodez, *and Others*, which opened on October 9, 2012.[3] Terry had found gallerist Tim Nye "likable" when he visited Santa Fe, but his initial impression curdled. Due to a pricing blunder, a clutch of significant sales to collectors evaporated, and it took Allen and Kimberly at L.A. Louver months of threats and bargaining to extract Terry's work from the warehouse where it languished.

The increased visibility did, however, earn Allen some notable New York press. Although the description of Terry's work as "Old West Psychedelic" made Allen cringe, Ken Johnson observed in the *New York Times* that "there is just one person whose art has been seen in highbrow museums around the country and is an inductee of the Buddy Holly Walk of Fame in Lubbock. He is Terry Allen."[4] The *Times* also weighed in on the lyrical sleights of hand on display on *Bottom of the World*: "Mr. Allen's magic strength is that he can keep two or more big ideas in the air at once, juxtaposing them without explicitly merging them until they kind of belong together: sex and real estate, love and colonization, greed or guilt. . . . He's pretty close to a master lyricist."[5] In

his glowing review of the album, the *New Yorker*'s Ben Greenman wrote that "as always, Allen's songs extract strangeness from the known world and use it as a means of acquiring greater knowledge. . . . It's an old man's confirmation of a young man's speculation, which is as good a definition of wisdom as any."[6] Terry's favorite piece of press was published closer to home, however, a career-spanning cover story by Richard Skanse for *Lonestar Music Magazine,* which he felt finally positioned his art and music in balance as "one thing."

If, from the Allens' perspective—if no one else's—their work suffered and stagnated during this three-year fallow season of cancer, their relationship and mutual dedication grew stronger and more assured. Terry accompanied Jo Harvey to every single doctor's visit. "He was so attentive, just so great," Jo Harvey sighed. "He never left my side; he was unbelievably freaked out." He wrote journal entries tracking her test results and recovery and observational poems about their hospital visits. In one poem, titled simply "Cancer," he relates a conversation between a stranger and Jo Harvey in the elevator to the oncology department:

Do you have on perfume?

No. I only have on body soap and lotion. It must be my angels.

It smells really nice.

getting off, looking back

They say angels have a smell, you know.

WHISTLING THROUGH THE GRAVEYARD

So better break out the bottle
Bring on the glass
And fill it up with the good stuff
'Cause everything must pass

—"Sailin' On Through"

"IT WAS *BOTTOM OF THE WORLD* THAT LED ME TO PARADISE OF BACHELORS," Terry told me aphoristically on May 15, 2023. I had suspected as much, but he had never stated it quite so clearly and chronologically. We were sitting with Jo Harvey and my wife, Samantha, in the dark lobby of the Bowery Hotel in New York, where that night Terry was playing a song-swap "guitar pull" benefit concert at Town Hall for the Keswell School, a special education school for children with autism, which Steve Earle's son John Henry attended. Steve and Terry had grown closer in the wake of the death, by accidental overdose, of Justin Townes, Earle's eldest son, in 2020, after which Terry's phone call was the first that Earle answered: "I told Terry that I had talked to Justin the night he died. . . . The last thing I said to him was, 'I love you,' and the last thing he said to me was, 'I love you too.' And Terry interrupted and said, 'So you keep *that.*' And I owe him for the rest of my life for that. I knew it, but to hear somebody I respected as much as I respect Terry say it. . . . That was exactly what I needed at that point." Naturally, Earle invited Terry to join him at the annual benefit for his youngest son's school, which this year also featured David Byrne and Kurt Vile, all onstage at once, with backing by Bukka on accordion and Anna Wilson on pedal steel.

"I was so pissed at Sugar Hill for not supporting *Bottom of the World*," Terry elaborated, "but I was so adamant and stubborn about doing everything myself." Since my first interview with him in 2006, when I had tentatively floated the idea of helping him reissue *Juarez* with reproductions of the original suite of lithographs, we had maintained a sporadic email correspondence. After I cofounded the record label Paradise of Bachelors in 2010, with the aim, at least initially, of releasing new and archival Southern vernacular music (things have become more diffuse since then, generically and geographically), my occasional messages increased in frequency and fervor. My business partner, Chris Smith, is also an ardent Allen admirer, and *Juarez* had always been at the top of our list of potential reissues. When folks ask me "what kind of music" we release as a label—a completely fair, if impossibly vexing question—I'm tempted to describe it, as my son, Asa, once described any music he likes, as "Terryallen music" (elision his). In some essential if amorphous way, we shamelessly framed the label's emerging aesthetic around *Juarez* even before we reissued it, and now we are known to many fans as Terry Allen's record label, which suits me fine.

In 2012, Terry, aware that I was interested in working with him in some capacity, sent me a CD-R of *Bottom of the World* ahead of its release. I offered to help him with design, vinyl manufacturing, distribution, press contacts, writing, anything really, but he made it clear that he wanted to self-release the record. Although I suspected that the opportunity for some grand if ill-defined collaboration had most likely passed, I continued to bide my time.

Ultimately, it was the bottom of my world, "bottom" in the sense of "foundation"—the frontier of one fatherhood ending and another beginning—that led me back to Terry in a way that was more than merely conversational and academic and became, over time, deeply personal. In hindsight it is no accident that the dawn of my close working relationship with Terry followed the death of my own father, Kenneth Greaves, on November 6, 2013, ten days after the birth of my son, Asa. He was seventy-three and had been battling Parkinson's disease for almost a decade. He held on just long enough to see the image of his first grandchild flicker across the screen of a phone. Suddenly, reminded of limited time, the project of inhabiting the world of *Juarez* and opening it to a wider audience felt somehow more urgent to me. Although I did not

perceive it then and would have defensively denied it had anyone suggested the notion, in the wake of my dad's death, I was perhaps subconsciously seeking some paternal presence in my life. I would not be the first to turn to Terry for that. As a new father and a relatively new husband, I also marveled, like David Byrne and so many others have, at the longevity, tenacity, and sempiternal beauty of the Allens' marriage and family in the face of trauma and discord and sometimes ruthless jealousy, both self-imposed and external. I can't think of any comparable examples of prominent artists who have stayed together as a couple for so long, collaborating regularly, while also maintaining distinct careers. They're an anomaly by any measure, crossing boundaries not only between media but likewise breaking the established rules of thorny art relationships.

On January 26, 2015, marooned by a snowstorm at my friend Mike Colin's apartment in Brooklyn, I dialed Terry's cell phone. The Outsider Art Fair panel discussion on which I was scheduled to appear had been canceled due to the weather, as had my flight home to North Carolina. I was feeling trapped, jittery with a country boy's urban cabin fever. I had received a tip from a friend that very morning that another label had been sniffing around trying to contact Terry about reissuing his catalog. After so many years waiting for my chance, I could not allow that to happen.

"Hi, Brendan!" Jo Harvey declared with unseasonal, unexpected, and to me—given our total lack of acquaintance, having never once spoken—slightly unsettling cheer, volume, and warmth. They were driving, and after some fumbling, Jo Harvey managed to pass the phone to Terry. Before I could make any sort of pitch or appeal, as if he was expecting my call, he said, "I've actually been meaning to write to you." The Sugar Hill licenses to his back catalog, now controlled by Concord Music Group, were set to expire soon, and he had apparently been waiting for those contractual sunset dates so he could talk to me about licensing *Juarez*, and he hoped *Lubbock (on everything)* too, to Paradise of Bachelors, without any intermediary third party. He was not at all interested in working with any other label. He explained matter-of-factly, "I want someone who understands the art deal, not just the music deal."

We signed a licensing agreement six months later, after the rights to his first two records had officially reverted to Terry.

We finally met in person on February 17, 2016, over twelve years after we first began corresponding, in the lobby of the Allen Theater (no relation) at Texas Tech University in Lubbock. Terry was taller than I'd imagined, his shoulders, when I hugged him, as angular as a boom and as liable to heel. His wily smile spread as he immediately unloosed a torrent of wisecracks. Lloyd, rosy-gray and impossibly good-natured, his basso voice booming beneath his robust mustache, shook my hand and informed Chris and me gravely that he had just discovered that every previous release of *Lubbock (on everything)*, the album we were in the process of preparing for reissue, was out of tune, which would render the remastering process extraordinarily labor-intensive. Terry, beaming, recounted how, in a moment of "sweet revenge" earlier that day, as a guest artist in a music class at his alma mater Monterey High School, he had played "The Roman Orgy" on a grand piano in the very building where it had incited such controversy and censure fifty-five years earlier. "What were they going to do, kick me out again?" he asked rhetorically.

The next evening, for the first time ever, all the surviving members of the Panhandle Mystery Band performed the entirety of *Lubbock (on everything)*, presided over by Jo Harvey as emcee and joined by Bukka, Bale, and special guests, including Robert Earl Keen and Delbert McClinton. In his introduction to the concert, university chancellor Robert Duncan announced that Tech's University Library and Special Collections was acquiring Terry and Jo Harvey's extensive archives and papers for the Allen Collection (or, as the couple themselves refer to it, the Allen Center for Unlearning) to serve as a living archive of their artistic process. The university would accession everything: notebooks and journals, sketches, scripts, videotapes, audio cassettes, reel-to-reel tapes, ephemera, and hundreds of letters written when one or both Allens were traveling on tour, on stages, or on film sets. "Some of the letters we found are just full of old porno drawings and dirty stuff—I don't know who will want to see *those*," giggled Jo Harvey.

Originally the collection was intended for the Smithsonian Archives of American Art, with whom Allen had struck an agreement two decades earlier. But when Terry shared some preliminary materials, the agreement quickly unraveled: "They said, 'We don't want anything to do with your music. We only want your art.' It was like, 'We'll take this part of what you do, but this other part of what you do, we disdain.' It pissed me

off, so I told them, 'Forget it.' Art is about all of your senses, stupid. . . . You don't get up in the morning and say, 'Today I just smell.'"

The announcement made official a process that had been ongoing, at a glacial institutional pace, since at least 2005, when Tech's Southwest Archives hired writer and musician Andy Wilkinson to help build their collection of musicians' and artists' archives. The first trip he took was to Santa Fe to see the Allens. Two years later, Terry, sensing a "weird vacant sadness," watched him drive off with the first artifacts, several boxes of master tapes, bound for Lubbock. In 2016, appraiser Adam Muhlig began examining everything else, prompting a seesawing emotional reaction from Jo Harvey, who went from "giggling one minute to hiding in the closet and sobbing the next," alternately delighted and unnerved by poring through her past in such excruciating detail.

Finally, after several visits and further negotiation, yet another truck-load of art—full of Terry and Jo Harvey's material pasts—departed their home on July 5, 2018. Terry was relieved to get back to work after the upheaval of someone sifting through the tailings of his life, the boxes of stuff that accrete around you through decades of an art practice. Although he never publicly gloated, the bizarre irony of the university that represented everything against which he had rebelled as a teenager—all he had fled as a venomous college dropout in 1961, and which he viciously satirized in song—validating his life's work, much of which he created in direct opposition to its own institutional, civic, and cultural principles, was not lost on him.

"I've been referring to the whole thing as 'whistling through the graveyard,'" Terry slyly told me of the reissue campaign that launched in 2016 with an expanded gatefold edition of *Juarez*. "Jo Harvey hates that." He first used the phrase to describe the alloy of pride and unease at his handsome retrospective UT Press monograph in 2010, when he began the enduring legacy project of revisiting, scrutinizing, and reconstructing his past life and work. It has become a refrain for our work together as well as the process of appraising and donating his archives, which launched in earnest contemporaneously. Unfortunately, with the timing of the new edition of *Juarez*, the funereal choice of words rang too true.

At home in the small hours of May 17, 2016, Guy Clark finally succumbed to lymphoma, exacerbated by a litany of other ailments that

had plagued him for years. "Los Dos Rockin Tacos with one in absentia," Terry wrote that day. "I loved him and will miss him. The whole world of music will." He recollected later that Guy had once divulged with bravado that if his illness progressed irrevocably, he would "just eat a pistol." But he had not done so—"he was too curious," Allen wrote empathetically. "He wanted to wait and see what happens. Now he knows."

That same May day, Terry, Jo Harvey, and Bukka rallied, ashen and shaken, to perform *MemWars* at SITE Santa Fe, the live iteration of the vexed video installation that had opened on March 19. Allen had written the texts as an experiment, his own version of *sintesi*, fleeting Italian Futurist plays in miniature—"quick little stabs of theater"—that had first captured his imagination in 1976, while working on *The Evening Gorgeous George Died*, and his own interpretation of which he had long referred to in his journals as *Futurism (in Reverse)*. Consisting of three large, motorized video panels that moved on tracks, with talking-head footage of Terry and Jo Harvey telling nine stories about the origins of Allen's songs in their personal histories, cut with scenes of Terry playing the songs, shot from behind in front of green-screen images and textures, the *MemWars* installation was intended to encourage viewers to move among the screens, interacting with their unspooling stories. To Terry's enormous frustration, the creaky mechanical elements functioned properly only for about six hours total throughout the run of the show, repeatedly stalling and sticking. The opening was, as he wrote in disgust, "the first time in fifty years the work was not totally ready."

So Terry was already grieving and deep in the graveyard of his own memories when Guy's sideman and friend Verlon Thompson called Terry the next morning to ask if Guy had actually been serious about his oft-repeated proclamation that Terry would incorporate his cremains into a sculpture. In his final weeks he'd quietly repeated the request, between labored breaths, to every visitor: "Make sure Terry gets my ashes." Sighing, Terry had to admit to himself and to Verlon that, yes, he was afraid that Guy had in fact been serious after all. "Now Guy is laughing in his ghost," he wrote. "Now a busload of his best friends and musicians are bringing his ashes here for me."

Two days later, on May 20, Paradise of Bachelors released LP, CD, and digital editions of *Juarez*, including a liner notes booklet that

reproduced the *Juarez Suite* and other *JUAREZ* pieces from throughout Allen's career, with reflections from Dave Alvin, a reprint of Hickey's *a simple story (Juarez)* catalog essay, and an essay I wrote contextualizing the album within his art practice. I offered my condolences to Terry, regretting that I had only been able to speak to Guy once on the phone and had never met him—in rough shape and audibly tired, his primary, pithy comment on his friend was "I love Terry Allen; he's a funny son of a bitch."

On May 25, a tour bus pulled into the gate of the Allens' home and out poured Guy's honorary pallbearers, friends and family who had accompanied his ashes from Nashville to Santa Fe, including fellow musicians Rodney Crowell, Steve Earle, and Shawn Camp; photographer Jim McGuire; Clark's son Travis, his guitarist and sideman Verlon Thompson, and his biographer Tamara Saviano. The Elys; Vince Gill; Emmylou Harris; Robert Earl and Kathleen Keen; Jack Ingram; Lyle Lovett and his wife, April Kimble; Paul Milosevich; Bukka and Bale; and others flew or drove separately to meet them at the wake that Terry and Jo Harvey hosted. They ate green chile enchiladas and sang songs Clark would have requested under a rough-hewn pergola woven with wisteria. Summoned, Guy manifested, not as a crow but in an appropriately avian avatar. "A silver spotted hawk flew over and circled the house," Terry wrote. Everyone stared into what Earle declared "the most beautiful land-based sunset I've ever seen in my entire life—and believe me, I've *seen* some fucking sunsets."

When everyone left, Guy's boots and Randall knife remained, as did his cremains, which sat undisturbed in Terry's studio while he decided exactly what to do with them. "It was strange having him sitting on my shelf for a year," he told me. "Though I did speak to him quite often." Guy had been cremated wearing his favorite blue denim work shirt, with a joint tucked into his breast pocket, grave goods for one final smoke. While breaking down the altar after the wake, Terry remembered Guy's unfinished song "Caw Caw Blues" and his childlike amazement at the barbed-wire nest at the American Windmill Museum in Lubbock. An image of crows, flying through a West Texas dust storm, materialized through the memory. But the problem of how practically to integrate the ashes, clumped with bone fragments, into this corvine image persisted. Perhaps he could pour them into a viscous ink for drawing.

A recent public sculpture with similar memorial qualities, a literal vehicle into or from the past, helped guide Guy's crows away from liquid ink and into the commemorative solid medium of bronze, from which, due to its formality, Allen had initially shied. In December 2016, he oversaw the installation of *Road Angel*, a life-size bronze sculpture of a 1953 Chevrolet hardtop coupe, the same make and model as his first car, cast piecemeal, in a technically rigorous process, from an actual salvaged Chevy, at Deep in the Heart Art Foundry in Bastrop, Texas. Parked permanently in the forest of the Contemporary Austin's Laguna Gloria sculpture park, as if abandoned or run off-road—it's missing a wheel— the "radio," a hidden sound system, plays more than one hundred audio recordings (with more added periodically) contributed by an invited host of friends and family.[1] *Road Angel*, Allen's most recent public artwork, is in one sense a reprise of *Trees*, his first, but given the subject, it is both more personal and more metaphorically freighted. Terry considered interring Guy's ashes inside the Chevy, but he eventually decided that his friend needed his own funerary vessel in which he could take wing and not remain roadbound, even among the airborne songs and stories of so many friends.

CHAPTER 52

THE SILENCE OF THE NIGHT AND THE WHITENESS OF THE WHALE

Shuck some corn.
When the stalks break off,
the husks skinned,
the silk gone
the ear boiled
gobble and gnaw
and suck it raw
until there is just a cob, no more.

Shuck off my Mama and Daddy,
my lover, my babies, and my friends,
what you've taught me,
and all my skins have absorbed like lotion
Strip off all the silks one by one,
and what would be left
is a secret.

—Jo Harvey Allen

THE REISSUES OF *JUAREZ*, AND FIVE MONTHS AFTER CLARK'S DEATH, IN October 2016, of *Lubbock (on everything),* which included a booklet containing contemporaneous artwork, an oral history by Terry, and essays by David Byrne, Lloyd, and me, stoked Allen's late-career renaissance with a one-two punch, developing into a full-scale revival. The reissues garnered acclaim from the likes of NPR, *Frieze, Pitchfork, The Guardian, Rolling Stone, MOJO, Uncut, The Independent, The Wire,*

and more, a tide of press—still unebbed—that, in density and unbridled enthusiasm, surpassed any other era of Allen's career. His agent and drummer Davis McLarty intercepted a steadily accelerating volley of booking opportunities, including festival opportunities that exposed Allen to a wider (and more youthful) audience than he had faced in years.

IN EARLY 2017, Terry embarked on a series of concerts playing songs from *Juarez* and *Lubbock* in two sets, initiating a now-ongoing annual tradition of a Panhandle Mystery Band concert every January at the historic Paramount Theatre in Austin. The second annual Paramount show, 2018's *Everything for All Reasons* concert, with guest appearances from Ryan Bingham and Joe Ely, became the centerpiece to Scott Ballew's invigorating hourlong 2019 documentary concert film of the same name. The year before, Ballew had directed *The Midnight Hour*, a short film profile of Allen and Bingham's friendship for YETI Films, and the occasionally camera-shy Terry approved both, even if the reverent talking-head interviews of *Everything for All Reasons* made him sometimes feel curiously absent, as if the documentary was an elegy for his own ghost. (Filmmaker Paul Hunton has been working for several years on *Hold It on the Road*, a more comprehensive, less strictly music-focused film about the Allens.) *Everything for All Reasons* also marked the official introduction of both Charlie Sexton and his friend and collaborator singer-songwriter Shannon McNally as integral members of the Panhandle Mystery Band. McNally's voice lends a counterpoint, a wounded, honeyed burr, to Terry's increasingly grit-graveled subterranean yowl, a fierce, frayed instrument still capable of both benevolence and bile.

More festivals followed: Hardly Strictly Bluegrass and the Newport Folk Festival (with Kris Kristofferson and Ely) in 2016; the Lone Star Film Festival, at which Terry won the Stephen Bruton Award ("the best-looking trophy of the bunch") in 2017; and Marfa Myths in 2018. He won the inaugural Townes Van Zandt Songwriting Award in 2017, moved to accept an honor in the name of his old friend, and he and Jo Harvey appeared on *Austin City Limits* as part of Steve Earle's Guy Clark tribute show.[1] In early 2018, nearly twenty-five years after they abandoned it in critical tatters and interpersonal trauma, Terry, Jo Harvey, and Joe Ely revisited *Chippy* in a distilled revue version, playing three intimate

concerts that combined Jo Harvey's monologues with some of their favorite songs from the musical.

A new generation of younger fans, devotees, and disciples emerged from the digital woodwork, including predictable candidates who had inherited his postoutlaw mantle of iconoclastic, nominally country songwriting, like Jason Isbell and Sturgill Simpson, who covered "Amarillo Highway" together on tour, and Jess Williamson and Katie Crutchfield of the band Plains, as well as less expected outliers, such as Haley Fohr, the sonorous torch singer and composer of Circuit des Yeux, Faheyian fingerstyle guitarist Hayden Pedigo, and the poetic, country-inclined LA rock-and-roll band Gun Outfit. The visual artist Will Boone approached Terry to record voiceover for a video about the character Leatherface from *The Texas Chainsaw Massacre*. Jeff Tweedy of Wilco, years after recording with Lloyd Maines early in his career, has been vocal, as have his bandmates, about their admiration for Allen, repeatedly inviting him to perform with them.[2]

A SURVEY OF Allen's most significant bodies of work, sharply focused through the lens of drawings and works on paper, selected largely from his own collection and archives, *The Exact Moment It Happens in the West: Stories, Pictures, and Songs from the '60s 'Til Now* opened at L.A. Louver on June 26, 2019. Created after the suite of nine vibrant *MemWars* drawings, which obliquely illustrate the songs and autobiographical stories affixed to their surfaces, the most recent group of drawings was from *Homer's Notebook 2*, a return to Terry's recurring appropriation of cartoon characters and a sort-of sequel to the literary homage of *VOID-VILLE*. Behind what Terry admits is a "pretty obvious" mashup of *Iliad* text and *Simpsons* imagery—"both of the great Homers"—is a deep-seated somatic anxiety related to aging, a response to the cartoonish violence, the lyrical but literal "dismantling of bodies," found throughout the *Iliad*, as well as an uneasy interest in Homer's blindness.[3]

For Terry, *The Exact Moment*, which featured headphone sets throughout the gallery space on which to listen to recordings, was the first show fully to embrace his music as integral to the visual work, placing it in intimate dialogue with the two- and three-dimensional pieces. Significantly, L.A. Louver also underwrote a sold-out two-night stand, on July 18 and 19, of the Panhandle Mystery Band at Zebulon, an

intimate club in Frogtown that caters to a distinctly younger, hipper audience than Allen's accustomed circuit of southwestern venues. In collaboration with gallery staff, I produced and wrote notes for *Cowboy and the Stranger,* an accompanying limited-edition cassette of previously unreleased demos and work tapes from 1968 and 2018, released in collaboration with L.A. Louver. Allen attributed the new art-world recognition of his music to the Paradise of Bachelors reissues. "That was really a direct result of what you did with the reissues, finally reconciling the art and music as the same thing, in a way people could understand and could not ignore," he told me.

Although it was understandably light on theatrical evidence, large-scale installations, and public artworks, *The Exact Moment* was the first exhibition, and the only one to date, to attempt to offer a coherent overview of Allen's then fifty-three-year career. It was also, Terry wrote at its conclusion on September 28, "the longest running and most successful gallery show I've ever had," a remarkable achievement at seventy-six years old. For a few weeks he and Jo Harvey took up residence at Peter Goulds's art-thronged oceanfront Marina del Rey apartment, staring out over the balcony at the "ocean's relentless gray calm each morning" as they mentally prepared themselves to run the gauntlet of critics, collectors, gallerists, concertgoers, and dear old friends—and to face the onslaught of their own reminiscences. The critical response was rapturous, cutting through the Pacific smog. *The Los Angeles Times* raved that "if you see only one exhibition this year," it should be *The Exact Moment,* which is "so jampacked with love, suffering, and resilience that there's a good chance you'll be moved to tears. You may also laugh, gasp, and marvel at the humanity of Allen's artistry, which is flat-out inspiring."[4]

In December 2019, Nina Johnson, an energetic, nimble, and innovatively genre-agnostic young dealer in Miami, opened a show of new Terry Allen drawings at her eponymous gallery. Its opening coinciding with Art Basel Miami Beach, the waggishly titled *Some Songs and Other Pictures* extended the colorful press-type-and-icon drawing format Terry had explored with the *MemWars* drawings into similar as well as extrapersonal subject matter, charting simultaneously retrospective and futuristic paths, and featuring several diptych pieces. "Too good to miss," warned the *New York Times.*[5]

* * *

THE PANHANDLE MYSTERY BAND returned to Zebulon in LA in early 2020 for a two-night West Coast album release celebration of *Just Like Moby Dick*, Terry's first set of new songs since 2013's *Bottom of the World*. Press for the new album was universally affirmative, with coverage by the *New York Times* and the *New York Times Magazine* (who called him "a reigning deity of a certain kind of country music since the mid-70s"),[6] *The Guardian*, *The Wire* (extolling a "singular American artist who expresses the fundamental weirdness of his country"),[7] *Pitchfork*, and even the *Daily Mirror* (which proclaimed him the "poet wizard" to Willie Nelson's "outlaw king of Texas music").[8] Particularly inspired and fine-grained were features by fiction writer Odie Lindsey for *Southwest Review* (the journal of Pauline's old institutional foe, Southern Methodist University) and by John Lingan for the *Washington Post Magazine*, who declared that "in 2020, no veteran country songwriter sounds more attuned to the national mood. His songs still feel like little guidebooks for staring down a harsh universe."[9]

Just Like Moby Dick had taken shape in Marfa, where from July 2 through 11, 2018, Terry and the new Panhandle Mystery Band—with friends, including Dave Alvin and Joe Ely—descended in shifts on the St. George Hotel and the Crowley Theater to work on new songs together. Although Allen wrote the bulk of the album alone in the studio in Santa Fe, five Marfa cowrites made it onto *Just Like Moby Dick*, the most of any Allen album, making it the most collaborative record of his career.

In addition to its new emphasis on collaborative writing, and as a happy result of the Marfa sessions, *Just Like Moby Dick* was also unusual for the intensive workshopping of songs and preproduction planning before actual recording, a novelty for Terry. The band performed the songs-in-process at the Crowley in Marfa in December 2018 and again at a January 2019 Paramount Theatre concert, *Howlin' from the Houdini Hole* (a reference to Harry Houdini's proscenium-scarring 1916 performance at the Paramount as well as the future album's lead track, "Houdini Didn't Like the Spiritualists"). The first Paramount set audaciously comprised only new songs from the still unrecorded album, all unfamiliar to the audience, a nerve-racking experiment that paid off. When they stepped into Austin's Arlyn Studios in May 2019 under the direction of Charlie Sexton, taking the coproduction helm from Lloyd

for the first time, they were well prepared. "It was the first time I'd gone into the studio with a list of songs that we all actually knew how to play," Terry clarified, with some disbelief.

The real-life characters who inhabit the picaresque stories Terry and Jo Harvey tell in *MemWars* may bear monstrous names—The Wolfman of Del Rio, The Gorilla Girl, Monkey Man, Headlight Woman, the Burn Couple—but like all of us, they have endured mundane and all-too-human pain. Appropriately, the heartbreaking and hilarious album on which Allen labored while making the *MemWars* drawings takes its title from the archetypal monster of American literature and the American imaginary.[10]

"Memory shot her crystals as the clear ice most forms of noiseless twilights," Melville writes, and for most of the novel, Moby Dick himself remains hidden, haunting Ahab as a crystalline monster of fathomless memory, a terrible fever dream from the depths. The whale remains a specter on Allen's record too, appearing explicitly only in the briny final spoken line of the last song "Sailin' On Through," and on the artist's side D vinyl etching and CD insert drawings, where he lurks menacingly, as bristling with harpoons as the songs are barbed with wit, beneath the roiling seas of Thomas Chambers, the eccentric nineteenth-century maritime painter whose floridly freaky nautical scenes adorn the album jacket and gatefold. Terry was adamant about not depicting the leviathan himself except in linear shade, on the surface of the record itself. He was more interested in the unknowability of Moby Dick as an enduring symbol of the sublime—of nature, death, endurance itself, "that beauty which, as Milton sings," and as Wordsworth writes, "hath Terror in it."

The connections to Melville's 1851 masterpiece are strictly metaphorical and allusive, as elusive as the White Whale. The spiritual successor to *Lubbock (on everything)* and *Human Remains*—a final chapter, perhaps, in a loose trilogy—*Just Like Moby Dick* casts its net wide for wild stories, depicting, among other monstrous things, Harry Houdini in existential crisis, "The Death of the Last Stripper" in town, the bloodthirsty "Pirate Jenny" (an homage to Brecht and Weill's unrelated song), the wars in Iraq and Afghanistan, a vampire-infested circus, mudslides and burning mobile homes, and all manner of tragicomic disasters, abandonments, betrayals, bad memories, failures, and fare-thee-wells.[11] It begins graveside, with Houdini alone with his ectoplasmic doubts in

"the silence of the night" (another "noiseless twilight"). It ends with death too, old friends fading into "ashes, dust, and songs."

After mixing, Allen changed the album title from the original working title *Silence of the Night*, writing:

> *Just Like Moby Dick* is now the title of the new record. *Silence of the Night* is too quiet and melancholy—Moby Dick rages through that, or "sails" through it, like the song . . . I don't know why it is such a relief to me, but it is. The great battered whale. ~~I am Ishmael. I am Ahab. I am the whale~~ and every harpoon in it. (And hopefully—HA—I'm not just all wet.)
>
> . . . Call me Queequeg.

"It was the whiteness of the whale that above all things appalled me," reveals Ishmael in *Moby-Dick*. He reels off a litany of possible reasons—scientific, symbolic, cultural—why that might be, but it all boils down to absence, to blankness and emptiness. Pirate Jenny's ship and flag may be "as black as her past," but white is the color of death and surrender, of ghosts and the void—a symptom of "Abandonitis," that American disease (and the record's radio single). "All good luck has death in it" reads one of Allen's bloodred *Bleeder* drawings in *The Exact Moment It Happened in the West*, emblazoned beside a broken wishbone. So do most good jokes, most good songs, most wisdom, as Terry knows well. Memory shoots her crystals as clear, white ice.

BY THE TIME *Some Songs and Other Pictures* closed on March 28, 2020, the rest of the world had also effectively closed. For all the anticipation and press promise, the release of *Just Like Moby Dick* ultimately proved anticlimactic, its momentum forestalled by the COVID-19 pandemic, its songs decomposing into ashes and dust.[12] It sank like Ahab's *Pequod*.

IF YOU HAVE expectations about such things, you might not expect a Terry Allen show to begin with a ceremonial bagpipe overture, but that's what happened on July 5, 2017, at the public benefit concert in support of the Marfa Community Health Clinic, part of Terry and Jo Harvey Allen's weeklong fifty-fifth wedding anniversary celebration.[13] Rick Pratt, a sinewy man with a robust white moustache, a black pirate-style eyepatch

covering his right eye, and high-waisted blue jeans tucked into knee-high cowboy boots, blasted away on his pipes like it was a Scottish funeral.[14]

The show, it turned out, was framed as a revue, not the anticipated Terry Allen concert at all. After a few songs, Terry made way for friends and family. Bukka sat at Terry's keyboard to play a few of his own deliberately paced and lovely ballads, while his son Kru danced beside him. Later that night, the band cleared the stage, leaving only the two drummers, Bale and Fran Christina of the Fabulous Thunderbirds; it was the only time stalwart, perennially good-natured fiddler Richard left the stage all night. David Byrne, sporting a guitar so tiny it appeared shrunken, played the Talking Heads classic "Life During Wartime," and the crowd lost itself in a frenzy of movement. Byrne's cover of "Love Hurts" catalyzed a clot of slow-dancing couples, including Terry and Jo Harvey, who shut their eyes, Jo Harvey's head on Terry's shoulder. Terry returned for "Buck Naked," prompting a psilocybin-fueled flasher named Dragon to run across the stage as if on cue, allegedly prompted by Sharon Ely's $100 dare.

Toward the end of the night, Jo Harvey recited a poem from *Homerun*. In her voice, it sounded like a song and laid bare the heart of the night, this celebration of togetherness, in a movingly perverse and ironic way: revealing that once you strip away those who surround you, family and friends, what's left—your identity, your true self—is "a secret." We can know ourselves, she suggests, only through the eyes of those we love.

The following night, six of the former cast members of *Chippy*—the Elys, the Allens, Robert Early Keen, and Butch Hancock—sat around a fire pit at the home of Dick and Janie DeGuerin, trading songs in the dark. "Another one, please," piped Jo Harvey in the silence following "Desperadoes Waiting on a Train" by Guy Clark, who was notably absent from the celebration. Terry, Joe, and Butch obligingly played Butch's "Roll Around," from *Chippy*: "Roll around and sing forever . . . Spread your wings and fly tomorrow."

On the final night in Marfa, at Fran Christina and Julie Speed's place on the edge of the Chinati Foundation property, someone wandered up to congratulate Terry and Jo Harvey, asking if he had any advice on maintaining a marriage for so long, to which he replied, "Hell, no! We're still just winging it. Have a bad memory, I guess; that helps."

LA DESPEDIDA

The Midnight Hour

No stories left to sell
No lies left to tell
All that's left is Fare-Thee-Well

 —"All That's Left Is Fare-Thee-Well"

TERRY DELIVERED *CAW CAW BLUES*, HIS FUNERARY MEMORIAL FOR GUY, to representatives of the Witliff Collections at Texas State University in San Marcos on April 22, 2020, during the early uncertainty and precarity of the COVID-19 pandemic, in what looked like a surreptitious exchange of illicit contraband. (If so, he had no alibi; he'd once titled an album *Human Remains*.) "It was like a drug deal," he laughed. "Guy would have loved it—it went down in a parking lot, and everyone was wearing masks and gloves." Allen had found a taxidermy crow at Uncommon Objects in Austin, the same shop where Bale bought the lickspittle Jesus painting that graces the cover of *Salivation*. "I kept going back and looking at it," he explained, "and then I finally just bought it." He had a 3D print made of the bird, which he used to create a mold with which, at Deep in the Heart Art Foundry in Bastrop, he cast two crows, twins but for their divergent scales, pouring a portion of Guy's ashes into the molten bronze of the oversized bird and sealing the remainder inside its hollow ribcage, a corvine urn containing and composed of cremains. "It was windy, so we all breathed in some of the ashes," he remarked.

The surface of the sculpture is ash-encrusted, feathers frayed and grayed with osseous fragments that suggest that the crow has just flown through a dust storm. A jeweler inscribed the base with lyrics from Clark's song "The Cape": "He's one of those / Who knows that life / Is just a leap of faith / Spread your arms / And hold your breath / Always trust your cape."

Heckle and Jeckle, as Guy referred to them in his song—"so cold jet black / You could see 'em at night in the cactus, Jack"—returned to Allen's studio for one more year, until he agreed to donate the larger one, the "Caped" crow containing Clark's cremains, to Texas State. *Caw Caw Blues* now stands in a vitrine, guarding the entrance to the Witliff Collections, which safeguard the papers of Cormac McCarthy, Sandra Cisneros, J. Frank Dobie, Willie Nelson, Sam Shepard, and Jerry Jeff Walker, among others.

At the *Caw Caw Blues* dedication ceremony on October 30, 2022, Terry joked that "my only regret, of course, is that I didn't shove any ashes up the crow's ass."

IN JUNE 2021, Samantha and Asa, nearly eight, joined me at the Allens' home in Santa Fe. After a songwriting session with their new family band the Bloodsucking Maniacs, impelled in part by their eighteen-year-old grandson Calder's recent, and increasingly notable, embrace of a music career, carrying on the family tradition, they were still in Papa Rat and Mammy mode (their grandchildren's nicknames for them).[1] They fawned over Asa. Terry and Asa watched baseball together for hours, and Terry set him up with paper and pencils to draw secret bases in his studio. Asa referred to Terry exclusively as "Terryallen," elided into a single name, so Terry called him "Asagreaves" in return. When Nina Johnson and Dan Milewski and their two sons, Lee and Cy, visiting from Miami, stopped by for a meal, the three boys, much to the Allens' delight, ran off into the dusty arroyos behind the property, spending hours "mining" for rocks and artifacts—archaeologically dubious but warmly indulged by the adults. They arrayed their precious finds on a weather-grayed wooden worktable in the Allens' patio, posting a sign reading "Rock Shop," with extravagant and inscrutably variable prices. Terry bought twenty dollars' worth of rocks from his own backyard, a fortune.

In his studio, he showed me recent drawings for a new commission titled *The Midnight Hour*, after his standard evasive answer to queries about his faith—"That's between me and the midnight hour"—that imagines the future of Christianity in the United States (or what is left of both) two thousand years from now.[2] A few alarming lines leapt from the paper: "notes on the ghost of Jesus," "a rupture from the rapture," "wreckage of heaven." ("And heaven," as he quacked on "Salivation," "is just an adjustment that moves on down the road.")

In March 2022, Terry underwent an ablation procedure to treat atrial fibrillation, the recovery from which forced him to cancel scheduled appearances that month at Willie Nelson's Luck Reunion, exactly fifty years after Nelson's original Dripping Springs Reunion in 1972, and the adventurous Big Ears Festival in Knoxville, Tennessee. (He made up the missed engagements the following year, appearing on a bill with Los Lobos at Big Ears.)

As always, curiosity carried him through health aggravations. After healing and marking his seventy-ninth birthday, in May 2022 Allen performed with the Panhandle Mystery Band at Wilco's Solid Sound Festival at Mass MoCA—with special guest David Byrne. In the spring of 2023, as a survey show opened at the Amarillo Museum of Art, a few miles from 1501 South Rosemont Street, and a limited-edition *Juarez* book of lyrics and twelve new etchings, published by Nazraeli Press, began shipping, Terry was also planning a related *JUAREZ* exhibition with Kimberly Davis and Lisa Jann at L.A. Louver, which would position the new prints in conversation with the 1976 *Juarez Suite*.[3]

He and Jo Harvey eagerly awaited the October 2023 release of Martin Scorsese's *Killers of the Flower Moon*, in which they both appear in small parts as the racist Aunt Annie and Uncle Jim (Terry suggested to Scorsese that in the credits he should bill the characters as The Two Assholes). During their two weeks on location in Pawhuska, Oklahoma, in the spring of 2021 (bookending his seventy-eighth birthday), Terry— unlike Jo Harvey, unfamiliar with film sets—had marveled at Scorsese's deft direction and openness to feedback and improvisation, as well as the sheer scale and logistical complexity of the production's set and choreography, which struck him as a superlative embodiment of his own integrative ideas about theater, installation art, and collaboration. "What surprised me the most was how close it was to theater," he told me in

awe. "It was probably the most controlled chaos I've ever been around." He returned to Santa Fe reinvigorated about *The Midnight Hour.* "I've rebooted *everything*," he shared with me conspiratorially.

AS HE TRAINED his gaze backward and forward, Terry was unexpectedly finding newfound popularity with admirers not just one but now two generations younger. Among the new relationships Allen has forged in recent years with younger songwriters and artists, the most surprisingly simpatico is his unlikely friendship with the droll Philadelphia folk-rocker Kurt Vile. A reverent fan since the release of the Paradise of Bachelors reissues—he first fell into the world of *Lubbock (on everything)* while shoveling snow in the winter of 2016 outside his home in Mount Airy—in March 2019 Kurt approached me about inviting Allen to a show he was playing at Meow Wolf in Santa Fe. Instead, Terry invited Kurt to his home the next morning. Kurt was so nervous to meet his hero that he took a Valium in advance, and Terry was similarly anxious about the blind-date nature of the meeting, worrying what to do with Vile if he didn't like him. The worry was wasted, as this oddball duo bonded quickly over their compatible senses of humor and the easy, if unexpected, compatibility of their different but equally idiosyncratic song structures and singing cadences. (Behind Kurt's deceptively slouchy and stoned style is a compositional and improvisational rigor that Allen admires.) By June 2022, they were performing Vile's "Bassackwards" and Townes Van Zandt's "Loretta" at a benefit for SITE Santa Fe and talking about recording together.

Vile joined the Panhandle Mystery Band onstage at the Paramount in January 2023 for the *SMOKIN* show, in celebration of the May 2022 reissues of *Smokin the Dummy* and *Bloodlines.* During intermission Terry arranged to project onstage a video of Kurt's nine-year-old daughter Delphine, born and raised in Philly, singing a line from the *Smokin the Dummy* trucker's anthem "The Night Cafe" in an exaggerated Lubbock accent: "That ol' *juke*box is *play*in' his *love* song / And the *coff*-eeee is hot! . . . in the cu-*uwp*." Terry chuckled every time he shared the video on his phone.

In May 2023, over breakfast in Manhattan, Terry and Jo Harvey revealed to Samantha and me that they had left our son's patio rock shop sculpture undisturbed for nine months. It reminded them of Asa, Lee,

and Cy darting through and digging in the arroyos behind their house, not far from where they found Queenie one bad New Year's, laughing and shouting out their discoveries drawn up from the dirt and then, like little alchemists, assembling their excavated specimens into an instinctual and empirical order, into a marketplace, into art. Perhaps it reminded the Allens of the four rocks that they once found with young Bukka and Bale on the Mojave roadside between Fresno and Lubbock, tattooed in quadrangle on their hands to symbolize the quartet of their family, to preserve the memory, and their unity, in imperfect skin. Like Chic, like Terry, like the entire Allen family, three grandsons included, the three boys were writing on rocks, as good a definition of art as any.

From the middle of an azure-tiled fountain, a gunmetal crow of bronze, sentinel to its sarcophagus brother—"angels of the mystery," the final avatars, perhaps, of the "rusty wing / dead dark thing" of "Red Bird"—kept watch over the boys' rock shop, just a few feet from where Terry and Guy liked to sit and talk and drink and watch the stars pierce the firmament above the mountains. Staring south from the patio, as Terry often does, alone or with Jo Harvey or with nocturnal guests, you can unloose your "high mountain's eye" to fly as the crow flies, along the spine of the Rio Grande Rift, between the Colorado Plateau and Cortez to the west and the Llano Estacado and Lubbock to the east, over Agua Fría and the western reaches of Santa Fe, past Galisteo, where Bruce Nauman lives with his horses and his ideas, and over Clines Corners, where Dave Hickey and Richard Bowden once fled an Allen altercation to eat a desultory truck-stop Thanksgiving dinner together. Fly south through Truth or Consequences, gathering blessings from the Buddha of Las Cruces along the way, into the Chihuahuan Desert and toward the dim lights of distant Ciudad Juárez. Fly into the silence of the night, beyond the midnight hour, into the mystery. It is there where we reckon with the wreckage of heaven.

Look, now, listen:

> I been born
> And I'm gonna die
> Blood red wing
> Gonna make me fly

ACKNOWLEDGMENTS

This book, my first, has consumed me for five years, more or less—with some significant pandemic-era delays and interruptions—beginning in August 2018, when Terry and I first discussed it. Countless people have helped, supported, and tolerated me since then, and, with apologies to those I've inadvertently overlooked, I'd like to recognize as many as possible for their generosity and time.

Thank you, first and foremost, to Terry, Jo Harvey, and the entire Allen family. You changed my life, and I'm grateful to call you friends. I remain stunned by your irrational trust in me. This is for you.

Thanks to my family, especially my wife, Samantha, and my son, Asa, without whose strength, patience, humor, and wisdom I would never have finished, or even begun, this project. Thank you for allowing me to reside in someone else's memories for so long and for knowing when to give me space—and when not to. Thank you to my mother, Antoinette Greaves, and my in-laws, Clio and Philip Coles, for their steadfastness. I inherited the absurd notion that writing is a reasonable pursuit from my father, Kenneth Greaves, who I wish could read this.

Thank you to my astute agent, Meg Thompson of Thompson Literary Agency, and to my perspicacious editor, Ben Schafer of Hachette Books—and to their colleagues, particularly Fred Francis, my project editor at Hachette—for believing in this book, for allowing me the time, length, and format it required, and for expertly guiding me through the publication process.

Many thanks to my friend Salvatore Borriello of The Reading List, who was instrumental in hewing and shaping a story from my

interminable original manuscript, through months of discussion and editing. Let's do it again with a shorter book.

I'm grateful to Chris Smith, my longtime friend and business partner at Paradise of Bachelors, and to all our employees who have contributed over the years to transcribing interviews and otherwise assisting with Terry's releases, including David Smith, Kat Kucera, and Greta Travaglia. Thanks to our artists for bearing with me and for providing me with a writing soundtrack.

My thanks also to the following, each of whom contributed in some way to my efforts: all Panhandle Mystery Band members, past and present, with special gratitude to Richard Bowden, Lloyd Maines, Kenny Maines, and Davis McLarty; John Ollman and Ann Hammond Ollman for the introduction and the revelation; Kimberly Davis, Peter Goulds, Lisa Jann, Christina Adora Carlos, Ella Andersson, and everyone else at, or previously at, L.A. Louver; Katelin Dixon, Curtis Peoples, Jon Holmes, Amy Devoge, Jennifer Spurrier, and Andy Wilkinson at the Southwest Collection/Special Collections Library at Texas Tech; J. Gabriel Boylan, Bill Ferris, Marcie Cohen Ferris, Glenn Hinson, Jesse Jarnow, Rafil Kroll-Zaidi, Amanda Petrusich, and Christine Smallwood for their early counsel; Casey Kittrell at UT Press for the consideration; Nina Johnson and Dan Milewski for their camaraderie on the road; Scott Ballew, Anthony Elms, Derek George, Joe Hagan, Paul Hunton, Adam Muhlig, Peter O'Brien, Tamara Saviano, Sylvie Simmons, David Suff, Judd Taylor, Franklin Teagle, and Andrew Witkin for sharing their own research materials and media; Lindsey Alexander, Odie Lindsey, John Lingan, William Pym, and Wells Tower for writerly and editorial encouragement; Dave Hickey, Harry Mathews, A. J. A. Symons, and my teacher Peter Schjeldahl—requiescat in pace—for their writerly examples; Chris Taylor and Ingrid Schaffner for their hospitality; Tim Johnson and Caitlin Murray for Marfa intel; Ethan Wiley and J. C. Gordon; Jack Lemon and everyone at Landfall Press; the staffs of the Getty Research Institute and the archives of LACMA; Dane Reeb at the Norton Simon Museum; Jean Porter at SMU; The Wrist and Pistols and SNAKE, for decades of listening; and all my friends, for holding fast and not forgetting me in my solitude and absence.

Finally, thank you, dear reader, for spending your hours here with us.

METHODOLOGY

In writing this book, given my personal and professional relationships with Terry, I have necessarily discarded the pretense of dispassionate objectivity. I am neither a journalist nor a historian. My approach and perspective as a writer, curator, and critic has instead been shaped by the field of folklore studies, a discipline that, at its best, foregrounds subjectivity and strives to avoid positioning those about whom we write as clinical "subjects," instead regarding them as consultants and teachers, partners in production, and perhaps even as friends.

Terry's open-hearted cooperation and contributions—including the years spent enduring my prying and reading my work—have been invaluable, and I know his candor, retrospection, and forbearance were both unprecedented and sometimes uncomfortable for him. This book is not, strictly speaking, a collaborative ethnography, in which author and consultant deliberately cocreate a text throughout the research and writing process. Voluminous quotations aside, the perspective, interpretations, and text are entirely my own, frequently diverging radically from how Terry himself might frame the stories and analyses of his life and work. But because of my close relationship with him, spanning twenty years, and the nature of my research, which synthesizes archival and historical sources, hundreds of hours of interviews and oral histories, and innumerable less formal conversations and correspondences, this book does share with collaborative ethnography the conviction that proximity and intimacy can reveal truths at least as, if not more, valuable than distance and feigned journalistic objectivity, which is of course

an impossible ideal, anyway, a misplaced faith in a twentieth-century fiction.

"The truth," as Terry has often insisted, "is multiple," and it is my hope that this biography braids a fair-minded—if not cold-blooded— parallax perspective from Terry's memories, my research, and our friendship.

SOURCES

I have cited all published and publicly available sources in the endnotes. However, the vast majority of quotations throughout this book—and all the uncited quotes—derive from two primary sources: personal interviews, conversations, and correspondence with Terry and my other interviewees, and the Allens' numerous unpublished private journals, notebooks, letters, and other assorted writings, papers, and media currently housed in the Allen Collection of the Special Collections Library at Texas Tech in Lubbock and at Allen's home and studio in Santa Fe.

Throughout the book, I liberally quote and excerpt Terry's visual artworks, lyrics, poems, videos, scripts, and other works not easily citable in a traditional manner. (His autobiographical texts, including *MemWars* and *Dugout* and drafts thereof, have furnished particularly productive wellsprings of quotations.) In all such cases, I have tried to make the sources clear. Unless otherwise specified or cited, all artwork images, lyrics, and texts (except those drawn from my own interviews, conversations, and writings) are courtesy of Terry Allen, who controls all relevant copyrights therein. Lyrics to his songs are reproduced courtesy of Allen and Green Shoes Publishing Co., BMI.

Thanks to the photographers and rights holders, noted in the image captions, who kindly permitted the reproduction of the other photos herein.

INTERVIEWS

My interviews and oral histories with Terry date back to 2006, but I recorded the bulk, approximately fifty, conducted weekly specifically for this book, from August 2020 through October 2021. I also interviewed nearly ninety other individuals, several of whom have passed since we spoke. I enjoyed multiple conversations with several patient consultants, most notably Jo Harvey, Bukka, and Bale Allen, to whom I am especially obliged.

Nearly everyone I contacted was delighted to talk about Terry, whom they each considered a friend, mentor, ally, or influence. The outpouring of admiration and goodwill about not only his art but his character—his work ethic, his generosity, his kindness, his loyalty and devotion to family and friends, his sense of humor, even his dancing skills—was overwhelming and heartening to behold.

I am so grateful to all my interviewees for sharing their time, insights, memories, personal correspondence, and research materials. Thanks, y'all.

JoAnne Akalaitis
Bale Allen
Bukka Allen
Calder Allen
Jo Harvey Allen
Sled Allen
Terry Allen

Jacki Apple
Anna Axster
Mary Beebe
Larry Bell
Bruce Botnick
Marie Botnick
Richard Bowden

Richard Buckner
Bryn Burrows
David Byrne
Don Caldwell
Guy Clark
BJ Cole
Claire Copley
Susan Conway
Ron Cooper
Rodney Crowell
Kimberly Davis
Greg Douglass
Steve Earle
Joe Ely
Sharon Ely
Lynda Forsha
Glenn Fukunaga
Liz George
Jimmie Dale Gilmore
Ron Gleason
Peter Goulds
Mathieu Gregoire
Mike Henderson
Dave Hickey
Jamie Howell
Fredericka Hunter
John Jackson
Jim Jard
Jun Kaneko
Ree Kaneko
Peter Kaukonen
Robert Earl Keen
John Kenyon
Alexa Kleinbard
Jack Lemon
Adelle Lutz
Donnie Maines

Kenny Maines
Lloyd Maines
Tina Maines
Jack Massing
Ed McGowin
Davis McLarty
Shannon McNally
Paul Milosevich
Betty Moody
Bruce Nauman
Patrick Oliphant
Steve Oliver
Rita Box Peak
Barry Poss
Jock Reynolds
Kimmie Rhodes
Jim Roche
Al Ruppersberg
Carl Ryan
Tamara Saviano
Paul Schimmel
Charlie Sexton
Will Sexton
Kiki Smith
Brian Standefer
James Surls
Joan Tewkesbury
Verlon Thompson
Loung Ung
Michael Ventura
Kurt Vile
Evan Yianoulis
Allison Walton
Doug Wheeler
William Wiley
Andy Wilkinson

NOTEBOOKS

Allen's notebooks merit special attention as a primary source. His earliest extant journal dates to 1960, beginning on New Year's Day, three months after his father's death. It records common teenage concerns: girls, dances, and "parking"; school and sports worries; trips to "the face doctor" (the dermatologist), church, and Sunday school; excitement about travel and parties; fights with rivals; reports on cars, movies, concerts, and records; early attempts at songwriting, fiction, poetry, and other juvenilia; speculation about his future; and considerable angst about his parents. Except for some mid-'60s gaps during his febrile college years and subsequent period of postcollegiate penury, the journals span the rest of his life to date, growing more tightly structured and compulsively rendered over time, moving gradually from agitated, callow entropy toward eccentric, elegant order as the artist ascertained, standardized, and diligently deployed the forms most useful to his practice and personality.

Studying these books, as I did in the summer of 2021, entombed in the reading room of Texas Tech's Special Collections Library and in Terry's studio, I witnessed the authorial persona evolve and the visual vocabulary ripen over time (though not without numerous detours and dead ends). Even the penmanship coalesces as Terry focuses the identity of his hand and heart—the juvenile cursive that resembles his mother's left-leaning slant tentatively alternates with, and then is fully supplanted by, the Montblanc-inked all-caps of his mature style. By the 1980s, the books are all systematically titled with a span of dates on their covers, opening with frontispieces and endpapers densely enumerating long

lists of books read and media consumed during the notebook's term and containing contact information for friends and associates; ephemera from recent exhibitions, concerts, and trips; and family photos.

Within, the pages brim with daily to weekly entries of diaristic and aesthetic accountings both profound and banal, running the spectrum from sublime to ridiculous, magnanimous to petty, sanguine to desperate: meditations on family, friends, work, and health; iterative drafts of letters and lectures; fragments of memoirs, frankly self-assessing artist bios, scorekeeping autobiographical timelines, and curricula vitae arranged by year; travelogues and itineraries; press clippings and his own reviews of books, films, albums, exhibitions, and performances by others; dreams and fantasies; art historical, sociopolitical, and numerological musings; complaints, dumb jokes, and pornographic diversions; rough sketches, studies, schematics, and full-fledged drawings; research materials, bibliographic citations, and quotations; song lyrics, poems, and album ideas; budgets and financial calculations; pasted-in photos and ephemera; and lots of lists: to-do lists, studio and installation checklists, track lists, and set lists.

Several series of specialized notebooks are dedicated entirely to specific projects or disciplines. The songbooks compile transcripts of all his lyrics to date into formal, usually typewritten, annotated compendiums. His large-format public art workbooks, full of plans and process Polaroids, are intended for formal presentation. His TV notebooks contain drawings made while watching (though almost never related to) television. In the I Ching books he logged, in colorful ink bleeding through rice paper, his six-coin throws and potential interpretations to questions posed about his life and work, especially while embroiled in *YOUTH IN ASIA*. In his so-called buddha books, every day for four years (2000–2004), on each dated page, he drew or painted a single colorful buddha, according to the most catholic (and sometimes sacrilegious) interpretations of the icon, occasionally deconstructed or dissolved toward abstraction, or more often, transmuted into, or superimposed onto, such heterodox forms as Ella Fitzgerald, Martin Luther King Jr., Jesus Christ, and Keith Richards, as well as less beatific incarnations like Richard Nixon, a German SS soldier, and various other demons. The notebooks, like so many of his projects, epitomize Allen's encyclopedic impulse toward absorbing and reflecting, literally, everything—an

unattainable aspiration, recalling Michel de Montaigne's sixteenth-century essays, to record the entirety of his experience, in case any scrap might inform, transform, or be incorporated into his art.

Reflecting, after he had read this book, on "the turbulence" that roils his journals, Terry explained to me, "During many of those times, I think I wrote things to dis-remember. Like if I put it down it would get out of me and cease to exist . . . except on the paper. . . . These became vaults of weirdness, road maps to fears and anger in many cases . . . possibly even psychosis if you read them from *now*. . . . But for me *then* it was a garbage dump, a landfill. . . . An attack-release to hide in, remove myself from, and momentarily pretend there was some kind of exit."

Or, in other words, as he wondered privately as early as 1969, at age twenty-six, writing with some measure of anxiety and frustration about his prospects for a viable career as an exhibiting, salable artist, "maybe these notebooks *are* my art."

NOTES AND CITATIONS

INTRODUCTION

1. With Clark's blessing, Rodney Crowell eventually completed and recorded the song himself, including it on his 2019 album *Texas*. It shares its title, "Caw Caw Blues," with Allen's sculptures and related drawings.

2. "Without a story that is easily conveyable in a sentence, you can't be famous in America," the art critic (and my teacher) Peter Schjeldahl maintained (Peter Schjeldahl, "Peter Hujar," in *Hot, Cold, Heavy, Light, 100 Art Writings 1988–2018* [New York: Abrams Press, 2019], 314). This isn't that story, and Allen isn't exactly famous, at least not in our hyperactive contemporary sense of the word, as arbitrated by the panoptic abyss of screens.

3. Terry Allen, with David Byrne, Dana Friis-Hansen, Dave Hickey, and Terrie Sultan, *Dugout* (Austin: University of Texas Press, 2005), 153.

CHAPTER 1

1. The story of that October evening in 1959, and its subsequent revisions and clarifications excavated through my research, offer a case study of "the invention of memory" that Allen's art explores, the processes that determine how, what, and why we remember. The way he recounts it in *MemWars*, the film he was waiting to see the evening his father died, and that he returned to see the following week, was *Mandingo*, a racist, big-budget exploitation film, directed by Richard Fleischer, that slavered over delusional slavery fantasies. In his *MemWars* poem "Mandingo," he even associates a particularly loathsome image from the film—"James Mason's feet on a black boy's belly"—with his own guilt, shame, and anger at his father's death and his absence from his deathbed. In fact, *Mandingo* was not released until 1975, sixteen years after Sled's death. A 1977 notebook reveals that the film was *Tamango* (1958) and that his mystery companion that night was Betty McAbee.

2. The Llano Estacado's ambiguous Spanish name—apt for such an ambiguous landscape—has long been the subject of debate. Many historians and maps have

translated it as "Staked Plains," pointing to evidence that early Spanish and Mexican explorers, encroaching on the Comanchería, drove rows of stakes into the ground, either as navigational markers delineating routes through the otherwise featureless expanse of the Great American Desert or to provide hitching posts for their horses in lieu of trees. (Today, instead of stakes, it bristles with windmills, of both the massive industrial and lonesome, creaky, and rusty varieties.) The more likely interpretation of *estacado* is "stockaded" or "palisaded," a description of how this vast plateau appears looking up from the steep escarpments that surround it on three sides, defining its geological boundaries. Today, locals refer to the region, the southernmost extremity of the High Plains, as simply the Llano or, more plainly, the South Plains.

CHAPTER 2

1. Following Allen's own (sometimes inconsistent) orthography and fondness for capitalizing the titles of his most significant and enduring bodies of work—and for many years, due to a broken caps lock on his typewriter, capitalizing *everything* he typed and wrote by hand, an enduring mechanical habit that, for reasons of legibility and flow, I have chosen not always to transcribe—*Dugout* refers to specific iterations, generally the 1993 radio play or 2005 book, while *DUGOUT* refers to the body of work at large, in its multiple iterations and formats. Similarly, *Juarez* generally refers to the 1975 album or later theatrical iterations, while *JUAREZ* refers to the body of work, ongoing since 1968, as a whole.

2. Allen generally capitalizes the pronouns he uses to designate the two anonymous primary characters in *Dugout*—undisguised surrogates for his own parents—so I have done the same, when relevant, throughout this book.

3. In *Dugout*, the Sled Allen character cusses the Yankees for winning the World Series and then dies. In reality, the Los Angeles Dodgers defeated the Chicago White Sox on October 8 to win the 1959 World Series, eight days before he passed.

4. Terry Allen, with Dave Hickey, Marcia Tucker, and Michael Ventura, *Terry Allen* (Austin: University of Texas Press, 2010), 263.

5. Whether by inclination or happenstance, the ancestral Allens and the Pierces habitually made their homes in the margins, on the edges of places, and at the borders of counties, states, cultures, and nations. Much like their descendant Terry and his artistic preoccupations with mapping borders both literal (domestic state lines and national perimeters, in particular the Mexico-US frontera) and figurative (his lifelong refusal to segregate creative or career disciplines in word or action), they seemed drawn to the liminality, instability, and strife of border territories.

6. Hampton Sides, *Blood and Thunder: The Epic Story of Kit Carson and the Conquest of the American West* (New York: Anchor Books, 2007), 14.

7. Cairo, Illinois—Huck and Jim's intended destination in Mark Twain's *The Adventures of Huckleberry Finn*, published two years before Sled's birth—was later immortalized in W. C. Handy's classic 1914 "St. Louis Blues," a favorite in Pauline Allen's vast repertoire, the only song she ever taught Terry to play, and a leitmotif in *Dugout*. Cairo is, consequentially, also the subject of *The Blue Rose of Cairo*, an important "Prologue" drawing of *DUGOUT*.

8. "Prominent Citizen Dead," *Journal* (Geary, OK), December 9, 1916, 1.

9. Community Conflict: The Impact of the Civil War in the Ozarks, "Howell County, Missouri," Missouri Digital Heritage Initiative. https://ozarkscivilwar.org/regions /howell.

10. In 1903, when Sled was seventeen—his family was gone by then, living in Oklahoma—Black families fled West Plains after their white neighbors delivered anonymous letters threatening the murder of adults and enslavement of their children unless they vacated their community.

11. "El Paso-Cheyenne Series Is Opened," *El Paso Herald*, October 20, 1910, 8.

12. It was not all macho blood and thunder; Sled nurtured a secret sentimental side, even amid the hard rigors of the road. He collected dainty souvenir spoons from the cities he visited. In March 1911, while staying at the Broadway Hotel in Louisville, Sled heard crying and found a three-week-old infant, abandoned in the open room next door, wrapped in a flannel blanket beside a bottle and a note from her mother. He comforted and fed her, telling a reporter, "She fell for the hit-and-run sign and went to it for fair" ("Baby, Deserted by Mother, Found by Ballplayer," *Courier-Journal* [Louisville, KY], March 16, 1911, 3).

13. "Busy Bee Café Changed Hands Last Monday," *Lubbock Avalanche*, March 31, 1922, 4. Perhaps too much time was devoted to baseball, because some of the only practical career advice Sled ever imparted to Terry was never, under any circumstances, to own or run a nightclub or café.

14. "Sled Allen to Manage Texan Club Next Year," *Amarillo Globe*, October 25, 1927, 1.

15. "Sled Allen Expects to Open Boarding House on March 1," *Amarillo Globe-Times*, February 29, 1928, 10.

16. "Sled Allen Takes Over Management, Local Fight Hall," *Lubbock Avalanche-Journal*, October 1, 1933, 5.

17. Ibid.

18. "Business Women," *Lubbock Avalanche-Journal*, May 9, 1937, 23.

19. Classified advertisement, *Lubbock Avalanche-Journal*, September 29, 1935, 5.

20. Paid advertisement, *Lubbock Avalanche-Journal*, December 25, 1938, 33.

21. Admission was advertised as forty cents (general), ten cents (ladies, apparently in short supply), or sixty-five cents (ringside).

22. Bob Wills, whose "Big Balls in Cowtown" was an early Allen favorite, grew up in Hall County, also home to the Pierces' farm in Brice.

CHAPTER 3

1. "Industrial Loop Starts 24th Year," *Wichita Eagle*, May 2, 1943, 13.

2. Terry views the location of his birth, so dislocated from his public identity as a citizen and artist of the American West—West Texas, northern New Mexico, California— as a source of confusion, bemusement, and some degree of nagging but faint embarrassment. In a *MemWars* piece called "Wichita," he wonders if he was truly even born there at all. He would return to this cipher of a city exactly twice in his life, brief visits freighted with breezily oracular—and aeronautical—import. Once, on a flight from California to the East Coast, likely in the mid-1970s, there was a short layover in

Wichita: "When it landed, I jumped up and rushed down the aisle, down the ramp, down the hall of the terminal, out the front and grabbed a handful of dirt from a planter box just outside the entrance. I shoved the dirt in my coat pocket and ran back to the plane. When I eventually got back home I dumped the dirt into a small paper cup and set it on a shelf in my studio. I scrawled 'WICHITA' on masking tape with a ball-point pen and stuck it on the cup. Proof."

Many years later, likely in the mid-1980s, he was at Wichita State University for a desultory and truncated guest artist visit. On the drive back to the airport, the cab passed John Wesley Hospital, "where I was born. So I was told. I looked out at the big brown nondescript building and instantly had the worst sneezing fit I ever had in my life. What was that about? I never went back."

3. Allen, *Dugout*, 192.

4. Like all children, he eventually came to resemble his parents, in certain ways. In a letter mailed two days before Christmas in 1971, in a spasm of nostalgia to which she was prone in her older years, Pauline wrote to her twenty-eight-year-old son: "You're like your daddy and you're like me: bullheaded, sentimental, and temperamental."

5. Cal Farley, "At World Series Man at Second Chases Ball Like Kitten," *Amarillo Daily News*, October 1, 1942, 1.

6. "Senior Golfers Practice Today for Annual Tourney," *Amarillo Daily News*, June 28, 1943, 5.

7. "News Briefs," *Lubbock Avalanche-Journal*, July 11, 1943, 4.

8. The staff at Cal Farley's Boys Ranch, a tough-love reform camp for boys and young men founded by Sled's boss, would later be accused of horrifying physical, psychological, and sexual abuse of their child wards.

9. Terry harbored a secret, grudging respect for the Presbyterian preacher, based on an inebriated, late-night run-in with him as a teenager: "A friend and I were drunk, pissing in the street, and the preacher drove by and saw us. I gave him my keys, he drove me home, never said a word about it to anyone. I always thought that was a kind thing to do."

10. "Pony Boy, Pony Boy / Won't you be my tony boy? / Don't say no / Here we go / Off across the plains . . . "

11. "The Roundup," *Lubbock Evening Journal*, April 2, 1948, 6.

12. Joe Kelly, "Between . . . the Lines," *Lubbock Evening Journal*, February 19, 1948, 8.

13. *Hee Haw* did not premiere until 1969. The point, and the aesthetic, stands, since hillbilly and country and western sartorial stereotypes had long been codified in popular culture by that point.

14. "That whole side of the family always implied I was a bastard," Allen told me after learning more about the timing of his parents' relationship, "but I assumed it had to do with them being Catholic and my mom being who she was. So I knew I was a bastard, but I never knew that I was an *official* bastard."

15. On the corner of Twenty-Sixth and Knoxville, two blocks north and one east, was a small neighborhood market with a hand-painted sign above the door that read "GROCY." The owner, known as "The Headlight Woman," had survived a lightning strike directly to her face. It was rumored that "she didn't need to turn on the lights because her head glowed so bright."

16. "Lubbock is always defined," Terry wrote in a 1972 notebook. "Rigid patterns laid out as if all plans were drafted by some secret fear that if one thing is crooked everything will have to start over. It is the most potent dilemma I have carried from this place."

17. Terry's earliest surviving drawings presciently showcase some favorite lifetime themes: violence, vehicles, and a surrealist's absurd and hilarious reimagining of the mythos of the American West. A pencil drawing depicts two American Indians engaged in riverine combat, with voluptuous mountains humping in the background. A figure in a canoe fires a pistol (grunting: "uHn") into the chest of a warrior standing on shore and raising a tomahawk (screaming: "yAAAAA"). Interestingly, given the subject, Allen's lean, long-limbed, linear rendering of the figures, all in profile, closely resembles the nineteenth- and early twentieth-century Plains Indian tradition of ledger drawings. The other piece, drawn in bright crayon colors, depicts a smiling black-and-orange locomotive belching smoke. A clown in a pink conical cap and pink pointy elf shoes stands upon a flatcar, grinning maniacally and holding aloft a small black flag. Neither drawing is dated, but the Native American scene is signed "Terry"; they appear to be the work of a child between the ages of six and ten.

18. Although football was his main high school sport and athletic preoccupation as a player, as a spectator baseball was always Terry's favored game—Sled cast a long shadow, long after he was gone. He continued with football longer, playing end for the Plainsmen through junior year in high school. "I really want to do good in football," he wrote in January 1960, just a few months after Sled had died, "more than anything in the whole world (for DAD)." His zeal faded during preseason training camp in August 1960, just before senior year started, when he "flat chickened out" and quit. Terry recognized his limitations—he was fast and tough but lacked some of the ball-handling coordination and grace of his teammates. "I guess I just don't love it enough," he admitted guiltily in his diary. Anyway, by that time, he'd decided he'd "rather drive around and smoke cigarettes and listen to music" than run up and down a dusty field.

CHAPTER 4

1. Herbert E. Bolton, *Coronado: Knight of Pueblos and Plains* (Albuquerque: University of New Mexico Press, 2015), 254.

2. William T. Hagan, *Charles Goodnight: Father of the Texas Panhandle* (Norman: University of Oklahoma Press, 2007), 30–31.

3. With such unparalleled long-range vantages, parallax is inevitable. Lubbock's flatness is only boring or barren from one perspective; from another, that relentless, brutally elegant geometry is charged with elemental potential. In such an otherworldly, monotonous landscape, one suspects geological and geographical catalysts, in addition to cultural explanations, for why Lubbock and its environs, despite their hard-nosed historical conservatism, have produced so many radically inventive musicians: Buddy Holly and the Crickets (including Sonny Curtis, Jerry Allison, Jerry Naylor, and, on bass, Waylon Jennings), Delbert McClinton, Rolling Stones saxophonist Bobby Keys, Mac Davis, Tommy X. Hancock and the Supernatural Family Band, the Flatlanders (Butch Hancock, Jimmie Dale Gilmore, and Joe Ely, all of whom pursued accomplished

solo careers), the Legendary Stardust Cowboy, Jo Carol Pierce, Kimmie Rhodes, Tejano group Los Premiers, and of course the various members of the rotating Panhandle Mystery Band (Jesse "Guitar" Taylor, Don Caldwell, Ponty Bone, and the preternaturally talented Maines family—Lloyd, Donnie, Kenny—and so on).

Surrounding boroughs produced country music legends Jimmy Dean (Plainview), Floyd Tillman (Post), and Don Williams (Floydada). Terry and others have sometimes jokingly attributed the proliferation of notable musicians who grew up in the Lubbock area in the 1950s to extraterrestrial influence—the Lubbock Lights "zap[ping] the Great South Plans that evening" back in 1951.

Subsequent generations of native Lubbockites include Amanda Shires, Kevin Morby, and, perhaps the city's most widely known and acclaimed contemporary star—and, sadly, also its most widely reviled and unfairly blacklisted, due to local outrage over her remarks critical of George W. Bush—Natalie Maines of the (Dixie) Chicks (Lloyd and Tina's daughter).

Many of these folks, like Terry, left as soon as they could risk it or as soon as their families could find work elsewhere—the Hub City is spoked with highways to take you away, to anywhere else, to anyone else.

4. Bert the Turtle makes an appearance, as "turtle in a helmet," in the "Civil Defense" chapter of the "American Childhood" triptych of war songs on Allen's 2020 album *Just Like Moby Dick*.

5. In *Warboy*, Terry sets the scene at a Friday Night Double Feature of *The Steel Helmet* and *When Worlds Collide*, the perfect alloy of war film and science fiction film. This apropos combo is in fact too perfect, because *When Worlds Collide* was not released until November 1951.

6. In the *Avalanche-Journal*'s contemporaneous reporting of the Lubbock Lights, the phenomena were referred to as "flying whatsits," a term Allen appropriated for himself in *DUGOUT*.

7. As he writes in *MemWars*, "My father said his father said the sky will kill you, and if it doesn't, the wind will." Or as he joked with me after experiencing a dust storm together in Marfa, Texas, in 2017, "Now you know what it was like growing up in Lubbock, and why we're like this—eroded!"

8. Terry Allen, "A Self-Interview on Tape: Radio Memories and Other Things," 1994, New American Radio digital archive, New Radio and Performing Arts, Inc. (NRPA), http://www.somewhere.org/work_excerpts/allen/media/interview.htm.

9. Joe Carr and Alan Munde, *Prairie Nights to Neon Lights: The Story of Country Music in West Texas* (Lubbock: Texas Tech University Press, 1997), 72.

10. He caught Jimmy Reed (for a second time) and John Lee Hooker (for the first time) in LA in the mid-'60s, though he found them both disappointingly drunk. Reed's set consisted of only one song, "Got Me Running," dilated into a narcotic drone that stuttered on for thirty interminable minutes. Contrastingly John Lee Hooker was so pissed—in both senses, at least in Allen's estimation—that he played only one regular-length song before shuffling off stage and leaving the venue.

11. He also had tutors: "There was always some old guy coming in that would help you clean up a nipple or something you were trying to draw" (Peter O'Brien, "[Everything

on] Terry Allen," interview with Terry Allen, Jo Harvey Allen, and Lloyd Maines, *Omaha Rainbow* 29 [Spring 1982]: 5).

12. "Comings, Goings: Brief News of People," *Lubbock Evening Journal*, June 11, 1954, 13.

13. The owner of Mr. Spudnuts Donuts, whom kids like to watch toss his dough high in the air like a pizza chef, was also rumored to "wipe his ass with the donut dough."

CHAPTER 5

1. Terry did take a few clumsy and ill-fated guitar lessons—as well as a few grade-school piano lessons from a Ms. Carl Schafer—but otherwise, he was self-taught.

2. Elsewhere, Allen has written that Pauline may also have taught him the standard "Sentimental Journey," which, with "St. Louis Blues," comprises a perfect pair of traveling tunes.

3. In "Self-Interview," Allen recounts a story of "Blue Suede Shoes" and rock-and-roll fever:

> There was a popular disc jockey who evidently did not want to work on New Year's Eve, and barricaded himself in KSEL . . . and began to play everything he wanted to play and . . . profusely curse on the air, and it kinda spread like wildfire all through the town. Everybody said, "you HAVE to listen to KSEL. So and so has flipped!" So everybody tuned in to KSEL and sure enough here was this guy just screamin' and cussin', and I don't know if this was before the FCC that's getting into everything now. . . . Anyway it took the cops about an hour to attack the station, break through the barricade and drag the disc jockey out. And I remember one of the songs he kept playing over and over was "Blue Suede Shoes" by Carl Perkins.

4. Allen, "Self-Interview."

5. These pyres prefigured the 2003 Lubbock backlash to Natalie Maines's comments criticizing President George W. Bush, which included everything from CD steamrolling to death threats. When Maines and Jo Harvey Allen were simultaneously inducted into the West Texas Walk of Fame in 2015, the process helped Maines reconcile somewhat with her hometown.

6. Varying accounts, by the Allens and others, place the infamous cosmopolitan dance anywhere between 1956 and 1959. Adding to the confusion is the fact that Ray Charles played Lubbock on multiple occasions, including a memorable but poorly attended 1961 show, after Charles had been blacklisted following a heroin bust, that Terry also attended, sitting on the stage beneath the Raelettes.

7. According to Terry and his parents, as well as the published obituaries, the cause of Sled's death was bone cancer. However, his death certificate cites multiple sclerosis, diagnosed two years prior, with no other contributing causes listed (cancer is not mentioned). Unless the multiple sclerosis diagnosis is an error—which is certainly a possibility—it is worth noting that, in its advanced stages, neurosyphilis, "the Great Imitator," can mimic the symptoms of MS and numerous other conditions. Bone lesions, for example, are symptomatic of both bone cancer and syphilis. So bone

cancer, MS, and syphilis are not mutually exclusive as potential causes of Sled's death. He could conceivably have suffered from any one or more of these three afflictions, one or more masquerading as another.

Over the course of a thirty-two-year marriage, Sled would have been extremely lucky not to have contracted syphilis from Viola—if he did not transmit it to her in the first place, as Terry suggested as a possibility, given Sled's itinerant lifestyle. Because of his status in the community, there would have been ample reasons to conceal a disabling neurological disease, whether MS or certainly neurosyphilis, and for a tactful family physician, likely familiar with Viola's heretofore hidden cause of death sixteen years earlier, to avoid mentioning an underlying cause or precise etiology on Sled's death certificate.

When I told him what I had discovered about the circumstances of his parents' relationship, after he recovered from the shock, Terry was ready with a joke: "Maybe I'm a syphilitic bastard."

CHAPTER 6

1. Their song was Tommy Edwards's 1958 hit "It's All in the Game," and whenever they played it on a jukebox, Terry would unplug the machine from the wall in mock annoyance and jealousy and put on W. C. Handy's "Yellow Dog Blues"—the 1958 version by Joe Darensbourg and His Dixie Flyers—instead.

CHAPTER 7

1. It was still part of Virginia when Reuben was born there in 1832.

2. "6.I: Notice for Publication," *Mangum Sun-Monitor* (Mangum, OK), June 29, 1905, 7.

3. "You All's Doin's," *Hollis Post* (Hollis, OK), July 13, 1905, 3.

4. When he first met Jo Harvey Allen in 1961, S. A. beckoned her over to him, posing an ominous and enigmatic riddle about the nature of darkness: "Hey, girl, come here. . . . What's a *shadow*?" Alarmed by this obscure line of questioning, Jo Harvey didn't have an adequate answer, apparently, because he then accused her of having oversized feet. Employing his powers of phrenological discernment, he informed Terry that he could tell his girlfriend was a liar from the line between her eyes. "Yeah, you're telling me," responded Terry in stride.

5. Dave Hickey claimed that while reporting a story on Herbert's son Garner Ted Armstrong, he witnessed consumption of the most prodigious quantity of cocaine he'd ever seen in his life, which is impressive considering the company Dave kept in those years.

6. Sometimes it's Cleveland, depending on the iteration of the *DUGOUT* text.

7. The later the hour, the more gospel songs threaded into Pauline's repertoire, replacing the profane likes of "Darktown Strutters Ball," "Tiger Rag," "Beer Barrel Polka," and "Hindustan." "She despised Liberace and his frilly TV show," Allen writes, "because she thought she could play circles around him. But she never missed a program."

8. There are, however, records of Pauline attending Clarendon College after her graduation from Clarendon High School in 1921. Judging from materials dating to 1922 and 1923—including football game schedules, newspaper clippings, and a photograph

in plaid skirt, scarf, and knit cap captioned "The College Vamp"—Pauline's ignomini-
ous spell at SMU occurred sometime during one or both of those years, during which
she dated a W. Boyd Rowland, class of 1922.

9. A notice in a local paper, pasted in her scrapbook, describes a few details of "the
simple but pretty wedding . . . using the single ring ceremony." Pauline, "well known
and . . . very popular in Clarendon," wore a "lovely afternoon dress of poudre blue
crepe, with slippers of the same shade."

10. A mantra in *DUGOUT* describes the death-wish decline of the disease: "All alco-
holics are blue death rats."

11. On a three-week Allen family trip to California and the Pacific Northwest in July
and August 1953, Pauline pointed out to Sled and Terry a Bay Area bungalow where
she'd lived, and they drove around for hours until they finally found a San Francisco
dive bar of special but (to Terry) obscure significance to her. The place was called
Tony Panty's, which ten-year-old Terry found hilariously scandalous.

12. Pauline told Terry a vividly sensory story about December 8, 1941, the night after
the bombing of Pearl Harbor: "There was a blackout in San Francisco, because every-
one was expecting a possible Japanese invasion or bombing, and she said everybody
was hanging out on their steps or little balconies or whatever on the block that she
lived on. . . . There were hundreds of little red dots from hundreds of people smoking,
and it was very quiet. And this guy came out on a fire escape and started playing sax-
ophone, and she said it was just this mournful kind of sound. And after he finished
playing, he said, 'That was the Pearl Harbour Blues.'"

CHAPTER 8

1. Richard Skanse, "Truckload of Art: Terry Allen (on everything)," *LoneStar Music
Magazine* 6, no. 1 (January/February 2013), https://lonestarmusicmagazine.com/lsm
-cover-story-terry-allen.

2. Late in life, Pauline began composing songs and poems of her own, though only
after *Juarez* was released: standard-issue gospel tunes like "The Man Upstairs"; songs
doubtful of hypocritical religious notions of sin and sexual propriety ("Tall Blond");
and songs about jobs and coworkers ("TSA Girls" and "Jim"). Most interesting are the
songs about the alcoholism that furnished the sickly bond between her and her fourth
husband, Oliver Daugherty ("A.A." and "I Thought You'd Change Your Life"). Terry
recollects a song called "Carizozo Jail" about her and Oliver getting arrested—likely
for public drunkenness or drunk driving—in the eponymous New Mexico town, and
the resulting perceived miscarriage of justice, in "the Land of Encroachment."

3. It was also not a literary household. When he wasn't installed behind the *Avalanche-
Journal*, Sled rotated through a small, treasured cache of books: *The Blue-Eyed Kid*,
a 1932 Western by E. B. Mann; the Holy Bible; and "a little purple medical book on sex,"
in which the intrepid young Terry, as he writes in *Dugout*, dared to peak, surreptitiously
learning (in the most sanitized and unsexy terms) about human anatomy and (in the
most hysterical and moralizing terms) about the terrible psychic and physiological tolls
of masturbation, that "crazed demonic act against God [that] would make you lethar-
gic and queer, a dangerous spendthrift, a hopeless dope fiend. . . ." A grade school

friend informed Terry that "the Chinese Commies, while attacking our boys in Korea, would suddenly just stop in the middle of a mass bugle charge and whack off."

4. After retirement, I. B. Pierce, a talented carpenter and Terry's one known direct genetic link to a visual artist, traveled the country in a camper, collecting and painting rocks—a progenitor of Chic the rock writer in *JUAREZ*—and carving figurative wooden sculptures depicting Western motifs like cowboys, roadrunners, and rattlesnakes.

5. In 1964, thirty-two-year-old Coleta Joy Solomon, known as Joy, Guy and Mary Pierce's daughter and Terry's closest cousin, who, like Pauline, "loved to dance and smoke and raise hell," was found hanging by her neck from a knotted garden hose tied to the rafters of her garage in LA. Her mouth, throat, and organs were grotesquely scarred, apparently the result of swallowing lye. Although it was officially determined to be a suicide, relatives whispered dark suspicions about Joy's husband, Tiny (one of three), "a jolly gambler with his fine clothes and fat pink fingers," and his purported links to organized crime; he promptly vanished after her brutal death.

6. Jo Harvey found Terry's late '50s pretensions amusing: "Terry wanted to go to Cuba to fight in the revolution. He had the beret and bongos and everything. My mother's friend saw him outside and said, 'There's a real beatnik in the yard talking to Jo Harvey!'" But it was the literature of the Beat scene that most inspired Allen. He discovered the writing of William Burroughs, Allen Ginsberg, and Jack Kerouac—the "Huey, Dewey, and Louie of a great generation," as he wrote in a 1997 notebook—likely through attending readings at a coffee shop, though he only grasped it in its most superficial terms at the time. He mail-ordered *The Beatnik Dictionary* in April 1961, the same week he read Exodus: "Shakespeare, Chuck Berry, the Beats—I began finally to realize that it was all the same, how all of that was one thing, even though at the time it seemed so disconnected and disjointed."

7. The American Museum of Agriculture, now the FiberMax Center for Discovery, opened in 1969, eight years after Terry had left Lubbock, so his pre-exodus museum inventory may actually be unfairly generous.

8. This hoary quip, in its many variations, has been ground down to a nub by years of blunt usage—other iterations involve additional details of posture and gradations of elevation, such as standing on a tin can, a tuna can, or an anthill, for a few more or less inches—and, though many attribute it to Terry, it's not clear who originally came up with it. ("Who knows who said it first?" wonders artist Paul Milosevich.) All the Flatlanders—Joe Ely, Jimmie Dale Gilmore, and Butch Hancock—have deployed the same wisecrack with regularity, on and off stages, as have many others, to the point where it has become a folkloric and aphoristic element of the traditional comic repertoire of musicians from the Llano Estacado.

CHAPTER 9

1. David Box, Ben Hall, Roland Pike, and Ray Rush, producers, *The David Box Story*, Rollercoaster Records RCCD 3024, 2002, compact disc, liner notes, 14.

2. "It was not dirty," Terry objected years later in a 1981 letter, "simply unsettling."

3. Perhaps in an attempt to reclaim the song he later amended the title to "The Roman Orgy Moves Home," formalizing a compositional segue into "Gouge Eyes."

4. Pachucos belonged to a vibrant Mexican American, and originally specifically Tejano, subculture that emerged in El Paso and thrived from the 1930s through the '60s. Although they predated rock and roll by two decades, pachucos' defiant, extravagant street style and rebellious image were a clear precursor to greaser styles eventually associated with rock and roll and motorcycle gangs. With their wild fashions—colorful, oversized zoot suits, chains, tattoos, and pompadours and ducktails for the men and high bouffants, sometimes reportedly hiding razors, for the women—and a distinctive argot (known as Caló), pachucos were hard to miss in Texas in the 1940s and 1950s, though Terry only admired their audacity from afar. He would later identify Jabo and Chic of *JUAREZ* as pachucos.

5. The whole Black family registered as white on census records. (Alton and Charoletta's mother was named Juanita, though her maiden name was Beesinger.) Nicknames were popular and colorful among the Blacks; Juanita's husband, Anthony Clayton, was known as A. C. and Blackie. Their son, Alton, aka Jabo, graduated from Lubbock High in 1961 (the same year Terry graduated from Monterey), served in the Vietnam War, returned to Lubbock to marry and attend Texas Tech, and became an insurance claims adjuster—likely losing much of his perceived "pachuco" menace in the process. The real Chic's fate is, appropriately for her namesake *JUAREZ* character, more obscure; like Pauline, Charoletta left sparser public records. She lost her first son to meningitis at age two, after which she apparently remarried and eventually left Texas for Oklahoma.

6. The Highwaymen who popularized Lead Belly's "Cotton Fields (The Cotton Song)" were the politely anodyne Yankee folk-revival hootenanny combo from Wesleyan University, not the later country supergroup.

7. After graduating from Lubbock High, David continued to record and perform, particularly in Nashville and Houston. In the fall of 1964, when he was on the verge of signing a recording contract with RCA Victor, his sister, Rita, invited him to return from Houston to Monterey to accompany her and her friends in an assembly performance of his song "Sweet Sweet Day." It was a gamble, given David's blacklisting at Monterey, but Rita hoped that the fact that he'd only be playing guitar in a backing role, as well as his stated willingness to apologize and promise not to surprise the audience with any blue material, would satisfy the judges.

To the Box siblings' frustration, Rodgers and company—"all those little Caesars," as Rita called them—were, in fact, not satisfied. They declined the request for David to sully again their sanctified stage.

Instead of flying back to Lubbock on a commercial flight, David, disappointed, stayed in Houston, and on October 23, 1964, on a lark, he went on a pleasure flight with some fellow musicians. For unknown reasons, the plane crashed. There were no survivors.

"If he'd been allowed to come to Lubbock to perform with me," Rita reflected to me, "that would have been just enough to put him somewhere else. But fate is cruel."

8. In an early piece of fiction by Terry, a short story called "The Party," seemingly loosely based on the 1960–61 New Year's Eve party, the rowdy partygoers demand that he play "The Roman Orgy" as well as another original drinking song titled, simply, "Hell."

9. Hagan, *Charles Goodnight: Father of the Texas Panhandle.*

CHAPTER 10

1. Terry and Jo Harvey often remark that, growing up in predominantly Baptist Lubbock, the oft-repeated conventional wisdom, imparted to generations of children, was that "sex is disgusting, sinful, vulgar, and horrible . . . and you should save it for the one you love."

2. Jo Harvey and Pauline had previously met in passing in December 1960, the day of Senior Carnival.

3. In January 1961, he wrote, "She's the happiest girl I ever met. . . . I'm having a problem understanding her, but I can't even understand myself, so what the hell." Around the same time, he reflected, with remarkable clarity and self-awareness: "I am eighteen years old, and my mind is a great jumble."

CHAPTER 11

1. "Cause I'm gonna California with the snakes in my mind
 And when I get there everything'll be fine
 Or so I'm schemin
 And I'll smile when I reach
 A strip of plush promised beach
 But I'm dreamin"
 —"Gonna California" (begun in 1961, recorded in 1968)

2. The Llano tapers ever so slightly as it slouches delicately eastward. According to Chris Taylor, director of the Land Arts of the American West program at Texas Tech, the caprock is, technically speaking, not actually completely flat but ever so slightly graded, sloping uniformly about ten feet per mile, or 0.11 degrees, descending from over five thousand feet at its northwest peak to about three thousand feet at its southeastern limits. Because the surrounding landscape is so comparatively level, even the slightest dips or depressions fill with rainwater runoff or snowmelt from miles around to form round, shallow bodies of water known as "playa lakes." These evanescent bodies of fugitive precipitation are more numerous on the Llano than anywhere else on Earth, numbering nearly twenty-two thousand pockmarks on the plateau.

In *The Terry Allen Year Book*, Terry reveals that he and his friends "had been smoking pot" before their plunge into a playa lake, but more recently he has denied that, saying they were drunk on whiskey.

3. Allen claims he has written most of his songs while roadbound, and you can hear the rattling whine and whisper of tires on sandy asphalt in his left-hand rumble and in the lonesome cadence of his singing. "I think there are three great American inventions," he opined in his "Self-Interview": "one is duct tape, one is hot glue, and the other one is putting radios in cars."

CHAPTER 12

1. In his senior year, Allen scored high in the literary, artistic, and musical categories in the Kuder Career Assessment aptitude test.

2. Among the Chouinard students associated with the so-called Cool School or LA Look, including the Light and Space and Finish Fetish movements, among other

phenomena, were John Altoon (attended in 1950), Robert Irwin (1952–54), Larry Bell (1957–59), Ed Ruscha (1956–60), Ken Price (1957), Doug Wheeler (1961–65), Allen Ruppersberg (1962–67), Chuck Arnoldi (1968), and Boyd Elder (1963–68).

3. His answer was not snide or sarcastic. Terry, like his future friend Dave Hickey, who has written eloquently and earnestly (and controversially) of the perennially unhip Rockwell's significance in American art history, appreciated those *Saturday Evening Post* images for their careful rendering, Renaissance-inspired compositions, and sly narrative dimensions. See, among other writings, Hickey's essay "Shining Hours/Forgiving Rhyme" for an unfashionable—but deadly accurate—championing of the *Post* painter whose rich narrative work entrenched itself in an entire genera-tion's psyche (Dave Hickey, "Shining Hours/Forgiving Rhyme," in *Air Guitar* [Los Angeles: Art issues. Press, 1997), 32–41).

4. In "Gonna California," Allen's anticipation and anxiety take the form of various West Coast tropes: costumes he'll don (dark sunglasses, flowered shirts, glitter) and places he'll hide (dim-lit bars with old movie stars, beaches, neon-lit Hollywood) to heal all of his hurts. Though he'd briefly visited California three times before—once with his folks, once to visit Lubbock expat Wayne Dresser, and once with Duane Hausauer—and recognized such stock LA motifs sufficiently to toy with them, he still knew very little about his destination. Despite such bromides, Allen managed to squeeze in some lines of evocative poetry—"I'll be the bluebird rider in a red-panel truck" and "a strip of plush, promised beach"—but it's likely the thrilling occasion of the song and its resonance that made it the first recording he would ever release.

5. "Home, in the twentieth century," Dave Hickey once wrote, with particular rele-vance to Allen's experience, "is less where your heart is, than where you understand the sons-of-bitches. Especially in Texas, where it is the vitality of the sons-of-bitches which makes everything possible, where there is more voracious mercantile energy, more vanity, and more pretentiousness than any place I've been—excepting Manhattan" (Dave Hickey, "The Texas to New York via Nashville Semi-Transcontinetal Epiphany Tactic," *Art in America* 60, no. 5 [September–October 1972]: 54). Similarly, "Every-body knows, as Kris Kristofferson observed, that it takes more brains to get out of Kentucky"—or Texas—"than it does to get out of Connecticut, and that's a comfort" (Dave Hickey, "Wonderful Shoes," in *Perfect Wave: More Essays on Art and Democ-racy* [Chicago: The University of Chicago Press, 2019], 33).

6. After spending an awkward night with his cousin Myron (Uncle Ott's son) in Globe, Arizona, they visited a bizarre, circus-themed bar called the Clown's Den in Phoenix, where they ate a desultory, papery lunch. Danny found the garishly candy-colored, creepily puerile murals hilarious; Terry felt the whole place exuded a sinister vibe and was relieved to step back outside into the baking heat. There was an old, broken-down drunk at the door, and they speculated for the next one hundred miles of their drive if that was the Clown. The cryptic motto inscribed on the Den's postcards and matchbooks sounded like a threat of voluptuary violence: "Every ingredient of pleasure underscored."

7. Outside Safford, Arizona, they had crested a hill, unused to such geological won-ders, at high speed—Terry reckons one hundred miles per hour—and the Ford caught air for a few vertiginous, heart-in-throat moments before crashing down to the highway

with a gut-wrenching jolt that sent all four hubcaps flying off and rolling into the desert. Standing there on Venice Beach the next day, Terry could have thrown a stone to the future site of L.A. Louver, the gallery that, beginning a quarter of a century later, would eventually represent him longer, and more successfully, than any other.

8. The Wilshire location of Terry and Danny's apartment was freighted, though only in retrospect, with symbolic import for Allen's art. The English poet and novelist Malcolm Lowry wrote the second draft of his masterful novel *Under the Volcano* (1947) largely in the Hotel Normandie, three blocks north on Normandie Avenue and Sixth Street, the lobby pay phone of which Allen habitually used to call Jo Harvey in Lubbock. A kaleidoscopic, omnisciently narrated, virtuosically composed, and deeply depressive modernist epic revolving around the alcoholic dissipation and psychological disintegration of the main character, former British consul Geoffrey Firmin, *Under the Volcano* influenced both Terry and Jo Harvey enormously when they first encountered it in Fresno a decade later. The novel's setting in Quauhnahuac (or Cuernavaca), Mexico, at the brink of World War II (the story begins on the Day of the Dead, 1938, exactly four years prior to Jo Harvey's birth); its clinical depiction of the destruction wrought by addiction; its portrait of a failing marriage torn apart by infidelities and miscommunications; its shifting perspectives and narratives; its numerological structure and symbolist underpinnings; its violence both internal and external, psychological and physical; its compulsive, forensic description of the slippages of consciousness and memory; and its sheer scale, formal complexity, and tumbling skeins of involute Mellvillean sentences—with echoes of Conrad, Joyce, and Faulkner—all left a deep impression on Allen, directly influencing works such as *JUAREZ, RING, DUGOUT, YOUTH IN ASIA*, and *Ghost Ship Rodez*.

Across the street at 3400 Wilshire Boulevard was the luxurious Ambassador Hotel, which hosted the Academy Awards in the early 1930s and which housed the famous Cocoanut Grove, once the city's premiere nightclub. Today the Ambassador is primarily remembered as the site of Robert F. Kennedy's assassination in the spring of 1968, almost exactly six years after Terry left the neighborhood. The day after Sirhan Sirhan shot Senator Kennedy, Allen wrote "New Delhi Freight Train" in response to watching the unremitting TV news coverage of the tragedy (intercut with the regularly scheduled programming, the 1957 Western *The True Story of Jesse James*). Footage of the Ambassador's exterior and of Kennedy lying wounded and bleeding on the hotel's kitchen floor flashed onscreen between cinematic gunfights between outlaw and lawman. Terry and Danny also availed themselves of the Ambassador's pay phone on a weekly basis.

9. "Jo Harvey would send us supplies," Allen explained, "but it was often boxes of shit we didn't need. We needed food. Instead she sent a group of orange-looking African figurines staring at an egg. We were hoping it would be beans. We were speechless, looking at this thing. We called it 'The Onlookers.'"

CHAPTER 13

1. The Student Nonviolent Coordinating Committee, founded in 1960.

2. The earliest known recordings attributed to Dylan's pseudonym Blind Boy Grunt were made later in 1962, so it's unclear what it was that Reagon played—maybe an early

demo or live recording of "Black Crow Blues" prior to its inclusion on *Another Side of Bob Dylan* two years later? Allen revisited the subject decades later with *Caw Caw Blues*.

3. In a 2015 notebook, Allen recalls a memory from mid-'60s San Francisco, when he stood outside the theater emptying out after a production of *One Flew Over the Cuckoo's Nest*, wearing sunglasses and playing harmonica, with a sign around his neck reading "Blind Boy," in order to make enough money to get back to LA.

4. The Allens finally saw Dylan in concert on December 7 or 8, 1965, at the Santa Monica Auditorium. He played two solo sets, an acoustic set of older material and an electric set of newer songs. In 2011, when asked about his favorite artists, Dylan cited only Allen and a miniature golf course designer. Allen supposed he was on Dylan's mind because Charlie Sexton, who plays guitar with both men, had recently given him a copy of Terry's UT Press monograph (Rachel Monroe, "Terry Allen on the Texas Roots of His Music and Art," *New Yorker*, January 4, 2022, https://www.newyorker.com/news/q-and-a/terry-allen-on-the-texas-roots-of-his-music-and-art).

5. To Terry's credit, at least some of the lyrics were relevant to the occasion: "See the girl with the diamond ring / She knows how to shake that thing . . ."

6. Dave Hickey, "Terry Allen's *YOUTH IN ASIA*," in Allen, *Terry Allen*, 118. Allen cites an incident (possibly spurious) of kids who were mauled by bears at Yellowstone in the wake of Disney's innocuous *Davy Crockett* television series (1954–55), drunk on cuddly fantasies of Frontierland, the Country Bear Jamboree, and actor Fess Parker's filmic bear-hunting escapades (including a scene where he "grins down" a bear).

7. Most of Terry's surviving teenaged photographs of Disneyland show the attractions and architectural simulacra, not him or his bride. He photographed the white Italian marble statues of Snow White and the Seven Dwarves in the forced-perspective Snow White Grotto, an uncanny diorama that he appropriated, bleached princess and all, in his *China Night* installation twenty-three years later. He seemed to favor the rides with a literary dimension, which he photographed dutifully: the Jungle Cruise, 20,000 Leagues Under the Sea, Tom Sawyer Island, Captain Hook's *Jolly Roger*. The newlyweds rode the monorail and took in a performance of Plains Indian dancing (featuring redface dancers and thoroughly dubious ethnographic merit).

CHAPTER 14

1. At the opening that evening, which Allen missed, Duchamp sat once again at the chess table in the gallery for what would become his most famous match. This time his opponent was Eve Babitz, a young LA artist, writer, and student at Los Angeles Community College one week younger than Terry but far more worldly. She happened, on this occasion, for the sake of an iconic photo session, to be completely nude—a provocation to her lover Walter Hopps, who had not invited her due to his wife's presence.

CHAPTER 15

1. A couple of hours after Kennedy had been pronounced dead at 1:00 p.m., Terry picked up Jo Harvey at a Catholic church where she'd stopped to pray after being let off work early. On the way home, while stopped at a crosswalk, a pedestrian approached the car, spied the Texas plates, and red-faced, spittle spraying, shouted "MURDERER!" at the teenaged couple. The confused, devastated wrath toward all

things Texan was so pervasive that a sympathetic gas station employee advised them to remove their plates temporarily or get the car off the road and park it in a garage for a couple of days until temperatures subsided. It did not matter that the Allens were staunch Kennedy supporters or how huge and diverse Texas was. Murry Kellum's song "Long Tall Texan" had supposedly been racing up the charts, ubiquitous on the radio, until the assassination and the subsequent backlash against Texas stalled its ascent and effectively silenced the single.

2. Globe was coincidentally also the home of Terry's cousin Myron and his wife, Doletta.

3. Cooper's dish of choice was an improvised jambalaya of white rice topped with cans of tuna, scallions, and whatever else was on hand.

4. Doug Edge and others sometimes lived at Beaudry Street; Ron's "ad hoc" band the Duke Savages sometimes rehearsed there. It was here where their buddy Rick Griffin, the underground comix artist and designer who was responsible for some of the earliest psychedelic posters, including iconic concert images for the Fillmore and Avalon in San Francisco and the cover of the Grateful Dead's 1969 *Aoxomoxoa* album, first introduced "newly minted bohemian" Al Ruppersberg, and several others of their crowd, to psychedelic drugs with their first doses of LSD. Terry O'Shea, another artist friend known for his sculptures in resin, lived out back in what Cooper called a "funky dirt-floor garage" and had installed a "rain machine" sculpture in the yard.

5. There are, however, in his college notebooks, hints of self-interrogation and things to come, such as moments of tentative, jokey conceptualism (and, arguably, regionalism). One notebook drawing is captioned "2 tracings of taco chips that I ate before I ate them" and comprises exactly that, the outlines of tortilla chips, lumpen and inexact (if you have never tried, it is no easy or tidy thing to trace *un totopo*).

6. Nick Roberts was an ex-wrestler who promoted weekly matches at Fair Park Coliseum, and his wife, Lorraine Johnson, was a well-known and groundbreaking female wrestler. The couple's daughter, Nickla Roberts, followed in the ring-crazed family's footsteps, growing up, like Terry, selling concessions at Fair Park Coliseum and eventually becoming "The Perfect 10" Baby Doll of the NWA, known for her leather-and-spikes punk style and persona.

CHAPTER 16

1. Responding to a bulletin board posting at Chouinard, Allen also applied for a set-painting job for an August 1964 UCLA production of *The Deputy*, a controversial play by Rolf Hochhuth about the implication of Pope Pius XII in the Holocaust. It paid an unbelievable one hundred dollars, "good money in those days." He read the play and created a monumental backdrop mural that felt, to him, suitably grisly and disturbing given the subject matter, populated with "all these horrendous prison camp people, piles of skulls, and all kinds of stock prison horror images." The director and set designer were horrified by this luridly gruesome scene, however, and promptly offered him two hundred dollars, double his initial fee, to paint it out black. "So I got paid twice, three times the original rate! I was thrilled. We needed the money so bad."

2. Titles include "Django Calliope Montague," "The Sanitary River/Mississippi Mystic Mystery Patrol," "Watteau Walker," "Prince Gypsy Lover," "Funk Funk Funky Mama,"

"The Fat Man (Rolo Monday, Rotund)," "The Hard Cold Road Ahead," "The Hokey-Pokey Drive-in, or Mogul of the Carhops" and "Nouveau Queen (Pop-Op Drop) " (both Jimmy Reed–inspired 1950s period pieces that Allen recognized later as "TIME-LOCKED IN THAT CHROME BLOWN DOPE HOPE ERA"), "The Smooth Butter Device" (a precursor, at least in title, to "The Juarez Device"), and "Little Ted's Dream Song" (in which the mother of the protagonist demands he buy her booze, and instead he buys a shotgun and murders her).

3. After Black Wall broke up, a California man named Tyrone Swader was indicted at least twice, in 1967 and 1985, for large-scale, seaboard marijuana smuggling operations.

4. Through his acquaintance with Laurie Anderson, Terry and Jo Harvey met Reed about ten years after that journal entry, on June 8, 2009, when they all had lunch together at the Inn of the Anasazi in Santa Fe. Lou was cordial but distant, seemingly more interested in his tiny dog Lola Belle than the present human company, though he did ask Allen to send him his records, which Terry did.

CHAPTER 17

1. Rrose Sélavy was Duchamp's double-punning pseudonym and drag alter ego.

2. The prominent Light and Space artist Larry Bell is most visible to the majority of people, though not many could easily identify him, as one of the figures on the cover of the Beatles' *Sgt. Pepper's Lonely Hearts Club Band*, along with Allen's mentor H. C. Westermann. In Terry's workbooks from this period, foregrounding his obsession with puns and satire, as well as perhaps some unease with the recent onslaught of art historical education, he enumerates dozens of puerile puns on artists' names. The playful list features older friends and mentors ("Billy Al Bing Bing" for Billy Al Bengston, "Robot Irwin" for Robert Irwin, and "Larry Dong" for Larry Bell); the Dadaists most dear to him, both those he'd happened to meet ("Marbell Doo-champ" and "Man Gas [the only American]" of the "Ba-Ba" or "Do-Do Movement"); and those he'd never encounter but admired ("Hands Harp" for Hans Arp and, one of the most moronically inspired, "Huge Ball" for Hugo Ball).

3. Craig Krull, *Photographing the L.A. Art Scene, 1955–1975* (Santa Monica: Smart Art Press, 1996), 5.

4. Ibid.

5. Taking a page from Duchamp's catalog of readymades, Ruppersberg showed a five-dollar toy mailbox, displayed on a pedestal. Influential LA gallerist Riko Mizuno, who would later exhibit Allen's work, bought this elevated tchotchke for one hundred dollars, a veritable fortune, earning Terry's enthusiastic admiration. "I remember thinking, 'Damn, that's good, Al,'" he chuckled.

6. The promotional buttocks belonged to a Chouinard model named Linda Albertino, a performance artist and singer who, according to Allen, performed with Linda Ronstadt and the Stone Poneys. "But her real claim to fame back then," Terry needled, "was that photo of lips on her ass. I remember Jo Harvey was furious at me for weeks for using that photo."

7. His notebooks from this period dive deeper into the anatomy of desire. In a drawing titled "Birth of a Nation," George Washington fucks Lady Liberty as Betsy Ross, inseminating her with the Stars and Stripes. Grotesque captions describe the imagery

with hilarious literality: "A human's ass transplanted with a dog's ass . . ."; "Fingers become tongues and lick and caress everything . . ." A head with wagging tongues emerging from every orifice is titled "CRITIC." "Mr. and Mrs. Frank Stella" appear as a human rose and a zebra centaur in formalwear. On another page, Mrs. Stella's rose totem parachutes into "a zebra's ass hole." One note without an accompanying image reads, simply, "Marilyn Monroe with a large male dick." Pages later, someone's large male dick waltzes across a map of Texas to ejaculate onto Lubbock. Then, "A Hippie's Asshole Explodes from Dope." A joking letter to the dean of Chouinard exposes Allen, "the pres. representative of the fine art department" as being "pre-occupied by pornography symbols (namely dicks)" and encourages his dismissal. It's signed with a penis wearing a Mouseketeer hat.

8. US Patent 252,112, January 10, 1882, reproduced in Siegfried Giedion, *Mechanization Takes Command: A Contribution to Anonymous History* (Minneapolis: University of Minnesota Press, 2014).

9. Ibid.

10. Terry Allen interview by Paul Karlstrom, Santa Fe, New Mexico, Smithsonian Archives of American Art, April 22, 1998, transcript, 37.

CHAPTER 18

1. Dave Hickey, "Vietnam and a Betrayal of Childhood," *Los Angeles Times*, July 4, 1993, 183.

2. Ibid.

3. Although this is the contracted chronology Allen recalls, it appears the tragic accident may have happened a few years later, in 1973.

4. Hickey, "Vietnam," 183.

5. Years later while living in Fresno, SFAI invited Allen to teach, and he got his revenge: "I had saved their letter and my crushed slides, so I put them all in a box and sent it back with a note that said, 'No, thank you, I don't teach at schools like this, and I'm not interested in this kind of job.' I did get a very nice, apologetic letter from the director after I sent it back." Regardless, he would go on to exhibit at SFAI and befriend several faculty members.

6. The Allens had still paid nothing for Dr. Fox's treatment and supervision of the births, but like a benign Reynardine of the old ballad, Fox tracked them down in an unlikely location: "Several years later in LA, we were at one of the famous early porno movies, I don't remember which one, for a big opening, and we saw him. . . . We got a note later saying, 'I'm sure you enjoyed the movie. If you can afford going to this porno movie, now it's time you start paying my bill.' So we paid him off. . . . It was hard to keep us down when it came to movies."

7. "Terry Allen: The Exact Moment It Happened in the West—Early Drawings (Mid '60s)," L.A. Louver Gallery, https://lalouver.com/theexactmoment/early-drawings.

8. "Pacific Standard Time: Nicholas Wilder Gallery," Getty Museum blog, 2011, accessed October 16, 2020. https://blogs.getty.edu/pacificstandardtime/explore-the-era/locations/nicholas-wilder-gallery/.

9. Palmer D. French, "Terry Allen," *Artforum* 7, no. 3 (November 1968): 66.

10. Ibid.

11. Fidel Danieli, "Four-Man Show," *Artforum* 7, no. 2 (October 1968): 68.

12. Larry Palmer, "Local Art and Artists . . . Terry Allen Show," *Independent Star-News* (Pasadena, CA), September 28, 1968, 26.

CHAPTER 19

1. "Save Woman from Fire," *Amarillo Daily News*, March 16, 1967, 31.

2. "MYTHOMANIC IMPRESSION / EXHIBITIONS INTO BUBONIC STRAIN / DEFINI-TIVE SPEED BURNS / WITNESS DREAM DAMAGE / VISIONS OF THE GOOSE HELD / SEE THE MIST."

3. For example:

> "YOU DRINK JISSOM.
> YOU'RE JUST MIDDLE CLASS.
> YOU CAN'T RAISE A HARD ON.
> YOUR ASS IS FILTHY, A BLOODY CHERRY READY TO POP.
> YOU GET THE RED ASS AFTER KIM CHEE.
> YOU, YOUR DICK IS TOO SMALL.
> YOU JUST FARTED, I CAN SMELL IT.
> YOU'VE FUCKED A DOG."

4. Michael Walls, "Passing on Through: Thoughts on the 'Juarez Series,'" in *Juarez Series: Terry Allen* (Houston: Contemporary Arts Museum, 1975), 7.

5. Nelson's publishing companies controlled mostly torch and novelty songs recorded by Frank Sinatra, Doris Day, Nancy Wilson, and other less established crooners. Allen clarifies that Nelson was not Ricky's brother of *The Adventures of Ozzie and Harriet* fame—though ironically, Ricky Nelson would later cover Terry's song "New Delhi Freight Train"—or the future cofounder of the New Riders of the Purple Sage.

6. Under the direction of Nelson and Tipton, unknown musicians later overdubbed additional instrumentation on "Gonna California," including a strident fiddle and an incongruously overripe muted trumpet. "Color Book" remained comparatively, and mercifully, unadorned, featuring just the original session quartet of piano, guitar, bass, and drums.

7. "It's just so hard for me to get past me sounding like a chipmunk," Allen cringed. "My voice was so much higher then."

8. One letter of response, dated June 25, 1968, thanks Nelson for sharing Terry's two songs but frostily regrets to inform him that "I am unable to use them at this time." It's signed "Chet Atkins, Division Vice President, RCA Victor Record Division, Nashville."

9. The *Cowboy and the Stranger* cassette includes 1968 solo demos of the title track as well as "Truckload of Art" and "Red Bird."

10. In turn, Bruce was impressed by Terry's own gyrations at their wedding: "I love the way he dances. I didn't know anything about Texans. . . . But I had never seen anybody dance like that before, or since. He was like a crab with rubber legs."

11. "We're birds of a feather flying them opposite wings / And what we say to each other means them opposite things."

12. Even without its outro, the song "The Beautiful Waitress" colonized other media:

> Around the same time I made a sculpture piece called *The Beautiful Waitress*, which was one of those Mexican glass boxes . . . like a little display box with metal edges. I filled it up with sugar, and in the center I put one of those classic plaster figures from Tenochtitlan, the Aztec warrior leaning over the sleeping woman. I discarded the warrior, and the sleeping woman became the beautiful waitress. I put her in this box full of sugar and then stuck crackers around it and placed the whole thing on a sheet of glass, like a tabletop that sat on a thin pedestal, which I stuck gum all underneath, so it was like under a table in a café. I recorded the song, which has the line "cracker crunch," and put [the tape] in a little box and put it inside the pedestal. It was in the di Rosa collection in Northern California until . . . [it] completely deteriorated; all of the sugar had been eaten by some creatures. It had become pretty funky and *un*beautiful.

13. 　　　　　　　　　"Jesus [*pronounced in the Spanish manner*]
　　　　　　　　　　　What's the use
　　　　　　　　　　　Of your dyin
　　　　　　　　　　　When there ain't nobody round
　　　　　　　　　　　Even tryin
　　　　　　　　　　　Yeah you went for your cross
　　　　　　　　　　　But drew slow and lost"

14. Terry and Al disagree about the name of the vinyl meal.

15. In November 1972, Terry finally recorded "Al's Cafe," dedicated to Al, at his home on Belmont Avenue in Fresno, during what sounds like a small party:

> And you can't get anything you want
> But you can get everything you need
> From a precious Patti Page Pretty Paddy Melt
> To five rocks with a side of seeds

On the tape of the same night is also likely the oldest extant recording of "Amarillo Highway," a leisurely take of the song he sent to his new friend Dave Hickey, "a man who changes jobs more than most people change clothes."

CHAPTER 20

1. In 1970, they shortened it to an abridged one-hour show that aired from noon to one on Sunday afternoons. Dr. Demento got his start in underground radio—literally—in the same basement just as the Allens were wrapping up their tenure at KPPC.

2. At the opening of every episode, while the jaw harp and fiddle of Buffy Saint-Marie's "They Gotta Quit Kickin' My Dawg Around" ring out, Jo Harvey introduces the show with a smile in her voice: "Hi, this is Jo Harvey Allen, bringin' you a little *Rawhide and Roses*, right on your corner, left at your heart, and straight on your way home. *Rawhide and Roses*: sashayin' and dashayin', rip-roarin', wild and woolly, ripe and unpredictable, one hour of the best past, present, and future of pure down-home, honest-to-goodness country music. We're gonna feature a loosely documented look

into the backwater origins of honky-tonk glitter and the Cadillac glamour of the music that makes America home."

3. Allen remains a Beefheart fan to this day, admiring his uncompromising and unpredictable oscillation between three-minute blues blasts and the furthest reaches of inaccessible, abrasive art music. The unaccompanied ballad "The Dust Blows Forward and the Dust Blows Back" on *Trout Mask Replica* is a particular favorite track.

4. "MY NAME IS BIG BEEF . . . BE-EF . . .

I'M A MEAT PROPHET . . . PRO-PHET . . .

IT IS MY PROPHECY THAT, FROM OUTER SPACE,

A GREAT NEW ALBUM IS COMING . . . FAR-OUT

ON BLUE THUMB RECORDS . . .

CAPTAIN BRETHEART AND HIS MAGIC BAND . . . BEEF-HEART, GOOD-
 MEAT . . .

GREAT FUNKY CHUNKS OF MEAT WILL RAIN DOWN FROM THE SKY ON
 THE CITY . . .

beef it to me"

5. It was on this trip they found the Red Bird "den," a tavern that shared its name with the song; Terry photographed it and used the image in a collaged drawing called *Red Bird*.

6. Patchily shot, raggedly improvised, and incoherently edited deep under the influence of narcotics, *The Last Movie* was, unfortunately, an unmitigated disaster by most metrics, leading to Hopper's self-imposed exile from Hollywood for nearly a decade.

7. Duel appeared in *Gidget* the television serial that premiered in 1965, starring Sally Field, not the 1959 Sandra Dee film to which Jo Harvey aspired.

8. Duel was cast in 1970, and the series ran from January 1971 through January 1973, after the Allens had left LA.

9. For the record, the Allens loved *Once Upon a Time in Hollywood*, feeling it captured Duel's sadness and fragility as well as the edge-of-madness tenor of LA in 1969. Their admiration for DiCaprio in the role of their friend also played into their acceptance of roles in Martin Scorsese's 2023 adaptation of *Killers of the Flower Moon*, which also stars DiCaprio.

10. Tapes accompanied *The Arizonia Spiritual, Gun . . . or the 3701 28th St. Cowboy Blues*, and *Tear*.

11. "I made another sculpture piece called *Lucky's Last Song*, which was a guitar case filled with sand. I added little cactuses to grow in it. I put a transistor radio in the pick case that was tuned to a staticky country music station moan. I put a bronze horseshoe in it and set it on a platform that had a bunch of rabbits' feet hanging from it. The idea was for the radio to play until the batteries went dead, and whatever the last song was, that was Lucky's last song. I remember going in and buying about three hundred rabbits' feet at a store in Hollywood. When I was paying for them, the guy at the counter said, 'Man, you must be one unlucky son of a bitch.'"

12. "Los Angeles songwriter and aspirant to universal-genius Terry Allen . . . expresses a scarifying view of Western nostalgia. . . . His drawings, which are at once ingratiating and frightening, like much that comes from Los Angeles, tell us in various ways that they are about art and artifice and the world of entertainment. They are also

about lying and Texas lying. Texas must be a very great state. One should add that although his style suggested the Hairy Who and the underground comic book in some respects, Terry Allen is a meticulous draftsman and has a vision of his world that makes Robert Crumb look like Shirley Temple. A very talented and workmanlike and variously ambitious freak, this man" (Jerome Tarshis, "San Francisco," *Artforum* 8, no. 10 [Summer 1970]: 91–92).

CHAPTER 21

1. Inveterate animal lovers, the Allens have always owned dogs, a long lineage of varied breeds, sometimes several simultaneously, with some cats thrown into the mix for good measure.

2. The inventory of "amazing anomalies" found in the aftermath of the tornado supposedly included "whole cigarettes, broom straws, plastic knives and spoons, shoelaces, even a single piece of typing paper, all embedded halfway or completely through the trunks of various elms and cottonwoods. An open Bible was found lying on top of a pile of debris. Its tattered pages turned to the 13th verse of Psalms, which begins: 'So persecute them with Thy tempest, and make them afraid with Thy storm.'" Allen's song "The Lubbock Tornado (I don't know)," on *Smokin the Dummy*, describes the prairie dog decimation wrought by the 1970 tornado, which carried hundreds of projectile critters from Prairie Dog Town in Mackenzie Park a mile away to smash them against the city's tallest building, supposedly—according to local folklore—embedding their bones like tiny corkscrews of shrapnel in the battered bricks: "Tiny creatures went flying / Right out of Prairie Dog Town / Smack up against the Great Plains Life / Little bones in the rain fallin down."

3. Jo Harvey put out the flames by throwing flour on them, and neither Bale nor Sunshine was harmed.

4. Allen, who admired Crews's novels, met and befriended him in 1985 when, during a symposium for the exhibition *Laughing to Keep from Crying: Dark Humor in the South* at the Alexandria Museum of Art in Louisiana, Terry helped carry the drunk author to the podium, where he pulled himself together to deliver a lecture on Flannery O'Conner.

5. In LA, he kept a sign on his studio doors that read: "Do not disturb, even if you're Dylan."

6. Beans symbolized more than Tex-Mex and Mexican cuisine. In a note "ABOUT BEANS" in an explicatory text, Allen implies an allusive historical connection to Chic Blundie, the bruja character of *JUAREZ*, and to death, quoting Collin de Plancy's *Dictionary of Witchcraft*, published in 1818: "Pythagoras prohibited his pupils from eating beans, which he revered especially because they were useful to him with magic, and because he was convinced that they were animate. . . . He borrowed his ideas about beans from the Egyptians who would not touch them. He is said to have preferred death at the hands of his pursuers to safety when the latter entailed crossing a beanfield." Apparently the Greek philosopher believed gas from consumption of beans expelled "the breath of life" and that fava beans housed the souls of the dead.

7. Gloria Anzaldúa, *Borderlands/La Frontera: The New Mestiza* (San Francisco: Aunt Lute Books, 1987), 25.

8. As he wrote a few years later of *The Juarez Device*:

"A TRAVELOGUE
THIS DRAWING INITIATES THE SERIES.
IT IS A MACHINE WITH BAIT.
THE MACHINE IS ACTIVATED BY THE RIO GRANDE WHICH LOOKS
 SIMILAR TO SILVER BACON.
THE BAIT IS WHATEVER URGE THAT LEAKS IN AND CALLS 'MEXICO' . . .
 PARADISE. THE 'MERICAN' MIRROR . . . AND A DIM VIEW, at that, OF
 WHAT GLOWS.
THE VICTIM IS AIR, WATER, AND EARTH. FIRE LOOKS."

9. "The banks of the river between El Paso and Juárez are concrete, and they are at weird angles, almost like a dam, and there's graffiti, especially all over the Mexican side. So I proposed a public piece for the border there: two big mirrors, so each bank of the river was just a mirror. Because I always did think each side was kind of a mirror image of the other side, but a very distorted funhouse mirror."

10. The cited pairs of twins and doubles include: Sailor/Alice, Jabo/Chic, Jabo/Sailor, Chic/Alice, Spain/Aztec Empire, Cortez/Montezuma, Mexico City/Tenochtitlan, Mexico/United States, California/Texas, LA/Abilene, El Paso/Juarez, and San Diego/Tijuana.

11. A crucifix with three lines emanating from its top, the pachuco cross symbol is associated with Tejano and Chicano gang culture; Allen's personal modification, which appears as a recurring symbol in his *JUAREZ* work, has a pendent head anchoring its stem, its crosspiece serving as flag—a hybrid of crucifix and musical eighth note. Allen's pachuco cross is at once emblem and insignia, ideogram and rune, a literal "Juarez Device" that has served as a metaphorically freighted colophon or seal on prints, books, and artworks. In 1977, artist Ruth Marten tattooed it on his right pinkie finger.

12. Dave Hickey, "Born in a Trailer: Borne Forth on the Perfect Ship," in Terry Allen, *a simple story (Juarez)* (Columbus: Wexner Center for the Arts, 1992), 71.

13. Lotería is a traditional game of chance involving a deck of fifty-four cards with strong resemblances to tarot imagery.

14. Oulipo, or OuLiPo, is an acronym for Ouvrir de Litterature Potentiale (Workshop for Potential Literature), an association of mostly French writers and mathematicians—Harry Mathews was one of two American members—founded in Paris in 1960 and interested in, among other things, applying mathematical rules and playful procedural, metafictional, and systemic "constraints" to literary composition, in order to sever stale semantic connections and forge new linguistic possibilities. Allen admired Italo Calvino in particular, but other notable members included Georges Perec and cofounders Raymond Queneau and François Le Lionnais.

15. Terry went to school with Dale Buckner's daughter Gail.

16. "POWER, POWER . . . LUBBOCK POWER
PEOPLE, PEOPLE . . . PEOPLE POWER
YEAH,
LUBBOCK PEOPLE ARE THE POWER AND LUBBOCK POWER IS THE KIND
TO GET IT ALL TOGETHER NOW
AND LET THE GOOD LIGHT SHINE . . . SO TURN IT ON!"

17. Dave Hickey, "Earthscapes, Landworks, and Oz," *Art in America*, September–October 1971.

18. Ibid.

19. Martha Utterbeck, "South Texas Sweet Funk," *Artforum* 9, no. 9 (May 1971): 76.

20. Ibid.

21. Ibid.

22. Hickey, "Vietnam," 3, 75.

CHAPTER 22

1. Amirkhanian was the music director at KPFK-FM Pacifica and invited Terry to perform on air, which led to later bookings at experimental music festivals like Mills College's Speaking of Music program at the Exploratorium in 1979 and the New/Music/America/81 festival at the Japan Center two years later. At the latter, Terry, feeling rather out of his element, played a solo version of "Wolfman of Del Rio." Allen's ongoing, tentative involvement with new music served as a ligament between his music, his visual art, and his reluctant academic career.

2. Joe Hagan, *Earl's Closet: The Lost Archive of Earl McGrath, 1970 to 1980*, Light in the Attic LITA 180, 2022, vinyl LP, liner notes.

3. Ibid.

4. The previous evening, Jo Harvey, presuming that "no one else there could cook anything but spaghetti," prepared a big meal for Earl and all his guests at an impromptu dinner party, laying out her best West Texan country-cooking spread: fried chicken, corn on the cob, chili, and all the fixings. The guests, largely musicians and actors, dressed to the nines, were all so fussy and self-consciously obsessed with their appearances and the consumption of other intoxicants that hardly anyone ate a bite, because they didn't want greasy fingers or corn in their teeth—or gas.

5. Bob Mehr, "Early McGrath Was a Character. His Closet Was Filled with Rare Recordings," *New York Times*, July 12, 2022, https://www.nytimes.com/2022/07/12/arts/music/earl-mcgrath-rolling-stones.html.

6. One wonders if the name of Mizuno's gallery, 669, was also potentially an in-joke homage to Gallery 66, which preceded it by a year.

7. Of Mizuno, Walls wrote: "She always sounds like her head fell off into the chop suey."

CHAPTER 23

1. "The Juarez Device (aka Texican Badman)," "Cortez Sail," "Border Palace," "Dogwood," "Writing on Rocks across the USA," and "The Radio . . . and Real Life."

2. "New Delhi Freight Train," "Truckload of Art," "The Pink and Black Song" ("another song about the past"), "Red Bird," "The Night Cafe," and, reluctantly, because Jo Harvey asked him to, "Cocaine Cowboy."

3. Tragically, in the summer of 1987, long after a promising early art career that proved unsustainable, the mentally ill and acid-damaged Balog, wearing a black martial-arts uniform over a body laced with arcane tattoos, hiked to the top of a hill in Ventura and shot himself with a rifle, rendering the dedication of "Off Malibu" eerily prophetic.

Shortly before he died, Dave Hickey, a surfer himself in his youth, following a rash of butt dials, called me out of the blue to proclaim to me, with commanding breathlessness, that "Off Malibu" was his favorite song that Terry had written, and the most underrecognized and unappreciated. He hoped I'd mention it.

4. When Allen later drunkenly encountered Ertegun outside the home of a mutual friend at a party, he facetiously and melodramatically bowed down to the great man, prostrating himself on his knees with arms raised. In a journal decades later, he referred to the admittedly obnoxious incident as "Bowing Down to the Slave Man."

5. In his first Fresno notebook from 1972, Allen wrote with self-effacing dismay:

> My music is built on masturbated isolation. It doesn't come from playing with anybody—and the little bit of listening-to-somebody it comes from is so general that it couldn't really count (this is due to my total ignorance of radio-record music in:
>
> 1.) how it is played
> 2.) how it is recorded
> 3.) how it is structured
>
> Basically I am crude with music—because the only songs I can remember are my own and the only ones I want to sing are my own.)
> I play with myself—so to speak . . .
> It is hard for me to sing other people's songs because it is hard to do other people's drawings.

6. Perhaps in a once-removed gesture of reconciliation, Terry soon thereafter traded a tape of a different version of "Truckload of Art" to Ruscha for a copy of his *Royal Road Test* artist's book. "People like the song," he wrote, "but artists love it." "It's a deal," Ed wrote to Terry on stationery with the letterhead "EDWARD RUSCHA / young artist."

7. Hellman, who was operating on a shoestring budget, revealed in an email to me that he did not remember holding on to any audio recordings after the film had been edited, and Hagan's thorough search of McGrath's archives turned up nothing.

8. In 2010, Terry received an email from Quita MacPherson, Stanley's widow of forty years, about finally hearing and being moved by "Blue Asian Reds" at Stanley's mother's ninetieth birthday party.

CHAPTER 24

1. The NEA panel that year included Stephen Prokopoff of the Museum of Contemporary Art Chicago and fellow museum curators Jim Demetrion, previously of the Pasadena Art Museum; Marcia Tucker of the Whitney Museum; and Anne D'Harnoncourt of the Philadelphia Museum of Art (where she oversaw the permanent installation of Duchamp's last major work, *Etant Donnés*). Among the other panelists were Terry's Berkeley buddy Peter Voulkos, as well as the artists Roy Lichtenstein, George Segal, and Wayne Thiebaud.

2. *The Cortez Slab* (1973) features a miniature balsa-wood bridge affixed to its surface, representing the El Paso–Juárez border bridge, so the blood spattered on it was particularly appropriate.

3. Bertoldi died tragically in 1981 after falling off the roof of a studio he was renovating in Brooklyn.

4. Zenny's was an actual Mexican American restaurant in Fresno.

5. The other characters were the Newsman (George Lewis), whose head was a pencil tip resembling a KKK hood and who, in his gender fluidity and garters, reminded Terry of Joel Grey in *Cabaret*; and the Boy, outfitted with a "purple prick head papier mâché mask," a codpiece, and elephantine, dragging testicles made of volleyballs encased in pantyhose, complete with black yarn pubic hair.

6. Allen eventually saw both the 1967 film *Marat/Sade* and the Royal Shakespeare Company's production of *A Midsummer Night's Dream* at the Orpheum (his former workplace) during its 1972–73 world tour—two daring, radically experimental adaptations of their source material, both directed by visionary English director Peter Brook. "That made a very big impression on me," he remembers. As did The Living Theatre's production of *Frankenstein* in 1968, which, with its scaffolding set, redefined for Terry how sculptural installation and performance can share the same space onstage and off.

CHAPTER 25

1. "THE LEAD TAKING HIS BRAINS ALL THE WAY INTO THE DRIVEWAY OF THE STUCCO GLITTERED APARTMENT BUILDING ACROSS THE STREET . . . CONCRETE . . . DIDN'T EVEN HAVE THE DIGNITY OF LANDING ON THE LAWN . . . BUT THEN, PETER WAS DRUNK, AND IF HE'D BEEN THINKING CROOKEDER, HE WOULD HAVE PLANNED IT STRAIGHTER."

2. "A story about a boy raised in two houses—exactly alike . . . (the first until he was 3 years old—the second . . . built on the same plans as the first but miles away, until he was 18. He left, married, became a . . . His father died—his mother alcoholic and insane—sold the 2nd house and later again purchased the 1st—the returns were traumatic for the boy but constituted a motivation. His duality. His marriage was a by-product. . . . He had a friend, an actor named Duel, who killed himself."

3. Stephen S. Prokopoff, *Terry Allen: Mixed-Media Drawings* (Chicago: Museum of Contemporary Art, 1972), exhibition catalog, 1.

4. Harry Bouras accidentally lent his name to the Hairy Who when, in a conversation among young Art Institute of Chicago grads, the topic of his radio show arose, and artist Karl Wirsum asked, "Harry *who*?"

5. Jane Allen, "Two Generations Show Gap in Paint," *Chicago Tribune*, January 2, 1972, 303.

6. Ibid.

7. Marcia Tucker in *American Narrative/Story Art: 1967–1977*, ed. Paul Schimmel (Houston: Contemporary Arts Museum, 1977), 20.

8. The song embedded itself in Nauman's psyche that day, and he revisited it decades later. In 1996, on Terry's suggestion, Nauman commissioned Lloyd Maines to play several instrumental versions of "The End of the World" for an eponymous three-channel video piece that focused on his hands and his pedal steel guitar. The session at Nauman's studio was, unbeknownst to him, freighted with import: "Terry came to help us

keep things moving. . . . Lloyd's wife was with him, and I didn't know this, but they'd just found out that day that she had cancer. So he's sitting in my studio playing 'The End of the World.' . . . It turns out she recovered, but it was very heavy on one side, and I had no idea." Tina did indeed recover, and she and Lloyd attended Nauman's opening in November 1996 at Castelli Gallery in New York, where, to their delight, David Bowie approached them, introduced himself, and said to Lloyd, "I have to let you know, I so admire your playing. I love steel guitar, and I love this project." A few months later, after Castelli sold *The End of the World*, Lloyd unexpectedly received a check from Bruce for $10,000.

9. Rumors percolated in the 1980s that Tucker was a member of the anonymous, gorilla-masked feminist art collective the Guerrilla Girls, dedicated to unmasking the rampant sexism and racism in the art world.

10. Marcia Tucker, "TERRY ALLEN (on everything)," *Artforum* 19, no. 2 (October 1980), 49.

11. Ibid., 48.

12. Ibid., 49.

13. When Doty was unable to secure a loan of the *JUAREZ* drawing *Border Vows* from collector James Speyer, he instead selected *Stat Eline*, the ruptured title of which ("State Line") suits its fractured desert scene of fish and scaffolding surrounding roadside signage. In the catalog for *Extraordinary Realities*, which opened at the Whitney in October 1973, seven months after the Biennial closed, the reproduction of the piece is oriented incorrectly as a landscape instead of a portrait (so much for the "transformed but recognizable spaces" of which Doty wrote).

14. Marcia Tucker, "RING: A Story Which Swallows Its Own Tale," in *Terry Allen: RING*, by Terry Allen (Kansas: Contemporary Arts Society, 1981), 20.

CHAPTER 26

1. The song "Ladies Love Outlaws," written by Dripping Springs performer Lee Clayton and most famously recorded by Waylon Jennings in 1972, provided another source for the still-percolating term "outlaw country."

2. *San Marcos Record*, March 9, 1972, quoted in Dave Thomas, "40 Years Ago, Dripping Springs Helped Created Austin's Musical Identity," *Austin-American Statesmen*, June 24, 2016, https://www.statesman.com/story/entertainment/music/2016/06/24/40-years -ago-dripping-springs-reunion-helped-create-austins-musical-identity/10225070007/.

3. The attraction between the Allens and Claire was immediate and familial—though initially spookily antagonistic, according to Claire: "I had with me a nice tooled-leather handbag. Jo Harvey said to me, 'I wish I had that purse, and you had a wart on your nose.' Within three months, I grew a wart on my nose and gave her my purse."

4. The Allens had recently befriended Sam's brother Denver ("Denny") Peckinpah, a Fresno County Superior Court judge whose wife, Betty, had enrolled in one of Terry's drawing classes at Fresno State (Sam's alma mater).

5. Tom Donahue at KSAN had assigned Jo Harvey to interview Waylon Jennings for a proposed syndication of *Rawhide and Roses*. Hickey arranged an introduction to Jennings, and Jo Harvey and Waylon sat happily chatting and joking for a while, getting

along so famously that Jo Harvey forgot that she was supposed to be conducting a formal interview. By the time the opportunity presented itself, she froze.

Right after the Reunion, on Billy Copley's insistent and generous invitation, the Allens flew from Austin to New York City, where they saw Jennings play at Max's Kansas City. It was their first visit to New York. Donahue's failure to follow through on his *Rawhide and Roses* promises indirectly led to Jo Harvey's exploration of autobiographical and ethnographic writing and performance with the *Counter Angel/The Beautiful Waitress* project.

6. Payment took a long time. "For years I had an insufficient funds check from Dripping Springs in our kitchen, stuck on the refrigerator," Terry said.

7. Thomas, "40 Years Ago."

8. A few months later Allen inspired another landmark Ruppersberg work, *A Lecture on Houdini (for Terry Allen)* (1972), a critical and populist highlight among the videos exhibited at the 1975 Whitney Biennial, in which Al reads a text about the life and career of the great illusionist while struggling to escape from a straitjacket. Ruppersberg dedicated it to Terry to thank him for a salient bit of advice on the piece (long since forgotten) and because of their shared interest in Houdini. Two decades later, in 1997, Al reprised *Where's Al?* for a "Part 2" installment documenting the Allens' 1997 anniversary convocation in El Paso and Juárez.

CHAPTER 27

1. Raphael Rubinstein, "Books: The Houston Solution," *Art in America*, June 1, 2019, https://www.artnews.com/art-in-america/aia-reviews/houston-contemporary-art -1972-1985-book-review-63641/.

2. On meeting Townes Van Zandt at CAMH: "We walked inside the doors, and there was this skinny guy leaning against the wall, playing songs. He'd been hired to be the background music for the opening. Jo Harvey and I leaned against the wall nearby, just listening to him. I remember being really knocked out by his songs, and I talked to him a little bit. It wasn't until years later that I made that connection, talking to him. He and Guy were living down there doing gigs at the Old Quarter and in Galveston."

3. "When you drink with him," Schimmel observed of Allen, "he's such a sweet guy, and after the first drink he chills, but by the fourth he's turned into a wolf, you know? I remember him being agitated and nervous, and understandably. He was a young guy, and this was a big fucking deal."

4. William Wilson, "Art Walk," *Los Angeles Times*, May 25, 1973, 77.

5. Dave Hickey, "Terry Allen's Juarez Artifacts," in *Juarez Series: Terry Allen* (Houston: Contemporary Arts Museum), exhibition catalog, 20.

6. Ibid.

7. Ibid.

8. Michael Walls, "Passing on Through," 7.

9. Alvin Lubetkin and Marilyn Oshman Lubetkin, heir to the Oshman's Sporting Goods retail empire, who would become a longtime patron and friend to Terry, owned *Melodyland*, and Fred Gerson, an Oshman protégé who cofounded Oshman subsidiary Abercrombie and Fitch, owned *Booth*.

10. Ironically for such a watery image, *Border Vows* was destroyed in a fire while in the possession of its owner, James Speyer. Also lost to flames was *Aztec Vendetta*, which, according to Terry, mysteriously combusted at the home of its owner Marguerite Peters in 1973.

CHAPTER 28

1. The affiliation with Cirrus Editions produced *Pinto to Paradise* and a small solo show, *Two Pinto Fantasies*, in 1971.

2. Lemon took artists to the Double R Ranch to hear house band the Sundowners, a classic honky-tonk group active since the 1950s whose debut LP he would release on his personal Fate imprint EJ Records in 1980 (produced by Lloyd Maines).

3. Many artists who recorded at Wally Heider's Allen admired and helped promote at Spot House. Notable artists who recorded there include the Byrds (for their self-titled 1973 reunion record, Roger McGuinn's eponymous solo album, and Gene Clark's cocaine classic *No Other*); Betty Davis (her eponymous debut the same year); Creedence Clearwater Revival (*Green River*, *Cosmo's Factory*, and *Pendulum*); Crosby, Stills, Nash, & Young (collectively for *Déjà Vu*, and separately, for Neil Young's self-titled debut and *Everybody Know This Is Nowhere*, the Croz's *If I Could Only Remember My Name*, and Nash's *Songs for Beginners*); the Grateful Dead's *American Beauty*; Herbie Hancock (*Mwandishi*, *Head Hunters*, and *Sextant*); the debut of the Rowan Brothers; Santana (*Abraxas*); T. Rex (*Electric Warrior*); Van Morrison (*Tupelo Honey* and *Saint Dominic's Preview*); Gram Parsons (*GP* and *Grievous Angel*); Link Wray (*Be What You Want To*); Tim Buckley (*Look at the Fool*); and Tom Waits (*The Heart of Saturday Night*).

4. According to Hickey, Bare was "one of the few genuinely funny people in Nashville. . . . He had a whole category of songs he sang called 'We Just Lost Lubbock,' which were a little risqué," so he was primed to appreciate Allen's music.

5. Hickey's "Calgary Snow" and the poignant "Speckled Pony" (based on a line from the Book of Revelations, and the title of which Terry lifted for a 2019 drawing) appear on Bare's *Cowboys and Daddys*.

6. The "Diane Harris" listed in the credits for *Juarez* is also known as Diana Voudouris Harris.

7. Dates on the extant track sheets and tapes indicate that the recording, mixing, and mastering likely happened on scattered dates throughout August, including the ninth, nineteenth, twenty-first, and twenty-eighth. Studio C boasted a state-of-the-art twenty-four-channel mixing console, but they never needed to use more than a few tracks per song, six or eight at the most.

8. Allen recalled paying Peter, Greg, and Diana small sums for their overdubs. He recollected also paying the engineers, but well below the standard rate and under the table, for their labor. Allen gave Jamie a set of the *Juarez Suite* of prints to thank him for all his help. As Howell joked with me, "I have never been paid, not a cent. I complain to him about this all the time. Tell him I'm still waiting for my royalties."

9. Dan Fox, "The Reissue of Two Country Music Albums by Conceptual Artist and Musician Terry Allen," *Frieze*, October 2016, 53.

10. Other examples of country music concept albums include Woody Guthrie's 1940 *Dust Bowl Ballads*, Ray Price's 1964 *Night Life*, 1973's Silverstein-penned *Bobby Bare Sings Legends, Lullabys and Lies*, David Allan Coe's *Requiem for a Harlequin* (1973), and Nelson's own *Yesterday's Wine* (1971) and *Phases and Stages* (1974).

11. As described by folklorist Américo Paredes in his groundbreaking 1958 study of "El Corrido de Gregorio Cortez," "the epitome of the border corrido," the corrido is a narrative ballad that recounts local history and folklore, often dealing with subjects of oppression, revolution, and the resulting violence of "intercultural conflict," usually told from the partisan perspective of working-class witnesses (Américo Paredes, *With His Pistol in His Hand: A Border Ballad and Its Hero* [Austin: University of Texas Press, 1958]). The tradition continues unabated today with the popularity of *narcocorridos*, the form's adaptation to the borderland drug wars.

12. Hickey, "Born in a Trailer."

13. Allen, *Terry Allen*, 2.

CHAPTER 29

1. Little did the manager know how they left the room: "We had to get the horse out and put the bed back in, and we just left the horseshit in the plastic to see if these guys from Oklahoma would ever know. They never mentioned it. The whole time, there was a plastic sheet filled with horseshit under their bed."

2. "Instead of taking drugs, I live in Fresno," he joked to the Western-attired attendees.

3. The jukebox records included, among the classic fare, contemporary selections like Bobby Bare's cover of "High Plains Jamboree" (the B-side of his new "Cowboys and Daddys" 45) and multiple songs by Moe Bandy, Waylon Jennings, and Gary Stewart (whom Terry had seen play Lubbock's Cotton Club a few times on visits home).

4. A dresser with open drawers was strewn with the detritus of a road-worn, working cowboy: rolling tobacco, roadmaps, loose change, condoms, photographs, and paperback self-help books (according to Terry, "rodeo guys love self-help books").

CHAPTER 30

1. Allen, *Terry Allen: RING*, 4.

2. In attendance was Billy James, manager of Talent Acquisition and Development at RCA Records, who wrote to Claire to ask for a new copy of the record, since his had been "warped by the California sun." She complied, but once again, a record deal was not forthcoming, not that Terry particularly wanted one anymore.

3. William Wilson, "Art Walk," *Los Angeles Times*, May 14, 1976, 28.

4. The triumvirate of Dannys comprised Danny Parrish, Danny Thompson, and Danny Harris.

5. Westermann explored the motif of the "death ship" throughout his career.

CHAPTER 31

1. The mask Jo Harvey wore for this performance and video—a clear plastic cheapie that Terry had painted an "anonymous gray"—was more than a costume. She wore it throughout rehearsals, even sometimes at home or in their hotel room. After several

days it began to serrate the commissures of her mouth, filling the channels around the plastic lips with rivulets of blood. "My mouth would get all bloody, because I just loved the feeling of being another person," she explained to me with a sigh. "She was so enamored with this change of identity. . . . I think that spurred her into wanting to act," Terry surmised.

2. A prodigious soundtrack accompanied the performance, with early scenes deploying disparate recordings by Bach, Doug Kershaw, and Lydia Mendoza, as well as Jo Harvey's live unaccompanied vocal performance of "Penitentiary of Jealousy," which she wrote for the piece, and Terry's own "My Amigo." A lengthy collage of jazz, classic pop, rhythm and blues, and early rock and roll, dating to the midcentury setting of *RING* (and Allen's own childhood spent ringside), accompanied the middle third of *The Embrace*: Sonny Rollins, the Shangri-Las, Dean Martin, Johnny Mathis, the Platters, Elvis Presley, Ketty Lester, LaVern Baker, Mickey and Sylvia, Joe Darensbourg and His Dixie Flyers, Tommy Edwards, and Ike Quebec.

3. *Messages from Wrestlers in Hell and Pieces from Fighters in the Darkness*, an April 1978 show at Hansen-Fuller Gallery in San Francisco (the invitation featured the photo of Terry's grandfather posing at ease with two dwarf women wrestlers); *RING: Fighters of the Darkness* at Nancy Lurie Gallery in Chicago in November (prolonged and updated with new work, into January 1979, as *Terry Allen: Extended and Augmented with Underlying Events from "Fighters of the Darkness"*); and *Work from "Fighters of the Darkness"* at the Morgan Gallery in Kansas City in November 1979. (Claire Copley had closed her gallery as of December 1, 1977, otherwise he would likely have exhibited this work with her.)

CHAPTER 32

1. *Time Loves a Hero* was George's final album with Little Feat. When he heard the *Lubbock* version of "New Delhi Freight Train," "he said he wished that he'd played on it. Said he had never thought of it as being done fast." To thank him, Terry gave George and his wife, Liz, a drawing, entitled *Saddle Peak*, a reference to the location of their Topanga home. It includes inscriptions referring obliquely to the Clean boondoggle and George's gesture of kindness: "Water is just the same as upside down birds. . . . A guitar covered with hair oil . . . A Criminal Record . . . great reviews, no commercial potential. . . . How to write a song . . . with a pencil."

2. Milosevich's wife, Debbie, happened to be Danny Thompson's sister, so there was a family connection to stoke his curiosity. In December 1977, Milosevich finally called the Fresno State Art Department to locate Terry and order *Juarez*. Although initially wary of this unknown voice from Lubbock, hearing Debbie's name quickly reassured him, and on his next visit home for the 1977 winter holidays, Terry knocked on the couple's door to hand deliver an LP. That copy, possibly the first in Lubbock, quickly made the rounds, via dubbed cassettes, among select musicians, including Joe Ely.

3. Taylor's hearing impairment was the result of a teenaged car accident also involving playwright, songwriter, and future Allen collaborator Jo Carol Pierce.

4. Tom T. Hall even wrote a song about Stubb's, "The Great East Broadway Onion Championship of 1978."

5. Allen noticed Ely's social anxiety and jumpy energy, his habit of playing a new record when he seemed nervous. "In that respect I felt kin to him," he remarked, since "I must love being alone and hate being alone more than anybody else."

6. Lloyd Maines, "Honky-Tonks, Blood, and Love: The Roots of *Lubbock (on everything)*," in *Lubbock (on everything)*, by Terry Allen, Paradise of Bachelors PoB-027, 2016, vinyl LP liner notes, 26.

7. Incredibly, no one noticed for thirty-eight years. In February 2016, while rehearsing for the first-ever concert during which they would perform the entirety of *Lubbock* in sequence, appropriately at Texas Tech, Maines realized he was unable to play along in tune with either his CD or LP copies. (The first words he spoke to me when we met in person in the theater lobby were, "Man, it's great to meet you; we have a problem.") For the 2016 reissue, mastering engineer Patrick Klem, working from the original analog master tapes, painstakingly corrected the tape speed and pitch discrepancies evident on all prior editions.

8. The final bill, including all studio expenses, lodging, reimbursement for the Koontzes' babysitting expenses, and musicians' fees, came in at $3,275, mercifully less than Terry's $4,000 loan from Jack.

CHAPTER 33

1. David Byrne writes of the album's "tender, loving sarcasm, which is a default with Terry. You know you're OK when he starts seriously teasing you" (David Byrne, "A Sleeping Bag in the West Texas Scrub: Reflections on *Lubbock [on everything]*," in *Lubbock [on everything]*, by Terry Allen, Paradise of Bachelors PoB-027, 2016, vinyl LP, liner notes, 25).

2. "We'd all been drinking some [Dickel] bourbon to celebrate and taking photographs around the room. There weren't enough chairs at Caldwell's, so Don had brought in that red chair with the green cactus from his uncle's cattle office. . . . It was one of a pair. Now Bale has it—it was really beat-up, so he reupholstered it in black, and it's beautiful. I sent Jo Harvey's photo to Landfall Press, and the guy that did the layout said, 'What *is* this? This is crazy; I can't use this. This is a snapshot, not a cover for an album.' 'Yes, it is,' I told him."

3. *Them Ol' Love Songs* was initially a print that I did at Landfall Press. It was a funky drawing of a piano with knives and hatchets and axes stuck in it. . . . When I was invited to Texas Tech in Lubbock to be in a show [*Honky-Tonk Visions (On West Texas Music: 1936–1986)*, 1986], I built it as a sculpture for that. But I changed the piano to a bed. While I was working on it, and every place it was shown afterward, whenever there was a concert or somebody playing in a club, the word went out for musicians to come and sign the bed and write a lyric from their favorite love song on it. That's what's scrawled all over the surface."

4. In a January 1987 letter to director JoAnne Akalaitis, Terry elaborated on the influence of women in his life:

THE WOMEN WHO HAVE HAD THE MOST INFLUENCE ON MY LIFE HAVE ALL BEEN STRONG, FIERCELY INDEPENDENT, DEEP-HEARTED, AND SMART. LIKE ALL OF US HUMANS, THEY HAVE ALSO BEEN FUCKED-UP,

DEAF DUMB BLIND AND BEWILDERED, SWEET, MEAN AS HELL, AND OF
GREAT COURAGE. THEY HAVE BEEN A MONUMENTAL PAIN IN THE ASS . . .
AND MY TOTAL SALVATION.

 THESE WOMEN ARE MY MOTHER . . . AND JO HARVEY.

 5. Titles included *Lubbock (on everything)*—a map drawing, an early version of
which had provided the album's final title—*Vampire over Broadway, The Lubbock
Lights (Coming in Low over an Abandoned Beauty), The Only Mountain in Lub-
bock*, and *1959. The Secrets* was a hand-annotated, typewritten list of sarcastic "Rev-
elations on How to Write a Song," such as "Have the blues"; "Drive a car as fast as it'll
go late at night with the radio full blast"; "Smoke millions of cigarettes"; "Learn, and
put to memory, the names of all American trucks"; "Wink at women with gold teeth";
"Eat bar-b-que and chicken fried steak in the South, but <u>never</u> in the North . . . Just talk
about it"; "Avoid Los Angeles if at all possible"; and "Don't take drugs unless you need
too [*sic*]." He eventually broke several of his own rules, including "Never use your pets
for subject matter" (see "Queenie's Song").

 "There's one photograph of Stubb and me at the opening, standing in front of a piece
called *Stubb's BBQ, Heart & Soul of Lubbock, TX*," Terry remarked. "It has a lot of
generic postcards of Lubbock around the outside border, and in the center there's a
drawing of a plate with a barbecued heart on it. I gave it to Stubb for his café." Years
later, in trouble with the IRS for failure to pay back taxes, Stubb asked Terry if he
minded if he sold the piece. Allen said of course not, it was a gift; Stubb could do
whatever he liked with it. Nodding thoughtfully, Stubb replied, "Well, will *you* buy it?"
Terry declined this unusual deal, but Jim Morgan, in a characteristic gesture of gener-
osity, purchased the drawing, which he let Stubb keep. "People talk about what a bad
businessman Stubb was, but that was brilliant!" Terry laughed.

 6. Ultimately Tewkesbury, who had written the scripts for Robert Altman's films
Thieves Like Us and *Nashville*, became a closer creative partner to Jo Harvey, midwif-
ing and directing *Counter Angel* before directing the first iteration of *Chippy*.

 7. "I had that weird experience a number of times of playing one night in a club, and
then the next night playing a concert at a museum—same band, same set list, and the
difference between the two audiences was at times stunning. When you play in a club,
the response is very direct, and people deal with the music straight on: dance, howl,
drink. But in the museums back then, they didn't quite know how they should think
about it. So there were a lot of people who didn't register what was going on until after
it was over. They were often pretty passive crowds, though in Texas they usually cut
loose."

CHAPTER 34

 1. In his journal he also assessed Hawaii as "a good fuck zone."

CHAPTER 35

 1. Westermann was such an enthusiastic fan of the album that the only time Terry
has ever performed the entirety of *Juarez* live was at the 2001 Westermann retrospec-
tive at the MCA Chicago.

2. Inside the lid, the artist inscribed a message:

DEAR TERRY & JO HARVEY,

ALL MY FUCKING WORDS DONT DO YOUR TWO BEAUTIFUL ALBUMS JUS-
TICE. I NEVER HEARD ANYTHING THAT GOT TO ME SO OR THAT I LIKED
BETTER. I MEAN I LOVE EVERY GODDAMNED NUMBER. PERFECT!

"AFECIONADO,"

CLIFF

3. Carol Flake, "Art Rock, Panhandle Style," *Village Voice* 36, no. 24 (June 17–23, 1981): 78.

4. Russ Parsons, "Country Style," *Lubbock Avalanche-Journal*, January 25, 1981.

5. Terry and Richard drove from Lubbock in Bowden's '66 Mustang with no AC, Katie Koontz's cookies melting onto the dashboard. On the same route Stubb's Cadillac Coupe de Ville broke down in Santa Rosa, New Mexico, with a trunkful of barbecue. While being towed to Santa Fe, Little Pete slept in the backseat on a mattress of bread. When they arrived, Terry and Jo Harvey served as food tasters to prove the safety of the trunk-marinated meat, and Stubb devoured Katie's sun-softened cookies, astonished that they were "still warm from the oven" days later.

6. "This has been the most difficult [album]—recorded piecemeal, money deception, nerves, waiting, embarrassment, and still not out!"

7. Terry reprised the crumpled album cover concept, a detail of a painting of Jesus carrying a lamb that he found in the gutter outside a Lubbock botánica and manipulated, for Dave's 1989 collection of youthful short stories, *Prior Convictions*—but with Jacques-Louis David's 1793 bloody-bathtub painting *The Death of Marat* as a replacement savior.

8. Mikal Gilmore, "When Artists Sing the Tale," *Los Angeles Herald Examiner*, March 16, 1984, D24; Mikal Gilmore, "Lonesome Punks Raid the Honky-Tonks," *Los Angeles Herald Examiner*, May 11, 1985, B1.

CHAPTER 36

1. While in residence in July 1981 at the Visual Arts Center of Alaska in Anchorage, where they had been invited by Boyd Wright, Terry and the pianist Dick Dunlap devised a low-budget, low-concept video, *La Rondo de la Condo*, in which Dunlap, costumed as a devil, plays a concerto for solo piano and putters around a kitchen smoking. Allen screened it on a monitor as an element in *ORNITHOPERA*.

2. Forsha took over from curator Robert McDonald and director Sebastian "Lefty" Adler, who, coincidentally, had also been fired from CAMH as a result of zoological mishaps.

3. Allen, *Terry Allen*, 93.

4. Ibid.

5. Terry Allen, *Rooms and Stories: Recent Work by Terry Allen* (La Jolla: La Jolla Museum of Contemporary Art, 1983), 79.

CHAPTER 37

1. Allen, *Terry Allen*, 118.

2. "The soundtrack for the installation consists of songs by emblematic figures including Creedence Clearwater Revival, Jimi Hendrix, Jefferson Airplane, the Doors, the Rolling Stones, the Who, Marvin Gaye, Bob Dylan, Janis Joplin, the Beatles, Frank Zappa, and a few lesser-known performers including Captain Beefheart and the Fugs" (Craig Adcock, "Image/Music/Text: Terry Allen's 'Youth in Asia' Series," in Terry Allen, *Youth in Asia* [Winston-Salem: Southeastern Center for Contemporary Art, 1992], exhibition catalog, 3).

CHAPTER 38

1. Allen traveled to Lyon with seventeen-year-old Bukka as his translator. One day the staff at a local bar told Terry and Jo Harvey about "the mysterious American" who had lately been stopping by to play their piano beautifully. Intrigued, that evening they waited for this mysterious American to appear; it was Bukka. While in Lyon, the Allens saw both the movie adaptation of *Under the Volcano*, starring Albert Finney as Geoffrey Firmin, and *Paris, Texas*, which intensified Terry's admiration for Wim Wenders and his new friend Robby Müller.

2. *Summer Exhibition* in 1977 and *"Messages from Wrestlers in Hell"* and *Pieces from "Fighters in the Darkness"* in 1978.

3. Mark Epstein, "What's Wrong with Being Angry?," *Oprah*, https://www.oprah.com /relationships/whats-wrong-with-being-angry/all.

CHAPTER 39

1. These are the anglicized spellings in the liner notes of *Amerasia*, provided by the Caravan's charismatic translator Sinai, to whom Terry dedicated the album, along with Harvey Koontz and Boyd Wright. The band members' names are sometimes transliterated elsewhere as Surachai "Nga Caravan" Jantimatawn, Mongkhon Uthok, Thongkran Thana, and Wirasak Sunthawnnsi. Allen memorialized Sinai, following his death by drug overdose, with his 1988 *YOUTH IN ASIA* piece *Missing Footsteps*, featuring a tilted Buddha and, decades before *Caw Caw Blues*, a taxidermy crow above a quote by its honoree: "Next life I will be the rainbo I have been the crow."

2. A week later, Kenny's knowledge had vanished, and he was never able to recapture his can technique. "It was really bizarre," he remarked. "One of those strange happenings."

3. By "song-based records," I intend to differentiate from his long-form narrative audio works, radio plays, and sound design for installations, videos, and theater pieces.

4. Debora Iyall of the San Francisco new wavers Romeo Void audited his Fresno State classes, and Terry had been buying records by a new generation of punk-adjacent LA bands like the Blasters and X, whose Dave Alvin and John Doe, respectively, would many years later become his songwriting partners. While working on *Billingsgate* and *Bleeder*, he listened obsessively to the Talking Heads and *The Catherine Wheel*, the 1981 dance score by David Byrne, with whom he would later collaborate.

5. My essay for *Pedal Steal + Four Corners* was nominated for a Best Album Notes Grammy. It did not win.

6. "Wayne Gailey," Gordon writes, "was an artist coming close to my definition of artist as magician. . . . In Gailey I found magic so great and so unbounded that it killed him" (Roxy Gordon, "Whatever Happened to Wayne Gailey?" *Omaha Rainbow* 20 [Spring 1979]).

7. According to Jenkins, the set was "pretty controversial, because it had the words 'fuck you' on it in big pink letters, and it wasn't something that I was going to be able to tour to a lot of different cities because of the language. There needed to be warning signs in the lobby that some of the language might be offensive."

8. Their friendship also solidified through an embarrassing bathroom mishap several years prior. Nauman was staying with the Allens in Fresno while working at a nearby quarry, and they had cooked a squid dish that resulted in the entire household contracting diarrhea the next day. "We used up all the paper towels, all the sanitary napkins, everything—there was nothing left to wipe your ass with," Bruce laughed. A week later, after Nauman had returned home, the Allens received an enormous carton of 500 rolls of toilet paper, signed, with love, from Bruce. Although teenaged Bukka and Bale realized later that this shipment probably constituted a valuable work of conceptual art, they were delighted to have sufficient supplies for Halloween toilet-papering for years. Terry sent Bruce back a single toilet paper roll, painted in tar, to thank him for the "donation." Repurposed as a candlestick, it still sits on Nauman's dining room table.

9. The day before recording at Caldwell's, in February 1988, while cleaning out his studio, Allen accidentally snagged his index finger on the metal meridian of a globe, which sheared it to the bone. After a trip to the hospital for stitches, he played piano with a jury-rigged splint constructed from a carrot, the subject of outtake "Three-Finger Blues." Lloyd teased him that this vegetal handicap had actually improved his playing. During downtime in the studio, the band amused themselves by alternately watching, in a profane echo of Nauman's two-channel video, Jimmy Swaggart's recent sweaty, tearful televised confession to soliciting prostitutes and a pornographic film starring Traci Lords.

10. Dave Hickey, "Terry Allen's *Big Witness*: A Less Perfect Union," in Terry Allen, *BIG WITNESS (living in wishes)* (San Francisco: San Francisco Art Institute, 198), exhibition catalog, 11.

11. Kachinas are, in Allen's words, "ghosts, presences of the dead, in Pueblo culture." They appear throughout *YOUTH IN ASIA*.

12. Hickey, "Big Witness," 11.

13. Other notable incidents on Allen's first UK tour included sharing a bill with Jonathan Richman; performing with Peter Rowan, Jerry Douglas, and Butch Hancock; a BBC interview with Andy Kershaw; and filming an episode of *The Old Grey Whistle Test*.

CHAPTER 40

1. Over a pale and peeling azure wash, Allen painted two deliberately amateurishly rendered Native Americans' heads, a rattlesnake encircling a hand-lettered legend reading, "COLD BEER/SEE SNAKES LIVE," and five large kachinas: Kokopell' Mana, the Assassin Fly Girl; Kokopelli, the Assassin Fly Kachina; Hemis Kachin' Mana, the

Yellow Corn Girl; Ahota; and Umtoinka, the Making-Thunder Kachina (Craig Adcock, "Youth in Asia: Ka/China Night," in Terry Allen, *Kachina Knight* [Tallahassee: Florida State University Fine Arts Gallery], exhibition catalog, 5–6).

2. Elsewhere additional neon text reads "NEVER HAPPEN" and "DON'T MEAN NOTHIN," patois advertising, in "US grunt soldier vernacular," the denial and meaningless of death.

3. The North American music featured in *China Night* repeats some of the *Youth in Asia* installation soundtrack, with additions including Bo Diddley, George Jones, Lydia Mendoza, Violeta Parra, and Townes Van Zandt (Adcock, "Youth in Asia," 7).

4. Roxy Gordon, "Making Sense: The Magic: The Art: The Artist," in Terry Allen, *China Night* (Fresno: Fresno Art Center and Museum, 1985), 55.

5. Jo Harvey borrowed the title *Tables and Angels* for the original version of her performance *Counter Angel.*

6. In a profile of these Lubbockite artists-in-residence, the *Washington Post*'s Henry Allen was dubious of the success of their ambitious assignment, sardonically noting "the cigarettes that Allen keeps installing in his mouth as if he's treating some ailments that the cigarettes don't seem to do any good for" and determining that "something about [the four Texans] suggests that an appropriate accessory for their slow, nervous, and pallid demeanor might be handcuffs."

7. "It's not like it resolved itself," Terry explained. "I just quit. The work doesn't ever resolve itself; it just becomes something else." The *YOUTH IN ASIA* catalog ends with a speculative quote from Allen: "The number of suicides by Vietnam veterans is now double the number of names on the Vietnam Veterans Memorial wall. Where's the memorial to that?" (Terry Allen, *Youth in Asia* [Winston-Salem: Southeastern Center for Contemporary Art, 1992], exhibition catalog, endpapers).

CHAPTER 41

1. David Byrne, "A Sleeping Bag in the West Texas Scrub," 25.

2. Although they batted around other ideas, including a *Snow White and the Seven Dwarves* adaptation, the Byrne-directed Jo Harvey solo vehicle has not yet happened. "I was the Lying Woman, but *he* was the liar," she cracked.

3. The dirt floors of *Secreto Engel* (1985), *Blue Dear* (1985), *Ohio* (1986), and *Chippy* (1993) were inspired by Terry's visit to Sydney, Australia, in the spring of 1982 for the Bienniale, where he showed *RING* work. After the stress of a frantic install, he witnessed a ceremonial Aboriginal *corroboree*, performed on red outback soil, that affected him more profoundly than any of the contemporary art on display. "It encompassed all of the arts; it was very beautiful and moving to me," he reflected. In the men's room afterward, he met some of the dancers, who were slipping out of dreamtime and into Gucci loafers and sportscoats over their elaborately painted bodies.

4. "I've got others too," he qualified—mentioning Jo Harvey, Bukka and Bale, the Elys, Al, and Lloyd, "my brother and anchor . . . but these three move in my mind." A couple years later, he added Ed Ruscha to the list of Dave, David, and Bruce as the friends with whom he feels, despite himself, most competitive.

5. Bale at one point devised a detailed architectural plan to excise a door from an exterior wall and surgically graft the defunct family VW bus onto their bedroom as a Frankensteinian addition. After some good-faith discussion with his parents, the scheme was deemed impractical and abandoned.

6. Five years later, Bruce Nauman considered proposing a similarly scathing and queasily reductive Holocaust memorial in Hannover, Germany, a large sign that read: "We are sorry for what we did, and we promise not to do it again."

CHAPTER 42

1. It was January when Terry left Lubbock for LA in 1961, and it was January when he left Lubbock a second time, once again for California, in 1971. When in 1989, he left California for Santa Fe, it was, inevitably, January.

2. David Dowis was the younger brother of the Allens' friend Dorothy Wiley, William T.'s wife.

3. Santa Fe also lay at the terminus of the Santa Fe Trail, which began in Independence, Missouri, near where Allen's forebears, Allens and Pierces, lived for generations before "jumping off" for Texas.

4. Elements of this scene remain, as I discovered when I first visited them in Santa Fe in 2017. "Guess who I ran into at Whole Foods?" Jo Harvey asked Terry as I helped her carry brown paper shopping bags into the kitchen. "Bruce!" ("Bruce" was fellow shopper Bruce Nauman.)

5. Their integration into Santa Fe society was not always so seamless. They once attended a Halloween party at a mansion located brazenly and rather insensitively very near the sacred Puye Cliff Dwellings site on Santa Clara Pueblo land near Española, north of Santa Fe. It was not their kind of party. The table was set, elaborately, with placards with guests' names, and Terry sat at the one marked "Terry," right next to Shirley MacLaine. Little did he know that was MacLaine's dog's name and the canine's seat at the table. "It didn't set the dinner off right. She was upset she wasn't next to her dog, and I was upset I was next to her."

6.
> "They said
> I had a head
> for business.
> They said
> to get ahead
> I had to lose
> my head.
> They said
> be concrete
> & I became
> concrete.
> They said
> go, my son,
> multiply,
> divide, conquer.
> I did my best."

7. A cartoon published in the *New Yorker* alongside a complimentary capsule review of his winter 1989 show at John Weber Gallery—"a gonzo, pop-philosophic, white-trash-populated overlook on culture" by an "American original" who is "admirably uncompromising"—depicted a disembodied mustache (captioned "gone") floating above a cigarette (captioned "still there") ("Goings On About Town," *New Yorker*, December 25, 1989, 21).

CHAPTER 43

1. Many of the taxidermy animals Allen used in his sculptures were gifts from his San Francisco dealer Paule Anglim, who bought them in Paris shops like Deyrolle and shipped them to him.

2. "Yeah I'm crashin the state lines / Headed for a high time . . . this Sunday / An I need your tattoo / Next to mine when I do . . . ahhh / Chic Blundie."

3. Dave Hickey, "Born in a Trailer."

4. Disappeared or otherwise unavailable mothers abound throughout *Pedal Steal + Four Corners*, suggesting a chronic absence of maternal succor: Billy's damaged mother in *Pedal Steal*, Torso's missing mother (supplanted by his evil aunt), Alicia's mother Carlotta in *Juarez*, the ballplayer's mother in *Dugout*.

5. The radio play includes excerpts from "What of Alicia," a fragment of "Parts: Jabo / Street Walkin Woman," and a recurring pedal-steel theme that sounds like a reduction of "There Oughta Be a Law against Southern California."

6. In a notebook, Allen compares this "mummy" to the lava-cast bodies of Pompeii, the mummies of Guanajuato, and JFK's body lying in state.

7. Milagros are small religious charms long used throughout Latin America for healing and as votive offerings.

8. Rosetta Brooks, "From the Middle of Nowhere: Terry Allen's Badlands," *Artforum* 31, no. 8 (April 1993): 90.

9. What Allen refers to as "catch wands," a recurring image in *JUAREZ* dating back to its early iterations (see the drawing *La Despedida*), are cardboard cones affixed with wire to broomsticks, used by children to catch coins and other gifts tossed off the El Paso–Juárez border bridge by tourists.

10. The note, which Allen saved, reads:

"we are all travelers in the wilderness of this world,
and the best that we can find in our travels is an honest friend.
please fill out this card for me.
thank you.
enjoy your stay.
i am keeper of this house and your friend."

Allen awarded Byrne 25 percent of the "Wilderness" publishing, instead of 50, a rejoinder to the split of Byrne's song "Something Ain't Right," the lyrics of which Terry wrote at David's request. (As Byrne explained apologetically, his publisher only agreed to give Terry 25 percent of the publishing income instead of the standard fifty-fifty split.)

11. Wheeler had already unsuccessfully tried to ratify a budget in which David's artist fee was three times Allen's.

12. Many have noted superficial similarities between *Juarez* and Barry Gifford's 1989 novel *Wild at Heart*, on which David Lynch loosely based his film of the following year, a Technicolor, kitsch-saturated tale of a passionate couple of outlaws, and occasional murderers, named Sailor and Lula. Certainly Lynch shares certain notable thematic interests with Allen: twins, doppelgängers, and recombinant and interpenetrative dyad identities; the aestheticization of graphic violence and sexuality; and the darker mythologies of American vernacular culture and history. The producers of Allen and Byrne's abortive *Juarez* musical theater piece were sufficiently anxious about perceived similarities that they asked if Terry would be open to changing the Sailor character's name (he was not).

Allen is somewhat dismissive of any purported links: "*Juarez* was written long before *Wild at Heart*. A lot of people said that it was lifted from *Juarez*. . . . I saw it, but the name was the only real connection I really saw. . . . But the climate of the thing was like *Juarez*, the violence and sexuality and so forth."

CHAPTER 44

1. *Amarillo Highway (and Other Roads)* also played at Butch Hancock's funky Austin gallery, studio, and shop Lubbock or Leave It and at St. Ann's Warehouse in Brooklyn.

2. Allen met Allen Ginsberg at the premiere of *Pioneer*.

3. John Henken, "Performance Art: Dresher's 'Pioneer' Explores Psychological Frontiers," *Los Angeles Times*, October 17, 1991, https://www.latimes.com/archives/la-xpm-1991-10-07-ca-61-story.html.

4. It was a family affair: Pierce and Gilmore were married for four years in the 1960s.

5. Terry disputes this account, allowing that they argued but claiming it never came close to an actual physical altercation.

6. At the time, Hollywood Records was known primarily for controlling the US rights to Queen's catalog; representing Mickey Mouse Club alumni, Roseanne Barr, and Stryper; and releasing the soundtrack to *Three Men and a Little Lady*.

7. The song, popularized by the Clovers in 1954, likely predated this recording.

8. Among this gang of accomplished drinkers, Tubb—the only trained actor among the original cast, as he liked to remind everyone—reportedly distinguished himself as the drunkest. At call time, Keen and Allen sometimes had to search for Wayne "The Train" around Rittenhouse Square, where he wandered nightly looking to score weed.

CHAPTER 45

1. Soon after they met, enamored of Terry's bronzes, Poss inquired about buying one. "He sent me some slides, and I loved several, but it rather quickly became apparent that they were beyond my budget," said Poss. "But then I spotted a drawing, a study for *Chippy*," a perfect piece to memorialize the occasion of their meeting. When they next saw each other, Barry gamely offered to buy it.

"How much do you want for it, Terry?" Barry asked.
"Oh, let's say seven. Does that work?"
"Absolutely, thank you. Can I mail you a check?"

A couple of weeks after mailing Terry a check for $700, "I received a very nice note back," Poss laughed. "It said, 'Dear Captain Zero, thank you for my down payment.' And he went on to inform me there was another zero on the price." By "seven," Allen had meant $7,000. Poss eventually paid off the bill on an installment plan, but thereafter in correspondence, Terry referred to him exclusively as Captain Zero, a particularly acerbic and amusing sobriquet for someone responsible for paying him royalties. This misunderstanding aside, Barry had already earned Terry's trust.

2. The Allens met Anand Sarabhai, a molecular biologist hailing from a prominent and wealthy Indian family, through his partner and Terry's new Art Foundry buddy, the artist Lynda Benglis. Sarabhai invited them to visit the family's artist residency in Ahmedabad, and when they decided to travel instead to Chennai, where David Byrne would be working, he encouraged them do so. Once they arrived, Sarabhai's promises of support, financial and otherwise, quickly evaporated, leaving them effectively stranded. After leaving, Byrne sent money back to Chennai to bail out Terry's mounting studio costs, and the Allens escaped with the tapes and a pile of credit card debt.

CHAPTER 46

1. "It was a reaffirmation of how much vibrant life is in Mexico, and how corpselike the US is in comparison. . . . On the Mexican side, it was always a celebration, with ice cream vendors and crowds, and on the US side it was so much more constipated."

2. Lloyd, who had met David but never worked with him, was impressed with his idiosyncratic musicianship on the seven tracks on which he sang or contributed guitar, but particularly on "Gone to Texas": "He hung out for a week, and I swear he hardly said a word. . . . He just sat there, playing these muted, percussive backbeats, and he'd turn his head to the right and left on every beat. He did it in one pass and said, 'Is that OK?' It was fantastic—it added a hypnotic dimension I'd have never thought of. . . . I remember thinking *this* is why David Byrne is David Byrne."

For his part, David, who corresponded extensively about both *Human Remains* and *Salivation* with Terry, offering—in addition to his cowrite "Wilderness of This World"—thoughtful compositional, lyrical, and production notes that Allen took to heart, found it difficult to adjust to accompanying his friend in a studio context. Terry's ductile sense of meter and chord duration confounded David: "As a musician, you're expecting the chord to change, but it doesn't. You have to hang with it. . . . That was all very new to me. In the context of Terry singing and performing, it makes total sense, but outside of that, it really messed with my head. Lloyd got a laugh out of that."

3. Byrne wrote "Buck Naked" to sing at the funeral of Boney's sister, the model Tina Chow, who died of AIDS in 1992. Terry dedicated "Hearts Road" to Boney and Tina.

4. "Galeria del Armi" concerns a World War I–era Italian train wreck that Will Sexton read about in an old almanac.

5. Jesse Taylor died of sclerosis of the liver in March 2006.

CHAPTER 47

1. Aptly, Kenyon and Allen's nicknames for each other were "Saint" and "Savior," respectively.

2. Dave Alvin, "Moses on Mt. Sinai: One Night in Italy," in *Juarez*, by Terry Allen, Paradise of Bachelors PoB-026, 2016, vinyl LP, liner notes, 23.

3. The Allens donated the proceeds from their concerts to a charity for indigent residents of the vast municipal Juárez dump.

4. On the Fourth of July, in the midst of the celebrations, Juárez Cartel boss Amado Carrillo Fuentes, known as El Señor de Los Cielos ("The Lord of the Skies") died as a result of complications from extensive plastic surgery to alter his appearance. The retaliatory murders began immediately, and the atmosphere was charged with violence.

5. "England scares me," Allen wrote before leaving. "The first time I was there, my mother died in Amarillo, and I flew back as quick as I could. The second time Boyd.... Now I'm going back the third time."

6. "An amazing collision of feelings, a tornado," he mused in his journal, regretting that Jo Harvey had not been nominated simultaneously. (She was eventually inducted, with Natalie Maines, in 2015.)

7. Recording began the day after Terry wrote to fellow CalArts alum Ed Harris, who had asked him to advise on the script for his forthcoming film *Pollock*: "The main thing I remember is saying the paintings should be the main character instead of the drunk."

8. At the dedication by the Lubbock Arts Alliance on August 29, 1999, when the checker tablecloth was removed, unveiling *Stubb (Bar-B-Que Beyond the Grave)* to the modest crowd gathered, Terry heard a young Black boy exclaim with surprise, "Mama, that's a Black man!" He welled up.

9. "I get super emotional with 'Queenie's Song,'" Allen's grandson Sled told me. "His relationship with dogs, the healing power they have for him, the energy and love he puts into his pets and dogs . . . It's super powerful, what that dog meant to him."

CHAPTER 48

1. One of the earliest references to *DUGOUT* dates to a 1982 interview with Peter O'Brien for his country and folk zine *Omaha Rainbow*: "I've been working on this piece called *DUGOUT*, and I've got a few songs coming out of it. I don't know what it's gonna be yet, but it's based on that idea of my mother coming from a dugout-like structure and my father spending all his time in a whole other kind of dugout. Somehow that word's become a kind of meeting point or focal point between these two people that are still real kind of mysteries to me." (O'Brien, "[Everything on] Terry Allen," 10.)

2. Ultimately, a relative walked Ung down the aisle at her wedding.

3. One by-product of this revitalized art-world visibility was the Panhandle Mystery Band's invitation, extended by dealer Larry Gagosian, to perform at Ed Ruscha's after-party for the opening of his American Pavilion exhibition at the Venice Biennale in June 2005. After their brief palazzo performance, they busked and danced in Piazza San Marco until morning.

4. "What does this mean?" Allen wrote in a journal of the AICA Award. "Is it an insult?"

5. Christopher Miles, "Terry Allen," *Artforum* 42, no. 10 (Summer 2004): 254.

CHAPTER 49

1. Beckett's erstwhile mentor, employer, and friend James Joyce once lived in Bray.

2. The now traditional anniversary charity concert raised $30,000 for the threatened Marfa medical clinic, thanks to prominent Houston criminal defense attorney Dick DeGuerin, who challenged all the lawyers present to match the door revenues. (The lawyer for Waco cult leader David Koresh, infamous murderer and real estate scion Robert Durst, former Republican House majority leader Tom DeLay, and genius country songwriter and musician Billy Joe Shaver, among other high-profile cases, DeGuerin is a Texas legal legend.)

3. When Ryan and Anna Axster married three years later in Malibu, Terry, a newly minted online-licensed "cyber preacher," officiated.

4. The painter Susan Rothenberg married Nauman in 1989.

CHAPTER 50

1. When composer Steve Reich heard the piece, he conceded only that "it's probably music . . . or it could be."

2. Allen also noted the irony of his final project with Jack Lemon, "after all the shit [they'd] been through together," referencing John Wayne, since several film posters featuring Wayne hung in the Landfall studio.

3. Like the radio play *Ghost Ship Rodez (A Radio Play)* (2010), *Bottom of the World* was technically released on TLA, an expedient new imprint named for Allen's initials but not clearly cited in the credits of either album.

4. Ken Johnson, "Terry Allen: 'Ghosts: Works from "Dugout"/"GHOST SHIP RODEZ"/ AND OTHERS,'" *New York Times*, December 12, 2012, https://www.nytimes.com/2012 /12/21/arts/design/terry-allen-ghosts-works-from-dugout-ghost-ship-rodez-and -others.html.

5. Ibid.

6. Ben Greenman, "Terry Town," *New Yorker*, March 4, 2013, https://www.newyo rker.com/magazine/2013/03/04/terry-town.

CHAPTER 51

1. *Road Angel* includes recordings by, among others, Bukka and Bale and Jo Harvey, Dave Alvin, Ryan Bingham, David Byrne, Shawn Colvin, Rodney Crowell, Steve Earle, Joe and Sharon Ely, Alejandro Escovedo, Inara George, Jimmie Dale Gilmore, Butch Hancock, Robert Earl Keen, Lloyd Maines, Delbert McClinton, Bruce Nauman, Michael Nesmith, Joe Nick Patoski, Jan Reid, Al Ruppersberg, Ed Ruscha, Joan Tewkesbury, Jerry Jeff Walker, Doug Wheeler, and me.

CHAPTER 52

1. On Earle's corresponding 2019 tribute album *Guy*—which features a study draw-ing for *Caw Caw Blues* on the back cover—the Allens appropriately reprised their *Austin City Limits* guest appearance by singing on "Old Friends," alongside Rodney Crowell, Emmylou Harris, and Jerry Jeff Walker. On December 1, 2022, Allen and the

full Panhandle Mystery Band returned to the stage of *Austin City Limits* as a headliner for the first time since 1998.

2. By special invitation, Terry performed new friend Jeff Tweedy's "One Sunday Morning" at the Austin City Limits Seventh Annual Hall of Fame induction in October 2021 honoring Wilco as well as his old friends Lucinda Williams and Alejandro Escovedo. Tweedy has also covered "Death of the Last Stripper" from *Just Like Moby Dick*.

3. Allen had cataract surgery in 2017, the prospect of which he understandably found "extremely frightening" as a visual artist. "It doesn't stop once it starts," he warned me. "At a certain age your body crosses over into the garden of weirdness."

4. David Pagel, "Review: The L.A. Art Exhibition that Will Have You Laughing, Gasping and Crying," *Los Angeles Times*, July 16, 2019, https://www.latimes.com/entertainment-arts/story/2019-07-16/terry-allen-review-la-louver.

5. Brett Sokol, "Art Basel Miami, Where Big Money Meets Bigger Money," *New York Times*, November 11, 2019, https://www.nytimes.com/2019/11/29/arts/design/art-basel-miami.html.

6. Daniel Wagner, "The T List: Five Things We Recommend This Week," *New York Times Style Magazine*, January 30, 2020, https://www.nytimes.com/2020/01/30/t-magazine/catskills-nightlife-tlist.html.

7. George Grella, "Panhandle with Care," *The Wire*, February 2020, 18.

8. "Album Releases: Terry Allen, Just Like Moby Dick," *Daily Mirror*, January 17, 2020.

9. John Lingan, "Border Crossings," *Washington Post Magazine*, February 2, 2022, 22.

10. Coincidentally—or not—Paradise of Bachelors also takes its name from a Herman Melville story. It took Allen a long time to come to *Moby-Dick* the novel, but when he finished it, on July 31, 2013, he wrote breathlessly of his awe at its magisterial power: "I've never read anything like it. It annihilated me."

11. Allen's "Pirate Jenny" appropriates only the title of the Brecht and Weill song from *The Threepenny Opera*, which Terry admires. The two songs share nothing else in common beyond general subject matter.

12. The Allens remained productive during the pandemic. Their proudest accomplishment was organizing *Food for Love*, an ambitious benefit livestream that aired on February 13, 2021, and raised nearly $1 million for the New Mexico Association of Food Banks to help fight hunger in every county, Native American reservation, and pueblo in New Mexico, the second most impoverished state in the nation. Everyone they invited answered the call, resulting in an extraordinary lineup of artists that included the Allen family, Marcia Ball, Jackson Browne, David Byrne, the Chicks, Shawn Colvin, Rodney Crowell, John Densmore of the Doors, Alejandro Escovedo, all three Flatlanders, Rosie Flores, Alvin Youngblood Hart, Mickey Hart of the Grateful Dead with Steven Feld, Native hoop dancer ShanDien SonWai LaRance, Lyle Lovett, James McMurtry, Diné duo Sihasin, and Kurt Vile, among many others. Terry sang "Bloodlines." Ali McGraw hosted, and George R. R. Martin, N. Scott Momaday, and New Mexico governor Bill Richardson all made appearances to express their support.

The event was so successful that, as of the time of publication, Terry and Jo Harvey were planning a second, non-virtual installment in Santa Fe.

13. Though somewhat tamed and shrunken by the COVID-19 pandemic, the Allens' sixtieth anniversary party, in July 2022, also took place in Marfa.

14. Pratt is a boatbuilder of some renown who lived in landlocked Fort Davis, near Marfa.

LA DESPEDIDA

1. In his teens, Calder, the younger son of Bale and Jennifer (born on November 9, 2002), added songwriting to his primary pastime of fishing—both activities often pursued in collaboration with his brother Sled. He has since recorded and performed with Panhandle Mystery Band members, including Charlie Sexton, Glenn Fukunaga, Richard Bowden, his uncle Bukka, and his grandfather Terry. As of late 2023, he and the rest of the Allens were in the midst of gradually tracking a "family album" as the Bloodsucking Maniacs.

2. The year 4000 that *The Midnight Hour*—commissioned by the Tia Collection—augurs in some ways resembles the postapocalyptic, post-Christian futures of Walter M. Miller Jr.'s classic *Canticle of Liebowitz* (1959) and Gene Wolfe's twelve-novel *Solar Cycle* (1981–2001).

3. In 2018, Allen wrote of the origins of *JUAREZ* as antirevelation, a "dark swirl of black" that foretold these twelve etchings, which were exhibited at L.A. Louver as part of *JUAREZ: Now and Then* (October 2023–January 2024):

> *JUAREZ* came on like a blindness
> Suddenly exposing all I hadn't seen
> Couldn't see, wouldn't see
> Before it came
> A dark swirl of black—
> That passed through and ravaged
> All the preconceptions of how things
> Were or might be in myself
> And left only hunger and desire and motion
> Into the mystery

INDEX